Sumptuous Arts at the Royal Abbeys
in Reims and Braine

MADELINE HARRISON CAVINESS

Sumptuous Arts at the Royal Abbeys in Reims and Braine

ORNATUS ELEGANTIAE, VARIETATE STUPENDES

PRINCETON UNIVERSITY PRESS

PRINCETON, NEW JERSEY

Copyright © 1990 by Princeton University Press

Published by Princeton University Press, 41 William Street,
Princeton, New Jersey 08540
In the United Kingdom: Princeton University Press, Oxford

LIBRARY OF CONGRESS CATALOGING-IN-PUBLICATION DATA

Caviness, Madeline Harrison, 1938–
Sumptuous arts at the royal abbeys in Reims and Braine : ornatus
elegantiae, varietate stupendes / Madeline Harrison Caviness.
p. cm. Includes bibliographical references.
ISBN 0-691-04058-3
1. Glass painting and staining, Romanesque—France—Reims.
2. Glass painting and staining—France—Reims. 3. Saint-Nicaise de
Reims (Abbey) 4. Glass painting and staining, Romanesque—France—
Braine. 5. Glass painting and staining—France—Braine. 6. Saint-
Yved (Church : Braine, France) I. Title.
NK5349.R3C38 1990 748.594′32—dc20 89–10608

Publication of this book has been aided by a grant from

The Millard Meiss Publication Fund of
the College Art Association of America

Published with the assistance of the Getty Grant Program

Color plates printed by Eastern Press of New Haven, Connecticut

This book has been composed in Linotron Bembo and Weiss

Princeton University Press books are printed on acid-free paper,
and meet the guidelines for permanence and durability of the
Committee on Production Guidelines for Book Longevity of the
Council on Library Resources

Printed in the United States of America by Princeton University Press,
Princeton, New Jersey

10 9 8 7 6 5 4 3 2 1

Designed by Laury A. Egan

THIS BOOK IS DEDICATED TO

Jean Taralon

WHOSE DEVOTION
TO FRANCE'S MEDIEVAL TREASURES
HAS BEEN AN INSPIRATION

CONTENTS

Contents

LIST OF ILLUSTRATIONS

Color Plates

Figures

Black-and-White Plates

NOTE: The medium is stained glass, unless stated otherwise. All photographs of Saint-Remi glass were taken after restoration, unless noted; all those of glass in Soissons show a prerestoration state (i.e., ca. 1920) since unfortunately none were taken after repairs.

PREFACE

Women may, for example, enter academe in the first place and choose a particular field of study following interior promptings alone, without ever asking themselves practical questions about the shaping of a career in their chosen fields. . . . This is a stage of transformation we call loving not wisely—a period marked by women's virtual love relation to the subject matter of their work. That is, our stories show that women . . . view the texts and methods of their chosen fields as all but sacred and the proper objects of loving devotion.

Nadya Aisenberg and Mona Harrington[1]

IN THE 1970s I envisaged a slender book dealing with the glazing campaigns of Saint-Remi in Reims; it would present the observations I was beginning to make on workshop practices, and it would "solve" the vexed problems of chronology. Following a series of heated debates with Louis Grodecki, which were occasionally suspended while I took the train to Reims and climbed round the choir with a Polaroid camera to present "proofs" on my return to Paris, he generously ceded the study of this magnificent glass to me, but not without the warning that no conclusions could be drawn from it; the subject was impossible. He continued to goad and inspire up to his death in 1982; after that it became much harder to disagree with him. My *libellus* remained unfinished, despite the fact that in 1980 I had completed restoration charts for all the windows but a few on the south side of the nave, and had thoroughly combed the archives in Paris, Châlons-sur-Marne, and Reims for restoration documents. Grodecki proved to be right, in the sense that many of the answers we had looked for were not forthcoming, despite some very notable discoveries.

Meanwhile, Saint-Yved in Braine began to hold a compulsive attraction for me. I had resolved to piece together the remnants of its glass that survive elsewhere because of their similarity to the Saint-Remi windows, and I began this work in Soissons in 1979; the survival of at least part of the church at Braine was a pleasant shock, its impact immediate. I could not rest until I had wrenched a new date from its charters, thereby also establishing Agnes of Braine as its patron.

During the fifteen years since I began the field work and archival research that are the basis of this study, the discipline of art history has changed rapidly. By 1980

contextual studies were as dominant in the United States as they had been earlier in England; art was no longer studied only intrinsically, but looked at in a larger historical context that took account of patronage, social and economic conditions, politics, and prevailing modes of thought. It is no longer possible to think of windows in isolation from these factors, even though I do not allow causality between different strands of this cultural fabric. Nor could I view the glass in isolation from an artistic context that included the buildings and all their furnishings and decorations; yet despite the thematic links that I perceived running through each of these buildings, the inference that they were the result of a sustained programmatic intention made me uneasy, and it is one I have wished to avoid.

In insisting on readings of these complexly accumulated monuments as far as they had been "completed" by about 1205, I am influenced by developments in literary theory. A more open hermeneutical approach than that of the traditional archaeologist allows readings even when historical details of chronology or placement cannot be established; it allows us to go beyond uncertainties and ambiguities since they can be dealt with in the general context of interpretive acts. In attempting to give an approximation of medieval readings I have allowed their legendary histories, or myths, greater weight than our "factual" ones, as being truer; and I have aimed at representing a multiplicity of levels because even the most esoteric imagery must have had an impact on an unsophisticated audience.

Rereading my text as it goes to press, eighteen months after its last major revision, I find it curiously postmodern; it has the multivalence of approach and emphasis that one finds in many nineteenth-century studies, just

[1] Nadya Aisenberg and Mona Harrington, *Women of Academe: Outsiders in the Sacred Grove*, Amherst, 1988, pp. 30–31. I am grateful to

have been part of this study and delighted to find how normal my eccentricities are.

as eclecticism in current architecture recalls that of the last century.[2] Yet if postmodern architectural design lacks the structural innovations that were the great contribution of that era, the situation is reversed in the dis-

cipline of art history, now informed by theory to a greater extent than ever before.

Charlestown, Massachusetts *August 1988*

[2] A random example: In an essay by Edward Seymour, "Historical Sketch of the Cathedral," in *The Cathedral of the Trinity commonly called Christ Church Cathedral Dublin*, ed. G. E. Street, London, 1882, pp. 30–31, we are informed that the tomb of Strongbow, conqueror of Ireland in the twelfth century, was the place where "bonds, rents and bills of exchange were usually made" from the sixteenth through the eighteenth centuries. Wisely, no attempt is made to substantiate the historical existence of this aptly named hero.

ACKNOWLEDGMENTS

Many colleagues over the years have helped this study along in specific or general directions. Its genesis is due to Louis Grodecki, who gave me the topic of the Saint-Remi glass, and who helped to institute the conservation program that allowed examination of some, at least, of the glass in the laboratory. Jean-Marie Bettembourg and his colleagues at the Laboratoire de Recherche des Monuments Historiques of the Ministère de la Culture, Direction du Patrimoine, at the Château de Champs-sur-Marne, were generous with discussion and photographs. Meredith Lillich carried out the first examination of the choir clerestory windows with me, in the summer of 1971, and photographed the original borders that we discovered. Jeanne Vinsot, formerly of the Archives Photographiques, shared her notes on Saint-Remi and Soissons with me, and provided negative numbers.

Anne Prache was always ready to discuss or answer questions on Saint-Remi and gave me valuable introductions in Reims. Charles Marq and Brigitte Simon, and their son Benoit Marq, welcomed me to their atelier in Reims on many occasions and made available all the early documentation assembled by Jacques Simon as well as the glass under restoration. M. André, architecte des bâtiments de France responsible for the churches of Reims, lent me his keys to Saint-Remi, acclaimed by one curé as "les clés du paradis." Marc Bouxin facilitated study of objects in the Musée Saint-Remi, even when it was closed for renovation, and encouraged me to publish for the first time the mosaic fragments that he had found in storage, despite his long-term interest in doing so. M. Hubert Fondre arranged access to the Treasury of the Cathedral in the Palais du Tau, and discussed several objects in it with me; he also introduced me to the Sima window in the church of Saint-Jacques. M. Mary has given me slide shows, and supplied many of the color transparencies for the plates. The welcome extended by all of these rémois more than offset the nasty vigilance of M. Massin, abbé de Saint-Remi, who never failed to interrupt my study, in the most extreme case by getting the municipal police to take me into custody when I was examining the glass on the south side of the nave clerestory; this examination, consequently, could never be completed. It will be no surprise that this philistine incumbent had never even heard of Peter of Celle.

In Soissons, on the other hand, I was fortunate enough to have the use of a hydraulic ladder belonging to the local fire brigade in order to examine the upper parts of a choir clerestory window. The mayor, M. LeFranc, and his cultural attaché were most helpful and considerate. My welcome there was entirely due to the goodwill of Jean Ancien, whose years of retirement were dominated by his love of the cathedral and the local patrimoine; his friendship is much missed. His wife also made me welcome in their home, and his daughter, Anne-Marie Ancien, in Reims. Carl Barnes gave much advice and support with the Soissons campaign, both by introducing me to the Société Archéologique as well as to the Anciens, and by his willingness to share his findings on the cathedral. June Lennox in Canterbury also generously arranged access to the clerestory to make rubbings.

Nancy Purinton, one-time student but now conservator of the Norton Simon Museum, helped me during the summer of 1980 with rubbings, measurements, and photography in Reims and Laon. With her cheerful companionship and tireless assistance we got through a daunting amount of work. Who else would respond with a Tarzan call when locked alone in the church at the end of the day by M. Massin? In 1982 my daughter Gwen accompanied me through France and Germany to study comparative material; she carried the camera and tripod, took legible notes, and expressed only surprise when she found we had been in the choir of Cologne Cathedral for six hours without a break. Between 1986 and 1988 my daughter Chantal organized files and printed photographs. I am grateful to both of them for their enthusiasm.

Michael Cothren, Elizabeth Pastan, Anne Prache, and Virginia Raguin read the manuscript at various stages and gave excellent critical advice, which I have taken into account in the final revisions. Ernst Kitzinger read a draft of Chapter 2, which benefited from his criticisms; Daniel Sheerin's liturgical knowledge improved it at a later stage; and Peter Reid has helped with sticky bits of Latin. John Benton and Andrew Lewis commented on a draft of Chapter 3. Catherine Grodecki checked my readings for the texts in Appendix 1. Team teaching, shared reading, and many conversations with Charles G. Nelson have served to steer me toward new ways of thinking about the material.

Several colleagues in the United States have facilitated my examination of glass in collections; the Reverend Pryke was especially helpful with the Pitcairn collection, and the late David DuBon always met my needs for ladders in the Philadelphia Museum. Jane Hayward lent a keen eye at Bryn Athyn, the Cloisters, and Forest Lawn. Robin Zierau examined the St. Louis museum panels with me.

Catherine Brisac has provided a home in Paris during

the many short visits that I have used to check details, consult "last" references, and order photographs. Her conversations about glass have always been stimulating, and she has shared the resources of the Ministry of Culture openly. Claudine Lautier, also of the French Corpus Vitrearum team, has facilitated the ordering of some photographs, as has Chantal Bouchon. Wolfgang Kemp was of great assistance at Marburg, and also generously discussed the ideas for his new book. Peggy (E.A.R.) Brown, Bruno Klein, Naomi Kline, Jeoraldean Mc-Clain, Joàn Vila Grau, and Dr. Fridtje Zschokke have loaned photographs, and my work has benefited from Naomi's study of the glass at Orbais.

Several research assistants have contributed to the work. Ellen Shortell helped me examine the came-mold in Reims. Norma Steinberg and David Yount executed the line drawings. Larry Holloway made many prints from my sometimes poor negatives. Susan Lewis organized the plates in the final stages, and Sharon Worley worked at the word processor. Marilyn Beaven compiled the index.

My investigations have been enabled by numerous institutions not all of which can be mentioned here; it is characteristic of our field that rare manuscripts are made more readily and instantly available than the printed materials in large public collections, yet one is beholden to both systems. Thirteen libraries in France served my needs, and learning to use them sharpened my wits and challenged my determination. The manuscript curators of several provincial town libraries allowed photography as well as study; they include Arras, Reims, and Soissons. Study photographs were supplied, promptly and at little cost, by the Archives Nationales in Paris and by the Archives Départementales at Laon and Reims. Much

bibliographical work was saved at the eleventh hour by employees of the Lost Property Office of the London Underground when my note cards had been stolen; urged on by my sister-in-law, Jenny Harrison, they retrieved them from a trash bin.

A number of grants, awards and gifts have made this work possible. A Tufts University Faculty Research Award in 1978–1979 enabled me to examine some of the Braine glass in U.S. collections, and a National Endowment for the Humanities Summer Stipend in 1979 supported the campaign in Soissons. A Whiting Foundation travel grant in the summer of 1982 enabled me to see a great deal of comparative material, especially in the Meuse basin and the Rhineland. Two sabbatical leaves were supported by American Council of Learned Society Fellowships (with NEH funding), in calendar 1980 and academic 1986–1987, and an ACLS travel grant in 1983 allowed me to share some of my findings on Saint-Remi with colleagues at the Colloquium of the Corpus Vitrearum and the International Congress of the History of Art in Vienna. An anonymous female donor generously supported a leave in the spring of 1988, during which the text and illustrations took their final form. The Getty Grant Program provided a publication grant. Lastly, the Millard Meiss Foundation has provided a subsidy for the plates, administered through the College Art Association.

Humanist scholars are always in debt for the sporadic support that is made available for research. Yet the sacrifices on the part of their families, allowing stipends intended to cover living expenses to be spent instead on photographs and travel, should not be forgotten. For these I am equally grateful.

A NOTE ON THE NUMBERING
OF THE WINDOWS

The system for window numbering that was devised some thirty years ago for the publications of the Corpus Vitrearum Medii Aevi has been adopted here for the Abbey Church of Saint-Remi, with the approbation of Anne Prache, president of the French Committee of the Corpus Vitrearum (Fig. 2). It has the advantage of situating each opening on the north or south side of the building in relation to the axial light (I), and of differentiating upper windows by the use of upper case N and S from lower windows with lower-case n and s; the tribune is designated Nt. I.[1]

No other system of window numbering had been published for Saint-Remi, but the photographic archive of the Ministry of Culture, comprising a black-and-white record of the glass before and after the twentieth-century restoration taken for the most part to scale, had used another scheme. For the convenience of those who need to use these photographs, a concordance of those numbers with the Corpus Vitrearum ones is given here:

MONUMENTS HISTORIQUES		CORPUS VITREARUM
	Retrochoir Clerestory	
Fenêtre I N baie 1		N.VI a
I N	2	N.VI b
I N	3	N.VI c
II N	1	N.V a
II N	2	N.V b
II N	3	N.V c
III N	1	N.IV a
III N	2	N.IV b
III N	3	N.IV c
IV N	1	N.III a
IV N	2	N.III b
IV N	3	N.III c
V N	1	N.II a
V N	2	N.II b
V N	3	N.II c
E 1		clerestory I c
E 2		clerestory I b
E 3		clerestory I a
I S	1	S.VI c
I S	2	S.VI b

MONUMENTS HISTORIQUES		CORPUS VITREARUM
	Retrochoir Clerestory	
I S	3	S.VI a
II S	1	S.V c
II S	2	S.V b
II S	3	S.V a
III S	1	S.IV c
III S	2	S.IV b
III S	3	S.IV a
IV S	1	S.III c
IV S	2	S.III b
IV S	3	S.III a
V S	1	S.II c
V S	2	S.II b
V S	3	S.II a
	Nave Clerestory	
N.1, S.1, etc.		N.XXVIII, S.XXVIII, etc.
N.2		N.XXVII
N.3		N.XXVI
N.4		N.XXV
N.5		N.XXIV
N.6		N.XXIII
N.7		N.XXII
N.8		N.XXI
N.9		N.XX
N.10		N.XIX
N.11		N.XVIII
N.12		N.XVII
N.13		N.XVI
	Retrochoir Tribune	
A		Nt.II a
B		Nt.II b
C		Nt.II c
D		tribune I a
E		tribune I b
F		tribune I c
G		St.II a
H		St.II b
I		St.II c
J		St.III a

[1] Another system, better adapted to the computer age since it uses only arabic numerals, has been adopted by the Inventaire général des Monuments et des Richesses artistiques de la France, and is used in the *Recensement* series of the *Corpus Vitrearum*. At the time of writing it had not yet been applied to Saint-Remi.

ABBREVIATIONS

A.N. Archives Nationales, Paris
B.L. British Library, London
B.M. Bibliothèque Municipale
B.N. Bibliothèque Nationale, Paris
Caviness/Conway Conway Library, Courtauld Insti-
 tute, London (Caviness copyright)

M.C.C. Ministère de la Culture et de la Communica-
 tion, Direction du Patrimoine, Paris
R.C.H.M.E. Royal Commission on Historical Monu-
 ments, England
S.P.A.D.E.M. Service Photographique of the M.C.C.

Sumptuous Arts at the Royal Abbeys
in Reims and Braine

INTRODUCTION

The Issues and Their Background

Traditionally, we would look "up" for authoritative, symbolic, or spiritual objects. . . . The characteristics of our response to objects located within this zone of space reverse those of the democratic, analytic space where faces appear. The upward space is not shallow, nor is it crowded. Details are less important because they cannot be read. It is a crucial fact about most religious art and sculpture that in our modern meaning of the word it cannot exactly be seen.

Philip Fisher[1]

THIS IS the second book in a series of studies of glass painting from the era between the glazing of Abbot Suger's choir at Saint-Denis, toward the middle of the twelfth century, and the glazing of Chartres Cathedral, which was begun about 1200.[2] In style, the glass painting of this era has generally been regarded as late Romanesque or transitional, yet the painters collaborated with the first generation of "Gothic" architects.[3] The problems that these painters addressed are central to our understanding of stained glass as a monumental art form that evolved with architecture in this period. The broad lines of this development were sketched by Louis Grodecki thirty-five years ago.[4] Whereas he saw changes in the design and colors of stained glass throughout the period 1140–1260 as general responses to changes in architectural design, it has been my task to establish for at least two sites—Canterbury Cathedral and now the Abbey Church of Saint-Remi in Reims—how specific were these responses.[5]

Formal and stylistic considerations provide an essential underlying unity for this book, but it is even more concerned with the character of patronage and iconographic choices, and with the intellectual and artistic climates in which the glass paintings under scrutiny were created, factors that are intimately connected with style. It also traces the impact of these programs, not only in the limited sense of their artistic influence, but as powerful spiritual and political "statements" affecting the minds of those who were conditioned by them.

Two important early Gothic sites in northern France are the foci of this study: the Benedictine Abbey Church of Saint-Remi, which in the Middle Ages lay outside the city walls of Reims, and the Premonstratensian Abbey Church of Saint-Yved in Braine near Soissons (Fig. 1). Each has demanded different methods of research. The glass of Saint-Remi has long been justly famous and is frequently referred to in general works.[6] However, difficulty of access and uncertainty about the extent of res-

[1] Philip Fisher, "Hand Made Space," *Arts Magazine* 51 (1977): 97–98.

[2] Caviness, 1977a.

[3] Grodecki and Brisac, 1977, pp. 130–40, 203–14, discussed all the glass of Saint-Remi, and all but the latest group of Trinity Chapel windows of Canterbury in these terms; the latter are treated in Grodecki and Brisac, 1984, pp. 178–80.

[4] Louis Grodecki, "Le Vitrail et l'architecture au XIIe et au XIIIe siècle," *Gazette des Beaux-arts* 36 (1949): 5–24.

[5] For Canterbury, see most recently Caviness, 1982.

[6] Among general works that refer to the high quality of the glass are Didron, 1844, p. 4, fig. 3; Clovis Poussin, *Manuel d'Archéologie chrétienne depuis Jésus-Christ jusqu'à nos jours*, Paris, 1865, p. 80; Viollet-le-Duc, 1868, pp. 420–22, 448; Westlake, 1881, 1: 58–62, pls. XXXIII–V;

torations have prevented its thorough study.[7] The recent publication of a monograph on the architecture, by Anne Prache, made investigation of the glass timely.[8] She charted the rebuilding of the west end and of the choir, and the remodeling of the eleventh-century nave, under Abbot Peter of Celles and his successor, between 1162–1164 and 1190–1195. I have tested whether her comparative chronologies coincide with those that can be independently established for the glazing, where internal evidence exists, and whether her dates can be broadly accepted for the glass. Prache had also broached the problem of restorations to the glass, in a study of the Crucifixion window of the tribune.[9] Louis Grodecki, who had long insisted on the importance of the Saint-Remi glass, published a study of the fragmentary figures in the nave clerestory in which he revived the daring hypothesis that some of the figures predated the renovations of the late twelfth century and might belong to a glazing campaign before 1151.[10] His conclusions merit reexamination.

Unlike that of Saint-Remi, the glass of Saint-Yved is virtually unknown to art historians. Highly praised in the eighteenth century, it was dispersed soon after the Revolution.[11] A few medallions in Soissons Cathedral that were said to have come from Braine attracted the attention of Ellen Beer in her studies of the great rose window at Lausanne, but panels that were created in the nineteenth century were confused with the originals.[12] Even the provenance of the medieval medallions was recently doubted.[13]

It may seem curious to examine two such different monuments as Saint-Remi and Saint-Yved together. At first glance they seem to have nothing in common, and have never been closely associated in historical studies. Indeed, the differences between them cannot be overlooked: Saint-Remi was one of the oldest Benedictine foundations in France, already a repository of ancient treasures, books, and tombs by the second half of the twelfth century.[14] Saint-Yved, though possibly as ancient, was of almost no importance until it came under the administration of the new reformed order of Premonstratensian canons toward the middle of the century.[15] Saint-Remi was closely associated with the archbishops of Reims who, in earlier history had been titular abbots;[16] Saint-Yved was in the diocese of Soissons, and secular patronage was a powerful force. The architecture of Saint-Remi has been placed by Jean Bony among a group of galleried, four-story structures that formed a "resistance to Chartres"; he placed Saint-Yved third, after Chartes and Bourges, among dominant Ile-de-France types.[17] Sculpture at Saint-Remi is of minor importance, the most interesting figural programs being reserved for the monks' choir;[18] the exterior sculptural ornament and especially the portals of Saint-Yved rival those of cathedrals such as Laon and Senlis.[19]

The stained glass of these two monuments, however, has to be treated together. With the redating of the building and the rediscovery of a substantial amount of panels surviving, the Saint-Yved windows can now take their deserved place in the history of glass painting, alongside those of Canterbury, Saint-Remi, Laon, Saint-Germer-de-Fly, Orbais, and Notre-Dame of Paris. As mentioned, the large figures from the clerestory windows first came to my attention because of a close stylis-

Karl Baedeker, *Le Nord de la France jusqu'à la Loire, excepté Paris: Manuel de voyager*, Leipzig, 1884, p. 31; Magne, 1885, pp. 151–52, 159; Merson, 1895, p. 21; Ottin, 1896, pp. 151–52, pl. I; Heaton, 1908, pp. 366–68; A. J. de Havilland Bushnell, *Storied Windows: A Traveller's Introduction to the Study of Old Church Glass from the 12th Century to the Renaissance, Especially in France*, Edinburgh and London, 1914, pp. 297–98; Emile Mâle, "La peinture sur verre en France [de l'époque romane]," in *Histoire de l'Art*, ed. André Michel, Paris, 1905, vol. 1, pt. 2., p. 792; Charles J. Connick, "Windows of Old France," *International Studio* 79 (January–February 1924): 405, 408 (illus.), and Connick, 1937, p. 300, pl. XXXIII; Edmond Harancourt, "Church Windows," *Stained Glass* 18, no. 3 (April 1924): 9; Helen Gardner, *Art through the Ages: An Introduction to Its History and Significance*, 6th ed., New York, [1975], pl. 10.1; Aubert, 1946, p. 18.

[7] For these difficulties, see comments by Grodecki in the literature cited in n. 10. Other important treatments of the glass include Povillon-Piérard, MS 1837, pp. 93–100 (appendix 2); Lacatte-Joltrois, 1843, pp. 83–85; Tarbé, 1844, pp. 431–34; Guilhermy, MS 6106, f. 420; Tourneur, 1856, pp. 88–90; idem, 1862, pp. 87–102; Lacatte-Joltrois, 1868, pp. 61–69; Alphonse Gosset, *La Basilique Saint-Rémi à Reims: Histoire—description—construction*, Paris, 1900, pp. 49–51, pl. XXXII; Louis Demaison, "Eglise Saint-Remi," in *Congrès archéologique de France* 78 (Reims I, 1911), Paris, 1912, pp. 57–106, 92–93; Simon, 1959; Hinkle, 1965, appendix G (n.p.); Lillich, 1970, p. 28, n. 17.

[8] Prache, 1978.

[9] Prache, 1981.

[10] Grodecki, 1975. Earlier studies by Grodecki include 1953, no. 10, pp. 46–47, pl. 7; in *Vitrail*, pp. 105, 108, 109, 117, 130, 140; 1963, p. 134.

[11] Martène and Durand, 1724, 2: 32; Carlier, 1764, 2: 65; Le Vieil,

1774, p. 24.

[12] Beer, 1952, pp. 54–58; idem, 1956, fig. 15, is modern.

[13] Louis Grodecki, "Un Vitrail démembré de la cathédrale de Soissons," *Gazette des Beaux-arts* 43 (1953): 174, n. 8; Ancien, 1980a, pp. 13–18, 96–98.

[14] Saint-Remi was founded as a Benedictine house in the second half of the eighth century by Archbishop Tilpin; an excellent survey of the history of the abbey is given by Prache, 1978, pp. 1–27, with literature.

[15] Most histories treat the early cult of St. Yved (Evodius, bishop of Rouen) in the proximity of the Merovingian castle with brevity; they give more detail after Goslin, bishop of Soissons, introduced the Premonstratensian canons about 1130–1145; see *Gallia Christiana*, cols. 488–89; Hugo, 1734, cols. 394–95; and Château, MS 1019, p. 17. Prioux, 1846, pp. 18–77, is one of the fullest accounts.

[16] Saint Remi (Bishop Remigius of Reims), who had baptized Clovis about 500, was interred on the site in 533 and the church was enlarged and dedicated to him later in the century (Prache, 1978, p. 2); after Tilpin several archbishops were also abbots of Saint-Remi, and many even later were principal benefactors, and chose to be buried there (Prache, 1978, pp. 4–5).

[17] Bony, 1957–1958, pp. 35–43.

[18] For the consoles of the piers that distinguish the first four bays of the nave as part of the liturgical choir, see Prache, 1978, pp. 86–88, figs. 92–99; related figures are in the tribunes (Prache, figs. 90–91). The sculpture of the west facade is limited to two elements of the capital frieze and two large statues, of St. Peter and St. Remigius, set above the portal (Prache, 1978, pp. 56–57, figs. 33–37).

[19] Sauerländer, 1972, p. 429, figs. 73–75; Deuchler, 1973, pp. 55–56, figs. 61, 62, 70. McClain, 1974, is the most detailed study to date. For the ornament, see Caviness, 1984, figs. 3–6.

tic affinity with the work of one of the glass painters at Canterbury of the "middle period," which I placed about 1190–1207. Now, more urgently, the Saint-Yved series demands attention in the context of Saint-Remi: I shall present the working hypothesis that it fits into the chronological development of the rémois atelier, providing the link that was formerly missing between the choir and nave clerestory glazing. Just how close is the affinity between the glass of the two sites is indicated by the long-standing attribution of the head of Abiud in the Metropolitan Museum to Saint-Remi, when in fact it belongs to the Saint-Yved series (Pl. 192).[20] Other attributions, such as that of the small figure of Synagogue in the Glencairn Museum and the ornamental border in the Cloisters, cannot be made to one or the other monument with complete certainty (Pl. 215 and Catalogue D, B/R?b.1).[21] In short, the productions of this atelier, whether from Reims, Canterbury, or Braine, are remarkably consistent.

Saint-Remi and Saint-Yved

ARCHAEOLOGICAL CONSIDERATIONS

The method of study I have used was essentially the same as for Canterbury: Similar emphasis was placed on the degree of authenticity of the surviving panels, but different limitations prevail.[22] There are fewer nineteenth-century drawings than for the Canterbury glass, but some have been found for Saint-Remi (Pls. 95, 101, 102, 162, 172, 176, 187); they are fortunately supplemented by photographs of ca. 1870–1895 that provide valuable insights into the appearance of the glass prior to its damage in World War I (Pls. 92, 93, 103, 127–29, 132–41).[23] For documenting the twentieth-century restorations by Jacques Simon some notes were available in the atelier, and complete photographic records were made for the Archives Photographiques before and after restoration (Pls. 186, 188). It is very much to be regretted that no art historian benefited from the long period, between 1917 and 1958, when the glass was out of the building, and unfortunately none of the personnel, who had handled it at that time was available to examine it with me. The modern replacements in the Saint-Remi glass, however, were not difficult to detect; virtually all the glass was examined at close quarters from the exte-

rior, and, in addition, the tribunes gave access on the interior to the glass at that level. Rubbings made in the course of this examination turned out to be a useful tool by which to study the process of design. Some doubts remain as to the extent of the retouching of the paint in the clerestory figures, but a few panels were fortunately taken down for conservation in 1980; the subsequent technical analyses, carried out in the laboratory of the Monuments Historiques at Champs-sur-Marne, and the opportunity for extended visual study were invaluable (Pls. 70, 75, 76, 83, 86).[24]

The most drastic limitations for the art historian at Saint-Remi have been set by early losses and restorations. Among lost elements are the original stone surrounds of the windows, which would give reliable dimensions, and above all the iron armatures that would have indicated panel shapes and sizes. This is particularly regrettable since there is evidence that some glass survived in the lower openings of the west facade into the nineteenth century and it is likely now to be dispersed in collections. As it is, the glass from the lower windows seems to have disappeared without trace, with two possible exceptions (Pls. 211, 215, and Catalogue C). Nor are there any early descriptions that allow a reconstruction of the iconographic program, as there were for Canterbury.[25] Furthermore, ornament cannot be used as a tool in establishing chronologies of glazing, as it could at Canterbury where it remained in situ; and, disassociated from the figures it once framed, it cannot be used as an additional means of defining individual or shop styles. The rationale has to be reversed, and an attempt is made to classify the surviving ornament according to scale and style in order to place it in an approximate chronology (Chapter 4 and Catalogue D). A similar problem is encountered in relating the programs of Saint-Remi to later ones in the Abbey Church of Orbais and the cathedrals of Reims and Châlons-sur-Marne. It is tempting to designate these as monuments glazed under the influence of Saint-Remi, yet there is some danger of a circular argument, since they might also be called upon to corroborate the suggested reconstruction of the Saint-Remi programs; I will therefore attempt to establish the original placement of the Saint-Remi glass from internal evidence.

The archaeological problems of the Saint-Yved glass were even more difficult than for Saint-Remi. No me-

[20] Following correspondence from L. Grodecki in 1953, Jane Hayward in the *Year 1200* I, no. 202, pp. 195–96, attributed this panel to the choir of Saint-Remi; the two panels that completed the figure she classified as replacements, but closer examination has revealed that they are from another of the Saint-Yved figures. Grodecki reaffirmed the rémois provenance of the head (1975, p. 67, n. 9, and Grodecki and Brisac, 1977, pp. 134, 288, fig. 115). For the attribution to Saint-Yved, see Caviness, 1985, pp. 40 and 46, n. 43, and the section in Chapter 3 on glass surviving elsewhere.

[21] See below, Chapter 4, "Synagogue from a Symbolic Crucifixion Window," and Catalogue C.

[22] Caviness, 1977a, "Methods of Study: Problems of Restoration and the Authenticity of Medieval Glass," pp. 13–22.

[23] A few of these photographs were published in F. Rothier, *Souvenir de l'Eglise St.-Remi de Reims*, Reims, 1896, pls. 4, 13, 14. This brochure gives the information on the title page that the Maison Rothier was founded in 1867; it was at 9 Place Saint-Maurice, Reims. I am grateful to the Société des Amis de Vieux Reims and to the Marq atelier for allowing me to study and copy their set of prints. Unfortunately the negatives were lost, but a set of copy negatives have been made by J. Babinot of Reims.

[24] Unpublished report by Bettembourg et al., 1981.

[25] Medieval records of the inscriptions in the lost typological windows, in conjuction with the original armatures, allowed a detailed reconstruction: Caviness, 1977a, appendix figs. 8–19; idem, 1981, pp. 77–156.

dieval glass survives in the building. It has been laboriously traced so that pieces are now inventoried in half a dozen collections on both sides of the Atlantic (Catalogue A).[26] Nineteenth-century claims that a substantial amount of glass was taken to Soissons Cathedral about 1816 were confirmed by descriptions dated before the Revolution and by measurements at both sites. Panels have indeed been proved to come from each of the three rose windows that were famous in the eighteenth century. Even more satisfying, reconstruction of a series of ancestors of Christ in the clerestory windows, similar to that at Canterbury, complements stylistic affinities noticed earlier.[27] Most important, an excursion into the medieval documents that survive from Saint-Yved led to a new date for the building; the traditionally accepted consecration of 1216 has no foundation in fact, but the building was essentially complete by 1208.[28] An altar was probably ready for use by 1179, and the beginning of construction can be moved back to about 1176 when a papal bull confirmed possession of the land on which the present church stands. Saint-Yved is thus to be reassessed as a precursor of Chartres, and a slightly younger contemporary of Saint-Remi.

CONTACTS BETWEEN THE TWO HOUSES

Once the close visual similarities between the glass at Saint-Remi and from Saint-Yved are admitted, other affinities and links between the two sites emerge. Principal among them are the royal connections of both houses. Like Saint-Denis, Saint-Remi had a number of tombs of Frankish rulers that were refurbished in the twelfth century, about the time of the rebuilding of Suger's choir.[29] Through its possession of the ampulla of oil that was

said to have been brought from heaven by a dove when St. Remigius baptized Clovis, Saint-Remi played a role in the coronations of the French kings, one that was strengthened under the Capetians.[30] Tombs and a liturgical relic also commemorated the royal presence at Saint-Yved; with the exception of Louis VII's brother Robert of Dreux, the prominent members of this line were buried there, and his third wife, Agnes of Braine, was celebrated as foundress of the church.[31] She was also intimately connected with one of its few relics, a host consecrated during a Mass by which some Jews were converted on seeing the crucified Christ appear in it; one of the young women had been taken into Agnes's household because she hoped to convert her.[32] A Mass was instituted in Saint-Yved in 1179 for the soul of Henri de France, another brother to Robert of Dreux;[33] he had been archbishop of Reims during the early years of rebuilding at Saint-Remi, and is represented in the choir clerestory glass (Col. Pl. 5; Pl. 145). Furthermore, the abbot who began that rebuilding, Peter of Celle, was a relation of Agnes of Braine, if John of Salisbury is accepted as a reliable authority;[34] in 1173 he was one of two churchmen sent to Saint-Yved by the pope to adjudicate a quarrel with a neighboring house, and a few years later he lent support to Robert of Dreux.[35]

Another affinity between the two houses, already hinted at, is the rivalry of each with Saint-Denis. The Benedictine houses were almost on an equal footing in terms of antiquity, treasures, relics, tombs, and perhaps libraries; each claimed the relics of an evangelist of the French, each had been a major Carolingian center;[36] each housed a relic that was indispensable to the crown, the oriflamme of St. Denis rivaling the Sainte Ampoule of Saint-Remi.[37] Likewise, both were partially rebuilt and

[26] Caviness, 1985. Some of these finds were reported by Hayward and Cahn, 1982, nos. 46, 47, pp. 124–29.

[27] Caviness, 1977b; idem, 1981, p. 16. I had previously noticed affinities between the style of the "Petronella Master" of Canterbury and that of the choir clerestory glass of Saint-Remi (1977a, pp. 79–81, 98, n. 46) and laid little emphasis on the connection with figures from Braine. In 1975 Jeanne Vinsot visited me in Canterbury, bringing me photographs of the figures in Soissons.

[28] Caviness, 1985.

[29] Prache, 1969, p. 26; she attributed this campaign to Suger's contemporary Abbot Odo (1118–1151) and remarked on the possible connection (p. 73).

[30] Coronations in Reims Cathedral, using the Sainte Ampoule from the abbey, were established custom by 1129; see Péré, 1921, pp. 20–24. The growth of the legend of the ampoule is traced by Oppenheimer, 1953.

[31] The positions and epitaphs of the tombs were recorded in the Herbelin, MS 855, pp. 29–34; see the edition by Prioux, 1846, pp. 312–24. The obituary of Saint-Yved, which included a solemn Mass for the foundress, was edited by Brouette, 1958; see p. 317.

[32] Herbelin, MS 855, pp. 17–21, and the edition by Prioux, 1859, pp. 7–8.

[33] Charter copied into the *Cartulary*, MS 1583 pp. 77–78, no. 39, edited by Hugo, 1734, appendix, col. cccxxv.

[34] Gérard de Martel, "Pierre de Celle à Reims," *Mémoires de la Société académique d'agriculture, sciences, arts et belles-lettres du département de la Marne* 89 (1974): 72, n. 4, misquotes the *Histoire Littéraire de la France,*

Paris, 1817, 14: 237, in attributing the letter to Thomas Becket, although it was edited among his correspondence (*Epistolae et Vita divi Thomae martyris et archiepiscopi Cantuariensis*, Brussels, 1682, 2: 47, no. xxxi). See now the edition and translation of John's letters: W. J. Millior and C.N.L. Brooke, *The Letters of John of Salisbury II: The Later Letters (1163–1180)*, Oxford, 1979, no. 144, pp. 31–37; Morizot, 1939–1942, p. 259, is skeptical of the relationship because he found no archival evidence; but see also Prache, 1978, pp. 30–31.

[35] In a papal bull, Alexander refers to Peter as "dilectus filius"; *Cartulary*, MS 1583, p. 12.

[36] Oppenheimer, 1953, p. 263; Prache, 1969, pp. 73–74, and idem, 1978, p. 26. Wander, 1978, pp. 4, 12–17, has stressed the spiritual affinities, rather than the mere rivalry, that seem to have resulted in the reconstruction of a number of choirs in the twelfth and thirteenth centuries, including these.

[37] Gabrielle Spiegel, "The Cult of Saint-Denis and Capetian Kingship," *Journal of Medieval History* 1 (1975): 60. Philip Augustus was crowned at Reims in 1179, and at Saint-Denis with his queen, Isabella, in 1180, according to Jean-Pierre-François Alexandre Le Noble, *Histoire du Sacre et du couronnement des rois et reines de France*, Paris, 1825, p. 156. Guillaume le Breton mentions both events: *Oeuvres de Rigord et de Guillaume le Breton, historiens de Philippe-Auguste*, ed. H. F. Delaborde, Paris, 1882, 1: 9, 13, 21. A detailed account of the first is in Roger of Hoveden, *Chronica Magistri Rogeri de Hovedene*, Rerum britannicum Medi Aevi Scriptores 51, no. 5, ed. William Stubbs, London, 1869, 2: 192–94. Andrew W. Lewis, *Royal Succession in Capetian France*, Cambridge, Mass., 1981, pp. 74–76, suggests that an early coronation was

refurbished in the twelfth century, each campaign spurring on the next. The claims of Saint-Yved are more humble, but its choice as dynastic pantheon of the House of Dreux is surely connected with the confirmed use of Saint-Denis as the burial place of the Capetian rulers. Significantly, one of the few manuscripts that can be traced with certainty to its library contains texts concerning Charlemagne and Louis le Gros that were written at Saint-Denis in the twelfth century.[38] The grandeur of the Premonstratensian church and its lavish decoration are in scale with these royal pretensions, rather than with its rural setting or ecclesiastical status. To this extent, these religious foundations had become consonant with the public image of their donors.

It is also worth enlarging upon the relationship of each house to England, and especially to the Benedictine Monastery and Cathedral of Christ Church, Canterbury; because I will argue from visual evidence that the same glass-painting atelier worked in all three locations, it is useful to inquire what other ties existed between them. At Saint-Remi, long-standing English associations can be documented. The very letter that helps to date the rebuilding of the west end and choir of Saint-Remi was written by Peter of Celle to Richard, a canon of Merton, Oxford.[39] The eminent humanist John of Salisbury, perhaps this Richard's brother, was Peter's close friend and spent his years of exile, resulting from his association with Thomas Becket, at Saint-Remi; his letter, previously cited, that mentions Peter's connection with Agnes of Braine was directed to Becket. After Becket's martyrdom, Peter wrote twice to Christ Church to report miracles associated with the saint.[40] John of Salisbury had returned from exile about 1169 and was chiefly at Christ Church Canterbury until 1177—that is, during the early campaigns of building and glazing there.[41] In the period of building and glazing

at Saint-Remi there resided in that house at least one English monk, who ostentatiously signed a book in display capitals "Frater Robertus Anglicus."[42]

There were also ties between Canterbury and the Cathedral of Notre-Dame in Reims. John of Salisbury was a close friend of William of Champagne, archbishop of Reims (1176–1202).[43] Another "son of Canterbury" in Reims was Ralph of Sarre in Thanet, who was dean of the cathedral from 1176 to 1194.[44] He gave a manuscript from northern France to Christ Church.[45] These contacts are significant since the two rémois churches were virtually symbiotic in their relationship, the abbey having served as necropolis for the archbishops from earliest times, and they as its titular abbots; even when these titles were separated, the archbishops seem to have been major benefactors of the abbey. The two foundations played reciprocal roles in the coronation of the French kings, because the chrism for unction was kept at Saint-Remi but taken to the cathedral for the rite. Institutionally, therefore, they were almost as closely bound as the monastery and cathedral of Christ Church at Canterbury.

The case for direct relations between Saint-Yved and Canterbury is somewhat tenuous; it will be given more detailed attention in Chapter 4. It came about through the royal patrons, and ties of marriage between the Capetian and Angevin line, rather than through the ecclesiastics. John of Salisbury in the letter cited previously that mentions Agnes of Braine and Robert of Dreux warned Becket that they had sided with the English king, and referred to gifts passing between them. There is an often-repeated claim that Agnes was given the glass for Saint-Yved by her relative the queen of England.[46] Louis VII provides another link, because he was in Canterbury in 1179 and made gifts at the tomb of Becket; he had been an early benefactor of Saint-Yved.[47]

held because of Louis VII's illness, and the need to involve the crown prince in administration; it also, of course, secured the succession.

[38] London, B. L., Add. MS 39646 of the latter part of the twelfth century; a *vita Karoli Magni* was noted in the library at Braine by Martène and Durand, 1724, 2: 25, who recorded the now missing ex libris. See British Museum, *Catalogue of Additions to the Manuscripts 1916–1920*, preface by H. Idris Bell, London, 1933, pp. 123–29; there are correspondences with Paris, B. N., MS lat. 17656 from Notre-Dame in Paris, as well as lat. 12710 which was written at Saint-Denis.

[39] Prache, 1978, p. 37, with discussion of Richard's identity.

[40] See n. 42 below, and Prache, 1978, pp. 34–36. For one miracle, see *P.L.*, 202, ep. 150, col. 594; the miracle occurred at the altar of St. Thomas in Saint-Remi. The other took place at the Abbey of Mont-Dieu near Sedan: Benedict of Peterborough, "Miracula sancti Thomae Cantuariensis," *Materials for the History of Thomas Becket*, Rolls Series, 67, ed. James Craigie Robertson, London, 1876, bk. IV, chap. lxxxvii, p. 252.

[41] Clement C. J. Webb, *John of Salisbury*, London, [1932], pp. 111, 122, 140, 169; see also Caviness, 1977a, p. 58.

[42] An English monk Robert is the subject of Peter of Celle's letter reporting a miracle of Becket to Canterbury (n. 40 above). He may be the same Frater Robertus Anglicus who signed the second volume of a St. Augustine, *Expositio in Psalmis*, Reims, B. M., MS 90, ff. 89 and

201; he added an anathema and the ex libris of Saint-Remi.

[43] Webb, *John of Salisbury*, p. 121; Morizot, 1939–1942, p. 260.

[44] William Stubbs, "Learning and Literature at the Court of Henry II," in *Seventeen Lectures on Medieval and Modern History*, Oxford, 1886, p. 131. He too was a friend of Becket and John of Salisbury; see the *Letters* (n. 34 supra). pp. 188–89.

[45] Probably the Old Testament now in Colorado Springs, Colorado College, in the same style as the "Becket books"; see: *Year 1200* I, no. 240, p. 241.

[46] Hugo, 1734, col. 395 (see Chapters 2 and 4 and Appendix 6).

[47] His pilgrimage to Canterbury to pray for the recovery of his son Philip Augustus was recorded by Benedict of Peterborough; see William Stubbs, ed., *Gesta Regis Henrici secundi Benedicti Abbatis*, London, 1867, 1: 240–42. The gifts he made at Becket's tomb were also recorded in the lost Martyrology of Canterbury; see William Stubbs, ed., *Chronicles and Memorials of the Reign of Richard I*, London, 1865, 2: 557–61. It is erroneous, however, that Louis's vision of Becket is represented in the Trinity Chapel, as supposed by Bernard Rackham, *The Ancient Glass of Canterbury Cathedral*, London, 1949, p. 88, and Grodecki and Brisac, 1977, p. 212; see Caviness, 1981, p. 182. A transfer of land to Saint-Yved was made by charter in 1143; see *Cartulary*, MS 1583, p. 75, no. xxxvii.

WORKS IN OTHER MEDIA FROM
REIMS AND BRAINE

The immediate artistic context of both monuments under purview will be sketched in here. Begun with a view to revealing stylistic and iconographic models for the glass painters, the study of these other works has been as fruitful for their interaction with the stained glass windows in each site.

The uncertain state of our knowledge of scriptoria and metalworking centers in Champagne and the north of France has been a severe handicap.[48] A rapid survey of the manuscripts that survive from the various medieval libraries of Reims has indicated that there is no evidence of a scriptorium at Saint-Remi in the latter part of the twelfth century with a distinctive way of decorating books, nor even can a "rémois" school be defined. This survey, however, is limited in its conclusions because most of the Saint-Remi books were burned in a library fire in 1774.[49] Such diversity as is indicated by surviving books may indicate that few were made in Reims, or that they are products of traveling illuminators.[50] The question of localization, however, is of intrinsic interest, but of little importance for the study of the glass; what is essential is that works such as the Bible from the Abbey of Saint-Thierry or the exquisite Peter Commestor manuscript from the Abbey of Saint-Denis, both in Reims, may be representative of works known to the glass painters (Pls. 156, 250). It would be parochial, however, to restrict comparisons to works of local provenance; other books from the north and east of France must have been known in some form. For Saint-Yved, for which I have found no illuminated books of undisputed provenance, the variety of books made for the Premonstratensian order, their iconographical preferences, and their high quality are all relevant to the glass, but not exclusively of other great books that remain

without secured provenance, such as the "champenois" Bible that imitates the iconographic program of the Bible des Capucins and the Manerius Bible (Pls. 112, 173, 195, 207, 208, 216, 217).[51] I have identified one group of books that have such striking resemblances to the Braine glass that it may be questioned whether they originated there (Pls. 181, 183, 191, 200, 222, 230, 240). Indeed, in the absence of other evidence, an established affinity with stained glass, since its place of production is known, can help to localize manuscripts.[52]

Similar problems are encountered with works in other media, such as the shrines, tombs, and altar furnishings of the two monuments; the Revolution took a great toll. Nonetheless, many ornamental motifs in the glass can be paralleled in metalwork and manuscripts from a broad region extending as far as the Rhine and Meuse. Some objects from the treasury that can be tentatively identified, such as the ivory shrine of Sts. Barnabas, Luke, and Nicaise from Saint-Yved, now in the Cluny Museum in Paris, demonstrate the diversity of styles that coexisted in one site; probably this work is an exotic import (Pl. 61).[53] Many of the choir furnishings of Saint-Remi, such as the fragments of the mosaics and of the great candlestick and remnants of the tombs, predate the major glazing campaigns by a generation; the sumptuous decorations of Odo's choir evidently set a standard for the glass of the later building, which was placed so as to create a luminous shrine around the early choir (Figs. 2, 3; Pls. 24, 25, Col. Pl. 1).[54]

The Larger Art Historical Context

In this section I will digress to sketch in the legacy of related studies, including traditional views of the period, and to survey some material that may not be wholly fa-

[48] Manuscripts dating from the first half of the twelfth century have been easier to localize—e.g., A. Boutemy, "Enluminures d'Anchin au temps de l'abbé Gossuin (1131/1133 à 1165)," *Scriptorium* 2 (1957): 234–48; Farquhar, MS, 1968.

[49] Contemporary accounts of the fire are in Reims, B. M., MS 1426, f. 6, and MS 1492, f. 257; see Henri Jadart, ed., "Journal de Dom Pierre Chastelain bénédictin rémois, 1709–1782," *Travaux de L'Académie nationale de Reims* 110 (1902): 1–181 (p. 143 for the library); N. Humann, "Les Constructions mauristes à Saint-Remi de Reims, "*Mémoires de la Société d'agriculture, commerce, science, et arts du départment de la Marne* 74 (1959): 47, n. 21. B. de Montfaucon, *Bibliotheca Bibliothecarum manuscriptorum nova*, Paris, 1739, 1: 1288–90, 1335, and 2: 1369–75, estimated eight hundred volumes in the library and commented on the most unusual titles. Emile Lesne, *Histoire de la Propriété ecclésiastique en France IV: Les livres, scriptoria et bibliothèques du commencement du VIIIᵉ à la fin du XIᵉ siècle*, Lille, 1938, p. 603, estimated five hundred to six hundred volumes of that period. Other inventories are listed in A.-M. Genevois et al., *Bibliothèques de Manuscrits médiévaux en France relevé des inventaires du VIIIᵉ au XVIIIᵉ siècle*, Paris, 1987, pp. 199–200, nos. 1615–21. I am informed that François Dolbeau has been able to reconstruct the contents of much of the thirteenth-century library. Surviving books from Saint-Remi can be identified through Léopold Delisle, *Le Cabinet des manuscrits de la bibliothèque impériale*, Paris, 1874, 2: 411, and the *Catalogue Général des manuscrits des Bibliothèques publiques de France: Départe-

ments*, 39, pt. 2, Paris, 1905. I have examined many of these.

[50] A Sacramentary, Reims, B. M., MS 307, with illuminations of Ecclesia and Synagoga, and a Crucifixion, was brought from Chartres, according to Victor Leroquais, *Les Sacramentaires et les missels manuscrits des bibliothèques publiques de France*, Paris, 1924, 1: 290–92; the style is close to one hand of the Bible des Capucins (see n. 51–52 below); for an illustration, see Lemps and Laslier, 1978, no. 29 (n.p.). The famous Harmony of the Spheres drawing in MS 672 (my Pl. 111) is now bound in as a frontispiece to an earlier collection (Lemps, no. 26).

[51] Paris, B. N., MSs lat. 11534–35; *Year 1200* I, no. 246, pp. 247–48, and MSS lat. 16743–46 (Capucins), *Year 1200* I, no. 247, pp. 248–49, with bibliography. Newer studies are cited in Chapter 3.

[52] Grodecki, 1963, p. 139, argues that the Bible des Capicins was produced in the region of Troyes on the basis of affinities in style with glass from Troyes.

[53] Paris, Musée de Cluny, no. 1564, purchased in 1846. Sars and Broche, 1933, pp. 263–66, identify this ivory reliquary as one mentioned by Hugo, 1734, col. 403, as a "theca eburnea, arte eleganti elaborata." Birgit Bäusch in *Ornamenta Ecclesia: Kunst und Künstler der Romanik in Köln, Katlog der Ausstellung* ed. Anton Legner, Cologne, 1985, 2: 415, supposes it was made in Cologne in the late twelfth century.

[54] Prache, 1969, pp. 69, 73, has associated the tombs with Abbot Odo and dated them in the second quarter of the twelfth century;

miliar to the general reader. At the same time, some concerns of great import for stained glass design in the early Gothic period are introduced here because they provide essential background for the study of the atelier that worked at Reims, Braine, and Canterbury. In fact consideration of these issues has led me to new observations on the Canterbury clerestory glass, which are presented for the first time here.

FORMAL CONSIDERATIONS IN
STAINED GLASS DESIGN

Taken together, the surviving windows of Saint-Remi and of Saint-Yved provide a wealth of material for the study of glass paintings of truly monumental scale; they were created for the upper levels of two buildings that were preeminent in architectural experiments of the second half of the twelfth century. It will be worthwhile to outline the formal problems that confronted the designers of such windows, before enlarging on the general art historical context in which they worked.

One design problem was that of quantity, the sheer expanse of glass that had to be created to fill the larger number and larger size of the Gothic lancets and roses.[55] Whether glazing such a building took a long time or required a large number of artisans is always arguable; the two variables would be in inverse proportion.[56] However, an increasing tendency to organize large shops to ensure speed and coherence in the execution is to be expected; such seems to have been the case for the Sainte-Chapelle of Paris at mid-thirteenth century.[57] No facts

are documented about the organization of stained glass ateliers, but a great deal can be learned from close observation of their productions about the relationship of design to execution and the adaptation of both to the demands of the architecture;[58] both developments from bay to bay in a single site, such as the choir clerestory of Saint-Remi, and connections established between a shop or shops working in distant sites, such as Braine and Canterbury, can help reconstruct a view of the entire process of design and execution for a series of windows. In an era in which paper for large drawings was not available, and from which no drawings for glass have survived in any form, we can yet perceive the roles played by iconographic guides for the figures, by *moduli* or motif books for figures and ornament, and by full-size patterns or cartoons for both.[59] The full-size patterns may be reused or adapted elsewhere, although if they were on setting boards as the twelfth-century technical treatise by Theophilus indicates, they would be too cumbersome to store long or transport far.[60] Possibly designs were made and conserved on linen. It has been noticed by Demus that in the mosaics of San Marco three groups of designs, spanning the late twelfth to the early thirteenth century, are very closely related to each other, and within the latest group one design is repeated in reverse, a process that linen would allow.[61] In ornamental window borders at Canterbury and Sens, I have observed the use of the same cutline, design, and color distribution, with only a slight change in the style of execution of the leaves; such a small repeating element, however, could have been transmitted full-size on parch-

Erlande-Brandenburg, 1975, pp. 119, 156, is inclined to concur, although he oscillates between ca. 1135–1140 and mid-twelfth century. S. Collon-Gevaert, "Le chandelier de Reims," *Revue Belge d'archéologie et d'histoire de l'art* 12 (1942): 21–30, has suggested a slightly later date for the bronze candlestick, of which one foot is well preserved in the Musée Saint-Remi.

[55] According to *Vitrail*, p. 124, Chartres Cathedral has twenty-six hundred square meters of stained glass in 173 openings; the increase in height of the clerestory and the use there of doublets with roses is as much responsible for the great increase over the previous "generation" of churches as the size of the building. The 104 openings of the choir, eastern transepts, and Trinity Chapel of Canterbury have been contrasted with the 173 openings of Chartres (Caviness, 1977a, p. 4); Noyon Cathedral had at least 36 medallion windows that survived until 1425, according to a document of that date itemizing restorations (Beauvais, Archives départementale de l'Oise, dossier G. 1357, studied by Evelyn R. Staudinger, "Thirteenth Century Stained Glass in Notre-Dame of Noyon," M.A. thesis, Tufts University, 1980, pp. 42–54); the tribune and clerestory, if glazed with figural subjects, would add another 94 bays to the program, giving a total of 130. At Laon, however, the present distribution of colored glass in the four rose windows, and the triplet beneath the east rose, may represent the thirteenth-century arrangement; the three tiers of windows in the longitudinal bays may have been filled with grisaille ornament.

[56] Contrary to suggestions made by Frankl, however, there are no known facts about the rate at which a group of artisans could have produced windows for Chartres Cathedral; he recognized five masters, on the basis of style, and suggested if they worked simultaneously and independently, each producing two windows a year, the nave aisles could be glazed in a year and a half; however, if they were all in one

shop he would prefer to leave six or seven years for the execution. Both formulas are entirely speculative. See Frankl, 1963, p. 816; cf. the critique by Grodecki, 1964, pp. 99–103.

[57] Louis Grodecki has recognized at least three ateliers with distinctive ways of designing windows, and an indefinite number of painters involved in the execution, but he observed that the whole iconographic and decorative program must have been controlled by a single master; see Aubert et al., 1959, pp. 92–93.

[58] For a very astute analysis of the way in which designs were generated in an Austrian workshop of ca. 1340–1350, see Frodl-Kraft, 1985.

[59] The distinction between iconographical guide and pictorial model book, first made by Ernst Kitzinger in relation to Sicilian mosaics, is very useful in glass studies: see Ernst Kitzinger, *The Mosaics of Monreale*, Palermo, 1960, pp. 43, 48–49; Caviness, 1986, pp. 262–66.

[60] Theophilus, bk. 2, chap. 17; see the edition by Dodwell, 1961, pp. 47–48, and by Hawthorne and Smith, 1963, pp. 61 62.

[61] I am extremely grateful to Professor Demus for his comment to this effect following my paper at the Corpus Vitrearum Colloquium in Vienna in 1983. *Moduli* for full-length standing prophets that were designed in the latter part of the twelfth century for the east dome were adapted, by changing the proportions and the style of execution, by later artists for use in the aisles of the west arm; see Otto Demus, *The Mosaics of San Marco in Venice*, Chicago, 1984, 1 (text): 287, and 2 (text): 51–53; cf. 1 (pls.): pls. 70 and 210, 71 and 209, 63 and 212, 62 and 215. The same *moduli* lie behind bust-length prophets in medallions in the First Joseph and Abraham cupolas of the atrium. In this sequence, one cartoon is repeated and flipped; see Demus, 2 (text): 154–56, and 2 (plates): pls. 53, 58, 193, 235–38, 258–60.

ment.[62] I have also suggested that the best working definition for an atelier, to be tested by other examples, is a group of artisans sharing the same models.[63]

The choir clerestory windows of Saint-Remi have now provided the earliest known example in glass of the repetition or adaptation of the same cartoon. In some cases the cartoon is repeated exactly, in some the colors are changed, and in a third type of reuse the proportions are modified in some way (Figs. 6, 7; Pls. 153–155). One of the questions that has to be considered is whether it was merely a need to speed up the execution of the glazing or rather an active pursuit of unity in the overall design that led to these repetitions. The aesthetic principles that essentially distinguish decorative from pictorial art lie in the rhythms established through repetition, and in this sense one sees the atelier evolving toward a decorative mode.[64] So too, most of the revisions made in the process of adapting a cartoon seem to have involved the elimination of detail in favor of bolder and simpler designs, and this might be taken as a sign of haste; but it may be seen in a more positive light as a response to the distance the glass was placed from the viewer.

Indeed, because their work was to be placed in ever vaster interiors, the second new design problem confronting the early Gothic glaziers is that of scale. It would be logical to eliminate detail that was not normally visible to the naked eye. One would also expect adaptations manifested in the planning of larger compositional units, and an impact on the absolute size of design elements, as well as on aspects of execution such as the range and intensity of colors, the boldness of the painting, and the technique used. The need for these adaptations has been remarked by Brigitte Simon in relation to her recent designs for lower windows in Reims Cathedral; she vividly described to me the experience of transporting her first trial panel to the site and finding it created a hole in the wall; neither the colors nor the lead lines and painting were strong enough to carry in that space. A grisaille window on that scale has to contain vivid colors to give the impression of contrasting warm and cool grays and whites, and the linear design has to be stated with great clarity. Another practicing glass designer, Robert Sowers, was first with the insight that the three twelfth-century windows in the west facade of Chartres Cathedral were radically altered to view when the floor level immediately below them was eliminated in the rebuilding, leaving their small-scale narrative medallions suspended above the portals and dominating the entire length of the interior.[65] As he remarked, the result was to subordinate iconographic detail to the general effects of luminous color; or, as might be stated in more formalistic terms, the glass was transformed into texture, serving to dissolve the wall.[66] Indeed, it seems that it was the norm in medieval glazing to fill only lower windows with a number of historiated medallions set in intricate ornament.[67]

The problem of scale is evidently exacerbated in the upper levels of high buildings, in rare glazed tribunes such as that at Saint-Remi; and especially in the clerestories (Pls. 24–26). The large size of these upper windows is compounded by the distance at which they are seen, far above the head of the viewer and frequently across a vast space; they lack the possibility of proximity and intimacy that could allow the eye to travel successively through multiple subjects, as it often does when the viewer stands in an aisle or chapel.[68] Furthermore, figures that are naturally proportioned appear squat, with small heads, when viewed from the pavement, because of perspective distortion. This, as much as the actual size and proportion of the window openings, may have led to experiments with height and proportion in the figures.

TRENDS IN LARGE-SCALE
MONUMENTAL DECORATION

To see the achievements of Saint-Remi and Saint-Yved glass painters in their late twelfth-century context, it will be useful to consider in some detail the treatment of clerestory compositions, including their figure styles, in

[62] Caviness, 1977a, pp. 88–89, figs. 175–78; unfortunately fig. 175 is inverted. No such cartoons on parchment are preserved from before the fourteenth century; one fortuitously preserved in a bookbinding is noted to be transparent, and therefore could be reversed by using it from either side: Eva Frodl-Kraft, "Ein Scheibenriss aus der Mitte des 14. Jahrhunderts," in *Festschrift Hans R. Hahnloser*, ed. Ellen J. Beer, Paul Hofer, and Luc Mojon, Basel and Stuttgart, 1961, pp. 306–16. For the general problem of the transmission of designs in that period, see J. Helbig, "Circulation de Modèles d'ateliers au XIVᵉ siècle," *Revue Belge d'archéologie et d'histoire de l'art* 8 (1938): 113–18.

[63] Caviness, 1977a, pp. 36–37, 84–93; the concept was tested in relation to thirteenth-century Burgundian glass by Virginia Raguin, 1982, pp. 11–12.

[64] These questions have been debated from the mid-thirteenth-century glass of the Sainte Chapelle in Paris. Mâle found it hasty in execution, while admitting that its defects were not noticed by the population at large; see Emile Mâle, "La Peinture sur verre en France [à l'époque gothique]," in *Histoire de L'Art* vol. 2, no. 1, ed. André Michel, Paris, 1906, pp. 380–81; cf. Aubert, 1946, p. 27, and L. Grodecki in Aubert et al., 1959, p. 91.

[65] Robert Sowers, "The 12th-Century Windows in Chartres: Some

Wayward Lessons from the 'Poor Man's Bible,'" *Art Journal* 28 (1968–1969): 166–73.

[66] As used by Paul Frankl, texture is one of the features that distinguishes later Gothic architecture from its antecedents: *Gothic Architecture*, Harmondsworth and Baltimore, 1962, p. 12.

[67] The development that is traced here in clerestory glazing has a parallel in lower windows. There is a trend toward monumentality in figure styles and in ornament; the simplification of vegetal motifs, or their abandonment in favor of geometric designs, saved labor in the execution and increased legibility in the final product. These formal trends have been outlined elsewhere, and need not be reviewed here; see Caviness, 1977a, pp. 43–45.

[68] Even there the impact of the Gothic window is dramatic, as compared with that of its Romanesque counterpart which was set high in the wall and the glass removed from the viewer by a deep sill; see Caviness, 1977a, pp. 84, 139–40. For the enrichment of narrative in lower windows in this period, see M. H. Caviness, "Biblical Stories in Windows: Were They Bibles for the Poor?" in *The Bible in the Middle Ages*, ed. B. S. Levy, Medieval and Renaissance Texts and Studies, Binghamton, 1990 (in press).

the preceding and later periods. It will also be useful to review parallel developments in monumental sculpture. In both, media tensions and conflicts will be noted between the demands of the monumental scale and decorative mode, and those of naturalistic representation.

It was evidently a Romanesque tradition to fill the upper lights with single autonomous figures, either standing or seated, and this type was perpetuated (Pls. 1–9, 11–12, 77–80). Analogous monumental figures had appeared on the upper wall zones of Byzantine and Romanesque churches, as in the procession of saints in the nave mosaics of Sant'Appolinare Nuovo in Ravenna, and in the apse paintings of Catalonia.[69] A closer parallel for the development in glass is in the autonomous figures of contemporary sculpture from northern France, whether the column statues of portals or the larger figures in galleries above. Sauerländer has commented on the fact that the royal statues on the north transept towers of Reims Cathedral were evidently meant to be seen from below and from a great distance.[70] A schematic "development" can be traced from the approximately life-size column statues of the west portals of Saint-Denis or Chartres, which were characterized by exquisite, miniaturesque detailing of the hair and drapery folds, decorated hems, subtly varied textures, and rich, dense ornament in their surrounds.[71] These traits gave way about 1170–1180 to the more volumetric and sweeping forms of Mantes, Senlis, and the Porte des Valois of Saint-Denis; and those, eventually, to the massive, generalized, and almost architectonic figures on the transept towers of Reims and on the portals and gallery of the west facade of Amiens.[72]

Yet to trace "development" in such a straight line is to deny the naturalism of the "proto-Gothic period," an interlude during which, despite the sometimes superhuman scale of the work, artists investigated the fully three-dimensional rendering of forms, the appearance of drapery falling by its own weight or caught across an organically articulated body, or the physiognomy of portraits—in short, the individual nature of things that could be rendered.[73] The Nativity portal of Laon, the central north transept portal of Chartres, the Judgment portals of the north transept of Reims Cathedral, and above all the Visitation by the Antique Master of Reims on the west portal are the epitome of the trend in France (Pls. 13, 14).[74] It is tempting to associate its beginnings in the twelfth century with the revival of humanism in letters, and with the rediscovery of Aristotle's works on the natural sciences, and its dying out in the thirteenth century with the suppression of Aristotle and the rise of scholasticism;[75] yet the naturalistic style was apparently perpetuated in some works, such as the rémois master's, into the 1230s.[76] And from the upper levels of the Gothic facades it has now been possible to recognize several heads from Sens and from the gallery of kings of Notre-Dame in Paris, which span the period ca. 1220 through the 1230s; they are astonishingly realistic in their detailing, in spite of a destined position that did not allow close scrutiny.[77] Amiens appears as a reaction against this mode.[78]

In the creation of large figures for the glazing of clerestory windows, there was also no straight line of development toward monumental concepts. It is a truism that Romanesque styles are essentially abstract and monumental; small objects often impress the viewer with a grandeur that is persuasive of larger size.[79] The earliest

[69] For Sant'Appolinare Nuovo, where the new mosaic program is dated ca. A.D. 560, see Kitzinger, 1977, pl. IV, fig. 106. For twelfth-century Catalonian paintings, see Otto Demus and Max Hirmer, *Romanesque Mural Painting*, New York, 1970, pls. 199–209. The type is not restricted to Spain; other examples from Italy, France, and England are in pls. 85, 187, 233 and fig. 15.

[70] Willibald Sauerländer, "Les Statues royales du transept de Reims," *Revue de l'Art* 27 (1975): 12.

[71] Sauerländer, 1972, pls. 2–3, 8–14 and ill. 1–3.

[72] Ibid., pls. 42–50, 160–71.

[73] One of the earliest studies of this phenomenon dealt with some of the sculptures of the north transept at Chartres: Wilhelm Vöge, "Die Bahnbrecher des Naturstudiums um 1200," *Zeitschrift für bildende Kunst* n.f. 25 (1914): 193–216, translated as "Pioneers of the Study of Nature around 1200," in *Chartres Cathedral*, ed. Robert Branner, A Norton Critical Study in Art History, New York, 1969, pp. 207–32. A review of this and other contributions was given by Louis Grodecki, "La 'première Sculpture gothique': Wilhelm Vöge et l'état actuel des problèmes," *Bulletin Monumental* 118 (1969): 265–89. The phase has subsequently been variously defined as a proto-renaissance of the twelfth century (Erwin Panofsky, *Renaissance and Renascences in Western Art*, Stockholm, 1960 [references are to the paper edition, New York, 1972], pp. 58–81; the "Year 1200" (*Year 1200, I* and *III* but see the criticisms stated by Willibald Sauerländer, "Exhibition Review: 'The Year 1200,' A Centennial Exhibition at The Metropolitan Museum of Art," *Art Bulletin* 53 (1971): 506–7); an anti-Romanesque trend that precedes the Gothic style (Grodecki, 1963, pp. 140–41); and proto-Gothic (Grodecki, 1969, p. 76).

[74] Sauerländer, 1972, pls. 69–71, 199, 202–3, 236–49.

[75] I have associated some of its exponents, notably the Methuselah Master of the Canterbury windows, with the generation of humanist scholars such as John of Salisbury who revived the study of Aristotle's works on nature (Caviness, 1977a, pp. 150–53).

[76] The chronologies have been revised since Panofsky formulated his idea that the humanistic revival in letters occurred well in advance of "intrinsic classicism" in art; see the discussion in Caviness, 1977a, pp. 151–55. The Visitation at Reims is still dated well into the thirteenth century, despite arguments by Hamann-Mac Lean, 1949–1950, p. 230, that it was sculpted ca. 1210 for the north transept portal.

[77] For Sens, see Léon Pressouyre, "Sculptures Retrouvées de la Cathédrale de Sens," *Bulletin Monumental* 127 (1969): 107–18; for the heads discovered in Paris, see François Giscard d'Estaing, Michel Fleury, and A. Erlande-Brandenburg, "Les Statues des rois de la façade de Notre-Dame," *Archéologia* 108 (1977): 20–51, with copious color plates; by the same authors, *Notre-Dame de Paris: Les Rois retrouvés*, Paris, 1977, pp. 34–69; Carmen Gomez-Moreno, *Sculpture from Notre-Dame, Paris: A Dramatic Discovery*, exhibition catalogue, Metropolitan Museum of Art, New York, 1979, pp. 25–27.

[78] Work on the facade of Amiens, traditionally dated in the 1220s, has been moved up to the 1230s by Alain Erlande-Brandenburg, "Le septième colloque international de la Société française d'Archéologie: La facade de la cathédrale d'Amiens." *Bulletin Monumental* 135 (1977): 253–93.

[79] Swarzenski, 1967, p. 12; Margaret Rickert, *Painting in Britain: The Middle Ages*, 2d. ed., Harmondsworth and Baltimore, 1965, p. 85.

surviving clerestory figures, in fact nearly two and a quarter meters (over seven feet) tall, bear this out; for sheer monumentality of conception they stand comparison with the vast prophets in the south transept of Chartres, which are half as large again.[80] They are the four standing figures of patriarchs that survive from the decoration of ca. 1100 in Augsburg Cathedral (Pls. 1, 281).[81] Each is composed of two glazing panels, a straight bar dividing the figure horizontally. Silhouetted on white grounds, the figures are severely frontal, their rectilinear forms alleviated only by the varied curves of their scrolls and by colorful decoration in the drapery. They appear to have been designed in series, so that motifs such as the mantle falling in a v-shape in front of Daniel and David are repeated, but otherwise each figure is varied. Complementary colors of green and red are juxtaposed, contributing to the clarity of the designs. Instead of integrating the lead lines as far as possible with the drapery folds, the designer has made bold use of modular panes that cut across the design in horizontal rows;[82] these are not visually disturbing because of the greater thickness and strength of his painted tracelines. The linear abstraction of the facial features contrasts with subtle effects of modeling in an earlier head of smaller size from Wissembourg.[83] This comparison lends support to the argument that already at Augsburg one can in fact speak of an adaptation of style and technique to the large size and high position of these clere-

story figures, their inherently "Romanesque" character notwithstanding.

No such figures survive in glass from the first sixty years of the twelfth century, unless the early date proposed by Grodecki for some of the Saint-Remi kings and bishops prevails; the complete lack of comparative material is one of the greatest difficulties in deciding the question of their date.[84] Suger wrote of glazing both the upper and the lower windows of Saint-Denis, from the chevet to the west end, but no glass survives from the upper levels; if any was preserved in the thirteenth-century reconstruction, it disappeared after the Revolution.[85] So, too, the famous windows of Conrad's choir at Canterbury, admired by William of Malmesbury, are generally assumed to have been victims of the fire of 1174.[86] For both Saint-Denis and Canterbury, however, the question has been raised whether remnants from their early clerestory programs were incorporated into the later medieval glazing; if so, they help to fill the gap before 1160.[87] On the other hand, arguments that a seated archbishop under a canopy, recorded in a nineteenth-century drawing but not extant, came from the clerestory of Roger of Pont L'Evêque's choir at York Minster are not convincing;[88] the figure panel was less than a meter (barely three feet) high, and the red ground behind the figure as well as the asymmetry of the canopy suggest it was cut down from a narrative scene, as Jeremy Haselock and David O'Connor have remarked.[89]

[80] For the Chartres figures of ca. 1220, see *Vitrail*, pl. xiv, and Frodl-Kraft, 1970, pl. xx. The precursors in the north transept, without figures on their shoulders, are fully four meters tall: Aubert and Claudel, 1937, pl. xiv. The dimensions of the lights are ca. 7.50 meters high and 1.50 meters wide.

[81] Daniel, Hosea, David, and Jonah; the fifth figure, Moses, is a sixteenth-century copy. See Grodecki and Brisac, 1977, pp. 50–54, 269, figs. 36–40, with bibliography and a summary of arguments on dating; other opinions have ranged from ca. 1065, the date of the building, to ca. 1125, on the basis of comparisons with manuscripts illuminated in Hirsau.

[82] *Suevia Sacra: Frühe Kunst in Schwaben, Ausstellung im Rathaus vom 3. Juni–16. Sept. 1973*, Augsburg, 1973, pp. 221–24, pls. I–IV, catalogue entry by Gottfried Frenzel, who was responsible for the latest restoration; the original leadlines are drawn in pl. III.

[83] Now in the Musée de l'Oeuvre Notre-Dame, Strasbourg. Dated by Grodecki and others to ca. 1060: Grodecki and Brisac, 1977, pp. 49–50, 295, fig. 35. Including a modern nimbus, the piece is 25 centimeters in diameter. Grodecki interprets the difference of style between this head and the Augsburg prophets as a sign of an earlier date, rather than of scale.

[84] Grodecki, 1975; he noted the lack of comparative material, p. 76, and proposed a hypothetical date during the abbacy of Odo for the decoration of which these figures were a part (p. 77).

[85] "De Administratione, XXXIV," Suger, 1979, pp. 72–75: "Vitrearum etiam novarum praeclaram varietatem, ab ea prima quae incipit a *Stirps Jesse* in capite ecclesiae usque ad eam quae superest principali portae in introitu ecclesiae, tam superibus quam inferius magistrorum multorum de diversis nationibus manu exquisita depingi fecimus." An alternative, or additional meaning to the phrase "both upper and lower" windows may include crypt windows—i.e., windows of the upper and lower church. The point is discussed by Grodecki, 1976, p. 27.

[86] William of Malmesbury, *De Gestis pontificum anglorum*, ed.

N.E.S.A. Hamilton, London, 1870, p. 138: "Cantiae dejectam priorem partem ecclesiae, quam Lanfrancus aedificaverat, adeo splendide reerexit, ut nichil tale possit in Anglia videri in vitrearum fenestrarum luce, in marmorei pavimenti nitore, in diversi coloribus picturis quae mirantes oculos trahunt ad fastigia lacunaris" ("He rebuilt the destroyed front part [i.e., the choir] of the church of Canterbury, which Lanfranc had built, so splendidly that nothing like it could be seen in England, either for the brilliancy of its glass windows, the beauty of its marble pavements, or the many colored pictures which lead the eye to the very summit of the ceiling"); n. 4 says that the phrase following *picturis* had been crossed out in the Oxford, Magdalen College, MS 172, which contains the author's autograph corrections of ca. 1140. The account was composed about 1125 (p. xiv).

[87] Lenoir indicated figures of French kings, including Pepin le Bref, in the later Gothic triforium at Saint-Denis; Grodecki, 1976, p. 30, n. 26, dismisses the claim, but it is conceivable these were remnants of Suger's clerestory glass reused in the later remodeling of the choir; see Caviness, 1986, p. 268. For Canterbury, see Caviness, 1987, pp. 37–38.

[88] John Browne, *The History of the Metropolitan Church of St. Peter, York*, York, 1847, 2: pl. cxix H (colored lithograph): redrawn in Westlake, 1881, 1: pl. xxiva. The latter, p. 42, suggests that the partly effaced inscription named St. Paulinus or St. Wilfred, but in the Browne lithograph the letters seem to be: CUI: RICHA . . . , evidently not a mere name band. W. R. Lethaby, "Archbishop Roger's Cathedral at York and Its Stained Glass," *Archaeological Journal* n.s. 22 (1915): 45, envisaged two or three such figures superimposed, with "a field of plainer glazing round about, and . . . wide borders."

[89] The scale given in Browne's lithograph indicates a height of 34 inches (88 centimeters), and a width of 10½ inches (27 centimeters). David E. O'Connor and Jeremy Haselock, "The Stained and Painted Glass," in *A History of York Minster*, ed. G. E. Aylmer and Reginald Cant, Oxford, 1977, p. 322; the figure is identified as St. Richarius.

Among the earliest surviving clerestory figures after Augsburg are the ancestors of Christ from the north side of the choir of Canterbury Cathedral, designed I believe as the rebuilding progressed under the architect William of Sens, after the fire of 1174.[90] The series was extended through the eastern transepts and Trinity Chapel, some figures being added at least as late as 1220. This program is the most complete, except for that of the choir of Saint-Remi, to have survived from the era before Chartres; exactly half the figures are extant, although moved to other parts of the building.[91] Each of these important iconographic programs can be reconstructed with a good deal of certainty, and for St. Remi the nineteenth-century photographs provide a visual record of lost figures. The formal compositions are broadly similar in placing two seated figures, in frontal or three-quarter view, one above the other (Pls. 2, 3, 6, 77, 78).[92] The same arrangement can be reconstructed at Braine, and in the nave of Saint-Remi (Pls. 79, 80). The Braine program, with ancestors of Christ, was evidently similar in iconography as well as composition to that of Canterbury. Canterbury, then, has to be considered a possible antecedent for both Saint-Remi and Braine, although its long period of glazing indicates an overlapping chronology, which would allow an exchange of ideas; the latest figures at Canterbury may even depend on chartrain developments.[93]

CANTERBURY CLERESTORY GLAZING

In view of the seminal importance of Canterbury, it will be useful here to summarize the compositional and stylistic developments that occurred during the long period of execution of that series, and to reexamine them for adaptation to the increased height of the building.[94] Three major groups of figures have been recognized, the first from the choir, the second from the transepts and

presbytery, and the third in the Trinity Chapel, which had been closed off by a temporary screen in 1180 so that the choir could be put into use while the construction continued beyond. There is strong evidence that 1180 is the terminus ante quem for the first two groups.[95] The distinctions between the three groups are both formal and iconographic, and style comparisons support a chronology that coincides with a sequence of rebuilding that had begun from the western transept and proceeded east.

The earliest group is from the north side of the choir and comprises Adam, Jared and Enoch, Methuselah and Lamech (Pls. 2, 3), by the so-called Methuselah Master.[96] The design and execution of both figures and ornament are distinctive and of the highest quality. The ancestors are imposing and monumental, their restless sculptural volumes filling half the lancet within an ornamental frame. The same master seems to have supplied glass for the choir aisle windows below, but in the clerestory his figures tend to be more dramatically silhouetted, often with an arm set akimbo and the feet placed on different levels.[97] He used fewer colors in bolder masses in the clerestory, such as green draperies contrasting with white, yellow, or purple, whereas there are subtle tints of pale and deep, warm and cool purple in the lower windows, and even the use of blue in the foreground.[98] The brushwork also seems to be adapted to the more distant view, strong sweeping strokes replacing the richer tonal modeling and variety of textures suggested in the smaller figures.

Also observable is a development between the first lancet of the clerestory of the choir (beginning from the west), for which Adam was designed, and the fourth and fifth lancets. This is immediately apparent in the ornamental borders, which remain in situ (Pls. 2, 3).[99] The first is a rich and delicate design with curling berried palmettes framed by fleshy stems bent in a lyre shape; there

[90] Caviness, 1982, pp. 50–51.

[91] Forty-three of an original eight-six figures survive, at least partially; the proportion at Saint-Remi is higher, with three-quarters of the figures preserved, and almost all prove to be in situ. The most complete description of the Canterbury figures is in Caviness, 1981, pp. 7–62, pls. 2–6, 15–42.

[92] Each of the Canterbury figures from windows to the west of the Trinity Chapel is divided by a straight horizontal bar into two glazing panels measuring about 70 to 75 by 68 to 75 centimeters, giving a total height of ca. 1.45 to 1.60 meters. The Remois lancets are larger; the lateral pair are just over 4 meters high (cf. Canterbury's height of just over 3.5 meters) but they are glazed in the same manner with four panels; the center lancets are nearly 4.5 meters high and each figure is composed of three glazing panels.

[93] Caviness, 1977a, pp. 98–100.

[94] The contemporary chronicles of Gervase, a monk of Christ Church Canterbury, emphasized the increased height of the choir piers, the addition of upper galleries or stories, and the greater height of the building: Gervase, 1879, p. 27; trans. 1930, pp. 20–23. Woodman, 1981, pp. 66–68, discusses the changes in levels.

[95] The evidence is fully presented in Caviness, 1982, and may be summarized: Gervase recounted that the choir was reentered at Easter, 1180, and that the wooden partition had three glass windows in it, an unlikely embellishment if the permanent openings had not yet been

glazed. One window on the south side, probably in the transept, did not have ancestors; the original program, to fit the shorter east end planned by William of Sens, presumably included figures only from Luke's genealogy and one such lacuna was inevitable in a symmetrical plan; these figures must therefore have been in place before English William decided, in the winter of 1179–80, to prolong the Trinity Chapel; this resulted in adding figures from Matthew's genealogy to fill out the series to the east.

[96] Caviness, 1977a, pp. 49–58, 108, 112–14, 120, 123–24, 151–53, pl. I, figs. 1–3, 6, 8, 9, 12, 13, 19, 21, 23, 25, 27, 30, 37, 44, 48, 51, 55, 60, 63, 66. See also Louis Grodecki, "A Propos d'une étude sur les anciens vitraux de la cathédrale de Canterbury," *Cahiers de Civilization médiévale* 24 (1981): 62–63; and Helmut Buschhausen, *Der Verduner Altar: Das Emailwerk des Nikolaus von Verdun im Stift Klosterneuburg*, Vienna, 1980, p. 109, pls. 45, 46.

[97] Compare Caviness, 1981, figs. 155, 156, 162, 165 with the clerestory figures in figs. 14–17.

[98] Caviness, 1981, pls. I, II; cf. V–VIII. The comparatively long wavelength of blue generally makes the eyes focus more distantly than do warm colors such as yellow and red, and empirical knowledge led to its use as a background color. To keep the illusion that a blue is in the foreground, its tint has to be carefully selected.

[99] Caviness, 1981, figs. 6–8, pp. 17, 20–21.

are nearly three units of the repeating design to each glazing panel, whereas in the fifth light (N.XXI) only two elements fit in each panel; this design is composed of simplified palmettes in ellipses. In the adjacent window to the west (N.XXII), the border appears yet clearer and simpler; although the elements are smaller, with three to a panel, they consist of severely geometric quatrefoils of leaves within circles, of a kind that we will encounter again at Saint-Remi (Catalogue D, R.b.11); they are cut from only six shapes and one color is eliminated. This design, rather monotonous from close view, is the one that stands out most clearly from the floor.

Some of the same distinctions can be made between Adam and the later figures (Pls. 2, 3). Adam is the only figure surviving from the first two bays of the choir that were vaulted in 1176–1177; the others are from the third bay, vaulted later in the same year, which encloses two lancets on each side under the sexpartite vault.[100] It is plausible conjecture that the glass in the first bay was critiqued from the floor, and modifications made in the design and execution of the work in progress.[101] The most obvious change is one of scale: Adam is smaller than the other figures; he stands in a garden landscape to till the soil and a tree fills much of the right half of the panels, whereas the other figures occupy the whole field. Adam's name band floats above him, whereas inscriptions are placed behind the heads of the other figures, to save space. The painterly execution of Adam is miniaturesque. The hair and beard are finely stranded, more like those of Herod in the scenes below than like Jared or Methuselah, and they are cut from the same light purple glass as the face, though painted brown to distinguish them from the flesh tone; the locks of most of the ancestors had to be separately cut and leaded, because they are deeper but less naturalistically colored and stand out more dramatically.[102] The fine tufts of Adam's goatskin and the legs that dangle from it, as well as the intertwined branches and delicate foliage of the tree, are scarcely visible from a distance.

It is also important to note that the Methuselah Master did not begin with the concept of a uniformly seated position so it is unlikely that an earlier series was a common source for both Canterbury and Saint-Remi. The Canterbury Master used an ancient manuscript as an iconographic guide, the Anglo-Saxon Cotton Aelfric; it offered a choice in some instances between a seated and

narrative posture for the ancestor, and here he consistently preferred the narrative to the static mode.[103] Adam, however, is the only one without a throne or bench; the Creator above him may have been enthroned as in the Byzantine tradition, but more likely was based on the stooped image on the Cotton Aelfric.[104] For Jared the iconographic guide offered only the possibility of a seated patriarch, but for Enoch the glass painter could choose over this the dramatic moment of the patriarch's ascension to heaven, his arm grasped by the hand of God issuing from a cloud. This time, however, he adapted his model more radically, to achieve a compromise within the seated posture: Enoch is pulled from his throne instead of ascending a ladder. An Evangelist startled by divine inspiration might have been the pictorial model.[105] The fusion of types is ingenious, because it increased the formal unity of the series. It also allowed Enoch to be scaled with Lamech, with whom he was paired in adjacent lights of the same bay, and whose restless posture almost mirrors his (Pl. 3). Despite the individual character of each figure, it is evident that Jared and Methuselah were also designed as a pair, placed in the original arrangement above Enoch and Lamech. They adopt similar postures and each is clad in green and white; warmer color masses of purple and yellow are introduced into the lower pair.[106] Each of the figures was worked up from an entirely new cartoon, and based on a different model, but it is evident that as the glazing progressed the designer began to take into account the unity of the lights paired within a sexpartite vaulted bay.

The Methuselah Master seems to have left the Canterbury shop abruptly after the completion of the choir glazing; Noah, originally set in the first lancet in the northeast transept, was probably designed by him—the posture is based on the same iconographic model that had guided him in the choir figures—but the painterly execution is by a different hand.[107] There seems even to have been some confusion in the glazing of this bay: The figures in this window and the one facing it invert the normal order, so that the earlier ancestor is placed in the lower half.[108] Perhaps in adjusting the design of Noah for this position, and in order to accommodate the extra height of the transept clerestory lancets, a simple trilobe arch was placed over the figure. This bay had been vaulted just after William of Sens fell from the scaffolding in the adjacent crossing bay in 1178, and it is likely the glaziers had not yet caught up with the masons.[109] It

[100] Gervase, 1879, p. 20; trans. 1930, p. 11: "Deinde fornicis magnae tres claves, a turre scilicet usque ad cruces" ("after that, three keys of a great arch, namely, from the [Great] Tower to the crossing"). For a plan with vaulting, see John Newman, *The Buildings of England: North East and East Kent*, Harmondsworth, 1969, p. 165.

[101] Copies, made from tracings in the twentieth century and placed in the clerestory windows, are extremely helpful for an understanding of these effects; only two original figures remain in situ, in the transepts: Isaac (N. XIII), Rhesa (S. XIII); Caviness, 1981, pp. 33, 58.

[102] Typically deep purple, yellow, or even green.

[103] Caviness, 1977a, pp. 11–15, figs. 7, 11, 15–17, 69.

[104] Illustrated in Don Denny, "Notes on the Lambeth Bible," *Gesta*

16 (1977): fig. 17.

[105] Cf. St. Mark in the Ottonian Gospels, Munich, Bayerische Staatsbibliothek, MS 4454; see George Leidinger, *Miniaturen aus Handschriften der bayerischen Staatsbibliothek in Munchen*, Munich, 1922 6: pl. vi, 16.

[106] For color reproductions, see Caviness, 1981, pls. I, II (Jared and Methuselah).

[107] Caviness, 1977a, p. 52, figs. 66, 69.

[108] Caviness, 1981, pp. 22, 32: Shem and Noah in N.XX, Jacob and Isaac in N.XIII.

[109] Gervase, 1879, pp. 20–21; trans. 1930, p. 13. William of Sens continued for a time to direct the work from his sick bed: "Magister

seems that the Methuselah Master's departure coincided with that of the first architect, and that he was replaced by a team who worked rather hurriedly in order to complete the transept glazing by Easter 1180.

From this point in the transept the character of the work changes radically, demarcating a second group which extends through the presbytery.[110] Canopies continued to be used; initially a convenient way to fill the taller lights of the transepts, they were also included in the designs for the shorter presbytery windows.[111] The figures of this group are less active, less involved in space, and less massive than the first; they tend to be contained in a closed outline, although the draperies and some angularity in the limbs create surface tensions (Pls. 4, 5). The iconographic guide used by the Methuselah Master was abandoned in favor of a more homogeneous type. Almost all the ancestors hold scrolls and gesture with one hand; some are frontal, although most turn their heads in the direction of the eastern axial window.

Although these figures are less powerful than those of the choir, there are trends that suggest an adaptation to their clerestory position; they are notably more narrow-shouldered and attenuated than the earlier group and consequently look less squat in proportion when seen from below. Variations of the same posture and drapery system in Thara, from the north transept, and Phares from the presbytery may be interpreted as essays in counteracting perspective, although they are evidently not by the same designer (Pls. 4, 5). On the other hand the small, delicate face of Phares and the minutiae of folds in the drapery are not successfully adapted to the distant view. Other figures do show a cursoriness and boldness in the execution, with simplified facial features and drapery folds. This feature is more apparent in figures such as Semei and Joseph from the south transept than in those from the north, and may have been a progressive trend.[112] It might also be related to the haste with which the new architect, English William, had to prepare for the reentry into the choir at Easter 1180.[113]

It is not possible to establish with certainty when glazing was resumed in the part of the building beyond the temporary screen that closed off the presbytery in 1180. A halt in glazing activity is probable, perhaps extending beyond the completion of the building in 1184, because of financial duress and political disturbances.[114] Presum-

ably it was once more underway by 1200, but it must have been broken off again by the Interdict and exile of the monks between 1207 and 1213.[115] The dating of these windows will have to be reconsidered later, in light of the related figures from Braine, but it will be useful here to review the compositions and styles of these eastern bays.

Rather astonishing revisions of the formula for the seated ancestors occurred in this third group, in the Trinity Chapel. The lancet windows, made in this part of the building, according to English William's design, rise to a higher pointed arch in a slightly taller clerestory wall, and they are narrower.[116] Curiously, in light of developments in other early Gothic monuments, instead of attenuating the figures or providing taller canopies over them, the glaziers of the third campaign at Canterbury elected to frame them in varied geometric compartments, paired in each lancet and constructed with curved-bar armatures, in contrast to the straight bars of the first two groups.[117] These compositions reduced the actual size of the seated figure, and provided for the first time in the clerestory an ornamental field as well as a decorative border (Pl. 6). The ornament in the series passed through a standard development, from richly curled and intertwined vegetal fronds in the westernmost lancets to geometric designs in the apse, indicating a west-to-east chronology, but the development in the figures is neither as clear nor as consistent.[118] In many there is a reintroduction of active poses, reminiscent of the first group, but more elegant in gesture and decorative effect. The figures are not involved in narrative events, but some hold attributes that remind the viewer of their story. Thus Josiah displays the scroll of Hebrew scripture that he discovered in the Temple and his companion, Hezekiah, the sundial that foretold his return to health, but both figures remain seated. These changes might be imputed to the use of a different iconographic guide since some figures are taken from Matthew's genealogy instead of Luke's, but this would not explain the introduction of geometric frames and the concurrent elimination of canopies throughout the Trinity Chapel, involving figures from Luke as well.

As in the transept and presbytery, several hands seem to have participated in the design and execution of this third group; after the four windows in the first sexpartite

tamen in lecto recumbans, quid prius, quid posterus fieri debuit ordinavit. Factum est itaque ciborium inter quatuor pilarios principales; in cujus ciborii clavem videntur quodammodo chorus et cruces convenire. Duo quoque ciboria hinc et inde ante hiemem facta sunt." No more was done that year, and William returned home to France.

[110] Caviness, 1977a, pp. 60–62, figs. 67–86; Caviness, 1981, pp. 15–16, pls. III, 7, 8, 15–20, 36–42.

[111] The choir and presbytery windows are ca. 3.65 meters high, as compared with 4.06 or more in the transepts.

[112] There is no reason a priori to suppose that the south side was glazed later than the north, but the stylistic progression seems to follow the iconographic sequence of the figures.

[113] Gervase, 1879, p. 22 (idem, 1930, p. 14), stressed the great

amount of work to be done and the necessity for haste: "Chorum itaque, cum summo labore et festinatione nimia utcunque vix tamen praeparatum, vigilia Pasche cum novo igne intrare voluerunt."

[114] Caviness, 1977a, pp. 24–25, 30–32.

[115] Ibid., pp. 25, 32–35. These events have been associated with breaks in the glazing, and with continental influences; the results were summarized on p. 154.

[116] Caviness, 1981, fig. 2b; the height of these lancets varies but it is generally ca. 3.70–3.75 meters (cf. 3.65 meters in the presbytery).

[117] The armatures are illustrated together in Caviness, 1977a, appendix fig. 5.

[118] Caviness, 1977a, pp. 98–100, figs. 151–53, 213–18; Caviness, 1981, pp. 36–55, pls. 21–35.

bay, the head of the shop must have imposed an ordered repetition of compositions in facing windows, which lent an impression of unity. The general character of the work is miniaturesque and decorative, apparently antithetical to monumental trends elsewhere, as Grodecki has remarked.[119]

The suggestion has been made, however, that some of the figures from the Trinity Chapel had survived from the earlier building and were incorporated here both to save money and labor and out of deference for their age.[120] The figure of Abijah, especially when the original head that is now lost is replaced in the photograph, is strikingly like wall paintings in the crypt Chapel of St. Gabriel, which have recently been dated about 1155–1160; among "archaic" features for 1200 would be the rosette decorations on Abijah's thighs, the elliptical folds in his mantle, and the geometric abstraction of the facial features (Pl. 7). A date range of ca. 1155–1165 would be acceptable on stylistic grounds.[121] This may be too late for St. Anselm's choir, which William of Malmesbury said was resplendent with glass in 1125, but decoration and conventual projects continued under Prior Wilbert (1153–1167).[122] The small size of the figures, little over a meter high or two-thirds the size of those from the transepts, could have been accommodated two by two in the clerestory of Anselm's choir as reconstructed by Francis Woodman, if it had not been completely glazed by 1125.[123] The grounds, which now describe a lozenge or ellipse, and some of the drapery might be imputed to a restoration at the time of their reinstallation.[124] According to this hypothesis the desire to incorporate these smaller figures after 1180 would have dictated the scale throughout the Trinity Chapel and therefore would have suggested the compositional solution of geometric forms that reduce the central field of the windows.

The decision to use this compositional type seems to have been made after the first pair of figures had been designed; Amminadab and Nahshon, from the first lancet on the north side over the steps up to Trinity Chapel, conform in height and type to those in the presbytery

and transepts; they are quietly outlined and hold scrolls, and the lower figure has an abbreviated canopy (Col. Pl. 9, Pl. 78). They are frames, however, in curved vertical bars, which are reflected in the leading and placement of decorative red roundels in the blue ground. Although we shall see that the figure type, the glass itself, and the painting style are entirely consistent with works from Braine, the grounds, like those of the "archaic" figures already discussed, may have been adjusted to the new compositional schema some time later.[125] It will remain to consider this chronology in light of the French material, including compositions in the nave clerestory of Chartres, which I have previously indicated as possible antecedents for the Trinity Chapel type.

CLERESTORY GLAZING ON THE CONTINENT

In fact, monumental figures in straight-bar armatures remained the norm for upper windows on the Continent during the late twelfth and well into the thirteenth century. Both Braine and Saint-Remi conformed to this type.[126] They were also briefly in vogue for lower windows: Two standing figures of St. John the Evangelist and St. John the Baptist from the second half of the twelfth century, now in the transept in Strasbourg Cathedral, are relatively small, although each is composed of two panels of glass (Pl. 8).[127] Far from expanding on the monumental tradition of Augsburg, these figures with their multicolored grounds and marbled columns are delicately executed so as to resemble manuscript illumination or metalwork; their halos are painted with beaded edges, resembling granulation, and with petalic forms as produced in repoussé. The predominance of white and yellow brings to mind silver and gold. The figures, however, are naturalistically proportioned, their volumes revealed by damp-fold drapery. They bring into focus the conflict that surfaced around 1200 between naturalism and abstraction already referred to in relation to sculpture, because they make no concession to monumentality.

[119] Grodecki and Brisac, 1977, pp. 210–11.

[120] Caviness, 1987, pp. 35–38.

[121] The later range is suggested by affinities with the Eadwine portrait, such as the folds in Rehoboam's mantle as compared with the lectern cover, or the elliptical contour of Abia's and Eadwines's thighs. The portrait, in the second copy of the Utrecht Psalter, Cambridge Trinity College, MS R 17.1, f. 283v, is now convincingly dated after the rest of the text and illustrations, about 1170, in part on the basis of comparison with the Copenhagen Psalter; see George Zarnecki, "The Eadwine Portrait," in *Etudes d'Art mediéval offertes à Louis Grodecki*, ed. Summer McK. Crosby, André Chastel, Anne Prache, and Albert Chatelet, Paris, 1981, pp. 93–98, with a note by Christopher Hohler, pp. 99–100. See also C. M. Kauffmann in Zarnecki et al., 1984, p. 119. For the new dating of the St. Gabriel's Chapel wall paintings, see Deborah Kahn, "The Structural Evidence for the Dating of the St. Gabriel Chapel Wall-Paintings at Christ Church Cathedral, Canterbury," *Burlington Magazine* 126 (1984): 225, 228–29.

[122] The choir was not completed by Anselm's death in 1109; it was dedicated in 1130. Robert Willis, *The Architectural History of Canterbury Cathedral*, London, 1845, pp. 17–19, gives the history of these cam-

paigns and cites Gervase for the dedication date. Woodman, 1981, pp. 76–86, has enumerated Prior Wibert's new works, including the Water Tower, vestiarium, and Aula Nova and attributes some of the reused sculpture found in the cloister to his priorate (fig. 56).

[123] Woodman, 1981, pp. 66–67; the levels in St. Anseln's choir are predicted from those preserved in the northeast transept stair turret, giving a clerestory wall 3.05 meters high. This would easily allow windows with two superimposed figures 1.09 meters high and a border.

[124] The iron bars that now divide these figures horizontally may also be due to compositional changes in the thirteenth century.

[125] The cutline and red roundels describe arcs in parallel with the bars, and thus the background must have been replaced at the time of the adaptation to the new format.

[126] No examples of the Canterbury type of curved-bar armature with two or more superimposed figures are to be found on the Continent.

[127] Grodecki and Brisac, 1977, p. 292, pl. 146 (dated ca. 1190–1200); they are only 1.15 meters high, and probably came from the Chapel of St. John, demolished in the thirteenth century. See also Beyer et al., 1986, figs. 8, 15, pp. 77–84, where they are dated ca. 1150–1176.

More than twice as large, the figures of seated and standing saints, patriarchs, and emperors now in the north nave aisle at Strasbourg are more brilliantly colored and less volumetric (Pl. 9).[128] The glass painters have leaded their eyes and hair as separate colored elements from the faces and simulated jewel work is arranged in broad flat bands of strongly painted detail. Perhaps a decade later than the Sts. John, it is tempting to see a development here toward a more monumental figure type, in response to the size of the window; yet it is notable that they seem to have been made for both the aisles and the clerestory of the Romanesque nave. The emperors appear quite satisfactorily incorporated into the later thirteenth-century rebuilding, with Gothic canopies and abstracted borders added as filler, except that their position in an aisle appears anomalous: The standing figures occupy three panels, to a total height of nearly three meters (nine and a half feet), a very unusual size for lower-window compositions. The program of which they were originally a part, in the Romanesque nave, has often been compared with that of Saint-Remi, since it comprised both patriarchs and medieval kings.[129] Both the iconographic and the stylistic relationships deserve reexamination, with the aid of the new study of the Strasbourg glass by Victor Beyer and Christiane Block; following Zschokke, they envisage a single figure in each light, comprising seated apostles in the clerestory, with standing prophets or kings in the aisles.[130]

The type of composition used at Canterbury, Reims, and Braine, with two seated figures in each light of the clerestory, could be adapted to varied iconographies. Despite its flexibility, however, it seldom appeared in later monuments, except in the Abbey Church of Orbais and in Reims Cathedral, both of which may be directly connected with Saint-Remi (Pls. 143, 283). Theoretically, the glass of Saint-Yved could have influenced the clerestory of Chartres, because the impact of its architecture is now apparent. Yet the designers at Chartres adopted a bewildering variety of compositional types, even within restricted areas such as the nave or in such discrete units as the doublets of the straight bays. The

nave lights are most frequently dominated by a very large single standing figure under a canopy, with a subsidiary figure or scene in the foot of the light (Pls. 11, 277). The arrangement might stem from other monuments, such as Strasbourg, but the closest analogue is in the chartrain sculpture; on the north and south transepts canopies were developed over the column statues, and console figures were placed at their feet. Indeed, some of the figures in glass seem to recall sculptural folds and distribution of weight, as if some of the portal figures were the immediate inspiration for the painters (Pls. 10, 11).[131] Only two of the twenty-six lights in the nave present two superimposed seated figures, under canopies; the arrangement recalls that of the transepts of Canterbury (Pl. 12).[132] Others of the Chartres nave lights have three seated figures, or two or three pairs of figures, superimposed in each case; they are framed in varied geometric medallions and thus resemble the Trinity Chapel of Canterbury, except that the armatures are not curved to conform to the geometries but are rather of the time-saving straight-bar type.[133] There is no sign of a progression at Chartres from one type to another, in line with the Canterbury chronology, nor is there any indication of internal development of the kind we shall follow at Saint-Remi. As an alternative to autonomous seated or standing figures, narrative scenes are also introduced; in the nave is one large-scale rendering of Abraham sacrificing Isaac, reminiscent of the new narrative interest of the north portal column statues;[134] in the north transept and in the choir, narrative series in medallions fill some lancets, several of them pairs.[135] The only consistent design principle throughout the Chartres clerestories is the use of straight bars in the armatures that provide a modular structural unit, dividing medallions and figures alike into anything from two to seven panels.

The various compositional types offered at Chartres do not lend themselves to chronologies argued on the basis of formal development, whether internal or reflecting varied sources.[136] It would equally be an anachronism of twentieth-century art history to interpret the

[128] Zschokke, 1942, with reconstructions of the original compositions, figs. 37–42; Grodecki and Brisac, 1977, p. 293, pls. 147–48, 152.

[129] Grodecki, 1975, p. 65; Grodecki and Brisac, 1977, p. 293.

[130] Beyer et al., 1986, figs. 10–11, pp. 28–29; pp. 150–51, 155–62, 182–200, and figs. in text.

[131] The apostle illustrated here, from the north side of the nave, is not directly copied from a sculptural model at Chartres, but seems to have been designed according to the same tenets, and with reminiscences of several figures from the central north portal of about 1205–1210 (cf. the turn of the head of Abraham, the pleated folds of the mantle of "Isaisah"; Sauerländer, 1972, pls. 82, 83). Grodecki, 1978, pp. 57–58, figs. 24, 25, 27, has compared the south transept clerestory window with St. Denis and a knightly donor (Baie 102) with the statues of St. George and Theodore added to the south portal about 1230–1235, and postulated that the same designer may have been involved.

[132] The paired lancet to Baie 156, no. 155, has a similar figure of Christ in Majesty in the upper half, but two scenes of the life of St. Martin in the lower; Delaporte and Houvet, 1926, pl. cclxv. On the south side of the nave, in Baie 78, are seated figures of Bartholomew

(above) and Moses, but they are almost entirely hidden behind the organ; Delaporte and Houvet, 1926, pl. clxxxix.

[133] On the north side, Baies 173, 168, 165; Delaporte and Houvet 1926, pls. cclxxiii, cclxx, cclxviii; Caviness, 1977a, p. 100, figs. 212, 213.

[134] Baie 158; Delaporte and Houvet, 1926, pl. cclxv. The upper part of Abraham has been renewed, but the outlines of the scene are authentic. Cf. the same subject in the north portal sculpture, Sauerländer, 1972, pl. 82.

[135] Baies 152, 153, 149, 150, 136, 137 in the transept; Delaporte and Houvet, 1926, pls. cclxii–iii, cclix–x, ccxliv–v. Baies 112, 127, 128, 133; Delaporte and Houvet, 1926, pls. ccxx, ccxxxv, ccxxxix.

[136] In a posthumously published article, Frankl argued that there was a development from Romanesque additive compositions to Gothic unified compositions in the lower windows following a chronology from east to west: Frankl, 1963, pp. 301–22; see also the critique by Grodecki, 1964, pp. 99–103. Arguments for a west to east chronology, however, are more cogent, based on style and ornament.

phenomenon of Chartres as experimental or problem-solving, in the sense that there was an intention on the part of the artists to investigate new forms and try out a variety of solutions. The primary choice—one presumably made here by the individual donors—was that of subject matter, whether iconic or narrative; the number of figures to be included, and therefore the amount of space allowed to each, may also have been a part of that choice. It seems that the lack of a coherent iconographical program, such as existed at Canterbury, absolved the various ateliers at Chartres from the necessity to work out consistent formal solutions. In the Chartres nave, however, there is a subtle dovetailing of composition and execution in that one atelier is not only distinguished by its figure style and color harmonies, but also by a preference for small paired figures, as if it specialized in a certain kind of composition.[137] There is a lack of formal, stylistic, and iconographic unity within each doublet and rose composition in the nave; this may result from haste in the glazing, since simultaneous commissions to more than one shop would save time in the execution.[138] The only real change in attitude during the glazing of the entire clerestory is in the treatment of most twin lancets in the transepts and choir as iconographic and compositional units.

That form cannot be separated from content in medieval art is not a new observation.[139] The intimate connection is corroborated by an example contemporary with Chartres where an iconographic program was adhered to in the clerestory. The Cathedral of Saint-Etienne at Bourges in fact has two upper levels of glazing, one in the clerestory of its inner aisle, the other in the central vessel.[140] Each has triplets of lights with single standing figures under canopies. In the choir, the Virgin and Child are flanked by prophets to the north and apostles to the south; in the aisles Christ with the Virgin and St. Stephen are surrounded by bishops of Bourges (Pls. 279, 280). The entire program may be seen as an adaptation from Saint-Remi, and the triplets are simultaneously treated as formal units. Grodecki has suggested that two ateliers executed these figures; the differences in style of execution again reinforce the point that it was the coherence of the iconographic program that provided the impulse for the formal unity.[141]

Another unified program is the choir clerestory of Auxerre Cathedral of about 1240–1245, in which the doublets and roses follow a program that pairs Old Testament figures and apostles; the large single standing figures are framed by panels of grisaille decoration giving quite different coloristic effects than the medallion windows of the aisles, by the same atelier. Here Virginia Raguin has noted the adaptation of scale and color to the upper windows, including the manipulation of normal proportions in the faces.[142]

Contemporary work in the Cathedral of Reims includes some of these color and grisaille band windows, but shows a preference for very large seated figures and aediculae that fill the lights (Pls. 283–85).[143] The program there was probably adapted from Saint-Remi and it is all the more apparent the extent to which the figures have departed from humanistic proportions; they belong to the same colossal order as the sculpture from the upper reaches of the west facade, such as the David and Goliath who now confront the viewer in the Musée de l'Oeuvre.[144]

Remnants of similarly huge figures in glass survive from the Cathedral of Soissons; ironically they have found a resting place beside those from Braine in two American collections as if to emphasize the contrast (Pl. 278).[145] It is easy to imagine that the appearance of the figures in the clerestory of Notre-Dame in Paris was similar; Pierre Le Vieil described, without regret, how his father replaced the choir clerestory figures by white glass in 1741, referring to the colossal figures of bishops at least eighteen feet (five and a half meters) high as painted "d'une manière trés grossière."[146] Such works

[137] Baies 168, 165; the paired lancets in each case are entirely different in composition and colors and it is not plausible that they were planned as a pair and have changed places. I believe these lancets to be the work of the Joseph Master who worked in the aisle below, and whose repertory of figures and palette are closely allied to the Fitz-Eisulf atelier at Canterbury: Delaporte and Houvet, 1926, pls. cclxx, cclxviii.

[138] Connections between the clerestory and the lower windows, and the probable sequence of glazing (from west to east) have been worked out in detail by Nancy Netzer, "A Stylistic Analysis of the Chartres Cathedral Nave Stained Glass Windows," M.A. thesis, Tufts University, 1976.

[139] Their interdependence has dominated the work of Meyer Schapiro, Adolf Katzenellenbogen, and Ernst Kitzinger, for instance. Schapiro was first to suggest there were " 'modes' practiced by the same artist or school of artists according to the content to be expressed," as distinct from "styles" in the historical and regional sense; see his review of *Early Christian Art*, by C. R. Morey, *The Review of Religion* 8 (1943–1944): 181–83. See also Kitzinger, 1977, pp. 18–19, 71–74, 118–19; A. Katzenellenbogen, "Form and Meaning," in *The Sculptural Programs of Chartres Cathedral*, Baltimore, 1959 (reprint, New York, 1964), pp. 37–49; M. H. Caviness, 1983.

[140] Robert Branner, *La cathédrale de Bourges et sa place dans l'architecture gothique*, Paris, [1962], figs. 78, 80, 96.

[141] L. Grodecki in *Vitrail*, pp. 46, 139, figs. 25, 48, 103 (dated ca. 1220). See also Cahier and Martin, 1841–1844, pp. 281–99, pls. xvii–xxvii; Amedée Boinet, *La cathédrale de Bourges*, Paris, [1925?], pp. 81, 83, fig. 17; Aubert and Claudel, 1937, col. pl. xvii (the height of the lancet, 4.45 meters, suggests that the figures are about 3 meters high).

[142] Raguin, 1982, p. 30, fig. 2, pp. 58–63, figs. 127–29. See also Lillich, 1970, pp. 28–29, figs. 3–6.

[143] Reinhardt, 1963, pp. 183–85, pls. 42–45. His thesis, that the figures now set in grisaille bands were reused from an earlier program, is in large part sustained by L. Grodecki in *Vitrail*, p. 140, and Frodl-Kraft, 1972, pp. 53–57.

[144] Other figures from the level of the rose are illustrated in Sauerländer, 1972, pls. 226–28.

[145] Baltimore, The Walters Art Gallery, 46.40 (figure under an arch inscribed Prophet Habacuc) and 46.41 (inscribed "Senizien," frequently identified as St. Savinien); see Lazare Bertrand, "Note sur un Vitrail de la cathédrale de Sens conservé au musée de Baltimore," *Bulletin de la Société archéologique de Sens* 43 (1939–1943): 535–38 (with the attribution given by the dealer Heilbronner). Pennsylvania, Bryn Athyn Museum, Pitcairn Collection, 03.SG.234 and 235, two apostles (inscriptions with Thomas and Paul are incomplete). Each pair was acquired with Braine glass, which had been stored at Soissons.

[146] Le Vieil, 1774, pp. 24–25.

have always shocked a classicizing taste. Indeed, this is a category of representational art, typified by the remnants of the seated Emperor Constantine that belong in his Basilica in Rome, by these Gothic giants of the mid-thirteenth century, and by the extravagances of the Baroque, that sets itself apart from human experience.[147]

THE STYLISTIC CONTEXT AROUND 1200

The artistic value and historical interest of the Saint-Remi and Saint-Yved clerestory figures derive in part from the position they occupy—with Canterbury—between the monumental Romanesque stylizations of Augsburg and the gigantic Gothic stylizations of Auxerre; they belong to the brief period in western medieval art that was characterized by humanism. Any scholar writing about this phase of monumental painting in the north of France in the latter part of the twelfth century has to contend with previous definitions of this "Year 1200" phenomenon, especially the concept of the classicizing style; the latter is evoked all the more in Reims where the Roman presence was still strong in the Middle Ages, where the Carolingian renaissance had in part centered, and where the Antique Master evolved his sculptural style in the cathedral chantier of the thirteenth century (Pls. 13–15, 19).[148]

Definitions of this style, however, are still confused.[149] One style that has been designated as preeminently classicizing, by Grodecki and Deuchler among others, encompasses the work of the painters who provided the Jesse Tree and other windows in Soissons Cathedral, some of the glass in the eastern wall of Laon Cathedral, and the Ingeborg Psalter (Pls. 184, 219, 227, 236, 278).[150] This style is characterized by composed and idealized facial expressions and features, calm gestures, and substantial forms swathed in bulky drapery that is increasingly articulated by hooked folds or *muldenfalten*. It is the painterly counterpart of the work of the Antique Master of Reims, although its origins may be traced back to the 1190s—if the Ingeborg Psalter was produced then—or even to common antecedents in the work of Nicholas of Verdun, including the Klosterneuburg ambo of 1181.[151] This style has little to do with the actual appearance of Classical work; its closest visual counterparts are in late and sometimes provincial Roman works, even including some now generally classified as subantique (Pls. 13, 14).[152] Also worth noting is a visual relationship to Carolingian works such as the Gospels of Archbishop Ebo, which were produced in Hautvillers, close to Reims, in the early ninth century (Pl. 15).[153] The French term *antiquisant* is preferable for this group of works.

The works studied here belong to a distinct but parallel style group;[154] indeed, the very evident contrast between the Jesse Tree figures of Soissons and the ancestors of Christ that have been in the adjacent window of the choir since the first half of the nineteenth century has in part allowed recognition of the ancestors as products from Braine (Pls. 182, 184, 190, 193). Yet the two styles seem to have evolved in much the same period and region, and traits in the Braine style have also to be designated as antiquizing. It is as if a selection were made of different models, however; if Roman, they led more directly back to Greek precepts of bold surfaces, catenary folds, and an understanding of the organic unity of the figure in action.[155] Both styles evoke Carolingian works, but this one is closer to the Court school, with reminiscences of the energetic line of the Ada group, and of the massive rendering of the Palace school (Pls. 16, 17). Like the other "classicizing" group, it comprises developments in Gothic sculpture, specifically in the Nativity portal of Laon Cathedral (Pl. 238).[156] The portal sculpture of Saint-Yved is closely related, if somewhat less vigorous (Pls. 189, 214, 234, 241). These fully plastic renditions combine a delicate, even exquisite exploration of minute planes and troughs in the drapery with a bold, organic, and monumental conception of the human form. This sculptural style may be viewed as a full maturing of the tentative graphic statements of some of the choir clerestory figures in Saint-Remi (Pls. 186, 189). Such a development would parallel the maturing of the *muldenfaltenstil* between the Klosterneuburg plaques and the Visitation of Reims Cathedral.

[147] For the first and last, see Frederick Hartt, *Art: A History of Painting, Sculpture, Architecture*, Englewood Cliffs, N.J., and New York, 1976, 1: 227, figs. 302, 305, and 2: 221–24, figs. 238, 241–44.

[148] Adhémar, 1939, pp. 58, 79, 110, 143, 146, 150–55, 175, 273–83; Hamann-Mac Lean, 1949–1950, pp. 183–84, 187, 191–93, 216, 228–30, figs. 34–35, 69, 73–74, 96, 161–65.

[149] See n. 73 above.

[150] Grodecki, 1965; and idem, 1978, pp. 43–44; Deuchler, 1967, pp. 133–45.

[151] Grodecki, 1969.

[152] Walter Oakeshott, *Classical Inspiration in Medieval Art*, London, 1959, pp. 107–9, figs. 140B, C, gradually retracts his claim that the Antique Master of Reims was familiar with "classical" works, in favor of Augustan copies such as the Ara Pacis, or even an Early Christian sarcophagus in Arles (Oakeshott, pl. 122B). For the late figure illustrated here (Pl. 14), see Jean Charbonneaux, *La Sculpture grecque et romaine au Musée du Louvre*, Paris, 1963, pp. 175–76.

[153] Compare, for instance, the turbulent *muldenfalten* and large head of the angel next to St. Remigius on the Calixtus portal of Reims, (Sauerländer, 1972, pl. 247) with the St. Matthew portrait of the Ebo Gospels, Epernay, B.M., MS 1, f. 18v (Florentine Mütherich and Joachim E. Gaehde, *Carolingian Painting*, New York, 1976, pp. 25, 58, pl. 14).

[154] Caviness, 1977a, pp. 57–58.

[155] Roman statuary found in Soissons in the nineteenth century, or similar pieces, exhibit a fluidity of drapery and certain anatomical treatment that recalls Greek works such as the sculpture from the Temple of Asklepios at Epidauros, and appear to have had an impact on the sculpture of Laon and Braine: Cf. Hédron de Villefosse, "Les découvertes faites depuis le XVIe siècle au chateau [sic] d'Albatre [sic]," *Congrès archéologique* (Reims, 1911), 1912, illus. facing pp. 90, 92; Gisela M. A. Richter, *A Handbook Greek Art*, London and New York, 7th ed., 1974, figs. 183, 184; Sauerländer, 1972, pls. 70, 73.

[156] Sauerländer, 1972, pp. 425–28, ill. 49–52 and pls. 69–71; on p. 429 he also connects the styles of the Laon and Braine portals. McClain, 1974, has argued that the same sculptors worked for both sites (pp. 148–50).

The Issues

The initial aims of this book were to reconstruct the iconographic programs of the virtually unpublished glass of two great early Gothic monuments, to elucidate the design process in relation to chosen iconographies and architectural settings, and to establish comparative chronologies for the extant glass. Beyond these, I have tried to place the programs of the windows in larger contexts. One such context comprises glazing traditions in France, Germany, and England, as outlined here. Another includes the intellectual and artistic climates prevailing at each site, the relationship between the glass paintings and other modes of sumptuous "decoration," and its formal, liturgical and spiritual functions within each building. The accord of these solemn "decorations," at the time of their execution, with the ambience created accumulatively by earlier and contemporary patrons will be taken into account, as will also their supposed impact on the viewer around 1200.

With the exception of exterior monumental sculpture, glass painting was the most public art of its time, yet it was also the most mysterious and the hardest to "see." It is this element of mystery, achieved in part through the physical removal of these translucent images to a zone above the normal human experience, that gives them the character of "authoritative, symbolic, or spiritual objects." To adapt the famous words of Abbot Suger, the images themselves may be seen to be "dwelling, as it were, in some strange region of the universe which neither exists entirely in the slime of the earth nor entirely in the purity of Heaven."[157]

Entirely in keeping with this aura, the figures in these windows remain inactive and expressionless; the narrative reference that was present in the precursors of the Canterbury choir is suppressed in Saint-Remi and Saint-

Yved, so that each class of beings takes its place immutably before the Celestial Jerusalem. These images are not portraits, even though they have historical identities; nor are they primarily icons, symbols, or allegories; they resemble personifications in their embodiment of the office they held, but as Wirth has pointed out the term *conformatio* as used in rhetoric may be more appropriate; as defined by the anonymous author of the *Rhetorica ad Herennium*, this term applies "when an absent person is assumed to be present, or when a dumb or formless thing is under discussion, and is endued with shape (*forma*) and speech (*oratio*), or a particular form of action (*actio*)."[158] Such an image may give form to an absent king and to Majesty, to a virgin saint and to Chastity, to an archbishop and to Priesthood. Not surprisingly, the images in the glass will be found similar to those on the seals that connoted the authority and authenticity of office (Pls. 114–20). Furthermore, the kind of decorum they exhibit appears to emanate from appropriate customs (*consuetudines*) and beliefs (*credulitates*), as they are termed in an admittedly later Latin translation of Averroes, rather than from character and thought, as Aristotle had originally stated it.[159] These figures are thus imbued with essentially medieval *personae*, severely circumscribed by social conventions even in this age of humanism in which we are often led to expect a more developed sense of the individual. If they at first strike us as monotonous, we might do well to recall Herbert Moller's response to the repetitiveness of troubadour poetry: "The whole corpus of courtly poetry was a product of the interplay between the poets and their public and reads like a compulsive reiteration of a few themes. If a society does not weary of the continual repetition of the same imagery, and rewards its poets and performers for it, the assumption is warranted that this imagery is emotionally stirring and fascinating."[160]

[157] Suger, 1979, pp. 62–65; the context is Suger's contemplation of many-colored gems, corresponding to those of the Heavenly Jerusalem; it could as well apply to glass, and he uses similar phrasing to introduce his analogical window (pp. 74–75). Eva Frodl-Kraft (1972, p. 54) has also applied Suger's words to the clerestory windows of Reims Cathedral.

[158] Wirth, 1970, pp. 22–24, quoting Pseudo-Cicero, *De Ratione dicendi*, ed. and trans. Harry Caplan, Cambridge, Mass., 1964, p. 398: "Conformatio est cum aliqua quae non adest persona confingitur quasi adsit, aut cum res muta aut informis fit eloqens, et forma ei et oratio adtribuitur ad dignitatem adcommodata aut actio quaedam."

[159] Judson B. Allen, *The Ethical Poetic of the Later Middle Ages: A Decorum of Convenient Distinction*, Toronto, 1982, pp. 18–28. Hermann's translation from the Arabic of Averroes was made in Toledo in 1256, but the precepts he follows may well have been accepted seventy years earlier. I am grateful to my colleague Charles Nelson for this and the following reference, and for discussion of these issues during our course on medieval German art and literature.

[160] Herbert Moller, "The Meaning of Courtly Love," *Journal of American Folklore* 73 (1960): 39.

CHAPTER I

Saint-Remi: The Campaigns of Construction and Decoration, Destruction and Restoration

Le malheur, c'est que de toutes ces anciennes verrières, il ne nous reste que de vénérables fragments qui n'inspirent que plus de regrets sur tout ce qui a disparu. Ce n'est point la révolution de 93, c'est l'esprit de la réforme qui, en se glissant furtivement dans le cloître, a consommé cette oeuvre de destruction.

Abbé Clovis Poussin, 1857[1]

ANY DETAILED TREATMENT of the extant stained glass of Saint-Remi or the larger program of which it was a part requires consideration of both the history of the construction and decoration of the abbey church, and its tragic losses since the twelfth century. This chapter therefore presents a diptych in which these events mirror each other, ending more dismally than the Abbé Poussin could have imagined; even as he wrote, one of the most scandalous and extensive revisions of the entire glazing program was being carried out without official approval or documentation, and after it the German shelling of Reims in 1915–1918 destroyed many precious panels of the twelfth century.

The early history of the abbey need concern us here only insofar as it allows us to reconstruct the decoration of the late twelfth century in its entirety; it is of interest to know the nature of earlier elements that were pre-served during the reconstruction of the choir under Peter of Celle, and how they were incorporated into the later program, even if they are now lost. Full consideration will be given to that program in the next chapter, after this review of the antiquarian and documentary evidence.

The abbey was situated on a chalky knoll overlooking the River Vesle, nearly three kilometers (about one and a half miles) upstream from the cathedral, outside the Roman and medieval city walls. Rugged country isolated it from the city as late as the end of the twelfth century; in 1192 the emperor's assassins lay in wait outside the city for Bishop Albert of Liège, intending to murder him if he made the pilgrimage to Saint-Remi. The abbot and his party rode this route in the procession that took the Sainte Ampoule, containing the chrism for unction, to Notre-Dame for the coronations.[2] A church

[1] "The tragedy is that of all this ancient stained glass only precious fragments remain, and these all the more bring home to us the sadness of the loss. It is not the Revolution of 1793 that wrought the destruc-tion, but the spirit of [Maurist] reform that insidiously invaded the monasteries." Poussin, 1857, p. 173.

[2] L. Demaison, *Reims à la Fin du XIIᵉ siècle d'après la vie de Saint Albert*

on the site had been dedicated since the second half of the sixth century to St. Remigius, the bishop of Reims who baptized Clovis in about A.D. 500 and who was buried there. The Benedictine foundation dates from the Carolingian period, and the church was rebuilt by archbishops Ebo and Hincmar.[3] The association of the coronation with the unction by the archbishop also dates from this period, in the form of Hincmar's *Vita sancti Remigi*.[4]

THE ELEVENTH-CENTURY CHURCH

The oldest parts of the building that can be seen today date from the eleventh century; the church was entirely rebuilt between 1007 and a consecration by Pope Leo IX in 1049.[5] The nave, with the lower parts of the southwest tower, and the transepts including two orientated chapels still give a clear impression of the magnificence of this structure, despite later modifications and repairs (Figs. 2, 3; Pls. 18, 20, 24, 25, 32). The nave consists of eleven bays between the west towers and the crossing, the arcade carried on bold piers and surmounted by a tribune of almost equal height. The clerestory walls were probably not originally articulated except by an arched window pierced over each opening of the arcade; similar windows opened into the tribune and the aisles below, although those on the north side have been blocked by conventual buildings (Pls. 35, 36). The elevation of the transepts was essentially the same, with tribunes on the east and west, the former opening into upper chapels. The decoration included rich stucco capitals, of which some remain.[6] The consecration, performed by the pope on October 2, 1049, was described in detail in contemporary records, of which copies survive.

Of some interest for scholars of glass is the mention in the accounts of the consecration that the reliquary of St. Remigius, which had been processed around the city,

had to be passed into the church through a window over the Oratory of the Trinity, which was on the south side at the end of the ambulatory, because the crowd that had entered the nave for the ceremony was so dense.[7] However, it would be rash to assume from this that the windows were not for the most part glazed. Two early references to glass painting in Reims, at least, suggest an established local tradition. The first is in the chronicle of Richard; in describing additions to the cathedral church by Archbishop Adalbéron (969–989), he mentions the seven-branched candlestick, the sonorous bells, and historiated windows; here there can be little doubt that stained glass is meant.[8] The other concerns a certain Roger who was brought from Reims to the Abbey of Saint-Hubert in the Ardennes, to the north of his native city, in order to make beautiful glass windows for Oratories of St. Stephen and the Holy Jerusalem, some time between 1068 and 1091.[9] In this case there has been some doubt whether historiated glass was involved, but it seems most improbable that mere decorative glazing would deserve mention in the chronicle or necessitate bringing in an artist. The contemporary head from Wissembourg in Alsace and scattered earlier finds attest to the technical proficiency and refinement of glass painting in this period.[10] For many scholars the mention of Roger of Reims is significant for the history of *rémois* glass painting.[11] On the other hand, there was a good deal of sheer speculation on the part of nineteenth-century glass painters and antiquarians that some of the figures that had evidently been used to fill gaps in the choir clerestory windows of Saint-Remi dated from before the 1049 consecration.[12] As we shall see, despite the probability that the church consecrated in 1049 contained stained glass, and the fact that several extant figures seem to have been scaled to the small window openings of which vestiges remain in the eleventh-century building, there figures belong to later glazing campaigns;

de Liège, Reims, 1925, pp. 33–35; idem, *Une Description de Reims au XIIe siècle*, Paris, 1893; for a detailed history of the town, see Marlot, 1843–1845, esp. vol. 2. For the coronation procession, see Père, 1921, pp. 31, 34.

[3] Prache, 1978, p. 2, with bibliography, and pp. 10–15.

[4] Prache, 1978, pp. 3–4; *P.L.*, 125; *Passiones Vitaeque sanctorum aevi merovingiei*: vol. 3, *Vita Remigii*, ed. B. Krusch, *Monumenta Germaniae Historica, Scriptores rerum merovingiarum*, 3d, ed., Hanover, 1910.

[5] Ravaux, 1972, is the most thorough study to date of the eleventh-century church. Although excavations to establish the west and east ends have not been entirely conclusive, it has been possible to correct the erroneous plan, with radiating chapels, drawn by Viollet-le-Duc; see Françoise Boudon, "Le réel et l'imaginaire chez Viollet-le-Duc: Les figures du *Dictionnaire de l'Architecture*," *Revue de l'Art*, 58–59 (1982–1983); 104, fig. 12. For the eleventh-century building, see also Prache, 1978, pp. 15–24, figs. 54, 57, 70, 71–89.

[6] Louis Grodecki, "Les chapiteaux en stuc de Saint-Remi de Reims," *Atti dell'ottavo congreso di studi sull'arte dell'alto medioevo*, Milan, 1962, 1: 186–208.

[7] Prache, 1978, p. 17, with references.

[8] "Historiarum libri Richeri," *Monumenta Germanine Historica Scriptores*, 3: 613, cited by Reinhardt, 1963, pp. 41 and 226, n. 2: "Fecit quoque candelabrum septifidem, in quo cum septem ab uno surgerent, illud significare videbatur, quod ab uno Spiritu septem gratiarum dona

dividantur. . . . Quam [ecclesiam] fenestris diversas continentibus historias dilucidatam, campanis mugientibus acsi tonantem dedit." For the dates of Adalbéron, see Reinhardt, 1963, p. 39.

[9] Karl Hanquet, ed., *La Chronique de Saint-Hubert, dite Cantatorium*, Commission Royale d'histoire: Recueil de textes pour servir à l'étude de l'histoire de Belgique, Brussels, 1906, p. 50; "Illuminavit quoque oratoria, que extruxerat, pulcherrimis fenestris." For the dates of Henri de Verdun, bishop of Liège 1076–1091, who consecrated the oratories, see p. 26, n. 3.

[10] For the head from Wissembourg, now in the Musée de l'Oeuvre Notre-Dame in Strasbourg, and earlier fragments, see Frodl-Kraft, 1970, pp. 22, 23, 63, and figs. 5–7, 12.

[11] E.g., Reinhardt, 1963, pp. 48–49, and Merson, 1895, p. 14. I have not, however, discovered the source for Merson's claim that Roger worked with a person named Herbert, that both were monks of Saint-Remi, that the windows were commissioned by "Adeladis comitissa Areleonis," and that they contained griffins on a ground of rinceaux.

[12] Tourner, 1856, pp. 88–90; idem, 1862, pp. 93–97, where he claimed support from the glass painters Henri Gérente, J. Lassus, and Nicolas Coffetier at least in his opinion that these figures were earlier than the others, but his views were not generally accepted at the Congrès (pp. 97–98). They were rather tentatively restated by Magne, without claiming the mid-eleventh-century date (Magne, 1885, pp. 151–52).

they either replaced or complemented any program that may have existed before.

CHOIR FURNISHINGS OF THE SECOND QUARTER OF THE TWELFTH CENTURY

The next important period for the history of the church fabric was the abbacy of Odo, 1118–1151.[13] This was a prosperous time for the monastery, and the abbot seems to have directed lavish spending on the interior decoration of the choir. He also traveled widely, including at least one visit to Italy in 1134, from whence he returned via Cluny. The result was an eclectic decorative program, which has considerable importance for this study, since most of it was preserved in the later rebuilding.

Most famous among the lost works of the choir is a mosaic pavement, perhaps made in imitation of ones seen south of the Alps; Saint-Denis was also richly paved in the twelfth century, but existing parts of the pavement probably postdate that of Saint-Remi by a decade or two.[14] The one at Saint-Remi had an encyclopedic program of subjects, extending throughout the monks' choir and the sanctuary. It expands upon terrestrial themes that had considerable currency in early pavements, and which were revived in the eleventh and twelfth centuries.[15] The original Saint-Remi floor mosaic has disappeared since the Revolution except for a few fragments excavated in the mid-nineteenth century, now in the Musée Saint-Remi (Pl. 37). There are no drawings of it before its destruction, but the sixteenth- and eighteenth-century descriptions provide valuable information for an iconographic study of the choir; some of the elements will be discussed in connection with later decorations in the next chapter. The layout suggested in

Fig. 3 is based on these descriptions, especially that of d'Expilly, which are reconciled with the dimensions of the bays.[16]

The question might be raised whether the choir mosaic was planned and executed as an entity. The subjects above the altar steps seem to have been executed in a different medium; they were either in opus sectile or, more probably, inlaid dalles of a type common in Saint-Bertin of Saint-Omer.[17] The mosaics below the steps were in small tesserae "no larger than a fingernail," of natural colored marble or "enameled" (glazed) mosaic, so fine that the subjects appeared to have been painted, according to Bergier.[18] Opinion is divided whether the juxtaposition of different techniques in the later pavement of the Trinity Chapel in Canterbury Cathedral is indicative of different campaigns, but other examples can be cited where the combination of techniques is certainly original.[19] The dating of the Saint-Remi pavement is difficult to establish due to the scarcity of visual evidence.[20] The painterly quality described in the tesselated mosaics suggests a classicizing work of the twelfth century, perhaps analogous to the scenes with Abraham and Isaac formerly in the Chapel of St. Nicholas of the Hospice in the Cathedral of Reims; these are known from photographs, and have been dated by Barral I Altet about 1160.[21] Fragments of tesselated mosaic excavated in the cloister at Saint-Remi, where they might have been used as fill, seem coarser, although the modeling is subtle (Pl. 37b).[22] The difference supports Barral I Altet's dating of the abbey pavement to about 1135–1150.[23]

Several inscribed tomb slabs were apparently integrated into the layout of the mosaic below the altar steps at the time that it was laid;[24] they commemorate tenth- and eleventh-century burials, and seem to have replaced

[13] Prache, 1978, pp. 24–27, with bibliography; much of what follows is summarized from Prache. Further references will be found in Chapter 2.

[14] Adhémar, 1939, pp. 194, 196, 255; Mâle, 1953, pp. 318–19; Henri Stern, "Mosaiques de pavement préromanes et romanes en France," *cahiers de civilization médiévale* 5 (1962): 28–30; Prache, 1978, p. 25; Hamann-MacLean, 1983, pp. 148–49. For Saint-Denis, see Xavier Barral I Altet, "The Mosaic Pavement of the Saint Firmin Chapel at Saint-Denis; Alberic and Suger," in *Abbot Suger and Saint-Denis*, ed. Paula Gerson, New York, 1986, pp. 245–55.

[15] Ernst Kitzinger, "World Map and Fortune's Wheel: A Medieval Mosaic Floor in Turin," *Proceedings of the American Philosophical Society* 117 (1973): 344–73, has discussed this revival in relation to the later mosaic of Turin. A transalpine connection is not, however, necessary to impute for Saint-Remi, since there are antecedents in France, including fragments of a zodiac cycle of ca. 1109 from Saint-Bertin, now in the Musée de Saint-Omer, and a lost cycle of liberal arts and other figures that survive in part, dating from ca. 1106, in Saint-Martin d'Ainay of Lyon: Stern, 1957, pt. 1, fasc. 1, pp. 98–99, pls. LIV–LVI, and pt. 2, fasc. 1, pp. 119–23, pls. LXXXVI–XCIII.

[16] Jean Joseph d'Expilly, *Dictionnaire Géographique, historique et politique des Gaules et de la France*, Paris, 1770, 6: 148–49. His description is very precise as to the position of the epitaphs; it seems to me that they must have occupied ornamental bands between the units of the mosaic, coinciding with the position of the piers, since this arrangement has the advantage of providing the squares that are specified in the accounts. Other authors are cited in Chapter 2.

[17] Such dalles, or monolithic medallions with incised figures filled

in with colored mastic or stone inlay, were also used behind the shrine of Thomas Becket at Canterbury; see N. E. Toke, "The Opus Alexandrinum and Sculpted Stone Roundels in the Retro-Choir of Canterbury Cathedral," *Archeologia Cantiana* 42 (1930): 1898–221; and Eames, 1982.

[18] Quoted by Baral I Altet, 1980, p. 83.

[19] The large panel of opus alexandrinum at the top of the steps from the level of the main altar has been variously dated ca. 1180–1190, after 1215, or even ca. 1270; Caviness, 1977a, p. 71 (cf. Eames, 1982, p. 70), and E. Hutton, *The Cosmati: The Roman Marble Workers of the XIIth and XIIIth Centuries*, London, 1950, p. 26 (I am indebted to M. W. Cothren, "Cistercian Tile Mosaic Pavements in Yorkshire: Context and Sources," in *Studies in Cistercian Art and Architecture*, ed. Meredith P. Lillich, Kalamazoo, 1982, 1: 124, n. 29, for the last reference), Kitzinger, p. 355, cites S. Donato in Murano, 1141, as an example combining opus sectile and tesselated mosaic; he tells me this is not uncommon.

[20] Povillon-Piérard, MS 1837, p. 135, seems to have been the first to attribute the mosaic to the time of Odo; Marlot had ascribed it to Abbot Wido in the eleventh century. However, Povillon-Piérard could not have seen it, and his description follows Marlot quite closely (pp. 130–33, 160).

[21] Barral I Altet, 1980, pp. 95–97, fig. 17.

[22] The piece of inscription, ECLARAT, coincides with *declarat rugas* that had been recorded in the eighteenth century in the scene with Moses and the New Law (quoted in full in Chapter 2, n. 15).

[23] Barral I Altet, 1980, p. 95.

[24] Prache, 1978, pp. 13, 25–26, quoted a reliable eighteenth-century

the original markers. That of Queen Gerberge survives, currently displayed in one of the chapels on the north side (Pl. 39). The epigraphy is analogous to the display capitals in a late eleventh-century manuscript from the cathedral (Pl. 38), yet differences are sufficient to indicate a date close to mid-twelfth century for the tomb, just before the Gothic rebuilding of the choir; comparison with the script of a rémois Bible of about 1150–1160 confirms this dating (Reims, B.M., MS 19), as does the similarity to letter forms in the inscriptions of the so-called tomb of Odo, which is generally dated about the same time (Pl. 85). A large group of dated inscriptions studied by Deschamps, including a mid-twelfth century one from Reims, confirms a date between about 1125 and 1165.[25]

Other members of the Carolingian line, including Louis IV d'Outremer, to whom Gerberge was married, were given sculpted effigies; fragments of these survived the Revolution, to be excavated in 1842, and are in the Musée Saint-Remi (Pls. 45, 46). Their style and iconography is in keeping with the time of Abbot Odo, and his refurbishing of the Carolingian tombs may be associated with Suger's efforts to commemorate the Frankish kings at Saint-Denis.[26]

The other important furnishings of the choir and chapels were the reliquaries and altarpieces in precious metals and jewels. None of the material from the early period seems to be preserved, and it is hard to be sure, from sporadic mentions, about the date of their facture. There must also have been important liturgical objects; a twelfth-century inventory of the treasury lists two chalices of gold and eighteen of silver.[27] Most disappeared in the Revolution; some idea of the value of the objects seized and melted down is given in the records of 1790; the total revenue from Saint-Remi was more than

four times as great as that from the Augustinian house of Saint-Denis in Reims, for instance.[28] The "calice de Saint Rémy," which was used in the coronation rite at the cathedral, has been misnamed through a confusion in the records, but it represents a vestige of metalwork known in Reims in the late twelfth century; unfortunately it was heavily restored in the nineteenth century.[29]

Most of the Carolingian furnishings had been preserved in the twelfth-century campaigns, again in parallel with Suger's activities at Saint-Denis. Added to these, probably in the time of Abbot Odo, were two great gilded bronze light holders, a candlewheel or polycandelon over the monks' choir in the nave, and a seven-branched candlestick set at the top of the steps to the choir, that is to the east of the crossing and to the north of the high altar. Of the first, nothing but descriptions and a sketch survive, although a modern rendition hangs in its place (Pl. 25).[30] On the other hand, one of the four feet of the great candlestick base is in the Saint-Remi Museum; a nineteenth-century engraving suggesting an original height three-and-a-half times that of a man, with candles matching his height, is probably not exaggerated (Pls. 41–44).[31] Both light holders were evidently preserved when the choir was enlarged under Peter of Celle, most likely in their original positions. Their iconography and their actual and symbolic association with light are of interest in the context of the late twelfth-century building, and will be discussed in detail later.

It is quite possible that Abbot Odo would have also provided new stained glass, as Grodecki has argued.[32] The mosaic and the tombs corresponded to features of Saint-Denis, and the resplendent glass there might be expected to have had a counterpart as well. The only hindrance would have been the small window openings

antiquarian, Dom Eget, who observed that the epitaphs were all made at one time; Bergier, however, claimed that they had disturbed the mosaic (Barral I Altet, 1980, p. 84). The following were recorded: Arthaud, Archbishop of Reims (d. 961); Gerberge, queen of Louis IV d'Outremer (d. 969); Albrade, daughter of Louis IV d'Outremer and her husband, Arnoul, count of Roucy; Abbot Airard (d. 1035) and Abbot Thierry (d. 1046); Guy de Châtillon, archbishop of Reims (d. after 1049); and Count Bourchard (d. 1060).

[25] Farquhar, MS, 1968, catalogue pp. 172ff. for the dates of these manuscripts. In the epitaph, *h* and *t* replace the square letter forms of MS 294, and uncial *m* with symmetrical inward-curved bows, as in the manuscript, is replaced by a closed bow on the left and ogee curve on the right. In MS 19 both forms of uncial *m* are found, with *h* and *t*. Uncial *t* is also present on the "Odo tomb," and square *A* and *N* are similar to those in the Gerberge epitaph. For the history and dating of the tomb fragment (actually that of an archbishop, with a secular figure inscribed "Odo"), see Sauerländer, 1972, pp. 394–95, pl. 27. P. Deschamps, "Etude sur la Paléographie des inscriptions lapidaires de la fin de l'époque mérovingienne aux dernières années du XIIᵉ siècle," *Bulletin Monumental* 88 (1929); 42–44, has indicated dated examples of these usages, and especially the usefulness of uncial *m* in dating. Compare his fig. 21 (epitaph of Hubert, mid-twelfth century), which is widely spaced and resembles Roman capitals, with figs. 32–40, dated 1126–1162; the latter group includes uncial *e* and *m* and occasionally *t*, and some have the *N* with a dropped bar that is seen in the Gerberge inscription.

[26] Prache, 1969, p. 73; her suggested date for the Saint-Remi tombs, in the second quarter of the twelfth century, leaves the chronology open (p. 69). It is debated whether Suger provided monuments (see Chapter 2).

[27] Reims, B.M. MS 93, garde A verso.

[28] "Envoi par les Districts et des communes des matières d'or et d'argent provenant des églises," Paris, A.N., F¹⁹ 611⁶ (1790 an II); the figures given are L.123,354.2s.6d as compared with L28,927.14s.8d.

[29] Musée des Arts Décoratifs de France, *Les Trésors des Eglises de France*, Paris, 1965, no. 132, pp. 65–66, pl. 99; Marie-Madeleine Gauthier, "Un Patronage énigmatique: Les Orfèvres-émailleurs à Paris au Temps de Philippe Auguste," in *La France de Philippe Auguste: Le Temps des mutations*, Colloques internationaux du Centre National de la Recherche Scientifique, 602, ed. Robert-Henri Bautier, Paris, 1982, p. 990, fig. 7.

[30] Marlot, 1845, 2: 540–541.

[31] Prache, 1978, pp. 26–27; the engraving was published in Alexandre Lenoir, *Architecture Monastique*, Paris, 1856, 2: 141; reproduced in George Zarnecki, *The Monastic Achievement*, New York, 1972, fig. 124. Povillon-Piérard, MS 1837, p. 157, says it was 16 feet (4.9 meters) high and 15 feet (4.6 meters) wide, and that it had four evangelists on the foot; on pp. 158–59 he quotes the *Histoire Littéraire de France* 12: 234, to the effect that Odo's gifts to Saint-Remi included a seven-branched candlestick.

[32] Grodecki, 1975, p. 77.

in the eleventh-century church, but they were numerous enough to encompass a large program nonetheless. Furthermore, the apse was very shallow, and without ambulatory, apparently consisting of a hemicycle with five windows, so that relatively little glass would have been disturbed in later rebuilding when the apse was demolished; the greatest changes would have taken place in the transepts, possibly at all three levels. Ravaux's plan of the Romanesque church shows three orientated chapels opening off each transept, only the outermost of which were preserved; these have a single window each (Fig. 3).[33] Most of the windows were in the nave and it is questionable whether all would have had colored glazing; however, the monks' choir extended four bays to the west of the crossing and it is likely that the mosaic embellishment was complemented by clerestory glazing at least in these bays.[34] This was the distribution of stained glass that Povillon-Piérard recorded early in the nineteenth century, though of course there may have been a regrouping of the figures in a previous restoration.[35] In this way, an early clerestory program might have filled at least thirty-five windows; extending the program throughout the nave would bring the number to fifty-one, without counting openings in the west facade. Seated figures of saints, patriarchs, and kings preserved in the nave clerestory appear to have been superimposed in pairs originally, so that an extensive program could have been accommodated (Pl. 80).

It is very tempting to associate the inclusion of Chilperic, and presumably other Frankish and Carolingian kings, with Odo's program, but the dating of these figures will have to be considered very carefully in conjunction with the late twelfth-century choir glazing. Prache has convincingly shown that the nave was the last part of the church to be remodeled following the campaigns at the west end and the choir under Abbot Peter of Celle (1162–1181); the walls were heightened and responds hastily provided for vaulting, most probably in the time of his successor, Abbot Simon (1181–1198).[36] It is unlikely that this project could have been done without taking down any glass that was in the clerestory, although it could have been replaced again after.[37]

THE CAMPAIGNS OF CA. 1165–1205

The most resplendent chapter in the history of the building followed surprisingly quickly after Odo's refurbishing of the choir, but it may be seen as an extension of that program, rather than a revision. In fact, because of the cramped eastern arm of the church in Odo's time, the decoration and furnishings were concentrated in the crossing and in the monks' choir in the nave, and these areas were little disturbed in the next campaign (Figs. 2, 3).

Prache has demonstrated from internal evidence that work under Peter of Celle began about 1165–1170 with the reconstruction of the west end, just as it had at Saint-Denis twenty-five to thirty years earlier.[38] The new facade, replacing a porch between the two eleventh-century towers, included three doorways with large windows set between them (Fig. 2; Pls. 18, 23). Sculptural decoration of the portals is scant, limited to figural capitals on either side of the main door (Pl. 90). At the level of the tribunes are large statues of St. Peter and St. Remigius (Pl. 91), and five windows, much larger than the lower ones, with an interior passage passing below the triplet in the central vessel; in the original arrangement, as in the current restoration, they were surmounted by a rose window, which may have had smaller lancets flanking it.[39] The design requires a great amount of stained glass, although its effects are somewhat mitigated by the slender columns placed in front of the lateral pair of lancets at tribune level (Pl. 23). No original glass has survived in situ, for reasons that will become clear later, but there is evidence for colored glass in the rose as late as the seventeenth century.

As indicated in letters written by Peter of Celle, about the same time that work was progressing on the new facade a new chevet was laid out, with five radiating chapels and an apse of three bays with ambulatory, an extension that increased the total length of the church about 50 percent over the Romanesque structure (Figs. 2, 3). Construction of this great four-story choir evidently took longer than the west facade, and Prache has argued that it had reached only the tribune level by about 1175, and that the clerestory and vaulting may have been completed only about the time Peter of Celle left to become bishop of Chartres, in 1181 (Pls. 20, 26).[40]

The chevet increased the amount of glazing in the abbey church out of all proportion to its mere length. Three tiers of windows added eighty-five lancets to the edifice, twenty-nine in the aisles and chapels, twenty-three in the tribunes, and thirty-three in the clerestory (Fig. 2). Viewed the length of the nave, which becomes

[33] Ravaux, 1972, pp. 79, 92.

[34] Prache, 1978, pp. 26, 83.

[35] Povillon-Piérard, MS 1837, f. 53v. Grodecki, 1975, p. 73, understood eight figures, but it is clear he is referring to the eight windows of the choir bays; unfortunately, he did not specify whether each contained one or two figures.

[36] Prache, 1978, pp. 42–43, 75–88.

[37] Documents for Saint-Vincent of Rouen indicate that in 1528–1529 a glazier was paid to take out and put back the clerestory glass during the construction of the vaults; see Françoise Perrot, "L'Eglise Saint-Vincent," *Le vieux Marché de Rouen*, Bulletin des Amis des monuments rouennais, numéro spécial, Rouen, 1978–1979, p. 57.

[38] Prache, 1978, p. 45. The connection with Saint-Denis is again significant; of the group of buildings to have new chevets in the twelfth and thirteenth centuries, discussed by Wander, 1978, these are the only two in which the west end was also enlarged. Comparisons of the compositional features of a large group of west ends have not suggested a close association between Saint-Denis and Saint-Remi: Pierre Héliot, "Avant-Nefs et transepts de façade des XIIᵉ et XIIIᵉ siècles dans le nord de la France," *Gazette des Beaux-arts* 95 (1980): 129–36.

[39] For a review of possible changes in the upper facade made in the course of restorations, and prerestoration drawings of the nineteenth century, see Prache, 1978, pp. 45–49, figs. 9–11.

[40] Prache, 1978, pp. 72–74.

a comparatively dark tunnel, the retrochoir is resplendent with light, taking on the appearance of a great many-tiered candlewheel (Col. Pl. 1; Pl. 24). It is here that at least some of the glass contemporary with the building remains in situ, comprising an important program of archbishops, apostles, and Old Testament patriarchs in the clerestory, once flanking the Virgin and Child, and a monumental Crucifixion in the axial window of the tribune (Col. Pls. 2–8, 10; Pls. 100, 127–41). Other figures, now gathered in the tribunes, and their settings of ornamental glass, may have been moved from elsewhere; as suggested by Grodecki, some could have been made in the time of Abbot Odo for the eleventh-century apse.[41]

As already indicated, the campaigns of remodeling in the transepts and nave were probably carried out later, under Abbot Simon, and they affected chiefly the upper stories. Prache has suggested that the master who designed the facade and chevet had left the site and that a new team of masons was responsible for this work, which was apparently of lesser quality; the nave buttresses for instance were insufficient, which would scarcely be expected of the architect who had provided the flying buttresses of the chevet.[42] In the 1180s William of Champagne (archbishop of Reims, 1176–1202) contributed liberally to the abbey, possibly toward the financing of church building; the nave may have been completed at the time of Abbot Simon's death, in 1198, since his tomb was placed in it with an epitaph mentioning his association with the construction.[43] Prache has indicated the unlikelihood of construction work continuing during the administrative difficulties of 1203–1206.[44] In view of the tenacious way that the glazing program was resumed after two such periods in Christ Church Canterbury, these dates cannot be so readily accepted as a terminus ante quem for the Saint-Remi glass.[45]

Thus, a period after the glazing of the choir, perhaps extending into the thirteenth century, is the third that has to be considered in relation to the campaigns of glazing. In conjunction with structural changes in the aisles and clerestory of the nave, and as part of a campaign that was to join the chevet with the west end in a unified manner, it is indeed probable that glass would be provided to extend the choir program in the same way, un-

less preexisting panels could be reused. If one supposes the existence of earlier glass, strong argument may be made for its having been replaced in the clerestory lights of the nave after the remodeling on the basis of the economy that is apparent in the choir bays. The masons there abandoned a design that would have divided the bays by two responds, possibly intended to frame triple lancets as in the retrochoir, and instead preserved the old round-headed lights, adding an oculus above each in the raised upper wall (Pls. 35, 36); but this decision could have been governed as much by a desire for speed and cheapness of construction as by one to conserve an original arrangement of glass.[46] Unfortunately, not a vestige of glass that can be proved to come from the oculi has survived, so it cannot be judged whether the figures from the earlier lights below belong to that later campaign of glazing.

We have now covered the ascending part of our diptych, to the moment around 1200 when the abbey church was complete with its decoration; what is now left of the glass will be reviewed at the end of this chapter. It has been estimated that during the lengthy period of its large-scale constructions, between 1050 and 1200, the monastery housed about 150 to 200 monks, whereas there were only 50 at Saint-Nicaise in 1200.[47] By the early thirteenth century Saint-Remi was a very powerful house, with eleven dependent priories and 135 churches—an increase of 100 parishes since the tenth century.[48] It is the appearance of the abbey church at its apogee that will be my principal concern; my aim is like that of some anthropologists who wish to describe a society before its transformation in colonial times, and who evoke an "anthropological present." Yet in order to achieve this vision, it is necessary to study the process of transformation and loss that has intervened.

LATER TRANSFORMATIONS CA. 1350–1800

Many of the changes took place in an atmosphere of optimism and were envisaged as improvements; they began in the later Middle Ages at Saint-Remi, as elsewhere. It seems, however, that there were no such major changes as took place, for instance, in Suger's choir at Saint-Denis until the postmedieval period.[49] At Saint-Remi a bell tower collapsed in 1387, and another was

[41] Grodecki, 1975, pp. 70–73.

[42] Prache, 1978, p. 75.

[43] Prache, 1978, pp. 41–42; she has reconstructed the epitaph from the eighteenth-century notes in the Latin text of Marlot, Reims, B.M., MS 1619, p.356:

Prudens sensu erexit Ecclesiam
Praeclarus doctrina rexit monacho
Largus munere dispersit danda
Devotus mente respuit cavenda
Abundans bonis emit Deum.

He built the Church with intelligent wisdom
He ruled the monks with a clear understanding of doctrine
He distributed gifts with great generosity
He rejected worldly cares with single-minded devotion
He repaid God with ample goodness.

[44] Prache, 1978, pp. 42–43.

[45] Caviness, 1977a, pp. 23–35, 106.

[46] Prache, 1978, figs. 80, 83, where the bases for the colonettes are barely discernable. I am grateful to William W. Clark for a typescript of his paper "The Chevet and Choir of Saint-Remi at Reims," presented at the Fourteenth International Congress on Medieval Studies, The Medieval Institute, Western Michigan University, Kalamazoo, 1979.

[47] Coutansais, 1961, p. 807.

[48] Ibid., pp. 804, 806, 799.

[49] For Saint-Denis, especially the thirteenth-century campaigns that affected the glass, see Grodecki, 1976, pp. 19, 29–33.

built about that time; in 1506 Archbishop Robert de Lenoncourt, commendatory abbot of Saint-Remi, had the south transept facade rebuilt with a large sculpted portal and rose window, apparently replacing the earlier structure.[50] He also gave a tapestry with the life of St. Remigius to hang in the choir around the new tomb.[51] The south transept rose was glazed by de Lenoncourt, whose arms were still to be seen in the transept up to the mid-nineteenth century.[52] Poussin and Reimbeau also described the evangelists and other figures in this flamboyant stonework, and remarked on a medallion of twelfth- or thirteenth-century date, containing a single figure, in each of the six lights of this great window;[53] perhaps these were "belles verrières" from an earlier rose incorporated here in the fifteenth century, but they could equally have been placed here in some subsequent reordering of the glass. They have since disappeared.

The opposite wall, with the entrances to the monastic buildings surmounted by a rose window, was reconstructed a century later. In this north rose, Tarbé recorded a Baptism of Clovis surrounded by the counts of Champagne and Toulouse, the dukes of Burgundy and Normandy, and the bishop of Laon, which he took to date from the construction of 1602–1610; parts had been damaged in the fire (presumably 1754) and filled with plain glass.[54] Reimbeau's notes confirm the existence of some of these subjects in 1857, and he concurs with the seventeenth-century date.[55] This program stands out as an example of continuing postmedieval concern with the coronation rite and its antecedents. There is no indication that this transept facade had earlier medieval glass reinstalled, and such a case would be surprising in the

seventeenth century; it might be considered whether earlier programs were repeated, as at Angers in the fifteenth century, but the inclusion of the Peers of France with the Baptism of Clovis would have been unlikely in the twelfth century.[56] They were, however, included on the new tomb of Saint-Remi placed in the choir in 1537 under de Lenoncourt.[57] The continuing royal cult at Saint-Remi is attested to in 1654; eight years before, the shrine of St. Remigius had been opened and in 1651 the relics were processed to cure the plague, but now, immediately following his coronation, Louis XIV visited the neighboring Hôtel Dieu to touch the sick.[58]

Next begins a period of dilapidation, occasional repairs, wanton destruction, and drastic reordering of the glass. It is debatable to what extent each of these actions should be attributed to the Reformed Order of St. Maur, which had taken over the administration of the abbey in 1627 under the English archbishop of Reims, William Gifford. According to a study by Humann there was a lapse of some forty years during which the order continued to use the old buildings and consolidated its finances before beginning major campaigns of repair or reconstruction.[59] However, there is a detailed schedule of repairs dating from 1643; this offers a good deal of information about the glass in the church and in the conventual buildings, although it is not always clear whether colored glass is involved.[60] Jacques le Gros was paid for extensive repairs to the large window on the side of the Brothers of St. Francis of Paula, including the provision of seven feet (2.13 meters) of painted glass, the repair of seven panels, and the releading of six; this was perhaps the south transept rose. A much lesser amount

[50] Prache, 1978, pp. 75–76.

[51] Chastelain, MS 1828, p. 30; a description and engraved plates are in Thomas Prior Armand, *Histoire de Saint-Remi précédée d'une introduction et suivie d'un aperçu historique sur la ville et l'église de Reims*, 2d. ed., vol. 2, Paris, 1857. The tapestry hung until recently in the nave of the cathedral, but the Rothier photographs showed it still in Saint-Remi. It is now splendidly installed in the renovated monastic buildings of the Musée Saint-Remi.

[52] Povillon-Piérard, MS 1837, f. 55v, recorded that the angels with arms were in the first window on the right on entering the transept. Reimbeau, MS 2100, III i no. 6, f. 1, indicated two shields of arms, one in each light of this fifteenth to sixteenth-century window, which he sketched. The arms, and evangelists, were mentioned by Tarbé, 1844, p. 432, who commented on the fragmentary condition of the glazing.

[53] Poussin, 1857, p. 179. Reimbeau, MS 2100, III i no. 6, f. 1.

[54] Tarbé, 1844, p. 431. Povillon-Piérard, MS 1837 f. 56, indicated that both transept roses had been replaced by white glass, the north following a fire of 1774, the other after damage by the wind. He seems to have overlooked vestiges of original glass. Poussin, 1857, p. 179, recognized the baptism and mentioned other figures but described the general condition as dilapidated.

[55] Reimbeau, MS 2100, III i no. 6, ff. 2v and 1 (the fold forming this bifolio has been turned back so that the order of leaves is reversed; the text on f. 1 follows from 2v):

Grande Fenêtre du portail méridional.
Le sommet de la partie flamboyante est rempli de veres blanc à droite et à gauche en haut les armes de R. de Lenoncourt un peu plus bas les quatres évangélistes dans cet ordre en allant de gauche à droite St. Jean, St. Luc, St. Marc, St. Mathieu, ils tiennent des

philactères ou sont écrit Près de St. Jean on voit un guerrier et une femme portant une croix près de St. Mathieu des anges tenant des banderoles une femme tenant un listel ou j'ai cru lire, Clotilde. Dans le bas et dans la partie droite 2 hommes dans un appartement au sommet de chacune des éclaires formant cette fenêtre, il y a un petit médaillon du 12ᵉ ou 13ᵉ siècle un seul personnage y est representé il y en a de fort endomagés Aupres de cette verrière dans le transept (coté de l'Abside) les armes de Lenoncourt se trouvent 2 fois 1 et 2 dans la fenêtre à 2 baies baties au XVᵉ et XVIᵉ siècles.

[56] Jane Hayward and Louis Grodecki, "Les vitraux de la cathédrale d'Angers," *Bulletin Monumental* 124 (1966): 53–54. See also Gloria Gilmore-House, "The Mid-fifteenth Century Stained Glass by André Robin in Saint-Maurice Cathedral, Angers," Ph.D. dissertation, Columbia University, 1982. The Peers came into existence only in the course of the twelfth century: Sandler-Davis, 1984, p. 65, n. 136, cites Ferdinand Lot, "Quelques Mots sur l'origine des Pairs de France," *Revue Historique* 54 (1894): 35ff.

[57] Marlot, 1845, 2: 539–40. Jean Feray, "Le Tombeau de Saint Remi et ses problèmes," *Les Monuments Historiques de la France* n.s. 5 (1959): 10, gives the date without documentary references.

[58] *Monasticon Benedictinum*, vol. 37, Paris, B.N., MS lat. 12694, ff. 94r–97v. See also Marc Bloch, *Les Rois thaumaturges*, ed. Jacques Le-Goff, Paris, 1983, pp. 75–79, 284–93, for the long-standing belief that the coronation unction bestowed on the king the power of healing.

[59] Nicole Humann, "Les Constructions mauristes à Saint-Remi de Reims," *Mémoires de la Société d'agriculture, commerce, sciences et arts de la Marne* 74 (1959): 35–36.

[60] "Compte des Reparations des lieux reguliers, 1643," Reims, Archives de la Marne, dépôt annexe, MS H 411, ff. vᵛ–vii.

was spent on four new panes or panels in the west rose, and for putting back glass that the wind had blown out; similar work was done in three oculi of the nave. The term used here, *pans de vitre*, is the same used in repairs to many of the conventual buildings and may mean simply unpainted white glass. On the other hand, releading of "pans" that had been blown in in the Lady Chapel suggests stained glass is meant. Repairs are also mentioned in the chapels of Sts. Lawrence, Peter, Gibrien, and Benedict (the latter being referred to as the Sacristy). Overall, the text may be taken, cautiously, as proof of the survival into the Maurist period of some stained glass in the west rose and in the chapels, and of attempts to maintain it. Other, unspecified, repairs to glass were carried out in 1640, according to a page in the same manuscript.[61] In 1697 the cloister vaults were raised and the dormitory over them rebuilt; windows were supplied with the arms of Abbot Le Tellier and of the monastery, and with a Crucifixion "peint sur le verre" in the central opening.[62]

Between 1738 and 1753 the abbey contracted with their glass painter, M. Payen, for more extensive work on the ancient stained glass (Appendix 1).[63] In line with international trends of the period, the terms of the contract suggest that very little value was placed on the old colored glass;[64] a certain amount was to be cut up to make a "mosaic" for seventeen windows, and the rest was to be kept for future repairs. Another contemporary document indicates that much of the work was done by Payen in 1737–1739; it refers to a thorough restoration of almost all the windows of the church by which "the greater part of the stained glass was replaced by new, especially in the great rose of the portal and the three windows below.[65] In 1747 other necessary repairs were enumerated, and work seems to have continued on the fabric over a fairly long period.[66] In this schedule the west rose is stated to be unsound, although it still held some ancient-looking panels of stained glass. The tribune of the nave held some windows already blocked with masonry in the place of glass. Water entered through the sills in the nave and choir, and new roofing was recommended to provide better run-off; several windows had broken stonework around them. There is

little concern with the glass, but it is likely that it was at least as dilapidated as the surrounding masonry. No systematic restoration of the glass seems to have been envisaged, and it is probable that the colored glass that was made available to M. Payen to cut up for "mosaics" had been taken from windows in which the stonework was being renewed. By 1757, according to Pierre Chastelain, almost all the stained glass had been replaced by uncolored panes, but his ironic tone suggests some exaggeration, and the quantity of glass that has survived in the clerestories to the present day belies his claim.[67]

The next period of intense loss was surely the Revolution; its effect on the royal tomb effigies, the floor mosaic, and the reliquaries and furnishings of the choir have already been alluded to. Unfortunately, no inventory or chronicle details these destructions or specifically mentions glass. If any stained glass remained in the lower windows, it was likely damaged at this time, but it has been seen that some, if not all, of the colored glass had already been eliminated here. Clearly, however, there was no strenuous or systematic effort to remove royal images from the windows; in the choir clerestory, the upper half at least of Henri de France is almost perfectly preserved, with inscription intact, and the Virgin as Regina Coeli survived at least in part; several crowned Old Testament figures are also preserved. The greatest damage may have occurred through neglect during the period that the church was abandoned, and even after it was used as a parish church. Documentation is scarce, no doubt in part because the church was not scheduled as a historical monument by the Ministry of the Interior until August 6, 1842.[68]

NINETEENTH-CENTURY RESTORATIONS

The west facade had fallen into extreme decay by 1824, when preparations were begun for the coronation of Charles X; the west rose was especially unsound.[69] Complete restoration projects presented by the architects Hittorf and Lecointe were not carried out in time for the 1825 ceremony; the king had to be content with a wooden covering over the dilapidated steps to the portals and a wooden scaffold that was designed to prop up

[61] "Anné 1640. Memoire des Reparations de l'abbaye de St. Remy de Reims. . . ." The summary indicates that L.697.14.0 was spent "pour les grosses reparations tant de couverture, que de vitres."

[62] *Monasticon Benedictinum* vol. 37, Paris, B.N., MS lat. 12694, f. 101. It is somewhat ambiguous whether cloister or dormitory glazing is meant.

[63] Reims, Archives de la Marne, MS H. 413, dossier no. 22. The contract is not dated.

[64] Jean Lafond, *Le Vitrail: Origines, technique, destinées*, new ed., Paris, 1978, pp. 142–46. See also M. H. Caviness, "Some Aspects of Nineteenth Century Stained Glass Restoration: Membra Disjecta et Collectanea," in *Crown in Glory: A Celebration of Craftsmanship—Studies in Stained Glass*, ed. Peter Moore, Norwich, 1982, p. 70.

[65] Reims, B.M., MS 1824, f. 124v. Under 1737: "Cette meme anné et les suivantes on a fait retablir toutes les vitres de l'église dont on a remis la plus grande partie à neuf, et particulièrement la grande Rose du portail et les trois fenêtres du dessous. Cequi a couté 6000ᴸⁱ." To

which a note was added: "pour la moitié de l'ouvrage. Il y a encore autant à faire. Le tout a eté fini en 1739 par Payen maître-vitrier."

[66] "Procès avec l'abbé pour les reparations de l'église abbatiale" [1720–1759], Reims, Archives de la Marne, MS H.409, ff. 63–145. Some accounts and correspondence of the early eighteenth century in London, B.L., MSs Add. 20,324, f. 167, and Add. 20,401, f. 236, do not add any information for the fabric.

[67] Reims, B.M., MS 1828, p. 21: "Mais afin de donner a cette grande Basilique un air de majesté et de magnificence qu'elle n'avoit pas les Religieux de St. Remi poussés par un zele ardent pour la decoration du temple du seigneur non contents d'avoir fait mettre presque toutes les vitres en verres blancs, quelques années auparavant . . ."; there followed the inevitable whitewashing of the interior.

[68] Châlons-sur-Marne, Archivs départementales, 4 T 44, "Avis du classement."

[69] Prache, 1978, pp. 46–48.

the stonework of the rose and the first bay of vaulting. New glass for the rose, mentioned in the proposal of 1827, does not seem to have been supplied.[70] A meticulous description of the building, including its painted glass, by Povillon-Piérard is in the Municipal Library in Reims (Appendix 2). Writing about 1825, he confirmed that the rose and five of the lights below and on a level with it were filled with colorless glass, as one would expect from the eighteenth-century documents. In the tallest light in the center below the rose, however, he recorded an ill-proportioned representation of Clement I, and in each light on either side an "image of the Virgin" with a scroll inscribed with the *Ave Maria*. Below these, on either side of the main doorway, were represented Clovis, on the right, and his queen Clotilde, on the left. The placement of only one figure in each of these openings suggests either that they were of colossal order, or that they were set in an ornamental surround, whether original or not; these questions will have to be taken up later, but there is some probability at least that the figures had been in these positions since the twelfth century. Again in confirmation of the earlier documents, Povillon-Piérard counted eighteen openings with white glass in the nave aisles, and he commented on the date of 1740 in one of them.

The chapels of the chevet are also described as having colorless glass; Povillon-Piérard counted twenty-eight openings between the transepts, whereas twenty-nine would be the correct number, to include the Lady Chapel (Fig. 2). He qualified his statement, however, by adding that a few of these windows had colored ornamental borders, an observation confirmed in 1857 by Reimbeau.[71] This arrangement probably dated from the eighteenth century; examples in Canterbury, Troyes, and Poitiers, however, suggest two possibilities: It may be that fragments of early glass had been leaded into borders (Payen's "mosaics"), or that ornamental borders had remained in situ.[72]

The count of eighty-four openings given for the upper windows of the nave and choir must include the tribunes, but at the same time it seems to indicate that the windows of the nave tribunes had been blocked. Some of these upper windows were filled with white glass, others are described as having "kings, archbishops, Old and New Testament saints, and popes"; there can be little doubt that the present series in the choir clerestory is referred to here, despite the iconographic discrepancies, and the author's impatience with the apparent lack of chronological ordering. Of the clerestory lights of the nave, four on each side in the liturgical choir are de-

scribed as having kings and saints; the first on the right contained the inscription Chilperic, but no others had names. All the windows in the nave proper were filled with uncolored glass.

Povillon-Piérard is quite clear that the Crucifixion was in the axial window in the tribune, then as now. Furthermore, he described several of the figures of kings, ancestors of Christ, and saints that are in the other windows of the tribune, including St. Martha and St. Agnes with scrolls inscribed with the *Ave Maria*, all against grounds of white glass. Presumably, then, the other women saints corresponding to this description were not removed from the west end until later, and it seems probable that all once belonged to the same series.

Even though it is clear that the order of the glass has in many instances already been altered, the great value of Povillon-Piérard's account is that he wrote before the extensive restorations directed by abbé Aubert, the incumbent of Saint-Remi from 1840 to 1870. Dilapidations had apparently continued, including the collapse of some of the nave vaults, but these had been repaired and the south aisle reglazed by 1840.[73] Restoration proposals made in 1839 included new borders in the chevet, and the restoration of the upper windows in the choir and nave.[74] In 1840 a good deal of oil and aluminum paint corresponding to "the tone of old stone" was used by the glass painter Jaloux, working at some height, perhaps on the exterior of the old glass; a few repairs to the windows were made at the same time.[75] Over the next few years much glazing went on, using ordinary glass. A series of projects for such glass is preserved in the Bibliothèque Municipale of Reims, dated 1841–1851; it includes compositions for the rose and lower windows of the west facade, several chapels, and the baptistery in the south transept, with detailed notes on the condition of the south transept rose (Catalogue C). All are described as being executed by Casciani, "vitrier-peintre à Reims," and designed by Charles Givelet.[76] Lacatte-Joitrais published a brief description in 1843, by which time the west rose, with a new cast iron frame, had been glazed with plain colored glass (1841), and the old figures below eliminated; he clearly relies on Povillon-Piérard for their description. The north transept rose had also been reglazed, in 1842, with a medley of painted and plain glass arranged nonrepresentationally, and the Lenoncourt glass in the south transept was in a very poor state.[77] A series of impassioned letters from the abbé Aubert, written in 1840–1842 to the king, the archbishop, and the minister of religion, pleaded for money for new painted glass in the five lancets of the west facade.[78]

[70] Paris, A.N., F¹⁹ 4699, no. 2447.

[71] Reimbeau, MS 2100, III i no. 6, f. 1: "Dans les chapelles et en haut, il y a des très belles bordures anciennes."

[72] Caviness, 1981, pp. 254, 203–4; Lafond, 1955, pp. 29–30; Virginia Raguin has pointed out to me the colored borders that remain in some of the quarry-glazed lights of Poitiers Cathedral.

[73] Paris, A.N., F¹⁹ 4699, reports of 1838–1840.

[74] Paris, M.C.C., 821bis.

[75] A.N., F¹⁹ 4699, "Travaux de peinture et vitrerie, 1840."

[76] Reims, B.M., Estampes XVIII, Ifa. There are forty-four colored drawings, indicating straight-bar armatures and geometric ornamental panels, with a note of the subjects intended; only one is a design for a figural subject.

[77] Lacatte-Joltrois, 1843, pp. 83–85.

[78] A.N. F¹⁹ 4699, nos. 1520, 5436, 5393.

In 1842, the abbés Tarbé and Aubert, both members of the archaeological committee of Reims, reported on the lamentable condition of the old glass in the apse: The replacement of the sloping chapel roofs by flat ones had uncovered the lower part of the windows in the tribunes, but the glass was in very poor condition; the remaining colored figures should be given a new surround, to replace the eighteenth-century white glass, now broken, which allowed the rain to enter.[79] Indeed, a photograph of the south side taken in 1851 shows many distorted panels of plain quarry glass in the tribune, and a few that may be new.[80] Meanwhile, the Crucifixion window, or at least the "sunflowers" as the trees were referred to, became rather well known through the publications of Bourassé and Didron.[81] In 1844 the architect Narcisse Brunette stated that the building had been put back in use and that it remained only to restore some of the sculpture and stained glass; in 1843 he had proposed to engage Maréchal of Metz to supply new figural stained glass.[82] In 1847 glazing still remained to be done; some money for colored glass had been given in the community.[83] Government documents of 1852–1854, however, indicate that Maréchal and Gugnon of Metz were working on new historiated windows for the facade, including figures of Clotilde and Clovis, in order to replace glass "lost through the ravages of time and of vandalism."[84] Not long after, Viollet-le-Duc published a drawing of a colossal king's head that may have been Clovis, which he found in storage (Pl. 201); he also referred to debris of ornamental glass in the workshops.[85]

There is a curious gap in the official restoration documents between 1854 and 1872.[86] In 1877, correspondence between the archbishop and the architect Boeswillwald indicates that abbé Aubert, who had died in 1870, had caused a public scandal by "completely rearranging the stained glass in his church, without anyone taking stock of it"; he had apparently got rid of Maréchal of Metz's glass in the west rose and facade, which was not to his liking; the figures of Clovis and Clotilde were to be put back on either side of the portal.[87] Boeswillwald emphasized that the mayor of Reims must make sure that no rearrangement or repairs be carried out on the thirteenth-century [sic] glass of the apse without authorization.

The lacuna in the restoration documents can be sketchily filled from several sources, unfortunately none of them complete. One is the notes of Baron François de Guilhermy, who visited Saint-Remi in 1828, 1841, 1854, and 1864. On one visit he saw fragments of the Lenoncourt glass in the south transept, but commented in a later note that it had gone.[88] It had also been noted by Tarbé about 1844, and it was still described in place in Poussin's publication and Reimbeau's notes of 1857, so its disappearance may be placed between 1857 and 1864.[89] Each of these nineteenth-century accounts is incomplete and somewhat confused, but Tarbé gives the information that there were lacunae in the choir clerestory figures and that the colored borders had been replaced in white glass, whereas only borders remained of the chapel glazing.[90] Guilhermy expressed his intention to return to Saint-Remi for a whole day to see the glass from the tribunes, but his sketchy notes do not indicate that this was done. The only marginal correction is to give a better reading of the inscription for Chilperic in the nave; he had described it as *Eliakim* or *Hilderic*, relying on others, and corrected this to *Cha . . . eric*. In describing the choir clerestory, he noted bishops below other figures, beginning with St. Remi below Balaam on the north and listing all the figures in the first three bays. Henri de France he placed on the south side, but he did not record the other figures there (Appendix 3). He confirmed the lack of colored borders in these windows, and the existence of very beautiful original borders elsewhere; he also commented on the elimination by the Maurists of a large number of small subjects from the apse tribune, of which only fragments remained. He confirmed that the Crucifixion, female saints, and ancestors of Christ were still in the tribune.

Apparently the plea of 1842 for new borders in the clerestory of the choir was answered: In 1855 Tourneur reported to the Congrès archéologique that new borders in the choir clerestory had been copied from the large number of original designs in the lower windows and galleries, and in a second paper he gave the glass painter's name as Ladan, working under the direction of the abbé Aubert; another source places this work in 1846–1847.[91] These borders, presumably, can be seen in some of the Rothier photographs (Pls. 92, 128, 132–34). He also indicated that the large figures were supplemented in "eight or ten windows" by smaller figures that were more severely weathered, among them St. Remi.[92] He implied this to be an original arrangement of the twelfth

[79] M.C.C. 821bis, report dated November 11, 1842.

[80] Paris, Monuments Historiques, Archives Photographiques (S.P.A.D.E.M.), cliché MH 7521.

[81] J.-J. Bourassé, *Du Symbolisme dans les églises du moyen age*, Tours, 1842, p. 93 (I am grateful to Walter Cahn for this reference); Didron, 1844, p. 4, fig. 3.

[82] A.N., F¹⁹ 4699, no. 16201.

[83] Châlons-sur-Marne, Archives départmentales, 4 T 44, pp. 23ff.

[84] M.C.C. 821bis.

[85] Viollet-le-Duc, 1868, p. 448.

[86] M.C.C. 821bis; also Châlons-sur-Marne, 4 T 44, 1854–1887.

[87] M.C.C. 821bis: "M. Abbé Aubert . . . a manié et remanié de toutes façons les vitraux de son église sans que personne au monde y ait jamais pris garde."

[88] Guilhermy, MS 6106 , ff. 360, 420.

[89] Tarbé, 1844, p. 432; cf. Poussin, 1857, p. 179.

[90] Tarbé, 1844, p. 434;

[91] Tourneur, 1856, p. 88; cf. idem, 1862, p. 91. The colored borders are also admired by Poussin, 1857, p. 178. Victor Tourneur, "De la Peinture sur verre à Reims," *Mémoires de l'Académie de Reims* (1850): 9, says the curé hired Ladan in the miserable winter of 1846–1847 in order to give him work. According to Elie Guillemart, *La Peinture sur verre à Reims*, Reims, n.d., p. 10, Ladan was the first Gothic-revival glass painter to set up shop in Reims, about 1835.

[92] Tourneur, 1856, pp. 88–89.

century, reusing glass from the earlier choir, but in view of Guilhermy's comment on missing figures, it seems more probable that these smaller figures were brought from elsewhere when the new borders were put in. Poussin and Reimbeau described most of them as seated figures of kings, without names, of the same size as those in the tribune (Appendix 3).[93]

In fact Tourneur's longer article of 1862 relies on his earlier notes, since he was no longer in Reims, and it supplies a good deal more information about the arrangement of the choir clerestory as seen in about 1855.[94] He described in more detail the smaller figures that were interpolated in the clerestory, including both St. Remi and St. Nicholas below the Virgin in the axial light, and a dozen kings in the three bays to the south, with other figures made up from fragments, and borders used as fill. His account is complemented by those of Poussin and Reimbeau in 1857 and of Lacatte-Joltrois in 1868, the only ones to attempt a complete listing of the figures named in the inscriptions (Appendix 3).[95] These correspond quite closely with the incomplete listing of Guilhermy, and with indications given by Tourneur. Some unlabeled anonymous drawings in the Musée des Arts Décoratifs seem to date from the same period since they agree on the inscription *Iacob* for a figure that had been renamed Isaiah by 1896 (pls. 186, 187). By then also the interpolated figures had been removed, their places filled with new figures designed to scale with the original; the authority for this change is the Rothier photographs (Pls. 136, 138, 141).

The nineteenth-century restoration of the glass seems to have been quite extensive, because the Crucifixion window in the tribune was also transformed by the addition of angels and of personifications of Ecclesia and Synagoga (Pls. 101–3); from evidence discovered by Prache, this restoration can be situated between 1844, when the plate from which it was inspired was published in Cahier and Martin's great monograph on Bourges, and 1896, when Rothier published his photograph of the restored window, and she argued that it probably took place between 1847 and 1870.[96] In fact, the dates can be narrowed further. A drawing in London showing the prerestoration state is a copy of one done in 1861 by John P. Seddon (Pl. 102); indeed the restoration must have taken place after 1868, since none of the descriptions up to and including Lacatte-Joltrois mention the additions to the Crucifixion iconography, and it was probably completed by 1872 when the official documents are resumed, since none thereafter and up to 1896 mention significant expenditures on glass.[97]

The identity of the restorer remains uncertain, but one document has come to light that may implicate the Didrons—a series of detailed drawings of the Crucifixion window and of the figures of Martha and Agnes before restoration, published on the death of Didron jeune in 1902 (Pls. 95, 101).[98] Guilhermy had recorded the information that Didron aîné had directed work on glass in Saint-Remi some time between 1851 and his death in 1867.[99] His design for a new window in the south transept is corroborated by Lacatte-Joltrois, and by Poussin who described it as new in 1857.[100] Didron's interest in the old glass, however, is also in evidence in his publication of details from the Crucifixion window in 1844.[101] It is possible that Edouard Didron, who directed the stained glass atelier after his uncle's death, was involved in the large-scale restoration that occurred soon after 1868. Tourneur has spoken of consultations with Henri Gérente in 1845, and later with Lassus and Coffetier, but they may not have been involved in later restoration plans.[102] On the other hand Lacatte-Joltrois mentions modern work by Jean-François Martin Hermanowska of Troyes, who executed designs of Viollet-le-Duc, by Louis-Germain Vincent-Larcher of Troyes, by M. Bourgeois, and by M. Leclère of Mesnil-St.-Firmin, in addition to Didron and Ladan.[103] The first two are known for their restorations to the twelfth- and thirteenth-century glass of the Cathedral of Troyes, where Vincent-Larcher was also very busy with commissions for new windows up to 1886.[104] In the same period he supplied four new windows in Saint-Remi, most of them in the Lady Chapel, so he could well have been involved in restoration too.[105] A role for Hermanowska

[93] Poussin, 1857, p. 177; Reimbeau, MS 2100, III i no. 6, f. 2.

[94] Tourneur, 1862, pp. 88–95.

[95] Poussin, 1857, p. 178; Lacatte-Joltrois, 1868, pp. 65–66.

[96] Prache, 1981, p. 148; the subjects of Ecclesia riding the Apocalyptic beast and Synagoga on an ass were borrowed from a window in Freiburg-im-Breisgau, reproduced in Cahier and Martin, 1841–1844, Etude XII. Unfortunately, the prerestoration states have caused confusion: Ellen Beer, *Die Glasmalereien der Schweitz aus dem 14. und 15. Jahrhundert*, Corpus Vitrearum Medii Aevi: Schweitz, III, Basel, 1965, p. 255, n. 679, cited Louis Grodecki's opinion that the white ground was original; Grodecki also concurred with William M. Hinkle, "The Gospels of Cysoing: The Anglo-Saxon and Norman Sources of the Miniatures," *Art Bulletin* 58 (1976): 507 and n. 102, that Ecclesia and Synagoga were original, an opinion taken from Gérard Cames, *Allégories et Symboles dans l'Hortus Deliciarum*, Leyden, 1971, p. 48, n. 5, although the earlier sources cited by Cames do not mention the Saint-Remi glass.

[97] M.C.C. 821 bis, 1872–; Châlons-sur-Marne, Archives départe-mentales, 4 T 44, Réparations 1887–.

[98] *L'Art Sacré*, [1902], p. 2.

[99] Collection Guilhermy 34, B.N. MS n. acq. fr. 6127, f. 417.

[100] Lacatte-Joltrois, 1868, p. 68; Poussin, 1857, pp. 176, 250, who describes the nineteenth-century windows in some detail.

[101] Didron, 1844, p. 4, fig. 3. Curiously, however, he made no mention of glass in an earlier publication: "Génie Esthétique de la ville de Reims," *Chronique de Champagne* 4 (1838): 399–411.

[102] Tourneur, 1862, p. 95.

[103] Lacatte-Joltrois, 1868, pp. 67–69.

[104] Lafond, 1955, pp. 33–34. Elizabeth Pastan has found evidence in the restoration dossiers for a new axial window commissioned from Vincent-Larcher in 1846, for the restoration of two windows by 1861, of a further nine, and another new window, by 1864, and three more restored and one new by 1889. According to O.-F. Jossier, *Monographie des Vitraux de Saint-Urbain de Troyes*, Troyes, 1912, p. 227, Vincent-Larcher was active from 1843 to 1886 and died in 1894.

[105] Jossier, *Monographie*, p. 227.

can be ruled out since he died in 1860.[106] Edouard Didron and Vincent-Larcher remain the most likely candidates.

During this late nineteenth-century restoration each of the original figures in the choir clerestory was coherently completed, and in most cases the inscriptions were renewed, apparently in an attempt to systematize the iconography. In many cases old borders were substituted for those of Ladan, presumably moved from the lower windows where it seems they had been preserved. Other changes that were made will be considered in detail later. New figures were made to fill the gaps that had been stopped with smaller ones; these include a full-scale Saint Remi below the Virgin and Child, and six new figures for the fourth bay on the south side. The Rothier photographs, evidently taken when this glass was quite new, clearly show its more brilliant tones; this is the restoration that can still be seen in the panels as photographed after World War I damage, and it is noticeable that the thin nineteenth-century glasses had shattered to a greater extent than the thicker medieval ones (Pls. 135, 186, 188). Some of this restoration was retained in subsequent campaigns; the subjects added to the Crucifixion window were not put back after World War I, but they were preserved in the atelier of Jacques Simon in Reims and are now stored in the government Dépôt at Champs-sur-Marne.[107] It will therefore be possible at some time to identify the style of the restorer.

One of the questions raised by the elimination of the small figures from the choir clerestory about 1870 is whether they were all preserved elsewhere in the church, and to what extent their preservation occasioned a reordering of other windows. At least three figures documented by Tourneur in the clerestory, the small images of St. Remi and St. Nicholas and a composite figure with the inscription *Andreas*, were evidently placed in the tribune below, after restoration (Pls. 92, 269). Since Lacatte-Joltrois had already recorded several Old Testament kings and ancestors of Christ in the tribunes in 1868, it may be inferred that the twelve kings and other fragmentary figures seen by Tourneur in the choir clerestory were moved to the clerestory of the nave. The Rothier photographs show them distributed through those windows, completed by new panels where necessary and surrounded by nineteenth-century ornament

(e.g., Pl. 35b). One shows the upper part of a king with a face—evidently a stopgap—only half the width of his crown, corresponding to a figure previously in the choir where it was remarked on by Tourneur.[108] Eleven complete figures and parts of nine others more than account for the dozen removed from the choir, and it is indeed probable that some of this series had remained in the nave where Povillon-Piérard and Guilhermy had seen them earlier in the century.[109]

Other records, however, imply some attrition during or after the restoration. The famous head that Viollet-le-Duc drew may no longer exist (Pl. 201); before 1868 he had seen it in the attics of the presbytery, having apparently been removed with other panels from the choir of Saint-Remi.[110] His interest in it was the colossal scale, and the way in which leading around the eyes and the coarse tracelines of the paint were softened when viewed from a distance; his scale drawing would give an original height of twenty-seven and a half centimeters for the face alone (almost eleven inches), and nearly fifty including the neck and crown, or about a third larger again than the mitered heads of the archbishop in the choir clerestory. It might be questioned whether he was confused in the provenance since the scale seems more appropriate to the nave clerestory of the cathedral, but surviving thirteenth-century heads there that employ the technique of leading the eyes separately place the lead at the eyebrow instead of the upper lid; nor are the crowns designed in the same way. This fragment may have been a vestige of the west facade glazing, and its loss is very much to be regretted.

Similarly, some borders that were recorded in nineteenth-century watercolors have since disappeared from Reims (Catalogue D, R.b.6, 14, 16, 17, 17a, 31, 32, 33a, 33b, 34, 36).[111] Only a few of these have been traced through the Maignon collection to the Musée de Picardie in Amiens.[112] It is presumably fortuitous that they had been attached to a figured panel with a seated St. Remigius from Beauvais Cathedral.[113] Another border fragment, which matches pieces still preserved in Saint-Remi, was attached to a panel of the Visitation from Gassicourt, which has remained in Didron's atelier after restoration.[114] Such composite arrangements were not unusual in the nineteenth century.[115] Jadart, reminiscing about the disappearance of glass from Puiseux in the

[106] Ibid., p. 226, gives his dates as 1806–1860. Elizabeth Pastan pointed out to me a design, preserved in the restoration dossiers, for a Passion window in Troyes that resembles the Saint-Remi Crucifixion window restoration in figure types, but the drapery and features are less heavy. The personal or workshop styles of these nineteenth-century restorers are as yet too little known to make attributions on that basis.

[107] Prache, 1981, pp. 145–46, fig. 5.

[108] Tourneur, 1862, p. 95.

[109] Guilhermy, MS 6106, f. 420, recorded figures of prophets, including Daniel, as well as Chilperic and other kings; Povillon-Piérard may have referred to as many as sixteen figures, two in each window of the choir bays (MS 1837 f. 53v).

[110] Viollet-le-Duc, 1868, pp. 421–22; translation and reproduction in Westlake, 1881, 1: 61, pl. xxxv a and b.

[111] Buckler Bequest, nos. 25, 28, 30, and Dessins, Vitraux, n.p. The latter group of borders are indicated as belonging to the cathedrals of Soissons and Laon as well as Saint-Remi, and they are reproduced in color in Cahier and Martin, 1841–1844, Mosaïque 8a M. There are also some watercolors by Noel Heaton, dated about the turn of the century, in the Heaton Collection. See Catalogue D.

[112] Musée des Arts Decoratifs, Album 482/5, Vitraux—France, Moyen Age, Villes S–Z, black and white photograph of a panel in the collection of Albert Maignon; the border panels were subsequently removed: *Corpus Vitrearum France Recensement* 1, p. 222, fig. 125.

[113] Cothren, 1980, pp. 393–97, fig. 184.

[114] Caviness et al., 1978, pp. 31, 34; documented by Guilhermy, MS 6100, f. 393.

[115] Caviness, "Some Aspects," pp. 69–70.

1870s, recalled the custom of glass painters of creating very decorative panels from debris that they had acquired here and there; he cited especially the creations of MM. Bulteau and Haussaire in Reims, which were widely sold and very costly.[116] Bulteau is in fact the glass painter mentioned in Boeswillwald's report of 1877 who was involved in unauthorized removal of glass from Saint-Remi.[117] In 1884 a border panel was openly loaned by Didron to the exhibition at the Union Centrale des Arts Décoratifs in Paris.[118]

In 1900 a Parisian glass painter, H. Coulier, wrote an indignant letter to the Ministry of Fine Arts complaining that two complete and original lancets of twelfth-century mosaic glass were exhibited at the Invalides as the property of M. Babonneau, also a glass painter, and expressing concern for the safety of other panels that were stacked in the choir tribunes; the galleries were not locked and casual visitors were in the habit of taking pieces away with them.[119] Perhaps the sizable piece of ornamental glass in the Cloisters collection in New York left at this time (Catalogue D, R.o.5).[120] Other forms of vandalism were also known: In 1903 the curé and the architect Darcy complained that ancient glass in the choir clerestory had been damaged by objects hurled from adjacent houses; a plan shows these to the southeast, within the present enclosure. Protective grills for the glass and the demolition of the houses were recommended.[121]

TWENTIETH-CENTURY DAMAGE AND CONSERVATION

Some casual vandalism appears insignificant beside the war damage that followed. In June 1915 the architect Max Sainsaulieu reported the emergency removal, at night, of the Crucifixion window and four others in the tribune that had been damaged by shelling. The glass had been taken down and put in cases for safe storage by men from Paul Simon's atelier. The Crucifixion had already been damaged, as confirmed in the prerestoration photographs: "Les très beaux vitraux à fond bleu du XIII^e (ou XII^e) qui sont dans la galerie haute du chevet ont particulièrement souffert—et particulièrement celui du milieu représentant le Christ en croix avec la Ste. Vierge et St. Jean. Il y a de nombreux trous et toute la mise en plomb est ebranlée." Further shelling damaged the north transept in September.[122] Later photographs show collapsed vaults in the choir tribunes and Lady Chapel and twisted panels of glass hanging in the window frames;[123] the clerestory glass was in the process of being taken out for safekeeping when the town was abandoned to the Germans in 1918, and the panels were evacuated from the city in crates.[124] Some glass seems to have been lost from the three turning bays of the apse, either before it was taken down or in transit. The nave likewise suffered great damage, the complete destruction of the vaults being followed by the collapse of the clerestory wall on the south side (Pl. 23);[125] Simon, however, noted that the glass was unharmed, although he does not refer to its prior removal.[126] In the course of clearing the site, some excavations were carried out, and in 1928 the architect Deneux reported the find of a medieval chalk mold for lead cames, and some associated leads, in an old well (Pl. 67); he rightly concluded that the original stained glass had been fabricated on the site.[127]

Following the war, the first part of the church to be restored and put back into use was the nave; by October 1931 it had been reconstructed and reglazed under the direction of Deneux, although Simon referred to the restoration of the glass as provisional.[128] He complained of a great deal of pastiche glass, and indeed comparison of the present state with the Rothier photographs indicates that rather crude restoration was left unchanged. Only one panel seems to have been lost.[129] The borders and grisaille surrounds, however, were renewed; probably the nineteenth-century ornament had not been taken down. The documents indicate further restoration; the glass was again dismantled in 1939, and some new pieces were painted for the figures in 1947, before new photographs were taken and the panels put back.[130]

Funds were not approved for the reconstruction of the choir until the summer of 1939; work by Paul Simon on the choir glass continued during World War II and af-

[116] Henri Jadart, "Le Vitrail de Puiseux et autres anciens vitraux des Eglises du Départment des Ardennes," *Revue Historique ardennaise* 7 (1900): 318, n. 3: "Les peintres verriers fabriquent avec les mille débris qu'ils enlèvent de tous côté des vitres en mosaïque d'un très riche effet. Nous en avons vu chez MM. Bulteau et Haussaire à Reims, qui ont été vendues au loin et très cher."

[117] M.C.C. 821bis, March 28, 1877. I have not been able to find a source for the statement by Simon, 1959, p. 15, n. 1, that the Abbé Bulteau had reported that fragments of glass were scattered on the floor of the tribunes and that M. Bulteau-Jupin, a rémois sculptor, had collected some.

[118] M.C.C. 821bis, letter dated September 24, 1900; a second reference gives the glass painter's name as Bonbonneau, perhaps mockingly. There is no sign of a response.

[119] Magne, 1884, p. 30, no. 46.

[120] It was a gift from the Pratt collection in 1926, but the provenance is not recorded beyond that.

[121] M.C.C. 821bis, letters of October 8, etc. Photographs in Paris, Monuments Historiques, Archives Photographiques (S.P.A.D.E.M.), MH 7521 (dated 1851) and 52 890, show the proximate structures.

[122] M.C.C. 821bis.

[123] Prache, 1978, fig. 52.

[124] Simon, 1959, p. 15.

[125] Prache, 1978, p. 78, figs. 19, 84, 85.

[126] Simon, 1959, p. 16.

[127] Henri Deneux, "Un Moule à plombs de vitraux du XIII^e siècle," *Bulletin Monumental* 87 (1928): 149–54. In 1987 M. Bouxin allowed an impression to be taken from the mold with the museum, and we tried it for size on the old cames in the Marq atelier (pl. 131). The fit was not perfect, but the dimensions matched.

[128] Simon, 1959, p. 16. Accounts are in M.C.C. 822, 5^e dossier.

[129] The upper half of the figure in N.XIX, with a cap; it appeared heavily restored in Rothier's photograph.

[130] M.C.C. 823, 7^e dossier.

ter.[131] The panels were photographed before and after restoration (Pls. 186, 188); considerable trouble was taken to keep some border panels in their original leads, and Simon was very actively concerned with the overall harmony of light and color (Col. Pls. 2, 3, 7, 8, 10; Pl. 68). As far as possible ancient borders were used instead of the nineteenth-century ones, and the records indicate that some that had been preserved in the chapels on the north side at ground level were now moved to the tribunes.[132] Unfortunately, a plan of the surviving glass made in 1942 is not preserved in the ministry dossiers, but for the borders there are watercolors and measurements in the atelier. Some of the nineteenth–century figures in the clerestory, visible in the Rothier photographs, were replaced; the archaizing work of Paul Simon matches the original glass so well that Grodecki has referred to ancient figures not only in the triplets on both sides of the three straight bays but also in both of the first turning bays;[133] in fact the first turning bay on the south side (S.III) had lacked its original glass since at least mid-nineteenth century, as we have seen. My examination showed that Simon had carefully restored the nineteenth-century figures in most cases, but he misleadingly reproduced a photograph of the whole bay with a caption indicating that the figures as well as the borders were largely ancient.[134] The nineteenth-century restoration was not, in fact, systematically eliminated; it was repaired and replaced when the color effects were not found to be too strident, and sometimes it was toned down with a false patina on the outer surface.

The progress of the restoration can be followed schematically in the official dossiers. By June 30, 1945, eighteen lights from the straight bays of the choir clerestory were ready to go back, but the armatures had not been repaired. The nave figures were replaced in 1947. The three central bays of the tribune, including the Crucifixion, were ready for installation by May 1950, but these were still waiting to go back in November 1951; by then twenty-four lights were ready for the clerestory of the choir and nine for the tribune. In June 1952 concern was expressed that the ancient borders from the three bays of the apse hemicycle had still not been put in order and risked being misplaced or damaged.[135] In 1953 the recently restored Crucifixion window was lent to the stained glass exhibition in Paris.[136] The nineteenth-century restorations had been eliminated, the ground replaced with modern blue scattered with red roundels similar to those in the nave clerestory panels, and the border extended to fill the light (Pls. 100, 103). In June

1955 it was proposed to finish the restoration of the tribune glass, including a lancet of ornamental glass that had recently been rediscovered.[137] Simon informs us that work on the new designs for the lateral bays, to replace the nineteenth-century grisailles that were too light, continued up to 1958.[138] By then the process of refurbishing the choir windows had dragged on for nearly forty years.

The only grave error in this lengthy restoration was to overlook some figural panels in the cases in storage. About 1954, figures were supplied for the nine openings of the apse clerestory hemicycle from modern designs by Simon. The Rothier photographs had shown twelve of these eighteen figures to be essentially old, with the upper two-thirds of the Virgin and Child in the axial light (Fig. 5, Pls. 139–41). Simon's notes in the atelier about 1955 indicate that they were considered lost, possibly during the evacuation. Later, however, the upper panel with the Virgin's head and shoulders very well preserved was found in storage; it was releaded and placed, with other fragments, in the south transept in 1963 (Pl. 142).[139] Apparently the rather damaged upper half of "Zacharias" from the second bay on the north side (N.Vc), where it had already been replaced by a copy, was also discovered and it too is in the transept (Pls. 129, 130).

THE SURVIVING CORPUS OF MEDIEVAL GLASS

The dozen apostles and archbishops from the hemicycle have never been found, and this loss must be counted among the great artistic tragedies of World War I. Yet the condition of the ancient panels that remain in the retrochoir clerestory is not as poor as once feared. Whereas the tribune glass bears the scars of wide leading that had probably been used in the eighteenth century, there is no sign of it here; this observation is confirmed by the fact that the leads taken off Isaiah from N.Va, which are preserved in his atelier, are medieval (Pl. 131). In other words, there was no very extensive restoration to the glass, involving a complete releading, prior to the twentieth century; nineteenth-century replacements, which can be recognized in the prerestoration photographs, could have been eased into the old leads. It is also fortunate that the thick medieval glasses generally proved tougher than the nineteenth-century ones in resisting the impact of the shelling; most of the breakages and losses seen in the prerestoration photographs stand out in the

[131] Ibid.

[132] The borders are mentioned in M.C.C. 823, 7ᵉ dossier, in documents of April 18, 1942 and May 19, 1944. Photographs of the exterior of the Lady Chapel, dated 1940, in the same dossier, show several fragmentary panels of ornament of the kind now in the tribune of the choir and previously given to the Cloisters in New York. Poussin, 1857, p. 177, had recorded that Ladan made two ornamental windows for the Lady Chapel, copying original designs.

[133] Grodecki, 1975, p. 66; his total of forty-eight figures, also given in the restoration documents, is correct, but the distribution is wrong.

[134] Simon, 1959, p. 21. The Rothier photograph clearly shows new glass in this bay.

[135] M.C.C. 823, 8ᵉ dossier: "Elles gisent sur des plateaux appelés à être changés de place et risquent de soubir avec le temps et les imprévus, des erreurs de classement et des accidents."

[136] Grodecki, 1953, no. 10, pp. 46–47.

[137] M.C.C. 823, 8ᵉ dossier.

[138] Simon, 1959, p. 20.

[139] A dated inscription indicates that the arrangement was the work of Brigitte Simon.

Rothier series as replacements. Other kinds of alterations to the old glass, however, have to be suspected. Although there was little sign of cleaning with acid, and therefore probably little or no repainting and refiring of the glass, the photographs suggest some cold retouching, before the twentieth-century restoration, in areas where there was considerable loss of paint; such alterations were confirmed in panels that were examined on the bench, such as "Fulco" in whom the eyes and major traits have been strengthened (Pl. 147). The exterior surface has also been tampered with: Signs of vigorous scrubbing are all too evident, and traces of back painting, though limited, are sufficient to indicate its liberal use (Pl. 69). Here again, the glass in the tribune has fared less well (Pls. 81–83, 94, 99, 248, 251).

Since 1980 further work has been cautiously undertaken on the windows. They have gradually darkened with patination, until the north is so somber in winter that the colors can barely be seen, except the more stable greens, yellows, and blues. Examination from the exterior was extremely difficult a decade ago because the glass has an oddly uniform grayish patina (Pl. 69). In recent years this has begun to separate from the glass, revealing flaky corrosion layers under it on the original glasses; it has become possible to chart the windows accurately. Recent laboratory tests of selected panels confirmed a grayish layer on both surfaces.[140] Conservation is urgently needed, especially because moisture must be trapped under the peeling layers, even though these may have provided some protection for a period of time. Furthermore, lichens are so thick on the lower panels of the clerestory lights on the north side that the surface cannot be examined; judgments of authenticity here were based on the assumption that they grow more thickly on the old glass, but closer examination of panels from the second bay in the atelier in 1985 indicated this is not a secure premise. The present situation has been urgently stated: "Les vitraux de XIIème siècle de la basilique Saint Rémi de Reims sont dans un état de dégradation des plus alarmant."[141] If funds become available for the needed treatment of this precious glass, it may be possible both to save it and to proceed to a more thorough examination of the paint surface.

The history of the glass passed in review here has established a base for the following chapters. We will not expect to find panels surviving from the mid-eleventh century, despite the probability that the basilica had stained glass windows in that era. Careful consideration will have to be given to the possibility that some of the panels no longer in situ date from the mid-twelfth century decorative program of Abbot Odo. The proportion of surviving glass from various parts of the building is variable. Enough seated figures of uniform size survive from the nave clerestory openings to fill half of them— more than enough for the four bays that served as part of the choir—and for these a coherent iconographic theme can be suggested. Early descriptions give some indication of the program of the west facade, and indicate that two figures once in it are related to two preserved in the choir tribune. The rich series of figures that are essentially in situ in the clerestory of the late twelfth-century retrochoir comprise about two-thirds of the original program; this proportion is improved by photographic records of another three bays, so that in a final analysis only one of the eleven three-light bays is completely lost to knowledge (Appendix 3 and Fig. 5). Other prerestoration records aid in establishing the identity of some of the figures (Pls. 175, 176, 186, 187).

In the tribune of the choir, on the other hand, only one light has glass that can in any sense be said to remain in situ, and its Crucifixion has been several times placed in new surrounds; the nineteenth-century drawings indicate that the principal figures had already been isolated, probably by a surround of colorless glass (Pls. 100–103). The old glass assembled in the other fourteen lights of the hemicycle seems to have been moved from elsewhere at various times, and it will have to be rigorously questioned whether the band-window compositions reflect an original arrangement. No trace is left of the glass from the double lights in the two straight bays of the tribunes, and overall not enough is preserved from this part of the building to be able to reconstruct a program.

For the windows of the lower story the record is even more dismal, since no figural glass from them survives in Saint-Remi; indications that some small-scale panels survived into the nineteenth century offer the possibility of tracing some to collections, and a hypothetical reconstruction of part of one of the small windows in the west wall of the south transept will be presented, using two pieces in the Glencairn Museum (Pls. 211, 215, and Catalogue C). There is also a strong possibility that some of the ornamental borders were made for these windows.

[140] Bettembourg et al., MS, 1981. They were not able to establish whether the gray substance was the paint used by Jaloux in 1840 (n. 75 above).

[141] Bettembourg et al., 1983, p. 10.

CHAPTER II

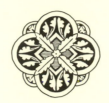

The Decorative Programs of Saint-Remi: Images and Readings

Atrium interius dicitur claustrum. . . . Iuxta sanctuarii introitum atrium interius collacatur, extra se habens atrium exterius, et intra primum tabernaculum quod dicitur sancta. Novitius igitur ad religionem veniens, in confinio rationis et sensualitatis positus, iam quidem non est in carne, sed necdum in spiritu. . . . Est et gazophilatium claustrum, ubi aurum, argentum et lapides pretiosi reconduntur, et ubi thesaurum nostrum in vasis fictilibus, id est conscientiam bonam in observantiis regularibus, habemus.

Peter of Celle[1]

Thus in 1179 Peter of Celle developed the theme of the cloistered life, alluding frequently to the Judaic Temple with its ark of alliance as a type or allegory of the monastic church, and to the monastic church and its treasure as metaphors for the spiritual life.[2] His quietly phrased description of the position of the novice, "neither entirely in the flesh nor yet in the spirit," is reminiscent of Abbot Suger's more dramatic "strange region of the universe which neither exists entirely in the slime of earth nor entirely in the purity of Heaven."[3] Suger, however, was more frank in allowing himself to "delight in the beauty of the house of God" and in "the loveliness of many-colored gems," so that meditation upon them would lead him "anagogically" to the immaterial world. Indeed, there are great differences between the spirituality of the two abbots, even in the audience to which they addressed their major treatises;[4] and, whereas Suger's writings offer very specific insights into the works

[1] Peter of Celle, 1977, chaps. 12, 13, pp. 192–197: "The cloister is known as the 'inner courtyard' . . . The inner court is situated near the entrance to the sanctuary; without is the outer court, and within is the first tabernacle, known as the holy. So the novice who enters the monastic life, placed between the confines of reason and of sensuality, no longer dwells in the flesh, nor as yet in the spirit. . . . The cloister is also the 'treasury' where the gold and silver and precious stones are deposited, and where we keep our treasure in earthen jars—that is, we have a good conscience in regular observance."

[2] For the date of the treatise, see Peter of Celle, 1977, pp. 26–27.

[3] Suger, 1979, pp. 62–65: ". . . quasi sub aliqua extranea orbis terrarum plaga, quae nec tota sit in terrarum faece nec tota in coeli puritate. . . ."

[4] The *De Disciplina claustrali* has come down to us in only two copies, one from Clairvaux (Troyes, B.M., MS 253) and one from an English house of canons, now in Cambridge, University Library, MS Gg IV 16: Peter of Celle, 1977, pp. 75–78. The surviving manuscripts coincide with the expressed intent of Peter to write a spiritual guide for Richard of Salisbury, canon of Merton College in England, and the dedication of a copy to Henry the Liberal, count of Champagne (ibid.,

of art he engendered about 1140–1145, Peter's are more abstract, never once overtly referring to the material building that he was at the same time engaged in constructing and decorating. Yet von Simson and Prache have perceptively drawn parallels between his allusions to the Tabernacle of Moses and its analogue in the reconstructed choir of Saint-Remi.[5] Their insights have led me to a close examination of the text of the treatise *De disciplina claustrali* and other writings of Peter of Celle in relation to contemporary imagery in the stained glass.

Those late twelfth-century images, however, have also to be understood in the context of the whole program, because they complemented earlier decorations in the choir. The sumptuous ornaments probably supplied under Abbot Odo before midcentury were themselves part of a dialogue with both Suger and Bernard; the latter had found support for his austere attitudes to monastic art among other Benedictines in the archdiocese, and Odo's choir program may well have been his nonverbal response.[6] Later, it seems that the decoration applied by his predecessors stimulated Peter's visual imagination as he wrote, so that text and image were mutually dependent in their genesis.[7]

This chapter will therefore deal with the decorative program in its entirety, from its inception before midcentury under Peter of Celle's predecessors to its completion after his departure from Reims. I will not, however, focus on the genesis of the early decorations, or their sources, tantalizing though it might be to make such an excursion. My concern here is not so much with the chronology and detailed reconstruction of the successive layers of the decoration, as with its totality, in the final form in which it appeared by about 1200. Thus, works of different dates, and in a variety of media, are grouped under three broad thematic headings that can be followed throughout. The first comprises the Tabernacle of Moses and the Old Testament precursors of Christ; the second, the coming of Christ and his Church, and the establishment of his heavenly kingdom; the third is that of *regnum et sacerdotium*, the interaction between kingship and priesthood, secular and sacred power, as manifested in the rulers of France and the archbishops of Reims, and in their Old Testament precur-

sors. Overlapping and interconnections between these thematic groups prevent categoric divisions, but a schematic presentation serves to clarify the main issues.

To a great extent a Tabernacle of Moses had been created in the liturgical choir of Saint-Remi by Peter of Celle's predecessor, Abbot Odo (1118–1151). Underfoot was an encyclopedic mosaic (Fig. 3); among its several extensive themes was the role of the Old Law as a type of the New. Overhead was a great candlewheel representing the heavenly Jerusalem (Pl. 25). Each of these themes was developed again toward the end of the century, in the sculpted consoles applied to the capitals of the piers in the choir bays of the nave, and in the series of patriarchs, forerunners of the New Testament saints gathered at the celestial court of the Virgin, in the glass of the new retrochoir (Pls. 32–34, 29, 127–41).

The Tabernacle of Moses and the Precursors of Christ

THE FLOOR MOSAIC

It was seen in the last chapter that a decorative pavement had been laid in the choir of the Romanesque church; the mosaics are almost entirely lost, but the description of 1622 by Nicholas Bergier allows us to place the various iconographic elements quite accurately in relation to the main altar in the crossing, despite the fact that some parts were hidden by the monks' stalls.[8] Barral I Altet has recently made a thorough study of this and other first-hand descriptions, and suggested a schematic layout for the sequence of images; he has also found affinities with Italian pavements.[9] My own reconstruction differs somewhat from his (Fig. 3). In the center of the western end of the choir, which extended four bays into the nave, was a representation of King David playing the harp; next, a large rectangle contained St. Jerome closely surrounded by the Evangelists and apostles with books and, more distantly, by prophets with scrolls; this area extended to the eagle lectern, probably positioned at the foot of the altar steps.[10] Ascending the steps was the Ladder of Jacob; at the top, before the altar, was the Sacrifice

pp. 27–33); the audience addressed, however, could as well be the Benedictine monks of Saint-Remi, although if a copy existed in Saint-Remi it was destroyed in the library fire.

[5] Prache, 1978, pp. 40–41, citing Otto von Simson, *The Gothic Cathedral*, London, 1956, pp. 193–94.

[6] The Benedictine reform movement was led by William of Saint-Thierry in Reims, to whom Bernard addressed his famous outburst against certain kinds of images, ca. 1125; in 1131 William and other abbots attended a council in Reims, but Odo was not among them. See S. Ceglar, "Guillaume de Saint-Thierry et son rôle directeur aux premiers chapitres des abbés bénédictins: Reims 1131 et Soissons 1132," in *Saint-Thierry: Une abbaye du XIe au XXe siècle*, Actes du colloque international d'histoire monastique, Saint-Thierry, 1979, pp. 320–33; Adriaan H. Bredero, *Cluny et Cîteaux au douzième siècle: L'histoire d'une controverse monastique*, Amsterdam and Maarssen, 1985, pp. 78–79 and 88–89, n. 29.

[7] Nilgen, 1985, p. 230, accepted the dates for the glass proposed by

Grodecki, thus situating the figures in the nave and tribune before Peter's abbacy, and the choir clerestory after it, so that his direction of the program is dismissed a priori.

[8] Nicholas Bergier, *Histoire des Grands chemins de l'Empire romain*, Paris, 1622, pp. 189–91; repeated by Marlot, 1843–1845, 2:542–44 with additions, and with the claim that the mosaic was begun in 1090 by the treasurer Wido. Both are quoted in full by Barral I Altet, 1980, pp. 82–84.

[9] Barral I Altet, 1980, pp. 84–94, fig. 4.

[10] The reference of Bergier to "l'Aigle" without further explanation seems to me to mean the lectern rather than a large mosaic with an eagle, as suggested by Barral I Altet (p. 82; cf. 84 p. and fig. 4). I am indebted to Ernst Kitzinger for his opinion; he notes that in Bergier's description the eagle "appears to figure only as a point of orientation" and that in Stern, pt. 1, fasc. 1, 1957, pp. 91–92, no eagle is mentioned. An eagle lectern occupied the center of the choir in Suger's Saint-Denis (Suger, 1979, pp. 72–73); this position was common in the early

of Isaac by Abraham. The altar was probably placed in the crossing, since the shrine of St. Remigius must have occupied much of the early retrochoir (Fig. 3).

This sequence of images along the axial approach to the altar is obviously carefully positioned. King David would have greeted the crown prince as he came to visit the shrine of the Holy Chrism, reminding him of the Biblical precedents for annointing and for good kingship. The figure, through its association with Carolingian imagery, would also have invoked the ancient tradition of the Frankish coronations.[11] David's harp referred to his psalms which were chanted daily in the choir before the high altar, as he had made music before the ark of the covenant, but there was also a tradition that associated this figure with Christ crucified and his Church.[12] Hierarchically placed closer to the altar was the father of the early Church, St. Jerome; he was appropriately placed before the lectern from which his translation of the Bible was daily read, and surrounded by the authors whose books of the Old and New Testament he had translated. If the Evangelists, apostles, and prophets were arranged in successive rings the whole composition would have occupied a large part of the central space of the nave, but we shall see that this creates problems for locating the lateral elements. The concept of placing Jacob's Ladder on the steps that led to the altar seems novel and ingenious; perhaps Jacob was recumbent below. Here and in the other scene before the altar, Old Testament types prefigured the New Alliance; sacrifice under the Old Law was contrasted with the Eucharist, and Isaac was seen as a type of Christ.[13] Such an approach to the Christian altar by way of Old Testament prefigurations was not unusual; even in the curiously ordered vault paintings of Saint-Savin-sur-Gartempe, Noah makes and drinks wine at the entrance to the sanctuary, his story then doubling back as he falls from grace.[14]

The lateral fields included, to the south of the altar and

on the same level, a personification of Wisdom enthroned, an orb in her left hand, and a stick in her right to goad Ignorance and Sloth, who were represented at her feet. An inscription indicated that she ruled over the seven Liberal Arts, personifications of which were perhaps placed at the foot of the steps. The pavement that extended down the same side of the liturgical choir was divided into four large squares. If these extended the full length of each architectural bay, they would leave only a strip two and a half meters wide for the central subjects, so it is suggested that decorative bands containing the new tomb slabs reduced their size (Fig. 3); even so, there are difficulties with reconstructing the exact layout. The first square, as already mentioned, was occupied by the Liberal Arts, probably placed in a circle; the next had a male personification of *Orbis Terrae* with the four seasons in the corners; the following was filled with a foliate rinceau or tree design; the fourth had *Terra* and *Mare* with the Four Rivers of Paradise in the corners. These segments seem less to invite a spiritual progression than to be read paratactically; but in juxtaposition they might be seen to present the descent of man from paradise to earth, and his quest for salvation through learning; these would be paths symbolically taken toward the altar.

The arrangement in the left section, on the north side, also seems paratactic, but this impression may in part be due to the fact that the stalls obscured Bergier's view. First on entering the choir from the nave were two circles inscribed in a rectangle twice the size of the other square units. The one to the west had Moses in the center and the labors of the months in circles on a band around the circumference; the patriarch was inscribed to indicate that he prefigured Christ and, most unusually, carried an infant or an angel on his knee, explained in the inscription, a fragment of which is preserved, as a personification of the New Law (Pl. 37a).[15] The next circle had the twelve signs of the zodiac on the perimeter, with

church according to Parker, 1978, pp. 132–33. On the other hand, the proportion of the compartments in the central field of the Saint-Remi mosaic is awkward, since two large squares extending the length of the liturgical choir would not allow room for the lateral panels described; this difficulty is discussed again in that context.

[11] Barral I Altet, 1980, pp. 86–88, figs. 6–8; he compares prefatory pages, and the ivory covers of the Psalter of Dagulf in the Louvre, which have both David and Jerome. See also, Steger, 1961, pp. 125–38. David is associated with the zodiac in a pavement at Saint-Bertin of Saint-Omer, according to Panadero, 1984, p. 141, n. 54, with bibliography.

[12] Steger, 1961, pls. 27, 25.

[13] The Sacrifice of Isaac as a type of the Crucifixion was evoked in early texts, including those of Ambrose and Isidore of Seville, but the association does not seem to have been common in art until the twelfth century. It is then found on Rhenish portable altars, in the stained glass of Châlons-sur-Marne and Orbais, in the Averbode Gospels and on a few Mosan enamel plaques; see Kline, 1983, pp. 112–13, who relies a good deal on Heide Lenzen and Helmut Buschhausen, "Ein neues Reichsportatile des 12. Jahrhunderts," *Wiener Jahrbuch für Kunstgeschichte* 20 (1965): 29–30.

[14] Demus, 1970, pp. 420–21, diagram E. The paintings date about 1100. For other examples in floor mosaics, see Barral I Altet, 1980, p. 92, n. 36.

[15] The fragments were recently rediscovered unlabeled in storage by

the curator of the Musée Saint-Remi, Marc Bouxin, and he has been kind enough to allow me to photograph and publish them. Other pieces include parts of the legs of figures. They are presumably those excavated in the mid-nineteenth century: Isidore J.-L. Taylor, *Reims, la Ville des sacres*, Paris, 1860, p. 172. Marlot, 1845, 2: 543, and Nicolas Bergier, *Histoire des Grands chemins de l'Empire romain*, Brussels, 1728, 2: 201–2, noted that only part was visible:

> . . . Lex Moïsique figuras
> Monstrant hi proceres.

The copy of Marlot annotated in the seventeenth century (Reims, B.M., MS 1619, p. 333) completes the inscription:

> *Declarat rugas nova lex Moysique figuras.*
> *Monstrant hi proceres, quod sub his Christe latens es*

(Dan Sheerin has noted in a personal communication that Pauline usage of *rugas* [Eph. 5:27] could give the sense of inadequacies or defects in the Old Law, which suits the juxtaposition of old and young faces in the image: "The New Law draws attention to the defects in the appearance of Moses. These nobles show that under them you, O Christ, are hidden." Alternatively, but less in keeping with the pictures in the mosaic, he has suggested that *ruga* is a veil, giving the reading: "The New Law explicates the veils and figures of Moses.) Stern, 1957, pt. 1, fasc. 1, p. 92, n. 1, omits *figuras*, but as Ernst Kitzinger has pointed out to me, this gives a hexameter, followed by another.

the serpent, stars, and two bears in the center, forming an astrological sphere. Next Bergier mentioned the four Cardinal Virtues and the four Corners of the Earth, although only *Prudentia*, a female figure with a serpent, and a man representing the south, inscribed *Meridies*, were visible, since they extended beyond the choir stalls. He was not specific about the sequence of the two groups, and Barral I Altet envisaged the Virtues surrounded by the points of the compass, with *Meridies* to the southwest, whereas I imagine two canted squares with *Prudentia* and *Meridies* at the southern corners, thus visible in front of the stalls (Fig. 3). By placing the directions next to the astronomical sphere and the Virtues in another square next to the altar steps, a continuous spiritual progression from west to east, and from worldly things and the Old Law, to the virtuous life in Christ, would be developed; and the Virtues are then placed in parallel with the Liberal Arts across the choir. The loose association of Moses and the Cardinal Virtues of Prudence, Fortitude, Temperance, and Justice on the north side of the building has an analogue later in the north transept oculus of Canterbury Cathedral.[16] Bergier omits any subject that might have balanced Wisdom at the top of the altar steps, and it is tempting to suggest that it might have been Charity either overcoming vices or with Faith and Hope.[17]

On the whole the mosaic does not seem to have been tightly ordered; it reads rather like a series of prefatory pages despite its encyclopedic scope. A parallel that comes to mind is the *Liber Floridus* of Lambert of Saint-Omer, composed about 1120, and representing a compendium of monastic learning. This manuscript, which existed in very few recensions, included terrestial and astrological diagrams; not surprisingly there are no specific correspondences with the rémois program as far as can be ascertained from the scant description of the mosaic, but the broad themes, dealing with universal order and world history, and their unconnected arrangement, seem to have been similar. The *Liber Floridus* also contains several images of trees, including a palm that seems

to be associated with paradise and several species that symbolize the beatitudes; a recent study has associated the palm with cosmic kingship. One of these images might have elucidated the enigmatic square with vegetation in the mosaic, if an inscription had been recorded in it.[18]

The Saint-Remi mosaic seems to be one of the earliest monumental collections of subjects—such as the zodiac, the seasons and months, the virtues and the liberal arts— that were later used in the programs of rose windows, as noted by Beer, but there is no evidence whether these aspects of the mosaic were taken up again in the rose windows of Saint-Remi;[19] local examples, however, include the north transept rose of Laon Cathedral and the three rose windows of Saint-Yved in Braine, which will be discussed later (Pls. 243, 244). It must be noted too that the monumental sculptural program of Chartres west, with its Liberal Arts encircling the Virgin as Sedes Sapientiae, the Evangelists, apostles, and elders surrounding Christ, and months and zodiac signs around the Creation or Ascension, might be contemporary with the rémois mosaic;[20] the problems of dating the mosaic have been outlined in Chapter 1.

THE SCULPTED CONSOLES

Several of the Old Testament prophets and patriarchs represented in the floor mosaic were later repeated in the sculptures applied to the inner sides of the three pairs of piers that divided the four bays of the liturgical choir (Fig. 3; Pl. 32). Prache has commented on the extent to which they complement the mosaic, as well as their problematic condition, and has suggested that the style of the surviving fragments would place their execution about 1190.[21] Nineteenth-century prerestoration accounts record some important features since lost, such as painted inscriptions, and indicate the ambiguity of fragmentary parts.[22] Despite a few unsolved questions concerning the original identity of some of the figures, it is clear that pairs of seated prophets and precursors

[16] Caviness, 1977a, p. 104, and idem, 1981, pp. 25–29.

[17] For instance, a full-page illustration to a recension of Pseudo-Hugo, *De fructibus carnis et spiritus*, dating from the second quarter of the twelfth century (Salzburg, Studienbibliothek, MS Sign. V.i.H.162, f. 76) shows Caritas in the main trunk of a tree that encloses the other theological virtues in branches at the same level, and the Cardinal Virtues in lower branches; see Adolf Katzenellenbogen, *Allegories of the Virtues and Vices in Mediaeval Art*, London, 1939, pp. 66–67, fig. 67. The *Liber Floridus* of Lambert of St.-Omer also had a tree with Charity treated as the central figure; Katzenellenbogen, p. 65, fig. 64; *Liber Floridus*, p. 462, f. 231v.

[18] Ghent, Bibliothèque de l'Université de la Ville, MS 16; page references refer to the 1968 facsimile edition. The signs of the zodiac are arranged around the sun and planets on f. 88v (p. 180); a lily combines the gifts of the spirit and the seven Liberal Arts on f. 230v (p. 460); a tree fills the Holy City of Jerusalem on f. 52r (p. 105), and the palm follows this sequence of images of paradise (f. 76v, p. 156); *arbores significantes beatitudinum ordines* on f. 139v–140r (pp. 282–83) include the cedar, cypress, etc. See Penelope C. Mayo, "The Crusaders under the Palm: Allegorical Plants and Cosmic Kingship in the *Liber Floridus*," *Dumbarton Oaks Papers* 27 (1973): 29–67. Wirth, 1970, pp. 27–29, has

demonstrated the christological import of a tree associated with the Liberal Arts, and designated as *sapientia dei*, in the margins of an early Psalter, and pointed out an affinity with the illustration to Psalm I in the Utrecht Psalter.

[19] Beer, 1952, p. 41.

[20] Katzenellenbogen, 1964, pp. 15–22; Jan van der Meulen and Nancy Waterman Price, *The West Portals of Chartres Cathedral I: The Iconology of the Creation*, Washington, D.C., 1981, pp. 7–49, have argued for a Creation rather than an Ascension of Christ in the north portal.

[21] Prache, 1978, pp. 86–88.

[22] "Notes communiqués par M^r Mauberge: Recherches sur les sculptures mutilées des piliers du choeur de l'église St Remi de Reims," and drawings made before 1857 are in the Reimbeau MS, III, iii, no. 6, ff. 1–2v and no. 7. The drawing, entitled "Eglise de Saint-Remi à Reims, peintures décoratives," was published in J. Gailhabaud, *L'Architecture du V^e au XVI^e siècle et les arts qui en dépendent*, vol. 2, Paris, 1858, n.p., and reproduced by Prache, 1978, fig. 92. At the time of the restoration, an article was published by Collery, 1857–1858. Guilhermy, MS 6106, ff. 416v–417v, is also cited by Prache for notes after the restoration.

were represented with symbols referring to the incarnation and Passion between them and with appropriate Biblical quotations. The symbols on the south side (facing north) belong to the animal world, whereas on the north side (facing south and flooded with light) are angels holding attributes (Pls. 32–34).

The pair of piers nearest to the sanctuary have suffered the least damage and restoration (Fig. 3, s1 and n1). On the left of the sanctuary (south) are Aaron, vested as a high priest with a conspicuous breastplate, saluting a brazen serpent that is probably authentically restored, and Moses, horned and holding the tablets of the Old Law. Inscriptions above Aaron gave his name and the phrase *in cruce regnum*, apparently referring to rule under the cross or the era under the New Law; the brazen serpent was a common symbol of Christ crucified since he used that image in referring to his own fate.[23] Opposite, on the north, are Jeremiah and Ezekiel, the first with a quotation from 1:11: *virgam vigilantem ego video* ("I see a rod of an almond tree"), referring to the flowering branch or scepter carried by the adjacent angel. This symbol may also have been intended to evoke Aaron's rod, which replaced the brazen serpent, and which was placed in the Tabernacle; or it could refer to the tree of life that served as the cross of Christ.[24] The inscription for Ezekiel was adapted from 47:1 and referred to waters flowing from the Temple: *vidi aquam egredientem* ("I beheld water issuing out"); the Biblical text appropriately indicates that it flowed down the right side, although the altar of the Temple was not oriented so that the water is described as flowing on the south side, toward the east.[25] Yet Mauberge was correct in associating the phrase in the inscription with the Easter liturgy, where it was augmented by verse 9: *et sanabunter et vivent omnia ad quae*

venerit torrens ("And it shall come to pass that everything that liveth, which moveth, whithersoever the rivers shall come, shall live").[26] In fact the antiphon *vidi aquam* was associated with the asperges, or purification by holy water, during the Paschal season, and with monastic Easter liturgy.[27]

The next pair of piers had David and, most probably, a pelican in its piety, as restored, with perhaps Solomon, on the south, and two prophets with an angel holding instruments of the Passion, perhaps Daniel and Habakkuk, on the north (Pls. 33, 34). The inscriptions read by Mauberge and Collery belong to these prophets, and the quotations are appropriate to the authentic attributes:[28] Habakkuk holds a pair of horns according to the inscription *cornua i[n] m[anibus eius]* (3:4 "he had horns coming out of his hand"), and Daniel's words from 9:26, *Occidetur Christus* ("Messiah shall be cut off"), refer to the cross and nails held by the angel. Opposite these, the pelican, reconstructed from vestiges of its wings and perhaps a nest, is a type of the Crucifixion; the bestiary recounted that she wounded herself with her beak to feed her blood to her young. As Kline has pointed out, King David is also associated with the pelican in the east window of the Abbey Church of Orbais, near Reims, in glass of about 1200; the inscription on his scroll, *similis sum pellicano*, is based on Psalm 101:7, although the bird is not represented.[29]

The identification of the figures on the third pair of piers is uncertain. Mauberge and Guilhermy accepted an unbearded figure on the south side as John the Baptist, based on a tentative reading of ECC as *Ecce Agnus Dei* ("Behold, the Lamb of God"). An animal with four cloven hooves in the center was therefore reconstructed as the lamb, although Mauberge considered other possibil-

[23] The inscription may refer to the words found in some versions of Psalm 95:10 (96): *Dicite in nationibus Dominus regnavit a ligno et enim correxit orbem terrae*, etc., e.g., Robert Weber, ed., *Le psautier romain et les autres anciens psautiers latins*, Collectanea Biblica Latina 10, Rome, 1953, p. 237; see also A. S. Walpole, *Early Latin Hymns*, Cambridge, 1922, pp. 175–76, and John Julian, *A Dictionary of Hymnology*, rev. ed., London, 1915, p. 1220, where the use of this phrase as a versicle during the Easter week liturgy is cited. John 3:13 is illustrated with the brazen serpent in the eleventh-century Byzantine Gospels, Paris, B.N., MS grec 74 (Omont 1908, pl. 148). In one of the stained-glass panels mentioned by Suger and preserved in the Moses window of Saint-Denis, Moses points toward Christ on the cross placed atop the brazen serpent on the column; Louis Grodecki, "Les vitraux allégoriques de Saint-Denis," *Art de France* 1 (1961): 38, illus. facing p. 24.

[24] Aaron's rod is introduced in Numbers 5:8; in Hebrews 9:4 it is described in the tabernacle. It was associated with the cross in a verse inscribed on a lost twelfth-century Crucifixion in the nave of Saint Emmeram in Ratisbonne; this and other examples are discussed by Lech Kalinovski, "*Virga Versatur*: Remarques sur l'Iconographie des vitraux romans d'Arnstein-sur-la-Lahn," *Revue de l'Art* 62 (1984): 17 and 20, n. 90. For the cross as tree of life, represented with sprouting branches and often green, see Romauld Bauerreiss, *Arbor Vitae: Der "Lebensbaum" und seine Verwendung in Liturgie, Kunst und Brauchtum des Abendlandes*, Munich, 1938, pp. 7–12; among earlier examples illustrated are a sixth-century ampulla from Monza, and, from the eleventh-century, the Evangeliary of Henry II, Munich, Clm. 4454, the Uta Codex, Clm. 13601, and the ivory cover of the Bamberg Gospels,

Clm. 4452. The cross in the Saint-Denis panel, referred to in n. 23 above, is green with damask rinceaux.

[25] Ezekiel 47:1 . . . *ecce aqua egrediebantur . . . aquae autem descendebant in latus templi dextrum* (". . . and the waters came down from under the right side of the house").

[26] Reimbeau, MS 2100, iii, no. 6, ff. 1v–2r.

[27] *Vidi aquam egredientem de templo a latere dextro, alleluia, et omnes ad quos pervenit aqua ista, salvi facti sunt, et dicent alleluia*, etc.; see René Jean Hesbert, *Corpus Antiphonalium offici*, Rome, 1968, 3: 537, no. 5403. For the use, see C. Goeb, "The Asperges," *Orate Fratres* 2 (1927–1928): 339; *Consuetudines et Observantiae Monasteriorum Sancti Mathiae et Sancti Maximini Treversensium ab Iohanne Rode Abbate Conscriptae*, ed. Peter Becker, Siegburg, 1968, p. 136, and *Consuedudines Fructuariensis-Sanblasianae*, ed. Luchese G. Spätling and Peter Dinter, Corpus Consuetudinum Monasticarum 12, Siegburg, 1985, 1: 195, 2: 147.

[28] Collery, however, thought he deciphered older lettering with the name YSA.AS under the quotation from Daniel, and GER or GOR under that of Habakkuk.

[29] Ps. 101:7: *Similis factus sum pelicano in solitudine* (Robert Weber, ed., *Le Psantier romain et les autres anciens psautiers latins*, Collectanea Biblica Latina 10, Rome, 1953, p. 245. Kline, 1983, pp. 113–16, fig. 388; she indicated a number of examples of the pelican as a type of the Crucifixion or Resurrection in twelfth-century Saxon art, notably in two manuscripts in Wolfenbüttel, Herzog August Bibliothek: Helmst., Missal 569; and the Gospels of Henry the Lion, Cod. Guelf. 105 Noviss. 2°, f. 74r (Kline, 1983, figs. 188–89).

ities such as the ram in the thicket associated with Isaac (who would have been unbearded) or Abraham. On the north side Mauberge read ENOC for Enoch and another E, which he took to be Elijah; he said nothing remained of the angel's attribute in the center. Both attribute and inscription were subsequently restored, the former as a book, although Collery would have preferred to see a sword.[30]

Whatever the uncertainties about specific identifications, it seems possible to conclude that the program of subjects applied to the piers of the liturgical choir was typological; it evoked, through precursors, prophecies, symbols, and attributes, the Passion of Christ, and ultimately the baptismal and eucharistic functions of the church. References to the priesthood of Aaron and the flowing waters of Ezekiel's visionary Temple maintained the allegories suggested in Odo's decorative program but encyclopedic imagery has given way to a narrower Biblical repertory, as also in Peter of Celle's exegesis of the Tabernacle of Moses. It is interesting to note that both genres are present in the *Hortus Deliciarum* of Herrade of Landsberg; the layering of representations in different modes in the manuscript resembles the accumulation of images in the liturgical choir of Saint-Remi.[31] The purpose of the two programs, which were brought to completion about the same time, was in fact similar; each was intended as a vehicle of instruction for a Benedictine community, and to lead them to spiritual things.

THE GREAT CANDELABRUM

The floor mosaics and sculpted consoles of Saint-Remi extended through the liturgical choir toward or into the crossing in which the main altar was situated. Odo seems to have supplied two important light sources in this part of the church: a seven-branched candlestick once placed to the north of the high altar, and a great candlewheel in the choir, now replaced by a modern reconstruction in its approximate original position (Pls. 41–44).

The great seven-branched candlestick referred directly to the furnishings of the Judaic Temple but it contained an allegory of the monastic church. The double frame of reference is apparent in its position on the north side, which is frequently given to the precursors, and in the imagery on the surviving fragments of the base; a tonsured cleric is reading, atop a great dragon and a dense thicket of foliage entwined around centaurs and chimeras (Pl. 43). The scriptural source for candlesticks of this kind, as frequently pointed out, is Exodus 25:31–40 and 37:17–24. In the first, the Lord instructed Moses in the furnishings of the sanctuary "that I may dwell among them"—that is, the children of Israel;[32] it was to be set "over against the table on the side of the tabernacle toward the south."[33] Medieval diagrams of the Temple placed the holy of holies to the west, so that if the sanctuary were oriented the candlestick would occupy the north side, as it did in Saint-Remi (Pl. 40).[34] In the second passage, the candlestick was made of beaten gold, according to the specifications. Bloch has traced the impact of this description of the menorah, including the Christian commentaries that gave it spiritual significance.[35] In the Epistle to the Hebrews the sanctuary in which it stood is referred to as a type of the "greater and more perfect tabernacle, not made with hands," which was entered by Christ, the "high priest of good things to come" (Heb. 9:11). A drawing in an English manuscript of about 1160–1170 with Bede's Commentary on the Apocalypse evokes this connection: Preceeding the image of Christ with the sword in his mouth is a full page with the seven towers and the seven candlesticks of the seven churches from Revelation 1:20, but the candles branch from a single candelabrum.[36] By the mid-twelfth century its seven branches had been associated with the four corporal and three spiritual qualities of man, and with the seven gifts of the Holy Spirit; its central blossom was the Virgin or Christ.

Several powerful antecedents may have prompted Abbot Odo to supply such a candlestick for his choir. Charlemagne had given one to his foundation at Aniane about 780, and Hrabanus Maurus supplied one for

[30] Collery, 1857–1858, p. 271.

[31] The original manuscript, produced in Alsace over a period from before 1176 to about 1196, is lost; nineteenth-century copies have been used in a reconstruction in the 1979 edition of *Hortus Deliciarum*, vol. 2 by Green et al.; several subjects illustrated offer affinities with elements of the choir program of Saint-Remi. Following the account of the creation of heaven, the separation of earth and water (the latter personified, f. 8r, p. 13), and the creation of the animals are diagrams of the celestial sphere (f. 10r, p. 17), the zones of the earth and signs of the zodiac (f. 11v, p. 20), the winds and directions (f. 13, p. 23), followed by a man representing the microcosm (f. 16v, p. 30); after the creation of Adam and Eve are the tree of life with the four rivers of paradise (f. 18v, p. 34), Philosophy with Socrates and Plato at her feet, surrounded by the seven Liberal Arts (f. 32r, p. 57; the affinity with the Reims mosaic is noted, 1: 105), Abraham and the angel (f. 34r, p. 61, lost), Jacob's dream (f. 36v, p. 66), the Temple of Moses and its furnishings (f. 46r, p. 81), King David enthroned with his harp (f. 59r, p. 97), sixteen prophets with scrolls (ff. 63r–63v, pp. 103–4), and

Christ as priest and king surrounded by virtues (f. 67v, p. 112); angels with the instruments of the Passion (f. 253r, p. 433).

[32] Exod. 25:1–8.

[33] Exod. 27:35; the table was to be outside the veil of the holy of holies, on the north.

[34] P. Bloch, "Siebenarmige Leuchter in christlichen Kirchen," *Wallraf-Richartz Jahrbuch* 23 (1961): figs. 51, 52 (Vienna Nationalbibliothek Cod. 10, f. 325r); *Hortus Deliciarum*, 1979, 1: 116, fig. 70 (Innsbruck, Universitäts Bibliothek, MS 88, f. 1r); 2: ff. 45v. 46r, pp. 80–81. For other examples of the layout of the Temple sanctuary, see Bezalel Narkiss, "The Scheme of the Sanctuary from the Time of Herod the Great," *Journal of Jewish Art* 1 (1974): 6–15, and Elisabeth Revel-Neher, "[Le Plan] du Codex Amiatinus et ses rapports avec les plans du Tabernacle dans l'art juif et dans l'art byzantin," *Journal of Jewish Art* 9 (1982): 6–17.

[35] Bloch, 1961, pp. 56, 68–88.

[36] Cambridge, St. John's College, MS H. 6, f. 3; see Bloch, 1961, p. 128, fig. 73; Kauffman, 1975, p. 122, fig. 244.

Fulda.[37] These Carolingian precedents may have been persuasive at a time when the abbey was capitalizing on its ancient royal past. Furthermore, a piece was made for the cathedral under Adalbéron in the tenth century.[38] Competition with other great Benedictine houses probably also entered in. Cluny had a candlestick by 1109, and both Christ Church and St. Augustine's in Canterbury by 1126; the latter was known as a Jesse, apparently signifying the genealogical tree of the house of Judea, which was often represented with the seven doves of the Holy Spirit as well as the Virgin and Christ at the top.[39] Unfortunately none of these candlesticks is extant in order to make a comparison.

The Saint-Remi candlestick was evidently very large; early descriptions give a height of eighteen feet (five and a half meters), the same as that of the Cluny piece, and a breadth of fifteen (four and a half meters).[40] It is shown this size in a drawing by Lenoir, and the base looks in proportion (Pl. 41).[41] In a crossing only about twelve by sixteen meters, and under thirty meters high even after its Gothic remodeling, it would have provided a monumental accent, rising the full height of the transept arcade.[42] The Lenoir drawing, possibly worked up from sketches or notes made prior to the Revolution, is accurate in rendering the seated clerics atop dragons but it does not show any figures on the upright or branches. In this way the Reims candlestick may have resembled the smaller piece of about 1170–1180 in Braunschweig Cathedral, with which it is often compared.[43] Like the earlier Gloucester candlestick, the vaster piece made for Saint-Remi does not seem at first glance to have a clear iconographic program, at least of the encyclopedic kind later incorporated in the Milan candlestick.[44] Nor does it bear any resemblance to the great foot of the cross that Suger had made in enamels for Saint-Denis, with a dense typological program.[45] It may be for its apparent lack of meaning, as much as that it recalled the "ancient Jewish rites," that St. Bernard attacked the purpose of this kind of furnishing in his famous treatise addressed to William of St. Thierry, a text to which I will return shortly.

Closer scrutiny of the subjects on the foot, however, does reveal rich layers of symbolism (Pl. 42). The surviving fan-shaped panel of openwork that fitted between two of the four feet is composed of spiraled rinceaux with "Byzantine blossoms" and acanthus foliage with berries, a decorative vocabulary common in manuscript illumination.[46] The centers of the four spirals are occupied by chimeras, a pair of female centaurs below and a pair of nude bearded men with winged thighs riding Sirens above (Pl. 44). The openwork foot consists of a bejeweled dragon's head and its front paws, laid on a circular base, with a pair of lions biting its ears, their tails entwined on the dragon's tongue. The neck of the dragon, with its front legs, forms one of the four corner supports of the piece, rising sharply to a jeweled shoulder. Figures perched on it are fully human. One, with short hair and dressed in a short secular tunic, is kneeling on the dragon's back holding onto its wings. Another, tonsured and wearing the chasuble and pallium but barefoot, is perched above the tail reading a book; he actually sits astride a third barefoot figure, perhaps a deacon or acolyte (Pl. 43). This last adopts an acrobatic posture, lying on his stomach to form a bench and at the same time bending back to serve as a lectern, holding the book in both hands above and behind his head. The episcopal image, interpreted by Otto von Falke as St. Remigius who quelled evil spirits when he baptized Clovis, is perhaps more general in intent, referring to the protective and disciplinary powers of the clergy.[47] It was presumably repeated on the other three supports.

The whole candlestick must have taken on the appearance of the *Perindeus* in bestiary illustration, a mythical tree with sweet fruit that dragons feared.[48] In the Bestiary, however, the lower branches are inhabited by doves, whereas in the candlestick the Holy Spirit was in the seven lamps, and the dragons are tamed by priests. The inhabited foliage probably refers in a general way to pre-Christian, heathen, or sinful states.[49] This at least is the meaning given to the figures entrapped in foliage on the candlestick commissioned in 1107–1113 for the Benedic-

[37] Bloch, 1961, nos. 3, 17, pp. 182, 184.

[38] The reference in the chronicle of Richardus is cited in Chapter 1, n. 8.

[39] Bloch, 1961, nos. 8–10, pp. 182–83. Christ is surrounded by the doves in the Jesse Tree window of Saint-Denis; see Grodecki, 1976, pl. VI, figs. 34, 47, 48. See also the slightly later west window of Chartres (Delaporte and Houvet, 1926, col. pl. III, pl. III).

[40] Bloch, 1961, no. 44, p. 189, citing Marlot and Lenoir. His is the best description and discussion of the piece to date (pp. 140–43, with bibliography, p. 189).

[41] Alexandre Lenoir, *Architecture Monastique*, Paris, 1856, 2: 141. The surviving base, now in the Musée Saint-Remi, is 92 centimeters high.

[42] The height of the transept is about 30 meters in Ravaux, 1972, fig. 19, and Prache, 1978, fig. 70.

[43] Bloch, 1961, pp. 145–47, figs. 82, 83.

[44] For a listing of the subjects on the Trivulzio candlestick in Milan Cathedral, see Peter Lasko, *Ars Sacra: 800–1200*, Harmondsworth, 1972, pp. 249–50, fig. 292; full illustration is in Otto Homburger, *Der Trivulzio-Kandelaber: Ein Meisterwerk frühgotischer Plastik*, [Zurich], 1949. Peter Barnet has found documentary evidence that it was

brought from France in the sixteenth century: "The Seven-Branched Candlestick in the Cathedral of Milan: A Study in Medieval Metalwork," Ph.D. dissertation, Yale University (in progress).

[45] Suger, 1979, pp. 58–61; Philippe Verdier, "La grande croix de l'abbé Suger à Saint Denis," *Cahiers de Civilization médiévale* 13 (1970): 1–31, with a synopsis in English, "What do we know of the Great Cross of Suger in Saint-Denis," *Gesta* 9 (1970): 12–15. See also D. Gaborit-Chopin, "La Croix de l'abbé Suger," *Bulletin Monumental* 128 (1970): 243–47.

[46] [Collon]-Gevaert, 1942, figs. 4–7, from the Floreffe Bible, B.L. MS Add 17737–38.

[47] Otto von Falke, "Französische Bronzen des XII. Jahrhunderts," *Jahrbuch der preussische Kunstsammlungen* 43 (1922): 57–58. Similar reading figures are on the late eleventh-century base of a cross from Lüneberg, now in the Hanover Museum, and I doubt they are evangelists as suggested by Swarzenski, 1967, p. 54, figs. 209, 210.

[48] T. H. White, *The Book of Beasts*, London, 1954, pp. 159–61.

[49] An analogy in monumental sculpture is in the "decorative" columns of the west portals of Saint-Denis and Chartres, in the same lower zone as the Old Testament figures: Sauerländer, 1972, pls. 9–13.

tine house of St. Peter in Gloucester, according to its inscription: "This flood of light, this work of virtue, bright with holy doctrine instructs us, so that Man shall not be benighted in vice"; the thicket in that case is surmounted by the four Evangelist symbols.[50] Thus, the exhuberent decoration and sensual qualities of the Saint-Remi candlestick take on meanings appropriate to its position in the monks' choir, where Peter of Celle was to observe that the novices were "placed between the confines of reason and of sensuality."

In fact, elsewhere Peter of Celle systematically explained the mystical and moral significance of the Tabernacle of Moses; and although his text is based on Exodus 25–27, it reads almost as a justification for Odo's choir program.[51] Before listing the physical things described by Moses in the Tabernacle—its dimensions, the tablets of the testaments, the rod of Aaron, the urn with manna, the candlestick and seven lamps, and so on—he stresses that his real subject is not this man-made tabernacle but the heavenly, spiritual, and eternal one, and that the function of these earthly things is to lead the attention from the visible to the invisible.[52] The visible structure, he asserts, leads to an explanation of the invisible purpose; "if you believe you have only a likeness and not the truth itself, let the likeness lead you to the truth."[53]

Accordingly, he finds hidden meanings in the text; for instance, gold designates the brilliance (*claritatem*) of true wisdom, the aromatic oil for the lamps is the effusion of charity and pity, the human heart is to be understood to function as an ark for both God and the devil.[54] The rings on the ark are likened to the four books of the Evangelists, the four corners are the four directions of the world, and the wooden staves that hold it are the doctors of the church.[55] Elsewhere he compared the rings to the four Cardinal Virtues of Prudence, Fortitude, Justice, and Temperance, centering on Wisdom which repels Folly.[56] The treatise reads here almost like

a description of the mosaic pavement, and it is tempting to think that Peter of Celle composed it as he contemplated the choir decorations. He also elucidated typological meanings, in the vein of the later stained glass and pier sculptures: The vessels of Exodus 25:9 are the chalice and patten of the Eucharist; they allude to the Passion of Christ and the sacrificial lamb; the prophets and patriarchs prefigure Christ whose incarnation was foreseen from the beginning.[57] But it was in another treatise on the Tabernacle of Moses that he constructed a parable of the life of the Church couched in the imagery of a royal palace, and this will be examined in the next sections.

The Celestial City and the Church of Christ

THE GREAT CANDLEWHEEL

The other great piece of metalwork probably commissioned by Abbot Odo was the polycandelon that hung in the liturgical choir before the altar. It has been said that Odo was inspired by the candlewheel that he would have seen at Cluny, but the type was quite prevalent in England and France, and there was already one at Monte Cassino in the eleventh century.[58] A later example is preserved in Aachen (detail, Pl. 105).[59] One in Abingdon was said in the twelfth- and thirteenth-century accounts to date from the time of Ethelwold, bishop of Winchester (963–984), but I am skeptical of this early date.[60] The candlewheel in Saint-Remi was restored or replaced in the eighteenth century, and again in modern times (Pl. 25), but a description and drawing were made in 1583–1587; according to this authority, its ninety-six candles honored St. Remigius, who lived so many years.[61] The twelve towers and their paired figures, however, surely evoked the Celestial Jerusalem as described in Revelation 21:10–27, and as represented in the *Liber Floridus* and re-

[50] ✠LUCIS ON[VS] VIRTVTIS OPVS DOCTRINA REFVLGENS PREDICAT VT VICIO NON TENEBRETVR HOMO, transcribed and translated by Neil Stratford in George Zarnecki et al., *English Romanesque Art 1066–1200*, exhibition catalogue, Arts Council of Great Britain, Hayward Gallery, London, 1984, no. 247, p. 249, with bibliography, pl. 73.

[51] *Mosaici Tabernaculi mystica et moralis expositio*, P.L. 202, cols. 1047–84. See Peter of Celle, 1977, p. 21, for the flavor of this work, rooted in a love of Old Testament liturgy and of symbolism.

[52] *P.L.* 202, col. 1047: "Tabernaculum vero de quo tractare proposuimus est non manufactum, id est non hujus creationis, sed admirabile, sed coeleste, sed spirituale, sed angelicum, sed perpetuum. Prae oculis tamen illud terrenum Moysi, opere terreno fabrefactum ponamus, et a visibilibus ad inivisibilia intentionem transferentes, non iter terram et coelum tepore vel diffidentiia infidenitatis haesistantes subsistamus, quia Judas ibi *crepuit medius* (Acts 1:18), sed semper coelos coelorum corde integro, ad orientem ascendamus cantantes: *Beati qui habitant in domo tua, Domine, in saeculum saeculi laudabunt te* (Ps. 83:5)." Leclercq, 1946, p. 33, has also emphasized this aspect of his work.

[53] *P.L.* 202, col. 1051: "Sed placuit profundo divitiarum sapientiae et scientiae Dei, inclinare ex hoc in hoc ad rigandum de superioribus ad inferiora, ut saltem similitudine gloriae Dei in speculo et aenigmate visibilis structurae Mosaici tabernaculi, praeriperet majestatem vero

rum bonorum interiorum oculus illuminatae rationis, et aestimaret utcunque de similitudine veritatem et inescaretur visibili specie, ad invisibilem gloriosae explanationem. . . . Si credis te habere similitudinem nondum veritatem, a similitudine pervenies ad veritatem."

[54] *P.L.* 202, cols. 1050, 1067.

[55] *P.L.* 202, col. 1066.

[56] *P.L.* 202, cols. 1057–58.

[57] *P.L.* 202, cols. 1053–54.

[58] Charles Carlier, "Couronne de Lumière d'Aix-la-Chapelle, et monuments analogues du moyen âge," in *Mélanges d'Archéologie, d'histoire et de litératures*, Paris, 1853, 3: 1–61 (pp. 51–54 for the example in Saint-Remi); see also Dow, 1957, pp. 264ff., and p. 267 for twelfth-century texts on lights in the church. Also Hamann-Mac Lean, 1983, pp. 150–53.

[59] *Zeit der Staufer*, 1: no. 537, pp. 396–98 with bibliography; 2: figs. 326–27.

[60] David Knowles, *The Monastic Order in England*, Cambridge, 1940, pp. 535–36, n. 1.

[61] Francoys Merlin, "Recherches de plusières singularitiés," Paris, B.N., MS fr. 9152, f. 86; "au meilleux [*sic*] du coeur de ladicte Esglise sainct Remy Laquelle a Este mise en cest endroict en honneur & souverance de Laays du dict patron qui vescut iiiiˣˣ xvj ans. Partat'y a alletours iiiiˣˣ et xvj csierges."

lated manuscripts.[62] The authority of Revelation and the numerology of twelve and eight, long associated with the Holy Sepulcher, resurrection, and salvation, is more likely to account for the number of candles than the legendary age of St. Remigius.[63] The text of Revelation in fact mentions the names of the "twelve apostles of the lamb" inscribed on the towers, and the precious stones that adorned each were glossed as the orders of angels that are personified in the drawing in the Oxford manuscript based on the *Liber Floridus*.[64]

PETER OF CELLE'S EXEGESIS

The candlewheel light source, floating above the heads of the monks in the choir, was the celestial analogue of the terrestial orders represented below in the mosaic pavement; together they demonstrated the role of the apostles in heaven as well as below in the world, where they had succeeded to the prophets. Its numerous flames reflected in gleaming gold and jewels must have seemed to illuminate the dimly lit interior of the eleventh-century building in the way envisioned by St. John: "And the city had no need of sun, neither of the moon, to shine in it: For the glory of God did lighten it, and the Lamb is the light thereof."[65] Once more, however, it is Peter of Celle's treatise on the mystical and moral significance of the Tabernacle of Moses that provides the most systematic elucidation of the work that literally crowned Odo's choir: The crown of gold to be placed over the ark (Ex. 25:11) evoked for him the crown of glory that surrounded Christ at his resurrection and ascension, and as he sits on the right of God in Majesty.[66] In the other treatise on the same topic, edited by Leclercq from a manuscript in Troyes, the setting is even more resplendent in its gold and silver and gems that delight the eye; the Tabernacle is portrayed mystically as the palace of a king, and each detail is richly and sensuously enumerated.[67] The work is introduced as a parable, and the imagery gradually reveals the court of heaven and its celestial liturgy.[68] In this case the ancient rites, instead of being viewed as types of the new sacraments, are interpreted eschatalogically.

Despite the evident friendship between Peter of Celle

and St. Bernard, and certain parallels that Leclercq has perceived in their formulations and in the tenor of their mysticism, the gulf that existed between them in their attitudes to art must be recognized.[69] Essential to Peter of Celle's scriptural exegesis is the tangible quality of works of art; he first renders them tactile and visible to the imagination, then elucidates their moral and spiritual qualities. The Old Testament especially lends itself to this approach, and it may be for that reason that the scriptural commentaries are all concerned with it. Another example of this "painting in" of detail is in the fifth sermon on the Annunciation, where the words of Isaiah 8:1, *sume tibi librum grandem*, lead to an exegesis of the entire process of production of a manuscript, including its illumination *sumptis*.[70] Because the sermons are addressed informally to monks, the reference to rich illumination underlines the opposition to Cistercian proscription. It is equally clear in the writings of St. Bernard that he denied the mystical meanings ascribed to art by Peter of Celle.

The verbal and visual statements that defined the attitudes to art of these two spiritual leaders may be described as a dialogue. Even if we cannot reconstruct the sequence of their statements, these may be seen as "responses" in the sense that the order of a series of opposed but unconnected position statements may be quite arbitrary. It has been remarked that St. Bernard seemed to have Saint-Remi in mind when he severely criticized some of the art forms current in monasteries.[71] If so, the mosaic, polycandelon, and candlestick, as well as the Carolingian altar and reliquaries, must have been in place before the mid-1120s. It is of little consequence whether one considers a decade too short a time for Odo to have consolidated his finances and redecorated the choir; if he applied this sumptuous program after the delivery of the treatise, it was in defiance of its ascetic tenets, and in either case Peter of Celle's subsequent decision to preserve it was a "response" to St. Bernard. The Cistercian's words do seem apropos; they were delivered to the abbot of the small Benedictine house of Saint-Thierry near Reims, and may well have had its vast neighbour in mind, in addition to Cluny.[72] Addressing himself specifically to monks, he criticized the use of

[62] *Liber Floridus*, 1968, f. 65v, p. 131; see also Hanns Swarzenski, "Comments on the Figural Illustrations of the Liber Floridus," in *Liber Floridus Colloquium . . . University Library, Ghent, 1967*, ed. Albert Derolez, Ghent, 1973, figs. 21, 26.

[63] Richard Krautheimer, "Introduction to the Iconography of Medieval Architecture," *Journal of the Warburg and Courtauld Institutes* 5 (1942): 1–33, reprinted in his *Studies in Early Christian, Medieval, and Renaissance Art*, New York and London, 1969, pp. 115–150.

[64] Oxford, Bodleian Library, MS Bodley 352, f. 13r; illus. Swarzenski, *Liber Floridus Colloquium*, fig. 26.

[65] Rev. 21:23.

[66] *P.L.* 202, cols. 1056–57.

[67] Leclercq, 1946, pp. 147–67. The manuscript is a twelfth-century collection from Clairvaux, Troyes, B.M., MS 253, ff. 63v–69v.

[68] Leclercq, 1946, pp. 34–35.

[69] Leclercq, 1946, pp. 11, 30, 37, 68–69, 88, 102.

[70] Cited by Leclercq, 1946, p. 29; sermon 26, *P.L.* 202, cols. 718–20.

[71] Marlot, 1845, 2: 541; N. Humann and J. Hourlier, "Les Constructions médiévales à Saint-Remi de Reims," *Mémoires de la Société d'agriculture, commerce, sciences et arts du Département de la Marne* 75 (1960): 69.

[72] *P.L.* 182, cols. 914–16. Translated by G. G. Coulton, *A Mediaeval Garner*, London, 1910, pp. 70–72, quoted by Caecilia Davis-Weyer, *Early Medieval Art 300–1150*, Englewood Cliffs, N.J., 1971, pp. 169–70; also quoted in part and discussed by Meyer Schapiro "On the Aesthetic Attitude in Romanesque Art," reprinted in his *Selected Papers: Romanesque Art*, New York, 1977, pp. 6–10, who suggested Cluniac art was targeted. A more recent translation is in M. Casey, *The Works of Bernard of Clairvaux, Treatises I, Cistercian Fathers Series*, vol. 1, Spencer, Mass., 1970. Most recently, Peter Fergusson, *Architecture of Solitude: Cistercian Abbeys in Twelfth-Century England*, Princeton, 1984, pp. 11–13, has discussed the inadequacy of the translations, and related the content to comments by other Cistercians, concluding that St. Bernard's views were widely held. He relies on Giles Constable, *Letters of Peter the Venerable*, 2: 272–73, for the date. See also A. H. Bredero,

gold in the sanctuary, especially in the reliquaries that brought in contributions from the laity, and in the gem-studded lamps resembling cartwheels; he complained that the bronze candelabra were as massive as trees, and they too were studded with gems, that the images of saints and the angels were inlaid in pavements and trodden underfoot. The only justification for these things might be given by the bishops, who could not otherwise instruct "carnal folk" in spiritual matters; monks, however, should eschew all sensual delights. He went on to lambaste the meaningless carvings in the cloister, including "those monstrous centaurs, those half-men"; although such capitals may have been in the cloister at Saint-Remi, the reference also fits the candlestick.[73]

Peter of Cell's statements were couched in his treatises on the cloister and on the Tabernacle of Moses, and in the new program for the retrochoir and chapels that he undertook. As already remarked, the very fact that he and his successors retained the offending decorations of the choir, honoring them with a new setting, would be a clear indication that they read the mosaics, candlewheel, and candlestick as symbols of higher spiritual truths. This exegesis ran counter to the literal way of the Cistercian, who seemed unable to penetrate their mysteries.[74] By 1162 Peter would have found inspiration for his response not only in the decorations of Suger's new choir, and in his treatise justifying them, but also perhaps in writings such as those of Hugh and Richard of Saint-Victor, Ruper of Deutz, and Honorius Augustodunensis, who drew powerfully on their visual imaginations. Furthermore, he belonged to the generation that was being formed when the new "Gothic" visionary architecture of Saint-Denis made its appearance, and mystical structures might naturally assume its forms in his mind's eye; in Paris he had entered the Cluniac Priory of Saint-Martin-des-Champs about 1120, at a very young age, and studied there until about 1140–1145; his adolescence was spent watching the new spaciousness of the chevet take form; by 1163, about the time he began building at Saint-Remi, the choirs not only of Saint-Denis but also of Saint-Germain-des-Prés had been consecrated.[75] Apropos these new Gothic spaces, Bony has recently commented on the particular power of architecture, "the only form of art that can model a space for

man to live in, a space in which man is enclosed, which conditions his actions, movements and even perceptions."[76] The conditioning was all the more complete for the cloistered monk whose entire existence, perhaps from the age of seven, was contained within man-made spaces. Peter of Celle's definitive response to St. Bernard was in the form of architecture.

THE STAINED GLASS OF
THE HEMICYCLE OF THE CHOIR

The effect of Peter's campaigns at Saint-Remi was to transform the allegory of the Judaic Temple, contained in the earlier monastic choir, into one of the Celestial City. Whereas the first treatise on the Tabernacle of Moses seems to have elucidated the program of the old choir, the second treatise stands in parallel with the realization of the celestial vision in the new retrochoir. To some extent also the preoccupation with the symbolism of light in the early twelfth century, demonstrated in the candlestick and candlewheel, anticipated the rebuilding of the choir. The stained glass of the new vast windows, miraculously allowing the matter of the light of the sun to pass through it without shattering it, just as the Light of God was miraculously transmitted by the Virgin, created a monumental polycandelon that encompassed the whole choir (Pl. 26).[77] In the hemicycle of the celestial zone of the clerestory were the Virgin and Child with the apostles and archbishops, seated as in a heavenly court (Pl. 141); below, in the intermediate zone of the tribune, was a eucharistic Crucifixion, demonstrating the role of the sacrament in salvation (Pl. 100). A procession of virgin saints, witnesses to the Church of Christ, addressed the Virgin in the words of the Angel Gabriel; these were perhaps in the west facade or, more likely, in the Lady Chapel (Pls. 94, 99).

Few buildings have been designed to place so much emphasis on light and its medium of glass as the choir of Saint-Remi; the four-story elevation with glazed tribune, though standard in a number of late twelfth-century buildings of the region such as Laon and Noyon, can also be seen as a precursor of the nave of Saint-Denis and the choir of Amiens with their glazed triforia (Col. Pl. 1; Pls. 20, 26). Yet the double-wall construction and

"Cluny et Cîteaux au XIIᵉ siècle: les origines de la controverse," *Studi Medievale* 12, 3d. ser. (1971): 135–75, who places the *Apologia* in the context of disputes with the Cluniacs. Odo has been described as both influenced by Cluny, and as a friend of St. Bernard: J. Hourlier, "Le Monastère de Saint-Remi de Reims et ses abords au moyen âge," *Mémoires de la Société d'agriculture, commerce, sciences et arts du Département de la Marne* 75 (1960): 53–54, and Coutansais, 1961, p. 25.

73 Capitals apparently reused in the Chapter House, and some fragments in the Musée Saint-Remi, are carved with various chimeras and rinceaux, as well as some figures remarkably like those on the candlestick. I am indebted to Peter Barnet for the last observation. See H. Jadart, "Notice sur l'ancienne abbaye de Saint-Remi aujourd'hui Hôtel-Dieu de Reims," *Mémoires de la Société nationale des Antiquaires de France* 5th ser., 5 (1884): nos. 5, 6; and Marc Bouxin, *Les Chapiteaux romans de la salle capitulaire de l'abbaye Saint-Remi de Reims*, Reims,

[1976], illus. pp. 18, 21, 22, 24, 27, 31 (harpies).

74 It is interesting to note that Umberto Eco puts the words of St. Bernard into the mouth of the aged Jorge of Burgos, who also (combating William of Ockham's argument) denied the risibility of Christ, and that art could be "an instrument of the knowledge of celestial things." See *The Name of the Rose*, trans. William Weaver, New York, 1983, pp. 88–91.

75 Anne Prache, *Ile-de-France romane* (*Zodiaque: La nuit des temps*), Paris, 1983, pp. 39–44, fig. 5, and pp. 34–38, fig. 4.

76 Jean Bony, *The English Decorated Style: Gothic Architecture Transformed 1250–1350*, Ithaca, N.Y., 1979, pp. 31–32.

77 For references to this miracle, which is argued from a Neoplatonic analogue of the spiritual light emanating from God to the material light of the sun and moon, which, being matter, might break glass, see Louis Grodecki, "Fonctions spiritutelles," in *Vitrail*, p. 40.

especially the way of screening the triplets of the tribune bays behind the slender columns of the double openings in the inner wall provide an air of mystery. These triplets are never wholly revealed to the viewer except from the gallery itself; from the pavement they are experienced kinetically, in a series of partial and shifting views (Fig. 4; Pls. 26, 30, 31). The screening column is most dramatically used in the axial bay, since from any vantage point in the center of the church it hides the Corpus of Christ crucified; he is revealed only from a peripheral position in the choir, as from the choir stalls, which must have backed onto the piers to the north and south, but no static position reveals the Virgin and St. John at the same time (Fig. 5; Pls. 25, 26). The distinction between lay and monastic viewer seems to have been emphasized: Christ was revealed only to those who had dedicated their lives to him; he was hidden from the secular dignitaries who processed toward the choir down the center of the nave to obtain the Holy Chrism.[78]

Both the spiritual writings of Peter of Celle and the choir that was in part his creation blend logic with mysticism. Each has the support of a rational system, of buttressing or argument, but each transcends this level. The glass is an integral part of a spiritual structure, not only in its expression of the Neoplatonic value of light, but in the kinetic experience that involves an active search, a pilgrimage, to achieve revelation. This chapter opened with a quotation from one of the treatises of Peter of Celle that is close in spirit to the actual church of Saint-Remi, his *de disciplina claustrali* (on the School of the Cloister), which makes frequent reference to the tabernacle, and to the sanctuary and holy of holies of the Judaic Temple as an analogue of those in the Christian Temple of the Lord. Written in 1179, it was not the textual source for the new choir, but rather drew its inspiration from that structure as it neared its completion.[79]

The last chapter, on the Eucharist, seems to Martel to have been included as an afterthought; it has a more didactic tone than the rest of the treatise, and he supposes it had been written earlier for some other purpose.[80] On the other hand it is a logical sequel to three chapters of meditation on death that deal largely with the Passion of Christ and the salvation it offered. Furthermore, its inclusion seems justified not only by the central position of the sacrament in the body of the Church, which Peter compares to that of the heart in the body, but also by its

relevance to the lay patron to whom Peter ultimately dedicated the whole work, Henry I, count of Champagne.[81] He notes, for instance, that the Eucharist is sufficient for the laity once a year, but for Mary Magdalen and those who are cloistered the "bread of the angels" is a daily necessity.[82] He cautions against approaching the sacrament profanely, since one must distinguish between physical and spiritual hunger:

> In fact one must use the greatest discernment in considering when to approach the body of Christ, when to abstain from it, and when to withdraw from it. To approach Christ, that is to approach the Lord, to approach the king, to approach the light, the fire, the bread, the vine, what is more, the life. Are you seeking liberty? Approach the Lord. Are you seeking safety? Approach the king. Are you seeking clarity? Approach the light. . . . Are you dead because of criminal acts and interred in hell? Withdraw. There is a great difference, besides, between withdrawing and leaving. In fact, to withdraw is a mark of respect; leaving, a mark of disrespect.[83]

He stresses the presence of the body of Christ on the altar, and again the necessity of receiving it with good intention, with faith, and with a clean conscience, recalling that the sacrament was instituted for the apostles.

In view of Peter's insistence, noted earlier, on finding truth in what might appear to be mere representation, it seems likely that he took the image of the Crucifixion as a symbol of the real Eucharist (Pl. 100). Its removal from the laity, and the necessity even for the monks to seek it actively by positioning themselves either in their stalls or in the tribune chapels, correspond to the sense of the passage just quoted (Col. Pl. 1: Pls. 26, 31). Even the positioning of the image midway between the earthly zone of the retrochoir and radiating chapels, and the heavenly zone of the Virgin and saints, makes reference to the salvation it offered mankind. Eucharistic reference is made by the chalice positioned below the feet of Christ, a symbol found in earlier Anglo-Saxon manuscripts and Ottonian ivories.[84] It also appears in a mid-twelfth-century Mosan ivory, between the suppliant figures of Conrad III Hohenstaufen and Abbot Wibald of Stavelot (Pl. 104).[85] Whether the altar in front of the Crucifixion window, in the tribune, was dedicated to the

[78] Péré, 1921, pp. 31, 34. The day after his coronation the new king heard Mass in Saint-Remi (p. 41).

[79] For the date of composition, see Peter of Celle, 1977, pp. 26–27.

[80] Peter of Celle, 1977, p. 31; the title is De communicatione corporis et sanguinis Domini, pp. 282–317.

[81] Ibid., p. 32.

[82] Ibid., p. 289.

[83] Author's translation, with the assistance of Dan Sheerin, from Peter of Celle, 1977, pp. 284–87: Nam summa discretione attendendum quando ad corpus Christi sit accendendum, quando cedendum, et quando recedendum. Accedere ad Christum accedere est ad Dominum, accedere ad regem, accedere ad lucem, ad ignem, ad panem, ad vitem, immo ad vitam. Quaeris libertatem? Accede ad Dominum. Quaeris securitatem? Accede ad regem. Quaeris claritatem? Accede ad

lucem. . . . Esne mortuus criminalibus et sepultus in inferno? Cede. Distat autem plurimum inter cedere et recedere. Nam cedere reverentiae est, recedere irreverentiae.

[84] Temple, 1976, pp. 60–61, no. 35, pl. 134 (Sherborne Pontifical, Paris, B.N., MS lat. 943, f. 4v; the chalice is of an early double-handled type), and pp. 74–75, no. 56, pl. 171 (Arenberg Gospels, New York, Morgan Library, MS 869, f. 9v). Among examples of Ottonian ivories are a Cologne plaque of ca. 1000, and the cover of the Evangeliary of St. Gereon, Cologne, of ca. 1050 (*Rhin-Meuse*, E11, p. 206; E13, p. 207). The last also includes Mary and John, and Adam.

[85] In Frankfurt-am-Main, Liebieghaus; see Schramm and Mütherich, 1981, 1: 179, no. 171, fig. 171. Conrad III ruled from 1138 to 1152; *Zeit der Staufer*, 1 and 2: no. 616.

Holy Cross or whether this was in the first bay of the monks' choir in front of the high altar cannot be decided, but in either case it would provide an additional reason for the location of the window above and behind it.[86] The true cross was especially venerated in the region, since St. Helena's body was believed to be at the nearby Abbey of Hautvillers; the story of the invention was represented later in the west facade sculpture of Reims Cathedral.[87]

The redemptive aspect of the Crucifixion, emphasized by Peter of Celle, is given additional emphasis in the window through the trees that rise over the heads of Mary and John, and the skull at the foot of the cross.[88] Life-giving force is symbolized by these two trees flanking the cross, rather than by any direct indication that the cross itself is of living wood. Such elaborate trees were placed beside Mary and John in the ninth-century ivory comb of St. Heribert from Metz, now in Cologne, and on an incised bronze plaque from the Aachen candlewheel of ca. 1165–1170, and they were also associated with the entombment and the ascension (Pl. 105);[89] in the *Te igitur* initial of a late eleventh-century Anglo-Saxon missal a single tree is between Mary and the cross, and in the contemporary Arundel Psalter two large trees replace the customary figures.[90] Grodecki has noted the parallel between the Saint-Remi window and a composition of about 1180 in the stained glass of the Abbey Church of Saint-Germer-de-Fly (Oise) where two trees are clearly displayed between the figures and the cross (Pl. 106).[91]

The comparison with the Saint-Germer window, which groups Church and Synagogue, Faith and Paganism around the Crucifixion, serves to emphasize the simplicity of the rémois image, apparently unencumbered by types and allegories. Yet a composition analogous to the Saint-Remi Crucifixion is in the late twelfth-century Genesis cycle of the Souvigny Bible, and it serves to elucidate the visual reference to trees of life and of paradise: Two elaborate trees are the first signs of life on earth, and they are present at the creation of the beasts and of Adam and Eve; in the culminating scene, one flanks Eve and the other is behind Adam as she offers him the forbidden fruit, while the serpent is entwined in the tree of life between them.[92] If one takes these as typological symbols, the serpent refers to Christ on the cross; Eve, to the Virgin; and the pensive or already repentant Adam, to St. John. Indeed, the Hildesheim doors had juxtaposed the two images, and on the ivory plaque of Adalberon II of Metz (984–1005) Adam and Eve kneel among trees at the foot of the cross.[93] St. Paul refers in a general way to Adam "the old man" as a figure of Christ "the new man" (Rom. 5:14 and Col. 3:9–10), but the association between Christ's death on the cross and the morality of Adam is more specific in the inscription on the late twelfth-century Alton Towers triptych, which is perhaps of Rhenish origin: "Christ dies on the cross; he repays the debt of the first parent"; here too the Crucifixion with Mary and John are flanked by prominent ornamental trees (Pl. 107).[94]

A more overt reference to Adam in the window takes

[86] I am grateful to Nigel Morgan for this suggestion. Arnold W. Klukas, "Altaria Superiora: The Function and Significance of the Tribune-Chapel in Anglo-Norman Romanesque: A Problem in the Relationship of Liturgical Requirements and Architectural Form," Ph.D. dissertation, University of Pittsburgh, 1978, p. 67, wrongly excludes the Gothic choir tribunes of Saint-Remi from his discussion because they are not paved; this almost certainly is not the original arrangement. Povillon-Piérard, MS 1837 f. 140 (p. 268), comments that all the altars in the upper chapels of the rond-point had been eliminated, although some vestiges of others remained in the transepts. On f. 136 (p. 260) he lists an altar of the Holy Cross among the twenty-one consecrated in 1049; this of course could not have been in the retrochoir, as yet unbuilt, and it has been surmised that it was in front of the crossing: Hamann-Mac Lean, 1983, text fig. 1, reproduces a plan of 1849–1850 by A. Reimbeau. Confirmation is offered by Prache, 1978, p. 16, who quotes the account of the consecration of 1049: Pope Leo IX prayed at an altar of the Holy Cross after entering the church, and proceeded to the altar of St. Christopher where the relics of St. Remigius were kept. In Bury St. Edmunds a sculpted crucifix between Mary and John was associated in the twelfth century with the monks' altar in the choir; according to most opinions, it was positioned on a beam above and behind it, but in front of the high altar: Elizabeth C. Parker, "Master Hugo as Sculptor: A Source for the Style of the Bury Bible," *Gesta* 20 (1981): 100–101, with references to previous opinions.

[87] For the local cult, and representations of St. Helena and the story of the invention of the True Cross in the west facade sculpture of Reims Cathedral, see Mâle, 1958, p. 366, n. 3, and Emile Mâle, *Art et Artistes du Moyen Age*, Paris, 1928, pp. 337–38.

[88] A useful discussion of "the typology of Adam" and the "symbolism of the tree in the Crucifixion image" is given by Schiller, 1972, pp. 130–36. See also Parker, 1978, p. 134, n. 75 for Christus–Adam. General material on tree symbolism is in Urs Kamber, *Arbor Amoris: Der Minnebaum: Ein Pseudo-Bonaventura-Traktat herausgegeben nach latein-*

ischen und deutschen Handschriften des 14. und 15. Jahrhunderts, Philologische Studien und Quellen 20, Berlin, 1964, pp. 29–140, and cf. Wirth, 1970, pp. 25–32.

[89] For the comb of St. Heribert, see Uwe Westfehling, *Schnütgen-Museum: Ein Führer zur Kunst des Mittelalters*, Cologne, 1977, pp. 28–29 (illus.); for the plaque from the Aachen candlewheel, see *Zeit der Staufer*, 1: 396–98, no. 537; 2: fig. 326. The tenth-century Egbert Gospels (Trier, Stadtbibliothek, Cod. 24) has trees flanking the Entombment of Christ, whereas the Hildesheim Gospels (Hildesheim, Domschatz) shows them beside Christ ascending: Albert Boekler, *Deutsche Buchmalerei vorgotischer Zeit*, Taunus and Leipzig, 1942, pls. 33, 27.

[90] Temple, 1976, p. 121, no. 104 (Red Book of Darley, Cambridge, Corpus Christi College, MS 422, p. 53); the iconography is compared with that of a relief in Romsey, Talbot Rice, *English Art 871–1100* (Oxford History of English Art, vol. 2), Oxford, 1952, pp. 191–92, pl. 18a. For the Arundel Psalter, London, B.L. Arundel MS 60, f. 52v, see Temple, 1976, p. 120, no. 103; Margaret Rickert, *Painting in Britain: The Middle Ages*, 2d. ed. Harmondsworth, 1965, p. 55, pl. 53; Dodwell, 1954, pl. 72f. An earlier relief carving, a stone panel of ca. 1020 from Romsey, has arabesques of foliage on either side of the cross: Rice, *English Art 871–1100*, pl. 18b.

[91] L. Grodecki, "Les vitraux du XIIᵉ siècle de Saint-Germer-de-Fly," in *Miscellanea pro Arte; Festschrift für Hermann Schnitzler*, Düsseldorf, [1965], pp. 154–55; see also Grodecki and Brisac, 1977, pp. 114, 291, no. 90, fig. 94.

[92] Moulins, B.M., MS 1, f. 4v; Cahn, 1982, pp. 180, 273–74, pl. 138. The stylistic affinities suggest a provenance in central France.

[93] For Christ's prophecy that he would be set up like the brazen serpent in the desert, see John 3:13. For the imagery of the Hildesheim doors, see Ernst Gulden, *Eva und Maria: Eine Antithese als Bildmotiv*, Cologne, 1966, pls. 3–5, pp. 242–43; for the Adalberon ivory, *Rhin-Meuse*, C6, p. 181.

[94] On the lozenge-shaped frame round the Crucifixion, the inscription reads IN CRUCE CHRISTUS OBIT—PROTOPLASTI DE-

the form of a disk at the foot of the cross that is crudely painted to resemble a skull;[95] it seems to anticipate the common representation of Adam rising from his tomb, and the general resurrection, as sculpted in the thirteenth century on roods such as those of Halberstadt Cathedral.[96] In mid-thirteenth-century glass of the Lady Chapel of Beauvais Cathedral it may be noted that this resurrection motif is combined with the chalice, and with trees flanking Mary and John.[97] There are, however, earlier examples, though rare, of the skull placed at the foot of the cross, symbolizing death overcome by Christ and referring to the legendary burial of Adam on Golgotha.[98] The motif appears eastern in origin, and it is already found on a mid-twelfth-century ivory plaque with the Deposition, probably from Hereford, whereas the eleventh-century Byzantine paten now in the Cathedral Treasury of Halberstadt probably came from Constantinople after 1204 (Pl. 108).[99] Thus, the prior contexts and associations of the Adam motif confirm a redemptive emphasis here, but the chalice indicates that the sacrament is necessary to salvation.

One earlier drawing combines all the iconographic elements later found at Saint-Remi; a page in the Gladbach Missal has branching foliage on either side of the cross, with Mary and John entwined in it, a chalice at the feet of Christ, and a large frontal head that has been identified as that of Adam supporting the tree of life (Pl. 109).[100] It is significant that it is in a Mass book, even though it is doubtful that this specific image exerted any direct influence. The general type of Crucifixion image represented at Saint-Remi was in fact commonly made to be used in conjunction with the Eucharist, whether in a Sacramentary such as the slightly later one from Saint-Remi or on altar furnishings such as a paten, a tabernacle, or even a portable altar (Pls. 113, 108).[101] Such miniature works were for the private use and contemplation of priests, and each in a different way was manipulated so that the Corpus of Christ was at times hidden—whether in the closed book, triptych, or tabernacle, under the host in the case of the paten, or by the removal of Christ from the cross in the case of the portable altar group. As a monumental image, the Saint-Remi Crucifixion window functioned as a great retable both behind the tribune altar and more distantly above the high altar (Pls. 26, 30). Neither a narrative nor a purely devotional image, it was rather a symbol of the Eucharist that was enacted before it in the heart of the church.

The iconography and position of the rémois window contrast with the highly visible narrative composition of the great east window of Poitiers Cathedral, a gift of Henry II of England and Eleanor of Aquitaine about 1175 (Pl. 28).[102] There, the flat east wall of the choir ap-

BITA SOLVIT; the trees were linked to Saint-Remi by Grodecki, "Les vitraux de Saint-Germer-de-Fly," p. 154. For the provenance, see more recently Nancy M. Katzoff, "The Alton Towers Triptych: Time, Place, and Context," *Rutgers Art Review* 3 (January 1982): 11–28. I am grateful to Marion Campbell of the Victoria and Albert Museum for an opportunity to examine the triptych.

[95] Although it must be noted that the disk appears blank in the nineteenth-century drawings (Pls. 101, 102), and is not referred to as a skull in the early descriptions, I have ruled out the idea that a paten or host was intended originally, in allusion to the bread of the Eucharist which was emphasized by Peter of Celle in a separate treatise (Peter of Celle, 1977, p. 21; *P.L.* 202, cols. 927–1046); there are no other examples in art to support this hypothesis. On close examination outside and in, the glass itself appears old, and Benoît Marq convinced me that some of the trace lines are original.

[96] Reiner Haussherr, "Triumphkreuzgruppen der Stauferzeit," in *Zeit der Staufer*, 5: 144–47, 158, figs. 55–58, 73–74, 76. In the example in the collegiate church of Wechselburg, a figure of Adam with a chalice is a nineteenth-century addition, according to Haussherr, p. 158.

[97] Cahier and Martin, 1844, Etudes IVc; Cothren, 1980, pp. 68–70, figs. 20–21.

[98] Schiller, 1972, pp. 130–31, traces the motif of the skull and the legend of the burial on Golgotha to Syria. Examples illustrated (figs. 335–337, 340) are Byzantine ninth- to eleventh-century manuscripts and ivory reliefs. François Bucher, *The Pamolona Bibles*, New Haven, 1970, 1: 202, notes that in the second Pamplona Bible of ca. 1200, Harburg Oettingen-Wallerstein Collection, MS 1, 2, lat. 4°, 15, f. 7v., the text of Genesis 5:5 is supplemented by an Apocryphal source that indicates that Adam died in Jerusalem and was buried on Calvary, but that after a period of time his remains were brought to Hebron; the illustration shows his funeral procession (2: pl. 14).

[99] John Beckwith, *Ivory Carvings in Early Medieval England*, London and New York, 1972, fig. 152, cat. no. 88. Parker, 1978, illustrates this example (fig. 70) as well as a tenth-century mural painting of the Deposition in the nave of the Old Church, Tokali Kilise, Cappadocia (p. 3, fig. 7). Her thesis is that the Deposition iconography developed in conjunction with Easter liturgy, and symbolies Christ's body being received in the Eucharist. For the Cappadocian paintings and their date, see Ann Wharton Epstein, *Tokali Kilise: Tenth-Century Metropolitan Art in Byzantine Cappadocia*, Dumbarton Oaks Studies 22, Washington, D.C., 1986, pp. 14–16, 65, fig. 38. For the Halberstadt paten, showing a living Christ crucified between the Virgin and St. John, see *Zeit der Staufer* 1: no. 567, pp. 435–37, 2: pl. 370. A later example is in the Psalter of about 1255 from Constance, now in Besançon, B.M., MS 54, f. 15v, where the Virtues crucify Christ and Ecclesia catches his blood in the chalice (*Zeit der Staufer*, 2: pl. 514).

[100] Münchengladbach, Minster Archives, Cod. 1, f. 2r, dated ca. 1140 by Schiller, 1972, p. 132 and fig. 435. It might be questioned whether the head is Atlas or Terra, rather than Adam.

[101] For a late twelfth-century paten in the Church of St. Mary in Kalisz from the Cistercian Abbey of Lad, see Haussherr, "Triumphkreuzgruppen der Stauferzeit," in *Zeit der Staufer* 5: 158, fig. 77. Marie-Madeleine Gauthier, "Du tabernacle au retable: Une innovation limousine vers 1230," *Revue de l'Art* 40–41 (1978): fig. 5, reproduces the open tabernacle of Saint-Aignan from the Chartres Cathedral treasury, dated about 1225–1230; the Crucifixion, with Adam rising at the foot of the cross, Mary and John, Ecclesia with the chalice, and Synagoga, is on the inner back panel; it is hidden behind twelve seated apostles on the valves when these are closed (fig. 1). Only the figure of St. John from a Crucifixion group survives on the early twelfth-century portable altar in Fritzlar; he is vested as a deacon, emphasizing the liturgical aspect of the iconography: *Zeit der Staufer*, 1: 513–14, no. 682, 2: fig. 483, and P. Springer, "Zur Ikonographie des Portatile in Fritzlar," *Anzeiger des Germanischen Nationalmuseums* (1975): 7–41.

[102] The Crucifixion, with Mary and John, Stephaton and Longinus, fills the center of the window, the cross nearly four meters high; above is the Ascension, while small scenes of the Three Marys at the Tomb and of the martyrdoms of Sts. Peter and Paul ordered by an emperor are placed below; Grodecki and Brisac, 1977, pp. 70–74, 286, pls. 56, 58, give the date about 1165–1170. Henry and Eleanor were married in Poitiers in 1154, but the window may have been offered by Henry in expiation for his having ordered the murder of Becket in 1170, in which case it is unlikely to date before his reconciliation with the church in 1172.

pears clearly to the laity in the nave, and the positions of the royal donors indicate that the representation of the Passion is viewed as an icon rather than as a symbol of the Eucharist. In a similar way, monumental sculptural groups were set up in this period on rood screens or *pulpita* dividing the nave from the choir, so that they were visible to the laity.[103]

Yet with the nineteenth-century censing angels now removed from the top and the figures of Ecclesia and Synagoga gone from the bottom, the Crucifixion window presents a surprisingly simple image, which avoids the late twelfth-century monastic vogue for typological appendages (Pls. 100, 103). There are no Old Testament allusions of the kind exploited in the pier sculptures of the liturgical choir, and in the east windows of Canterbury and Orbais (Pls. 33, 34, 213).[104] Again, it is to be noted that history and allegory were not Peter of Celle's preferred modes of exegesis; he concentrated instead on mystical and moral meanings.[105] Compared with the *de disciplina claustrali*, the contemporary treatise on the Sacrament of the Altar by the Cistercian Baldwin (archbishop of Canterbury, 1184–1190), for instance, is a rather plodding piece of exegesis, laying emphasis on the historical institution of the Mass at the Last Supper rather than on the Passion.[106] Only later, judging by the style, was an allegorical Crucifixion placed in a window of the south transept of Saint-Remi; Christ on the cross must have been placed between the surviving figure of Synagoga and a lost Ecclesia (Pl. 215 and Catalogue C).[107] This window seems to have been the gift of a laic, although the inscription *Petrus* is restored (Pl. 211).

The rest of the tribune windows were probably filled with ornamental glass, richly patterned with foliage and colored fillets but aniconic (Catalogue D, R.o.1–4); only in later reorderings do colored figures seem to have been set into these openings, using some of the original ornament as a frame (Pls. 92, 93, 246). The original effect would have been to concentrate the view from below on the central image of the eucharistic Crucifixion, and

thence on the clerestory zone above with its hosts of enthroned saints and prophets (Col. Pl. 1). Though not true grisaille in the Cistercian sense, these ornamental windows contained enough colorless glass to admit considerably more light to the tribune than would have been the case if all the openings had had deeply saturated panels. Similar ornamental windows were used, but in smaller number, in the side chapels of Saint-Denis.[108] The predominance of darker windows in Saint-Denis creates an effect that has been likened to the "divine gloom" described in the *Mystical Theology* of Pseudo-Dionysius the Areopagite.[109] It is doubtful that Peter of Celle or his successors sought a lighter effect in the glass of the choir for theological reasons, both because the Dionysian evocation of eternal darkness had not yet fallen into disrepute, and because it would be inconsistent with such an aim to revert to deeper colors in the celestial zone of the clerestory.

As in the tribune, so in the clerestory partial and shifting views are exploited. Since the wall passage is outside, the plane of the glazing is brought forward; the sills are splayed, and each triplet of lights almost fills the lunette under the quadripartite vaults so that maximum visibility of the glass seems to have been an aim, yet at the same time the springing of the ribs from the level of the triforium arcade means that the glazed surface partially disappears behind the webs of the vaults. This tendency is increased in the turning bays of the apse with the apostles, but the Virgin and Child were clearly revealed in the center of the axial triplet so that their image dominated the entire length of the church (Pls. 24, 26, 29). The Virgin was represented as Regina Coeli, enthroned and crowned, and framed between golden planets (Pls. 141, 142).[110] The rest of the program, easily comprehended on paper, has in fact to be sought and explored on the site in a series of zigzagging movements across the retrochoir. In the same way, repetitions of design and color that lend homogeneity not only to each triplet of lights but sometimes unite facing triplets across

[103] For an excellent overview see Haussherr in *Zeit der Staufer*, 5: 131–68.

[104] For the east window of Canterbury Cathedral, which I date about 1200, see Caviness, 1981, pp. 163, 165–72; for the contemporary window in the Benedictine Church of Orbais, see Kline, 1983, pp. 100–39.

[105] Beryl Smalley, "Stephen Langton and the Four Senses of Scripture," *Speculum* 6 (1931): 60–76, traced the development of four levels of exegesis: the historical and allegorical contrasting with the higher anagogical and tropological levels, though even in the thirteenth century they were not systematically separated. Hugh of Saint-Victor, writing in the first half of the twelfth century, articulated only two levels, corresponding to physical and spiritual sight (*P.L.* 176, col. 703), whereas Richard of Saint-Victor divided these into two categories each, the historical and allegorical, the tropological and anagogical (*P.L.* 177, cols. 374–75).

[106] Baudouin de Ford, *Le Sacrement de l'Autel*, ed. and trans. J. Morson and E. de Solms, 2 vols., Paris, 1963. The treatise was written at Ford, before 1180 (p. 9); the emphasis on the Last Supper is noticed (p. 34). The connection between the Communion of the Apostles as a *theoria*, and the Last Supper, which it interprets in a liturgical sense, as

a *historia*, was well developed in the East by then; see Christopher Walter, *Art and Ritual of the Byzantine Church*, London, 1982, pp. 185–96.

[107] A Crucifixion between Synagoga and Ecclesia at Orbais is also later than the east redemption window, and may have been supplied about 1215–1220 for one of the transept chapels; see Kline, 1983, pp. 151–56, fig. 70. Cf. also similar figures at Baye, fig. 197.

[108] Grodecki, 1976, pp. 122–26, pl. xv, figs. 183–92.

[109] John Gage, "Gothic Glass: Two Aspects of a Dionysian Aesthetic," *Art History* 5 (1982): 39–42; Meredith Parsons Lillich, "Monastic Stained Glass: Patronage and Style," in *Monasticism and the Arts*, ed. Timothy Verdon, Syracuse, 1984, pp. 222–25.

[110] For an outline of this iconography, see Klaus Wessel, "Regina Coeli," *Forschungen und Fortschritte* 32 (1958): 11–16. "Stars" are common in astrological illustrations, as in the *Liber Floridus*, f. 88v, where they surround the greater lights of the sun and moon; see also Walter Cahn, "The Tympanum of the Portal of Saint Anne at Notre Dame de Paris and the Iconography of the Division of the Powers in the Early Middle Ages," *Journal of the Warburg and Courtauld Institutes* 32 (1969): 59–61, for distinctions between representations of the sun and moon as greater and lesser lights.

the choir are much subtler when the viewer has to change positions in order to make the comparison from memory, than they seem when an art historian projects two slides or juxtaposes scale photographs. These formal traits will be more fully explored in the next chapter, after a careful reconstruction of the iconographic program from available documents.

The general composition of the choir clerestory windows of Saint-Remi followed those of Canterbury in presenting two large superimposed seated figures, as discussed in the introduction (Pls. 3, 77). The iconographic program, however, was different. Despite the loss without trace of twelve of the sixty-six figures that filled the clerestory windows of the retrochoir, and a more or less systematic "correction" of the inscriptions in the restoration of ca. 1860 during which all but seven were renewed, it is possible to reconstruct quite accurately the essentials of the iconographic program (Appendix 3).[111] It proves to be highly ordered and coherent; the selection of figures was evidently carefully planned in relation to the number of window openings, which comprise, in multiples of three, eighteen slots at each level in the straight bays to the north and south, and fifteen in the hemicycle (Fig. 5). These architectural units originally served to separate the New Testament figures in the easternmost lights from the Old Testament patriarchs in the less visible side windows. It was here that the worst blunder was made in the nineteenth-century restoration, since the barefoot disciple in the first turning light on the north side (N.III a), clearly labeled *Iacobus* in the earlier drawing, was renamed *Isaias* before the Rothier photographs were taken (Pls. 135, 186, 187, and Appendix 3). Evidently the Virgin and Child in the axial light originally presided over the twelve apostles and two additional disciples, a not uncommon number, in order to maintain the autonomy of the hemicycle; and it also gave seven on either side of the Virgin to give the number of regeneration, eight. The restorers, however, adhered rigidly and unimaginatively to twelve apostles of the canon of the Mass. The impetus for the changes can be seen in the carefully labeled plan of 1857 by Reimbeau, in which he recorded *S. Iacob* in N.III a and in N.II c, adding the note at the second occurrence *bis*, as though he did not understand the inclusion of James Major and Minor; his error was compounded when he transcribed *Ysaie* in N.V a, which can be verified in the Rothier photograph, as *Ysaac*, since this then allowed the

transformation of *Iacob* into *Isaias* (Pl. 166). The opposite bay, S.III, which had lost all its original figures, was at the same time supplied with one Old Testament patriarch, Jeremiah, facing Isaiah, and two apostles (Pl. 136). *Ieremias*, recorded in N.IV c by Reimbeau, was transformed into Ezekiel, as proved by the prerestoration drawing (Pls. 175, 176).

The original program does not seem particularly remarkable; the cult of the Virgin in the twelfth century, and the attention shown to her by Peter of Celle especially in his sermons, does not make her image a surprising choice even in a church that was not dedicated to Notre Dame, especially since there were relics of her hair and part of her tomb there.[112] That the Virgin and Child are placed between the enthroned disciples does, however, preclude a dominant image of Christ in Majesty and therefore any overt reference to the Last Judgment. In this, the clerestory program differs from that at Canterbury where a medallion containing the Last Judgment was placed in the axial window of the hemicycle and the Virgin and Christ must have been placed at the end of the series of genealogical figures, on the south side of the choir (Appendix 4; Pl. 205).[113] Another distinction of the rémois program is the inclusion of the Child, and the planets and crown. Evidently, though seated together, the Virgin and disciples cannot be interpreted as if gathered in the upper room at Pentecost.[114]

Partial analogues for the program can be indicated in contemporary reliquaries. One is the ivory shrine in the Musée de Cluny that supposedly came from Saint-Yved of Braine (Pl. 61).[115] It has Christ enthroned between fourteen disciples extending over three sides, with an angel between the Virgin and Child, with Joseph and Simeon, and the three Magi on the fourth face; sixteen Old Testament patriarchs, prophets, and kings, with four archangels, are on the cover. Another program that offers a general analogy is that of the Shrine of the Three Kings in Cologne, begun in the shop of Nicholas of Verdun in the 1180s, and thus largely contemporary with the Saint-Remi glass, though not completed until later (Pl. 27).[116] On the long sides two arcaded levels framed seated statuettes of the twelve apostles, in the upper register, and twelve prophets, below; each series was originally interrupted in the centers of the two sides by a seraph and a cherub above and King Solomon and King David below, and these have been reinstated in the recent restoration. The front end has the crowned Virgin and

[111] Invaluable prerestoration sources are the plan recording subjects and inscriptions made by Reimbeau, MS 2100, III, 1, no. 6 f. 2. These, with the notations made by Tourneur, are listed in Appendix 3. Some drawings preserved in the Musée des Arts Decoratifs in Paris may have been made by the restorer: Dessins, Vitraux, nos. 2508, 2509.

[112] Marlot, 1845, 2: 530–32.

[113] Caviness, 1981, pp. 8–9.

[114] The Virgin tended to occupy this position in works done under female patronage, such as the Shaftesbury and Ingeborg psalters; see Kauffmann, 1975, pl. 132, and Deuchler, 1967, pl. 36, whereas in the Cluny Lectionary St. Peter is in the center: Kauffmann, 1975, fig. 14.

[115] See discussion in Chapter 3, at n. 35.

[116] P. Bloch and H. Schnitzler, "Der Meister des Dreikönigenschreins: Ausstellung im erzbischöflichen Diözesan-Museum in Köln," *Kölner Domblatt* 23–24 (1964): 429, dates the campaigns 1181–1191 for the sides, ca. 1198–1206 for the front, and ca. 1220–1230 for the back; the program is briefly described on p. 428. Further reconstructions and analyses of the program were presented by Walter Schultern, "Die Restaurierung des Dreikönigschreines: Ein Vorbericht für die Jahre 1961–1971," and by Richard Hamann-Mac Lean, "Der Dreikönigenschrein im kölner Dom: Bemerkungen zur Rekonstruktion, Händescheidung und Apostelikonographie," *Kölner Domblatt* 33–34 (1971): 43–78.

Child between the adoring Magi and the Baptism of Christ, with Christ in Majesty above; the other end has the Flagellation and Crucifixion with Ecclesia standing above.[117] Evidently the parallels that can be drawn between the two programs are not very specific, but the general organization is similar, and the brilliant gold and enameled surfaces, set with gemstones, evoke stained glass. A much closer analogue, as recently pointed out by Nilgen, is the shrine of Archbishop Anno II of Cologne, which is also contemporary with the glass (ca. 1183).[118] In its original form, a single-story arcade encompassed seated figures of six canonized archbishops of Cologne, with the six saints whose relics were enclosed on the other side, and twelve seated apostles in the spandrels; on one end the patron saint of the Abbey of Siegburg, where Anno was buried, stood below the Virgin in the gable; on the front end was Anno below Christ.

Judging from a seventeenth-century drawing, a lost fresco cycle created for Pope Calixtus II in 1122 or 1123 in the Lateran Palace bears such a striking resemblance to the Saint-Remi retrochoir program, as well as to the shrines with which Nilgen compares it, that it may be a common source for these contemporary northern works; it is likely to have been seen by ecclesiastical visitors to Rome (Pl. 142).[119] In the apse was the enthroned Virgin, with the crown and cross of Ecclesia and with the Child, between angels and two standing canonized popes, Sylvester I and Analect I; this zone is studded with stars. Below the Virgin was St. Nicholas, patron of the Oratory, standing in the midst of eight popes who had held firm during the investiture conflict. The program was overtly topical and political, asserting orthodox papal authority and tradition in the face of the antipopes. The political aims of the Saint-Remi program will be examined in a later section.

In a sense, Peter of Celle's retrochoir, fashioned to contain the relics of St. Remigius, rivals the great shrines with which it shows so much affinity; the retrochoir evokes a monumental shrine just as powerfully as does the later Sainte-Chapelle (Pls. 26, 27).[120] Such effects were also sought in the almost contemporary Trinity Chapel in Canterbury Cathedral, which was expanded in the early 1180s to house the relics of the church's newest martyr, Thomas Becket.[121] At the same time, the ré-

mois program of glass recalls Peter's mystical interpretation of the "ancient rites" of Exodus as analogues of celestial liturgy, and his reference to the prophets and patriarchs as types of Christ whose incarnation had been foreseen from the beginning.[122]

The figures in the choir windows seem to exist in some eternal heavenly stasis rather than partaking in any event. Few were identified by attributes other than books and scrolls, although Peter had keys connoting heaven; none had scriptural quotations to evoke the actions of writing or speaking. The canonized archbishops seem originally to have been in the company of the apostles in the hemicycle, their less illustrious colleagues beneath the prophets in the straight bays (Appendix 3). The prominent positions of St. Remigius and St. Peter in the hemicycle would recall to anyone coming from outside the monastery the statues placed above the portals (Pls. 18, 91, 141); their more active stance and involvement with the viewer there serve to emphasize their removal to another world here.

One more element belongs to the Church of Christ. In the last chapter it was noted that Povillon-Piérard saw two large virgin saints with the *Ave Maria* in the west facade, flanking Pope Clement I, and St. Martha and St. Agnes with similarly inscribed scrolls in the tribune (Appendix 2, ff. 52v, 54, 54v). The second pair survive, transformed in the later restoration and the paint nearly gone from St. Martha; the glass is turned inside out to make the two figures parenthetical to the Crucifixion group, an arrangement that is already portrayed in drawings by Didron (Pls. 93–95, 99). Images of these saints may in part be explained by the presence in Saint-Remi of relics of St. Agnes, and by feasts for each in the calendar.[123] There is also the possibility that Martha was paired with Mary in the original scheme as exponents of the active and contemplative lives. Although Peter of Celle does not specifically address nuns, the abbey preserved the memory of Clovis's sister, Albochledis, since she was mentioned by St. Remigius in a letter to the king as having received the *benedictio virginitatis*.[124]

Other resonances are liturgical. The scrolls of both figures can still be deciphered to give: *Ave Maria gracia plena Dominus tecum*, the words of the antiphon to the Virgin: "Hail Mary, full of grace, the Lord is with you, blessed art thou among women."[125] Peter of Celle com-

[117] Bloch and Schnitzler, "Der Meister," pls. 18–19.

[118] In the Abbey Church of Siegburg: Nilgen, 1985, p. 222, fig. 5; for earlier cycles, see p. 221.

[119] Nilgen, 1985, pp. 223–24, fig. 6. The papal forerunners of Calixtus II, shown beside Sts. Nicholas, Leo, and Gregory, and all nimbed and titled saint, all combated antipopes during the investiture conflict.

[120] The same comparison is made by Anne Prache, "Les reliques de Saint-Remi à Reims et leur ancienne présentation," in *Hommage à Hubert Landais*, Paris, 1987, pp. 165–66. For this aspect of the Sainte-Chapelle, see Robert Branner, "The Painted Medallions in the Sainte-Chapelle in Paris," *Transactions of the American Philosophical Society* n.s. 58, pt. 2 (1968): 8–9.

[121] For the Trinity Chapel, see Madeline H. Caviness, "A Lost Cycle of Canterbury Paintings of 1220," *The Antiquaries Journal* 54 (1974):

69–71.

[122] Peter of Celle, "Mosaici Tabernaculi mystica et moralis expositio," *P.L.* 202, col. 1054.

[123] Marlot, 1845, 2: 532. M. Anstett-Janssen, "Martha von Bethanien," in *Lexikon der christlichen Ikonographie*, ed. Wolfgang Braunfels, Rome, 1974, 7: cols. 565–66. Ulysse Chevalier, *Sacramentaire et martyrologe de l'Abbaye de Saint-Remy*, Bibliothèque Liturgique 7, Paris, 1900, pp. 1, 2, 18. Other female virgin saints include Martha's sister, Mary; Salvina; Brigid; Agatha; Sotheris; Lucy; Eulalia; Tecla; Helena; Magra; Petronilla; Marina; Praxedis; Christina; Agapa; Cecilia; Radegund; Sabina.

[124] René Metz, "Benedictio, sive consecratio virginum?" *Ephemerides Liturgicae* 80 (1966): 272.

[125] Mary's name is not used by Angel Gabriel in his similar address

posed seven sermons on the Annunciation, including two that took this text.[126] He inquired rhetorically whether her name was inscribed in the heavens, and acknowledged that it is to be blessed and exalted throughout the ages, to be called out in danger and in fear, exulting the spirit and calming the mind. Mary is the star of the sea, the illuminator, our Lady. Her name is heard and inscribed in the eternal palace, on the lintel of the Temple, on the front of the tabernacle.[127] Again, the program coincides with the spirit of Peter's writings. Yet it also relates to the little office of the Virgin, recalling the outpouring of praises—"diffusa est gratia in labiis tuis"—and the procession of virgins who will enter the king's palace (templum regis) in Psalm 45 (44):2 (3) and 14–15 (15–16): "She shall be brought unto the king in raiment of needlework: The virgins her companions that follow her shall be brought unto thee. With gladness and rejoicing shall they be brought: They shall enter into the king's palace." At least one gloss emphasized that the Temple is the Holy Jerusalem, the virgins are like priests.[128] A fuller commentary by Peter Lombard relates the psalm to the theme of the sponsus and sponsa, and identifies three parts: the prophets at the court of heaven; the four forms of praise to the lord; and the praises sung to the bride by her female companions.[129] The virgin companions symbolize purity of mind brought by the grace of God (pudica mentes adducentur gratia Dei), and they approach the throne of the king in the Holy Jerusalem, or in the Church on earth. Because of its Marianic imagery, the psalm was sung at the Nativity, the feast of the Virgin, and the feast of the virgin saints, as well as the feast of the apostles.[130] Its phrasing is echoed in early versions of the hours of the Virgin, and in a hymn addressed to virgin saints as regi oblatae.[131] On the other hand, with more emphasis on the king of heaven, such allusions also had a place in hymns for the dedication of churches.[132] Of added significance in Reims is the association of Psalm 44 with the coronations, and associated ceremony of knighting.[133]

Whatever their original position, whether in the choir or in the west end of the nave, these virgin saints must have formed a liturgical procession, most probably addressing the virgin (rather than Christ) who would then be literally "blessed among women." The cadence of this virginal procession recalls that of the sixth-century mosaics of Sant'Appolinare Nuovo in Ravenna, and an unusual sequence of female saints on a middle-Byzantine copper plaque who adopt the same pose of intercession (Pl. 98).[134] In the Anglo-Saxon Benedictional of St. Ethelwold, the Virgin appears with six unnamed saints, some holding books, all crowned, forming one of the Choirs of Heaven.[135] It is unlikely that the Virgin of the Crucifixion was the recipient of these prayers, and the figures could not have been in the apse clerestory. The Lady Chapel provides the more likely possibility. Single figures are a rarity in lower windows, but Clark has suggested that the wide openings may have been masked by an interior arcade of the kind used in the west facade (Pl. 23), and they might thus have accommodated two slender figures in each light.[136] Alternatively there

at the Annunciation (Luke 1:28). The antiphon is found as early as the tenth century in a St. Gall manuscript; see R. Steiner, "Ave Maria (Antiphon)," New Catholic Encyclopedia, New York, 1967, 1: 1123.

[126] P.L. 202, cols. 705–25.

[127] P.L. 202, col. 714: "Ave ergo, sancte angele, cui loqueris? quod est nomen ejus? Estne in coelis scriptum, agnitum et nominatum? Novi, inquit, eam ex nomine. Quod est nomen? Et nomen virginis Maria. Hoc nomen benedictum et exaltatum in omnibus saeculis; adorandum et coelendum gentibus, tribubus et populis. O nomen nominabile! o nomen vererabile! o nomen semper nominandum in periculis, semper invocandum in angustiis! o nomen sanans palatum se nominans! o nomen linguam gratificans se appellantem! o nomen laetificans se nominantem! Maria, ridet coelum, cum audit Maria. Exsultat anima, tranquillatur conscientia cum audit Maria. Fugit tentatio, si fideliter reciprocatur Maria. Tempestas quiescit, si jusserit Maria: unda stat, si nomenata fuerit Maria.

Sed quid est Maria? maris stella. Quid est Maria? illuminatrix. Quid est Maria? domina. o Maria, o maris stella, o illuminatrix, o domina . . .

Ave, Maria: in palatio aeterno, in superliminari templi, in fronte tabernaculi, auditum est et scriptum nomen quod describetur a generatione in generationem."

[128] E.g., the commentary on the psalms once attributed to Rufinus presbyter, P.L. 21, col. 826; cf. Clavis Patrum Latinorum, rev. ed. Emile Gaar, Sacris Erudiri, Jaarboek voor Godsdienstwetenschappen 3, Bruges, 1961, p. 45.

[129] Peter Lombard, Commentarium in Psalmos, P.L. 191, cols. 437–50.

[130] Ibid., col. 447; Glossa Ordinaria, P.L. 113, col. 911. Several antiphons relate to this psalm: Henri Barré, "Antiennes et répons de la Vierge," Marianum 29 (1967): 229–35, esp. nos. 107, 109–11, 122, 124, 130. Recurrent themes are the daughters of Jerusalem, and the Virgin among Virgins. I am extremely grateful to Daniel Sheerin for this and

the following references and for bringing my attention to Psalm 45.

[131] For the use of Ps. 44:3, Diffusa est gratia in labiis tuis, in the hours of the Virgin, see E. S. Dewick, Facsimiles of Horae de Beata Maria Virgine from English MSs of the Eleventh Century, Henry Bradshaw Society 21, cols. 7, 8, 11, 14, 32; and J. Leclercq, "Formes Anciennes de l'office marial," Ephemerides Liturgicae 74 (1960): 95. For the hymn: Analecta Hymnica medii aevi 54, Leipzig, 1915, p. 133, no. 91: The Virgin is vested in gold, seated next to the king, and leads the virgins who are offered to the king, consecrated to Christ; verses 8–9 mention the daughters of Tyre, and Thecla, Agnes, Lucia, and Agatha.

[132] Analecta hymnica 54, p. 138, no. 94, v. 13–14.

[133] Jean de Pange, Le Roi très chrétien, Paris, 1949, pp. 377–79.

[134] See the Introduction, n. 69. The figures on the Byzantine plaque are tentatively described as the Virgin repeated, in Dumbarton Oaks, Handbook of the Byzantine Collection, Washington, D.C., 1967, p. 39, no. 143. The gesture was commonly adopted in byzantinizing objects in the West, such as the retable of ca. 1180 from St. Walburga now in Soest, Westfalia (Erich Kubach and Peter Bloch, Früh und Hochromanik, Baden Baden, 1964, pp. 217 [illus.], 220), and the thirteenth-century Psalter of St. Elisabeth, Cividale, Museo Archeologico, f. 168 (Erika Dinkler-von Schubert, Der Schrein der hl. Elisabeth zu Marburg, Marburg, 1964, pl. 26, fig. 77a).

[135] London, B.L. Add. MS 49598, f. 1b: Francis Wormald, The Benedictional of St. Ethelwold, New York, 1959, pl. 1, pp. 16–18 The association of other female virgin saints, including St. Agnes, with the Virgin is suggested by St. Ambrose, De Virginis Libri Tres, ed. Egnatius Cazzaniga, Corpus Scriptorum Latinorum Paravianum, Turin, [1948], pp. 3, 6–8.

[136] William W. Clark, "The Chevet and Choir of Saint-Remi at Reims," Fourteenth International Congress on Medieval Studies, The Medieval Institute, Western Michigan University, 1979; I am grateful to Bill Clark for a typescript of this paper, and for discussion of the

may have been a second image of the Virgin as Regina Coeli in the west facade above St. Clement, mirroring the one in the apse, but the openings here are out of scale with the figures.

Regnum and Sacerdotium

THE ROYAL AND EPISCOPAL TOMBS

The third major theme, that of kingship and priesthood, is directly related to the Frankish and Carolingian past of the the abbey church. The anointing of kings, at first adopted in imitation of Old Testament custom, included by the ninth century the use of the chrism that had been reserved for the priesthood, and the appellation *novus David* gave way by 900 to that of *christus*.[137] It has already been recalled that Reims laid claim to an essential role in the use of the chrism for royal coronations, because the legend was circulated in the ninth century that the Sainte Ampoule had been delivered from heaven into the hands of St. Remigius during the baptism of Clovis.[138] The expediency of perpetuating this legacy was no doubt a major factor in deciding the program of decoration at all times in the twelfth century.

As with the theological programs of Odo, so with the attention he lavished on the burial places of the kings and archbishops of that era, it may be questioned whether his works in Saint-Remi spurred Suger to compete by refurbishing the other royal Benedictine abbey, or whether Suger's ambitious programs inspired rivalry. Whichever took the lead, by the second half of the twelfth century each house had devised programs that drew attention to the emblems of temporal power that they enshrined, the Holy Chrism outside the gates of Reims and the Oriflamme outside Paris. Kings continued to be venerated at both sites. At Saint-Denis Suger revived offices in their honor.[139] The observation by Lenoir in the nineteenth century of figures of kings of France, including Pépin le Bref, in the windows of the thirteenth-century triforium of the choir of Saint-Denis

remains unconfirmed, and their date cannot be ascertained, although it is tempting to think they may have been saved from Suger's clerestory windows.[140]

Either under Abbot Odo, according to Grodecki, or in the era of the extension and decoration of the nave and retrochoir of Saint-Remi, programs in stained glass celebrated the regal nature of Christ's ancestors and included representations of Frankish kings. Such a concern with kingship does not appear appropriate to Peter of Celle so much as to his archiepiscopal colleague, Henri de France, or to Henri's successor, William of Champagne. At the time that Odo carried out his program of tomb sculptures, France lacked a royal saint, but in 1163 Charlemagne was canonized and his relics translated to a great shrine in Aachen.[141] He was immediately claimed by the German emperors as their saintly ancestor, and a magnificent program of windows in the Romanesque Cathedral of Strasbourg commemorated this descent (Pl. 9).[142] As Wentzel pointed out, these programs may be associated in their genesis;[143] it would not be surprising if the Rhenish program were challenged in Reims, an outpost of the French domain bordering on the Rhineland and hemmed in by the County of Champagne (Fig. 1). The latter had its own dynastic associations with both Carolingian and Norman rulers, and their memory was kept alive in Troyes.[144] This is the larger context against which the ambitions of Saint-Remi may be understood. Yet parochial motivation should not be overstressed, since it was common to regard Christian priests and kings as heirs to their Old Testament counterparts, unifying history. Even the *Liber Floridus* ends with lists of the princes and kings of the Jews after the Machabees and of the Jewish pontiffs after Moses, the descent of the Frankish line from Priam and the Romans to Emperor Henry, and the names of the archbishops of Reims and Cologne and of the bishops of Trier and other sees.[145]

Among the cenotaphs in Odo's choir, elaborate monuments were reserved for three monarchs of the line of Charlemagne and for Archbishop Hincmar (Pls. 45, 46, 272). The remnants of these, and the documents concerning them, have been carefully studied by Prache and

problems. The dimensions of the figured panels—a height of 2.20 meters and a width of 56 centimeters—need to be considered in this context.

[137] A useful synopsis of developments is given by Johan Chydenius, *Medieval Institutions and the Old Testament*, Societas Scientiarum Fennica, Commentationes Humanarum Litterarum 37.2, Helsinki, 1965, pp. 46–54.

[138] Oppenheimer, 1953, pp. 96–107; Percy Ernst Schramm, *Der König von Frankreich: Das Wesen der Monarchie vom 9. zum 16. Jahrhundert*, Weimar, 1960, p. 146.

[139] Suger, 1979, pp. 108–9, mentions only a Mass for Dagobert, and after combing the texts Elizabeth A. R. Brown and Michael W. Cothren do not believe Suger supplied tombs and attribute the lost statue of Dagobert to Suger's successor, Odo of Deuil ("The Twelfth-century Crusading Window of the Abbey of Saint-Denis: 'Praetorium enim Recordatio Futurum est Exhibitio,'" *Journal of the Warburg and Courtauld Institutes* 49 (1987): 24, 33. Cf. Prache, 1978, p. 26, and Erlande-Brandenbourg, 1975, p. 120, who are inclined to attribute the

statue to Suger.

[140] Grodecki, 1976, p. 30, n. 26. See also Caviness, 1986, p. 268.

[141] Cf. also Edward the Confessor, who was canonized in 1161, although his cult was not fully exploited at Westminster until the thirteenth century; see Madeline Harrison [Caviness], "A Life of St. Edward the Confessor in Early Fourteenth-Century Stained Glass at Fécamp, in Normandy," *Journal of the Warburg and Courtauld Institutes* 26 (1963): 25–26. Cf. Nilgen, 1985, pp. 224–25, who speculates that a great shrine was made in 1163 for the translation of the relics, thus contemporary with Charlemagne's shrine.

[142] Beyer et al., 1986, pp. 148–50.

[143] Quoted by Grodecki, 1975, p. 65.

[144] This has been demonstrated for the program of the tomb of Thibaud III of Champagne (d. 1201) in Saint-Etienne in Troyes: Michel Bur, "Les Comtes de Champagne et la 'Normanitas': Sémiologie d'un tombeau," *Proceedings of the Battle Conference on Anglo-Norman Studies* 3 (1981): 22–32, 202–3.

[145] *Liber Floridus*, ff. 233r–240v (pp. 465–80).

Hamann-Mac Lean, who have noted their political significance in the context of Odo's choir program.[146] Carloman, son of Pépin le Bref and brother of Charlemagne with whom he briefly divided the Frankish kingdom, was buried in Saint-Remi on his death in 771. According to Marlot, in the seventeenth century his remains were in an ancient white marble sarcophagus set up on four columns in the transept; it was very like the one then preserved in Saint-Nicaise. The latter, known as the Sarcophagus of Jovinus, is preserved in the Reims Museum, but no trace survives of the one from Saint-Remi. Its use for Carloman may have gone back to the Carolingian revival, since both Charlemagne and Louis le Débonnaire were placed in sarcophagi somewhat later.[147] However, interest in the reuse of Roman sarcophagi can also be cited in the mid-twelfth century; Gilbert de la Porrée, who died as bishop of Poitiers in 1154, was placed in an early Christian Arles sarcophagus, perhaps brought from Provence at that time.[148] In either case, Carloman's sarcophagus must have had an aura of sanctity since from the time of Gregory of Tours such receptacles had been used predominantly for the remains of saints, and consequently often served as altars.[149]

Similarly, Prache has pointed out the affinity that the seated effigies of Louis IV d'Outremer and Lothar had with reliquaries such as the famous one of St. Foi in Conques;[150] somewhat later the famous gilded portrait bust of Frederick Barbarossa in Cappenberg, containing a relic of St. John the Evangelist, evoked the same tradition.[151] The rémois effigies, however, represented a type that was entirely novel in stone carving of the twelfth century, in that they were enthroned on daises under canopies on either side of the main altar (Pls. 45, 46, 272). Slightly smaller than life-size, polychromed, crowned, and holding their scepters, these exquisite statues were the most "real" element of the choir program, occupying places of honor from which they wit-

nessed the Eucharist celebrated at the Carolingian altar. A parallel with Saint-Denis has been suggested, but Suger was content to evoke the ancient kinds by the restoration of the altar frontal given by Charles the Bald, by the revival of feasts and lamps in honor of Dagobert, and through the restoration of his throne.[152] The statues in Saint-Remi were more vivid and more literal.

The stone cenotaph of Hincmar, archbishop of Reims and abbot of Saint-Remi in the mid-ninth century, must have been even more imposing, judging from the surviving fragments in the Musée Saint-Remi and the Montfaucon engravings (Catalogue D, R.b.35).[153] The discovery of actual sculptural elements from the gables by Deneux after World War I settled the debate over its date, which must be twelfth rather than ninth century, but its iconography has been disputed.[154] In a well-argued thesis, Hamann-Mac Lean has settled on Ecclesia or the Church of Reims in the center, with the archbishop of Reims on her right; on her left appear the abbot of Saint-Remi, and the abbot of Saint-Denis whose presence was required at the coronation in the twelfth century; beyond them, to our right, a king is crowned and annointed by the archbishop.[155] The essential role of the abbey in the coronations, and the balance of ecclesiastical power, is stressed. In a letter to Charles the Bald, Hincmar had referred to the abbey as *monasterium Remense*, the monastery of Reims, and it was later referred to by Pope John XIII in 972 and by his successors as *Archimonasterium*.[156] The monumental treatment of these themes commemorated and perpetuated the ancient bonds between the abbey and the royal succession, and Hamann-Mac Lean argued a close association with the coronation of Louis VII in 1131. The central placement of the church, and the marginal one given to the king, state a clear position on the investiture conflict that had threatened the unity of the western Christianity early in the twelfth century.[157]

[146] Prache, 1978, p. 26; Hamann-Mac Lean, 1983, pp. 126–38, 158–62, 182–258.

[147] For Charlemagne's pagan sacrophagus, still in Aachen, see Prache, 1969, p. 68; for Louis's, an early Christian piece of the Red Sea type, see Edmond Le Blant, *Les Sarcophages chrétiens de la Gaule*, Paris, 1886, pp. 11–13, pl. III, 2, 3, 4, 5.

[148] A drawing of it, made before the Revolution, is described in Le Blant, *Les Sarcophages*, pp. 81–83. Other examples of reused sarcophagi are studied in B. Andreae and S. Settis, *Colloquio sul Reimpiego di sarcofagi roman nel medioievo*, Marburger Winckelmanns-Programm, 1983; I owe this reference to Ernst Kitzinger, but regret the publication was not available to me.

[149] Gregory is cited by Jean Adhémar, *Influences Antiques dans l'art du moyen-âge français*, Studies of the Warburg Institute VII, London, 1939, p. 133. A sarcophagus that served as an altar in Saint-Victor of Marseilles is now in the Musée Borély; see V.-H, Debidour, *Le Bestiaire sculpté en France*, Paris, 1961, p. 28.

[150] Prache, 1969, p. 73. These decendants of Charles the Bald were the last of the line to be interred in Saint-Remi. Louis died in Reims in 954, his wife Gerberge in 969, and their son joined them there in 986. For the Carolingian statue of St. Foi, with later additions, see most recently Jean Taralon, "La majesté d'or de Sainte-Foy du trésor de Conques," *La Revue de l'Art*, 40–41 (1978): 9–22.

[151] Dated about 1160: *Zeit der Staufer*, I: no. 535, pp. 393–94, cover

illus. and figs. 324–25.

[152] Suger, 1979, pp. 60–61, 128–33, 72–73, figs. 19–20, 22; for differing views, see above, n. 139.

[153] It seems to have been made to be applied to a wall or screen; Marlot saw it in the north transept against the choir closure, but this may not have been its original position. The plausible reconstruction achieved in the museum installation suggests a width of about 3.5 meters and a height close to 85 centimeters for the main relief (Hamann-Mac Lean, 1983, text fig. 31); the central enthroned figure would thus have been close to the effigy of Lothaire in size.

[154] Earlier opinions, including the Carolingian date proposed by Kingsley Porter on the basis of the engravings, and an attribution to Raoul le Vert (d. 1124) by Marlot, are reviewed by Prache, 1969, pp. 68–72. Her interpretation, based on Martène and Durand, of the central figure in the principal relief as Charles the Bald, giving a church and its charter to a bishop and receiving Hincmar's supplication for the return of alienated property to Saint-Remi, has been countered by Hamann-Mac Lean; I am grateful to Anne Prache for the reference to his work, and her expressed agreement with his thesis.

[155] Hamann-Mac Lean, 1983, pp. 207–33.

[156] . . . Archimonasterio, quod in Francia situm non longe a civitate Remensi, . . . (letter to Adalbéron cited by Poussin, 1857, pp. 49, 52–53).

[157] The intervention of several church dignitaries in this representa-

PRECURSORS IN THE GLASS: FRANKISH KINGS AND ANCESTORS OF CHRIST

The importance to the abbey of both archbishops and kings was no less great in the latter part of the same century. Whereas in the person of Hincmar, and many others of the period down to 945, the archbishop and abbot were one, in the abbacy of Peter of Celle the archbishop was a prince of the royal blood. The program of windows that eventually completed the choir and nave decorations commemorated both associations. The Frankish kings seem to have been relegated to the lower tier in the clerestory windows of the nave proper, below patriarchs, whereas this position in the liturgical choir and retrochoir was reserved for selected archbishops, ending with Henri de France, below patriarchs or New Testament saints (Appendix 3; Col. Pl. 5; Pls. 127, 145). It may be noted that each group, representing the medieval *regnum* and *sacerdotium*, can also be associated, more or less closely, with precursors. On the one hand, there is the series of figures from a genealogy of Christ that is distinguished by a liberal bestowing of crowns; I have tentatively suggested these were set in the nave aisles or tribunes at least after the Gothic remodeling (Col. Pl. 17, Pls. 246–48, 251).[158] On the other hand, and more clearly evoked as precursors since they remain in situ, there is the series of Old Testament patriarchs who complement the apostles and archbishops in the choir (Col. Pl. 2–4, 10; Pls. 127–41). There is also a fragmentary series of patriarchs that were placed originally above the kings in the nave (Col. Pl. 13; Pls. 80, 255–61).

Thus, the theme of kingship runs through the refurbished royal tombs, a number of surviving figures of enthroned kings in the nave clerestory, and the fragmentary series of standing ancestors now in the choir tribune. It seems that outside the monastic *claustrum*, the nave windows took up the theme of Frankish kingship that had been introduced in the tombs in the transept. Ten figures holding scepters are preserved, whole or in part, and where the upper panel is intact it shows the high back of a throne; apparently the foldstool that was more customary on royal seals was not represented (Pl. 115). Only a few have nimbuses. Most of the figures are frontal, their feet and legs symmetrically arranged; the general figure type and the high-backed throne are found in Carolingian manuscript paintings, such as the

throne effigies of Charles the Bald in his Psalter, in the Codex Aureus of Saint Emmeram, and in the Bible of San Paolo Fuori Le Mura (Pls. 270, 273).[159] Less commonly, the kings at Reims sprawl in three-quarter view occupying runged chairs that are turned at the same angle (Pl. 263). The late twelfth-century seal of Ermesende, Vicomtesse de Sens, shows this type, apparently shared by the nobility in this era (Col. Pl. 14; Pls. 262–63).[160]

Only one figure is named, in an inscription on a band that passes behind his crown and nimbus; despite breakages, and the insertion of the face and crown from elsewhere, the inscription is still virtually complete and clearly reads: *Chilperic'* (Pls. 75, 76, 265).[161] Other name bands may have been obliterated in the several changes of position that this series of figures have endured; several have been cut down across the top, flush with the crown, or even removing part of a nimbus (Pls. 263, 267, 270, 271).[162] The Merovingian Chilperic, son of Lothar I and grandson of Clovis, was king of the Franks from 561 to 584.[163] His third wife, Fredegund, bore Lothar II, father of Dagobert; but she is perhaps better known for plotting the murders of Chilperic's half-brother, Sigibert (who had ruled his part of the kingdom from Reims), along with his first wife, Audovera, and her son Clovis; Chilperic was responsible for the death of Sigibert's queen, Brunhild. These unsavory events were recounted by Gregory of Tours, who, however, is not sympathetic to Sigibert since he was constantly campaigning against his brothers with militia from across the Rhine.[164] Chilperic's elimination of this Germanic military threat may even have cast him in a positive light in Reims during the period of Hohenstaufen ascendancy.

The program in the glass apparently celebrated the line of Clovis, but there was not room for all twenty rulers from Merovech to Childeric III, especially since the series may have continued with the Carolingian line, a logical extension in view of the tombs in the sanctuary.[165] From the sole surviving example of Chilperic, it seems clear that the early rulers were not selected for their sanctity, despite some halos; they may rather have offered moral lessons in good and bad kingship to the secular dignitaries who viewed them in the nave.

Figures of Clovis and his queen, Clotild, were seen by Povillon-Piérard in the early nineteenth century in the

tion contrasts with an earlier representation of the coronation of Otto III by the direct agency of the Virgin/Ecclesia: Robert Deshman, "Otto III and the Warmund Sacramentary: A Study in Political Theology," *Zeitschrift für Kunstgeschichte* 34 (1971): 1–5.

[158] See discussion in Chapter 1.

[159] For color reproductions of the Psalter page (B.N., MS lat. 1152, f.3v) and of the Regensburg Codex Aureus (Munich, Bayerieche Staatsbibliothek, Clm. 14000, f.5v), see J. Hubert, J. Porcher, and W. F. Volbach, *The Carolingian Renaissance*, New York, 1970, figs. 135, 137; for the second and the frontispiece of the San Paolo Bible (Rome, Abbazia di San Paolo, f.1r), see Florentine Mütherich and Joachim E. Gaehde, *Carolingian Painting*, New York, 1976, pls. 37, 44. Although the Bible may have been illuminated in Reims about 870, it

was certainly in Rome by the later Middle Ages so could not have been the direct model for the glass. The throne backs vary, as in the glass. The ones in the Codex and the Bible have horizontal slats with closely packed rungs between, the one in the Psalter appears open within a heavy frame.

[160] Douët d'Arcq, 1863, 1: no. 505.

[161] Only the termination of the horizontal arm of the *L* and the stem of the *P* are in fact missing on close examination.

[162] See Chapter 1.

[163] Gregory of Tours, 1974, p. 18.

[164] Ibid., pp. 19, 241–48.

[165] Chilperic's son Lothar II (d. 629) is not to be confused with the Carolingian Lothar (d. 986) who was buried in Saint-Remi.

two lower windows of the west façade, on either side of the main door where they would have confronted the newly crowned king as he exited. An analogous position seems to have been given to Charlemagne enthroned, in the west window of Strasbourg Cathedral.[166] In the vast central window above was a poorly proportioned figure of St. Clement, which must have been colossal even if it shared the opening with the Virgin as speculated in the last section. Lacatte-Joltrois complained in 1843 that the figures had been eliminated.[167] However, the large head of a king that Viollet-le-Duc recorded in the attic of the presbytery in 1868 might well be a fragment of Clovis, since a single figure in proportion to it would fill the opening (Pls. 23, 201).[168] As far as can be judged from the drawing, the rendering of the features is not unlike that of the nave clerestory kings, and there is an even closer analogue in one of the figures from Braine, allowing for the difference of scale (Pls. 202, 256). Clovis and Clotild were thus separated from the representatives of their line, both as its founders and as the first Christian monarchs. Placed hierarchically below the pope, whose name was included in the dedication of the main altar, they reaffirmed the theme of the program. They also complemented the statues of St. Peter and St. Remigius that are placed on the exterior engaged columns at this level, and who announce the ecclesiastic program of the building to the approaching visitor (Pls. 91a, 91b).

In order better to understand the program of which the Frankish kings were a part, the remnants of these figures had to be examined with others of the same size, most of them also in the nave clerestory windows. Three iconographic series then emerged, one of which might, in the case of incomplete figures, be confused with the kings. The third, represented by only two fragmentary examples, comprised enthroned archbishops (or bishops or abbots) without names (Pls. 253, 254). The lower half of one is in a window of the nave, where it fits comfortably, but the upper half of the other is now in the tribune of the choir and its blue surround is not original; however, the scale and contour are very similar to those of several of the kings and it may be assumed it was made to fit the lower half of a lancet in the nave clerestory. As with the kings, it is quite possible that name bands were removed in cutting down the panels. The most likely original positions for these archbishops were in the clerestory windows on either side of the four nave bays

that comprised the liturgical choir, thus conforming with the program of the larger figures in the retrochoir. The Frankish kings would be accommodated in the lower half of the true nave windows, seven on each side, or nine if they extended into the larger openings of the western bay constructed under Peter of Celle (Fig. 2).

The other series comprises eleven unnamed seated figures, with halos and shoes, gesturing or holding scrolls like the prophets in the retrochoir; two have pointed caps of the type worn by Old Testament figures (Pls. 258, 261). The most distinctive feature of this group, as Grodecki has remarked, is that the blue ground above their shoulders originally curved in to form rounded arches that would fit under ornamental borders in the heads of the clerestory lights of the eleventh-century nave (Pls. 80, 255–58, 260).[169] Furthermore, photographs and drawings made prior to the rebuilding of the nave after the shelling during World War I clearly indicate that the lower part of these windows had been filled in by three courses of masonry, no doubt to increase the slope of the aisle roofs to improve drainage (Pl. 36); the restoration accounts indicate this may have been done in the eighteenth century.[170] Each original window opening would have accommodated two figures, a prophet or patriarch over an archbishop or king (Pls. 35, 80). In the course of the alterations to the sills, however, the glass had to be moved, and Povillon-Piérard saw figures only in the bays of the liturgical choir; apparently it was convenient to use some as stopgaps in the retrochoir, where they were recorded by Tourneur. This explains the curious appearances, and distorted iconography, of the figure now in the choir tribune that has an ancient inscription *S A[n]dreas*; its prerestoration appearance in Simon's atelier corresponds to Tourneur's description in that the stopgap head is turned the wrong way on the neck (Pl. 269).[171] The inscription evidently belonged to the apostle that this figure replaced in the turning bay of the choir, whereas the shod feet are appropriate to a king or patriarch. That the figure belongs with the nave series is confirmed by the fact that the same cartoon for the lower panel was used in slightly modified form for two of the kings; in "Andrew" the arms and hands are now adjusted to omit the scepter, of which Tourneur thought he saw a part, and the left hand holds a book instead of a fold of the mantle (Pl. 27).[172] This red and blue book provides the only iconographic anomaly, but the lead-

[166] Nilgen, 1985, p. 230. The figure is now in the Musée de l'Oeuvre.

[167] See Chapter 1, and Appendix 2. The three windows above had been heavily restored by Payen in 1720–1759 and the arrangement seen by Lacatte-Joltrois may not have been original.

[168] Reproduced to a fifth scale, the original fragment was about 49 centimeters high, or 20 percent larger than the mitered heads in the central lights of the retrochoir clerestory. The window measures approximately 4 by 2 meters.

[169] Grodecki, 1975, pp. 74–75; he, however, envisaged only one figure in each light, because the openings had been partially blocked.

[170] Exterior views of the south side of the nave by Rothier are in the atelier Marq; see also a photograph of the exposed interior of the north

wall after war damage: anon., *Ce qu'était Reims; ce qu'elle est devenue*, Reims, [ca. 1918], unnumbered plate, "L'Église Saint-Rémi après la guerre." For the restoration records, see Appendix 1, Reims MS H.409.1, f. 105v.

[171] Tourneur, 1862, pp. 94–95: "on a laissé le nom de saint André à un personnage chaussé, dont le visage regarde d'un côté, quand sa chevelure s'en va de l'autre. Il semble avoir trois mains, dont une, beaucoup plus petite que les autres, tient un commencement de sceptre. Au-adessus de lui, un roi, avec une tête moitié plus petite que sa couronne; une seule main, mais beaucoup plus grande qu'elle ne devrait l'être." The king below is also identifiable, now in the nave.

[172] The blue ground in the upper right segment might be thought to show part of the original configuration of the arched head of a nave

line passing across it horizontally indicates that the panel was at some time divided here—presumably when it was put in the choir—so the book might be an insertion, replacing a hand with a scroll or a loop of the mantle.

The significance of the juxtaposition of Old Testament figures with the Frankish kings will be considered later, but it may be noted that not only are the temporal rulers excluded from the sanctuary but they are also given the lower position in the window openings. In this they contrast with the thirteenth-century series in the nave clerestory of the cathedral, where Frankish kings were set above the archbishops of Reims (Pls. 80, 285). Tourneur has commented on their privileged position in the litany of the cathedral.[173]

The antecedents for the Saint-Remi cycle are harder to determine, but Nilgen has drawn attention to some early examples in other media.[174] One is the lost Carolingian cycle from the palace at Ingelheim, in the Aula Regia.[175] The early twelfth-century Kaiserchronik of Ekkehard von Aura from Urach has the marriage of Henry and Matilda, and seven ink drawings of enthroned monarchs.[176] More speculatively, Nilgen suggests that a shrine of Edward the Confessor, perhaps associated with the translation of 1163, had standing kings in ivory. The great Karlshrein of 1182–1215 has seated Carolingian kings along the sides, and several other examples of the late twelfth century are cited. Evidently it is of some interest whether the rémois cycle was among the earliest of a very significant group that revolved around the cult of regal saints in the latter part of the century, or whether it followed this fashion.

In Saint-Remi, a series of crowned ancestors of Christ, their names taken from the genealogies of both Luke and Matthew, may be regarded as precursors of the Frankish kings, regardless of whether they were planned in conjunction with them. Recorded since the early nineteenth century in the choir tribune, their original position is problematic.[177] They stand, turned in three-quarter view, holding scepters and gesturing, and they differ from all the seated series in having no halos (Col. Pl. 17; Pls. 246–48). Several name bands are more or less intact and reveal, in chronological order, Methuselah

(inscribed *Mat'.m*), Isaac (*Isa* barely legible, the rest restored), possibly Jacob (stopgaps and *ob*), Abiud (*Abiut*), and Eliakim (*Eliachim*). The Rothier photographs include another figure, which appears original except for the head, with an inscription *Ro . . .* , perhaps for Rehoboam; apparently this was lost in World War I, since the photograph in the Simon atelier is marked "manque." Povillon-Piérard mentions, in addition to Abiud and Eliachim, King Salathiel, Manasser, King Joram, and two unnamed kings.[178] Guilhermy's readings were very uncertain, but he too recorded Abiud and Eliachim, and perhaps as many as five other crowned kings.[179] All are ancestors of Christ, and the fact that among the securely identified figures Methuselah is only in Luke's list and Abiud only in Matthew's indicates, as Grodecki pointed out, that the series is based on both texts. In this it resembled the ones in Canterbury and Braine (Appendix 4).

The most distinctive feature of the series, however, as Grodecki also remarked, is the representation of the patriarchs Methuselah, Isaac, Jacob, Abiud, Eliakim, and perhaps also Salathiel, if we can credit the early records, in royal regalia.[180] As in the case of the Frankish kings, there may have been a Carolingian iconographic model. The Codex Aureus from Lorsch, probably produced in Aachen about 810, illustrates the Priscillian prologue to Matthew's gospel with a genealogy, showing three groups of thirteen standing figures holding aloft the portraits of their ancestors, Abraham, David, and Jechoniah (Pl. 252).[181] Whereas the last two have crowns, all the others wear diadems. In the emphasis on royal regalia the rémois series appears to be the direct antithesis of Canterbury's, in which kings Abijah, Rehoboam, Jechoniah, and Achim were deprived of their royal emblems. Each choice must be seen in light of local political conditions, which at Canterbury included the Becket conflict and reprisals by King John over the issue of archiepiscopal election; there had been only a brief interlude of cordial relations with Richard I in the last years of the twelfth century.[182] In Reims the general theme of adulation paid to kings once more bears an evident relation to the coronation rite; these pseudoroyal ancestors

light, in which case this would have been a patriarch. Close examination was not possible, and the figure is probably too patched with stopgaps to provide definitive evidence for one or the other identification.

[173] Tourneur, 1846, pp. 16–17, correcting an error in Tarbé, 1844, p. 270, who placed the kings below the archbishops and cited the *Laudes* of the Missal where prayers for the king are offered before those for the archbishop. This observation was confirmed in an early thirteenth-century Pontifical, Reims, B.M., MS 343 f. 12v.

[174] Nilgen, 1985, pp. 220, 224–30.

[175] W. Lammers, "Ein karolingische Bildprogramm in der Aula Regia von Ingelheim," in *Festschrift H. Heimpel* Göttingen, 1972, 3: 226–89.

[176] Cambridge, Corpus Christi College, MS 373: Schramm and Mütherich, 1981, p. 167.

[177] The dimensions of the figures are 1.60 meters high and 55 centimeters wide, whereas even the openings in the tribune of the nave are 2.05 by 1.28 meters, and the aisle windows are 2.50 by 1.40; however,

none of the surrounding masonry is original, so the eleventh-century openings could have been enlarged.

[178] Appendix 2, f. 54, where twelve subjects are listed in all, excluding Sts. Remigius and Nicholas and Andrew which were still in the clerestory. Manasseh could have been the genealogical figure from Matthew 1:10, the son of Hezekiah who ruled after him, or one of the archbishops of Reims.

[179] Guilhermy, MS 6106, f. 420; he suggested *Natan, Oseht, Ser . . .* , and *ior. . . .*

[180] Eliakim, son of Abiud in Matthew 1:13, is not the same as the son of King Josiah who ruled as Jehoiachim (2 Kings 23:34).

[181] "Genelogie Christi," *Monumenta Judaica* 1: 737, fig. 1. See also Wilhelm Köhler, *Die Karolingischen Miniaturen II: die Hofschule Karls des Grossen*, Berlin, 1958, pp. 88–100, fig. 104b; Robert M. Walker, "Illustrations to the Priscillian Prologues in the Gospel Manuscripts of the Carolingian Ada School," *Art Bulletin* 30 (1948): 9–10.

[182] Caviness, 1979, 42–51. See also Caviness, 1987.

of Christ appear as the most extreme statement of that theme, yet it might also be seen as honoring the patriarchs who are dignified by crowns. We shall see that this treatment was balanced by the great emphasis placed on the prophets as precursors of the archbishops in the retrochoir windows. The chronology of these statements and counterstatements cannot be established from political circumstances alone, but the abbacy of Odo is certainly one period in which a "royal" genealogical program could have been devised. On the other hand, the period after Peter of Celle's departure, during the ascendancy of Philip Augustus, cannot be ruled out.

THE ARCHBISHOPS
IN THE LITURGICAL CHOIR

The second major theme to be pursued is that of *sacerdotium*. Like the kings of France, the archbishops of Reims had a special relationship to the abbey, going back to Carolingian times. After the offices of archbishop and abbot were separated, in 945, some of the primates were consecrated in Saint-Remi, and all immediately confirmed the possessions of the abbey at the altar there and spent the night in the monastery, before being presented at the other houses by the Abbot: *Ecce pastor vester, successor Beati Remigii; ipsum vobis praesentamus.*[183] These connections with the abbey church were celebrated in a series of monumental enthroned figures of archbishops whose tenure spanned its history, set in the windows of the retrochoir.

As in the case of the Virgin, apostles, and prophets, in the upper parts of these clerestory lights, the archbishops below have been subjected to considerable losses and alterations, albeit without any evidence of the figures changing places (Appendix 3). The renaming of these archbishops of Reims was scarcely less drastic than that of the other series, probably because their lack of chronological order had been so severely criticized by the abbé Tourneur.[184] Of the eighteen inscriptions recorded by Reimbeau, only those of *Henricus* (Henri de France) and, in part, *S. Rigobertus* survive in the original; Reimbeau seems to have been correct in seeing S. Rigobertus in N.III b instead of "Sigobert" recorded by the draughtsman of the nineteenth-century drawing in the Musée des Arts Decoratifs (Appendix 3 and Pls. 145, 161, 162). In addition *S. Sinitius* and *Sansun*, corrected to read *Sansom*, were recorded by Reimbeau in the same positions in which they remain today (Pls. 128, 141). In the restoration that followed, a new figure of St. Remigius replaced the small one that had been positioned below the Virgin in the axis (Pl. 141), and to some extent the restorer established a chronology among the other figures. This followed from east to west, alternating north and south, from St. Sixtus and St. Sinicius in the

lateral lights of the axial bay to Samson (1140–1162) and Henri de France (1162–1175) in the last two lights flanking the transept on the south and north sides respectively. He also respected the original placement in the hemicycle of Sts. Reolus, Nicasius, Nivardus, and Amansius (inscribed *S. Amandus* in the Rothier photograph, but tentatively transcribed *Arna.s* by Reimbeau), yet changed their positions quite arbitrarily (Apendix 3; cf. Pls. 137, 139–41).

Judging by the seven names of archbishops recorded by Reimbeau in this part of the building, the first ten primates listed by Flodard in his *Historia Remensis Ecclesia* could have been included here—that is, down to St. Nicasius, with the addition of five later figures who had the distinction of canonization, Sts. Remigius, Romanus, Nivardus, Reolus, and Rigobertus. The early group, from the period before the foundation of Saint-Remi, clearly honored the precursors of the patron saint of the monastery as had become traditional; the remains of Sixtus and Sinicius had been interred in the abbey church by Archbishop Herveus early in the tenth century.[185] Of the saints, three had received burial on the site of Saint-Remi. This honored group was thus placed below the New Testament saints in a celestial hierarchy, at the feet of the Queen of Heaven. Less celebrated were the twelve archbishops recorded by Reimbeau in the straight bays, beneath the Old Testament prophets, but they too had special ties to the abbey; the group situated furthest to the east belonged to the period when the archbishops served as abbots of Saint-Remi (Engelbertus, Romulphus, Vulfarius, and Sonnatius), and several were buried in the abbey church (Romulphus, Sonnatius, Leudegesil, Mappinus, Manasses II).[186] Thus the program promoted the abbey as the *archimonasterium*. Overall, a selection of archbishops had to be made, since the thirteenth-century list given in a copy of Flodard includes forty-eight primates down to William of Champagne, whereas there was room for only thirty-three in the retrochoir; it follows that the decision to end the series with Henri de France was quite deliberate, and in the context it seems unlikely that he would have been so honored in his lifetime. The building dates in fact seem to indicate that the program could not have been planned until about the time of his death in 1175.

Some question still remains as to whether the figure below the Virgin in the axial window was indeed originally St. Remigius; and if so, whether it was designed at the same time as the other figures or whether the small image recorded there in the nineteenth century was in fact a "belle verrière," reused in the late twelfth-century building (Pl. 81). Certainly, the subject has been seen to fit the general scheme, which seems to have placed the canonized archbishops in the hemicycle, with the apostles. The small image, however, must have appeared

[183] Poussin, 1857, pp. 51, 54–55. He cites Hugues de Vermandois and Odalric as receiving consecration in Saint-Remi.

[184] Tourneur, 1862, p. 90: "sans ordre rigoureux ni chronologique, ni autre. . . ."

[185] Prache, 1978, p. 12, cites Flodard.

[186] Prache, 1978, p. 9. According to Poussin, 1857, p. 51, more than twenty archbishops in all were buried in Saint-Remi, but he does not name them.

quite incongruous, and any medieval reuse would surely not have filled the rest of the light with a fragment of St. Nicholas;[187] the dimensions show that there was room only for the top half of St. Nicholas, which no doubt explains why the original lower half is missing.[188] The curve above this saint's head in fact proves that it was made for one of the openings of the eleventh-century church, a scale to which both figures would be well suited (Pl. 82).[189] Their silhouettes are significantly slighter than those of the bishops made for the nave clerestory (Pls. 253, 254), and there are differences in the style of execution. They may well predate the rebuilding of the chevet, and the most logical position for the patron saint's image would have been directly behind his shrine, in the axis of the old choir. If this had been the case, the glass could have been saved by being set elsewhere during the demolition. More important, the image has to be seen as the prototype for the larger figures that filled the new choir; the similarities are clear (Pls. 81, 157–61). It is less probable that it was part of a program comprising exclusively rémois archbishops, since there was no St. Nicholas among them. The image of St. Nicholas may have been behind his altar in the chevet, consecretated in 1049 and renewed in 1181–1182.[190]

The iconography of the archbishops in the clerestory is worth examining. All the archbishops are nimbed, regardless of whether they had been canonized, just as are the patriarchs above. They are all seated, in Mass vestments with their croziers, and either blessing or holding a book. Some wear the prominent pectoral or rational that Hinkle has noticed in other contexts as an especial mark of the rémois primates, who wore it, however, only on solemn feast days (Col. Pl. 6; Pls. 147, 158, 159).[191] He refers to the similar rectangular plaque, studded with twelve gemstones, worn by Aaron on the sculpted console of the liturgical choir, and to its derivation from his breastplate as described in Exodus

28:15–30. Peter of Celle gave a lengthy explanation of it, referring to symbols of priestly virtue that it encompassed.[192] It is thus another element that serves to associate the archbishops with Old Testament precursors, this time with the Judaic priesthood.

The thrones on which the archbishops are seated are variously low benches with elaborate cushions (Col. Pls. 5, 7; Pls. 147, 148) or animal-headed foldstools (Col. Pl. 4; Pls. 114, 158, 159). The latter type resembles the throne of Dagobert from Saint-Denis, to which Suger had however added a back.[193] An example of the early thirteenth century from Admont, Steiermark, is preserved in Vienna.[194] The original form of *faldistorium* commonly appears on the seals of Capetian kings, including those of Philippe I (1082), Louis VI le Gros (1108), Louis VII (1175), Philippe Auguste (1180), Louis VIII (1224), and Louis IX (1240) (Pl. 115).[195] The type does not seem to have carried a uniquely "royal" connotation, however, and it is not used in the glass for Henri de France, even though his seal shows very prominent beast heads (Pls. 116, 145).[196] In fact the beast-headed foldstool used in conjunction with representations of churchmen appears to have been quite widespread by the late twelfth century, appearing on the seals of Maurice de Sully as bishop of Paris (1170), William of Champagne as archbishop of Sens (1176) (Pl. 117), Bishop Matthew of Troyes (1179), and of the Abbey of Prémontré (1203).[197] The seals of the abbots of Saint-Remi, Peter of Celle (1170) and Simon (1182–98), identical but for the inscription, displayed foldstools with long leafy finials (Pl. 119). The backless cushioned throne was also known on episcopal seals in northern France.[198] For earlier examples of either type, however, one has to look to Hohenstaufen lands: Henry I, archbishop of Mainz (1142), Rather von Malberg, abbot of Prüm (before 1155), Willibald, abbot of Hersfeld (1155), and Eberhard I, archbishop of Salzburg (1164) (Pl. 120).[199] To these examples can be added the archbishops

[187] The "Belle Verrière" of Chartres, for instance, is sensitively *mise en valeur* by the thirteenth-century surround; see Chantal Bouchon, Catherine Brisac, Claudine Lautier, and Yolanta Zalouska, "La 'Belle Verrière' de Chartres," *Revue de l'Art* 46 (1979): 19–22.

[188] The St. Remigious panels, which have been expanded at the top and bottom in some restoration, would exactly fill the intervals between the bars in the axial light; this is also true of the St. Nicholas panel (which exactly fits the bottom opening), though only the head and shoulders are old. The fragmentary inscription has been partly replaced in the most recent restoration; the authentic pieces give: *chola'*.

[189] The curvature is very close to that of the windows in the north transept chapel, as tested with the rubbing of the leadlines; that of the panels made for the nave clerestory is on a smaller radius.

[190] Prache 1978, p. 34.

[191] Hinkle, 1965, appendix C, where he discusses examples in the cathedral sculpture, and a few elsewhere.

[192] *De Tabernaculo Moysi*, ed. Leclercq, 1946, pp. 162–65.

[193] Now in the B.N.: Suger, 1979, pp. 72–73, fig. 22, Ch. Lenormant, "Notice sur le Fauteuil de Dagobert," in *Mélanges d'Archéologie, d'histoire et de Litteratures*, Paris, 1847, 1: 157–58, 175–78.

[194] *Zeit der Staufer*, 2: fig. 307, 1: 382, no. 514. A useful review article lists many examples, finding its use in the Middle Ages chiefly episcopal; see Alfred A. Schmid, "Faldistorium," in *Reallexikon zur deutschen Kunstgeschichte*, Munich, 1973, 6: cols. 1219–37.

[195] Those of Louis VI, Louis VII, and Philip Augustus are illustrated in Jacques Boussard, *Nouvelle Histoire de Paris de la fin du siège de 885–886 à la mort de Philippe Auguste*, Paris, 1976, title page and figs. 52, 53; the second seal of Philippe is reproduced (1209–1210, Douët d'Arcq, 1863, 1: no. 39), but it is very like the first (no. 38); the second seal of Louis VII is similar to the first (no. 36). For the others, see nos. 34, 35, 40, 41. I am grateful to Madame Annelise Rey and Monsieur Givert of the Archives Nationales for help in consulting the fichier and in supplying study photographs. Rezak imputes the use of the foldstool on Louis VII's seal to the throne of Dagobert: Brigitte Bedos Rezak, "Suger and the Symbolism of Royal Power: The Seal of Louis VII," in *Abbot Suger*, ed. Paula Gerson, New York, 1986, pp. 95–103.

[196] The seal attached to a charter of 1171, Archives de la Marne, dépôt annexe de Reims, H 401, liasse 11/1, is less well preserved but has the same configuration.

[197] Boussard, *Histoire de Paris*, pl. 66, for the first and Douët d'Arcq, 1863, 1: nos. 6782, 6386, 6912, and 8345.

[198] E.g., the seal of Bishop Didier of Thérouanne, 1189 (Douët d'Arcq, 1863, 1: no. 5939).

[199] *Zeit der Staufer*, 3: figs. 85, 86, 88, 89; the tradition continued to at least 1225 (figs. 91–93, 96, 98, 101).

of Trier and Cologne and the prince-bishops of Liège; the latter wear large rationales similar to those in Saint-Remi.[200] In the rémois context it is interesting to note that enthroned representations were not customary on archiepiscopal seals; Samson Mauvoisin (1145 and 1156), William of Champagne (1183), Aubrey de Humbert (1207), and William of Joinville (1220) are all represented standing.[201] The seals of the archbishops of Sens show a similar series of standing figures between 1067 and 1257, broken only by the seated image of William of Champagne (Pl. 117).[202] The same is true of the seals of the bishops of Soissons, on which only Nivelon de Chérisy is seated (1182).[203] For Noyon, Bishop Baudouin (1158) provides an early example of the seated type, whereas Etienne de Nemours (1188) is standing.[204] Despite this example, the general statement may be made that the enthroned image was current in France only in the last three decades of the twelfth century, a date that coincides with the glazing of Saint-Remi. The seal of the Abbey of Saint-Remi may have been consciously archaic in showing the patron saint enthroned on the foldstool as late as the 1240s to 1260s (Pl. 286).[205] Standing churchmen turned in three-quarter view had become the norm on the elliptical seals of the thirteenth century, including that of Abbot Milon of Saint-Remi (1206).[206]

The general composition of the clerestory windows may have invited the choice of a seated posture of the archbishops, yet it is still relevant to consider what associations these images had for the late twelfth-century viewer. We have seen that they were topical in relation to currently official episcopal images (the seals); the throne may be said to have served to identify the incumbent with his *cathedra*. They also, however, evoked an ancient pictorial tradition that was strongly associated with sanctity. As early as the Carolingian period, figures such as St. Jerome had appeared in manuscripts seated

on the beast-headed foldstool, and Christ and his evangelists occupied backless cushioned thrones (Pls. 15, 121).[207] When they appear in Anglo-Saxon manuscripts by the year 1000, these motifs are regarded as stemming from the continent.[208] Lenormant may have been correct in regarding this tradition as subsumed by the Ottonian Emperors as part of their programmatic claim to spiritual leadership.[209] The presentation page in a south German Commentary on Ezekiel by Gregory the Great maintains a hierarchical relationship between the canonized prelate, seated frontally on a cushioned throne in the upper zone, and the king (presumed to be Henry II) turning to receive the book and seated on a foldstool below (Pl. 122). Yet the frontal image of Otto III on a foldstool in his Gospels anticipates a remarkable resemblance to that of St. Mark in the Spier Golden Gospels of Henry III (Pl. 123).[210] Early in the eleventh century St. Willibrord had also been represented enthroned on the foldstool, between standing deacons;[211] he appears again under a baldachin in the early years of the twelfth century.[212] Bishop Ildefonsus and Abbot Godescalc are similarly represented in contemporary Cluniac manuscripts (Pl. 88).[213]

Closer in time and place to the Saint-Remi archbishops are the monumental full-page images of St. Augustine and St. Gregory from Marchiennes and Saint-Amand, the one on a foldstool, the other on a bench (Pls. 87, 124). In the Cartulary of Mont-Saint-Michel in Avranches, of about 1160, Bishop Manger's imposing frontal figure, on a cushioned throne, dominates the flanking figures of Duke Richard and another secular.[214] In a treatise on good and bad abbots from Heiligenkreuz, a distinction seems to be made between the secular ambition of the bad abbot (seated on a foldstool), and the spiritual strength of the good abbot (seated on a backless throne), yet these distinctions are not consis-

[200] Hillin of Trier (1152–1169), Reinald de Dassel of Cologne (1159–1167), and later examples; from Liège: Henri de Leez (1145–1164), Raoul de Zähringen (1167–1191), Hugues de Pierrepont (1200–1229), and Adolphe de la Marck (1313–1344): *Rhin-Meuse*, pp. 46–48, 52–53.

[201] Douët d'Arcq, 1863, 1: nos. 6341–44.

[202] Douët d'Arcq, 1867, 2: nos. 6381–92.

[203] Douët d'Arcq, 1867, 2: nos. 6869–75.

[204] Arthur de Marsy, "Sceaux des évêques de Noyon," *Société Archéologique, historique et scientifique de Noyon: Comptes rendus et memoires* 2 (1867): 321–30.

[205] A.N., Supplément St. 2153 (1241) and Archives de la Marne, Dépôt annexe de Reims, H 484 (1265). The only earlier seal of the abbey, dating from 1182–1198, is small and shaped like a spinning top, with a profile head (A.N., typescript list, vol. 14, R 469).

[206] Douët d'Arcq, 1863, 1: no. 339; in addition to those mentioned already is Anselm de Mauny, bishop of Laon (1220), Laon, Archives Départementales de l'Aisne, B 31/3.

[207] E.g., in the Christ of the Godescalc Gospel Lectionary, B.N., MS Nouv. acq. lat. 1203, f. 3r, St. Mark in the Gospels of Saint-Médard of Soissons, MS lat. 8850, f. 81v., and St. John in the Coronation Gospels, Vienna, Weltliche Schatzkammer, f. 178v (Florentine Mütherich and Joachim E. Gaehde, *Carolingian Painting*, New York, 1976, pls. 1, 6, 10; Dodwell, 1971, fig. 15).

[208] E.g., St. John on a foldstool, in an Evangeliary and Lectionary of ca. 1000 in Warsaw, Biblioteka Narodowa MS I.3311, f. 83v; see Tem-

ple, 1976, p. 107, fig. 281; also King David on a foldstool in the psalter of the mid-eleventh century, London, B.L., Cotton MS Tiberius C. VI, f. 17v (ibid., fig. 306) and many examples of Evangelists on cushioned thrones (figs. 283–84, 277–80).

[209] Lenormant, "Fauteuil de Dagobert," pp. 184–90.

[210] For Bamberg, Staatliche Bibliothek, Bibl. 84, see Schramm and Mütherich, 1981, p. 161; for Otto III: Munich, Bayerische Staatsbibliothek, MS Clm. 4453, f. 24r; see Dodwell, 1971, fig. 50. The St. Mark was copied in the 1050s in the Goslar Evangeliary in Upsala, as shown by Albert Boeckler, "Die romanischen Fenster des Augsburger Domes und die stilwendt vom 11. zum 12. Jahrhundert," *Zeitschrift des deutschen Vereins für Kunstwissnschaft* 10 (1943): fig. 2.

[211] Gradual from Echternach, B.N., MS lat. 10510, f. 20v; Georg Kiesel, "Die liturgischen Festtage des hl. Willibrord bis zum Ausgang des achtzehnten Jahrhunderts," in *Festschrift für Alois Thomas: Archäologische, kirchen- und kunsthistorische Beiträge*, Trier, 1967, fig. 46.

[212] Gotha, Membr. I.70, from Echternach: Boeckler, "Die romanischen Fenster," fig. 3.

[213] Another example is B.N., MS lat. 2833. f. 1v, from Saint-Martial of Limoges; see Meyer Schapiro, *The Parma Ildefonsus: A Romanesque Illuminated Manuscript from Cluny and Related Works*, New York, 1964, pp. 75–76, fig. 86; cf. also fig. 90. The recension illustrated here is from Cluny itself.

[214] Avranches, B.M., MS 210, f. 19v; the political implications are recognized in Caviness, 1983, p. 113, fig. 33.

tently drawn elsewhere (Pl. 126); meanwhile, the fold-stool as an attribute of sacred majesty was still quite current, being used for instance for the Virgin and Child of about 1130–1140 in an English manuscript of St. Augustine's Commentary on the Psalms.[215] Finally, it is significant in the climate of the second half of the century to find St. John "the Apostle and Evangelist" vested as a bishop and enthroned on a foldstool to receive the obeisance of the Venerable Bede in the frontispiece to his Commentary on the Apocalypse from Ramsey Abbey (Pl. 125).[216] Here and at Saint-Remi episcopal images are aggrandized; the throne type revived on their seals was doubly associated with Frankish and Imperial rulers, both through the throne of Dagobert and through Carolingian, Ottonian, and Romanesque pictorial traditions; it was also associated with sacred imagery, particularly that of their holy predecessors. Thus, in two comparatively public art forms of the second half of the twelfth century—the seals and the stained glass—the ancient sanctity of churchmen was invoked. To an audience of the turn of the century the figures in the choir clerestory would have a slightly archaic air, emphasizing the weight of tradition, and indeed recalling the seated effigies of the kings in the choir below.[217] They would seem to belong definitively to the court of heaven rather than to the episcopal curia, and they would function as antitypes of the prophets and apostles.[218]

THE PRECURSORS

The Old Testament patriarchs and prophets who complement the apostles in the upper range of the choir clerestory have been as much restored and renamed as the other two series there, but it can be assumed that they once filled the eighteen lights of the three straight bays. This would have given room for the four major and the twelve minor prophets, supplemented (like the apostles in the turning bays) by two additional figures, but the selection was evidently not so straightforward. The accounts prior to the nineteenth-century restoration record fifteen names (Appendix 3; Fig. 5; Pls. 127-34).[219] These include Isaiah, Daniel, and Jeremiah among the major prophets (Ezekiel was lacking), but only six of the

minor prophets (Hosea, Jonah, Malachi, Habakkuk, Micah, and Zechariah). They appear randomly arranged, although the sequence and visual coherence of the designs does not allow the possibility that the order of the figures had been changed prior to these records, and they are supplemented by six figures who seem arbitrarily chosen. Among these, Balaam, Nathan, and David were recognized in the twelfth century as prophets of the coming of Christ;[220] in modern terms, Elijah and Samuel are said to be precanonical prophets, and Abraham "scarcely" so, but all of the figures share the most important attribute of prophecy, in having received direct communication from the Almighty.[221]

One function of this series is christological, and in this aspect they anticipate the Christ Incarnate of the axial window, and recall Moses with the New Law in the choir mosaic. While most of these prophets were interpreted as foretelling the coming of Christ, some were also types of Christ (notably Elijah, Daniel, Jonah, Samuel, and David);[222] Malachi's prophecy of the return of Elijah was thus interpreted as foretelling the coming of Christ.[223] Abraham, accompanied by his son Isaac, also frequently figured among the precursors.[224] There is some overlapping with the predominantly typological figures sculpted on the consoles of the liturgical choir that were reviewed in the first section: Jeremiah, David, Daniel, Habbakuk, Elijah, and perhaps Abraham and Isaac were among them (Pls. 33, 34). Yet, unlike those, the christological aspects of the figures in the glass are not emphasized visually; they do not turn or gesture predominantly toward the figure of Christ in the east as did the ancestors at Canterbury, nor do they hold open scrolls to carry, or to suggest, their prophetic messages (cf. Pls. 2, 3, 6). None have any narrative involvement, secondary figures, or attributes, such as Abraham looking up at the angel, Elijah ascending to heaven, David playing his harp, or Jonah treading on the whale (Pls. 1, 2, 3).[225] Instead, the representations are remarkably unvaried in their calm mood and gravity; tightly furled scrolls suggest a command of ancient scripture, counterparts of the gospel or Mass books held by the archbishops, and gestures indicate speech, *predicans*, whether prophesying or preaching (e.g., Pl. 177).

[215] Oxford, Bodleian Library, Bodl. MS 269, f. iii; Kauffmann, 1975, p. 86, fig. 135.

[216] Jonathan Alexander and Michael Kauffmann, in *English Romanesque Art 1066–1200*, Hayward Gallery exhibition catalogue, London, 1984, p. 122, no. 66, comment on the stylistic affinity with German metalwork of about 1170.

[217] Somewhat later are the statues of standing bishops on the choir piers of the Cathedral of Troyes, but the changed posture is crucial; see Pastan, 1986, pp. 27–28.

[218] The entry for Henri de France in the Musée du Louvre, *L'Europe gothique XIIᵉ–XIVᵉ siècles*, catalogue d'exposition, Paris, 1968, p. 113, refers to the youthful archbishops in their sumptuous vestments as "les élus de la cour céleste."

[219] None were visible in the third bay on the south side; see Appendix 3.

[220] All appear for instance in the Canterbury glass, David and Balaam in the typological cycle, and Nathan in the genealogy of Christ,

where he represents both the son of David, as listed by Luke, and the prophet of I Kings 1:11–45 who kept the scepter of kingship from Adonijah and reminded David to settle the inheritance on Solomon; Caviness, 1981, pp. 85, 90–91, 42.

[221] James Hastings, ed., *Dictionary of the Bible*, rev. ed. F. C. Grant and H. H. Rowley, New York, 1963, pp. 801–3.

[222] For instance, in the Canterbury typological windows, the presentation of Samuel, Daniel judging the elders, Jonah cast up by the whale, and the ascent of Elijah were represented as types of the presentation of Christ, Christ among the doctors, the Resurrection, and Ascension; see Caviness, 1981, pp. 97, 103, 155, 170. For David, see for example the sermon of Hugh of St. Victor, *P.L.* 177 col. 1077–78.

[223] Mal. 4:5–6.

[224] As on the central north transept portal of Chartres, for instance.

[225] There is an evident contrast with the David in the floor mosaic. A later window in the nave of Chartres depicts the sacrifice of Isaac, but it is not part of a cycle.

More central to their message is the potency of the prophets vis-à-vis the kings of Israel and Judea; it is surely significant that they, rather than Old Testament priests even such as Aaron and Melchizedek, were chosen to be paired with the archbishops, in that they had an exalted status that allowed them to nominate, criticize, and influence kings: Samuel deposited the book of the rights of kingship in the sanctuary, and chose and annointed Saul and his successor, David;[226] Isaiah and Micah urged reform on Hezekiah;[227] Jeremiah and Habakkuk inveighed against Jehoiakim's backsliding;[228] Hosea denounced kings, Elijah condemned Ahab, and Nathan saved the scepter from the corrupt usurper Adonijah.[229] It might be surmised that John of Salisbury's presence in the abbey in the 1160s influenced the program; he wrote his *Policraticus* at that time, one of the most outspoken tracts against kings that was generated by the Becket conflict; like Samuel he regarded the rule of kings as a punishment.[230] Furthermore, the altar of St. Nicholas was jointly dedicated to Thomas Becket in the new chevet in 1181–1182.[231] The Old Testament prophets were spiritually superior to kings, and like twelfth-century priests, they annointed kings and each other.[232]

Another topical link is suggested by the association of Balaam with Henri de France in the first light of the north side (Pl. 127). Balaam had been sent by King Balak to curse the Israelites and prevent their victory in Moab, but an angel stood in his path and commanded him instead to praise Israel (Num. 24:17). His conversion might have been seen in Reims as a type of Henri de France, who employed secular forces, including some sent by his brother, Louis VII, to subdue the citizens of Reims; he was dissuaded from this policy by John of Salisbury, when he was at Saint-Remi, and by the pope, so

that by 1172 peace was restored.[233] Similarly perhaps, Samson, archbishop in the time of Odo, is paired with Zechariah in the facing light; the latter spurred Zerubabel and Joshua to build the Temple in Jerusalem, a model that is relevant to the refurbishing of the choir.[234]

Furthermore, in the context of the Crusades, and of increasing concern with heresy at home, the vehemence of several of the prophets in preaching against heathen practices is to be noted. In Reims, Archbishop Samson had imprisoned the Albigensian Eudes de Stella in 1148, and his followers were burned.[235] Several other cases were prosecuted in Champagne around the turn of the century.[236] So in the Old Testament, Elijah combated the cult of Baal;[237] Daniel attacked the idolatry of Belshazzar;[238] Isaiah opposed Ahaz's adoption of Assyrian cults;[239] Jeremiah preached a return to Mosaic practices;[240] Habakkuk saw the invasion of the Chaldeans as a punishment for neglecting God's ways, and his doctrine of faith was applied by Paul to Christ[241] and Jonah's causing the Ninevites to repent was recalled in the Gospels.[242] The prophets appear now as great reforming preachers, more like forerunners of St. Bernard and St. Norbert than of the twelfth-century archbishops of Reims.[243] Yet to their contemporary audience the figures in the glass must have recalled earlier periods of turmoil, as when Nicasius was martyred at the hands of invading heathen, like Isaiah in legend.[244] They would soon also bring to mind the murder of Bishop Albert of Liège, carried out by the emperor's men in Reims in 1192.[245] The visual images were powerful enough to create their own myth of succession and antitype: The archbishops of Reims had inherited the role of the prophets in annointing and counseling kings, and even David was among their precursors.[246]

[226] Isa. 10:17–27 and 16:1–13.

[227] Isa. 1 and 31, and Jer. 26:18.

[228] Jer. 7:17–19, 11:9–13, and Hab. 1:4.

[229] Hos. 1:1–2, 3:4, 1 Reg. 17:1, 3 Reg. 17.

[230] 3 Reg. 8 and 12; cf. John of Salisbury's claim that kings were given in the anger of God, quoted by John Dickinson, "The Medieval Conception of Kingship as Developed in the *Policraticus* of John of Salisbury," *Speculum* 1 (1926): 310–11.

[231] Prache, 1978, p. 34.

[232] Isa. 61:1 claimed Yahweh had annointed him; in 1 Kings 19:16, Elijah was instructed to anoint Elisha as his successor; in Zech. 6:9–15, Zechariah crowned the *priest* Joshua.

[233] Georges Boussinesq and Gustave Laurent, *Histoire de Reims depuis les origines jusqu'au nos jours*, Paris, 1933, 1: 262–64; Pierre Desportes, *Reims et les rémois aux XIIIᵉ et XIVᵉ siècles*, Paris, 1979, pp. 80–85.

[234] Zech. 6:9–15.

[235] Carl Schmidt, *Histoire et Doctrine de la Secte des Cathares ou Albigeois*, Paris, 1849, pp. 49–50.

[236] Ibid., pp. 363–65.

[237] 1 Reg. 18:18.

[238] Dan. 5:17–23.

[239] 1 Reg. 16:10.

[240] 2 Reg. 23:4–25.

[241] Hab. 2:4, cf. Rom. 1:17 and Gal. 3:11.

[242] Jon. 3:5–9; cf. Matt. 12:41 and 16:4; Luke 11:29–30, 32.

[243] Given the arbitrary choice of the prophets in the series, it may be foolhardy to speculate which the three missing names may have been.

However, Ezekiel, the priest and prophet who denounced idolatry, foretold the coming of a new shepherd of the line of David, and had visions of the heavenly Jerusalem, was surely not omitted. Among the minor prophets whose names are absent, Zephaniah, Haggai, and Joel share most characteristics with the rest of the group, though only Zephaniah might be described as the adversary of kings; Zephaniah and Joel preached judgment; Haggai urged the construction of the Temple. Of the other four, Amos was cursed by the priest Amaziah; Nahum was concerned principally with judgment on the Assyrians and Obadiah with the Edomites; Joshua was more of a military than a spiritual leader. Among patriarchs, Moses is an extremely likely candidate for inclusion, since his christological prophecies were recognized from the earliest time: Mâle, 1953, pp. 141–42, cites a sermon attributed to Augustine.

[244] The martyrdom of Nicasius outside his cathedral at Reims was depicted in an early thirteenth-century Soissons window of his life: Caviness, Pastan, and Beaven, 1984, pp. 10–11, fig. 3; for Isaiah see "The Lives of the Prophets," under Pseudepigrapha 12 in Hastings, *Dictionary of the Bible*, p. 823, cf. Heb. 11:37.

[245] Albert, a brother of Henry, duke of Brabant, was elected against the emperor's wishes to the bishopric of Liège in 1192; his consecration was ordered by the pope, and took place in Reims in September; a month later he was murdered in Reims; see *The Cambridge Medieval History*, vol. 5; *Contest of Empire and Papacy*, ed. J. R. Tanner et al., Cambridge, 1926, p. 466.

[246] John of Salisbury, in a letter to Gilbert Foliot in defense of Becket, recalled that David had taken a stone from his shepherd's bag,

The Cumulative Impact of the Imagery

The complex and interwoven themes of the "decorations" of Saint-Remi have been presented here under distinct headings for the sake of clarity. This has the advantage of avoiding too zealous an attempt to establish the temporal and spatial parameters of each component. Yet a rapid review of the building as it stood about 1200 would include as a nuclear cluster in the old choir the reliquaries, altars, royal and episcopal tombs, candelabrum, and floor mosaic. Absorbed into the vertically and horizontally expanded spaces of Peter of Celle's retrochoir, these were complemented, modified, or accented by the sculpted consoles of the liturgical choir and by new light sources, the candlewheel and the windows. They gave the liturgical choir and tribune chapels emphases that are largely celestial and ecclesiastical, and introduced Marianic themes. The old nave, last to be remodeled in these Gothic campaigns, was less sumptuously decorated, and new images of Frankish kings were relegated to this space, accompanied by Old Testament precursors. The west facade, outside and in, prefaced and concluded the programmatic treatment of the Church of Rome, the Church of Reims, and the Monarchy of Francia. Overall, as befits a monastic church, the choir was given the most lavish treatment, the nave less, while the exterior is as perfunctory as a title page.

Although fine chronological distinctions have generally been avoided, I have suggested that many elements can be related to the debates over the nature and function of art in the period, especially as they were articulated by the orders. The clarity of disposition of subjects in the windows contrasts with the extravagant richness of imagery in the mosaic pavement, laid out in the previous generation, and this may have been arrived at as a result of these debates; every element appears rationally justified. Yet at the same time, the program of the windows and their translucent medium transform the Gothic church into a visionary structure, an analogue of the heavenly Jerusalem. Here Peter of Celle's vivid observation of the first program, his lucid verbal explorations of scripture, and his visual imagination can be perceived to play a crucial role. The clarity of the conception has little of the obvious; at times it offers revelations, such as the concealed or revealed Corpus of Christ, that can scarcely be anticipated by the viewer, even though their effects were surely planned. The pedantry of typology is largely shed, just as the pedantry of logic was concealed by the generation that succeeded Abelard.[247]

Within the spiritual framework, another debate has been recognized, one that has political innuendos. On the one hand, the majestic images of rémois archbishops in the choir, associated with the prophets who were the spiritual advisors to Old Testament kings, seem to reflect some of the criticism of kingship that was current in the wake of the investiture conflict and the martyrdom of Becket. Not only are the Frankish kings confined to the nave, but they are predominantly represented in restless postures, sometimes even sprawled on their thrones, lacking the air of spiritual perfection that is maintained by the primates (Pls. 254, 263, 265, 270; cf. Pls. 145, 152). In this, they contrast also with the effigies in the choir (Pl. 272). Regardless of chronology, the difference of mode is essential to the "reading" of the image, as with the contrasted figures of good and bad abbots (Pl. 126).[248] On the other hand, a series of crowned ancestors of Christ places an unexpected emphasis on sacred kingship, and it may be wondered whether it represents a change of attitude or even royal patronage; wherever they were originally placed, this procession was far more insistent than a single Tree of Jesse window such as those that had been incorporated into Saint-Denis, Chartres, York, and Canterbury.[249] Even here, however, the distinction of mode prevails; despite their dignity, the three-quarter-view turn of the figures prevents their becoming icons (Pls. 247, 248, 251). Yet it is as a devotional image that the early figure of St. Remigius is best understood, one that served as a powerful prototype (Pl. 61). In a final analysis, the registers of single, autonomous figures in the upper windows of Saint-Remi represented classes of people, participants in the Judeo-Christian tradition under the law and under grace, in varying degrees of spiritual perfection. Neither actors nor portraits, they have some of the anonymity of signifiers.

Because of its static, repetitive, and even decorative qualities, it is easy to underestimate the impact of this kind of imagery about 1200. The newly refurbished Abbey Church of Saint-Remi impressed the traveler with its sheer mass, rising higher than the cathedral. The sculpted figures of the saintly founders of the Church of Rome and the Church of Reims presided over the entryway, declaring ecclesiastical jurisdiction; more specifically, the small relief below, showing secular combat—perhaps judicial—might recall the words inscribed on the portal of a distant church: "Leave all fighting, this is a place of peace," a reminder that Henri de France had given full reign to the archbishop's court in the city where he ruled as a prince (Pl. 90a).[250] When one entered the church, the first impression was of a vast tunnel, with a brilliant hemisphere beyond, seeming to offer a glimpse of the Celestial City. As one stepped from an

(i.e., that of a prelate or pastor) to kill Goliath, and so must bishops defeat the evil intent of wicked rulers (quoted by Beryl Smalley, *The Becket Conflict and the Schools: A Study of Intellectuals in Politics in the Twelfth Century*, Totowa, N.J., 1973, pp. 34–35).

[247] I owe this formulation to my colleague, Stephen Marrone, during discussion of a paper on Peter of Celle that I gave at Kalamazoo in 1985.

[248] The theme is dealt with more fully in Caviness, 1983.

[249] Royal patronage has been adumbrated for these, though the case cannot be proved: Caviness, 1986, p. 267.

[250] On the zodiac portal of Sagra di San Michele, quoted by Bornstein, 1982, p. 149.

outer world of earth colors and vegetable dyes, the bright hues of the windows must have dazzled the eyes. A slowly moving procession of ancient kings could be deciphered through the nave arcades, as if they accompanied the progress toward the altar; above them tiers of ancient men of god and of kings of the Franks were enthroned, some enlightened, many only striving for the decorum of the wise.

Reaching the enclosure of the monks' choir, a pavement stretched forward to the crossing, like a field in bloom, its symbols of the world, encompassing the earth and the heavens, mingled with sacred images that one might be hesitant to tread underfoot. This sanctuary is sheltered and lit by a great candlewheel, as gleaming as the one the emperor has given to the shrine of Charles the Great in Aachen. The novices who spend their days in prayer here must feel as though they hover between the carnal and the spiritual realms; they are urged on by figures that struggle to free themselves, with the help of their reading, from the heathen foliage of the great candlestick that is placed to the north of the altar to ward off darkness. Not far from it a place is found for the statues of enthroned kings, some of the ancients who are buried here, but their effigies are outdone by a vaster tomb commemorating an archbishop and celebrating the ascendancy of the Church of Reims; a king has to

approach humbly to receive a crown from so many prelates.

Beyond the altar and these furnishings another world is rendered in stone and glass. Here too Ecclesia presides, holding court with the apostles and their successors, down to our own times. However fragile the material, it is not shattered by the rays of the physical sun, so these images shed their brilliance on the interior. Here the spiritual life is brought to perfection, and the men of flesh and blood who have been active in the life of the Church from the beginning of time blend with the embodiment of Wisdom; they are, indeed, a golden priesthood.[251] And half hidden in the heart of the church is the mystery of the Eucharist; dissolved in light, it is hard to tell whether Christ is stretched on the cross, or whether a column takes on his form against the beams of the rising sun. His body is not to be gazed on by idle visitors.

The full impact of this imagery was turned in on the monks' choir, and its spiritual intensity was such that it could scarcely be replicated outside that context. Yet its sumptuous quality must have challenged other foundations to compete, especially the new Premonstratensian houses and the cathedrals. Saint-Remi, as much as Saint-Denis, may be claimed as a precursor of the great monumental "decorative" programs that burgeoned around 1200. One of these was at Braine.

[251] In 1076, during the investiture conflict, Pope Gregory VII (citing St. Ambrose) said of Emperor Henry IV and his counselors: "If you compare the episcopal dignity with the splendor of kings and the crowns of princes, these are far more inferior to it than the metal lead is to splendorous gold." Quoted by George Huntston Williams, "The Golden Priesthood and the Leaden State: A Note on the Influence of a Work Sometimes Ascribed to St. Ambrose: The Sermo de Dignitate Sacerdotali," *Harvard Theological Review* 50 (1957): 37.

CHAPTER III

Saint-Yved of Braine: *"Amplissima Ecclesia"*

Agnes . . . enim, ut proavorum tutelari patrono, suoque benefactori monumentum honoris et gratitudinis daret honorificum, amplissimam Ecclesiam, artis, ornatûs elegantiâ vix ulli secundam extruxit, et vitris ex Anglia adductis, mirabili penicillo colorumque inassequibili temperamento, et varietate stupendis, fenestras clausit.

anon. Chronicle, ed. Charles-Louis Hugo[1]

THE GOTHIC CHURCH of Saint-Yved is due to one campaign of construction and there are fewer documents concerning its maintenance than for Saint-Remi, so its history can be rapidly reviewed. The Revolution, however, had far more disastrous effects on Saint-Yved than on the rémois abbey, including the dismemberment of the sculpted portal, and the complete elimination of the glass and tombs from the site. Only a small percentage of original glass from Braine has as yet been traced in collections (Catalogue A).[2]

This chapter is concerned with the history of the church and with the pre-Revolutionary records of its treasury and relics, library holdings, tombs, and decoration; the reconstruction of its sculptural and glazing programs is placed in this context. As well as figures from the clerestory windows that clearly relate to those in Saint-Remi and in Christ Church Canterbury, there are important remains of the rose windows, which occupy a seminal position in Gothic programs, and these will be given full consideration. The stylistic parameters of the Braine glass are established here as part of the argument for the provenance of the scattered panels; stylistic relations with the glass of other monuments, and to works in other media, will be treated in the following chapter where comparative chronology is considered.

Legends and Histories of Medieval Braine

RELICS, PATRON SAINTS, AND PATRONS

With the exception of a thirteenth-century cartulary, and a few medieval copies of charters, primary documents for Braine are almost nonexistent.[3] Material from chronicles is used by later authors, notably Mathieu

[1] Hugo, 1734, col. 395: "For Agnes, in order to give to the protecting patron [saint] of her ancestors and to her own benefactor a monument of honor and a mark of her own gratitude, constructed a lavish church, scarcely second to any in the elegance of its art and decoration; and she filled the windows with stained glass brought from England that was amazing in its wonderful brushwork and in the unparalleled harmony and variety of its colors." I am grateful to Peter Reid for advice on the translation.

[2] A preliminary inventory was published in Caviness, 1985, pp. 38–40 and 46, n. 40. The figure of "David" in Forest Lawn Cemetery has been discovered since then.

[3] These are reviewed in Caviness, 1984, pp. 525–26, 534–35. Archival sources listed by Backmund, 1952, p. 485, were searched.

Herbelin in the sixteenth century, and Hugo, Lepaige, and the *Gallia Christiana* in the eighteenth, but none of these texts have the flavor of veracity in the modern sense; they read like legends, interweaving factual accounts with miracles. Fortunately, their credibility is of little concern here, since the essential issue is to understand the view of history that was held by the canons and their noble patrons in the twelfth and thirteenth centuries, and this they can help us do.

According to this view, the site that was given to Premonstratensian canons in Braine in the twelfth century was an ancient and hallowed one. A Merovingian *castrum* had been used as a strongroom to house the treasure of Clothair, alias Lothar I, king of Neustria in the sixth century, and the king also held episcopal councils there.[4] The *palatium Brennacum* continued in use by Chilperic, who seized its treasure, and by Dagobert. In fact the castle of Braine, positioned near a bend in the River Vesle about seventeen and a half kilometers (eleven miles) upstream from Soissons and controlling access to the city along the Roman road from Laon and Reims, was a logical site for a stronghold that could be used to defend or attack Soissons, the capital of Neustria during this disturbed early period (Fig. 1; Pl. 47). By the late eighth or early ninth century it had become a property of the Cathedral of Rouen, and it received the relics of St. Evodius (vernacular Yved), bishop "evangelist" of Rouen in the time of Clothair, when they were saved from the Norman by St. Ouen.[5] The feast of this translation was kept on July 8.[6] There is no indication whether the relics were

translated to the Gothic church on its completion; this may have been delayed until 1244 when they were placed in a new silver shrine (*capsula*). The inscription on that shrine, recorded by Martène and Durand in the eighteenth century, indicates the extent of local awareness of the Merovingian past in its mention of the Gallic kingdoms under Clothair.[7] There were also two relics, at least as recorded later, of St. Clotild, Clovis's queen, who had converted him to Christianity.[8] It will be recalled that this couple was represented in the west windows of Saint-Remi, as founders of the Christian Merovingian dynasty.[9]

According to Flodard, Braine was seized twice from Rouen Cathedral by local lords in the tenth century, and he refers only in passing to the church there.[10] By the early twelfth century its disturbed but illustrious early period had gone by, leaving a small and allegedly corrupt college of canons in the castle precinct. The lord of the castle was André de Baudemont, a seneschal of Thibaud II, count of Champagne.[11] He and his wife Agnes, apparently deeply affected like many of the nobility of their time by the new reform orders, invited Premonstratensians to take over the college in 1130, and the house began to thrive; its possessions were confirmed by Bishop Goslen of Soissons in 1137.[12] In the early 1140s the cartulary indicates a number of gifts deeded to the house by André and his wife, and by Louis VII and others. Agnes de Baudemont retired to the Premonstratensian nunnery of Frontenille where she died in 1149; her patronage of the order was celebrated in a *Vita Beati Ag-*

[4] This and the following information is based on Prioux, 1846, pp. 36–63.

[5] Prioux, 1846, pp. 72–74.

[6] Deuchler, 1967, p. 12, notes the local nature of this feast, which is in the calendar of the Ingeborg Psalter and in later books with the use of Soissons (Le Mans, B.M., MS 157) and Sens (Autun, B.M., MS 160); he cites Leroquais, 1940–1941, 1: 240–41, and 56–57. There is no entry for this little-known local saint in the *Lexikon der christlichen Ikonographie: Ikonographie der Heiligen*, 4 vols., ed. Wolfgang Braunfels, Freiburg-im-Breisgau, 1973–1976. The life in the *Acta Sanctorum*, Brussels, 1780, 51: 241–48, is under October 4, the older feast; it is from a rouenais manuscript, but the July translation is also mentioned (p. 248).

[7] Martène and Durand, 1724, p. 32:

> Praesule Rothomagus, sed et hospite Brana beato
> Gaudeat Evodio, capsa praesente locato
> Quem Florentinus Celinaque (regna regente
> Gallica Clotario) Domino genuere favente.
> Hoc vas fecisti gemmis auroqúe decorum,
> Abbas Gerarde, tibi pax coetu superorum
> Anno milleno ducenteno quoque quarto
> Cum guadrageno Domini pariter sociato.

A less good reading, with the line "Abbas Gerarde . . ." missing, is given in Hugo, 1734, col. 398; the same is in *Gallia Christiana*, col. 491. I am grateful to Peter Reid for a translation: "Let Rouen rejoice in its [arch]bishop and Braine in its patron [saint], Blessed Evodius, now placed in this present shrine, whom Florentinus and Cellina bore, with the Lord's favor, at the time when Lothar was ruling the Gallic kingdoms. You have made this vessel, Abbot Gerard, ornate with gems and gold: Peace be to you, together with the heavenly choir in the 1244th year of our Lord." The prose life of St. Yved in the *Acta Sanc-*

torum mentions the reign of Lothar, names Yved's parents, and refers to the fact that his birth was granted by God's favor. The address to Abbot Gerard as if dead is problematic; according to *Gallia Christiana*, col. 491, he witnessed an agreement in 1253; on the other hand Hugo, 1734, col. 398, credits him as thirteenth abbot with the arrangements for the translation, and says his successor, Humbertus, flourished in 1250. Perhaps he died just before the translation; Norbert Backmund, *Monasticon Praemonstratense*, Straubing, 1952, 2: 484, follows Sars and Broche, 1933, in giving his terminal date as 1244–1255. None of the charters in the *Cartulary* help to solve this problem.

[8] Hugo, 1734, cols. 403, 404. According to Gregory of Tours, 1974, p. 197, she died in 544 and was buried in Sainte-Geneviève, Paris.

[9] See the discussion in Chapter 2.

[10] Cited by *Gallia Christiana*, col. 488–89; Philippe Lauer, ed., *Les Annales de Flodoard*, Paris, 1905, pp. 49, 128.

[11] Du Chesne, 1631, pp. 13–18, who compiled his genealogy from original documents. Despite the clarity of his findings, there has been much subsequent confusion as to whether the second Agnes was daughter or granddaughter of the first. Bur, 1977, p. 237, n. 23, and p. 251, confirms Du Chesne. The first Agnes married André de Baudement (a seneschal of Thibaut II of Champagne), who witnessed a charter of Saint-Martin-des-Champs in 1108–1109 (Joseph Depoin, *Recueil de Chartes et documents de Saint-Martin-des-Champs monastère parisien*, Paris, 1912, 1: 204, no. 128). She died in 1149 in the Premonstratensian nunnery of Fontenille (*Gallia Christiana*, col. 488). Her granddaughter was sole heiress of Guy de Baudement and Alix; she first married Milon, count of Bar-sur-Seine, then Robert of Dreux.

[12] The date is that given in Hugo, 1734, col. 393, and *Cartulary*, MS 1583, pp. 47–48, no. 16. Backmund, 1952, p. 486, and the *Dictionnaire d'Histoire et de géographie ecclésiastique*, Paris, 1938, 10: col. 376, give 1130 as the date when André de Baudement invited Premonstratensians to take over the house.

netis that was printed next to that of the founder, St. Norbert, by Lepaige.[13] Their granddaughter and sole heiress, Agnes of Braine, was also remembered in the *Vita*, and in the necrology of the abbey.[14] She endowed her grandparents' foundation liberally, at the same time making provision for Masses for her soul and those of her first husband and their children.[15]

Mathieu Herbelin tried to trace Agnes of Braine's lineage to the counts of Champagne.[16] Perhaps this was to aggrandize her descendants, but he may also have puzzled why, as a mere local heiress, she would be able to take the king's brother, Robert of Dreux, as her second husband in 1152.[17] It must be significant that, as indicated previously, the charters record Louis VII's interest in the collegiate foundation at Braine nearly ten years before.[18] True, he made many such gifts to the new orders during the decade of his alliance with Eleanor of Aquitaine, but in this case his interest may have been motivated by two factors: One would be the Merovingian associations, including the presence of relics of St. Clotild; the other would be the desirability of controlling a defensible site on the approach to Paris.[19] Robert's other seat, at Dreux, was a comparable distance from the capital to the west and has been described as an outpost of the Capetian domain (Fig. 1).[20] In fact its history is remarkably parallel to that of Braine. A collegiate church of Saint-Etienne was in the castle precinct, and it boasted a charter from the Carolingian king, Lothar (954–986), though this document is probably a medieval forgery; the church was patronized by Louis VI as early as the 1120s; in 1131 the king referred to it as "nostro constructa," though an inscription, now lost, recorded some sort of new foundation in 1142; some time be-

tween 1137 and 1152 there were financial difficulties, and Louis VII appealed for contributions for construction.[21] It is unlikely that Robert was directly involved prior to that date; he seems to have received Dreux about the same time as his marriage to Agnes of Braine.[22] At Braine, construction of a new church came later and may have been largely financed by substantial revenues from Agnes's lands, which again underscores the advantages of this alliance for the Capetians.[23] As Lewis has pointed out, Robert was almost completely dependent on his brother until he had received from him the castle of Dreux and the hand of Agnes of Braine in marriage; even his right to the title of count stemmed from his marriages to two dowager countesses, since neither Dreux nor Braine were counties in the twelfth century.[24]

Agnes of Braine is associated with most of the important events in the early history of the Premonstratensian house of Saint-Yved. One was a miracle involving the host and the conversion of some Jews.[25] Agnes had taken into her household, by force, a beautiful Jewish girl from the local community, in the hope of raising her as a Christian. She, however, refused to believe in the presence of Christ in the host unless she saw him held bodily in the priest's hands. Agnes sought the help of the bishop of Soissons and he asked for processions from neighboring villages to Saint-Yved, and for the presence of the entire community at the Eucharist. Then all present saw Christ in the form of a child on the cross as the host was elevated, and the many Jewish nonbelievers professed their faith and were baptized. The anniversary was kept on the first Sunday after Easter, and a confraternity was founded to commemorate it; indulgences were given to those who made gifts to the church in

[13] Lepaige, 1633, book 1, pp. 480–81.

[14] She was commemorated on October 24: Brouette, 1958, p. 317; n. 34 erroneously gives the date of her death as 1217. Brouette used a late seventeenth-century copy by Roger de Gaignières, Paris, B.N., MS lat. 5479, ff. 115–41, for his edition; extracts are in Clairambault Collection, MS 561, pp. 405–16. Sars and Broche, 1933, p. 13, give July 24, 1204 for the death of Agnes. André de Baudement and his wife Agnes were commemorated on July 19 (Brouette, 1958, p. 303).

[15] *Cartulary*, pp. 58–59, no. 20. See also Caviness, 1984, p. 537.

[16] Herbelin, MS 855, pp. 6, 8.

[17] It is also possible he simply confused her with Thibaud II's daughter Agnes, who married Renaud II Comte de Bar (cf. Agnes of Braine's first husband, Milon Comte de Bar-sur-Seine); see Michel Bur, "Rôle et place de la Champagne dans le royaume de France au temps de Philippe Auguste," in *La France de Philippe Auguste: Le temps des mutations*, ed. Robert-Henri Bautier, Paris, 1982, p. 246. A good factual account of the alliance is given by Lewis, 1985, pp. 148–50.

[18] *Cartulary*, p. 75, no. 37, dated 1143, confirms the gift of all the land in "Vesliacum" to St. Mary of Braine; no. 36, signed at Soissons in 1138, refers to the same villa. He was remembered for this gift in the Necrology, on September 19: Brouette, 1958, p. 312.

[19] Marcel Pacaut, *Louis VII et son Royaume*, Paris, 1964, pp. 81–83, has analyzed these gifts to the new orders, and remarked on a more prudent and less generous attitude after 1152; Greenhill, 1976, p. 103, has commented on this "prudence" in relation to the loss of Eleanor of Aquitaine's revenues and influence after 1152. Lewis has noticed a similar propensity in Robert to favor canons and Cistercians, explaining this in part by the fact that his brother Henry was a canon and then a Cistercian, and another brother, Phillip, was a canon (Lewis, 1985, pp.

[20] Cahn, 1974, p. 16; also, Lewis, 1985, pp. 146–47. Dreux is close to 75 kilometers from the center of Paris, Braine nearly 95, as the crow flies.

[21] This synopsis depends on Cahn, 1974, p. 20, with bibliography.

[22] Stephen Gardner, "The Church of Saint-Etienne in Dreux and Its Role in the Formation of Early Gothic Architecture," *Journal of the British Archaeological Association* 137 (1984): 87, gives the traditional date of 1137 for the transfer of Dreux to Robert, but this has been challenged by Lewis, who found documentary evidence for 1152: Andrew W. Lewis, *Royal Succession in Capetian France: Studies on Familial Order and the State*, Cambridge, Mass., 1981, p. 62; and 1985, p. 146.

[23] Caviness, 1984, pp. 537, 539–40; Herbelin, MS 855, pp. 8–9, was followed by Prioux, 1859, pp. 12–13, in crediting Robert with the endowments for the building before his departure on crusade in 1187, and perhaps as early as 1180, but there is no evidence in the *Cartulary*, MS 1583, to support this. The assumption seems chauvinistic, and in any case such gifts prior to crusade are unlikely, since considerable material resources were diverted for the campaign.

[24] Lewis, 1985, pp. 146–47, 156–57. His first wife, who died in 1152, was the countess of Perche; Agnes when he married her later that year was dowager countess of Bar-sur-Seine as well as lady of Braine. The titles used by Robert vary.

[25] Herbelin, MS 855, pp. 17–22; Prioux, 1859, pp. 7–9. See also père Evermode, "L'abbaye royale de S. Ived de Braine et son miracle eucharistique," *Revue de l'Ordre de Prémontré et des ses missions* 14 (1912): 321–28; he cites the *Histoire d'Occident* of Jacques de Vitry (1230) as the earliest account (p. 322, n. 1).

honor of the miracle. The chalice and host were preserved as a relic in Saint-Yved, where they were described by Martène and Durand.[26] Henri de France is said to have given the richly embroidered chasuble worn by the celebrant at the miraculous Mass to Saint-Yved, and it too was revered; pilgrims came to view these relics.[27] Prioux recounts that the chasuble was unauthorizedly sold in 1789.[28] The date of this miracle is variously placed in 1133 or 1153 by most authors, but neither can be reconciled with other facts they recite.[29]

Whatever the exact date this miracle was recorded, the twelfth-century context is significant. Transubstantiation was being increasingly asserted, and belief in it became a powerful weapon against the heretical dualism of the Cathars early in the century. St. Norbert, who founded the Premonstratensian order in 1121, brought the heretical followers of Tanchelm back to belief in transubstantiation by preaching in Amsterdam in 1124, and in later art his attribute was a monstrance.[30] A miracle involving a vision of the Christ Child in the host occurred in Soissons in 1125; a childless woman had come to St. Norbert in Laon for help, and he promised she would have children if she gave all her wealth to the church. It was her small son who had the vision.[31] It is also notable how frequently women were witnesses to eucharistic miracles, and the extent to which they spread the practice of eucharistic devotion.[32] Consistent with this pattern, it is emphasized in Herbelin's account that Agnes had instructed the young Jewish girl on the bodily presence of Christ in the host. The role played by Agnes also fits the Premonstratensian context. Lay brothers and nuns attended at matins, morning Mass, and compline, and some artistocratic nuns read on Sundays.[33]

The possession of relics contributed to the prestige of a newly reformed foundation like Braine, and the provision of reliquaries was an indication of wealth. Some relics mentioned in the postmedieval accounts had more than local appeal; they were probably acquired in the latter half of the twelfth century. Given special veneration and placed in an ivory shrine (*theca eburnea, arte eleganti elaborata*) were those of St. Barnabas and St. Luke, and of Nicasius the martyred archbishop of Reims.[34] It has been suggested that this shrine is the late twelfth-century ivory reliquary now in the Cluny Museum in Paris (Pl. 61).[35] The identification is problematic, since the program of the ivory carvings suggests rather an association with the cult of the Magi, and the piece may in fact be Rhenish.[36] On the other hand, the Magi would be fitting subjects to associate with the royal house, since they demonstrate the right behavior of kings. Emperor Otto IV appears with them on the Cologne shrine of the Magi, offering a gift to the Virgin and Child (Pl. 27).[37]

Two reliquaries consisting of gilded plaques with compartments contained relics associated with the Holy Land, or with the early Christian martyrs of Rome.[38] This suggests they were acquired on crusade or pilgrimage, and Carlier in fact refers to relics brought back from the east in tiny reliquaries that were worn by the counts of Braine on crusade.[39] Robert of Dreux participated in the Second Crusade, one of his sons went on pilgrimage to the Holy Land in the 1170s, and two of his sons went on the Third Crusade.[40] These associations are also typical for the Premonstratensian context. Houses were established in the Holy Land in the 1130s and 1140s, and

[26] 1724, pp. 32–33.

[27] Prioux, 1859, pp. 9–11.

[28] Ibid., pp. 9–10, citing documents in the Mairie of Braine that I did not find in 1981; for a detailed description of its silk patterned with affronted lions, its bands of seed pearls and jewels, and a seraph and the Agnus Dei in pearls, he relies on Carlier.

[29] Herbelin, MS 855, p. 17, gives the date 1133, but Martène and Durand, 1724, p. 35, pointed out the inconsistency in the persons supposedly present, and suggested 1153 instead: Henri de France, "later" archbishop of Beauvais, 1149–1162; cf. Ansculphe de Pierrefonds, bishop of Soissons 1152–1158 (Pius Bonifacius Gams, *Series Episcoporum Ecclesiae Catholicae*, Ratisbon, 1873, pp. 511, 633). But a prior named Peter is only known in 1132–1149 or after 1193 to 1199, so 1153 is not consistent either. Hugo, 1734, cols. 401–2, quoted the date of 1153 from his "narrator antiquitae," but noted that it was not compatible with Henri de France in Reims and with an Abbot Peter at Saint-Yved. Carlier, 1764, 3: xiii–xv edited a supposed eyewitness account in Latin, with the same list of participants, and gave the date as 1163.

[30] Renate Stalheber, "Die Ikonographie Norberts von Xanten: Themen und Bildwerke," in *Norbert von Xanten: Adliger. Ordensstifter. Kirchenfürst*, ed. Kaspar Elm, Cologne, 1984, pp. 236–38; I am grateful to Ellen Shortell for this reference. Representations of Norbert are rare until after his canonization in 1582; for the date, see A. Erens, "Prémontrés," *Dictionnaire de Théologie Catholique* 13, pt. 1, Paris, 1936, col. 3. Petit (1947, p. 101) has emphasized the importance given to the cult of the Eucharist in the early years of the order, referring to a mystical treatise on the canon of the Mass by Richard the Englishman.

[31] Petit, 1947, pp. 70–71; the miracle was recorded by Guibert de Nogent, among others.

[32] Caroline Walker Bynum, "Women Mystics and Eucharistic Devotion in the Thirteenth Century," *Women's Studies* 11 (1984): esp. 181–96, 199–202.

[33] Petit, 1947, p. 47.

[34] Hugo, 1734, col. 403; this is the *Histoire générale des Abbayes de Prémontré* by Abbot Hugh of Estival, cited by Daras (see n. 35).

[35] As by l'abbé Daras, *Bulletin de la Société archéologique de Soissons* 4 (1850): 112–15, and by Sars and Broche, 1933, p. 265, who gives a full description, pp. 263–64. The museum inventory number is 1564. According to a letter from Roger Haution of Bazoches in the Cluny Museum file, the shrine was sold in 1815 by a curé of Braine, but I have not found this documentation; it was bought by du Sommerard in 1846. Daras, p. 113, identified it in the Brunet-Denon collection, citing its publication by Hauser, no. 107, but I have not found this reference; the shrine was not included in the sale: *Catalogue d'une belle collection d'objets d'art et de haute curiosité . . . composant le cabinet de feu M. le baron Brunet-Denon* (February 2), Paris, 1846.

[36] I am grateful to Alain Erlande-Brandenburg for discussing this problem and for searching the Cluny files. See Introduction, n. 53.

[37] Joseph Braun, "Die Ikonographie des Dreikönigenschreines," *Kunstwissenschaftliches Jahrbuch d. Görres-Geselleschaft* 1 (1928): 30, 38–39, figs. 15–16.

[38] Described as *tabulae inauratae, variis distinctis celulis*, in Hugo, 1734, col. 403; in one was part of the True Cross, relics of the apostles Peter, James, and Bartholomew, some hair of John the Baptist, and a rib of St. Cecilia, and in the other, relics of the apostles Matthew, Phillip, and Thomas, and of John the Baptist, St. Stephen and Leo the Great, and part of the tomb of the Virgin.

[39] Carlier, 1764, p. 73,

[40] Lewis, 1985, p. 151.

in Europe both laics and clerks supported the Crusades.[41] There seems to have been an increasing influx of eastern relics into northern Europe during the twelfth century.[42] The greatest number of eastern relics, however, came to the west after the sack of Constantinople in 1204.[43] In particular, Nivelon de Chérisy, bishop of Soissons, brought back at that time a number of relics for his cathedral church.[44] His administration was intimately concerned with the affairs of Braine, and it is possible that he, as well as the house of Dreux, made a gift of relics to the new church.[45]

THE "HISTORY" OF THE GOTHIC CHURCH
FROM THE CHRONICLES AND CHARTERS

In the same period that the treasury was being enriched, Agnes of Braine must be given credit for the construction of the new church and for the decoration that was so lavishly praised in the chronicles, as quoted in the chapter heading. The ancient author cited by Hugo also insisted that she "began the vast construction that we see which serves as the church, decorating it and carrying it to perfection at immense expense but with even greater piety; one would scarcely believe it could be finished in a century."[46] Herbelin's sources emphasized that the construction took only seven years and that the supervisor of the team of twelve masons never collected his pay; the inference is christological, as Herbelin noted.[47] According to him Agnes was old and infirm when the consecration took place; and in the face of claims that the Carolingian church at Saint-Denis had been consecrated by

Christ himself, she must have been content that an angel took the holy water and aspergillum from the archbishop and completed the consecration of Saint-Yved; this miracle occasioned further indulgences.[48]

The available charters and annals help construct a more factual account, and I have argued from these that the foundations for the Gothic church could have been prepared as early as 1176, and that the building was essentially complete by 1208.[49] Papal bulls in the 1170s confirmed the right of the canons to give the Eucharist to Robert and Agnes of Dreux and to perform burials, despite an interdict apparently imposed by Bishop Nivelon in 1175.[50] In 1176 a bull confirmed the possession of land for the church outside the castle, the first mention of this new site.[51] The first Mass for the dead to be endowed after that date was in memory of Robert's brother Henri de France, who had died in 1175 as archbishop of Reims; it was founded by substantial gifts in perpetuity, in 1179.[52] An altar may even have been ready in the new church by then.[53] In the same year a papal bull confirmed Braine as a possession of Reims, though in the diocese of Soissons;[54] a close alliance had apparently continued after Henri's death, since his successor as archbishop, William of Champagne, and Peter of Celle of Saint-Remi supported the reversal of Robert's excommunication about 1177.[55]

In 1205, during the period of the construction and decoration of the church, Braine figured briefly in the annals when a group of Cathar heretics were tried there by the newly appointed archbishop of Reims, Guy Paré, in the presence of Robert II of Dreux and his wife;

[41] Petit, 1947, pp. 80, 85–87.

[42] A number of famous examples, including the reliquaries of the true cross brought to Stavelot by Abbot Wibald about 1140 and incorporated into the great Stavelot Triptych now in the Morgan Library in New York, are discussed and illustrated by Marie-Madeleine Gauthier, *Les Routes de la Foi: Reliques et reliquaires de Jérusalem à Compostelle*, Paris, 1983, pp. 48–66.

[43] Ibid., pp. 66–82; The Metropolitan Museum of Art, *The Treasury of San Marco Venice*, exhibition catalogue, ed. David Buckton, Milan, 1984, pp. 65–66; most of the precious metalwork with enamel, is from Constantinople, often with Venetian additions (nos. 8–19, pp. 117–74).

[44] Alexandre Eusèbe Poquet, *De Terrā Iherosolimitanā, et quomodo ab urbe Constantinopolitanā ad hanc ecclesiam allate sunt reliquie*, [Laon, 18—], pp. 4–5, lists these relics; he also states that he made gifts to other churches "Alias etiam quamplures Reliquias, tam ipse quam socii eius, per Ecclesias parochiales et conuentuales infra Suessionensem Diocesim et quamplures extra dimiserunt." It is not clear whether he is quoting a medieval source. Jules Saincir, *Le Diocèse de Soissons*, Evreux, 1935, I: 104, mentions the head of St. Stephen, the veil of the Virgin, and a thorn from the crown of thorns, given to Nivelon by the new emperor of the Latin Kingdom of Jerusalem whom he had crowned in Constantinople.

[45] *Cartulary*, MS 1583, pp. 61–65; six charters were issued by him during his episcopacy, 1176–1205, presumably before his departure to the Holy Land in 1202.

[46] Hugo, 1734, col. 396: "Agnes . . . magnam scilicet Ecclesiae molem, quam cernimus, immenso sumptu, sed immensa magis pietate incohavit, ornavit, ac perfecit: uno seculo vix crederes perfectibilem." Hugo, however, was skeptical since he quoted a consecration date of 1216 (col. 398), and noted that Agnes was no longer living at that time;

so he concluded that her daughter-in-law Yolande built the church (col. 403).

[47] "Parquoy lon peult croire et estymer que cetoit ung oeuvre miraculeux et que Nostre Seigneur Dieu amplioit le dict nombre de treize"; MS 855, p. 17.

[48] Suger, 1979, pp. 44–45, called the late eighth-century nave the "noble church consecrated by the Divine Hand"; see also pp. 90–93; cf. Herbelin, MS 855, pp. 22–23, cited in full by Caviness, 1984, p. 546.

[49] Caviness, 1984. The "consecration of 1216," first referred to by Hugo (n. 46 above) and perpetuated by *Gallia Christiana*, cols. 489, 491, seems to have no foundation in fact (Caviness, 1984, pp. 525, 534–36). Klein, 1984, p. 21, has speculated that there may have been an interim consecration of the choir before Agnes's death in 1204. Kimpel and Suckale, 1985, pp. 266–68, 509–10, accepted a termination date of ca. 1204, but preferred ca. 1185–1200 for its inception, however, without dealing with my argument; Kimpel has since indicated he accepts the earlier date (personal communication).

[50] Caviness, 1984, p. 538; cf. the fuller account in Klein, 1984, pp. 12–13, who cites *Gallia Christiana* for the excommunication of Robert. Lewis, 1985, p. 153, n. 27, indicates he was excommunicated in 1154, 1177, and 1183!

[51] Caviness, 1984, p. 538.

[52] Ibid., pp. 538–39.

[53] Cf. Klein, 1984, pp. 17–18, who preferred the more generally accepted date for the new foundation after Robert's death in 1188; however, he argues a rapid completion of the choir and the eastern walls of the transepts (pp. 55–57, fig. 16).

[54] Bur, 1977, p. 409.

[55] Klein, 1984, p. 13, n. 48, citing *Gallia Christiana*.

among those found guilty and sentenced to be burned a few days later outside the castle was Nicholas, "the most famous painter in all of Francia" according to the contemporary account.[56] The event has attracted the attention of historians because it is a sign of royal participation in the inquests in the north.[57] It is also tempting to see the choice of Braine as the site of the trial and punishment as related to the miracle of the host that had affirmed transubstantiation; the relevance of this issue to the Cathers has already been pointed out.

Books and Burials

THE LIBRARY

This survey has already afforded a glimpse of the lost treasury of Saint-Yved, which seems to have been enriched after the middle of the twelfth century. The period of Agnes's patronage, and of the construction of the new church, also seems to have been a time of significant intellectual activity for the canons of Braine, coinciding with the growth of the library. Because the new orders could not rival the older Benedictine houses in their holdings of early manuscripts, they tended to concentrate a good deal of activity in the scriptorium. The copying of books was part of the clerks' manual work, and Pope Innocent II seems to have been pleased with the quality of a book from Prémontré.[58]

One indication of this activity at Braine is the recognition in the library there of several books from the hand of a single scribe, who signed a collection of saints' lives: "Johannes de Liviaco me scripsit."[59] Two of these passed into the collection of a local antiquarian, C.-R. Jardel, before the Revolution.[60] One of them is a well-known collection of texts including a *Vita Caroli Magni*, now in London.[61] Probably written in the late twelfth century, the last item in the collection is a list of the archbishops

and bishops who attended the Lateran Council of 1179.[62] The same texts are found in a contemporary manuscript from Notre-Dame of Paris that has been associated with an anonymous historian of Saint-Denis (B.N., MS lat. 17656).[63] They include a medley of Carolingian, Norman, Angevin, and Capetian material, apparently reflecting Robert of Dreux's delicate balance between political factions.[64] Narratives of Charlemagne, including the life commissioned on the occasion of his translation and canonization in 1165–1166, a forgery by Hincmar of Reims treating the damnation of Charles Martel, excerpts from William of Malmesbury's *De Gestis Requm Anglorum*, and a fragment of Suger's *Gesta Ludovici*, attest to a strong interest in kingship. The Suger fragment is particularly interesting, since it is related to a manuscript produced at Saint-Denis after 1180.[65] The Saint-Yved book, which ironically carries an anathema with the abbey's ex libris, is plain but handsome, of moderate size with two columns of script and capitals with penwork in red, blue, and green.[66]

Unfortunately, the *Vita Caroli Magni* is the only book from Saint-Yved to have been identified. Early losses apparently prevented the normal pattern of acquisition by the national or municipal libraries at the Revolution. The library was already described by Hugo as severely depleted in the 1730s, although only a decade earlier Martène and Durand found "a fairly good number" of manuscripts there.[67] The Maurist fathers referred to a very beautiful Bible in two large volumes, of the eleventh or twelfth century, which offers the tantalizing possibility of illuminations. They also mentioned a collection of authors who wrote "against the Jews" (probably theological arguments to refute Judaic unbelief), many works of the fathers, and a commentary on the Psalms, as well as several saints' lives and the collection of lives of Charlemagne. In fact, Hugo's list seems also to comprise most of these; in addition he referred to commentaries by Nicholas of Lyra, St. Bernard, Peter Lombard,

[56] Chronicle of Laon, Paris, B.N. MS lat. 5011, f. 160, edited by Alexander Cartellieri, *Chronicon Universale anonymi Laudunenses von 1154 bis zum schluss 1219*, with a study by Wolf Stechele, Leipzig and Paris, 1909, pp. 62–63: "AD MCCIIII . . . Guido in ecclesia Remensi Willelmo successit. . . . Huius presulatus mense primo quidam, eo presente, aput Branam de fide examinati, infideles reperti sunt in presencia comitis loci, Roberti scilicet patruelis Philippi regis Francorum, et Yolent comitisse et multorum aliorum; quorum iudicio post paucos dies extra castrum flammis sunt exusti. Inter quos erat famosissimus per omnem Franciam pictor nomine Nicholaus." I am at a loss to know why Nicholas is sometimes credited with the family name Perot, and why 1204 is erroneously quoted, e.g., by Stanislas Prioux, "Notice sur Nicolas Perot, fameux peintre par toute la France, brûlé à Braine en 1204," 1855, Soissons, B.M., Coll. Périn III no. 1029 (newspaper clipping).

[57] One source has suggested Robert was implicated in the heresy, but the annal does not allow that inference. See C[Karl] Schmidt, *Histoire et Doctrine de la secte des Cathares ou Albigeois*, Paris, 1849, p. 365, citing Daunon for the condemnation of the count and countess. Yves Dossat, *Eglise et Hérésie en France au XIIIe siècle*, reprint, London, 1982, pp. 64–65, places this event in the context of the earlier pursuit of heretics in Flanders by Henri de France and by William of Champagne, at

the instigation of Louis VII.

[58] Petit, 1947, p. 48, citing the chronicle of Aldenbourg.

[59] [La Curne de Sainte Palaye], "Notice sur un Manuscrit intitulé Vita Karoli Magni," *Histoire de l'Academie royale des inscriptions et belles-lettres* 7 (1733): 280–81.

[60] Stanislas Prioux, *Claude-Robert Jardel, bibliographe et antiquaire*, Paris, 1859, p. 32. According to Prioux, pp. 3–25, Jardel lived from 1722 to 1788; his library was catalogued in 1773 and dispersed in 1799.

[61] B.L., Add. MS 39646. Jardel's name and the date 1737 are on p. iii.

[62] On f. 152v, printed in D'Achery, *Spicilegium*, 2d. ed., 1723, i, p. 636.

[63] British Museum, *Catalogue of Additions to the Manuscripts 1916–1920*, London, 1933, p. 123.

[64] The contents are listed in British Museum, *Catalogue*, pp. 124–28.

[65] Paris, B.N., MS lat. 12710; see British Museum, *Catalogue*, p. 124, with bibliography.

[66] As trimmed and rebound in the eighteenth century, it is 32 by 21 centimeters.

[67] Hugo, 1734, col. 410; cf. Martène and Durand, 1724, 2: 25. A fuller listing of hagiographical materials had been given by Nicolas de Beaufort in 1590; Paris, B.N., MS n. a. lat. 950, ff. 4v–5v.

Peter Comestor, and five volumes by Jean d'Abbeville. There is fuller evidence from Jardel of serious theological works.[68] According to him, Saint-Yved produced some distinguished and learned writers. Among them was Jean d'Abbeville, whose fifteen- or sixteen-volume work on the church fathers, dating from about 1210, was still extant in 1765.[69] Another was Pierre de Braine, known to Jardel only indirectly; this abbot of the thirteenth century is also cited by Carlier, who notes that his works had remained unpublished.[70] At least one canon, named Walter, was revered as a teacher, and his aristocratic lay pupil rewarded the house with gifts in perpetuity in 1171.[71]

Until now no sumptuous illuminated books have been attributed to Braine or even to the larger houses at Prémontré and Saint-Martin of Laon.[72] Yet, further afield, those from Floreffe, Bonne Espérance, Saint-Marie du Parc, and Averbode are well known.[73] Even when resources were being lavished on the building and its decoration at Braine, it seems unlikely that Agnes would not have commissioned illuminated books; lacking any certain knowledge of these, I examined some manuscripts from the general region of the Aisne and Champagne in order to gain a broader view of the artistic milieu in which the glass and sculpture were produced. This in fact revealed a group of manuscripts that are so closely related in style to the glass that it is tempting to associate them with Braine, where the glass was surely painted. For others, a Braine provenance could be ruled out.

One of the books from the region is a moderate-sized Premonstratensian missal attributed to the Soissonais or Champagne. The Sanctoral includes some of the commoner saints whose relics were at Saint-Yved, but the absence of the patron saint rules out Braine usage.[74] There are no full-page illuminations, but nearly thirty historiated initials are placed throughout, including several for the feasts of the Virgin. The script and decorated initials appear earlier than the *Vita Caroli Magni*, and the style of the illuminations is more byzantinizing than the glass or sculpture of Saint-Yved, although some of the softer passages may be compared with the glass paintings (Pl. 220).

Illustrations in a famous large two-volume Bible in Paris (B.N., MSs lat. 11535–34) have been compared, like the Braine glass, with the rose window of Lausanne Cathedral; although she attributed the Bible to Canterbury, Beer linked it with other north French sources of the Lausanne iconography.[75] It also contains an image of a clerk in white, presumably Victorine or Premonstratensian.[76] Despite the ex libris of Sainte-Geneviève in Paris, Stirnemann now believes this Bible was made in Troyes, under the patronage of the house of Champagne.[77] And although some points of comparison with the Braine glass will be discussed later, the figures are generally more attenuated and the drapery more elaborately arranged (cf. Pls. 207, 221); in fact Pastan has made useful comparisons with some of the glass in Troyes Cathedral, which she dates ca. 1200.[78]

A psalter from northern France or eastern Flanders

[68] Quoted by Prioux, *Jardel*, pp. 31–32.

[69] Works by Johannes de Abbatis villā are also given a brief notice in Léon Goovaerts, *Écrivains, Artistes et savants de l'Ordre de Prémontré*, Brussels, 1899, 1: 417–18; he cites Remi-Casimir Oudin, *Commentarius de Scriptoribus ecclesiae antiquis*, Leipzig, 1722, 2: col. 1081, for the existence of three folio volumes with commentaries on the Psalms.

[70] Carlier, 1764, 2: 73.

[71] Matthew "Comitus Boloniae," agreed to these gifts by a charter under Abbot Balduin; it was confirmed by his daughter in 1188; cited by Hugo, 1734, col. 397.

[72] Edouard Fleury, *Les Manuscrits à miniatures de la bibliothèque de Soissons*, Paris, 1865, pp. iii, 51–60, 64, 78, describes MSs 97, 70, 110, 11, 3 from Prémontré, of the twelfth to thirteenth centuries; on p. 56 he mentions Braine among the regional houses from which manuscripts were brought to Soissons in 1789, but does not identify any from this period with an ex libris. Edouard Fleury, *Les Manuscrits à miniatures de la bibliothèque de Laon*, Laon, 1863, gives no books from Saint-Martin; a number are from Cuissy: part 1, pp. 71–72, 78, 100, 113, MSs 162, 116, 251, 225; part 2, pp. 13, 21, MSs 233, 13. Perusal of A. Boutemy, "Un Trésor injustement oublié; les mss. enluminés du nord de la France: période pré-gothique," *Scriptorium* 3 (1949): 110–22, did not reveal more.

[73] The mid-twelfth-century Floreffe Bible, London, B.L., Add. MS 17738; the Averbode Gospels, Liège, Bibliothèque de l'Université, MS lat. 363B; and manuscripts from other Premonstratensian houses in the region of Liège and Cambrai have been studied by Gretel Chapman, "The Bible of Floreffe: Redating of a Romanesque Manuscript," *Gesta* 10, no. 2 (1971): 49–62.

[74] Paris, B.N., MS lat. 833, formerly Regius 3876 and Colbert 422. Victor Leroquais, *Les Sacramentaires et les missels manuscrits des bibliothèques publiques de France*, Paris, 1924, 1: 307–10, no. 155; Nicaise and his companions have some significance, but their cult was quite wide-

spread in the region. Medard and Crispin and Crispinian point to Soissons. Saint Yved is found, however, in the calendar of the Ingeborg Psalter (see n. 6), and in a late thirteenth-century psalter of Soissons use, Le Mans, B.M., MS 157 (Leroquais, 1940–1941, 1: 240–42). Saints Nicase and Clotilde are also present in the latter, as are a number of canonized rémois archbishops, but these are outweighed by the importance given to Gervase and Protase, patron saints of Soissons Cathedral.

[75] Beer, 1956, pp. 51–52, figs. 17, 18; and Ellen J. Beer in Jean-Charles Baudet et al., *La Cathédrale de Lausanne*, Bibliothèque de la société d'histoire de l'art en Suisse, Berne, 1975, p. 240, figs. 311, 312.

[76] MS lat. 11534, f. 26v. The Cistercians also wore white habits, but richly illuminated books were not made for their own houses. Two of the Premonstratensian books in the Bibliothèque Municipale of Soissons, MSs 3 and 11, have portraits of the author or scribe in white; they are discussed by Fleury, *Soissons*, pp. 80, 101.

[77] Presumably for the college of Saint-Etienne. The Bible was ascribed to Champagne or the Ile-de-France by Harvey Stahl in *Year 1200* I, pp. 247–48, no. 246; Stirnemann's conclusions are based in part on affinities between the Bible des Capucines (Paris, B.N. MSs lat. 16743–46), the Manerius Bible (Paris, Bibliothèque Sainte-Geneviève, MSs 8–10), and this "Sainte-Geneviève Bible," which suggest they are the products of the same atelier over a period of time, and on her identification of some of the books known to have been made for Henry the Liberal and for Marie de Champagne, which have closely related ornament. See Patricia Danz Stirnemann, "Nouvelles pratiques en matière d'enluminure au temps de Philippe Auguste," in *La France de Philippe Auguste: Le temps des mutations*, ed. Robert-Henri Bautier, Paris, 1982, pp. 963–67, 970; and Stirnemann, 1984, pp. 31, 32.

[78] Pastan, 1986, chap. 4, p. 19, figs. 122, 125 (St. Peter window); cf. figs. 138, 139.

with an early coronation of the Virgin (Paris, B.N., MS lat. 238) deserves brief mention. Like the champenois Bible, Beer has drawn this book into the group of works, including the Braine glass, that influenced the rose of Lausanne.[79] There is nothing to suggest a specific Premonstratensian affiliation, however, except the Marianic program of the illustrations; a sermon in the vernacular at the end would be compatible with this or another of the newer orders, and Randall has associated it with a group of later psalters made for the Beguines in Liège.[80] David combating Goliath in the guise of a Saracen adds a topical, crusading note, and obits added in later hands include two kings of France, Philip (July) and Louis (August), indicating later ownership by a woman associated with the Capetian house. Although this is the kind of book I would have expected Agnes of Braine to have owned, it does not have sufficient stylistic affinity with the Braine glass to argue an origin or influence there.

However, the illuminations in three books of unknown provenance are so close to the glass that an association with Saint-Yved must be suggested. The group includes an unusual collection of texts by Virgil and others, with exquisite historiated initials; the poses and proportions of the figures, the drapery systems, and the crispness of the drawing immediately invoke the sculpture and glass from Braine (cf. Pls. 214, 237, 241, 242; for Pl. 221, cf. Pl. 222; for Pl. 228, cf. Pl. 230).[81] The many images of kings, queens and knights in medieval dress might have delighted a patron close to the court, and we will see that Agnes's grandson was likened to Classical heroes.[82]

Avril also noted that one of the hands of the Virgil illuminations can be identified in a large volume contain-ing the Epistles of St. Paul, with the commentary of Peter Lombard, in London (B.L., Royal MS 4 E.IX).[83] This book has been considered English and dated about 1200, on the basis of the style and the script, although the text was disseminated from Paris.[84] Ayres also attributed to Paris a large Bible in Berlin (Staatsbibliothek Preussischer Kulturbesitz, MS theol. lat. fol. 9), which I am adding to the "Braine group"; the illuminated initials are unmistakably from the same workshop as the Virgil manuscript and Royal Epistles.[85] Ayres, however, astutely commented on the monumentality of the figures, especially those of the initials to the Pauline Epistles, likening them to the sculpture of Sens (Pls. 239, 240). It seems likely that the atelier producing these books worked in various centers to the north and to the east of Paris, including Braine, in its formative years. Important new evidence presented by Avril reconfirms the localization of the stylistically related Ingeborg Psalter atelier in the region of Soissons and Noyon in the last decades of the century.[86]

It is in the repertory of seated author portraits in the Berlin Bible and Royal Epistles that the closest affinity is to be found with the Braine glass (for Pls. 182 or 202, cf. Pls. 183a, 183b; for Pl. 199, cf. Pl. 200; for Pl. 237, cf. Pl. 240). The Canterbury clerestory figures show an even greater rapprochement in that "miniaturesque" details such as the panel decoration of the thrones are also seen in the miniatures (for Pl. 180, cf. Pl. 181; for Pl. 198, cf. Pl. 200). Even small figures in historiated initials in the Virgil manuscript are similarly articulated in poses and drapery systems, and show similar facial types (for Pl. 190, cf. Pls. 191, 193). There seems little doubt that such figures were developed from common moduli.

[79] Beer, 1956, pp. 62, 67, fig. 27. Charles T. Little, "Membra Disjecta: More Early Stained Glass from Troyes Cathedral," *Gesta* 20 (1981): 124, figs. 5–8, has compared the iconography of twelfth-century fragments of glass now in Troyes Cathedral with the Coronation of the Psalter and with a later window at Saint-Quentin.

[80] Lillian M. C. Randall, "Flemish Psalters in the Apostolic Tradition," in *Gatherings in Honor of Dorothy E. Miner*, ed. Ursula McCracken, L.M.C. Randall, and Richard H. Randall, Jr., Baltimore, 1974, pp. 183–87, figs. 30–32. The psalter was formerly Regius 4303 and was assigned to northern France or Flanders by Leroquais, 1940–1941, 2: no. 282, pp. 36–39, pls. XLVI–LI; he notes a good many female saints from that region in the calendar, and patronage by a woman or by a female house. Harvey Stahl accepted Leroquais's localization, on the basis of iconographic affinities with books made for Arras and Bruges: *Year 1200* I, pp. 245–46, no. 244.

[81] Paris, B.N., MS lat. 7936; *Year 1200* I, pp. 252–53, no. 252, with bibliography, where it is associated with one of the Ingeborg Psalter styles. See also François Avril, "Un Manuscrit d'auteurs classiques et ses illustrations," in *Year 1200* III, pp. 261–82. It has attracted considerable attention among textual scholars: C. Jeudy and Y. F. Riou, "L'Achilléide de Stace au moyen âge," *Revue d'Histoire des textes* 4, no. 10 (1975): 148, n. 3, and 157, n. 2; Pierre Courcelle and Jeanne Courcelle, *Lecteurs Païens et lecteurs chrétiens de l'Enéide*, vol. 2: *Les manuscrits illustrés*, Mémoire de l'Académie des inscriptions et belles-lettres, n.s. 4, Paris, 1984, pp. 29–33, figs. 12–21.

[82] Also, Robert of Cricklade in his presentation volume of extracts from Pliny made for Henry II of England added a note likening one of his subjects to Queen Matilda, in that she was daughter, wife, and mother to kings (Stirnemann, 1984, p. 10).

[83] Avril, *Year 1200* III, pp. 268–69, fig. 31. A description is in George F. Warner and Julius P. Gilson, *British Museum: Catalogue of Western Manuscripts in the Old Royal and King's Collections*, London, 1921, p. 93, pl. 31c, d.

[84] T.S.R. Boase, *English Art 1100–1216*, London, 1953, p. 287, pl. 93c; C.F.R. De Hamel, *Glossed Books of the Bible and the Origins of the Paris Book Trade*, Woodbridge (Suffolk), 1984, p. 35.

[85] Larry M. Ayres, "Parisian Bibles in the Berlin Staatsbibliothek," *Pantheon* 40 (1982): 5–7, figs. 1–7. As well as the comparisons made here, the historiated initials (e.g., Ayres, fig. 1) have counterparts in the Virgil (e.g., Avril, fig. 16). In addition to the figure style, the repertory of ornament—such as entwined rinceaux, affronted lionceaux, and the beading or palmettes that fill the stems of letters—is identical. The scripts are also closely related, though not identical: The Virgil and the hand of the gloss in the Royal manuscript are close, as are the hands of the main text in the Royal Epistles and that of the Berlin Bible. Unfortunately, the *Vita Carolini* from Braine (Add. MS 39646) is in a different, more formal and elaborate hand, presumably earlier.

[86] François Avril, "L'Atelier du Psautier d'Ingeburge: problèmes de localisation et de datation," in *Hommage à Hubert Landais*, Paris, 1987, pp. 16–21. Among evidence adduced is the newly discovered psalter sold in Avranches in 1986, which appears to be a mature production of the Ingeborg Psalter atelier, made for Noyon (p. 17); and the liturgical manuscript drawn up by Bishop Nivelon of Soissons in 1180–1190, B.N. MS lat. 8898, which has two initials by the illuminator of Morgan Library MS 338, another of the Ingeborg group of manuscripts (p. 20, n. 26, figs. 3–6).

DYNASTIC TOMBS

Whatever the sumptuous quality of the books at Saint-Yved around 1200, there can be no doubt about the increasingly elaborate tombs that were enshrined there in the course of the thirteenth century. Agnes died in 1204 and was buried in the choir, near the main altar, where her stone tomb was recorded by Hugo. He described the tomb as having a *statua* or effigy of Agnes, as drawn by Gaignières (Pl. 62a).[87] It was found in the debris of the ruined church by the curé Beaucamp in 1813–1814 but is not preserved.[88] Robert of Dreux had not been buried in the church in 1188, but after his widow's burial there it became the pantheon of his dynasty.[89] Robert II (d. 1218) and his wife Yolande de Coucy (d. 1222) had elaborate tombs with enameled plaques and sculpted effigies, which Hugo and Prioux state had been looted by the Spanish during the civil war of 1650 (Pl. 62b).[90] These followed at some remove the fashion set by Louis VII, or rather by his widow on his behalf, for tombs resplendent with gold, silver, and jewels (Pl. 64).[91] About the same time an even more sumptuous tomb was made for Robert's brother Phillip, bishop of Beauvais (d. 1217), recorded in Beauvais Cathedral (Pl. 63a.)[92]

Robert III is said by Carlier to have founded two chapels in the church at Braine—that is, presumably the Masses in them—and he was buried there in 1233.[93] The inscription suggests that the counts were more eager to lay claim to the Classical past than to the Merovingian, perhaps because of exposure to Byzantium and to a veneer of learning in the aftermath of the twelfth-century renaissance:

Hic jacet illustris ex Regum semine satus,
Drocarum Branaeque Comes, Robertus humatus;

Hic in amicitia Theseus fuit, alter in armis
Ajax, consilio pollens, fuit alter Ulisses.[94]

One is reminded of Rupert of Deutz's quip that St. Norbert may not have known the letters of St. Jerome, but he surely knew Porphyrus and Aristotle.[95] The library at Braine may indeed have contained ancient authors, such as the Virgil manuscript mentioned previously.

Family burials continued into the fifteenth century, and the tombs seem to have filled a "chapelle des Seigneurs" in the south transept.[96] Among them was the innovative canopy placed over the effigy of Peter of Dreux, duke of Britany, called Mauclerc, who died in 1250; it was noticed by Bony as an early example of the ogee arch in the west, "fitting symbol for the tomb of a great Crusader" (Pl. 63b).[97] Mauclerc came of age too late to be able to contribute to the glazing of Saint-Yved, but he appears kneeling at the foot of one of the lancets in a great ensemble at Chartres; the south transept rose above is resplendent with the arms of Dreux (Pl. 281).[98] Not only did the tombs of the dynasty of Dreux in Saint-Yved rival those of the ruling house, but their gifts of glass seem to have outshone those of the Capetians.

The Gothic Church

CONSTRUCTION CA. 1180–1204/8

As noted already, there is evidence that a new site was selected for the collegiate church as early as 1176; the earlier church had been within the castle precinct, and seems to have survived into the eighteenth century, when Hugo says it was adjacent to new conventual buildings.[99] The layout of the buildings, including the

[87] A fragmentary chronicle from Braine gives the year of her death as 1204: Philippe Labbe, ed., *Novae Bibliothecae manuscriptorum librorum tomo primus,* [secundus]: *Historias, Chronica sanctorum, sanctarumque vitas,* Paris, 1657, p. 327. Comments on the tomb are found in Hugo, 1734, col. 404, where he states the tomb was in front of the altar; Prioux, following Beaucamp, ascribed the stone coffin without identification *behind* the altar to Agnes (1859, p. 24). For the appearance of the tombs, and the epitaphs, we have to rely on drawings by Gaignières on the one hand, and transcriptions by Herbelin on the other: The positions and epitaphs of the tombs were recorded by Herbelin, MS 855, pp. 29–34, from whom they were printed by Beaucamp, *Mémoire sur l'Eglise royale de Saint-Ived de Braisne,* Soissons, 1825, pp. 11–15, and Prioux, 1846, pp. 312 24; they were also printed in Hugo, 1734, cols. 404–6. Drawings by Roger de Gaignières were preserved in Paris, B.N., Clairambault Collection IX (1313), années 1195ff., ff. 5–6, 8, and 56, and in Département des Estampes, Gaignières Collection, Costumes Oa 9, ff. 37–40, 75. A plan prepared in 1825 by Duroche, when restoration of the church was being urged by Beaucamp, shows the positions of the tombs, at least as surmised (Archives Photographiques, MH 200 026) (Fig. 9). It differs so radically from one published by Prioux after LeBlan nearly thirty-five years later (Prioux, 1859, n.p.) that neither can be relied upon.

[88] A.N., F19, 662, dossier 13222, letter of November 21, 1826; Prioux, 1859, illustrated the sculpted effigy, which he said was still in a chapel in the church, though headless (p. 42; pl. facing p. 38).

[89] André Du Chesne, 1631, p. 23, cites the martyrology of Notre-

Dame of Paris for the date of his death, October 11, 1188; cf. also Prioux, 1859, p. 12. Just before his death he made gifts to a foundation dedicated to Thomas Becket, near the Louvre, but his burial place is not recorded.

[90] Hugo, 1734, cols. 404–10, gives their current condition, filling in losses from Herbelin; Prioux, 1859, p. 25, col. pl. facing p. 42, after Gaignières.

[91] Elizabeth A. R. Brown, "Burying and Unburying the Kings of France," in *Persons in Groups: Social Behavior as Identity Formation in Medieval and Renaissance Europe,* ed. Richard C. Trexler, Binghamton, 1985, pp. 243–44, fig. 1; Erlande-Brandenbourg, 1975, pp. 111–12, 120–21, 161, 204, and figs. 37, 38, where, however, the captions are switched.

[92] Prioux, 1859, pp. 47–54 and col. pl. facing p. 46, after Gaignières.

[93] Carlier, 1764, 2: 69; see also Prioux, 1859, pl. facing p. 54, and pp. 56–60.

[94] This may be translated: "Here lies buried Robert of the royal line, illustrious count of Dreux and Braine; in friendship he was another Theseus, in arms another Ajax, and in sound counsel another Ulysses."

[95] Quoted by Petit, 1947, p. 24.

[96] Prioux, 1859, pp. 60–88.

[97] Jean Bony, *The English Decorated Style: Gothic Architecture Transformed 1250–1350,* Ithaca, N.Y., 1979, p. 25, fig. 147.

[98] This gift will be discussed in more detail in the last chapter.

[99] Hugo, 1734, col. 395: "Junctum Ecclesiae monasterium quale ser-

relationship of the new site to that of the castle and the town, has changed little since the Middle Ages (Fig. 8; Pl. 47).[100] The west end of the nave and the cloister, however, have been torn down (Pl. 49).[101]

In 1208 Robert II and Yolande were signatories to a charter that rescinded a good deal of the revenues deeded to Saint-Yved by his mother Agnes, but left sums intended to maintain altar lamps and bell ropes; from this I have inferred that the building was essentially complete at that time.[102] It was evidently a truly splendid and highly original structure. The chevet, transepts, and first two bays of the nave of the Gothic church stand more or less intact, following nineteenth-century restorations (Fig. 9; Pls. 47–50).[103] The plan and elevation were unusual in the context of late twelfth-century construction, although there were many imitations.[104] The choir is terminated to the east by the hemicycle of a three-story apse without chapels, reminiscent in its simplicity of the plan of the rounded transept arms of Noyon, although those are of four stories, and of the Cistercian choir of Chaâlis, although it was of two stories.[105] Other prevalent plan types in large buildings of the period emphasized ambulatories or radiating chapels.[106] Here, the chapels are paired and diagonally positioned so that they

link the apse and transepts, seeming to provide for circulation around the crossing; their disposition is the hallmark of the Saint-Yved plan type, frequently copied elsewhere.[107]

The three-story elevation, another rare feature to the northeast of Paris in the period, is elegantly proportioned; a triforium passage with four arches in the straight bays and two in the hemicycle bays, and a tall clerestory with single lancets in each bay, together approximately equal the height of the lower story (Pls. 51, 58, 59).[108] Quadripartite vaults spring from the original sill level of the clerestory.[109] If my dating is accepted, the elevation may be viewed as a precursor of Chartres and of the choir of Soissons, but by raising the springing of the vaults to the midpoint of the clerestory windows the proportions are dramatically changed in the cathedrals.[110] The arcade supports are columnar, like those already used in Paris and Laon.[111] Klein has argued that the skeletal construction of the choir was more advanced than that of Laon, but an interval of more than a decade between them seems sufficient.[112]

The absence of chapels or ambulatory at the east end ruled out the use of flying buttresses; the hemicycle is instead strengthened by pilaster buttresses, pierced by an

vit primitûs, aedificiorum recens fabrica. . . ." Philippe Bonnet, *Les Constructions de l'ordre de Prémontré en France aux XVIIᵉ et XVIIIᵉ siècles*, Geneva, 1983, p. 122, refers to new buildings of ca. 1720–1725 which were destroyed in 1803–1813.

[100] Michel Boureux, *Le Passé de l'Aisne vu du ciel*, Laon, 1978, pp. 88, 100 (illus.), notes that the medieval street plan survives. The plan of 1782 from the archives in Laon was published by McClain, 1974, fig. 9, and Klein, 1984, p. 61, fig. 19. The present wall of the presbytery runs approximately at the angle of the castle enclosure as recorded in it. The castle enclosure followed the south wall of the nave and projected to the south in line with the west wall of the transept.

[101] A view of the rather brutal termination of the west end of the nave is given in *Courtauld Archives* 12.3.102.

[102] Caviness, 1984, pp. 539–41; the charter is edited in its entirety from A.N. L 1003, no. 4, pp. 546–48. A date soon after 1204 was accepted by Kimpel and Suckale, 1985, p. 268.

[103] The extensive bibliography since that time is cited in Caviness, 1984, p. 524, n. 1; Klein, 1984, pp. 4–9, gives an overview of the literature, including additional citations.

[104] Caviness, 1984, p. 524, n. 1; see also Peter Kurmann, *La Cathédrale de Saint-Etienne de Meaux*, Paris, 1971, p. 130; Bony, 1983, pp. 172–79, 328–35, fig. 113; Klein, 1984, pp. 214–49. An overview of Premonstratensian building types, without documentation, is given by Fritz Wochnik, "St. Yved zu Braine und die Mittelalterlichen Nachfolgebauten (Das Schema von Braine)," *Analecta Praemonstratensia* 58 (1982): 252–63 (without sequel as yet).

[105] Charles Seymour, *Notre-Dame of Noyon in the Twelfth Century*, New York, 1979, pp. 119–29, figs. 44–46, 47, 53, 117. E. Lefèvre-Pontalis, "L'Eglise abbatiale de Chaâlis (Oise)," *Bulletin Monumental* 66 (1902): 456 and plan facing. Chaâlis was under construction by 1202 (ibid. p. 452); André de Baudement had been its first abbot, from 1136 (p. 450). For more recent work, see Caroline A. Bruzelius, "The Transept of the Abbey Church of Chaâlis and the Filiation of Pontigny," in *Architecture Cistersienne: 6 abbayes*, Mélanges Anselme Dimier, III, Arbois, 1982, pp. 447–54, who however does not deal with the apse. It was not unusual for Premonstratensian churches to have "Cistercian" rectilinear apses, although this has recently been seen as merely a regional feature: Julia Fritsch, "Quelques Remarques sur l'architecture de l'église Saint-Martin à Laon," *Fédération des Sociétés d'histoire et d'ar-*

chéologie de l'Aisne 25 (1980): 69 and n. 13, and William W. Clark, "Cistercian Influences on Premonstratensian Church Planning: Saint-Martin at Laon," in *Studies in Cistercian Art and Architecture* 2, ed. Meredith P. Lillich, Kalamazoo, Mich., 1984, p. 176; he notes that there is "no identifiable premonstratensian architecture" comparable to that of the Cistercians (p. 180).

[106] Bony, 1983, figs. 116, 126, 130, comprising his Parisian and Northern schools. Notre-Dame of Paris was a prototype with double ambulatory, repeated at Bourges and Le Mans (cf. the single ambulatory of Laon and Mantes); Saint-Denis provided an influential prototype with radiating chapels, followed at Noyon, Saint-Remi, and Chartres.

[107] See n. 104.

[108] McClain, 1986, pp. 94–95, fig. 5, derives the proportions of the elevation from those of a regular pentagon (viz. 1.414 and 1.618).

[109] Cf. McClain, 1986, p. 95, who chides Prioux for not observing that the capitals are 0.25 meter below the base of the windows; the sills have been raised, to improve drainage from the exterior wall passsage (see below).

[110] In both Chartres and Soissons the upper story is approximately equal to the lower, and the triforium can be viewed as a sliding element, to be added to either story to give the golden ratio.

[111] Bony, 1983, figs. 114, 125, 131; W. W. Clark and R. King, *Laon Cathedral Architecture*, Courtauld Institute Illustration Archives Companion Text 1, London, 1983, 1: 28–31, figs. 15–17 (and *Courtauld Archives*, 3/6/99–106), place those in the first bay of the choir and on the east side of the transepts in the first campaign, in the 1160s.

[112] Klein, 1984, pp. 56–57. This chronology was anticipated by Pestell, 1981, and by Caroline A. Bruzelius, "Cistercian High Gothic: The Abbey Church of Longpont and the Architecture of the Cistercians in the Early Thirteenth Century," *Analecta Cisterciensia* 35 (1979): 71. More recently, Klein has placed the beginning of the construction of Saint-Yved ca. 1180–1190—that is, between the south transept and the choir campaigns of Soissons Cathedral, and slightly before a group comprising the cathedral and Saint-Vincent in Laon, and Saint-Michel-en-Thiérache: Bruno Klein, "Chartres und Soissons: Uberlegungen zur gotischen Architektur um 1200," *Zeitschrift für Kunstgeschichte* 49 (1986): 453–59.

exterior passage at the level of the clerestory sills (Pl. 48). The nave, however, because its straight upper walls would be weaker than those of the turning bays of the apse, and because the outer walls of its single aisles provide a logical foundation for them, has low flyers (Pl. 49).[113]

Foliate capitals tend to be delicate and leafy in the lower story to the east of the crossing, but are more severe and abstracted in the triforium and in the two surviving bays of the nave arcade; I have used them as aids for dating, even though Klein does not distinguish different campaigns of construction here (Pls. 58, 59).[114] Some are so close to those in the south transept of Soissons Cathedral that they appear to be from the same shop, and they confirm the date around the 1180s. Sumptuously carved cornices and drip moldings on the exterior corroborate an east-to-west chronology.[115] These are a regional feature in the late twelfth century, with parallels in Laon Cathedral and Notre-Dame-en-Vaux of Châlons-sur-Marne.[116]

The transepts, only two bays in length, do not seem to have served as major entryways, as they typically did in abbey churches and in later cathedrals such as Chartres and Reims, and as they seem to have in the original plan of Laon (Fig. 9; Pl. 58).[117] The episcopal palace and the canons' housing were usually situated to the north and south, making such access logical; at Lincoln the transept roses were known in the thirteenth century as the "Bishop's Eye" and the "Dean's Eye," perhaps in reference to their residences as well as to symbolism.[118] In the monasteries, transepts provided easy access from the dormitory and cloister on the north side, often on two levels as at Saint-Remi of Reims. At Braine the lack of emphasis on north-south circulation may in part be a question of the relation of the site to the housing for the canons. The document of 1176 referring to the new site for the church mentions that the housing would remain in the castle precinct, so the canons, like the lay patrons, would have entered from the west unless they came from the cloisters.[119] Their cloister was on the north side of the nave, but does not seem to have extended to abut the transept (Fig. 8).[120] It would not be surprising if the south transept was filled with later burials, as Prioux suggested.[121] On the other hand, it is significant that Braine did not adopt the plan without transepts that had appeared at Sens Cathedral about 1150–1160, and which was followed at Senlis, Paris, Mantes, and even Bourges.[122] Alone among these, the Cathedral of Senlis offers a significant resemblance to Saint-Yved in that it was rebuilt in 1153–1191 on a site facing the gateway of a royal castle, of which the substantial ruins can still be visited across the square in front of the west facade.[123] As of 1153 the construction there received energetic support from the king, yet despite royal patronage and its episcopal status, Senlis was no larger than Braine.[124]

The transepts at Braine in fact have major impact on the concentration of height and light at the east end; they allow a lantern tower at the crossing, and openings in the ends comprising large rose windows placed above an interior walkway that corresponds to the triforium level, and twin lancets that occupy the lower story (Pl. 58). The north rose stonework is in good condition; the south rose was rebuilt in the nineteenth century, but an earlier lithograph by Dauzats shows that its tracery was identical to that facing (Pls. 49, 50).[125] Bony has remarked on the early development of large rose windows in the design of transept ends, rather than in west facades; citing Saint-Etienne of Beauvais as an early example, ca. 1150.[126] Double-wall construction, such as that of Canterbury, had not lent itself easily to the inclusion of large roses; the transept oculi are interrupted by the slender shafts of an arcade on the inner plane of the double wall, and the circular opening has no stone tracery.[127] A closer antecedent for Braine is the north transept rose of Laon Cathedral, dating from the 1170s or 1180s.[128] The design there is of a different type, however, referred to by Pestell as the "inscribed circle type,"

[113] Prioux, 1859, "Coupe sur l'Abside" [*sic*], n.p. Bill Clark has compared these to ones originally on the south transept of Soissons; I am grateful to him for this information, based on an early photograph of Soissons. For more detail, see *Courtauld Archives*, 3/12/100–101.

[114] Caviness, 1984, pp. 543–44, figs. 9, 11 (cf. fig. 12); Klein, 1984, pp. 51–52, fig. 15. *Courtauld Archives*, 3/12/146–49 and 155–58 (cf. 151–54).

[115] Caviness, 1984, p. 542, figs. 2–5.

[116] Ibid., figs. 2–4, 6; for Laon: *Courtauld Archives*, 3/6/6, 11, 16, 18, 19, 23–25, 27.

[117] Small portals in the north and west walls of the north transept may have given access to the cloister, through a slype, and perhaps to a cemetery. Twin portals on the north in Laon still exist, but the embrasures were partly engulfed by later Gothic masonry: *Courtauld Archives*, 3/6/8–11. Hinkle, 1965, has studied the special function of the north transept portals of Reims Cathedral.

[118] Frankl, 1960, p. 758, quoting the *Metrical Life of Saint Hugh*; see also below for this elaborate metaphor.

[119] See above, n. 51.

[120] Klein, 1984, fig. 19.

[121] Prioux, 1859, plan, n.p.

[122] Bony, 1983, pp. 65, 122, 131–33, figs. 60 and appendix, 116 A

and D, 130 A, 147. Bourges, begun in 1195, has two pairs of porches on the north and south sides, but no interruption in the west-east flow; ibid., figs. 190, 192, 197.

[123] Marcel Aubert, *Senlis*, Petites Monographies des grands edifices de la France, Paris, [1921?], pp. 5, 118–25; he notes that a chapel was built in the castle by Louis VI, and there are other twelfth-century apartments (pp. 119–20).

[124] Aubert, *Senlis*, pp. 20–21; Eleanor Greenhill, 1976, p. 97, n. 142. Pestell has noted the comparable height and length of the two buildings: 1981, p. 12, n. 14.

[125] The transept ends as restored are well illustrated in *Courtauld Archives*, 3/12/100–101, 131–32.

[126] Bony, 1983, pp. 191 and 494, n. 28. Earlier roses in the west end, such as at Saint-Denis, were small and placed rather high and in isolation.

[127] Caviness, 1981, fig. 24. The transept ends were completed by 1180.

[128] William W. Clark and R. King, *Laon Cathedral Architecture*, Courtauld Institute Illustration Archives Companion Text 1, London, 1983, 1: 38, 52, 66, place this work in the third campaign, ca. 1170/75–1180/85.

also used for the west rose of Chartres (Pls. 243, 245).[129] The Braine roses belong to his " 'closed' centripetal type," and its stonework is much lighter than that of the Laon transept rose (Pls. 54, 58). This popular design evidently played a role in disseminating radiating tracery. Copies are found in two little local churches, in the east end of Vaux-sous-Laon and the south transept of Mons-en-Laonnois (Catalogue B);[130] and an adaptation, with an added ring of circular openings, is in the transept of the Benedictine Abbey Church of Saint-Michel-en-Thiérache in the Ardennes (Pls. 55, 56).[131] That the dimensions of these vary significantly has been of importance in establishing the provenance of the Braine glass (Catalogue B); of more immediate concern here is whether the differing proportions indicate a chronological sequence.[132] The awkwardness of the other two contrasts with the elegant repetition of modular circles at Braine, those formed by the cusps on the outer circumference being the same size as those at the inner extremity of the "petal" (Pls. 54, 244); in the east end of Vaux-sous-Laon the central opening is larger than at Braine, at the expense of the "petals" that appear truncated at the inner ends (Pl. 56). Most probably the nineteenth-century glazing scheme followed the original configuration for the armature, with only one large circular medallion in each section; in other words, as a window design this afforded a less rich program than the configuration at Braine.[133] The earliest appearance of this design type, however, seems to be the small rose in the upper level of the Salle du Trésor of Noyon Cathedral, as Pestell suggested, and as recently presented in greater detail by Hardy.[134] Exterior moldings create a deep recess in the thick wall, as in the north rose of Laon. The design is of eight petals instead of twelve, and the stonework, instead of openings, occupies the vertical and horizontal axes.[135] Seymour dated this part of the building ca. 1170–1185, and Hardy placed the construction of the

rose about 1170–1175, a dating that plausibly allows Braine to follow immediately.[136]

Another consequence of the design of the crossing and transepts at Braine was a lack of portal sculpture, and what might be seen as a concomitant "displacement" of figural sculpture to the interior of the crossing, and to the upper zones of the exterior (Pls. 54, 58). In fact these emplacements each have interesting antecedents outside the immediate region, as we shall see.

DAMAGE AND RESTORATION

At this point the reading of the monument becomes greatly complicated, however, by postmedieval losses and restorations that have to be taken into account. The structure that can be studied on the site terminates at the third nave piers from the crossing, and the upper levels of the lantern tower and transepts, including the south rose tracery, were rebuilt in the nineteenth century (Fig. 9; Pls. 48, 50, 51, 54).

In fact the roof of the lantern had already been replaced in the sixteenth century, and Spanish troops were supposed to have stripped some of the tombs in 1650.[137] Yet in general the church and its decoration seem to have remained intact up to the French Revolution. No doubt this is largely due to a certain conservatism and historicism that can be noted among the seventeenth- and eighteenth-century archivists, bibliophiles, and antiquarians who concerned themselves with Braine, in contrast to the predominant classicizing taste of the period that elsewhere destroyed much medieval art. Among such canons of Saint-Yved were Herbelin, Carnot, and Duflot; Jardel was a native of Braine. "Outsiders" such as LePaige, Martène and Durand, Hugo, Carlier, and Le Vieil served to spread the fame of the ancient church.[138] New construction in this period appears to

[129] Pestell, 1981, p. 5.

[130] For Vaux-sous-Laon, see Kimpel and Suckale, 1985, p. 521. I am grateful to Bill Clark and Chantal Hardy for pointing out Mons-en-Laonnais; see *Courtauld Archives*, 3/12/168, 171.

[131] Pierre Héliot, "Le Chevet de la cathédrale de Laon, ses antécédants français et ses suites," *Gazette des Beaux-arts* 6th ser. 79 (1972): 197, fig. 4, cites Vaux-sous-Soissons in error. I am grateful to Bill Clark and Robert Mark for discussions at these sites.

[132] Pierre Héliot, "L'Abbatiale de Saint-Michel en Thiérache, modèle de Saint-Yved à Braine, et l'architecture gothique des XIIᵉ et XIIIᵉ siècles," *Bulletin de la Commission royale des monuments et des sites* n.s. 2 (1972): 24–25, 28–30, 33, has insisted on the primacy of Saint-Michel, viewing Braine as a refinement, whereas I regard the Saint-Michel rose as a less bold derivative work (Caviness, 1984, p. 545, n. 83). Klein, 1984, pp. 136–40, brings additional arguments to conclude that Saint-Michel is not the prototype for Braine. Chantal Hardy informs me that she concurs with the chronology suggested here, as discussed in her thesis: "Les roses du XIIᵉ et XIIIᵉ siècle en Ile-de-France," dissertation, Université de Poitiers, 1983.

[133] A more convincing indicator of a later date for Vaux lies in the capitals of the choir, which resemble those in the nave of Braine.

[134] Pestell, 1981, p. 5. Chantal Hardy, "La Rose de Notre-Dame de Noyon et sa place dans la technique et le décor du troisième chantier de la cathédrale," *Revue d'Art canadienne* 13 (1986): 7–22.

[135] Suckale, 1981, p. 290, n. 34, notices the number, listing other

examples at Champeaux, Donnemarie-en-Montois, Beaune, and Santas Creus (Catalonia), none of which are earlier.

[136] Charles Seymour, Jr., *Notre-Dame of Noyon in the Twelfth Century: A Study in the Early Development of Gothic Architecture*, reprint, New York, 1968, pp. 59, 102, figs. 31, 117; Hardy, p. 16, figs. 1–3, 7. Another early example (ca. 1170) of the general type, with vertical stonework but with six *trilobed* petals, may be in the outer walls of the tribunes of the eastern parts of Notre-Dame in Paris, where it alternates with the form that we shall see was used in the west end of Braine, but the authenticity of these designs is in doubt.

[137] For a full discussion of the documents relating to the lantern tower, see Caviness, 1984, pp. 540–41, nn. 63–64.

[138] As noted by Prioux, Herbelin put the documents of the house in order during the Protestant wars; his manuscript history of the house of Dreux was presented to the countess of Braine in 1553, but the large number of extant copies (eight), one dated as late as 1570, and its tone suggest it was intended to earn protection for the abbey (Caviness, 1984, p. 534, n. 23). For his activities, and those of Simon Carnot who followed him as treasurer, see Stanislas Prioux, "Matthieu Herbelin, Religieux prémontré," *Bulletin de la Société archéoloique de Soissons* 1st ser. 10 (1856): 216–35. Both left notes in the *Cartulary*, MS 1583; Carnot signed an addition on p. 43. Nicholas François Duflot is mentioned as a canon regular of Saint-Yved in a Bournage Contradictoire of 1788, Laon, Archives Départementales de l'Aisne, E 153; his name is not given in full in Duflot, MS 1014. For Jardel, see above, n. 60.

have been limited to the monastic buildings, judging by Tavernier's watercolor.[139]

Inevitably the canons were dispossessed during the Revolution, and the "royal" tombs seem to have been desecrated. A confused period during which the church was abandoned, its furnishings in part sold off, and further sales urged by the authorities is poorly documented except by Château. His manuscript account of 1829 is preserved in Soissons, by which time he served on the Council of the Fabric of Braine.[140] A sale of March 17, 1809, by the Fabric of Braine, of "materials coming from [the church's] partial destruction" is cited in a later document.[141] Valuable graphic and literary records of the 1820s attest to the church's dilapidated condition by then, such as the Dauzats engraving (Pl. 50), and curé Beaucamp's correspondence and publication that urged the preservation of the church.[142]

By 1825 the tide had turned momentarily in favor of the restored monarchy, and the curé hoped to reinstate Saint-Yved at least as a parish church; Charles X, newly crowned in Reims, had passed through Braine and promised to repair it, with its tombs. Work was begun in 1828, after considerable debate whether to restore or to demolish the west work and part of the nave, but it was interrupted after the July Revolution of 1830. When it resumed in 1832 the west end was demolished despite recent classification of the church as a historic monument, and Ludovic Vitet reported that he had arranged to have some of the sculpture from it carried to the municipal museum in Soissons (Pl. 66).

Ownership of this sculpture was bitterly contested in 1840–1841, at which time it was admitted that it had been sold to a M. Bruneteau who passed it on to the museum. By that time an urgent need was felt to reintegrate the original sculpture into the new facade, and the desire was also feverently expressed to bring back the original glass, which was said to have been used in the repair of Soissons Cathedral.[143]

In fact, new figural glass was provided for the most visible openings of Saint-Yved before the crossing tower was roofed, as documented in photographs.[144] The three axial windows in the clerestory of the hemicycle, the pair of flanking windows below, and the two pairs of windows in the easternmost chapels had new glass, whereas others were either blocked up or had plain quarry glazing (Pls. 48, 54, 59).[145] The axial window is still walled up, creating a niche for a large statue of the Virgin and Child, of the same period as the pieces from the west portals (Pl. 59). Work was still being done in 1862–1864, when the hope was again expressed that the original glass would be brought back.[146] On the whole the lengthy restoration was meticulously conducted, care for instance being taken at that time to reproduce the varied original designs of the foliate moldings.[147]

However, the demolition of the four westernmost bays of the nave, and especially of the west work, during the restorations of 1828–1848 has created an irreparable loss (Pls. 49, 50). Despite recent excavations, and an exhaustive graphic reconstruction based on these and on early drawings and descriptions, one's curiosity cannot be satisfied on a number of points concerning the unusual west end of Braine.[148]

The views recorded before demolition indicate that the west work had lateral gables, giving the impression of a western transept, apparently without towers (Fig. 10a; Pl. 50). The disposition of interior space could have utilized these transepts to lighten the west end of the nave, as at Mantes, and apparently also at Laon originally.[149] I have suggested that Braine was intended to evoke a Carolingian west work, such as Corvey, although its filiations are evidently complex; a Capetian model such as Mantes could have filtered these associa-

[139] Reproduced in Jean-Benjamin de La Borde, *Description Générale et particulière de la France*, vol. 6: *Description de l'Ile de France, Valois et comté de Senlis*, Paris, 1787–1789, pl. 34, and Klein, 1984, fig. 25.

[140] Château, MS 1019. A few contemporary documents in Soissons, Société Archéologique, MS 203, including correspondence concerning the "Vente des matériaux provenant de Saint-Yved de Braine," and in Laon, Archives Départementales, ID1, ID5, ID7–9, do not add significant information. The "Registre des Délibérations du conseil municipal de Braine," for 1793–1795 in Braine, Archives Municipales, was not available to me (cited by McClain, 1974, p. 187).

[141] Quoted by McClain, 1974, p. 169, from "Registre des Délibérations du conseil municipale de Braine," Archives Départementales ID8, pp. 99ff.

[142] A comprehensive listing of graphic and literary sources is given by McClain, 1974, pp. 186–88, and an extremely useful "Annals of the Restoration of Saint-Yved de Braine 1822–1853," with selected translations from the documents, is on pp. 151–77, on which the following summary is based. One of the principal sources for 1825–1826 is Paris, A. N., F¹⁹ 662.

[143] Prioux, 1846, p. 298n: "Une grande partie de ces vitraux a été utilisée dans la restauration des fenêtres de la cathédrale de Soissons, et le bas-relief du Jugement dernier a été transporté de l'église Saint-Yved au musée de Soissons. Il serait bien urgent que la ville de Braine revendiquât ces précieux objets d'art, dont son plus beau monument fut jadis doté par une main royale."

[144] Paris, Monuments Historiques, Archives Photographiques, Contretype cl. 537, south side of the apse; MH 28024, north side, showing scaffolding on the tower; MH 65206, interior to the east. I am extremely grateful to Harry Titus for the loan of these prints, which I was able to copy and enlarge in order to study the windows.

[145] This glass was replaced after World War II by J.-J. Gruber. Some remnants of the nineteenth-century panels are stored behind one of the altars.

[146] S. Prioux, "Réparation de l'ancienne Abbaye royale de Saint-Yved de Braine," newspaper clipping, Soissons, B. M., Coll. Périn no. 1038.

[147] Viollet-le-Duc and Maurice Ouradon replaced the sculptural friezes and oversaw the repairs to the windows and tower, the transept gables with their gargoyles, and the roof (S. Prioux, "Notice sur la Restauration de l'église de Saint-Yved de Braine," clipping dated 1866, Soissons, B.M., Coll. Périn no. 1039). The present moldings, evidently restored but not entirely renewed, correspond to those recorded in King and Hill, 1859, pl. IV, figs. 9, 9b, 10.

[148] McClain, 1974, chaps. 1–3. Her major conclusions are published in 1985 and 1986, and the following description relies heavily on them.

[149] Bony has acknowledged a debt to Braine at Mantes: Jean Bony, "La Collégiale de Mantes," *Congrès Archéologique* 104, *Paris-Mantes, 1946* (1947): 203, 204. For Laon, see William W. Clark, *Laon Cathedral: The Aesthetics of Space, Plan and Structure*, London, 1987, pp. 55–58, fig. 18.

tions.[150] Braine surely had a local following, at Wassy and Glennes.[151]

In the center of the facade a third gable rose to the same height as the transverse ones, but it surmounted a large rose window (Figs. 10a, 10b).[152] Below this level a pent roof jutted forward over projecting portals, a configuration that disguised massive buttresses and stairwells; this roof line, like the upper one, was interrupted by a central gable that accommodated the voussoirs of a large portal. This was flanked by smaller portals, with less salient porches.

An anonymous drawing reproduced by Klein, and an engraving published by King in 1857, showed that the tracery of the west rose resembled a spider's web, a type that Pestell characterized as "'open' centrifugal" (Figs. 10a, 10b).[153] Like the transept roses, it had currency elsewhere, notably in the east and west ends of Laon Cathedral, and in the west end of Notre-Dame-en-Vaux of Châlons-sur-Marne; an expanded form appeared in the transepts of Chartres, and eventually in the north transept of Châlons Cathedral. (Pl. 281).[154]

The sculpture of the central west portal and the related Virgin and Child now in the apse are justly celebrated (Pls. 234, 241, in addition to those cited below).[155] The Coronation of the Virgin from the tympanum is closer in style and composition to the north transept portal of Chartres than to the portal of Senlis, and the style has affinities with Laon (Pls. 189, 214, 238).[156] The whole portal has recently been reconstructed on the interior of the west end, as far as is possible from surviving stones, including the angel returned from the Musée-Saint-Léger (municipal museum) in Soissons (Pl. 65).[157] The only fragment not incorporated is a head from a column statue, still incongruously placed on a damaged tomb effigy from Braine in the museum.[158]

More problematic is whether the pieced-together fragments from a tympanum representing Christ in Limbo, still in the Soissons museum, was sculpted for

the north portal of the west facade, as McClain has argued (Pl. 66).[159] The rounded instead of pointed head makes it an awkward companion to the Coronation, and she has suggested that it was prepared earlier; this was clearly the case at Laon, where the tympanum and archivolts of a Last Judgment portal antedate the rest of the facade program by nearly fifty years.[160] Unfortunately the pieces seem to have been detached from their original setting before the earliest record of them; Prioux mentioned that a "Last Judgment" was displayed in the gallery below the west rose before the demolition.[161] An extremely unusual subject in monumental sculpture of the period, we shall see that it is relevant to the site and that its most probable position was indeed on the west facade.

The Dispersed Glass

THE HISTORY OF THE GLASS CA. 1700–1900

In 1724 Martène and Durand published the earliest preserved accounts of the library, the relics, and the program in the windows, which they greatly admired (Appendix 6a); the monument they visited had probably changed very little since about 1250. Soon after the middle of the eighteenth century Carlier published a fuller account of the glass, and a decade later it was proclaimed by Le Vieil to be among the most ancient in France; the latter based his description on notes provided by Jardel, which are likely to be accurate (Appendix 6c). Unpublished notes by Duflot, made in 1786, expand upon the account of the glass in the rose windows (Appendix 6d).

Yet in none of the post-Revolutionary documents is there any mention of glass remaining on the site, nor any record of its removal and sale. By 1825 the architect Duroche, who made detailed proposals for the restoration of the church, estimated the cost of providing new

[150] Howard Saalman, *Medieval Architecture*, New York, 1967, figs. 34–36. Bony has stressed royal partonage of Mantes throughout the second half of the twelfth century ("La Collégiale," pp. 165–66). Pierre Héliot, "Avant-nefs et Transepts de facade des XIIᵉ et XIIIᵉ siècles dans le nord de la France," *Gazette des Beaux-arts* 6th ser. 96 (1981): 58–60, has suggested that Carolingian and Ottonian types played a general role.

[151] Héliot gives Wassy precedence (p. 60) but an earlier date is suggested here for the construction at Braine. For Glennes, see Stanislas Prioux, "Répertoire Archéologique de l'arrondissement de Soissons, canton de Braine," *Bulletin de la Société historique et archéologique de Soissons* 16 (1862): 35–36.

[152] McClain, 1985, fig. 16.

[153] Paris, B. N., Est. Ve. 140 a vol. 29 (Coll. Fleury, "Braine"), f. 33, was reproduced in Klein, 1984, fig. 32; the drawing from King and Hill, 1857, pl. II, was reproduced in McClain, 1985, fig. 4b; Pestell, 1981, p. 5.

[154] Cowen, 1979, pls. 13, 32–35; and Anne Prache, "Notre-Dame-en-Vaux de Châlons-sur-Marne: Campagnes de construction," *Mémoires de la Société d'agriculture, commerce, sciences et arts de la Marne* 81 (1966): pl. XV; Suckale, 1981, fig. 4.

[155] Apart from detailed studies cited below, see Etienne Moreau-Nélaton, *Les Eglises de chez nous: Arondissement de Soissons*, Paris, 1914, 1:

figs. 127–28; Richard Hamann, "Die Salzwedeler Madonna," *Marburger Jahrbuch für Kunstwissenschaft* 3 (1927): 97; Marcel Aubert, *La Sculpture française au début de l'époque gothique*, Paris, 1929, p. 83, pl. LXXII; Palais du Louvre, *Cathédrales: Sculptures, vitraux, objets d'art, manuscrits des XIIᵉ et XIIIᵉ siècles*, exhibition (February–April), Paris, 1962, pp. 61–63, nos. 45–48 (illus.); Sauerländer, 1972, p. 429, pls. 74–75; Deuchler, 1973, pp. 55–56, figs. 61, 62, 70; *Courtauld Archives*, 3/12/103–28.

[156] Deuchler, 1967, pp. 161–62, fig. 237 (cf. fig. 233–36); McClain, 1974, chap. 4; *Courtauld Archives*, 3/6/55–70.

[157] Amédée Boinet, "L'ancien Portail de l'église Saint-Yved de Braine," *Congrés Archéologique* (Reims, 1911) 78 (1912): 259–78; cf. Maurice Berry, "La Reconstitution du tympan de l'eglise Saint-Yved de Braine," *Bulletin de la Société nationale des antiquaires de France* (1971): 235–43. See also McClain, 1974, chap. 2, and 1985, pp. 108–10.

[158] McClain, 1974, pp. 89–91, figs. 134–36.

[159] McClain, 1985, pp. 114–15. See also Amédée Boinet, "Le Tympan de Saint-Yved de Braine au musée de Soissons," *Bulletin Monumental* 72 (1908): 455–60.

[160] Sauerländer, 1972, p. 427; a lintel and outer archivolts were added ca. 1205 (pl. 69, upper).

[161] Prioux, 1859, p. 22. As Boinet pointed out, the title commonly given to the scene was incorrect.

armatures and leaded glass for thirty-two windows, amounting to half the openings, and suggested the others be eliminated; we have seen that this was the plan eventually carried out. His proposal for the three rose windows was to fill in the empty lights and paint the masonry to resemble stained glass.[162] In the 1840s and 1850s, as the restoration progressed and the need for glazing was anticipated, several authorities who might have heard it from eyewitnesses claimed that two hundred fifty panels of stained glass had been taken to Soissons, where they had been used to fill gaps in the windows of the cathedral that had been caused by the explosion of a powder depot in 1815.[163]

There is circumstantial evidence that supports this claim. Documents concerning the repairs to the cathedral indicate that funds were lacking for new colored glass, and although a windfall from Braine is not mentioned, it is indeed plausible in those circumstances. The estimates presented by the architect Duroche in 1815—the same who was in charge of restorations at Braine a decade later—included large sums for colored glass, but early the following year P. Garrez, inspecteur général, responded for the Ministry of the Interior that he thought this too expensive, and that for the present they should repair damaged panels with colored glass, but replace lost panels with white glass.[164] In fact the expenditures detailed in 1817 amount to little more than half the original estimate; there is mention of new panels of colored glass, but it is also clear that much old glass was repaired and a great deal of plain white glass supplied.[165] A drawing submitted in 1842 in relation to new plans for restoration indeed shows four lancets in the nave clerestory that retained about half the original grisaille panels and had plain quarry glazing mixed in, apparently randomly as if in replacement of broken panels.[166] However, an eloquent letter from Debully in the office of the prefecture, dated May 25, 1816, had referred to the problem of mixing colorless glass with colored, and the shocking effects that may result from bursts of bright light next to areas of more somber luminosity.[167] One

can well imagine that panels of colored glass, if they were available in a disused church, might have seemed the answer to a prayer for patching up the colored windows of the cathedral.

The struggle to have these panels returned to Braine was never as bitter as the quarrel over the sculptural fragments, but there are indications that the decision may have been made in 1868 to return them; by that time Edouard Didron aîné had been involved in a major restoration of the cathedral windows, and it was convenient to remove panels that were quite incongrous in scale and iconography. This restoration had been envisaged in 1842, as we have seen, when it was suggested that the grisailles of the nave be replaced with colored glass; this had been postponed, pending a report on the amount of old glass remaining.[168] It may be significant that this is the year Guilhermy began his detailed notes. Meanwhile, local antiquarian concern found expression in the formation of the Société historique et archéologique de Soissons, of which Edouard Didron aîné was a founding member.[169] The restoration was begun in the 1850s; in 1855 a report bearing Viollet-le-Duc's name stressed the urgency of these repairs, and Didron took some of the nave clerestory glass to Paris for restoration.[170] He was to relead the old glass completely and provide grisaille ornament to fill the lights. In 1860 he complained that he had not yet been paid.[171] The following year a budget was submitted for work on the windows of the apse and aisles, which continued through the decade.[172] This phase coincides with Guilhermy's corrections to his notes on the choir clerestory, including recognition of a figure of April that he saw in Didron's atelier in 1864. His notes spanning this period indicate the extent of the patchwork that existed in the windows. They confirm the impression of de Laprairie that following the introduction of glass from Braine it would have been nigh impossible to install the panels in an orderly way, and that they had been placed at random to achieve a general effect.[173] In Appendix 7a I have endeavored to extract from Guilhermy's notes the pieces that coincide with

[162] "Premier devis . . . Duroche, Soissons 8 fev. 1825," Paris, A. N., F¹⁹ 662, dossier 12655, f. 1ᵛ: "7° Le retablissement à neuf de la moitié des vitraux tant en fer que plomb et verre, l'autre moitié des baies pouvant être entièrement condamnés." F. 5v: "*Vitrerie*. Vitrerie en Panneaux de Verre et Plomb, contenant chaque croisée 21 Panneaux, lesquels produisent 7.24 carré à 10 Livres valent . . . 72.40. Et pour 32 semblables . . . 2316.80. Nota. Les 3 Roses ne sont pas comprises ni pour ferrure ni pour Vitrerie. On propose de Remplir les vides entre les Rayons et peindre le fond en forme de vitreaux."

[163] Guilhermy may have been the first to record this claim; his notes in Braine were made some time after 1820, and he relied on Carlier for the former contents of the windows, saying that all the glass had gone, and that a good deal of it had been taken to Soissons; see the text in Appendix 6e. See also Prioux, 1846, p. 298; de Laprairie, "Notes" (cited below, n. 173); Prioux, 1859, p. 23; Edouard Fleury, *Antiquités et Monuments du département de l'Aisne*, Paris, 1882, 4: 121, 124.

[164] Duroche, "Devis sommaire," 1815, P. Garrez, "Rapport du Conseil des Batiments Civiles," 1815, "Observations," April 22, 1816, and M. G[arrez], May 2, 1816, Paris, A.N., F¹⁹ 7887, dossier 1681, ff. 1–2.

[165] Duroche, September 30, 1817, "Travaux de 1817 sur le fonds de 7000 francs: Cathédrale de Soissons: Vitrerie," A.N. F¹⁹ 7887.

[166] "Exercise 1842," in "Extrait du Rapport fait au Conseil Général des Bâtimens civils," February 20, 1843, and letter of January 24, 1844, A.N. F¹⁹ 7887.

[167] A.N. F¹⁹ 7887.

[168] Accounts for 1842–1843, including the devis (estimate) submitted, and the budget allocated, June 19, 1843, A.N. F¹⁹ 7887, dossier 10539.

[169] *Bulletin de la Société historique et archéologique de Soissons* 1 (1847): 33–34.

[170] "Rapport de l'Architecte Diocésain sur les dépenses à faire en 1855," and other documents of 1855, A.N. F¹⁹ 7888.

[171] Letter of April 4, 1860, A.N. F¹⁹ 7888.

[172] A.N. F¹⁹ 7888. The largest budget is for 1865.

[173] de Laprairie, "Notes . . . sur la provenance des vitraux de la cathédrale, et sur leurs diverses vicissitudes," *Bulletin de la Société archéologique de Soissons* 5 (1851): 105: "Pour réparer cet immense désastre, on ramassa les fragments qui n'avaient pas été mis en poudre, et l'on fit venir de Braisne deux cent cinquante panneaux provenant de

subjects recorded earlier in Braine, or which can be argued on more circumstantial grounds to come from there.

Next there is evidence of an attempt to bring some order to the glass of the cathedral. In 1868 and 1869 mention is made of new greenish glass for some choir clerestory windows, and in 1870 uncolored glass was to replace ancient glass in some part of the building.[174] A letter from Edouard Corroyer, architect in the office of the Ministry of Justice and Religion, dated June 7, 1884, sheds some light on these expenditures (Appendix 7b). He referred to an earlier authorization to take down some of the ancient glass and put it in one of the dependencies of the cathedral, stating that it was among the most beautiful examples of French glass of the twelfth or thirteenth centuries, much more worthy of exhibition at the Union Centrale des Arts Décoratifs than the figured glass of the nave of Soissons; he further stated that M. Didron would be able to choose from these panels in his atelier for the exhibition. Yet none of these panels are recognizable in the exhibition catalogue.[175] Unfortunately neither this authorization nor detailed estimates for glass restoration made in 1869 are preserved among the dossiers in the Archives Nationales, so I can only speculate that the intention had been to return them to Braine;[176] the timing would have been ideal, since we have seen that the window openings there were completed by 1866.

Corroyer, however, had submitted revised budgets for the restoration of the glass in the cathedral in 1877.[177] Increases in costs were explained in part by 15 percent inflation, in part by the fact that five large windows had not been included in the 1869 estimates. Perhaps those five, or an equivalent amount of glass, had been destined for the other church in the diocese. In 1882 the glass was taken out of five windows of the rondpoint of the apse clerestory, and others in the chapels, and stored in twenty cases in one of the towers, where they supposedly remained locked until 1889.[178] In that year Edouard Didron jeune was entrusted with the restoration of the Jesse Tree window in the axis of the hemicycle.[179] By 1905 the superb figure of the Virgin from that window

was in the Berlin Museums, where it seems since to have been destroyed, while Raymond Pitcairn eventually acquired the bust of a king that had been on the Paris market before 1910.[180] In 1890 Félix Gaudin won the commission from Didron for the restoration of three other windows in the apse clerestory.[181] Among them was one on the north side with four seated ancestors of Christ and several medallions that are the only recognizable panels of Braine glass left in the cathedral, a mere twenty-six of the two hundred fifty allegedly shipped there nearly a century earlier (Catalogue A, nos. 1–4, 17, 18, 20–24, 26–30; Catalogue D, B.o.1–2).[182] Gaudin does not seem to have had access to the original medallion with Grammar that complemented the Liberal Arts in the apse clerestory window, since his new design bears no resemblance to it. Probably most of the glass eliminated from Soissons had remained in Didron's atelier, since many panels seem to have come onto the Paris market soon after his nephew's death in 1902, but there is also a possibility that some were removed from the storage crates in Soissons in the 1880s.

GLASS SURVIVING ELSEWHERE

In view of the inadequate documentation of the removal and dispersal of the glass from Braine, and the fact that no original glass survives on the site, the claim that numerous panels in collections were made for Saint-Yved has to be argued on multiple grounds—iconographic, stylistic, and archaeological—as well as from the circumstantial evidence provided by the documents. There is a chain of interlocking evidence supporting the claim that much of the Braine glass was indeed taken to Soissons early in the nineteenth century: first, the presence in Soissons Cathedral of panels that are not in situ, that do not fit any of the openings there, and that belong to a different stylistic group than the cathedral's glass; second, confirmation from measurements that these panels would in fact fit the openings in Saint-Yved; third, subject matter that coincides with the eighteenth-century accounts of the Braine program and with Guilhermy's account of misplaced panels seen in Soissons; fourth,

l'ancienne abbaye de Saint-Ived. Il aurait été difficile de mettre de l'ordre dans ce pêle-mêle de vitraux; aussi tout fut-il replacé au hasard et seulement pour l'effet." The chaotic arrangement that prevailed beyond the middle of the nineteenth century is reconstructed by Beaven, MS, 1989, appendix 1, pp. 147–74, fig. 2a, b, c.

[174] A.N. F19 7888.

[175] Magne, 1884; in most cases the provenance is given.

[176] There are frequent references to authorization for a general restoration of the glass, apparently dated 6/10/1869, e.g. under February 11, 1884 in A.N. F19 7888.

[177] "Etat de situation de la restauration des vitraux," February 15, 1877, A.N. F19 7888.

[178] "Note de Contrôle 1883," A.N. F19 7888. The glass was taken down by Jules Hermerie, "peintre et vitrier à Soissons." A letter from the architect to the minister, dated August 1, 1889, pleads for a budget for restoration.

[179] Document of October 23, 1889, A.N. F19 7888. He offered a re-

bate of 18 percent as compared with 12.5 percent by Charles Leprévost and 10 percent by Eugène Oudinot.

[180] *Vitrail*, pl. 92; Hayward and Cahn, 1982, p. 140. For a full listing of dispersed glass from Soissons Cathedral, see Caviness, Pastan, and Beaven, 1984, p. 10. Didron seems to have been in the habit of keeping back panels from restoration in his shop; Guilhermy remarked that he had kept pieces from Gassicourt; these later passed into the Homberg collection in Paris and thence to a private collection in Massachusetts (*Corpus Vitrearum USA Checklist* I, p. 68). An unconfirmed rumor reached Jean Ancien that the Virgin survives in private hands in the Deutsche Demokratische Republik.

[181] Documents for 1890 and 1891, A.N. F19 7890.

[182] A useful restoration schema based on my examination of the glass in 1979, with an indication of the subjects, is given in Ancien, 1980a, facing p. 87. I have counted the foliate lobes, discussed below, as separate panels.

stylistic comparisons, combined with coincidence of subject matter, and of measurements, that identify panels in other collections as part of the same series.

The strongest case for a Braine provenance can be argued for several foliate lobes and figural medallions, now in the second clerestory lancet to the north of the axial window in the apse of Soissons, as restored by Gaudin in 1890. They would fit the existing stonework of the north transept rose of Braine, and in most cases conform with the subjects seen in the roses in the eighteenth century (Pl. 244). Three pairs of ornamental lobes, with palmettes of two different designs on blue grounds framed in red edges, have been used as stopgaps to fill the spandrels over three large seated figures representing ancestors of Christ (Catalogue D, B.o.1–2; Pls. 182, 190, 193). With the addition of a second edging line they would exactly fit any of the twelve cusps of the central field of the north transept rose.[183] They are of two designs: One is dominated by a heart-shaped palmette that fans out from a green calyx; the other centers on a stem that terminates in a yellow berry cluster. Two more lobes, identical in size and of the first design, are similarly incorporated into a figural panel now in the Glencairn Museum (Catalogue A, no. 8).

The stonework of the south rose appears to have been identical to that on the north, so any of the elements that fit the existing masonry could have come from either rose (Pls. 48–50, 54a, 58, 244). The foliate lobes may have been distributed on the north and south according to type, but it is equally probable they were alternated in the same composition; each has an analogue in the north rose of Laon Cathedral where the designs are alternated (Catalogue D, B.o.1–2). These are the only pieces of ornament that can be proved to come from Braine, although the candidacy of some borders will be discussed later.[184]

Also divided between Soissons and the Glencairn Museum are figural medallions that fit the Braine roses (Catalogue A, nos. 17–30).[185] The best-preserved panels are in Soissons, in the same window as the ancestors of

Christ (Col. Pl. 20). Eleven medallions of fairly uniform size are evidently remnants of five iconographic series.

Two series introduce a temporal theme. Near the top of the Soissons window the bearded figure of Winter, inscribed *Hyem .* , in green tunic and rose-purple hooded cape, carries a bundle of firewood on his back (Pl. 226). In the Glencairn Museum a similar figure of Spring or *Ver*, whose yellow cape, however, leaves his head uncovered, holds a nest full of young birds before him and a budding spray in the other hand (Col. Pl. 23; Pl. 221).[186] Below Winter in Soissons a medallion with a young man in a rose purple tunic pruning vines is inscribed *Marci'* indicating the labor of the month of March (Pl. 223). This tallies with evidence from Guilhermy's notes, and from Poquet and Daras, that the month of April was once also in Soissons; the former confirmed his reading of the inscription, and the attributes of a flower and a key, in Didron's atelier having first seen it in the Dormition of the Virgin Window in the apse clerestory (Appendix 7a, f. 256). A counterpart to the twelve labors of the months were twelve signs of the zodiac, of which only two somewhat restored medallions are preserved in Soissons and a third may be in a private collection in Germany (Catalogue A, nos. 23–25). The series was completed by Gaudin and now flanks Salathiel and Amminadab in the midzone of the window, with the original medallions inscribed *Gemini* and *Sagittarius* to the left (Pl. 228). Restoration and paint loss has somewhat disfigured the nude twins, although the original outline of the thighs is responsible for giving them the appearance of loosely jointed mannequins. In addition to these, Guilhermy had described a small figure with a flower, inscribed *Virgo*, and the sign of Pisces (Appendix 7a). The first has disappeared, but a panel inscribed *Pisc .* , evidently cut down in size and then augmented by edging lines to match Spring and Grammar, was offered to Raymond Pitcairn with them in April 1924.[187] Unfortunately the present location of this piece, or a replica of it, has not been disclosed (no. 25).[188]

There is evidence of both these cycles in Braine before

[183] The lobes measure 23 centimeters vertically and 28–29 centimeters across. The stonework of the rose, measured on Prioux's scale drawings, would accommodate panels 25 by 30 centimeters; in cases where his measurements could be checked, they were accurate. It is important to note that these pieces would be too small for the equivalent lobes of the Vaux-sous-Laon rose, and too large for Saint-Michel-en-Thiérache (see Catalogue B).

[184] A lobe with a radiating design of similar palmettes is in the Glencairn Museum, 03.SG.71. As Hayward points out, its large size (31.8 by 37.5 centimeters), harsher coloring, and harder execution indicate another provenance, perhaps the Cathedral of Soissons, although Laon would also be a candidate: Hayward and Cahn, 1982, no. 54, pp. 145–47. See also Michael W. Cothren in *Corpus Vitrearum USA Checklist* II, p. 114.

[185] These vary in diameter from 46 to 49 centimeters, including the red edging that is occasionally overlapped by the feet; each radiating petalic light in the stonework allows three circles this size, with an edging line added to give a diameter of 55 centimeters. It may be noted

that the dimensions at Vaux-sous-Laon and Saint-Michel are again different (Catalogue B).

[186] Jane Hayward in *Medieval Art*, no. 186 (ascribed to Picardy or Champagne, ca. 1220); Hayward and Cahn, 1982, pp. 125–27, no. 47A; Caviness, 1985, p. 34; Michael W. Cothren in *Corpus Vitrearum USA Checklist* II, p. 109.

[187] A photograph from Henri Leman, showing the three medallions leaded into a modern grisaille lancet, is in the Glencairn Museum; the glass went through the sale room later that year. The detached panel with Pisces, measuring 57 centimeters in diameter, seems to have been sold again at auction on the liquidation of Arnold Seligmann, Rey & Co. in 1947. I am most grateful to Jane Hayward for both references, for which see Catalogue A, no. 25.

[188] What appears to be the Pisces from the Leman composition was recognized by Willibald Sauerländer in a private collection. Like Grammar, this is a case where Gaudin's new piece has little in common with the original, one indication that they had long since left Soissons.

the Revolution. The signs of the zodiac and a calendar, presumably meaning the months, had been noted by Carlier and Duflot in the south transept rose (Appendix 6). Paired in the outer periphery of the "petals," they would have exactly filled the twelve lights; the reconstruction will be considered later (Pl. 244).

Carlier is quite definite that twelve apostles and twenty-four elders were to be seen in the north rose at Braine, and they would also exactly fill the two rings of medallions. Preserved in Soissons, in the summit of the "Braine Window" of the clerestory, is a nimbed and crowned king holding a flask and a viol, evidently one of the elders (Catalogue A, no. 30). Guilhermy saw another king with a vase and plectrum in the rose over the doublet of the third clerestory bay from the west on the south side of the nave of Soissons, and a third, nimbed and crowned, with a vase, in another of the clerestory roses (Appendix 7a, ff. 225v, 256v).[189] And although de Florival and Midoux recorded similar subjects in the east rose of Vaux-sous-Laon, the different dimensions of the stonework make it an unlikely provenance (Catalogue B).[190]

Lowest in the Soissons window in Gaudin's arrangement are the Liberal Arts, of which Music and Geometry are well preserved, whereas Grammar, Dialectic, Rhetoric, Arithmetic, and Astronomy are new (Col. Pl. 20).[191] The original figures are represented as female personifications, with long green robes, purple mantles, and white kerchiefs, each labeled in yellow and seated at their tasks (Pls. 233, 237, and Catalogue A, nos. 17, 18). Music is playing a carillon of bells while Geometry plies her compasses at a drawing board. A figure of Grammar in rather poor condition in the Glencairn Museum has been recognized as part of this series (Col. Pl. 24; Pl. 231; and Catalogue A, no. 19).[192] The medallion is badly corroded, but it shows an authentic outline of Grammer, with kerchief, pale yellow mantle, and green robe, seated in much the same posture as Music but reversed. She holds a birch and points at an open book held by a young pupil who is seated at her feet, wearing the white cowl of the Premonstratensian order.[193]

Lastly there are four angels in medallions in the Soissons window, one censing, another with hands outstretched in supplication, and a pair offering crowns (Pl. 218, and Catalogue A, nos. 26–29). Although these subjects were not noticed in Braine by any of the early authors, there can be no doubt from their style and dimensions that they belong with the other series.

The compositions of all these medallions from the rose windows are distinctive. Figures are elegantly positioned, their outstretched hands serving to balance them in their tondi (Pls. 218, 221, 223). It is remarkable how well each is adjusted to the rotating angles of the rose; in working out the reconstruction only one position was "right" for each composition, many of which have an element that parallels the spokes of the rose (Pl. 244). Further examination reveals a consistently miniaturesque style. Draperies form delicate catenary folds, and they hug the shoulders and thighs (Pls. 218, 233, 237). The palette is also distinctive, favoring a soft cool yellow combined with white, green, and purple (Col. Pls. 23, 24). There is a marked distinction from the stronger palette of well-preserved panels that originally occupied one of the lower windows in Soissons; nor do the Braine figures have the volumetric swathes of drapery slashed by *muldenfalten* that are typical of the cathedral glass (Pls. 184, 278).[194]

As we have seen, the foliate lobes from the rose windows have been placed so as to fill the spandrels over Jechoniah, Amminadab, and Salathiel in Soissons, and Jacob in the Glencairn Museum (Pls. 182, 190, 193, and Catalogue A, no. 8). Presumably the incongruous arrangement over these ancestors dates from the 1816 restoration of Soissons, when the Braine glass was used as stopgaps, but their association does not necessarily prove that the figures also came from Braine.[195] The cryptic reference by Martène and Durand to prefigurations or precursors of Christ taken from the Old Testament is ambiguous; the later descriptions refer to subjects from the New and Old Testaments, suggesting a typological cycle (Appendix 6). The Maurist fathers

[189] Although each rose in the clerestory would accommodate a medallion in the center, these were clearly not in situ there—the program seems to have consisted of large busts of crowned kings and queens, some of which are still in position (Ancien, 1980a, Pls. 4 and 8 between pp. 183–84). Another series of Elders, dating from about 1250, was apparently in situ in the west rose, according to Poquet and Daras, 1848, pp. 67–68; one is now in storage in Champs-sur-Marne, with two figures of prophets, a related bust-length Foolish Virgin, and some ornamental lobes as well as nineteenth-century complements. These were discovered by Jean Ancien in cases in the Cathedral; see Ancien, 1980a, pp. 181–83, and Madeline H. Caviness and Virginia C. Raguin, "Another Dispersed Window from Soissons: A Tree of Jesse in the Sainte-Chapelle Style," *Gesta* 20 (1981): pl. 5. I am grateful to Jean Ancien, Catherine Brisac, and Michael Cothren for an opportunity to examine this glass together, and for access to the inventory made by J.-J. Gruber. Deuchler, MS, 1956, 1: 143, noted that Elders from Braine were lost, but compared the program with that of the east rose of Laon.

[190] Thirteenth-century medallions with an Evangelist, apostles, and prophets were reported as irreparably broken in an explosion of 1870: Florival and Midoux, 1882, 1: 1–2.

[191] Some have been mistaken for authentic panels in previous publications, cited in Caviness, 1985, p. 45, n. 34. Thorough examination was made from the exterior sill in 1979.

[192] I am grateful to the Rev. Pryke of the Glencairn Museum for permission to examine this, and other pieces in storage, and to make rubbings.

[193] Hayward may be correct in suggesting that the purple drapery over the knees belonged to a second figure, unless it is an undergarment.

[194] For the section of the St. Nicasius and St. Eutropia window in the Gardner Museum in Boston, see Caviness, Pastan, and Beaven, 1984, pls. 5, 10, 11, and col. cover; *Corpus Vitrearum USA Checklist* 1, col. pl. p. 15.

[195] A photograph discovered by Jean Ancien shows the arrangement of the glass before it was taken down in 1882 (Paris, Archives Photographiques, MH 194.109, illus. Ancien, 1980b, facing p. 13); the heads of three figures with the lobes in the spandrels above can be seen, but otherwise radical changes have been made to give order to the subjects and a great many miscellaneous panels must have been eliminated by Gaudin.

may, however, have intended to refer to ancestors of Christ. The figures in fact comfortably fit the original dimensions of the clerestory openings of Braine if they are paired one above the other (Pl. 79);[196] it is crucial to note that the sills were built up by a course of masonry, splayed on the inside, after Prioux's measured drawings were made (Pl. 57).[197] Furthermore, despite a more hieratic mode and their large scale, the softly clinging drapery with catenary folds and meandering hems, and the predominance of purple, white, green and pale yellow serve to link these figures with the medallions from the rose windows (Col. Pls. 11, 12, 20–24; Cf. Pls. 193 and 237, 199 and 218).

Close observation of the physical qualities of the large figures in the "Braine window" in Soissons has now led to recognition of a relatively large group of pieces from the same series (Catalogue A, nos. 1–16). Indeed, for a considerable period of time a number of life-sized seated figures in stained glass had puzzled art historians; their provenance was variously suggested as Sens Cathedral, Braine or the Aisne, Saint-Remi of Reims or Champagne, and Canterbury. They are scattered in collections on both sides of the Atlantic and prior to 1982 had not been viewed as a group.[198] The extent of restoration to each figure and the techniques used to make replacements look old, the suspicion that at least one fake derived from the series, and the obscure provenance of pieces in American collections had served to prevent a full evaluation of these important early Gothic figures.[199] The entire group is closely connected in design and in style of execution with some of the Canterbury windows, and with those of Saint-Remi, yet the figures are scaled to fit perfectly the clerestory openings of Saint-Yved; and inscriptions, where preserved, conform to names in the Biblical genealogies of Christ, indicating a coherent iconographic series that has a counterpart at Canterbury (Appendix 4; Pls. 78, 79).

These seated figures are remarkably homogeneous as a group; this is especially apparent when rubbings of the leadlines are assembled together or laid over each other: There is a uniform shoe size, proportion of the limbs, shoulder width, and, in most cases, head size, and even identical sweeping lines of drapery, that indicate that

they were designed in series. It is as if each is composed from a repertory of set parts, or drawn with the same gestural strokes. Each figure was originally composed of three rectangular glazing panels, so that the horizontal bars of the window armatures passed through the chest and below the knees; parts of at least twenty-four such panels survive (Catalogue A, nos. 1–16). They have been completed, in the nineteenth century judging by the glasses and lead, to form eleven figures and a bust, but belonged originally to at least sixteen different figures; in two cases the fact that the mantle and robe at the neck do not match those lower down has been cleverly disguised by the restorer (Col. Pls. 11, 12; Pl. 202; and Catalogue A, nos. 5, 6, 12, 13).

Because the documents indicate a strong probability that some of the glass in the cathedral was brought from Braine, the Soissons figures will be used to give an initial definition of the compositional and stylistic parameters of the group, before attributing others to Braine; detailed observations that support the argument are placed in Catalogue A. Each of the figures in Soissons is named in an inscription; their present arrangement, one above the other, places *Cainan* in the top of the window, then *Salathiel, Amminadab*, and *Iechonias* (Col. Pl. 20). As has been noted by others, all are ancestors of Christ.[200]

Best preserved is Amminadab, the only figure from which all three glazing panels are extant, and which therefore gives an accurate dimension for the whole figure (Pl. 182; and Catalogue A, no. 1).[201] The patriarch is bare-headed and nimbed; seated on a high-backed throne he turns his head in three-quarter view to our right and gestures with the palm of his left hand open; the right hand lightly clasps a fold in his mantle. The composition has a monumental clarity; the figure is tightly outlined within the rectilinear frame of the throne, and geometric precisions control the outline of the halo and the curve of the inscription above. Yet there is little indication of volume or space in figure or setting. Elegantly tapering tracelines suggest a drapery that is smoothed and flattened over the shins, and similar lines give the sinews of the backs of the hands the appearance of the seams of a glove; the mantle is caught into decorative swirls and these passages are emphasized by pro-

[196] The present clerestory windows measure 3.92 by 1.43 meters, but if one allows 20 to 30 centimeters for a course of stonework added to the sills, the original openings would have been about 4.22 to 4.32 meters high. This would accommodate six panels about 61 centimeters in height, and a border of 30 centimeters in the top and bottom (total 4.26 meters). The width allows panels measuring 80 centimeters and borders of 30 centimeters (total 1.40 meters). The figure panels now in Soissons measure 61 by 80 centimeters, with modern edges: See Catalogue A, nos. 1–16 for the range.

[197] Prioux, 1859, "Coupe Longitudinale," and King and Hill, 1857, pl. 10, offer confirmation of the level of the sills. See also n. 109 above.

[198] Madeline H. Caviness, "Glass from Saint-Yved of Braine," International Center of Medieval Art Session on Medieval Art in North American Collections, Seventeenth International Congress on Medieval Studies, Kalamazoo, May 1982—since expanded and published in 1985.

[199] In 1975 Grodecki expressed the opinion that the figure in the

Philadelphia Museum of Art and lower two-thirds of Abiud in New York were fakes; see Catalogue A, nos. 6, 7). Close examination has revealed a core of original glass with much palimpsest glass skillfully used in restoration; original paint was cleaned off fragments of the right color by means of acid, and repainted and fired; examples are in the face and neck of Iacob, and in the throne base of Abiud (Catalogue A, nos. 7, 8). None of these figures can be traced back beyond European dealers of ca. 1905–1925, even if they can be identified earlier in Soissons through Guilhermy's notes.

[200] Caviness, 1977a, p. 40; Caviness, 1981, p. 16; Mlle. Jeanne Vinsot first drew my attention to the resemblances to the Canterbury genealogy, in 1971. See also *Corpus Vitrearum France Recensement* I, p. 171; Ancien, 1980a, p. 86.

[201] This was the only figure that could be closely examined from the exterior wall passage, and rubbings made of the lower panels; the rest of the window was seen from the hydraulic ladder of a fire truck, but I was unable to touch the glass.

nounced hooked folds or troughs, but the overall design remains two-dimensional. Only in the large triangular folds around the upper arm and shoulders do these troughs seem to convey the tensions of a heavy fabric draped around a volumetric human form. The face is substantially modeled and finely drawn, including minute creases between the eyes and at their outer corners, yet it lacks clarity in its bony structure; the chin is decoratively outlined with a circinate line that defies its plasticity. Flat bands of decorative patterns or textural marks articulate much of the surface of the panels, both in the throne and in the draperies. Most of the bands are emphasized by color, although the clarity of the monumental design is preserved in the yellow frame of the throne. This feature and the insert red panels of the base and back, provide a brilliant setting for the figure in which cool hues of green and white predominate. The hair is thickly painted on a corroded glass that may have been amethyst, against a red halo edged in white. The inscription is also white, the letters in reserve. A modern edging to the blue ground describes a pointed arch; the ornamental cusps that are used in the spandrels have already been identified as part of the glazing of one of the rose windows.

Before summarizing the range of design and execution present in the rest of this series, it will be useful to establish the contrast between Amminadab and figures that were made for the clerestory at Soissons, since it parallels distinctions noticed between the small-scale medallions. The heavily restored Tree of Jesse in the axial window is in situ, and very large figures, evidently once arranged two to a lancet and thus twice as large as the figures from Braine, are now in collections. The lower king in the Soissons Jesse window demonstrates the salient features of this group, although the head is restored (Pl. 184).[202] The broad feet and tubular legs turn out symmetrically, in contrast to the more elegant asymmetry of the "pose" in the Braine series (Pls. 185, 193); the hemline, though following an almost regular horizontal, is articulated by deep troughed folds giving the garment more body, and the skirt flares out; the knees are massive, forming a stable platform. The torso appears somewhat narrow and elongated, tapering to narrow shoulders; the mantle sweeps across the arm without articulating it and masks the volumes of the body by its own three-dimensional character, dominated by insistent *muldenfalten*. These traits are constant, though exaggerated, in the larger-scale figures that I have identified in the Glencairn Museum and in the Wal-

ters Art Gallery (Pl. 278).[203] Furthermore, the well-preserved upper half of another king from the Soissons Jesse window now in the Glencairn Museum was exhibited in 1982 alongside a composite king from Braine, inviting a contrast of the color harmonies as well as the design and style; the brilliant yellow of the Soissons king's mantle and crown, combined with a red band and nimbus and purple robe give a hot tonality quite distinct from the cool and crisp green, white, and blue, with accents of pale yellow and red, of the Braine figure (Col. Pl. 12).[204] This delicate palette has already been noted in the medallions from the roses (Col. Pls. 23, 34).

The King Jechoniah from Braine, now in Soissons, represented nimbed and crowned, with a scepter in his right hand, had been altered in appearance by the replacement panel in the center; the style of restoration is more energetic than the original, both in its modeling and in the arm set akimbo and breaking through the frame of the throne (Pl. 193, and Catalogue A, no. 3).[205] The composition of the upper and lower parts of the figure offer close comparison with Amminadab and the colors are comparable, although the painter may not be the same. The draperies over the legs are more plastically conceived; the hem of the mantle describes a series of folds that zigzag into depth and deeply curving catenary folds fall between the legs; a stiffer note is provided by the nested v-folds in the skirt and the final impression is of gaunt limbs to which the fabric clings tightly.

Salathiel, of whom the bottom panel is entirely new, also demonstrates variations in the execution, although the design belongs to the same series (Pl. 190, and Catalogue A, no. 4). The proportions of the figure differ from those of Amminadab and Jechoniah: His head, without a nimbus, is unusually large, his shoulders, intended to turn back into space, appear very narrow, and his gesture is more angular.

The fourth figure, Cainan, is extremely fragmentary; the lower third is new and the upper panels heavily restored (Catalogue A, no. 2).[206] The original drapery, on much of the shoulders, chest, stomach, and left knee, is painted with tapering tracelines and hooked folds like those of Amminadab, and his left hand has the usual sinews. The color scheme and composition depart, however, from those of the figures discussed so far, in that the hues give brighter contrasts. Also unusual is the book held in one hand.[207]

Four figures preserved elsewhere that I maintain belong to the series in fact have low canopies intact and were evidently seated on backless thrones, and four oth-

[202] The least restored of the Soissons Jesse figures, the Virgin from higher in the window, was acquired by the Berlin Museums, and see n. 180 above.

[203] *Corpus Vitrearum USA Checklist* II, pp. 111, 57; and see M. H. Caviness, "Ein Spiel des Zusammensetzens: Rekonstruktion der Hochchorglasfenster in der Kathedrale von Soissons," in *Festschrift für Edgar Lehmann*, ed. Erhard Drachenberg, Berlin, 1989.

[204] Hayward and Cahn, 1982, nos. 52, 46, color frontispiece, and pl. v.

[205] Again it is apparent that when Gaudin restored the figure in 1890

he could not have had an original panel to copy; nor was he as sensitive to the original style as the restorer who handled the figures in Baltimore (Catalogue A, nos. 2–4; cf. 12–14).

[206] The lower part of the face, which survived World War I damage, shows corrosion and backpainting outside, but the style as seen from the interior is suspect; it may have been heavily retouched in a previous restoration, or even used as a stopgap in reverse.

[207] A corner of the blue binding is old and the restoration probably appropriate; "Sophonias" in Baltimore holds a book also.

ers indicate vestiges of this arrangement. The best pre-served is in the City Art Museum of St. Louis, although here too the lower third is new and the upper panels heavily restored (Col. Pl. 22; Pl. 199; and Catalogue A, no. 11).[208] The figure is beardless, without nimbus; he holds a furled scroll in his left hand and gestures with the other, with the forefinger pointed to our right in the di-rection of his glance.

The painterly treatment of the St. Louis figure resem-bles that of Amminadab and Cainan in the general char-acter of the trace and modeling, including hooked folds; several triangular pouches are also present, and the sys-tem of the mantle as it is caught over one arm and falls behind the other to twist, ropelike, over the lap is much like that of Amminadab (Pl. 182). Yet there are modifi-cations in the execution that suggest an evolution within the atelier; stylized knuckles are added to the sinewy hands, the eyes are larger and more staring without sub-tle creases at the corners, the furrows of the brow are more pronounced, and there is a disjunction in the struc-ture of the face by which the nose is viewed in three-quarter view to the left while the chin is outlined on the right side (Pl. 71, 74). The hand is evidently not the same that was responsible for the more sensitive execu-tion of the face of Amminadab (Pl. 182). Overall one might perceive a trend toward clarity and monumental-ity at the expense of naturalistic detail, but there is noth-ing perfunctory or careless about the painting; exami-nation on the bench revealed a sophisticated control of two modeling washes, the densest placed on the exterior surface of the glass, and certainty and vigor in the appli-cation of the tracelines (Pls. 71, 72).

Next to be considered are two fragments in the Glen-cairn Museum. The authenticity of the first, inscribed *Iacob*, appears dubious, but Guilhermy attested to the presence of a seated and beardless figure under an arch, so labeled, in Soissons (Catalogue A, no. 8; and Appen-dix 7a). Except for a few pieces of white and rose-purple drapery, and the rose-purple hair, the figure has been somewhat tampered with.[209] Yet the cutline resembles that of the St. Louis figure so the general design may be original (Pl. 199).

Equally altered by the restorer is the incomplete figure of a king with a scepter seen by Guilhermy in the Chapel of St. Paul at Soissons; a bust under a canopy now in the Glencairn Museum has been completed with a modern center panel, and with the skirt and feet of yet another figure from the series (Col. Pl. 12; Pl. 194; and Cata-logue A, nos. 9, 10); the mantle on the shoulders is white, over a bright rose-purple robe, whereas the skirt

of the robe is white with a green mantle over it, lined in red.[210] The figure may be compared with King Jechoni-ah in Soissons, and points of resemblance include the broad neck, the fall of the mantle over one shoulder, and the domed imperial crown (Pl. 193). However, the coarser traceline in the drapery and beard, the broad face, and staring eyes are closer to those of Salathiel (Pl. 190).

A fifth figure with a canopy is in the Walters Art Gal-lery in Baltimore (Pl. 202, upper panel; and Catalogue A, no. 12).[211] Once more, it appears that it has been completed with fragments of another figure as well as a bottom panel that is entirely modern. The mantle draped around the neck, of a very unusual amethyst color, is not matched in the rose-purple mantle of the center part (Col. Pl. 21). Behind the head passes a frag-mentary inscription that had been completed to give "*Thadeus*," but the supposed apostle is not nimbed and the restorer has given him shoes. The separate leading of the beard departs from all other known figures of the series, although the square form it gives to the mouth is no surprise when compared with the outlining of Am-minadab's lips, and the head is no larger in actual size than that of the figure in St. Louis, allowing for the beard, or the king in Philadelphia (Pls. 182, 199, 204). The soft curves of the drapery around the neck are rem-iniscent of Amminadab's mantle, though less logical, and the execution is close to passages in Salathiel (Pl. 190). The figure is framed by red columns and an arch with turrets and masonry filling the spandrels.

The companion figure in Baltimore is labeled "*So-phonias*" in the modern upper panel, which was evi-dently restored with a canopy to form a pair with "Thadeus" (Pl. 203, and Catalogue A, no. 14). The au-thentic red columns that flank the throne in the bottom panel, however, indicate that the figure belonged to the type with such a baldachin. The figure gestures with his right hand and holds a blue book in the left, as did Cainan (no. 2). Decorative colored bands and cuffs, v-folds over the left shin, and zigzagging pleats in the man-tle recall similar features in Jechoniah (Pl. 193); the sys-tem of draping the mantle and its hooked folds are close to that of Amminadab (Pl. 182).

Another panel with the lower third of a figure, some-what similar to "Sophonias" in the foursquare position of the legs and feet and the use of a footrest, has been completed by a restorer who incorporated an original nimbus and palimpsest letters D and A, rewritten to form the name band *David* (Pl. 196, and Catalogue A, no. 15-16). Once in the Hearst collection, it was ac-

[208] Robin Zierau helped with the examination in storage.

[209] Notably, the green neckband is new, and the face and neck and beginning of the inscription show signs of acid cleaning; the features are overpainted and the beard probably added. Thorough examination of the piece was carried out in 1982, when it was also seen by members of the Corpus Vitrearum attending the colloquium that year, who confirmed my observations.

[210] This incompatibility was accommodated by the restorer when he

supplied the center part, by continuing the white mantle over the upper arms and draping a second mantle, of green to match the lower one, over the forearms so that its red lining masks the juncture of purple bodice and white skirt in the robe.

[211] I am grateful to Richard Randall for access to restoration charts made by Rowan Lecomte in 1966 when he releaded these panels; I ex-amined the glass from a ladder, but from the inside only.

quired by Forest Lawn Cemetery in 1956 and subsequently damaged in a fire.[212] Columns flanking the lower part of the throne may be original, but it was the restorer who provided the upper panel with an ornate canopy, including trilobe arch and even a late Gothic superstructure.[213]

As noted in the Introduction, the bust of Abiud now in the Metropolitan Museum, New York, has turned out to belong to the Braine series, despite its long-standing attribution to Saint-Remi of Reims (Col. Pl. 11, Pl. 192; and Catalogue A, no. 5).[214] The head and shoulders have been completed by the lower parts of another figure, which will be described separately. Abiud belongs to the same type as the Jechoniah, Amminadab, and Salathiel in Soissons, in that he is framed in a pointed arch, has a red nimbus, and is seated on a throne with a high yellow back. Other affinities with Jechoniah include the open frame of the throne back, the way the white mantle is draped over his left shoulder, the frontal view of the face with eyes averted to our left, and the drawing of the beard, nose, and wrinkled brow (Pl. 193).

The lower two-thirds of a figure that entered the Metropolitan collection with Abiud has long been thought to be largely modern (Col. Pl. 11; Pl. 185; and Catalogue A, no. 6). This may be explained by the suspiciously good state of preservation of the glasses, especially in contrast to the top panel, and in addition by the fact that the torso is evidently not well scaled to the head and shoulders. However, recent examination, including prying up many leads to find grozed edges, and the stylistic comparisons that can now be made with other figures, especially Amminadab, have led me to conclude that the design is essentially authentic.[215] Like Amminadab and Salathiel, this figure holds a fold of his mantle in one hand, while gesturing with the other; the position of his right hand, with forefinger pointed to his left, is like that of the St. Louis figure (Pls. 182, 190, 199). The painting of the hands, with their glovelike sinews, is familiar. The throne has features resembling those of Jechoniah and "Sophonias" (Pls. 193, 203). The general system of drapery and the position of the legs and feet closely resemble those of Amminadab, and the painting of the looping fold of the mantle, with hooked folds, is almost identical (Pl. 182). The color scheme, with green and white masses and some blue accents, warmed by purple and yellow decorative passages, is the same as others of

the group, and the hands are of the same streaky purple.

Apparent inconsistencies in color between the two panels attached to Abiud might lead to the suspicion that even these belonged to different figures, but the design is so perfectly coordinated that the two must have been made from the same cutline. The color distribution may better be explained by unusually elaborate garments: A long white tunic with blue cuffs and belt is worn over a purple robe with green hem and blue band in the skirt. In addition, a bright warm green mantle, with yellow decorative band, hugs the outlines of the torso. The brilliance and complexity of the garments recalls those of King David in Saint-Remi (Col. Pl. 10; Pl. 172).

The central panel of a figure with a scepter in the Philadelphia Museum of Art has also been taken to be modern because of the uncorroded appearance of the warm green mantle and white robe (Pl. 204, and Catalogue A, no. 7).[216] It has in fact been completed by a frontal head on a red ground under a garish modern canopy.[217] The authentic section of the figure shows a red throne back between yellow uprights, which the restorer has mistaken for columns. The lower part, which contains a few old fragments, is as awkward and unimaginative as those of "Thadeus" or the St. Louis figure, with a broad skirt and a large footrest drawn in inverse perspective (nos. 11 and 13). The center part, however, is close in conception to the authentic parts of Cainan (no. 2), and to passages in the St. Louis figure and the central panel attached to Abiud (Pls. 185, 199).

It remains to consider only one more fragment, the lower panel of the king in the Glencairn Museum (Pl. 194b, and Catalogue A, no. 9). The moldings of the throne base have a similar profile to that of Jechoniah, but the angle of the feet and footrest belong to the type of "Sophonias" and the lower panel of Abiud. Both composition and execution offer similarities to Jechoniah in that stiff, vertical folds in the skirt are contrasted with softer catenary folds between the legs and with the subtle plasticity of the hem of the mantle (Pl. 193).

Laborious comparison of the figures enumerated here, with the aid of rubbings of all but Amminadab, Salathiel, and Cainan, has confirmed the impression from photographs that the cutlines are in many cases adapted one from another. The scale and proportion of the figures is uniform, with the exception of the slightly larger heads of Salathiel and Abiud. Most unfortunately, every

[212] Its rediscovery in storage is due to the efforts of Jane Hayward with whom I examined the piece in 1986.

[213] The restorer does not seem to have had cutlines of the other figures of the series, since the panel sizes do not match. The crown contains palimpsest glass, formerly drapery.

[214] See Introduction, n. 20. Against this attribution is the fact that Abiud was not a prophet, so he is unlikely to have been included in the retrochoir program of Saint-Remi; he appears only in the Biblical genealogies, 1 Chron. 8:3 and Matt. 1:13. Furthermore, all the heads and shoulders of the frontal figures in that series—that is, in the center lancet of each triplet—are quite well preserved in situ. There are other irreconcilable features: Despite similar overall dimensions (a height and width of 195 by 89 centimeters for Abiud, and 192 by 84 centi-

meters in the case of figures such as "Osée" in N.V b at Saint-Remi), the panel sizes are different (a height of 67 centimeters for Abiud but e.g. 63 centimeters for "Osée"), and the placement of the inscriptions differs, at the level of the neck in Saint-Remi and slightly higher in Abiud and others of the Braine series.

[215] I am grateful to Jane Hayward of the Cloisters for agreeing to this examination, with the assistance of a conservator, in 1982. A rubbing in the Corpus Vitrearum archive at the Cloisters indicates the edges seen, as well as the extent of restoration found.

[216] As by Grodecki. On first examination in 1965 I agreed with this view, but I had not yet seen other authentic panels from Braine.

[217] The hair is original, and most of the face appears to be old glass but repainted with a substantially altered design.

figure but Amminadab is disfigured by extensive restorations, amounting to at least a third of new glass in every case. And the only complete figure of the series is one of the four that remained in Soissons, constantly exposed to the elements at clerestory level, so it is darkened by corrosion. Nonetheless, the original composition and program of the figures can be reconstructed with some confidence.

The Program of the Glass

THE CLERESTORY LANCETS

The original use of a canopy over eight of the large seated figures of ancestors just discussed and the presence instead of a high-backed throne for the five require explanation. If it was not for the turrets and masonry filling the spandrels over "Thadeus," it might be questioned whether the figures framed under round arches were made for Romanesque window openings, whereas the others are clearly outlined by pointed Gothic arches (Pls. 193, 202a). A logical explanation is provided by the original arrangement of Amminadab and Nahshon in a single light in Canterbury (Pl. 78); the lower figure is under an arch with slender columns that appear to support the throne dais of the upper, and the head and shoulders of the upper figure extend into the apex of the window.[218] Such an arrangement proves entirely satisfactory as tested by a scale montage of Jechoniah and the Pitcairn king, since with the addition of a decorative border of normal dimensions they exactly fit the original openings in the clerestory of Saint-Yved (Pl. 79).[219]

Other variations follow the use or absence of a canopy. A red nimbus, for instance, is given to Jechoniah, Amminadab, and Abiud, figures originally in the apex of their lights; an exception in this category is Salathiel whose long arching name band and large lead with domical cap scarcely leave room for a halo (Pl. 190). In the case of lower figures, under canopies, the nimbus is consistently omitted, but a red ground behind the heads of Cainan and the Pitcairn king and red bands framing the inscription of Jacob provide comparable accents in visual terms (Catalogue A, nos. 11, 12; cf. nos. 8, 9). Similarly, the vertical rungs of the high throne backs, present only for the upper figures, are analogous to the slender column shafts that flank the lower figures, even to the point that both are normally yellow, or occasionally red, and they are never used together. None of these variations is consistent with iconographic types, patriarchs and kings being treated indifferently as far as their

setting goes. Similarly, footstools cannot be associated with one or the other setting, and no iconographic association can be established.[220] In general the designs seem to have been generated by a flexibility and pragmatism that encouraged variety. In the same vein, although the top of the name band is most commonly aligned with the eyes, as in Abiud and Jacob, it might be adjusted higher, above the throne back in the case of Jechoniah, or lower in the case of the St. Louis figure, or even curved above the head to accommodate long names such as Amminadab and Salathiel (Col. Pl. 11, 21, 22; Pls. 182, 190, 192, 193). It is sometimes placed between colored bands, and the lettering, always in reserve, is variously white or yellow.

A few iconographic features appear frequently in this group: All the figures are shod, most gesture with one hand as if speaking, some hold a book or a scroll (though more often they simply clasp a fold of the mantle), and a few have crowns or Jewish caps. These characteristics are consistent with Old Testament patriarchs, such as those in the retrochoir of Saint-Remi, but the authentic name bands in fact identify them as ancestors of Christ. Thus not only the formal arrangement and style, which are comparable with a pair of figures from the "middle period" at Canterbury, but also the very theme of the program find their closest parallel in the English cathedral (Appendix 4).

The pointing finger and sideways glance of several of the figures becomes significant in this context; at Canterbury these were directed toward the east, with very few exceptions.[221] By analogy, assuming the series began with Adam on the north side of the building at the west side, Amminadab, Cainan, "Thadeus," the figure of St. Louis, and the one that complements Abiud would have been positioned on the north side of the church of Braine, whereas Jechoniah, Salathiel, and Abiud would be on the south. The frontal gazes of Jacob and the Pitcairn king are neutral.

So far as the identity of the surviving figures from Braine can be established, all apparently belonged to an extended genealogy of Christ that was drawn, like that at Canterbury, from two Biblical sources; the ancestors named in Luke 3:23–38 and Matthew 1:1–16 are listed and numbered in Appendix 4, where they are compared with the preserved figures from Braine and Canterbury. The earliest ancestor that can be identified in the Saint-Yved series is Cainan, whose name appears twice in Luke's list (Luke, nos. 4 and 13). His early occurrences in the texts confirm the north side position suggested on the basis of his turn toward our right. Jacob probably

[218] In this case the reconstruction was derived from the iconographic sequence, an eighteenth-century account of the subjects in the clerestory before the figures were moved to the west window, and the fact that the original window number was scratched on the faces at this time; the montage uses the armature that remained in situ. See Caviness, 1981, pp. 10–11, 36–37.

[219] This arrangement was suggested long ago, by Orin Skinner, for the St. Louis figure.

[220] Footstools are given to "Sophonias," and to the three figures that complement Abiud, the Pitcairn king, and the restored David; of these, the first and last may have had canopies originally, whereas the other two did not.

[221] Caviness, 1981, pp. 8–9, pls. 9, 14–17, 36, 38, 43, 44, 48–51, 53, 55, 60, 61, 63, 65, 68, 69, 72, 73, 78, 81, 82 (from the north side); cf. 88, 90, 93, 96, 99, 101, 106, 109 (from the south). Four surviving figures do not conform: pls. 75, 76, 104, 110.

came next (Luke, no. 23, and Matthew, no. 2), but the name also occurs later in Matthew's tree (no. 39). Amminadab (Luke, no. 28, and Matthew, no. 8), Jechoniah (Matthew, no. 28) and Abiud (Matthew, no. 31) came before or after Jacob. Jechoniah had a son called Salathiel (Matthew, no. 29) but these two figures cannot be consecutive since both were made for the upper part of a lancet; the surviving Salathiel must be the son of Neri (Luke, no. 55), from the opposite side of the building. Perusal of the Biblical lists indicates that Cainan must have been taken from Luke's longer genealogy, whereas Jechoniah and Abiud occur only in Matthew's list. Furthermore, it appears that "Thadeus," of which the "H" "A" and "E" are old, should be reconstructed as Phalec (Luke, no. 16) or Phares (Luke, no. 25, and Matthew, no. 5) from the north side. The St. Louis figure, with "M," "L" and perhaps "E," gestures to our right and is therefore more probably Melea (Luke, no. 38) from the north side, than Melchi (Luke, nos. 53 and 71) who would have been on the south (Pl. 199). However, caution has to be used in these two cases, since the letters are separately leaded and could have been misplaced.

The Canterbury genealogical program is the most complete known, and is unusual in drawing extensively on Matthew as well as Luke; it comprised eighty-eight figures including the Creator, the Virgin, and Christ, and extended from the northwest end of the choir through the transepts and Trinity Chapel to end on the south side (Appendix 4).[222] The clerestory of the entire church of Braine could have comprised only thirty-five lancets, counting four in the westwork, or a maximum of seventy seated figures. Yet despite the resemblances suggested here, the Saint-Yved series was not merely a selection from the Canterbury cycle; Abiud, for instance, was not among the ancestors taken from Matthew there. Nor is the Braine series any closer to the one at Saint-Remi, although it also drew on both texts, and included Abiud (Appendix 4); those standing figures offer no compositional analogues to these, and the liberal bestowing of royal regalia does not seem to be mirrored in Braine.[223] Given the royal connections of the Premonstratensian abbey, it is perhaps surprising to note no special emphasis laid on the royal lineage of Christ.[224]

The eighteenth-century descriptions of Braine refer to an image of the Virgin and Child at the end of the sanctuary, behind the main altar, no doubt in one of the axial lancets (Appendix 6). This raises the question whether they occupied the central position in the clerestory, as they did in the retrochoir of Saint-Remi (Pl. 141).[225] The

decision to give the Virgin and Child such an honored position would have been in keeping with the dedication of the church of Braine. The arrangement may thus have differed from that at Canterbury, where a Last Judgment was eventually placed in the eastern axis of the clerestory, and the Virgin presumably took her place at the end of the genealogy, on the south side of the choir. The close compositional and stylistic affinities between the Braine series and a few figures from the first bays of the Trinity Chapel at Canterbury, notably Amminadab and Nahshon, confirm some contact between the two sites at a time when the execution of the English program was well advanced but as yet not complete at the east end. In fact there are signs of some hesitation at Canterbury whether or not to place the Virgin and Christ in the axial window; Joseph, who was paired with Achim on the north side next to the axial window of the Trinity Chapel, should have been an immediate precursor of Christ, but the series instead was interrupted by the Last Judgment and then awkwardly reverted to Luke's list on the south side, out of chronological sequence. Thus, Braine proves to have had the more coherent program, consistent with its completion in a single campaign.

The early descriptions also indicate that Agnes of Braine and Robert of Dreux knelt at the Virgin's feet. The two figures had inscriptions above them: *Robertus Comes* and *Agnes Comitessa*. His effigy was certainly commemorative, whereas Agnes's might have been placed there in her lifetime (Appendix 6). They complement the tombs, since the count was buried elsewhere, and the countess's slab had no inscription (Pl. 62a). Guilhermy also mentions, at second hand, a representation of "St. Bernard"; the founder of the order, St. Norbert, who would also have worn white, was more probably intended, although he was not canonized until so much later.[226] "Beata Agnes," the founder of the house at Braine, and even her granddaughter who founded the new church of Saint-Yved, would have had parity with Norbert, still known as "beatus" in that era. Whether this figure was immediately adjacent is not clear; if so it would have broken the sequence of ancestors of Christ in the hemicycle. More probably it was in a lower window.

The founders together presented a model of the church to the Virgin. The dedication of the church was to Evodius as well as to Mary, but she seems to have been given greater attention in the programs; it will be recalled that Evodius's relics were not brought to the new church until 1244. The presence of the Virgin in the

[222] The only comparable contemporary cycle known is the seventy busts formerly in the wall paintings of the chapter house at Sigena, of which the remnants are preserved in the Barcelona Museum of Catalan Art: Caviness, 1977a, pp. 108–11. A shorter cycle was included in the Gothic program of Strasbourg Cathedral, in the north nave triforium, ca. 1240: Christiane Wild-Block in Beyer et al., 1986, pp. 261–62, 265–83, pls. 236–55.

[223] See Chapter 2. Among those surviving from Braine, only parts of three figures with scepters are to be listed, as compared with ten common patriarchs, and the only one named, Jechoniah, was a Biblical

king.

[224] Nor can the contrary be proved: There is no evidence to indicate whether the Canterbury tendency to suppress the regalia even of legitimate kings was followed in Braine.

[225] Less probably, given the scale that is implied, these images could have been in the lower window. The nineteenth-century glazier placed quite large kneeling figures of the donors, as described, in this window; above them was a Gothic canopy, and the Virgin and Child (Pl. 59).

[226] See n. 30 above.

axial window is relevant to the rose windows that occupy the other three cardinal points.

THE ROSE WINDOWS

The indications concerning the contents of the three great rose windows of the transepts and west facade are fuller and more precise than for the other windows (Appendix 6). The attention paid to them in the eighteenth century reflects both their dominance over the interior space, and their thematic complexity. The contents were not completely inventoried before the dispersal of the glass, however; questions will inevitably remain about the choice and placement of subjects, although some satisfaction is achieved by the attempt to visualize them in situ (Pl. 244). To some extent comparison with other examples, almost all of them later in date, aids in the process. The stonework of the Braine roses may be supposed to date from about 1185–1195 in the transepts and perhaps as late as 1200–1205 in the destroyed west end.

The reconstruction of the north rose program is the most straightforward, even though scarcely any of the glass recorded in it in the eighteenth century has survived. The texts call for the apostles and elders, which would fit the twenty-four medallions of the periphery and the twelve circles closer to the hub; we have seen that one elder is in Soissons (Catalogue A, no. 30). The east window of Laon, in which the tracery is identical to the west rose of Braine, places the Virgin and Child in the center of the apostles and elders.[227] The vast north rose of Notre-Dame in Paris of about 1255 placed the Virgin and Child among the prophets, kings, and patriarchs of the Old Testament, in multiples of sixteen.[228] In similar stonework, the north rose of Tours Cathedral multiplies the ranks of elders and prophets surrounding martyred saints and the Virgin.[229] Thus the Virgin might be expected to be in the center of the rose on the north side of the church, as also for instance at Chartres.[230] It is less likely that the elders and apostles at Braine belonged to an apocalyptic vision, with Christ in Majesty of the Second Coming in the center. This is the subject of the rose window in the south transept of Chartres given by Peter "Mauclerc," son of Robert II of Dreux, but it lacks the apostles (Pl. 281).[231]

The south transept rose, originally with identical stonework, gives more difficulty since an overabundance of subjects is referred to in the descriptions: Duflot listed celestial signs and constellations to which Carlier

added a calendar, and both referred to the triumph of virtues over vices and of religion over heresy (Appendix 6). The difficulty is compounded by the number of surviving subjects from these cycles, which indeed include the signs of the zodiac, and labors of both months and seasons (Catalogue A, nos. 20–25). The south transept rose of Lausanne Cathedral provides one of the few examples of a calendar extended to include four seasons as well as twelve months; the arrangement is entirely logical, since the stonework allows groupings of three months around each season, such as March, April, and May with Spring.[232] The signs of the zodiac are grouped in threes around each of the four elements.[233] As we have seen, in the south rose of Braine, the signs of the zodiac and labors of the months would logically fill the twenty-four medallions on the periphery, paired like those of the calendar pages in the psalters (Pls. 227, 244). This would leave room for twelve more medallions of the same size in the inner circle, four of which probably contained the seasons which would be evenly distributed (Pl. 244).

Two other subjects—the "triumph of the virtues over the vices, and of religion over heresy"—were also supposedly in the south rose window. An analogous association can be cited in the early thirteenth-century pavement in the Trinity Chapel of Canterbury Cathedral, which appears to have included Sobrietas and Luxuria among the labors of the months and signs of the zodiac.[234] A psychomachaea is more fully preserved in the west rose of Notre-Dame in Paris, alongside the months and signs of the zodiac, and even with the addition of twelve prophets encircling the Virgin and Child; personified Virtues in the upper half of the rim menace examples of their contrary Vices positioned in smaller medallions closer to the hub, while the labors of the months and the signs of the zodiac are similarly positioned in the lower half.[235] Such an extended program is scarcely possible in the "single" rose composition of Braine, and Carlier may have confused his list with the more famous Parisian cycle. Yet the triumph of Religion is a tantalizing suggestion, in view of the prosecution of Cathars in Braine in 1205; such an image might either have been looked to as an example, or made shortly after the trial so that it would not be forgotten. In the nave clerestory of Soissons Cathedral, adjacent to the north transept, Poquet and Daras saw a figure of "Religion, dressed like a queen and carrying the cross," that has since disappeared; it was not even recorded by Guilhermy (Appendix 7, f. 255v).[236] It is probable that Faith, or even Eccle-

[227] Deuchler, 1967, pp. 150–51, 153; Cowen, 1979, pls. 31, 32.

[228] Aubert et al., 1959, pp. 19, 36–37, pls. 5–6bis; Cowen, 1979, pls. 11, 40.

[229] *Corpus Vitrearum France Recensement* II, p. 130, with bibliography (sixteen "petals," however, should give thirty-two prophets, not twenty-six as here); Cowen, 1979, pl. 64 (wrongly labeled the south rose).

[230] Delaporte and Houvet, 1926, 1: 496–99, 3: pls. CCLIV–CCLVII; Cowen, 1979, pls. 6, 7. Four doves of the Holy Spirit, four censing angels, and four cherubim surround the Virgin, with twelve Old Testament kings in the next zone and twelve prophets on the periphery.

[231] Delaporte and Houvet, 1926, 1: 431–36, 3: pl. CIC; Cowen, 1979, pls. 10, 35–37.

[232] Beer, 1956, pp. 28, 32, 34–43, pls. 3–17; idem, "Les Vitraux du moyen âge de la cathédrale," in *La Cathédrale de Lausanne*, by Jean-Charles Baudet et al., Bern, 1975, pp. 221–24, fig. 299; Cowen, 1979, pp. 130–31.

[233] Beer, 1956, pp. 28, 30, 32, 43–50, pls. 3–4 and 18–27, col. pl. 4.

[234] Eames, 1982, pp. 68–69, pls. XV B, XVI B and C. The stones are no longer in their original configuration.

[235] Aubert et al., 1959, pl. 2, pp. 25, 31–34.

[236] Poquet and Daras, 1848, p. 67.

sia, was originally seated in majesty trampling heresy underfoot in the central opening of the rose (Pl. 244).[237] One is reminded of Wisdom goading Ignorance and Sloth in the Saint-Remi floor mosaic, where it is the culmination of sets of the Virtues and the Liberal Arts (Fig. 3).

The most likely reconstruction of the south rose is presented in Pl. 244. I have rejected the presence of other virtues and vices, even though they are invoked by Duflot and Carlier, in favor of accommodating a full series of Liberal Arts, of which three survive: Grammar from the Trivium and Music and Geometry from the Quadrivium (Catalogue A, nos. 17–19).[238] These panels are exactly the same size as the other medallions and would have fit either transept rose, but they cannot be accommodated on the north side. Whereas a normal cycle of the arts comprises seven, the four seasons could have been dispersed in the south rose, in cross formation, between eight Liberal Arts (Pl. 244). The north rose of Laon Cathedral, which may be slightly earlier, added Medicine to the curriculum in order to fill eight medallions, surrounding a figure that is restored as Philosophy (Pl. 243).[239] Correspondences between the two roses have already been noticed in the ornament, and the figure of Grammar at Laon also resembles the one from Braine except in the secular status of her pupils, as befits a cathedral school (Col. Pl. 24; Pls. 213, 232). In view of this, the south rose of Braine may be regarded as an elaboration on the simpler program of the north rose of Laon, and a precursor of the encyclopedic programs of Paris and Lausanne.[240] Its secular subjects were governed by Religion.

The specific iconography of the months and seasons deserves to be examined in more depth. As indicated by

Kroos, the attributes given to Spring are not rare in themselves, but the bird's nest is more often associated with Summer, the season of joy and fruitfulness, or with the month of May (Col. Pl. 23; Pl. 221).[241] In the Lausanne rose, Spring has only the budding branch, and the bearded head is restored.[242] The mature age of the bearded man in the Braine panel might suggest identification with Summer, but there can be no doubt about its authenticity. The iconography of the seasons was in fact borrowed from the earlier traditions for the months, and May belongs to Spring. In the same way the Winter from Braine has a parallel in the calendar illustration for November in the Ingeborg Psalter, although the hooded figure there is more stooped under a double load of faggots (Pls. 226, 227).[243]

That calendar also provides a parallel for the figure of March from Braine, although in the manuscript his head is covered like Winter (Pls. 223, 224). In the scene for March in the west rose of Notre-Dame in Paris the youthful vigneron's hood has slipped off and his posture mirrors that of the Braine figure, although a spade thrust in the ground behind him fills out the composition (Pl. 225).[244] The lost figure of April, apparently standing, has a counterpart in the Ingeborg Psalter, but in that case the youth holds leafy branches in both hands, whereas Guilhermy, who saw this medallion in the atelier, insisted on a key in one hand, and referred to him as a king (Appendix 7).[245] April is crowned in the Lausanne rose and opens the gate of his garden in accordance with the etymologies of Isidore of Seville that associated *aprilis* with *aperilis* or "he who opens the earth in flower"; Beer noted the affinity with the lost Braine figure.[246]

Carlier and Duflot agree that the west rose, its gallery then occupied by the organ, contained a Last Judgment.

[237] For discussion of this point, I am grateful to Ellen Beer, who believes this was the arrangement.

[238] The alternative hypothesis is that the four seasons were dispersed between four Virtues and only four Arts. Guilhermy saw two crowned female busts inscribed *Misericordia* and *Iusticia* in Soissons Cathedral, but there is no indication that they came from Braine; they were in the roses of the choir clerestory, and may well be the "queens" still to be seen, though without inscriptions now (Appendix 7). Four Virtues are in the earlier north oculus of Canterbury but they are in a different iconographic context, associated with an Old Testament program that includes Moses and Synagogue in the center and four prophets around them; see Caviness, 1977a, p. 104, figs. 105–7; Caviness, 1981, pp. 24–29, figs. 27–35. The complementary subjects on the south side at Canterbury were presumably Christ with Ecclesia, Faith, Hope, Charity and another Virtue, and the Evangelists. Furthermore, if the four seasons and as many as four Virtues were in the "petals" of the south rose of Saint-Yved, they would leave room for only four more subjects, but if four Arts were selected surely they would be the Quadrivium. Perhaps Carlier mistook the Arts for Virtues, and he was followed by Duflot.

[239] Unfortunately this rose was severely damaged by an explosion in 1870, and only four subjects escaped in part, but among them are fragments of Medicine with a vial: Deuchler, MS, 1956, 1: 23, 165–66. Florival and Midoux, 1891, 4: 53, cites other augmented series: ten figures in the Laon facade sculpture, twelve in the Sens portal, and a total of thirty-two at Reims. For some earlier examples of arts arranged as a wheel, see Philippe Verdier, "L'iconographie des arts li-

béraux dans l'art et philosophie au moyen âge," in *Arts libéraux et philosophie au moyen âge*, Actes du quatrième congrès international de philosophie médiévale, Montreal and Paris, 1969, pp. 316–17.

[240] Beer suggested that the Arts were represented in a lancet under the rose window at Lausanne (1952, p. 68).

[241] Renate Kroos, "Zur Ikonographie zeitensockels im Snütgen-Museum," *Wallraf-Richartz Jahrbuch* 32 (1970): 54–55. One Swabian psalter of the mid-twelfth century is cited as having a similar figure for May (n. 43), and she follows *Medieval Art*, no. 186, in suggesting that the inscription in the glass has been restored incorrectly (n. 57).

[242] Beer, 1956, p. 34, pl. 5. The long undergarment, however, suggests a female figure originally.

[243] Yet another parallel between the two series is provided by the posture of a sower—casting behind him the seed held in the pouch of his mantle draped over his left arm—for October (Deuchler, 1967, fig. 10); the modulus could have been adapted for spring in Braine by the addition of attributes. There are other rather general resemblances, as in Gemini and Pisces (Deucher, 1967, figs. 13c and 2). The two cycles are not entirely interdependent, however: Sagittarius in the psalter is a centaur, whereas in Braine he is a faun (Deuchler, 1967, fig. 11; cf. my Catalogue A, no. 24).

[244] Aubert et al., 1959, p. 33, [pl. 4]. A somewhat comparable figure in Lausanne is bearded and has a cap on his head: Beer, 1956, p. 37, pl. 9.

[245] Deuchler, 1967, fig. 4.

[246] Beer, 1956, pp. 37–38, pl. 10.

There are several later examples of Judgment roses, many of them with a similar placement. This may recall the medieval etymology that derived *occidens* (west) from *occidere* (to die), as Mâle pointed out.[247] Examples include Laon, Chartres, and Mantes, whereas at Donnemarie-en-Montois the Judgment rose is in the east end, and at Lincoln it is in the north transept.[248]

The medallions with angels preserved in Soissons should come from the west rose since the place was not found for them in the transepts (Pl. 218, and Catalogue A, nos. 26–29). The Chartres west rose in fact has an inner ring of small medallions with four Evangelist symbols distributed between eight half-length angels, who seem to pray or proffer gifts like the ones in Soissons (Pl. 245).[249] Six half-length angels emerge from cloud banks in the inner quatrefoils of the Mantes window, variously weeping or holding instruments of the Passion, whereas the trumpeting angels in this band are full-length.[250] In both these cases, the central figure is a Christ in Majesty displaying the wounds, as might be predicted from the instruments of the Passion. The Braine angels would better suit a glorification, although the crowns might be thought of as offered to the saved.

The outer periphery of Last Judgment roses generally has figures rising from their graves in the lower panels, with scenes of heaven and hell above. A few fragmentary scenes of the dead rising are preserved in the west rose of Laon despite damage to the west end in 1852, and the fact that the destroyed stonework of the west rose of Braine appears in the engravings to resemble that of Laon, might lead one to expect a thematic association, as was found for the other roses (Figs. 10a, 10b).[251] Thus these panels have raised the issue whether four similar ones in the Glencairn Museum could have originated in Braine.[252] Yet stylistic affinities with the Soissons glass, noticed by Hayward, and even the use of a design that appears based on one profile figure used in the restora-

tion of the Last Judgment lancet in the apse clerestory there, suggest rather that they were eliminated from that window during the restoration.

In a final resort it is unlikely that the roses of Braine can be fully reconstructed unless more complete descriptions are found. The comparative material already referred to indicates the extent to which the themes that tended to be used in early Gothic roses were mixed and blended. Although the subjects were always perfectly accommodated to the numerology of the stonework—or vice-versa—there was considerable flexibility in combining elements, and few combinations that can be described as normative.

Yet certain general themes have emerged. They involve time and eternity, but not history; there are no narratives, only cycles, no events, only images or icons. The high seriousness of the transept rose programs of Lincoln was emphasized soon after 1200 in the *Metrical Life of St. Hugh*, which singled out these windows for comment. They were likened to the two great lights, the sun and the moon, and did not depend on them, but shone without the sun and darkened without cloudiness; the greater was a symbol of the dean, the lesser the deacon; the north signifies the devil, the south, the Holy Spirit; and they are the two eyes of the church, one looking on the south to invite, the other on the north to evade; seeing the one, the viewer may be saved, seeing the other he may avoid damnation.[253] It is worth noting that the context is the saintly life of the bishop who built the cathedral; it was viewed as his work of piety as much as Saint-Yved was that of Agnes, and the greatest glory of his creation, as hers, was the stained glass windows.

No doubt an important part of the aura of the rose window was its geometric reflection of divine order. The circle was an ancient symbol of perfection, suitable to convey the divine and celestial.[254] The square, though not as perfectly symmetrical, was also a symbol of or-

[247] Mâle, 1958, pp. 5–6.

[248] For Laon, See Florival and Midoux, 1891, 4: 75–82; for Chartres, Delaporte and Houvet, 1926, 1: 519–21, 3: pls. CCLXXV–CCLXXXII; for Mantes, Guilhermy, MS 6103, ff. 139–140v, 150, and *Corpus Vitrearum France Recensement* I, p. 131, fig. 74. Françoise Perrot, "La Rose de l'église de Donnemarie-en-Montois," *Bulletin de la Société d'histoire et d'archéologie de Provins* 124 (1970): 53–69, who notes a general resemblance to the composition of the transept roses of Braine (p. 56); for Lincoln, Morgan, 1983, pp. 14–17, pls. 1, 8, with bibliography.

[249] There are also four large medallions with pairs of full-length trumpeting angels, and two with single figures holding instruments of the Passion, among those that fill the remainder of each petaled light; Delaporte and Houvet, 1926, 1: 519, 3: pls. CCLXXV–VII; a detail showing the smaller angel is in Cowen, 1979, p. 86.

[250] Cowen, 1979, pl. 65, and p. 42.

[251] The whole program at Laon cannot be reconstructed with certainty: Deuchler, MS, 1956, 1: 22, reviews the documents; Didron restored the remnants of the rose in 1875.

[252] 03 SG 204–207. Grodecki's opinion is quoted by Hayward and Cahn, 1982, pp. 132–34, nos. 49 A–D. These figures seem to be fragments from a restorer's bench, made up into octofoils about 35 centimeters across; see Cothren in *Corpus Vitrearum USA Checklist* II, p. 115.

[253] *Life of Saint Hugh*, pp. 34, 36, lines 896–909, 937–45:

Splendida praetendit oculis aenigmata duplex
Pompa fenestrarum; cives inscripta supernae
Urbis, et arma quibus Stygium domuere tyrannum.
Maioresque duae, tamquam duo lumina; quorum
Orbiculare iubar, fines aquilonis et austri
Respiciens, gemina premit omnes luce fenestras.
Illae conferri possunt vulgaribus astris;
Haec duo sunt, unum quasi sol, aliud quasi luna.
Sic caput ecclesiae duo candelabra serenant,
Vivis et variis imitata coloribus irim;
Non imitata quidem, sed praecellentia, nam sol,
Quando repercutitur in nubibus, efficit irim;
Illa duo sine sole micant, sine nube coruscant.
...

Praebentes gemine iubar orbiculare fenestrae,
Ecclesiae duo sunt oculi: recteque videtur
Major in his esse praesul, minor esse decanus.
Est aquilo zabulus, est Sanctus Spiritus auster;
Quos oculi duo respiciunt. Nam respicit austrum
Praesul, ut invitet; aquilonem vero decanus,
Ut vitet: videt hic ut salvetur, videt ille
Ne pereat. Frons ecclesiae candelabra coeli,
Et tenebras Lethes, oculis circumspicit istis.

[254] Caviness, 1983, pp. 103–4.

der, and the canted square frequently signified earth.[255] The stonework of the Lausanne window aptly expresses both forms, since the program is chiefly concerned with terrestrial hierarchies; indeed Beer has shown the extent to which it depends on earlier diagrams of the ordered universe.[256] Floor mosaics, since they inherently have the character of a *mappa mundi*, are often found to be forerunners of programs in rose windows, and it is not surprising to note the coincidences between the Saint-Remi choir pavement, with its circles within squares presenting the zodiac and the Biblical authors, and the arrangement of the Braine roses (Fig. 3; Pl. 244). Diagrams of the Virtues in twelfth-century school books also favored a concentric arrangement.[257] This layout focused on a unique central element, and the developed rose compositions invited an arrangement of ranks that passed from an elite near that central figure to larger classes placed more distantly, each with a predictable numerical relationship to the other. What is added to these schemata in rose windows, as previously on a smaller scale and more dimly in candlewheels, is brilliant light, itself a symbol of divinity.[258] Suckale has commented on the way that the early Gothic windows are composed with the lighted elements in mind, openings for instance being placed on the vertical and horizontal axes, whereas by 1260 or so, when the west rose of Reims Cathedral was composed, the stonework takes over these dominant positions, as if an important earlier principle was suddenly forgotten.[259] In this sense the highest meaning of the rose window was abstract, derived from geometry and light, and not from representation; it is notable that in the exegesis of the Lincoln windows quoted previously the specific subject content is never referred to, as though the symbolism of the northern light had decreed its containing a Last Judgment.

The subject content of the Braine windows, in avoiding narrative sequences in preference to ordered concepts, is in harmony with this quality of abstraction. Personifications can indicate a humanistic trend, as in ancient art, or even in the dramatized struggle of Virtues and Vices in Notre-Dame later, but at Braine it was rather a case of human endeavors abstracted or generalized to create emblems of the kind discussed in the Introduction. Taken as a group, the medallions from the roses are impressive for the subtle equilibrium of each composition. Geometry is the only motionless frontal figure, her feet firmly anchored in the edging band, her activity constrained by the relentless horizontals of her drawing board and name band, and by the triangle

formed by her own dividers (Pl. 237). Music, on the other hand, is more active, the sweep of her skirts suggesting movement, and a delicate equilibrium is maintained through diagonals (Pl. 233). Striding figures are either bound within the blue field, in the case of signs of the zodiac (Pl. 228, and Catalogue A, no. 24), or break into the red edging in the case of seasonal labors (Pls. 223, 226). It is also apparent that, in addition to the class distinction marked by the short tunics of the laborers, these garments fall in stiff pleats that contrast with the elegant soft style of the robes of the Liberal Arts and angels (e.g., Col. Pls. 23, 24; Pls. 226, 233). Visual expression is thus very finely attuned to iconographic distinctions.

Yet is it a lone peasant who trims the vines, or the Month of March? Such an image on the calendar page of a private psalter has a certain intimacy, especially when the page carries personal annotations such as obits of family members, but this is not present in a monumental setting, especially in that zone above us that was emphasized in the Introduction (Pls. 58, 227). Nor is there any sign that the Liberal Arts were accompanied by exponents, as they are in the twelfth-century voussoirs of the west portal of Chartres.[260] A contrast is provided in the small roses over the doublets of the choir clerestory of Orbais, where male practitioners were chosen over female personifications, bringing their activities directly into the daily experience of the Benedictines.[261] As Lafond has pointed out, secular subjects abound in the roses of Laon, Lausanne, and Braine.[262] Yet the solemnity of the mode and even the style, as well as the lofty setting, sanctify the normative activities of daily life and lift them above secular deviations.[263]

THE LOWER WINDOWS

In a final comment on the programs of Braine, the lost glass, and attributions that might fill the lacunae, must not be overlooked. The early descriptions refer to two rows of beautiful windows round the church, and Martène and Durand referred specifically to the life of our Lord represented with all the prefigurations of the Old Testament (Appendix 6). A typological program was of course in the choir of Canterbury, and in view of the connection between the clerestory programs of the two churches, it may be surmised that some at least of the same subjects were represented in the lower windows in Braine. The Canterbury program appears to have influenced some individual windows in northern and eastern

[255] Ibid., pp. 107–8.

[256] Ellen J. Beer, "Nouvelles Réflexions sur l'image du monde dans la cathédrale de Lausanne," *Revue de l'Art* 10 (1970): 58–62.

[257] Adolf Katzenellenbogen, *Allegories of the Virtues and Vices in Mediaeval Art*, London, 1939, figs. 32, 39, 68, 69.

[258] This aspect of the candlewheel is discussed in Chapter 2, in relation to the one in Saint-Remi. See also Dow, 1957, pp. 248–97.

[259] Suckale, 1981, pp. 259–63; this article also offers an overview of number symbolism, iconographic programs, and the "iconography" of schemata, with excellent bibliography.

[260] Michael Evans, "Allegorical Women and Practical Men: The Iconography of the *Artes* Reconsidered," in *Medieval Women*, ed. Derek Baker, Studies in Church History, Subsidia I, Oxford, 1978, pp. 305–28, has discussed this and numerous other examples of such expanded series.

[261] Klein, 1984, pp. 92–94; she has dated this glass before about 1215 (p. 96).

[262] Lafond, 1953, pp. 119–20.

[263] For a discussion of previous interpretations of these themes by art historians, and of medieval attitudes to time and labor, especially in the twelfth century, see Panadero, 1984, pp. 6–10, 149–54, 170–79.

France, notably at Saint-Quentin and Sens.[264] A typological program is a logical choice in Saint-Yved where Jean d'Abeville was apparently occupied with Biblical glosses during the period of decoration. One panel that could have belonged to such a series because it shows the Annunciation has been attributed to Braine on the basis of stylistic affinity with the west portal sculpture. In my view the attribution is not entirely convincing but the panel is tentatively included in Catalogue A (no. 33).[265] Another Marianic subject that is a likely candidate is a fragment assumed to belong to a coronation of the Virgin, showing Christ inclined to his right and blessing (Catalogue A, no. 31). The drapery and throne are similar to those of the Liberal Arts from Braine, but the head may have prevented this perception until now; in fact it is very close to those from the original chapel windows of Soissons Cathedral, and its use here as a stopgap increases the likelihood that the figure is from Braine. It would not be improbable there, especially in view of liturgical emphasis, to have had a coronation in one of the apse windows as well as in the exterior sculpture.

Whether there was also saints' lives and perhaps even a crusading window like the one in Saint-Denis is purely speculative. It is tempting to visualize a life of St. Nicaise, of whom a relic was in the ivory shrine, comparable with the one formerly in Soissons Cathedral.[266] One strong candidate for attribution to Braine, on stylistic grounds, is a fragment with a scene of massacre by vandals that has been cut down to a uniform size with the medallions from the south rose, and which was associated with them in its history; possibly seen by Guilhermy in Soissons, it is not in the style of the cathedral (Catalogue A, no. 32). The massacre of the rémois alongside Nicaise is perhaps a more likely subject than the decapitation of St. Denis and his companions, or of Gervasius and Protasius, since the victims here are not nimbed.

The Sculptural Programs

THE CROSSING PIERS AND TRANSEPT GABLES

The unusual distribution of figural sculpture on the interior and exterior of the transepts as well as in the west portals has been briefly described. Two angels, close to life-size, are placed at triforium level on the easterly crossing piers, holding scrolls and hovering over the entrance to the apse; together with consoles that take the shape of beasts trampled underfoot, and baldachins overhead, they form corbels for the engaged columns of the crossing arch (Pls. 58–60; the pair at the entrance to the nave are modern). Despite the probable restoration of the baldachins and the columns surmounting them, the positioning looks authentic, and I have suggested a date in the 1180s for the crisp sculptural style.[267] Schreiner indicated a parallel use of monumental figural sculpture on the crossing piers in Notre-Dame-en-Vaux of Châlons-sur-Marne, which are dated before 1183.[268] Angers and Vendôme provide other examples, less analogous in their positioning; in general the concept seems to belong to that region, or the "style Plantagenet" rather than to the north.[269] Fuller cycles of the early thirteenth century once existed in the choirs of Montier-en-Der and Troyes Cathedral, both in Champagne, but they are positioned in the main arcade below the triforia.[270] Whereas the Châlons figures are Moses and Aaron, Peter and Paul, connoting the Old and the New Law, the angels in Braine adhere to the theme of the celestial court that unites its programs. They presided over the tombs where, in some cases, smaller figures censed the effigies, protecting the souls of the dead (Pls. 62a, 63a).[271] Their presence may even have inspired the legend of the consecration, which claimed that angels took the aspergillum from the hand of the archbishop.

A significant contrast is to be noted between the transept roses and these angels in the choir, on one hand, and the curious sculpture that was applied to the exterior of the terminal walls of the transepts, in the gables above the roses (Pl. 54), on the other. The original subjects and setting are attested to by the Dauzats lithograph (Pl. 50) and field notes taken by Didron ainé in 1836.[272] Ignoring Didron's indication that two asses (or bears?) playing stringed musical instruments occupied the north gable, and two bearded male saints the south, all have been restored as bearded saints. A complete misunderstanding by Didron, however, is unlikely, since he would no doubt have preferred to recognize a subject such as the Evangelist symbols with musical instruments, and he

[264] Caviness, 1977a, pp. 130–37.

[265] A figure of Synagogue vanquished, also in the Glencairn Museum, evidently an Old Testament appendage to a Crucifixion, would be an appropriate subject for Braine and the style is close to small figures from the roses, but the panel is difficult to envisage in windows that size; instead it seems to belong to one of the small eleventh-century openings of Saint-Remi (Catalogue C, and Pl. 215).

[266] Caviness, Pastan, and Beaven, 1984; this window, now divided between the Gardner Museum in Boston and the Louvre, is dated about 1205.

[267] Caviness, 1984, p. 543, fig. 8.

[268] Schreiner, 1963, p. 122 and n. 28.

[269] Ibid., figs. 9–11, 77–83.

[270] Pastan, 1986, chap. 1, pp. 14–15, nn. 69–71, citing Pierre Arnoult, "Les Statues mutilés de l'église de Montier-en-Der," Gazette des Beaux-arts 19 (1938): 9–12; Pierre Héliot, "Statues sous les Retombées de doubleaux et d'ogives," Bulletin Monumental 120 (1962): 140–42, il-

lus. p. 143; and Norbert Bongartz, Die frühen Bauteile der Kathedrale in Troyes: Architekturgeschichtliche Monographie, Stuttgart, 1979, p. 211.

[271] E.g., on the tomb of Agnes, Prioux, 1859, illus. facing p. 38. Their specific apotropaic function is confirmed by late thirteenth-century to early fourteenth-century paintings on the inner sides of a group of tombs in Warneton (Hainaut) and in Notre-Dame of Bruges, which include paired angels, and other devotional images. See Isabelle Hennebert, "Les Peintures murales funéraires de Warneton: Identification et traitment" Mémoire de licence, Université catholique de Louvain, 1982, pp. 26, 27, 153, 168, pls. IV–VII, XXVIII, XLVIII, LVI.

[272] Didron's notes are quoted by Prioux, 1859, p. 22, n. 4: "Au croisillon nord, à l'extérieur, un âne (ou un ours?) debout, jouant de la guitare, servant de pendant à un autre qui joue de la viole. Au croisillon sud, deux statues également debout sur deux colonnettes. Ces statues, protégées par un dais qui garantit leur tête. Ce sont deux Saints, barbus."

was evidently puzzled at what he saw.[273] The essential factor in the original choice of subjects seems to have been to contrast the profane, on the gable facing darkness and the outside world, with the sacred, on the side facing the sun and the *castrum* with the canons' quarters.

The placement of a pair of figures on attached columns between window openings is quite like that of St. Peter and St. Remigius on the west facade of Saint-Remi (Pls. 18, 54). Given the lack of portals here they might be expected to announce the program of the church, as do the figures in Reims, but in fact this function was reserved for the sculpture of the west portals at Braine. It might be supposed that the musical beasts had no more thematic gravity than the enigmatic oxen that look out over the town from the west towers of Laon Cathedral.

Yet they represent a theme that had currency in the Middle Ages, from the Romanesque manuscripts and crypt capitals of Christ Church Canterbury, and the decoration of small French churches, to imagery in private psalters in the following centuries; in fact Didron's description suggests a resemblance to one of the early twelfth-century Canterbury initials, or to a sculpted capital at Fleury-la-Montagne, Sâone-et-Loire (Pl. 53).[274] Mâle and Dodwell have stressed the literary background, including the fable of Phaedrus in which an ass, on trying to play a lyre that it had found in its pasture, had to admit its ignorance of music, and reflected that another might have produced divine harmonies; Boethius gave currency to the ass with a lyre as a symbol of the inept.[275] Deuchler has noted the use of this motif in different contexts in the Ingeborg Psalter and a related manuscript from northern France.[276] It also occurs in a psalter of about 1225 with English connections but adapted for French use: Paris, Bibliothèque Ste. Geneviève, MS 1273, f. 135r (Pl. 52).[277] Asses, and less often bears, are found with various musical instruments in the drôleries of English and Franco-Flemish books of the early fourteenth century.[278] The Braine figures appear to be unique examples of the subject in large-scale sculpture, seeming to emphasize the idea that ignorance belongs outside the church.

THE WEST PORTALS

The surviving sculpture from the west portals has a different aura. The central portal was evidently a grand processional entryway, and it announced two of the principal themes of the interior: the glorification of the Virgin and the celebration of her descent from the kings of Judea. Its iconography has been studied in detail by McClain, and a synopsis of her findings will suffice here.[279] As correctly restored, the Dormition of the Virgin occupied half the lintel, originally no doubt accompanied by a scene with angels lifting her bodily to heaven (Pl. 65).[280] The tympanum contained Christ and the Virgin enthroned together; she bows her crowned head as he blesses her, and he is not crowned (Pl. 189, 214). They were flanked by censing angels, with a smaller pair in attendance beyond the columns that supported a trefoil-arched canopy. Angels also serve as corbels, holding up the lintel like Atlantes.[281] Four figural archivolts, and a fifth with fleshy rinceaux, allowed for as many column statues on each side, which are lost all except for one bearded head now in the Soissons museum. It is not clear where the enthroned Virgin and Child now in the apse came from, but Prioux may have been correct in envisaging it on the gable over the central portal; it is too wide to be a trumeau sculpture.

Voussoir figures from the three innermost archivolts are seated in the branches of a Jesse Tree. Most are crowned, including one female traditionally identified as Bathsheba, and their scrolls originally had their names, some of which were read by Boinet (Pls. 234, 241).[282] This group in fact represents the ancestors of Matthew's genealogy, not as a sequence of stereotyped rulers but in terms of good and bad kingship; and those who came after the fall of the kingdom of Judea have no crowns. The outer voussoirs lack foliage, and the figures are identified as ancestors of Jesse.

Interestingly, McClain has stated the overall theme in the portal, deriving from the voussoirs, as "the conflict between good and evil under the Old Law," seeing it as "a public exhortation to Christian conduct in life."[283] In

[273] His notes, as reported by Prioux, were followed by Edouard Fleury, *Les Instruments de musique sur les monuments du moyen âge du Département de l'Aisne*, Laon, 1882, p. 20, without however offering an explanation.

[274] For this and other early examples from Canterbury, see Dodwell, 1954, figs. 39d, 42a–d. Mâle, 1953, p. 340, fig. 197, gives French examples, including one next to the sundial of Chartres Cathedral; in n. 5 he remarks that the ass playing a harp is paired with a monkey at Saint-Parize-le-Châtel, Nièvre (see Marburg photo. 41738), and with a goat musician at Fleury-la-Montagne, Sâone-et-Loire. The only example he cites in the Aisne is on a cornice at Bruyères; on the south side of the choir, this is an ass, not a pig as he states (Marburg photo. 161988). All appear to belong to the first half of the twelfth century. V-H. Debidour, *Le Bestiaire sculpté du Moyen Age en France*, [Paris?,] 1961, pp. 255–58, figs. 361–66, adds a few more examples.

[275] Mâle, 1953, pp. 341–40, citing the *Consolation of Philosophy*, bk. 1, chap. 8; Dodwell, 1954, pp. 69–70, citing the introduction to *Pictor in Carmine*, a late twelfth-century English Cistercian tract on the decoration of churches that refers to "monkeys playing the pipe and Boethius's ass and lyre (M. R. James, "Pictor in Carmine," *Archaeologia* 94

[1951]: 141), and Philip de Thaun, *Le Livre des créatures*.

[276] Deuchler, 1967, p. 92, figs. 78, 186 (B.L. Add MS 15452).

[277] Caviness, 1979, p. 39, fig. 2. The patron was a woman, the original use monastic, and the litany English. A Saint-Bertin of Saint-Omer calendar of about the same date as the body of the manuscript has been added.

[278] Lilian M. C. Randall, *Images in the Margins of Gothic Manuscripts*, Berkeley, 1966, pp. 66–68.

[279] McClain, 1974, pp. 44–53.

[280] In the equivalent scene in the central north portal of Chartres Cathedral, Christ does not appear among the eleven mourning disciples to take the soul, since they are already laying her in her tomb.

[281] Schreiner, 1963, fig. 111.

[282] McClain, 1974, pp. 71–72, has discussed the authenticity of these inscriptions, which had surely been repainted after the thirteenth century, but not necessarily changed. She also argues the identifications from attributes and postures, pp. 76–81, figs. 108–31; see also McClain, 1985, p. 109, fig. 8b.

[283] McClain, 1974, p. 81.

this way it differs from similar programs at Senlis, Mantes, Laon, and Chartres, which may rightly be said to lay more emphasis on majesty. Yet the thematic connection with Mantes and Senlis, which certainly are earlier, underlines the tendency noted in the architecture to mimic these "royal" enterprises. With the earlier dating proposed for Braine, the portal sculpture might predate that of Chartres and Laon, as McClain argued on stylistic grounds (Pl. 238).[284]

Another parallel may be cited in Canterbury. In both monuments a fuller genealogy of Christ was placed first in the clerestory windows, and then partially duplicated in the different guise of a Tree of Jesse; at Canterbury this was in glass, in a lower window in the corona or easternmost chapel.[285] The Tree of Jesse inevitably treats kings more prominently than the longer genealogies, even when, as at Braine, a selection of earlier figures is added. The voissoirs of the west portal might be credited to Agnes of Braine's having followed a taste for Jesse Trees prevalent among the royal ladies of France. I have argued elsewhere a connection between her sister-in-law, Eleanor of Aquitaine, and the Jesse Trees in York and Canterbury that so much resemble the Saint-Denis composition.[286] Eleanor, as mother of three kings, and Agnes, as heiress of Braine whose title and arms passed to her sons, would have had a personal interest in the Virgin *genetrix*. Among women's books of the period, the Shaftsbury Psalter, the Ingeborg Psalter, and the Psalter "of Blanche of Castille" each give a full prefatory page to a Tree of Jesse, and two of the three belonged to queens.[287]

The attention paid to the Queen of Heaven by Agnes of Braine and her household coincided with Marianic emphases in the Premonstratensian liturgy.[288] The twelfth-century Missal from Antwerp contains an anthem for the Assumption that almost describes the tympanum of Braine: *Maria virgo celos ascendit, gaudete quia cum Christo regnat in eternum*; this has been described as the feast of the patron of the order.[289] By the thirteenth or fourteenth century, the feasts of the Nativity and Assumption of the Virgin had eleven lessons, and she was addressed as *genetrix* and *Virga Yesse*; an anthem at the Nativity began with her descent from Jesse.[290] The corollary is that relatively less emphasis seems to be placed on Christ in the sculpture and glass; as we have seen, if the Virgin was at the center of the north rose, facing Religion or Ecclesia in the opposite one, as well as in the east window and the west portal, she would be honored at all cardinal points of the church that was jointly dedicated to her.

There is, however, another sculpted tympanum that most probably came from one of the side portals of the west facade, and this shows Christ as the Savior (Pl. 66). The Descent into Limbo depicted in it is a curiously asymmetric composition, dominated by a great caldron full of the damned that is heated on the jaws of purgatory in the left half. A king and churchmen are herded toward it by a demon above, yet four heroic nude figures step over a bound Leviathan toward Christ who gestures toward them from the right. There is no indication of heaven or other elect.

The subject is so unusual in isolation that it is tempting to connect it with the trial of 1205; it seems to teach that even unbelievers (foremost among them Adam and Eve) can reach out to Christ and be saved from the flames, an example no doubt used to exhort the condemned heretics to repent. In the twelfth century, portals in fact seem often to have served as places of judgment; on the Cathedral of Ferrara, legal statutes were inscribed next to a tympanum with an image of Christ trampling the beast of Psalm 90, and the old Cathedral of Piacenza is known to have served as a backdrop to legal hearings.[291] Otto von Simson has pointed out in the case of the south transept portal of Strasbourg that the statues of Ecclesia and Synagoga and of King Solomon probably alluded to this function, since it is known that the bishop's tribunal was held there, opposite his palace, as early as the twelfth century.[292] It is impossible to resolve whether the Braine tympanum was already in place for the trial of the Cathars, or whether it was placed on the west facade soon after as a reminder and perpetual warning.[293] Like the lost figure of Religion

[284] McClain, 1974, p. 148.

[285] I have suggested that this reflected a change in attitude toward kingship, following the healing of the Becket conflict: Caviness, 1979, p. 49.

[286] Caviness, 1986, p. 267.

[287] London, B.L., Landsdowne MS 383, f. 15, made for an abbess of Shaftsbury, traditionally an aristocratic house, about 1130–1140 (Kauffmann, 1975, pp. 82–84, fig. 133); Chantilly, Musée Condé, MS 1695, f. 14v, where a crowned sybil is among the prophets (Deuchler, 1967, pp. 32–34, fig. 18); Paris, Bibliothèque de l'Arsenal, MS 1186, f. 15v, given by Blanche of Castile to the royal *capella* in Paris, perhaps in the 1220s when she was queen in her own right, or later as regent for her son (Madeline H. Caviness, "The Canterbury Jesse Window," in *The Year 1200* III, p. 376, fig. 5).

[288] Petit, 1947, pp. 47, 90, noted that the little office of the Virgin was added to the daily Mass, and that this also became popular with the Crusaders.

[289] "The Virgin Mary ascends to heaven, rejoice that she reigns forever with Christ": Placide F. Lefèvre, *La Liturgie de Prémontré. Histoire, formulaire, chant et cérémonial*, Louvain, 1957, p. 95. The MS is pre-

served in St. Willibrord in Berchem, near Antwerp, and has been more fully studied by N. J. Weyns, "Een Antwerps missaal uit de XIIᵉ eeuw," *Bijdragen tor de Geschiedenis in zonderheid van het Oud Hertogdom Brabant* 3d ser. 18 (1966): 5–42.

[290] Michel van Waefelghem, "Le Liber ordinarius d'après un manuscrit du XIII–XIVᵉ siècle de la bibliothèque de S. A. R. le Duc d'Arenberg," *Analectes de l'Ordre de Prémontré* 4 (1913): 333, 375.

[291] Bornstein, 1982, p. 146; and Bornstein, "Victory over Evil: Variations on the Image of Psalm 90–13 in the Art of Nicholas," in *Scritti di Storia dell'arte in onore di Roberto Salvini*, Florence, 1984, p. 45.

[292] An unpublished paper given in 1968 by von Simson is discussed by Louis Grodecki and Roland Recht, "Le quatrième Colloque international de la Société française d'archéologie (Strasbourg, 18–20 octobre 1968): Le Bras sud du transept de la Cathédrale: Architecture et sculpture," *Bulletin Monumental* 129 (1971): 18–23. For the documents concerning the tribunal, they cite E. Erler, *Das Strassburger Münster im Rechtsleben des Mittelalters*, Frankfurt, 1954. For northern examples, see also Hans Gerhard Evers, *Tod, Macht und Raum, Bereiche als der Architektur*, Munich, 1939, pp. 168–98.

[293] The situation is paralleled at Saint-Gilles-du-Gard (Provence)

trampling Heresy in the south rose, it adds a cautionary note to a program of decoration that is otherwise unusually serene.

A Reading of the Imagery

The programs of "decoration" of the Premonstratensian Church of Saint Mary and Saint Ived have so far been presented rather tortuously, from the point of view of archaeological reconstruction and iconographic tradition. Uncertainties remain, and to some extent they cloud the impression. Yet a more certain reading is possible. It recreates the experience of the building as it appeared around 1210 colored by legendary associations, rather than the form of the building devised by reconstructing the minutiae of its physical makeup. This experiential and kinetic overview will serve to clarify major themes and to suggest the way the images in various media functioned for the medieval viewer.

Whether the traveler came from Reims and Laon or from Soissons, such an experience began with the distant view, from across the valley, of an astonishingly large structure; the new church, with its lantern tower and westwork, rivaled the royal foundations of Mantes and Senlis, and was evident testimony to the aspirations of the House of Dreux and to the sumptuous quality of Premonstratensian church arts.

The lavish impression was confirmed on closer view; the even quality of the masonry, evidently laid in a single campaign as though with divine help, and the intricate finish of the sculptural detailing, outdid Peter of Celle's piecemeal remodeling of Saint-Remi, or the untidy chantiers of Laon and Soissons where breaks in the construction had occasioned radical changes in plan. A considerable array of vast and evenly spaced window openings quickened anticipation of the exquisitely painted glass, said to be unparalleled in the harmony and variety of its colors, that Beata Agnes had acquired through her relative, the queen of England.

But first, in baser material, strange figures on the gable of the transept mocked at the futility of inappropriate learning; those who stray unprepared into the new schools, or who listen to the new preachers and prophets, should beware of appearing like the ass of Boethius, unable to play the harp that he had chanced upon. True knowledge is linked to divine wisdom.

Since this is not a vulgar pilgrim church, access to its sanctuary is limited; the canons in Florence and elsewhere may complain that the merchants' donkeys soil the cathedral as they pass through the transepts from one side of the town to the other, but here sole entry and egress are in the west end. The main approach is down the Rue des Juifs. Its name recalls the miraculous con-

version of the Jews of the town in the time of Beata Agnes, effected by a vision of the Christ Child in the host, and serves as a reminder of the precious chalice and host that can still be venerated in the church, along with the vestments of Henri de France, *frater regis* and archbishop of Reims.

The great portals, rivals of those on the canons' church at Mantes and the Cathedral of Notre-Dame of Laon, and even of the ones on the north flank of Notre-Dame of Chartres through which the common people enter to sample the wine, have impressive sculptures. The smaller portal has served as a locus for the bishop's court, and it vividly treats the judgment that awaits the wicked; eerily real-looking people from all walks of life crowd into a fiery hell, foremost among them a Jewish moneylender clutching his purse. Yet even after they have entered purgatory, the penitent can reach out to be saved by Christ who has descended to free him; it would have been so for the sinners who burned here for their heretical beliefs shortly ago, even though they died in the flames. Being the most famous painter in all of Francia was no safeguard against perishing in that blaze; yet here we see works, by unnamed artisans, that may bring the viewer to salvation.

Not wishing to enter there, one turns to the other larger porch that offers the serene hope of heaven. Mary, Regina Coeli, *mater regis*, to whom this church is dedicated, is enthroned with her son, and as Ecclesia she is the bride of Christ. She was spared the experience of death and descent into hell, and was immediately taken bodily to heaven by angels, as confirmed in holy women's visions. The canons celebrate this feast with great solemnity. Born of a royal line, Mary is here surrounded by her ancestors and by the prophets that served as priests under the old law. She is attended by censing angels that bring to mind the story that they had aided in the consecration of this very church.

Stepping up to the level pavement of the interior is like entering the gates of heaven. Every church is a figure of the Celestial Jerusalem, but here a lofty second porch between the great bell towers scarcely prepares the viewer for the effect of the brilliant colored windows that render its walls immaterial. Impressive ranks of enthroned ancestors now float in the upper zone, motionless and dignified yet subtly indicating the east where the Virgin appears again, this time with the Child though already enthroned in heaven.

Progressing up the nave to the crossing one marvels at the lofty vaults of the lantern tower, seeming to soar unsupported to heaven; but the arches are carried by angels, and their weight crushes demons under foot, just as the church must crush heresy. From the vantage point of the crossing comes the breathtaking view of the three great wheel windows that protect the north, south, and west.

where the Crucifixion is the unusual subject of one of the tympana; Marcia L. Colish, "Peter of Bruys, Henry of Lausanne and the Facade of St. Gilles," *Traditio* 28 (1972): 451–60, has suggested the imagery

was a response to the heresy of Peter of Bruys, who taught that the cross should not be venerated, and was burned before the church in 1135–1136.

They were unrivaled in Francia, until imitations of the west wheel were placed at both east and west of Laon Cathedral complementing the north and south eyes. The west, lit by the dying rays of the sun, shows the Judge at the end of time, worshiped by angels offering crowns, and presiding over the resurrection of the dead. Here is greater hope than the punishment portal beneath it offered at our approach. The theme of Apocalypse seems to be reiterated on the dark side, where a dimly seen majesty at the very center (is it Christ or the Virgin?) holds court over the apostles and the elders. But the south wheel, which seems to radiate its own light independent of the sun, celebrates the orderly cycle of life on earth. Celestial signs govern the monthly and seasonal activities of the peasants as they produce the revenues that Beata Agnes doted on the church; their harvest keeps the altar lamps burning and provides stout ropes for the great bells, and pays the priests to say Masses for the souls of her household until eternity. In the center a queen tramples a deformed creature underfoot: Is it Divine Wisdom overcoming ignorance or Religion in the guise of Ecclesia stamping out heresy, yet another reminder of recent events, and another allusion to the Queen of Heaven who thus perhaps protects her church on all sides? She seems to be closely surrounded by the *artes* that are practiced by the canons and a few of their lay pupils, such as Grammar, Music, and Geometry, all of which serve the church. Now one sees why Boethius's ass is on the outer wall of the dark side, a parody of the true illumination received within.

Other windows, their subjects to numerous to recall, crowd close to the viewer so that one could almost touch the precious gems that fill them. They vividly recount past events and the deeds of Frankish saints, but in the sanctuary is the Christmas story, with its prefigurations in Old Testament history, as though the ancestors above are a recitation for the Christmas liturgy. This space seems dedicated for the private use of the canons and their patrons. Beata Agnes is buried there, and her image is painted with that of her husband, Robert of Dreux, *frater regis*, at the feet of the Virgin and Child in the window behind the great altar; they offer the new church to Our Lady.

In the other chapels, ingeniously laid out close to the transepts, are precious relics brought very recently from the Holy Land, carried as talismans during the Crusades by Robert of Dreux and his sons; and one can see the sacred relics of the miracle of the host. But the ancient remains of the patron saint, Evodius of Rouen, have not yet been brought to the new church, nor do the Premonstratensians favor canonization of their own founders so they have no saints here. Perhaps they are afraid of being overrun with the sick and needy, like the Benedictine brothers at Canterbury who have to keep watch day and night at the tomb of their martyr, Saint Thomas, or the Cistercians whose retreat has been threatened by the veneration of Saint Bernard.

It is easy to predict that this church will long continue to serve the dynasty of Dreux, adding sumptuous tombs, according to the new royal fashion, on which angels perpetually cense the corpse of the deceased and earning its revenues by providing Masses for their souls. In this way it is a kind of shrine; indeed it reminds one of the new gold and enameled reliquary of the Virgin recently made for the Cathedral of Tournai by the famous sculptor Nicholas, only this is so vast that one enters it to see the brilliant decoration on the inside. It may even be that Beata Agnes will be canonized for her great piety in building this *amplissima ecclesia*, scarcely second to any in the elegance of its art and decoration; surely her pious offering, and the years of her widowhood that she passed here almost like a nun, have prepared her soul for salvation. Her example can teach others likewise.

CHAPTER IV

The Rémois Atelier:
Design Process and Chronology

Unfortunately, evidence regarding the working methods of the Earlier Judenburg workshop seems to indicate that its practices compromised the artistic quality of its work. These methods, at times verging on an almost mechanical process, have revealed the repetitive traits of the workmanship. On the other hand, the aesthetic qualities cited here, including a degree of perfection in the craftsmanship, are acquired only through constant repetition.

Eva Frodl-Kraft[1]

THE CONCERNS of this chapter are formal and stylistic; analyses are presented with two questions in view. One is to exploit a unique opportunity of examining a group of life-size figures that were designed in a series, thus observing the process of artistic decision making in the late twelfth century. The adaptation of these designs to other architectural contexts can also be observed. The other concerns are with chronology and dating, including not only all the extant glass of Saint-Remi and Saint-Yved and the related figures in Canterbury, but also related works elsewhere and in other media.[2] These issues are traditionally integral with the

discipline of art history, and have therefore been a part of art historical debate for more than a century. Given the lack of contemporary documents for the glass, it is unlikely that there will be any firmly established dates, but relative chronologies are still useful as working hypotheses if a diachronic approach is admitted. However, as indicated by Frodl-Kraft in a similar context, observation of workshop practices provides a valuable counterbalance to modern aesthetic judgments and a priori concepts of development that might otherwise dominate chronological argument.[3] Similarly, as pointed out in the Introduction, formal changes in medieval art were

[1] Frodl-Kraft, 1985, p. 121; equally relevant to my theme, she continues: "The windows of this Judenburg workshop, whether in situ or reconstructed in a new context, such as that at the Cloisters, attract the viewer by their ornamental richness and their balanced form and color. The drawing technique reveals a mastery of ornamental formulas even when the windows are viewed from afar. The achievement of monumentality in the art of stained glass seems thereby to be perpetuated even at this late date. All of the characteristics are based on long-standing traditions of stained-glass craftsmanship." The glass referred to is from St. Leonhard in Lavantthal and dates from the 1340s.

[2] Papers offering preliminery explorations of these topics were pre-

sented in 1983: "The Glazing of the Choir of St.-Remi of Reims," in the session on Approaches to the Study of Stained Glass chaired by Michael W. Cothren at the College Art Association meetings in Philadelphia, and "Stained Glass of Saint-Remi de Reims: Problems of Dating and Chronology," at the 12th International Colloquium of the Corpus Vitrearum, held in conjunction with the International Congress of the History of Art in Vienna.

[3] Frodl-Kraft, 1985, as in n. 1 and also p. 114: "It should be stressed that neither 'modernism' nor 'conservatism' is a simple absolute value and their relationship to individual artistic quality is quite a complex one."

primarily intended to articulate iconographic distinctions and these have to be acknowledged in judging the comparative chronology of different programs.

Shop Production of Windows

Because I will argue in detail here that a single atelier supplied glass in Reims, Braine, and Canterbury, the chapter begins with a review of what these works hold in common. I have called this atelier rémois since it was evidently productive in Reims over a relatively long period, whereas its activity elsewhere seems to have been shorter. With a medium as large and fragile as stained glass, production must have taken place on each site; the find of a lead mold at Saint-Remi has been noted, seeming to bear this out, although ateliers could have taken some supplies of glass with them.[4] In Canterbury its work clearly appears exotic, more or less unrelated to the earlier productions of an indigenous shop whose development was outlined in the Introduction.

Some general characteristics of the windows by the rémois shop emerge immediately from a survey of glass from the three sites. These characteristics include the use of very conservative straight-bar armatures in all the clerestory lights (with a slight modification, and one exception, in Canterbury), and a division of the large figures by these bars into vertically arranged glazing panels, two or three in number depending on the size of the window opening (Col. Pl. 4; Pls. 77–80, 205). The blue grounds tend to be leaded in rows, and straight inscription bands are of fairly standard height, generally supplemented by colored edges.[5] Despite extreme differences in structure and design between the clerestories of Saint-Remi and Saint-Yved, the pointed arches that define the topmost glazing panels in the uniform lights at Braine and in the central light of each straight triplet at Saint-Remi appear to share the same template (Pls. 174, 192).[6] Since this arch is an even distance from the stone-

work, one might speculate that responsibility for window design was divided between the masons and the glaziers.[7]

At each site the atelier worked within similar iconographic constraints, at least in part; the series comprised of seated Old Testament figures use similar figure types, which, broadly speaking, have a certain elegant gravity, although they lack dramatic force. They are characterized by a frontal position modified at times by a three-quarter view of the head and one leg, and a tightly contained contour with restrained positioning of the extremities (Col. Pls. 2–14, 20–22; Pls. 163, 180, 182, 185, 193, 194, 197–99, 202–4, 255–60). In Chapter 3 such similarities allowed the attribution to Braine of a large group of figures now scattered in collections, whereas minor differences in dimensions and composition distinguished them from figures produced for Canterbury or Reims.

There are also similarities in the leafy palmettes used in the ornament.[8] The two types from the cusps of the transept roses of Braine each have a counterpart in borders at Canterbury, one in the Trinity Chapel window in which the figure style and palette of the rémois shop is recognized and the other now isolated on the south side (Pls, 182, 190, and Catalogue D, B.o.1–2, C.b.1–2). The latter was matched by an almost identical design in Saint-Remi, now in the Amiens Museum (Catalogue D, R.b.31).[9] Similar dense palmettes, sometimes with berry clusters like those of the jack-in-the-pulpit, and with fleshy leaves that turn over on themselves, survive in a few of the borders of Saint-Remi, and white bands may form a series of hoops or sprout calyxes that give rise to the palmettes (Catalogue D, R.b.12–25).[10] This hoop motif is also known in the Canterbury group (Catalogue D, C.b.1). Although the use of the same full-scale design at different sites cannot be demonstrated in the borders, as it has been for a "Canterbury-Sens atelier," there are coincidences that suggest the adaptation of the cutline to a different panel length, as in the case

[4] Chapter 1 at n. 127. Measurements and clay molds of the chalk came molds in the Musée Saint-Remi and the leads taken from a clerestory figure now in the Simon-Marq atelier (Pls. 67, 68), taken in 1987, indicate discrepancies, however: Although the width of the lead would be in the same range (0.4 to 0.6 centimeters), and the depth of the heart the same (0.7 centimeters), the profile of the heart generated by the came mold is more curved, producing a stronger lip than in the preserved twelfth-century leads. The conclusion is therefore only a general one, that some stained glass was manufactured on the site in the Middle Ages.

[5] The inscriptions, on white or yellow glass, range in height from 6.5 centimeters in the nave of Saint-Remi to 7.75 in the lateral lights of the retrochoir and 8.5 in the center lights; in the clerestory window at Canterbury they are 7 and 7.5 centimeters; the norm in the Braine clerestory panels is 7.5, with an exceptional 9 centimeters in the St. Louis figure. The rows in the blue grounds seem to be deliberately varied within panels.

[6] This was tested by superimposing rubbings of Abiud, once attributed to Saint-Remi, and "Osee" who is in situ there; red edging lines provide a "fudge factor" to absorb minor variations in window sizes even within a site, but the curvature of the panels is the same.

[7] This important issue also surfaced in my study of Canterbury, where the form of window openings and the style of the glass changed with the arrival of a new architect: Caviness, 1982, pp. 51–52.

[8] Unfortunately, if rinceaux were used in the grounds they are not preserved, except in the fragment with Synagogue attributed to Saint-Remi; their use in upper windows is excluded by the straight-bar armatures.

[9] Comparison reveals a slightly different proportion to the major elements of the design, and broader leaves with an additional element occupy the center of the palmette in Canterbury, precluding the use of the same cartoon. The color distribution is also slightly different: In Canterbury a pair of yellow fronds and a central purple leaf repeat in each palmette, but these are counterchanged in alternation in the rémois border.

[10] These bands are notably lacking the pearling or other painted detail that is characteristic of twelfth-century borders from Saint-Denis, York, and Le Mans; for these see Westlake, 1881, 1: pls. XI, XII, XXIII, and discussion by Caviness in Zarnecki et al., 1984, pp. 136, no. 90a. Nor are they punctuated by the "napkin rings" occasionally seen in Canterbury (e.g., Caviness, 1981, pls. 121, 323). Similarly, pearled edging lines are an extreme rarity.

just described (C.b.1; cf. R.b.31).[11] Another such case is provided by two borders with a meandering white stem between palmettes, one in a clerestory window of Canterbury adjacent to that occupied by Nahshon and Amminadab, and the other now in Amiens but presumed to be from Saint-Remi (C.b.5; cf. R.b.24a).[12]

On the basic of figural design, the atelier may be further defined as a group of craftsmen sharing and reworking full-size patterns, even though reuse or minor adaptation of the same cartoon are found only within a site. Such cases are frequent within Saint-Remi, though naturally restricted to figures within a given iconographic series, whether patriarchs, apostles, archbishops, ancestors, or kings. Only one example of reuse of a cartoon survives from Braine, in two angels holding crowns, although unfortunately one figure has been turned inside out, to face right, and the paint is severely damaged (Catalogue A, nos. 28, 29). The evidence from the clerestory of Braine, given that only parts of sixteen out of seventy figures are preserved, is insufficient to rule out the reuse of cartoons there also, but the inference is that if the practice was used, it was less frequent than in the choir or, certainly, the nave of Saint-Remi; rather, the Braine figures share partial repetitions, such as the size and angle of the feet, or the articulation of an upper arm. Furthermore, there are numerous cases in which a superposition of rubbings made from figures of different sizes belonging to different sites indicates significant coincidences in some contours, such as the outline of a leg or shoulder; it is as if existing cartoons were being freely adapted to changes in scale, or as if the draftsman's arm repeated the same gestural stroke by habit.

The choice and distribution of color were also noted on the full-scale designs, as indicated by Theophilus, but they could easily be changed if the cartoon was reused, as in the Gerona setting table (Pl. 144).[13] The notations, however, could not have conveyed precise tints. Yet the colors at each site have a similar range, including a good deal of purple and green, with smaller amounts of white, warm streaky red, and cool yellow (Col. Pls. 1–25). Next to the work of other glass painters at Canterbury, this glass stands out for its relatively cool and saturated palette; the same distinction has been made vis-à-vis the glass made for Soissons Cathedral. Notable at all three sites is the use of decorative multicolored bands to break up areas of solid color—for example, in the garments—and the blue grounds are also invariably punctuated by predominantly red or yellow accents, whether by roundels, edgings on inscriptions, canopies or throne backs, and even arbitrarily applied halos.

Other shared traits impinge on the execution of the designs. The glasses from each site are unusually dura-

ble; at Canterbury they stand out almost shockingly from the extremely decayed products of the indigenous atelier. Of the Braine glass, only some of the panels exposed in Soissons, one now in the Glencairn Museum, and the head of Abiud in the Metropolitan Museum are severely crusted and show some pitting; this deterioration might be due to local conditions at some time in their history, or to a destructive cleaning. In Saint-Remi corrosion of the interior surface, affecting the paint, and crusting outside are proceeding at an alarming rate, yet pitting is virtually nonexistent (Pls. 68–70, 75, 76). In general, the greens and purples vary in the extent to which they are crusted, but particular shades such as a warm bright green and a cool streaky purple are notable for their well-preserved, undulating surfaces; they are so thick in places that cutting and leading have been visibly troublesome (Pls. 70–72). By exploiting these variations, remarkable control of tonal gradation was achieved, as in the highlighting over Nahshon's knee and the dark troughs of the mantle to the left of it (Col. Pl. 9). In examining the various panels, the particular horny texture of these pieces of glass, as well as their optical qualities, became familiar to me.

Painting styles and techniques are less homogenous; for instance, there seem to be several painters executing figures, albeit based on the same cartoon, in the retrochoir of Saint-Remi (Pls. 145, 152). Yet one repetitive trait is the rendering of the sinews on the back of the hands of the large figures, and there is such a monotonous repetition of certain motifs throughout the production, such as the series of ellipses and circles that denote jeweled bands, that they preclude judgments as to chronological development (Pls. 81, 172, 173, 263).

In making attributions to a shop our concepts of continuity and change, of consistency and development must be different from those applied in attempting to reconstruct the oeuvre of a single master. Greater latitude has to be given to the stylistic and qualitative range of the products, especially if we are to discuss examples that might extend beyond the active life-span of a dominant artist. Furthermore, the medium makes greater demands on craftsmanship and technology than any other known in the Middle Ages so that a large number of workers may have been needed; the production of a window involved precision work in shaping iron bars, making molds and casting and joining lead cames, sizing wooden boards for full-scale designs, preparing vitreous enamels, painting, and firing in a kiln (Pls. 67–72, 131, 144); possibly making the frit for colored glasses, and glass blowing and annealing were also done within the shop, although by the late thirteenth century there is some evidence for independent suppliers.[14]

[11] For the three pairs of identical borders at Sens and Canterbury, see Caviness, 1977a, pp. 88–89, pls. 73 and 74, 175 (inverted) and 176, 177 and 178.

[12] Rubbings indicate that the curving stem and attached calyx follow the same cutline, but the Canterbury motif splays more widely, and extends to a greater width (14 centimeters; cf. 11 centimeters), so that

the repeat is at less frequent intervals.

[13] Theophilus, 1963, p. 62, where he mentions designating the color for each element on the setting board "with a mark in its proper place." In the case of the angels from Braine just referred to, one has a white robe, the other, green.

[14] Meredith Parsons Lillich, "Gothic Glaziers: Monks, Jews, Tax-

Given the complete absence of any contemporary account of the organization of a glaziers' shop, the number and special duties of its personnel can only be inferred from their products, from a knowledge of techniques, and very cautiously by analogy with later custom.[15] Since the appearance in 1949 of the pioneering article by Louis Grodecki on "a stained glass atelier," thinking about this subject has inevitably advanced.[16] He allowed for considerable latitude through time, and between such widely dispersed sites as Bourges and Poitiers or Chartres, yet his expectations were for a fairly consistent figure style throughout.[17] The great value of his initial contribution, however, was to insist on taking account of all aspects of design and execution, including the composition of the armature and the ornamental designs of the borders and fields, as well as the figural compositions and rendering. In using these criteria to recognize broad divisions among the windows of the Sainte-Chapelle, all of which must have been produced simultaneously between 1241–1244 and 1248, Grodecki conceived of a principal atelier doing most of the work with, among its many painters, one strong personality (The Ezekiel Master), and also identified a Judith Master, who used designs of a very different character in one bay.[18] Given the homogeneity of the iconographic program, scale, and palette, however, he proposed a single overseer. This raises semantic problems that underline the

difficulty of reconstructing social structures from visual evidence; it might have been more logical to speak of one shop, under an overseer, and two or more teams—unless perhaps the overseer was a theologian or an architect. Frodl-Kraft has recently described with great clarity at least four possibilities for the division of work in a shop.[19] The problems of terminology are compounded when shops are presumed to have traveled, or when designers seem to have moved about independently of painters.[20] By 1200 it must be taken into account that stained glass was a very public art in the sense that it could be freely seen by traveling artisans, and it may therefore be difficult to distinguish between cases where common models were genuinely shared—that is, derived from drawings within the shop as I claim for the rémois atelier—and where they were appropriated by sketches made on the site; direct comparison of rubbings from different sites is needed.[21] Close observation of other traits of the work, such as the durability and colors of the glasses, can provide deciding evidence, as in the case of one of the Beauvaisis ateliers identified by Cothren.[22] Within the ambulatory chapels of Troyes Cathedral, Pastan has also found that weathering patterns in the glasses provide an additional criterion to formal characteristics in distinguishing different groups of windows.[23]

More germaine to discussion of the rémois atelier are

payers, Bretons, Women," *Journal of Glass Studies* 27 (1985): 75, has pointed out the importance of pinpointing the separation of glaziers blowing glass from glaziers making windows, but the use of terms such as *vitrearius* or *verrier* for both complicates the issue; she assumes that such craftsmen clustered around the *Voirrerie* (glass works) were blowers, and cites a record of one woman in Paris as a *verriere, marchande* (pp. 76–78).

[15] Late medieval records are much more complete, but it is hard to know how far the practices described diverge from those of the earlier period. Among them are the mid-fourteenth-century accounts from Westminster, analyzed and edited by L. F. Salzman, "The Glazing of St. Stephen's Chapel, Westminster, 1351–2," *Journal of the British Society of Master Glass-Painters* 1 (1926): 14–16, 31–35, 38–41, and 2 (1927–1928): 189. A chief master-glazier supervised others who designed figures on sized tables, whereas ordinary glaziers and painters executed the work; all the glasses were bought from various sources in England. York records were examined by John A. Knowles, *Essays in the History of the York School of Glass-Painting*, London, 1936, pp. 9, 66–67, 196–203, 230–35, 236–53; colored glasses seem to have been imported into England; by the late fifteenth century, drawings, presumably on paper, as well as tools were being mentioned in glass painters' wills; the guild records give information on the numbers of apprentices, etc. The longevity of certain designs was imputed to the survival of paper cartoons: John A. Knowles, "Mediaeval Cartoons for Stained Glass: How Made and How Used," *Journal of the American Institute of Architects* 15 (1927): 12–22. Important records are now coming to light in Catalonia, due to the researches of Joan Vila-Grau.

[16] Louis Grodecki, "A Stained Glass Atelier of the Thirteenth Century," *Journal of the Warburg and Courtauld Institutes* 11 (1948): 87–111. Other recent contributions include Larry Ayres, "Collaborative Enterprise in Romanesque Illumination and the Artists of the Winchester Bible," *Medieval Art and Architecture in Winchester*, British Archaeological Association, Leeds, 1983, pp. 20–27; Eva Frodl-Kraft, "Zur Frage der Werkstattpraxis in der mittelalterlichen Glasmalerei," in *Glaskonservierung, historische Glasfenster und ihre Erhaltung*, Bayerische Landesamt für Denkmalpflege, Arbeitsheft 32, Munich, 1985, pp. 10–22;

Michael W. Cothren, "The Infancy of Christ Window from the Abbey of Saint-Denis: A Reconsideration of Its Design and Iconography," *Art Bulletin* 68 (1986): 398–420; Virginia Raguin, "The Visual Designer in the Middle Ages: The Case for Stained Glass," *Journal of Glass Studies* 28 (1986): 30–39.

[17] These ideas were somewhat modified by acceptance of a dating ca. 1205–1214 for the chevet windows of Bourges, based on Branner's dates for the building, thus contemporary with Chartres: "Le 'Maître du Bon Samaritain' de la Cathédrale de Bourges," *Year 1200* III, pp. 339–59.

[18] Louis Grodecki in Aubert et al., 1959, pp. 92–93.

[19] Frodl-Kraft, 1985, p. 108.

[20] E.g., Virginia C. Raguin, "Windows of Saint-Germain-lès-Corbeil: A Traveling Glazing Atelier," *Gesta* 15 (1976): 265–72; Caviness, 1977a, pp. 90–93, 95–96. Hans Wentzel, "Glasmaler und Maler im Mittelalter," *Zeitschrift für Kunstwissenschaft* 3 (1949): 53–62, had raised the important issue of painters working in several media, one that has not been followed in more recent literature.

[21] Madeline H. Caviness, review of *Stained Glass in Thirteenth-Century Burgundy* by Virginia Chieffo Raguin, *Speculum* 60 (1985): 456. Sketches after glass are not known from the period, but there are drawings after Byzantine mosaics in the Wolffenbüttel "Sketchbook" of about 1240 from Lower Saxony: *Zeit der Staufer*, I: no. 765, pp. 596–98. Peter Kurmann, "Die Pariser Komponenten in der Architektur und Skulptur der Westfassade von Notre-Dame zu Reims," *Münchner Jahrbuch der bildenden Kunst* 35 (1984): 75–76, has commented that the head master at Reims recombined facial types and drapery schemas from the statuary of Notre-Dame in Paris.

[22] Michael W. Cothren, "The Choir Windows of Agnières (Somme) and A Regional Style of Gothic Glass Painting," *Journal of Glass Studies* 28 (1986): 60–61. Caution has to be exercised, however, since an atelier might use more than one supplier, especially in different locations.

[23] Pastan, 1986, pp. 94, 116; assuming homogeneity is an indication that glasses came from a single batch, she postulates that differences confirm a different period of glazing. Communality of source rather than batch seems a more likely unifying factor.

recent findings concerning the nature of medieval cartoons for glass.[24] Vila-Grau has directed attention to an original early fourteenth-century sized board with part of a window design that is preserved in Gerona (Pl. 144).[25] The manner of drawing on it, including the details to be painted, and of marking the colors corresponds closely to the description of these procedures by Theophilus. Even more relevant to my findings at Saint-Remi, it is clear that the Gerona setting board was used more than once; below the canopy, and underlying the geometric motifs, is the "ghost" of the upper half of the Virgin Annunciate. There is no doubt the setting board was actually used in the glaziers' shop because it has the marks of the nails used to hold the glass in place in the process of leading, and, furthermore, extant glass in the cathedral exactly corresponds to the designs. The limitations of this kind of cartoon are that it cannot be flipped to reverse the design, and it is cumbersome to store or transport.

An alternative material that was available for large drawings before paper became current was linen, which had the advantage of being reversible, light, and easy to carry or store in rolls; documents attest to its use for stained glass designs in Germany, and for architectural drawings in England, in the fifteenth century.[26] Oiled cloth, however, had also been used very early as a temporary window filling, since it had the advantage of being weathertight and translucent as well as carrying designs.[27] The transition to cartoon would be very natural, since the design drawn on the oilcloth might function as a preliminary drawing in deciding the window composition, and even perhaps to block out the colors.[28]

In observing the finished products of the rémois shop both types of cartoon have been considered. The windows in Saint-Remi indicate that the same cartoon was partially redrawn to given an impression of mirror symmetry, rather than flipped to give total symmetry (Fig. 5). Overall a single cartoon was not used at more than one site. The inference is that setting boards were used, rather than more versatile drawings on textile.

The Comparative Chronology: Problems of Dating

Two models may be born in mind in considering the chronology of the windows supplied by the rémois atelier: One is the traveling glazing atelier, moving sequentially from site to site as work became available. The other is a large shop that could provide designs and personnel simultaneously, allowing contemporaneous execution in two or three sites. Either situation could be fostered by the ties of patronage that have been recognized in the Introduction. A review of the building dates per se will not resolve this question, but it does clarify the various possibilities and probabilities.

First, glass that is not in situ at Saint-Remi could predate the twelfth-century construction, its most probable period being between 1118 and 1151. Similarly, some glass from Conrad's choir in Canterbury that most probably dates about 1155–1165 was presumably reinstalled in the Trinity Chapel after its rebuilding (Pl. 7). Second, the dates at which construction was initiated at each site seem to give primacy to Saint-Remi: Peter of Celle's remodeling of the west end was begun about 1165–1170, and the radiating chapels about 1170–1175, whereas the laying out of the new church of Saint-Yved did not occur until at least 1176, and the upper and lower window openings in the Trinity Chapel in Canterbury that were to be glazed by the rémois shop must date after the choir was closed off in 1180, and probably after the completion of the structure in 1184.[29] However, work on all three sites seems to have continued through the remaining decades of the century: By 1181 the retrochoir of Saint-Remi was probably finished, and the remodeled nave by about 1200; the completion of the upper levels of the choir and transepts of Saint-Yved might belong to the 1180s at the earliest, and the building was probably not complete until 1208; at Canterbury the campaign of glazing into which the rémois glass falls may have extended up to 1207. In other words, if the windows under consideration were being glazed as soon

[24] See also Introduction, n. 62, for drawings.

[25] A paper was presented at the Corpus Vitrearum Colloquium in Vienna, 1983, and the material published in Joan Vila-Grau, "Girona, clau de volta per a l'estudi del vitrall gòtic," *Revista de Girona* 113 (1985): 360–63; *El Vitrall Gòtic A Catalunya—Descoberta de la taula de vitraller de Girona*, Reial Acadèmia Catalana De Belles Arts De Sant Jordi, Barcelona, 1985; and "La Table de peintre-verrier de Gérone," *Revue de l'Art* 72 (1986): 32–38.

[26] Records for Friedberg indicate that in 1476 enough good-quality linen was bought for the painter Henritz Heyl to make full-size designs for the glazier Konrad Rule to execute: Hermann Roth, "Der Maler Henritz Heyl und die spätgotischen Glasmalereien in der Pfarrkirche zu Friedberg/Hessen in urkundlichen Nachrichten," *Mitteilungen des Oberhessischen Geschichtsvereins*, Festgabe für Christian Rauch, n.f. 44 (1960): 86, 97. I am grateful to Rüdiger Becksmann for his comment on my presentation in Vienna, and for this reference. Lon R. Shelby, "Medieval Masons' Templates," *Journal of the Society of Architectural Historians* 30 (1971): 143, mentions the wooden templates documented at Exeter in 1316–1317 as opposed to the "tracynglyne" mentioned in

the Westminster Abbey documents of 1489–1503, which he takes to be tracing linen.

[27] Such painted linen was replaced by glass in York in 670: David O'Connor and Jeremy Haselock, "The Stained and Painted Glass," in *A History of York Minster*, ed. G. E. Aylmer and R. Cant, York, 1977, pp. 318–19. However, large amounts of canvas purchased in 1350 before beginning the glazing of St. Stephen's Chapel, Westminster, were merely to cover the openings; See Salzman, "The Glazing of St. Stephen's Chapel," p. 14.

[28] A recent discovery confirms the imitation of glass in other media; simulated ornamental stained glass windows were painted on the walls of a small church early in the thirteenth century, and real bars were attached inside to give a greater semblance of reality: Jean-Claude Rochette, "Seine-et-Marne: L'église de Champcenest et ses peintures murales," *Bulletin Monumental* 141 (1983): 197.

[29] The rebuilding of the choir had begun from the east immediately after the fire of 1174, but no glass by the rémois shop is preserved from windows to the east of the 1180 partition.

as the masonry was ready most of the glass would have been produced in a very narrow time span in the 1180s, perhaps even simultaneously, with work on the nave clerestories of Saint-Remi and Saint-Yved continuing later. The only group of windows containing internal evidence for immediate glazing is the retrochoir clerestory of Saint-Remi, where the masonry has been dated about 1175–1181 or so; whether any windows at either of the other sites were also filled at once, or whether there was a pause between construction and glazing, these retrochoir windows must have been begun first, but after that any chronology is theoretically possible.

To this extent, comparative dates for the windows will have to be argued from subtle changes in figure style; even ornament is of limited help, since we have seen that it is extremely improbable that any of the borders in Saint-Remi were returned to their original position, unless it were by chance. They are sufficiently varied, however, that it has seemed worth creating an inventory and typology in Catalogue D, and attempting to associate some designs with possible glazing campaigns and with figural groupings. The most satisfying result has been to identify a group of designs that relate closely to glass in eastern France of the 1160s to 1170s. Later examples have served to confirm the close relationship with Braine and Canterbury.

New observations have reopened the question of dating for the work of the French-trained artist at Canterbury; noting that his work is very close to that of the rémois shop, and that he knew the glazing of the retrochoir, I had proposed, and still believe, that he worked at Canterbury later; yet the revised date that will be argued here for the retrochoir windows (early 1180s instead of 1180s to 1190s) creates some difficulty in placing his activity in Canterbury as late as the thirteenth century. In connection with this question, three new factors have powerfully emerged. One is a fuller knowledge of the Braine glass, which unlike that of Saint-Remi offers comparisons of like scale both for the clerestory figures and for smaller medallions. The second is the discovery of a satisfactory, if still hypothetical, home for the wandering Synagogue and donor figure in a lower window of the south transept of Saint-Remi, thus supplying a unique example of small-scale figures for comparison (Catalogue C, and Pls. 211, 215). The third is the possibility of a connection between the patrons of Braine and these Canterbury windows, and a narrowing of the dates at which this could have occurred, either to the 1180s or to about 1200.[30]

Saint-Remi is the only site where stylistic differences between groups of figures and borders that are all attributed to the same shop seem to indicate significant differences in date, such that a more extended comparative chronology can be argued from internal evidence.[31] However, the dating of the nave clerestory figures is a classic problem in art history: The lesser quality of these figures in comparison to those in the choir may be understood either as a "primitive" or as a "late" phase in a stylistic evolution, according to whether we date them in the late 1140s with Grodecki, or even in the early years of Peter of Celle's abbacy, or whether we place their creation in the period of the Gothic vaulting, after the glazing of the choir (Pls. 253–71). I therefore decided to approach the question of the survival of early glass differently, by asking whether any group of figures or borders stands out from the rest of the glass as significantly archaic-looking.

The Earliest Glass of Saint-Remi

Confirmation that a group of windows were glazed before about 1175 comes from five surviving border designs that were very sensitively complemented by Simon in the last restoration. One is in the choir tribune, and four were placed in the hemicycle of the retrochoir clerestory (Catalogue D, R.b.1–4 and 27); one of these had also been recorded in the tribune in the mid-nineteenth century, although this is unlikely to be its place of origin. These are extremely narrow, the design element occupying only eight to ten centimeters (ca. three to four inches) and, even with three edges, still less than twenty centimeters (eight inches) wide.[32] The designs are characterized by their efficiency, involving from one to four shapes only, which are varied through changes of color and through reversals that give a mirror symmetry. They are also severe, tending to geometric cutlines, whether circular or straight leads were combined to create chevrons and lozenges. Painted decoration consists of stiffly curved foliage silhouetted against cross-hatching and, in reserve in the circles and lozenges, more delicate flowers with four pointed petals. These elements fill the surface so that one cannot speak of a ground, with the unifying chromatic effect that it normally gives, although in some cases a red edge may be original; yellow, purple, green, and blue are distributed in succession in the painted elements so that the repeat is defined by chromatic sequences rather than by motifs.

The density of these designs, the absence of intense red and blue, and the chromatic sequences group these pieces with Rhenish and east French glass of the Romanesque period. Densely painted borders go back at least as far as Augsburg, if we follow Frenzel's reconstruction of the design surrounding Hosias, which is based on one

[30] Caviness, 1985, pp. 44 and 47, n. 51.

[31] At Canterbury this is also true for the indigenous shop, which seems to have been the principal supplier of painted glass from about 1175 to 1220 or so.

[32] The norm for borders to lower windows in Canterbury is 23 to 28 centimeters, whereas clerestory borders from the early period are wider (30 to 50 centimeters; cf. 20 centimeters in the Trinity Chapel). The small openings at triforium level in the choir, however, have borders less than 20 centimeters wide.

surviving fragment.[33] A more colorful and miniaturesque variant before the figure of St. Timothy of about 1145–1150 from Neuwiller-lès-Saverne (Bas-Rhin), now in the Musée de Cluny, Paris.[34] Finer, more controlled designs appear as medallion edgings in the Relics of St. Stephen window in the Cathedral of Châlons-sur-Marne of ca. 1155, and also at Saint-Denis and Le Mans.[35]

The closest comparisons for this group are with narrow borders that are integral with panels from Troyes that probably date from the 1170s; one on the St. Nicholas panel in the Musée de Cluny uses virtually the same cutline and combinations of colors as type 27 at Saint-Remi, and is painted with similar foliage on a cross-hatched ground (Catalogue D, R.b.27).[36] A panel in London has crisp palmettes akin to those in type 1; in each case it is as if full border designs at Saint-Remi were being developed by doubling such narrow edgings in mirror image.[37] Both palmette edgings and curled acanthus foliage appear in a rare example of rémois secular sculpture of the 1160s (Pl. 89).[38] The earliest capitals of the new chevet, in the wall arcades of the chapels, bear reminiscences of these tight forms, but the general tendency is toward more organic double curves and fleshier surfaces (Catalogue D, R.b.8); it is tempting to place the glass in an earlier period.[39]

Another group of works with which these borders show some affinity, and yet which appear later, are the Romanesque borders recorded in Strasbourg Cathedral by Zschokke.[40] A few of these are as narrow as the ones in Saint-Remi, but in many such cases the original has been cut in half for use as fill; on the whole the Strasbourg borders, which may be as late as ca. 1200, are richer and fleshier, with pearled fillets and intertwined leaves, including several types that are closer to the later groups at Saint-Remi.[41] Decorative bands in the figural panels of this period also share motifs with the early Saint-Remi borders, notably simple quatrefoils in reserve and interlocking rosettes.[42]

An earlier date for the glass borders is also suggested by their affinity with frames in Romanesque manuscripts, especially from the northeast of France. A considerable repertory of very similar motifs is seen, for in-

stance, in the Cluny Ildefonsus manuscript, and in the author portrait of St. Augustine in a Marchiennes manuscript that has been dated about 1130–1160 (Pls. 88, 126); there is a variety of vestigial palmettes in the frame, whereas decorations in thrones and vestments are geometric, but both are varicolored in bands. These severer motifs also had considerable currency in twelfth-century metalwork, as indicated in Catalogue D. As is often the case with ornament, however, these motifs are so long-lived that they cannot be used per se for dating, though their manner of execution and of integration with other elements may be telling.

One slightly wider border is tentatively placed in this early group: Type 5 maintains a miniature, jewel-like scale, while moving toward greater complexity by combining a lattice of strapwork with a rich multicolored quatrefoil composed of separately leaded leaves that curl over on themselves (Col. Pl. 15, and Catalogue D, R.b.5). The palette is distinctive, combining an unusual reddish purple in the foilage with a light streaky red in the grounds of the lateral cells and in the circles at the intersections of the lattice. Two Saint-Denis borders offer general similarities, except in their use of beading, and similar heavy leaf forms can be documented in a rémois manuscript of the 1150s.[43] A date about midcentury, soon after Suger's glazing of Saint-Denis, does not seem improbable for this design. Comparison with another border in which the same type of composite leafy quatrefoil occurs demonstrates a more rudimentary and monumental execution, which I take to be a later date (Col. Pl. 16, and Catalogue D, R.b.11).

A pair of figures in the choir tribune might also be attributed to the period before 1175; they appear to be of a different facture than any others, although their condition is so poor that conclusions must be tentative. The principal figure is a seated St. Remigius, of very small size, with an almost effaced inspiration (Pl. 81). The upper half of another archbishop saint has an inscription in which NIC . . . LA' can still be read, identifying it as the fragment of St. Nicholas seen in the nineteenth century with the St. Remi in the axial clerestory window (Pl. 82). This panel would be comfortably accommodated in a round-arched opening of the size of one still preserved

[33] Grodecki and Brisac, 1977, pl. 40.

[34] Grodecki and Brisac, 1977, pl. 43, p. 285. The width of the border, without an edge, is about 6 centimeters. Small unpainted blue elements may be thought of as "ground," a meander, or a series of concave lozenges.

[35] Grodecki and Brisac, 1977, pls. 105 (Châlons), 80 (Saint-Denis), 49, 50, 54 (Le Mans).

[36] The pairing of green with purple, and yellow with blue shoots in Saint-Remi gives the same juxtapositions as the sequence of green, purple, blue, yellow in the Troyes panel (Grodecki and Brisac, 1977, pl. 124). For the date of these panels, and their possible origin in another building, such as the Collegiate Church of Saint-Etienne, rather than in the cathedral as had been assumed, see Pastan, 1986, pp. 4–5, 61–64, 80–81, 87.

[37] Cf. The Temptation of Christ, Victoria and Albert Museum, Grodecki and Brisac, 1977, pl. 118.

[38] The small secular tympanum in the Musée Saint-Remi, which

was excavated on former chapter land; Sauerländer, 1972, pl. 55, pp. 414–15.

[39] Skepticism has been expressed about the authenticity of sculpted capitals in Saint-Remi, in view of the extent of nineteenth-century and post–World War I restoration (Prache, 1978, pp. 60–61), yet many of these arcade capitals have vestiges of polychromy and gilding peeling off to reveal whitewash; I take these layers to date from the nineteenth century and the Maurist period respectively. Several are very accurately documented in nineteenth-century prints in Reims, B.M., Estampes, "St. Remi," ea 4.

[40] Zschokke, 1942, pls. 30–31, esp. nos. 23, 24, 27–30, 36, 37.

[41] E.g. Zschokke, pls. 30, nos. 19 and 17; cf. Catalogue D, R.b 29, 40, 41.

[42] Beyer et al., 1986, pls. 130–31, E 2, G 3–18, G 30, G 34, G 39–40, G 42.

[43] This Bible is dated ca. 1150–1160 by Farquhar, MS, 1968, no. 12, p. 151.

in the chapel off the north transept, dating from the eleventh century (n. XVI, Fig. 2).[44] Both may have belonged to a program in the earlier choir; a larger figure of St. Remigius was almost certainly placed in the axial window of the Gothic hemicycle, but the earlier building presumably had had an image of its patron saint, perhaps also originally placed behind his shrine. The "petit Saint Remi" has suffered much from apparent overpainting and corrosion, which render the inner surface opaque and give a reverse or negative effect with transmitted light. Reflected light, however, picks up fine painted detail and stickwork of a kind that is rare in other figures at Saint-Remi—the line ending has delicate arabesques, the pallium and miter are minutely jeweled, and the beard is densely worked in layers of paint (Pls. 83, 86); the treatment of the beard is comparable in St. Nicholas. In a raking light, the face of St. Remigius is dramatically highlighted and modeled, with high cheekbones, large eye sockets, and hollow cheeks. A mid-twelfth-century date might be argued, although the period of Peter of Celle's abbacy before the new construction of the east and (i.e., before about 1170) cannot be ruled out.

The general characteristics of the figure, built up in symmetrical additive compartments, the pallium and decorative hem of the dalmatic forming straight bands, belong to the Romanesque of mid-twelfth century, as in a figure of St. Ambrose in a manuscript from Rochester Cathedral (Pl. 84).[45] These characteristics are shared with a mysterious relief of an archbishop, evidently from a tomb, that was found in Reims, and which is customarily dated ca. 1160 (Pl. 85).[46] Yet the sculpture is more commanding, dramatically combining simple volumes with highly wrought surfaces. The secular tympanum from Reims, which may date from the 1160s, demonstrates a subtle variety of energetic drapery forms that are perhaps close in spirit to the small archbishops, and the vegetal scroll-work is closely comparable to the decorative line-ending of the St. Remigius inscription (Pl. 89). The sensitive style of the rémois painting is also to be associated with one of the byzantinizing trends of the twelfth century, such as appeared early in the Cluny manuscripts and in the wall paintings of Berzé-la-Ville; the facial structure is shared with these works, although there is no sign here of damp-fold drapery.[47] There are, however, figures in the Cluny Ildefonsus that have similar, if slightly harsher, folds (Pl. 88). A more massive

figure than St. Remigius is the author portrait in a manuscript of Gregory's Letters, from Saint-Amand; the hem of the alb is similarly drawn, with the back sagging below the front and delicate folds indicating the way it clings over the instep (Pl. 87). This book may date after midcentury.[48]

The Lower Windows of Peter of Celle's Chevet

No trace or record remains of the figural glass that must have been created for the new chapels, nor even of the armatures that contained it. Among the surviving borders, however, it is likely that a good many came from these windows, since some were recorded here in the early nineteenth century, whereas all were removed from the clerestory (Appendix 2, f. 51v).

Several narrow borders that might not be suitable for the clerestory provide a transition from the early group discussed previously, and they provide a valuable indication of continuity with the earliest phase of glazing: Type 28 bears a resemblance to type 27, but it has a more aerated appearance, uniform red ground, and simple alternance of color in the fronds, features typical of later glazing (Catalogue D, R.b.27, 28).[49] Types 29 and 30 have a density of foliage approximating that of the earlier group, and type 6 may also be transitional, yet a more luxuriant growth is evident like that of the glass of the late 1170s in Canterbury.[50] Another design that is now "lost" in the clerestory in Saint-Remi has such a close analogue in a stray panel in Canterbury that the latter may be its model (Catalogue D, R.b.12).

In general, by analogy with the pattern that evolved at Canterbury by 1180, one would also expect more intricate, small-scale designs in the lower windows of Saint-Remi, such as the lush double-branching rinceaux with vine leaves and grapes that resembles the twelfth-century sculpture integrated into the north portal of the cathedral (Catalogue D, R.b.34), or the spectacular branching palmettes in type 15, although in this case the original setting of an analogous design in Canterbury cannot be determined (Catalogue D, C.b.2). Fleshy foliage entwined with a trellis or describing elegant circinate forms in type 18 and in two or three lost designs (R.b.32, 33a, and 33b) also seems painted for close view-

[44] The measurements of the east window of the chapel on the north transept (n. XVI) are: radius of arch, 55.5 centimeters; width, 1.12 meters; height, 2.03 meters. The St. Nicholas panel measures 53.5 by 61 centimeters, leaving room for borders nearly 25 centimeters wide on either side, and a rubbing confirmed the correct curve of the arched top. A figure such as St. Remi (height, 1.10 meters) would not, however, fit below if the St. Nicholas were completed to the same dimension. The openings in the apse may have been higher.

[45] George F. Warner and Julius P. Gilson, *British Museum: Catalogue of Western Manuscripts in the Royal and King's Collection*, London, 1921, 1: 93, pl. 31c and d.

[46] Paul Vitry, *La Sculpture française du XI^me au XVI^me siècle*, Paris, 1939, pl. 8; Sauerländer, 1972, pp. 394–95, pl. 27; Hamann-Mac Lean,

1983, p. 205, pls. 154–57. It seems entirely unnecessary to date the piece by associating it with Abbot Odo of Saint-Remi on the basis of a small figure on the base inscribed with that name.

[47] Dodwell, 1971, pp. 173–75, pls. 200–202; opinion is divided whether the Berzé paintings date before 1109 or as late as 1140.

[48] Dodwell, 1971, p. 178, pl. 208.

[49] Cf. the counterpart in Canterbury, triforium of northeast transept, Caviness, 1981, pl. 135.

[50] It may be noted that close analogues of these are in the north choir aisle at triforium level at Canterbury (Caviness, 1981, pls. 114, 133); though scaled to the window opening, the delicate painting scarcely takes account of the distance from the viewer.

ing, although the tribune would have provided this as well as the lower chapels. The analogy with Canterbury borders is more precise, however, in the cases of types 16 and 31 (Catalogue D, C.b.1 and 2); one of these Canterbury borders is in situ in a lower window attributed to the rémois shop, and it can almost be taken for granted these two were intended for a similar position in Saint-Remi.

The Ornamental Colored Glass in the Choir Tribune of Saint-Remi

It is clear in the Rothier photographs that none of the figures in the tribune were framed in an authentic way by the 1890s; in each case, the figural panel had been set off by additional ground, that over the virgin saints rising to a half-round arch with a roundels on a plain ground (Pls. 92, 93, 246). Most of the windows had been filled with very harsh ornamental designs on a variety of scales, which appear to be the work of Ladan who had supplied the borders in the clerestory. Only the two lights with the virgin saints appear in these photographs to have had some ancient ornamental panels of ornament, identifiable as those since restored and replaced; it is possible these had been used in this way prior to the nineteenth century, since Povillon-Piérard saw the figures scattered as they are now. As presently seen, Simon's complements to the ancient ornamental panels blend almost imperceptibly with them; he provided surrounds in the early style to figures in four lancets, and completed one whole window. Other surrounds and some complete lancets were provided in a contemporary mode by Charles Marq; the scale, color harmonies, and vigor match the old glass very well, without imitating it (Pl. 247).

Four authentic designs survive on the site, others having presumably fallen prey to nineteenth-century collecting and possibly to war damage (Cols. Pls. 17–19, and Catlogue D, R.o.1–4). A fifth is preserved in the Cloisters, New York; allowing for some errors of draftsmanship, it appears to be the same reproduced in double quantity by Cahier and Martin and by Merson in the last century.[51] The motif also appears to have been copied in the nineteenth century, judging by a photograph in the Archives Photographiques in Paris (Pl. 31). A sixth design was recorded for Cahier and Martin be-

fore 1841, but does not seem to have survived (Catalogue D, [R.o.6]); rather arbitrarily, they included it among grisailles instead of "mosaïques," even though the use of yellow and red grounds and green fillets, with some blue and purple, give an overall saturation and brilliance as great as others under that heading.

The various foliate designs that survive anticipate the carpet windows that are typical of Rhenish and Austrian glazing a century later, and they are too colorful to be characterized as grisaille.[52] They seem in fact to belong to another tradition, stemming back at least to the famous griffin windows of Saint-Denis, which were antithetical to the colorless and often unpainted windows of the Cistercians.[53] Although the leafy elements are often painted on colorless glass, there is ample use of yellow and green, blue and red in grounds and fillets; the balance of luminosity is masterly in that the colorless glass is heavily painted, the design elements often surrounded by painted or stickwork cross-hatching (Catalogue D, R.o.1, 4, 5), whereas the more saturated glasses are sparingly used and given full transparency. The richness of the painting was noticed by Viollet-le-Duc who referred to panels in storage, astutely linking them to ones in Saint-Denis and Châlons-sur-Marne in their painting technique: "In storage at Saint-Deins, at Châlons-sur Marne, and at Saint-Remi of Reims, one can still see fragments of painted white glass that come most probably from twelfth-century grisaille windows. These early scraps are powerfully modeled, with smear shading, in the same way as colored ornament. The motifs are full and broad, their contours heavily reinforced, and the ground is relatively reduced and filled with cross-hatching in black or in reserve." On the other hand, he saw them as belonging to the pure grisaille tradition, not that of the colored ornament of the griffin window, a judgment with which I disagree.[54]

There seems little doubt that these bold and complex designs, involving the repetition of two or more convex shapes in close proximity, were intended to fill entire lancets; each design generates its own particular compositional rhythm and chromatic cast, just as do narrative windows. The only whole window in which this effect can now be seen is St.III a, where four authentic half-units of design have been complemented by modern replicas (Catalogue D, R.o.3). The pervasive sense of richness and energy owes much both to the vigorous

[51] For references, see Catalogue D, R.o.5.

[52] For carpet windows, see Grodecki and Brisac, 1984, p. 208, pls. 202–3. Cahier and Martin, 1841–1844, placed these immediately after the Reims and Soissons designs, classifying all as "mosaïques" as opposed to grisailles: Mosaïques G and Mosaïques etc. H.

[53] Grodecki and Brisac, 1977, p. 41, use the term "vitraux 'ornementaux,' " as also Morgan, 1983 ("ornamental windows"), to distinguish these from grisaille. Kline, 1983, pp. 48–52, 277, referred to this genre as "ornamental colored glass."

[54] Viollet-le-Duc, 1868 (reprint, 1870), p. 448: "Les grisailles pures, dont nous n'avons d'examples qu'au commencement du XIIIᶜ siècle, devaient cependant exister avant cette époque, car le dessin de celles que nous possédons accuse la trace de traditions antiérieures au XIIIᶜ

siècle. Dans les magasins de Saint-Denis, à Châlons-sur-Marne, à Saint-Remi de Reims, on retrouve encore des fragments de verres blancs peints qui proviennent très-probablement de grisailles du XIIᶜ siècle. Ces anciens débris sont puissamment modelés, avec demi-teintes, suivant la méthode adoptée pour les ornements de couleur. Le dessin en est plein, large, fortement redessiné avec fonds relativement réduits et remplis d'un trellis en noir ou enlevé au style sur noir. Les verres employés alors sont épais, légèrement verdâtres ou enfumés, souvent remplis de bouillons, ce qui leur donne une qualité chatoyante très-précieuse. Habituellement ces verres blancs sont peu fusibles, et one été moins altérés par les agents atmosphériques que les verres colorés, lesquels sont profondément piqués, surtout à l'orientation du midi."

painting technique, and to the reduction of negative or concave "spaces," which became larger in thirteenth-century narrative windows; it may be noted that the Becket Miracle window in Canterbury that is attributed to the rémois shop uses the same principles (Pl. 206). On the other hand, the repertory of motifs is not the same as will be noted in the rosettes of the Canterbury window, nor indeed in many of the colored borders of Saint-Remi.

The group of narrow borders that I have suggested are early, however, share some characteristics with the ornamental panels, and seem to have long been associated with them (Catalogue D, R.b.1–4 and 27); it is notable that the tribune windows do not now have an iron dividing off a border, as is the norm in large openings of this period, so the leading is integral, and this arrangement could explain the narrow widths of the "early" borders.[55] They share a light palette, with a good deal of green and yellow, the use of cross-hatched grounds, and in some cases motifs such as small quatrefoils or curled acanthus fronds. This possible association raises the question whether some ornamental colored windows were made for the lower story, or some of the "early" borders, for the tribunes. There may in fact be a certain latitude between different designs; one that is lost uses the same arrangement of curled acanthus fronds, in a saltire, as a border that I take to be later (Catalogue D, [R.o.6]; cf. R.b.11).

Comparative material assembled by Kline does not assist in dating these windows, although it allows a late twelfth-century origin.[56] Whether the related designs in the Benedictine Abbey Church of Orbais, near Reims, were made for the side windows of the axial chapel about 1180–1190, or whether they belonged to the clerestory campaign after 1210, when triplets of the Saint-Remi type were adopted, cannot be resolved. Whatever the case, it would appear that they are slightly later and simplified versions of the rémois carpet windows; notably, the ornamental colored panels lack the counterpoint alternance of geometric forms that is the hallmark of the Saint-Remi designs, and in cases where this does appear the windows are of a later painted grisaille type. (Catalogue D, R.o.3, comparison A).[57]

As pointed out in Catalogue D, the ornamental col-

ored panels recorded by Cahier and Martin in Soissons Cathedral in the 1840s might as well have come from Braine as from the south transept; in either case a late twelfth-century date is possible. Viewed together in Cahier and Martin's color plate, some general differences between the two series render them distinguishable: The Saint-Remi designs appear more controlled, the geometries clearly articulated by fillets, and the graphic style seems bolder.[58]

A firm conclusion cannot be reached as to the original position of these windows in Saint-Remi; the type would be appropriate in the straight bays of the chevet, to the west of the radiating chapels, by analogy with the griffin windows in Saint-Denis, and this at least is where some of the ornamental glass was installed at one time (s.XIII a and b).[59] On the one hand, an early date is supported by the extent of cross-hatching and stickwork, and the predominantly green, yellow, and purple palette in types 4 and 5, as well as the coincidence of some motifs with the early group of borders (Col. Pl. 19). On the other hand, the foliage is freer, and some designs at least introduce more red and blue (Catalogue D, R.o.1–3); furthermore, it is easy to envisage the tribune bays of the choir, other than the central one, glazed in this way because the proportion of colorless glass gives a rich luminous effect, enhancing the likeness to a great candle-wheel (Col. Pl. 1). The tribune seems to have been constructed in the same campaign as the clerestory, which we will see was possibly glazed in the late 1170s to early 1180s.

The Glazing of the Clerestory of the Retrochoir of Saint-Remi

This group of figures is the most coherent and the best documented, but in order to observe medieval modifications in design, and to analyze the original graphic rendering and use of color, it is essential to know how much of each figure is replaced. These questions have been answered in Chapter 1; the detailed history of the restorations given there provides some grounds for caution. A summary of the findings is rendered graphically in Fig. 5.[60]

[55] Yet it is unlikely even here that borders have not changed places, e.g. in the case of R.o.3 in Catalogue D.

[56] Kline, 1983, esp. pp. 220–25, and see Catalogue D. She relies on the dating of Saint-Remi to argue a late twelfth-century date for the related designs at Orbais, and for the lost examples recorded in Soissons in the nineteenth century (pp. 51–52, 78–79).

[57] Kline, 1983, painted grisailles 1–4, pls. 43–46.

[58] Cahier and Martin, 1841–1844, Mosaïques F, 3, 5–7; cf. 1, 2, 4, 8. There is also a slightly greater tendency to use more red and blue in Soissons (2, 4, 8), and a sheaf of acanthus with a cluster of berries in the center that is favored there is not found in the Saint-Remi examples (1, 2, 4).

[59] A photograph available from Roger-Viollet, Paris (cliché 13014LM) is not dated, but appears to be from the late nineteenth century, certainly prior to 1916 (illus. Caviness, 1990, fig. 8).

[60] Examination revealed that forty-one of an original sixty-six fig-

ures survive, at least in part; only twenty-nine of these retain old glass in each panel, while in the other twelve at least one panel has been entirely replaced. I have included in the figures for original glass the upper half of "Zacharias" from N.V c which is now in the south transept but which completes the figure in the clerestory, and the surviving top panel of the Virgin and Child from the east window, also now in the transept. Within the old panels the amount of original glass varies; replacements may be as much as two-thirds of the surface. There was some tendency to replace the heads in the nineteenth century, but this is not nearly as prevalent as it was in the comparable series of Canterbury. The distribution of the old glass very heavily favors the north side, and this was true by the late nineteenth century; at present twenty-one whole and three partial figures are preserved there, as compared with eight whole and eight partial figures on the south side. The Rothier photographs, taken before 1896, indicate that the fourth bay from the west on the south side (S.III) had been reglazed; the pres-

In Chapter 2 the iconographic program has been reconstructed as far as possible from prerestoration records, notably the notes by Reimbeau and the drawings in the Musée des Arts décoratifs. In this chapter authentic name bands are transcribed normally, whereas modern appellates are placed in quotation marks to indicate that they are so-called.[61]

A crucial issue for the analysis of the sequence and process of design and execution is whether the figures may have been moved from their original position and order. There can be no certainty a priori that each ancient figure has remained in its place of origin; in fact, two panels in bay N.IV are at present switched, and have been since the nineteenth century, so that the colors of the upper and lower halves of the figures do not match (Pls. 133, 175, 179). To test whether any whole figures have changed places, it will be useful to analyze the figure composition, including color balance, within one apparently complete triplet. The question can then be raised whether anomalies in other bays can be attributed to different workshop practices or to the intrusion of extraneous glass.

Analysis of the clerestory triplets will begin with the second bay from the west on the north side (N.V), since it is the only one from which all the original panels are preserved; the upper half of "Zacharias" was mislaid in storage and replaced in light N.V c with a modern panel by Simon, but the original has now been installed in the south transept (Pls. 129, 130). The three lancets were originally glazed in such a way as to give internal unity to the bay. The triplet is woven together by the distribution of color; large masses of brilliant yellow in the upper halves of the lateral lancets are balanced by white in the lower center; more somber harmonies of purple with green in the lower halves of the lateral lancets are picked up by green with purple in the upper center (Col. Pl. 4). The designs of the figures also contribute to the impression of unity. Those in the center lancet, composed of three panels each, are represented frontally, whereas the smaller two-panel figures on either side turn their heads in three-quarter view toward the center; the formal unity of the triplet takes precedence over the iconographic unity of the choir in that the prophets do not turn toward the Virgin and Christ Child in the axial window, whereas at Braine and Canterbury the ancestors of Christ, placed in single lancets, turned and gestured toward the east. Furthermore, none of the six figures in the bay have throne backs; four gesture with one hand, the palm open; the three archbishops hold their croziers vertically.

In fact, the same cartoon was used for the two prophets and the two archbishops in the lateral lights, and the colors are identically distributed; instead of reversing the

cartoon to give a consistent lateral symmetry, the glaziers redesigned the head and neck to turn the other way: In the case of "Zacharias," a beardless face originally contrasted with the bearded Isaiah (Pls. 129–31). I infer from this process that the cartoon was drawn on a sized wooden table top, as Theophilus described earlier in the century; if linen had been used it could have been turned to reverse the design of the whole figure, and although in the case of the archbishops this would have had the disadvantage of placing the crozier in the left hand, a readjustment could have been made almost mechanically without the expertise needed to design a head. Further, the cartoon seems to have indicated not only the cutline for the glass but also the tracelines for the painting, since the execution of the figures is remarkably similar (Pls. 130, 166). The execution throughout the bay in fact demonstrates a stylistic unity, and the modeling here is exceptionally strong, enhancing the plasticity that is suggested in the turn of the lateral figures in space (Pls. 130, 147, 158, 166, 169); the boldness of the colors and of the painting in the bay as a whole stand out in the choir series, almost as though all three lights are the work of a single distinctive artist.

An examination of the other bays in which substantial portions of the figures are intact will reveal whether they conform to the design principles observed in N.V. Each distinct cartoon has been given a letter on the plan (Fig. 5). I have ignored changes in the turn of the head, such as were noted in cartoons H and J in that bay, because they prove to be the norm, but other variants are designated by a "v"; for instance, the archbishops in the center lights of the first triplets on the north and south are cut from the same cartoon, E, with the same color distribution, but when the cartoon is used again in the north and south sides of the second bay there is a slight change of vestments and a complete change of colors so it is labeled Ev (Pls. 114, 157, 158). Complete reversals of a cartoon are expressed by an "r," and it will be seen at once that in every case these are restored figures. An a-b-a rhythm (better described visually as b-o-d) was noticed in the use of cartoon in N.V, where H-I-H, J-Ev-J involve only four designs; this repeats throughout the retrochoir clerestory bays in which a reliable judgment can be made with one exception: In N.VI six different cartoons were used (Fig. 5; Col. Pls. 2, 3, 5; Pls. 127, 148, 163, 164; A and D in the left lancet do not repeat in the right). Before trying to explain this anomaly, other patterns of reuse of the same cartoon may be observed.

The same cartoons are used in the central lights facing one another across the choir in each case: B and E in the first bay from the transept, I and Ev in the second, L and M in the third; the variant here is iconographic since Da-

ent figures, however, are the work of Jacques Simon and blend so well with the old glass that they have frequently been cited as old. There is unfortunately no evidence as to the original designs used in this bay.

[61] Two names only are completely old (Archbishop *Henricus* and the prophet *Samuel*), and original fragments in another five establish their

identity (*Balaan, Elie, Ysaie, David Rex,* and St. *Rigobertus*). The Virgin seems not to have had an inscription. In the other forty figures, although the upper panel with the inscription is preserved in each case, thirty-three name bands have been replaced. Isaiah and Rigobert are duplicated.

vid in N.IV has a crown and scepter (Col. Pl. 10; Pls. 157, 160, 171, 174). Unfortunately this pattern cannot be tested in the hemicycle due to the losses on the south side. There is generally no correspondence between facing lateral lights; the exception is D, which is used three times in the first vaulted bay. Repetition in adjacent bays is common: E is used in all four of the westernmost triplets (N.V and VI, S.V and VI), which occupy two vaulted bays. Cartoons C and F in N.VI correspond diagonally with S.V c and provide another link between these two bays. Similarly, O is used in S.IV and in N.III, and R in the center of N.III and N.II; these fall within the hemicycle bay. Only one cartoon, D-Dv, is used in both major architectural units, defined as the two straight quadripartite vaulted bays and the hemicycle bay; the latter contains the third straight triplet on each side, equal in width to the first two pairs, and five narrower turning triplets. Some impetus to provide new designs in the turning windows was provided by the change in iconography for the upper figures, and by the narrower openings, although this did not prevent O being used for S.IV and N.III (Pls. 153, 154)[62] Within the three pairs of straight windows new designs could theoretically have been generated for a number of reasons, such as the difficulty of executing two figures on the same table simultaneously, and the limited durability of the cartoon (D-Dv was used five times, others fewer). Following my definition, it is assumed that a different shop would introduce its own repertory of designs. It is thus of interest that the cartoons are reused in overlapping sequences so that at least one design in each triplet links that glazing bay to another. The only exception is the axial bay, with its unique iconography: The inference is that a single shop provided all the glass in one campaign, by a continuous process of designing in series.

If we assume cartoons that N, V, and W originally had matching counterparts in the other lateral lights of windows S.IV and S.II, to keep the b-o-d rhythm, there are only two cartoons that were not repeated, the Virgin and Child in the East Window (Z), evidently a unique representation, and A in N.VI. The first bay on the north side, N.VI, has already been noted as exceptional. The question might be raised whether the unique figure A is misplaced, but there is no satisfactory alternative for its placement.[63] The same is true of the companion archbishop, D; if F were repeated here, D would have to find a place in the hemicycle. The implications for the iconography would be considerable since this is the only archbishop with an original inscription: Henry of France. His position next to the transept has generally been imputed to the fact that he was the most recent incumbent to be included.

Closer analysis of the composition and style of N.VI suggests the figures were in fact planned for this bay (Pl. 127). An analysis of the colors used in these two figures, and in the triplets of N.VI and S.VI as a whole confirms that Balaam and Henry of France in fact belong here. These are the only lights in which various intensities of an extraordinary limpid, warm green are used (Col. Pls. 2, 5); the same tints are used in cartoon D for archbishops Henry of France and the two opposite (Fig. 6); in addition, a paler tone of the same green is used as an edge to the red nimbus of Balaam, and a slightly deeper one for his robe and for that of "Jacob" (S.VIa). The central figures of prophets are clad in cooler greens, the brilliant tone of the north side matching that used in "Noe" in the first light of the south side, whereas the robe of "Samuel" in the second light is lighter; each of these figures, like Balaam, has a white mantle. The color harmonies of the third light in N.VI, in which cartoons C and F are used, do not coincide with others in these triplets; the prophet is dressed in a white mantle over a purple robe, and the archbishop in a deep cool green chasuble (Col. Pl. 3). On the other hand, it might be suggested that the choice of green for the latter was an attempt to synchronize the distribution of colors in the bay.

The style of painting and conception of the figures in these first two triplets of the choir are heterogeneous, although their analysis does not serve to separate the two figures in N.VI c as clearly from the rest as one might have expected from the tonal range. In fact, Elias and Balaam may have been planned as partial mirror images of each other, each with the arm on the outer side of the triplet parenthetically set akimbo, that hand grasping a scroll, the other arm enveloped in a white mantle and crooked so that the hand gestures in front of the chest, and each one's head turned toward the center of the triplet (Col. Pls. 2, 3; Pls. 163, 164). Even the distribution of the mantles over the opposite shoulder and knee suggest a symmetry in the planning. On the other hand, one cannot deny certain contrasts between these two figures. There is a higher degree of spatial consistency and clarity in the rendering of Balaam, especially evident in the placement of the feet on the footrest, with heels together, and in the modeling of the heavy drapery that pulls away from his right shin and is smoothed over his left, falling in catenary folds between. In contrast, Elias's feet are placed wide apart, on different levels, and receive no support from a decorative arcade; his right shin, massively outlined in the leading, is disguised by a series of sweeping folds in the configuration of a "y," and another series collects over his left calf, instead of between the legs, again denying the volume of the limbs. His white mantle is draped in a serpentine mass over his right

[62] The lateral lights (1 and 3) in S.IV are 1.20 meters wide, whereas in N.III they are only 1.00.

[63] This is in fact one of the rare figures with an original inscription, identifying him as Balaam the prophet, so he cannot have been intended for S.III a, which required an apostle. Alternatively, if placed in S.IV a, he would not match the figure in the other lateral light, and

the latter has a prophet's shoes so he cannot take the place of an apostle in S.III or II. Although Balaam would have been better placed on the south side, since he now points to the transept instead of toward Christ in the axial window, it does not seem possible to move him without throwing out other patterns of consistency.

shoulder and left knee, and tends to be read in a single plane, thus mitigating the recession of the lap of the seated figure; this effect is enhanced by a colored band and hem that are arranged vertically. The breadth and massiveness of Balaam, on the other hand, are emphasized by the way in which the white mantle breaks over the left thigh and is pulled around the back of the figure to reappear over the right thigh and knee, and by the horizontal bands and hems in robe and mantle.

The contrast in painterly execution, as well as conception, that was observed in the lower halves of the figures is evident in the shoulders and torso as well; units of drapery are delineated with great certainty in Balaam, almost in the manner of wet-fold in that they seem to reveal the volume of the biceps and shoulder, whereas similar forms in Elias's left arm appear overworked and lose the meaning of the forms. The mantle is very elaborately draped on the right shoulder, where part doubles back and terminates in a domical fold, and part descends over the arm only to loop back into a large ropelike bunch of folds that hide the elbow; this passage is elegantly articulated by *muldenfalten* that reveal the volume of the drapery itself. The faces can be distinguished in similar terms; although they are of the same bearded type, with high cheek bones and severely angled eyebrows, the interpretation is softer and more decorative in Elias; the small downward drooping moustache of Balaam contrasts with the upward curling fringe of Elias, which seems to draw the corners of his mouth up, and the stark "wet-fold" chin of Balaam is covered with a soft growth of beard in Elias; even the cap of curls, like coiled springs, in Balaam contrasts with softly waving locks in Elias. Psychologically as well as physically Balaam gives the greater impression of force.

The same points of contrast separate the archbishops in the lateral lights, Henricus under Balaam and "Gervasius" under Elias (Pls. 145, 148). The former is articulated with great clarity, and the severity of his short beard and the bold sweep of the folds over his chest easily identify this figure as the product of the same hand as Balaam; "Gervasius," on the other hand, is awkwardly articulated in that his left arm disappears behind a large bunch of folds so that the sudden appearance of the back of the hand is difficult to understand; the fingers of Henricus, as they clasp his book, are far more convincing. At the same time it may be noted that the design, as well as the colors, of "Gervasius" may have been developed to be paired with Henricus, since the position of the book (and hand that holds it) and the diagonal crozier correspond; the chief differences are in the lower placement of the hand that holds the crozier and the absence of a throne back in "Gervasius."

The two prophets that face each other from the central lancets of each triplet in the first bay are virtually identical in design and coloring (Pls. 167, 168); "Nathan" on the north side is less well preserved than Samuel, but restorations carried out by Simon follow the other fairly closely. One is struck at first by a resemblance to Balaam

in the stable placement of the feet, the horizontal bands that emphasize the foursquare position of the knees, and the mantle that reveals the recession of the lap and the volume of the stomach (Pl. 163). The pointing gesture (in the case of Samuel, away from the east window) and close-cropped hair also resemble Balaam. There are, however, also marked points of resemblance to Elias (Pl. 164): the left arm is as closely modeled on that of Elias as the right is on that of Balaam, and the feet dangle in front of the decorated moldings of the throne base instead of resting on stools; the rather perfunctory sweeping folds between the shins, thrown off-center so that they mask the right calf, and the loop of the mantle that is apparently caught by the hand with the scroll have counterparts in Elias.

The design and execution of the two frontal archbishops in the lower part of the central lights, "Rainaldus" (N. VI b) and "Radulphus" (S. VI b), from cartoon E, depend largely on Henricus (Pls. 127, 128, 145, 157); the bulky folds of the chasuble over the right arm and the broad delineation of the left half of the chest required little adaptation. The animal heads of the foldstool give breadth to the composition, and the vertical crozier replaces the throne back. The other two archbishops in the south triplet, which correspond in design and color to Henricus, do not differentiate themselves in execution (Pls. 145, 146).

For the first two triplets it remains only to examine the lateral prophets, "Jacob" and "Noe" on the south side (Pls. 128, 165), made from cartoon G. They present a combination of elements from the other figures: The foursquare knees and symmetrically turned feet resemble the designs for "Nathan" and Samuel, but a colored band in the mantle denies the recession of the right thigh, as in Elias, and the feet are placed on a stool, as in Balaam (Pls. 163, 164, 168). The left arm, this time plausibly catching the mantle into a looped fold, has the tensile strength of Balaam, but the shoulders are less powerful. The execution, as far as it can be judged from the damaged condition of the paint in some passages, such as the loop of the mantle in both figures, is close to that of Elias; deep 'y'-folds over the left shin of Jacob are notable. On the other hand, the design does not allow the complexity of folds that is found in Elias.

As a working hypothesis, based on these observations, I propose the following: The westernmost quadripartite vaulted bay of the choir was glazed by two or more designers and painters who together worked out a master plan. Because of the division of labor the three lights of the north triplet did not achieve homogeneity and symmetry; although an evident attempt was made to design figures for the lateral lights, which, though different, would pair well, both the designs and the execution, including the quality of painting and the choice of glasses, give an impression of diversity. The attempt to work out correspondences may have been rather time-consuming, as was the effort expended in developing six different cartoons. Once installed and viewed

from below, features such as the contrived symmetry of the arms of Balaam and Elias are too subtle to be easily noticed, whereas the differences in posture and color are manifest (Col. Pl. 2, 3; Pl. 127). The decision may have been made then to impose greater formal control in glazing the opposite bay; identical designs and closely matched colors would tie the lateral lights together, but strict mirror symmetry would not be sought (Pl. 128).

Once the formula of design repetition had been decided upon, the execution of the first two triplets on the south side could, in fact, have proceeded very quickly. Cartoons C and F, already used for N. VI c, were repeated in S. V c and adapted, by changing the turn of the head, in the third light (Pls. 148, 150, 164, 177); cartoon E, which had been reused for the archbishop in the center light of S. VI b, was modified in design and colors for use in the second bay (Pls. 157, 158), and it remained only to design a new cartoon (I) for the prophet above. The repetition of cartoons in diagonally opposite lights instead of adjacent ones preserves the visual autonomy of the glazed triplet; C and F could not satisfactorily serve for N. V a and c as well as N. VI c. For the same reason, cartoon D could not be used in the second triplet on the north side, although G could have been utilized for the prophets. The fact that a new design, H, was developed instead might be explained if this was done simultaneously with the glazing of the first bay on the south side, when cartoon G was being used for the figures of "Noe" and "Jacob." This would also explain the appearance of a new style in the second triplet of the north side, as if another artist joined the team.

This hypothetical chronology, N. VI, followed by S. VI and N. V, and then S. V, has to be tested by detailed observation. It is, however, of interest to note that it coincides with the chronology of construction for the upper levels of the choir that was argued from internal evidence by Anne Prache; she observed that the north side proceeded ahead of the south.[64] The columnar supports under the buttresses provide a clear sequence, as shown schematically in the plan (Fig. 5): Those between N. VI and V, S. VI and V, and N. V and IV are engaged in the clerestory wall, so that the walkway curves out around them; between N. IV and III, the column is detached, but not moved out far enough for comfortable passage; the definitive adjustment was made, giving better clearance, at S. V and IV and this solution was followed subsequently round the hemicycle (Pl. 21). Drawings by Reimbeau confirm that these anomalies are not due to modern restorations (Pl. 22).[65]

Comparison of the execution of figures based on the same cartoon might be expected to confirm a chronology of execution. If we take cartoon C, used in N. VI c in S. V c in the same sense, and with the head turned in S. V a, the execution of Elias in the first bay seems more

assured than that of the other two figures (Col. Pl. 3; Pls. 164, 177, 197). The condition of the paint is poor in the second bay, but one can compare the complex folds over the right shoulder of "Malachias" with those in Elias; in the former there is a proliferation of strokes that do not serve to clarify the form, whereas fewer tracelines are used with great certainty in Elias. The same tendency seems apparent in the double lines of sweeping y-folds over the lower right shin of Moses, as compared with single lines in Elias. It would be foolhardy, however, to argue a chronology from these differences, especially since the condition might have warranted repainting at a later date. More cogent is the argument that Elias represents the first design; the turn of his head flows in a natural contrapposto from the lower position of his left leg and the bracing of the fingers of the left hand against his thigh. The powerful thrust of the arm and neck and proud carriage of the head lend authority to the gesture of the right hand; "Malachias" has a less commanding presence—the result, one might suppose, of redesigning the head and neck. It is also to be noted that the figures in the second bay are rather cramped within the red edging, whereas Elias has room to turn; since the figures are of identical size, this does not represent a correction in the design of Elias, and could scarcely be a correction in the size of the window opening given the chronology of the building; the most plausible explanation is that a successful design for the first bay was reused less successfully in the second. This suggests a chronology of glazing from west to east.

Another group of figures, with identical distribution, confirms this chronology. Cartoon F is used for archbishop "Gervasius" in N. VI c, in the same sense for "Lando" in S. V c, and with the head turned in S. V a for "Vulfarius" (Fig. 7; Pls. 148–50). The nineteenth-century restorer noticed the repetition, and used the design of the lower part of "Gervasius" to restore the other two; the design is unusual in that the hem of the dalmatic falls in a meandering pattern, replacing the stiff orphreys of other figures in the series (Pls. 127, 132). "Gervasius" seems to represent the original design. With crozier aslant, he fits comfortably in the available space, whereas the other two extend right up to the red edging at the sides; they have been adjusted so that the nimbus comes closer to the upper edge also, in order to keep a fairly even blue frame around the figure, an adjustment made by an addition to the bottom of the upper panel, below the left hand. In "Gervasius" and "Lando" the collar of the alb droops softly over the stiff amice, revealing a slender neck that sits comfortably on the shoulders, much as in Henricus (N. VI a; Pl. 145). The lappets of the miter frame the left shoulder. In "Vulfarius" these have had to be moved to the right shoulder, where the design is cluttered by the crozier, and the redesigned

[64] Prache, 1978, pp. 68–71.

[65] The positions of the shafts in pl. 22 are not noted on the original drawing. Reimbeau, MS 2100, III, I, no. 4, f. 1ᵛ–2, and no. 5 also show

details of the exterior masonry, including the sills and rubble wall above the openings.

face, neck, and collar appear large and clumsy; the collar is simplified, being cut from a single crescent-shaped piece of glass, and the amice does not seem to have been decorated. It may be noted that the outline of the large face resembles that of "Malachias," as if the same artist made the adaptation in both cases (Pl. 197). A distant view of the figures in situ, however, justifies the clumsiness of his design; there is much subtle detail in the original design that is lost to the naked eye when seen from the pavement, and the perspective makes the heads appear small. The design of "Vulfarius" is more legible.

The frontal archbishops for whom cartoon E was used in all four bays underwent a counterchange of color; the white pallium with purple chasuble of the first bay is more realistic than the purple pallium and white chasuble of the second, but that is not a consistent indication of the chronology.[66] In the second bay, "Hincmarus" and "Severus" wear the rémois breastplate or rationale that is not present in the first bay; to fit it in, the pallium has been lowered slightly on the shoulders, giving them a more sloping appearance and enhancing the coherence of the design as seen from below (Pls. 157–59). The inclusion of the rationale may have been an iconographic correction, but it appears also that the stained glass designer was able to critique the earlier designs after the glass was installed. There is, however, no appreciable change in the painterly interpretation of these cartoons.

The new design for archbishops (cartoon J), made for the lateral lights of the second bay on the north side, may have been executed before the boldly adapted "Vulfarius" of the facing triplet; "Rigobertus" and "Fulco" both have delicately draped collars like that of "Gervasius" (Col. Pl. 6; Pls. 147, 148). The turn of the head seems to have been allowed for by the vertical position of the crozier. Both have the rationale, thus conforming with the adaptation made for the center figure (E). The figures have a powerful physical presence, enhanced, as in Balaam and Henricus, by a three-dimensional footstool on which their feet seem firmly posed, and the hand that grasps the closed book from below is more functional than that of the "Gervasius" group (cartoon F; Pls. 148, 149). Equally powerful, but more restless, are the figures designed for the positions above, Isaiah and "Zacharias" (cartoon H; Pls. 129, 130, 166); the brilliant coloring—bright yellow mantle over a cool green robe—and the strong legs, planted firmly apart, the recession of the lap, the sweep of the mantle, the ease of the gesture of the turn of the head, all appear as criticisms of the nervous precisions and subtleties of Balaam, or the banal simplicity of "Noah" from the first bay (Col. Pls. 2, 4; Pls. 163, 165). On the other hand, there is a disregard for literal rendering in favor of the general impression; the swirl of folds that might be taken to indicate the position of the left forearm of Isaiah describes a limb that is entirely disjuncted at the emerging wrist, whereas both organic structure and the logic drapery folds are

carefully studied in Balaam's mantle and arm. The vigor of these figures in the second bay indicates a distinctive hand, and the breadth and plasticity of his forms, as well as the strident coloring, stand out from all the rest of the series. In fact, they appear rather squat from below, and in that sense are less successful than the more elongate figures of the Elias group, which might explain the decision to reuse that cartoon in the facing lights.

The design for cartoon I, used for "Osee" and "Abraham," may be from the same hand as cartoon H (Pls. 169, 170; cf. Pl. 166). The mantle sweeps across the chest and arm and hands in vertical zigzagging folds that frame the knee in much the same way; the slanting undulations of the hem of the robe, and the placement of the feet are almost mirror images. On the other hand, the insistence of y-folds and nested v-folds on the shins resembles the Elias group; in contrast the legs of both Isaias and "Zacharias" are articulated with catenary folds that seem to draw back round the calf. The design and execution, then, may be by different hands. The design bears the same relation to that of "Nathan" and "Samuel" (cartoon B; Pls. 167, 168) from the first bay as cartoon H did to A (Balaam); it uses the previous design as a point of departure and offers a critique of it. The scroll is eliminated so that the hand in the lap simply clasps the mantle; the pointing gesture, which reversed direction in S. VI b toward the transept, gives way to an open palm. The sweep of the mantle is adjusted to give a more even distribution of color masses, but there is a loss of coherence; it seems to bind the right arm to the torso, in the same plane, with the same effect of anatomical disjunction I noted in Isaiah, instead of hugging the torso, turning back to clarify the profile of the right forearm, and falling in a plane that corresponds to the middle of the thigh, as in "Nathan." Only the slanting sides of the bench and the oblique angle of the footstool preserve some impression of depth.

Close observation of the design and execution of the figures in the two westernmost bays of the choir has so far led to confirmation of a chronology that began with the first triplet on the north (N. VI) and proceeded rapidly with the one facing and the next one on the same side (S. VI, N. V), and then completed the second on the south side (S. V). The extant figures in S. IV, and especially in N. IV, indicate continuity in this shop tradition, even though only one cartoon from the earlier group is reworked (Dv). The adaptation from cartoon D as used in the first bay is fairly radical; although the lights are of the same dimensions, and the outlines of the figure and throne and the angle of the crozier have been retained, the feet, head, and nimbus of the archbishop, and the top of the crozier, have been much enlarged (Fig. 6; Pls. 146, 151, 152).[67] The footstool has been eliminated, the position of the orthogonal almost completely filled by the wider skirt of the alb; the hem has severe meander folds instead of softly undulating ones that hug the instep of

[66] In the last sequence, "Lando" had a blue pallium whereas "Gervasius" and "Vulfarius" both had white.

[67] The diameter of the nimbus, including the edge, is increased from 32.5 to 38.5 centimeters, or 5.4 percent.

the feet. Another change was to clarify the position of the left knee and place the hand under the open book; the book is larger, and, most important, the iron dividing the panels falls more coherently across the bottom of the white page, instead of conspicuously cutting across the lower part as in the earlier design; from the importance now given to them one might wonder if these pages were inscribed. A minor adjustment was made to the position of the right hand. The back of the hand is toward the viewer, and the thumb is seen to pass round the crozier, but this angle of view is in conflict with the foreshortened lower arm, which now appears stunted; the original arm and hand of "Sansom" or of "Manasses" are more plausible.[68]

There is no doubt, in superimposing the rubbings from these two groups (D and Dv), that the original cutline was available as a basis for the new design. Furthermore, the colors also follow the notations that would have been used for Henricus and the others in the first bay, though the green chasuble is interpreted as a brilliant cool hue, and one nimbus has a white instead of a green edging. Other aspects of the execution show adaptations of the same kind that were made to the cutline. The orphreys of the second group do not have elaborate diaper or jeweled designs, but are instead painted with sweeping folds or, in the front panel, with a coarse design in reserve (Pls. 145, 151, 152). The faces lack the precisely drawn beard that emphasizes the cheek bones of Henricus, and their large eyes and rounded jawline give a remarkably bland impression. In summary, the trend has been to enlarge and simplify the contour and painting of the figures in the third bay (N. and S.IV), and to intensify their color, at the expense of accuracy of rendering. The figures in the earlier group have a kind of tension that arises from the graphic precisions and from the subtle coloring, but these qualities are dissipated by the distant view. Those in the second group present themselves as a critique of the completed glazing of the first triplet on the north side, or of the first bay. The fact that the collar of the alb is not modified like that of "Vulfarius" in the second bay on the south side (Pl. 149) may be an indication that the third triplet on the north (N.IV) was glazed before, or simultaneously with that triplet, again coinciding with the sequence of construction; it is also to be noted that cartoon D was not used in the second bay, so its adaptation for the third bay could have proceeded simultaneously with the execution of figures for the second.

A new cartoon was supplied for the frontal archbishop in the central light of the third triplet on the north; the same was used in the opposite position. This design, "M," bears only a slight resemblance to the one that had served in the first two bays (E), chiefly in the gesture of benediction and the vertical position of the crozier (Pls. 159, 160). The figure is narrower, and appears cramped

between slender columns; it also appears taller, and does not assume the squat proportions of the earlier group when seen from below. The columns support only the inscription, as though it were an architrave, but since that on the north side ("Mappinius") is entirely replaced, and that on the south has been eliminated, it may be questioned whether this is the original arrangement. It is clear, however, that there is not sufficient room even for a simple arched canopy; in fact, other examples can be cited of inscriptions that are integrated in this way into an aedicula, notably in late twelfth-century panels that are now in the south rose of Notre-Dame in Paris, and in the window in the Trinity Chapel in Canterbury Cathedral that is attributed to the rémois shop (Pls. 206, 209, 212).[69] In other ways the execution of "Mappinius" parallels that of the two flanking figures; the position of the knees is clarified, although the chasuble has a checkered pattern instead of folds, and the front panel of the orphrey has a bold design in reserve. There are still vestiges of softness, in the collar and hem of the alb, but the large color masses of the purple chasuble and green dalmatic ensure the clarity of the design. The chasuble is broken only by white bands below the arms, which punctuate the vertical sweep; similar white bands are placed in the dalmatic below the knees of his companions.

The design for King David, and for "Ionas" facing him in the center light of the third triplet (L), may have been developed in parallel with cartoon I for the second bay; the manner in which the mantle hugs the narrow shoulders and the way it is distributed asymmetrically over the knees are very similar, though in reverse, and "Ionas" makes a similar gesture with open palm, though his hand projects to the side (Col. Pl. 10; Pls. 169, 170; cf. Pls. 171, 174). This gesture, which is inappropriately made toward the transept, may be explained if King David were the first of the two to be executed, since the position of his hand, holding the scepter, is quite natural; "Ionas" shows a slight adaptation of the cartoon. Some aspects of the David-"Ionas" design hark back to figures in the first bay; the mantle that cascades over the torso, the emphasis on the meander folds of the border of the white robe, the nested v-folds that pull aslant from the shin, and the footstool in perspective all recall Balaam in N.VI a, whereas the almost symmetrical placement of the feet is closer to design G in S.VI c and a (Pls. 163, 165). The ample mantle of David, however, frames an extraordinarily narrow body and it is this silhouette that argues for a relationship to "Mappinius" below (Pl. 160).[70] Otherwise, the design and color distribution in David lack the studied restraint and clarity of the archbishop. His bright yellow mantle is decorated with a blue band and a red hem, and is lined in white; the richness of effect is emphasized where the hem turns back to expose the white lining, and vestiges of paint that are

[68] The Rothier photograph appears to show a similar hand on Henry de France, presumably the original.

[69] See the subsequent discussion in this chapter.

[70] The proportion is "corrected" in the nineteenth-century drawing in the Musée Arts Decoratifs in Paris (Pl. 172).

visible in the prerestoration photograph and drawing indicate that it was painted to resemble vair (Pl. 172). His robe is brilliant warm green with purple cuffs and hem, and an undergarment has white sleeves with blue cuffs; traces of paint on the right sleeve of the robe suggest it had a damask pattern. Red shoes and a yellow crown against the red nimbus add to the warmth and brilliance of the palette. The colors are not as forceful, however, as the brilliant yellow and green of Isaias and "Zacharias" in the adjacent bay (Col. Pl. 4). It is also to be noted that the bright yellow of the mantle is used for the columns that frame "Mappinius" and for his orphreys, and thus serves to unify the light.

The color scheme of "Ionas" is far less rich, either for iconographic reasons, or because David was found to be too elaborate. The mantle is white inside and out, with yellow band and green hem; the robe, purple with green cuffs and hem. Bright blue is used next to red, instead of the yellow with red of David, in the sleeves of the undergarment, the scroll, and the hair. The shoes are yellow against cool green, although the base of the throne is red.

Flanking King David are paired figures, "Micheas" and "Ezechiel," from cartoon K (Pls. 133, 175, 179). These too could have been developed from designs in the first bay; in many ways they resemble "Noe" and his companion on the south side (cartoon G), but with more ample and fluid drapery (Pl. 165). The footstool is still used, giving stability to unevenly placed feet. Most of all, however, they resemble David—in the arm that is bent in front of the chest to hold a scroll, in the loop of the mantle that outlines one knee, a feature that is explained here by the hand that clasps it, and in the articulation of the hem of the mantle and of the skirt of the robe. Some confusion is created by the fact that the lower panels have been switched in a restoration prior to the late nineteenth century; this is perceptible because the colors of mantle and robe are counterchanged, a departure from the practice in other bays: "Micheas" was intended to have a white mantle with green bands and yellow hem and a purple robe with yellow cuffs and green band and hem in the skirt, "Ezechias" a purple mantle with green bands and yellow hem, and so forth. The decorative use of small areas of color, though not as pronounced as in David, is again noticeable.

The only original counterpart in the facing triplet, "Abacuc" in S.IV c, is cut from another design of this series (N; Pl. 178); the sweep of the mantle over his right knee is almost identical to the passage in "Ionas" and the scroll has simply changed hands (Pl. 174). The narrow shoulders, tightly constrained by the mantle, are very close to "Noe" in the first bay (Pl. 165). An innovation is seen in the yellow pointed cap, the only one preserved in the retrochoir series.

Only the upper part of one of the flanking archbishops survives on the south side (S.IV a "Flavius"; Pl. 153). This cartoon (O) shows some radical innovations, and is also used in the next triplet on the north side (N.III a and

c; Col. Pl. 7; Pls. 154, 155), where the figures are complete. There is only a slight change in color, from a white to a blue pallium; this may be seen as a correction since in "Flavius" the white book might be confused with the pallium. It is possible that the bright yellow chasuble and green dalmatic were designed to echo the color scheme of "Ionas" in the top center, if it was intended to keep the colors marked for David; the quieter colors of "Ionas" are thus an overcorrection.

Cartoon O was developed from the design for N.V (cartoon J) (Pls. 147, 153). It is not based on the same cutline, but the adaptation is similar to that made between D and Dv, indeed the resemblance to Dv is so great that it may be attributed to the designer who made that adaptation (Pls. 151, 152); it is also based on solutions tried in S.V in the process of designing the head of "Vulfarius" (Pl. 149), in that the amice is eliminated and the collar enlarged to a simple crescent shape. The comparison of "Flavius" in S.IV with "Fulco" or "Rigobertus" in N.V a and c is illuminating (Pls. 147, 153; cf. also Col. Pls. 6, 7). The lights in the third bay are slightly wider than those in the second, which may explain why the first cutline was abandoned; the new design is reversed, with the crozier held vertically to the side in the left instead of the right hand. The large book with prominent clasp held in the other hand is moved up so that the armature no longer cuts across it; but the rationale and amice had then to be eliminated, to keep the clarity of the design. The figure is broader, the head of the crozier is larger, and the nimbus placed off-center to allow more room for the crozier. Judging by the preserved lower panels in N.III, the lower part of cartoon O is even more radically changed (Col. Pl. 7; Pls. 154, 155). The footstool is eliminated and the feet appear to dangle to the lower edge, although the contours of the alb emphasize the high instep. The green dalmatic is decorated with a lozenge pattern that is outlined in the leading, and the front panel of the orphreys is decorated with a similar painted motif. The knees are so broad and massive that the throne is scarcely visible. The contrast with the carefully detailed orphreys, chasuble, and decorated cushion of "Fulco" and "Rigobertus" is marked (Pl. 147). Even compared with "Mappinius" in N.V b there is a simplification in the cutline here, although the sweeping folds of the chasuble, elongated square-jawed face, and the bold patterning of the dalmatic suggest that "Flavius" and the others of this group are from the same artist as "Mappinius" and his unnamed counterpart.

A new design was used for the frontal archbishop in the fourth bay from the west on the north side (N.III b), apparently correctly restored as St. Rigobertus (Pl. 161). He blesses with his right hand, as in cartoons E and M, but breaks from tradition in that his crozier is slanted (Pl. 160). His yellow throne back frames his narrow shoulders; he appears even more confined than "Mappinius" between his columns, though in fact this light is slightly wider than its counterparts to the west or east. The most radical departure, however, is in the lower

drapery, which returns to a type used in N.VI (F), but from the Rothier photograph I judge this to be a replacement (Pl. 135). The fact that an anonymous nineteenth-century drawing gives this figure a lower third like that of "Mappinius" suggests this authentic-looking design was for some reason changed during the restoration (Pls. 162, 160).

The upper figures in this bay unmistakably belong with the frontal archbishop in the tall and elegant silhouette, subdued colors, and softly clinging draperies (Pls. 135, 186); the louder colors, more robust silhouettes, and flat patterned fabrics of "Becasius" and "Nivard" in N.III a and c are a notable contrast (Col. Pls. 7, 8; Pls. 154, 155). The selection of a calmer mode of representation may have been intended to lend dignity to the apostles. Each has bare feet carefully placed on a brilliantly colored footstool, and their robes, instead of being trimmed to ankle length, have the full-length sweep of an alb. "St. Simon," in the center, holds his right hand open on his chest, a reversal of the dramatic open-palm gesture of "Osee" and "Abraham" in the second bay (cartoon I, Pls. 129, 132). His left hand holds the top of an open book, with brilliant red and blue pages; this rests on his knee with the same logic used in cartoon D for Archbishop Henri de France (Pl. 145). His soft cool green robe, like the dalmatic of St. Rigobertus below, has a yellow band in the skirt. The mantles of the apostles are white, with colored bands; they differ from those of the patriarchs in that they have no clasp at the neck and in the way that they are tightly swathed around the abdomen, like a cummerbund; only "St. Simon" shows a purple belt above. St. James ("Isaias") and "St. Bartholomew" are cut from the same cartoon (P); only the turn of the head was adapted ("Bartholomew" is unbearded, but the head of St. James is new) (Pl. 186). Each holds a scroll in the left hand and rests the right hand, with arm slightly akimbo, in the lap. The colors are identical, purple robes with yellow bands and green collars, white mantles with blue bands and green hems (Col. Pl. 8).

In some aspects, this group of apostles resembles figures in the first bay of the choir; the color scheme is similar, with white mantles enlivened by colored bands, but the increased amount of purple and the restriction of greens to cooler and softer tones provide a more sober palette (Col. Pls. 2, 3, 8). Similarly, there is a superficial resemblance in design between cartoons P, G (N.III a and c, S.VI a and c), and K (N.IV a; Pls. 165, 179, 186). However, comparison also serves to point up contrasts; the gesture of the hand in the lap has become purely ornamental in the apostles, whereas in "Noe" and "Micheas" the fingers grasp the mantle in such a way as to explain the cascade of oblique folds of the mantle; the mantle of the apostle denies the volume of his shoulders and neck and the recession of his lap, whereas it is used in the patriarchs to clarify depth. Older conventions for rendering folds, such as the v-folds, y-folds, and wet-folds used in "Noe" and "Micheas," are rejected in favor

of a more banal vocabulary of interlocking sweeping lines that give an overall unity of texture; the effect, though not the graphic forms, is like *muldenfalten* (Pl. 184). Most important, the overall proportion of the figures has been altered; the apostles are more attenuated and their heads are larger then even the most constrained of the figures from the western part of the choir, and the silhouette has been revised to approximate an elliptical form; the patriarchs are more active in space, more angular, and less regular.

Analysis of the original glass of the hemicycle has to be presented with caution; it rests upon the Rothier photographs and the one surviving fragment of the Virgin's head now preserved in the south transept chapel (Pls. 139–42). On the basis of the photographs it appears that six figures survived in the fifth triplet from the west on the north side (N.II) until 1917; in the center the frontal archbishop was made from the same design as his counterpart in N.IV, which I have just examined, but adapted to a wider light by widening the throne back (cartoon R; Pls. 139, 161). The flanking figures were from a new cartoon (S) that repeated the undulating hems of cartoon R and reverted to the use of columns that support the inscription as if it were an architrave, as in "Mappinius" and his counterpart in the third bay (cartoon M; Pl. 160). The arrangement is awkward, however, because the crozier is held vertically to the side of the figure and coincides with the positions of the column. The right hand appears empty, apparently pointing toward the axial window with the index finger. The pair seem to be vested in white chasubles, whereas the apostles above are clad in darker tones. "St. Peter," in the center, has a long banded robe and mantle with colored hem, like "St. Simon" in N.III b, but the book in his left hand is closed and held by his open palm in a gesture reminiscent of the group cut from cartoon F (Pls. 127, 135, 139). He holds a very large key, which rests on his right shoulder, and the silhouette is more compact than that of "St. Simon," filled out by a swath of mantle that fans out from his right knee, which also disguises the recess of the thigh and the outline of the waist. In these respects, the design recalls that of cartoons B and I from the first two bays, but the drapery seems to lack the swirling tension of those figures and to belong to the soft style of the fourth triplet (Pls. 127, 129, 135). The flanking figures of "James" and "John," cut from one cartoon with an adjustment for the turn of the head (S), closely resemble "Simon" in their slender silhouette, although an open gesture with the right hand breaks from the elliptical outline (Pls. 135, 137). In this, and in the banded robes that terminate in a straight hem, they recall "Noe" and his companion from the first triplet on the south side (cartoon G; Pl. 128). The left hand is laid on a closed book, whereas a loop of the mantle is drawn up arbitrarily over the left knee, without visible support; there again seems to be a dependence on draperies for visual pattern.

In the corresponding triplet on the south side it ap-

pears that the figures in the first two lights were nine-teenth century, made from cartoons that had been used in the original figures of the first triplet of the north side (B, C, E, F; Pl. 138). Archbishop "Matinianus" and St. "Thomas" in the third light, however, may have been original at least in essential outlines; they are based on new designs (W and V; Pl. 140, center). The archbishop is framed by columns, like his counterparts in the north triplet, but the diagonal position of his crozier and the rectilinear bands of orphreys and fringe indicate a differ-ent cartoon. He appears to hold a closed book in the right hand and points toward the axial light with his left, while holding his crozier in the crook of that arm; the gesture is paralleled in the lateral figures of the northern triplet. The apostle above him also points with his left hand; the other rests in his lap, perhaps holding a scroll. The compact silhouette and the horizontal band at the hem of his robe resemble Sts. "Peter" and "James and John," respectively (Pl. 137).

The original figures of the axial triplet appear to de-part in several ways from the norms established to this point, although the lateral pairs conform to the paren-thetical turn of the head and repetition of cartoons X and Y (Pl. 141). The archbishops appear to return to the squatter proportions of earlier designs such as those in N.III (Pl. 135), but they are uniquely framed under an arch bearing the inscription and a turreted canopy; there do not seem to be any columns at the sides to support the arch, which instead probably rests on corbels. Such aediculae had been introduced—perhaps even in-vented—at Canterbury, in the transepts, principally as ways of filling lights that are taller in proportion than others (Pls. 4, 5); here they were more likely favored for iconographic reasons, since they refer to the celestial city. The apostles above, like the archbishops below them, are stockily proportioned, and the white mantles draped across the left shoulder and evenly distributed over the knees add to the impression of breadth. They revert to the white mantles used in the fourth triplet, and retain the diagonally placed footstools, but they are alone among their group in having high-backed thrones of the type used for archbishops in N.III b and N.IV b, as well as further west (Pls. 127, 128, 133, 135, 137). Ad-ditional features are the arched name bands, no doubt original since the throne backs encroach on the zone pre-viously used for the straight bands.

In the central light only the upper two-thirds of the Virgin and Child appears original in the Rothier photo-graph, and only the top panel survived the war (Pls. 141, 142). The early photograph shows the Child seated side-ways on the Virgin's left leg, his arm reaching toward her face and apparently supported by her right hand. The surviving fragment, which coincides in most details with the photographs, has no throne back. The Virgin wears a white veil, the sensitively rendered undulating folds framing the regular oval of her face, and a tall

crown. The face is composed of a series of regular and clearly delineated forms, with large staring eyes, but the round chin and the furrowed brow are carefully mod-eled. Yellow stars are painted in reserve on roundels in the blue ground, an important innovation to provide a celestial setting and with the effect of enlivening the pal-ette. This window is the most important iconographi-cally and the most visible; if the construction of the en-tire choir had been finished before any glazing began, it would have been logical to fill the axial window first. Instead, it appears as the culmination of an elaborate se-quence by which figures had been gradually rendered more monumental, but which allowed enrichment of their settings.

A summary of these complex findings is offered, be-fore considering their broader implications: The most plausible order of glazing (i.e., of installing the glass), allowing for sequential use of the same cartoon and for compositional revisions, is: N.VI; S.VI and N.V; N.IV and S.V; S.IV; N.IV; then the rest of the hemicycle. Any attempt to reconcile this chronology with a standard no-tion of "stylistic development" would be bewildering. Organically articulated and plastically rendered figures such as Balaam in N.VI, whose classicism might have been labeled proto-Gothic, are succeeded by more ab-stract, monumental, and "Romanesque" types that have an affinity with much earlier paintings (Pls. 124, 152, 163), only to be replaced by elegant, attenuated "Gothic" figures (Pl. 186). Despite this "regression" to-ward Romanesque, the massive, compact form of "Be-causius" does, however, have a close affinity with illus-trations in a late twelfth-century copy of Peter Lombard's Sentences from the rémois Abbey of Saint-Denis; the heavy jowl and modeling of the face, the sim-plified amice and rigid patterning of the dalmatic are very close to the rendering in the glass (Pls. 154, 156).[71] Furthermore, the new monumentality seems to distin-guish these figures from the earlier-appearing St. Remi-gius and St. Nicholas (Pls. 81, 82).

Another observation worth emphasizing is that changes in design and execution—such as the repeated use or adaptation of the same cartoon and the elimina-tion of fidley shapes, subtle colors, and painted details—that might have been regarded as slipshod practices or responses to pressures of time, are better viewed as the result of experiments and empirical knowledge; the se-quence suggested here shows artists designing in series, each modification based on a critique of completed pan-els viewed in their intended position in the building.

Finally, it is clear from this, and from the fact that this chronology of work plausibly matches the order of con-struction, that the glass painters followed very closely behind the masons; their work may date soon after 1175 to 1181 or so—that is, contemporary with the earliest of the Canterbury figures of comparable scale, and the ex-periments there in the transepts (Pls. 2–5).[72] At Canter-

[71] Lemps and Laslier, 1978, no. 28.

[72] The year 1175 may be somewhat early for Saint-Remi; Henry of France died in that year, and the image in the first bay to be glazed is more likely a memorial than a living "portrait."

bury also the first generation of "Gothic" glaziers was keeping up with the masons. We need no longer a priori impose decades between the construction and the decoration of parts, at least, of these great buildings.

Some of the surviving borders may tentatively be discussed in relation to the clerestory glazing. Those in situ in the choir of Canterbury demonstrate an immediate rejection of a rich and delicate palmette design, used in the first light to be glazed, in favor of bold, flat, geometric designs in the next bay;[73] this is very much in line with the drastic revisions in the figures of Saint-Remi, between NVI and NIV (Pls. 2, 3, 145, 154). One group of Saint-Remi borders clearly marks such a trend: Type 2, probably from the earliest period, seems to have been amplified in a series of designs in types 8, 9, and 10; the simple leading and dense painting of the first design give way to clearer definition in the leading, a filet emphasizing the oval form of the central element, and finally the secondary motifs are dispensed with for greater clarity.[74] Several others may be paired, following my hypothesis that an intricate design with many shapes and colors was simplified in a second phase (Catalogue D; cf. R.b.35 and 36, 37 and 38, 33b and 39).

Many relatively simple designs are based on sideways-growing palmettes supported by hooped bands or meandering stems. One of each variety has an analogue in the clerestory of the Trinity Chapel of Canterbury, adjacent to the bay glazed by the rémois shop (Catalogue D, C.b.5, R.b.20 and 24), and one meander is reduced to abstract forms that are truely analogous to the final modification to cartoon D in the third bay on the north side (Pl. 151, and Catalogue D, R.b.26). Several of these are predominantly green and white, in harmony with the figural panels of the first bay, and parti-colored red and blue grounds with purple and yellow leaves are less common than in the more luxuriant group that I ascribe to the lower windows.

Another group has a monumentality of conception that arises from geometrically controlled compositions. The circular bands surrounding flat daisies in type 38 already lead in this direction. Type 11 may be seen as a very bold simplification of type 5 from the earliest phase, with the lattice eliminated so that the leaves arranged in a saltire are drawn with a compass (Col. Pls. 15, 16); this design was much used by twelfth-century metalworkers and it also occurs on a larger scale and with a solid red ground in glass once in Soissons, which might therefore be attributed to Braine (Catalogue D, B/S? b.7).[75] Types 40 and 41 are also dominated by per-

fect arcs, controlling the dense foliage in a way that is lacking in the more delicate banded trellis of type 35; type 41 may be seen as the earlier of this pair, however, in that the fronds are silhouetted against a cross-hatched ground. Red grounds, with white, yellow, and blue are the norm here; type 11 uses green instead of white for a bolder more saturated palette. A more leafy and richly painted version of types 40 and 41 is in Troyes Cathedral and probably dates from about 1200, a warning not to set too much store in chronologies outside the rémois shop.[76]

The borders discussed here are admittedly diverse. It would be foolhardy to deny that some may have been made for the choir tribunes, and others for the nave clerestory. Most persuasive of an origin in the clerestory of the retrochoir, perhaps, are the sequential modifications that I have suggested are paralleled in the figure designs. Notable among these is the apparent return to geometric "Romanesque" forms in what I take to be the most evolved group; size and color rather than conception seem to separate types 5 and 11, as they do the figures of St. Remi and "Vulfarius" (Pls. 81, 149).

St. Agnes and St. Martha

Two standing female saints, inscribed Agnes and Martha and each with the opening phrase of the Ave Maria, were designed to face in the same direction; both are now in the tribune, with a surround of ornamental glass, but, except for the inscriptions, Martha is turned inside out, with disastrous effect on the paint (Col. Pl. 18; Pls. 94, 95, 99).[77] About 1825 Povillon-Piérard referred to such figures in the west facade, below the rose window, although he also noticed saints with the Ave Maria in the tribune where they now appear (Appendix 2, ff. 51v, 54). This sequence may have originated in the west facade, although the Lady Chapel is perhaps a more suitable alternative; against an origin in the west facade is the fact that the figures do not comfortably fit any of the openings there, and they appear to have little in common with the severe monumental style of the king's head recorded by Viollet-le-Duc, which I believe to be Clovis from the great west window (Pl. 201). In either case, however, the date of the glazing could be as early as the 1160s to 1170s, but the provenance is uncertain enough that dating must be argued independently.

The two surviving figures are bulky but elegant.

[73] Canterbury, N.XXV (cf. N.XXI and N.XXII): Caviness, 1981, figs. 6–8.

[74] On the other hand, by the same analogy, some of the wide borders with fleshy foliage may as well belong early in the campaign of clerestory glazing as to that of the lower chapels or tribune (e.g., Catalogue D, R.b.14, 15, 18, 21, 22, 23).

[75] In Saint-Remi, type 11 has a yellow quatrefoil between the larger elements, in which green and blue fronds are diagonally paired on a red ground (Col. Pl. 16); the border in the Walters Art Gallery has blue and white fronds. The judgment as to whether this coarser version originated in Braine is difficult; it appears better scaled to the very large

figures from the Soissons clerestory, with which it is associated in the Walters Art Gallery, than to the king from Braine that it frames in the Great Hall at Glencairn, yet the colors would not be entirely out of keeping with the Braine series.

[76] Pastan, 1986, pp. 56, 104–5, who also referred to a later example of the type, in St. Kunibert, Cologne (her fig. 13).

[77] The inscriptions could have been reversed when the figure was turned around, certainly before the Didron drawing; it is in leads that could be eighteenth to early nineteenth century, with twentieth-century repairs.

Large rounded heads and prominent shoulders are covered by generous veils, so that bunched folds fame the faces and drape the shoulders, enhancing their mass; the silhouettes of the figures are also expanded by passages of long vertical folds in the mantles, before they taper to narrow banded skirts that sweep the ground. St. Agnes has a red nimbus, white veil with green hem, purple mantle, and soft green robe with yellow and blue bands (Col. Pl. 18); St. Martha has a white and gold robe, with green mantle, white veil, and unusual green nimbus. The colors, and the coherent three-dimensional rendering, find comparisons in the figures in the first bay and in the hemicycle of the choir clerestory (Col. Pls. 3, 8, 18; Pls. 127, 128, 137, 145, 157, 163–65, 167, 168, 186).

The moduli for the virgin saints, and further variants, were also used in the *Hortus Deliciarum*, judging by its copies, one indication of the widespread use of the type in the west in the 1170s or 1180s (Pl. 97).[78] Another example is in the Virgin of the Crucifixion page in a late twelfth-century missal that may be from Stavelot or further south (Br. L., Add. MS 18031, f. 18v).[79] These moduli clearly follow Byzantine types (Pl. 98).[80] A date just before the choir clerestory glazing campaign, that is in the 1170s, is also rendered plausible by comparison with the magnificent drawings in the Saint-Bertin Gregory manuscript, generally dated in the last decades of the century (Pl. 96).[81] The sharp, linear style of the drawings is closer to Mosan metalwork than to the softer passages in the glass, but the veil is softly draped over the shoulders and the firm, bulky contour and crisp vertical pleats attest to a common tradition, and to the widespread assimilation of the figure type to the north as well as to the east of Reims by the last quarter of the century.

The Crucifixion Window in the Tribune of Saint-Remi

The figures that form this group, Mary and John on either side of Chrsit crucified, have been accepted as being in situ in the axial light, even though their grounds are not original and there is no indication that the present border was here before about 1870; the nineteenth-century transformation of this window and its derestoration by Simon have been traced in Chapter 1 (Pls. 100–103). Examination indicated that all three heads are replace-

ments, as well as the lower third of St. John, and the paint is in very poor condition elsewhere.

If the clerestory was glazed as the building progressed, it is logical that the Crucifixion was created about the same time as the clerestory hemicycle figures were, since the upper levels of the choir seem to belong to the same campaign of construction. The attenuated figures and the use of colored bands in the draperies accord well with the apostles above, confirming this expectation (Pls. 110, 186). Furthermore, it was suggested in Chapter 2 that the architectural setting intentionally controlled the view of the Corpus of Christ from the body of the church, and that the structure and glazing of the tribune were thus planned together. A likely date for the Crucifixion window would therefore be about 1180–1185.

Comparison with St. Agnes and St. Martha is instructive, in that the Virgin follows almost the same modulus as St. Agnes, but the extreme slenderness of the silhouette and positioning of folds to mask anatomical structure contrast with the bulkiness of the latter (Pls. 94, 95, 110). On the other hand, an inviting comparison for the well-preserved muscular torso and arms of Christ is the celebrated drawing of Air in the Harmony of the Spheres page that has been inserted as a frontispiece in a rémois manuscript (Pl. 111).[82] The sweep of the arms, with firmly outlined biceps and larger forearm muscles, and the regular divisions of the torso are similar, even though the Christ crucified is stretched to accentuate a longer, slimmer waist; double lines in the drawing define the breasts and ribs, with space for the sternum between, and these are given greater emphasis by leadlines in the monumental glass painting. In both works the volume of the stomach is clearly expressed, with a dip over the navel, and although the drapery in the drawing is generally stiffer than in the glass, there are passages in the mantle of Orpheus, such as the crisply zigzagged hem and interlocking folds round the arm, that have parallels in the loincloth of Christ. One more point of comparison is offered by the range of treatment of the hair and beard of Air; the hair of Christ combines some of the rather formalized plaited locks that frame the head in the drawing with looser, more disheveled ends, resembling the beard of Air. The bister drawing has generally been dated in the latter part of the twelfth century.[83] There are no rémois manuscripts that relate to it,

[78] Cf. also *Hortus Deliciarum*, 1977, pl. xxv, for a softer copy of the Annunciation; and holy women gesturing with both hands in more profile postures, comparable with St. Martha: pls. xviii f. 51b, xxixter Supplément (two figures, lower left), and pl. lxix, the suppliant Virgin (top right).

[79] Maria-Rose Lapière, *La Lettre ornée dans les manuscrits mosan d'origine bénédictine (XIe–XIIe siècles)*, Paris, 1981, pp. 300–301, pl. 272; she has questioned the Stavelot attribution, associating the style with the candle wheel of Aachen.

[80] Tenth- to twelfth-century examples may be cited from John Beckwith, *Early Christian and Byzantine Art*, 2d. ed., Harmondsworth, 1979, figs. 174 (Deesis, tenth-century ivory triptych), 219 (Virgin of Crucifixion, Daphni mosaic, ca. 1100), 226 (Virgin, Palermo, Martorana mosaic, before 1148), 244 (Deesis, Venice, San Marco, marble relief, eleventh/twelfth century). A similar modulus was adapted for

Lot's wife in the Canterbury glass of about 1175–1180: Caviness, 1977a, pls. 51, 54.

[81] Moralia in Job, Saint-Omer, B. M., MS 12; Swarzenski, 1967, p. 80, pl. 494, illustrates another figure. These drawings were also compared, less convincingly I believe, to Nicholas of Verdun's work on the Klosterneuburg ambo, to make a general point about his stylistic sources: Helmut Buschhausen, "The Theological Sources of the Klosterneuburg Altarpiece," *Year 1200* III, p. 121, pls. 15–18.

[82] Reims, B. M., MS 672. The text begins with an abridged pontifical, and contains canonical material that can be dated about midtwelfth century. The frontispiece is unrelated, and may not have been bound with these other materials until the eighteenth century; Lemps and Laslier, 1978, no. 26, with bibliography.

[83] Swarzenski, 1967, pl. 492 ("c. 1170"), with bibliography, p. 80; Lemps and Laslier, 1978, no. 26.

whereas we have seen that the style and medium have analogues in a book from Saint-Bertin of Saint-Omer. Perhaps, however, the Harmony of the Spheres drawing was in Reims by 1180 since it is tempting to think that it inspired the Crucifixion painter.

The glass painting in turn may have had an impact on a group of missals made for Saint-Remi and for the cathedral around 1200. One of the most sumptuous full-page Crucifixions among these, in Reims, Bibliothèque Municipale MS 229, has bestiges of similar anatomical divisions but they are simplified and abstracted so that the figure seems weightless (Pl. 113).[84] More pertinent is the comparison with the Virgin, including the soft folds of the cowl that clings over her narrow shoulders, the pleated decorated hem form; yet the contours are again emphasized and elaborated at the expense of the volume of the figure, and the date should be significantly later than the glass.

The "Petronella Master" at Canterbury

Two large genealogical figures by the "Petronella Master"[85] in Canterbury were made for the first clerestory window of the Trinity Chapel to the east of the screen that in 1180 closed off the chantier from the completed choir (Pls. 78, 180, 198).[86] In the slightly curved vertical bars of the armature the designer seems to have made a concession to a radical change in design that was effected at this point in the program; the windows to the east all had smaller figures, framed by curved geometric forms, a change that I now think was influenced by the decision to reuse earlier glass in the third bay (Pls. 6, 7; cf. Pls. 2–5).[87] The figures of Amminadab and Nahshon bear striking similarities to the patriarchs in the retrochoir of Saint-Remi not only in general affect but in very specific traits of design and execution. Amminadab has the firmly planted feet and knees of a frontal figure from Saint-Remi, such as "Nathan" in the first bay to have been glazed, and his relatively broad shoulders are similarly emphasized by a sarilike sweep of the mantle; similar gestures and drapery rhythms are found in "Malachias," whereas the facial type and the positions of his head and hands, as well as the delineation of folds over the upper arm are closer to those of Balaam in the first bay (Col. Pl. 2; Pls. 163, 167, 197, 198). The draping of the mantle round the shoulders of this figure in turn re-

sembles that of Nahshon at Canterbury (Col. Pl. 9; Pl. 180).

Nahshon is even closer to a cartoon created for the third bay from the west in Saint-Remi, as represented by "Micheas"; the narrow shoulders, and the disposition of the mantle with softly creased "collar," the positioning of the knees and the catenary folds that outline the legs, the general position of the hands and the familiar sinews on their backs, are remarkably similar (Pls. 179, 180). Closer examination, however, reveals several differences that might be accounted for by adjusting the design to the attenuated proportions of the Canterbury panels, resulting in fact in a disjunction of the middle portion of the figure and a loss of gravitational logic, as well as in the addition of an aedicula above: Whereas "Micheas" rests his right hand on his knee, Nahshon's is awkwardly unsupported above, although it mimicks the gesture of clasping the mantle; the left hands are also subtly different, that of the rémois figure unceremoniously grasping his scroll close to his body, that of Nahshon extended into a more elegant drooping gesture. For no particular reason, the angle of Nahshon's feet is modified so that they no longer rest easily on the footstool. The interpretation is generally more decorative at Canterbury, both in the preference for a looped fold in the mantle of Nahshon as opposed to a cascade of pleats in the end held by "Micheas," and in the addition of an underskirt below the decorated hem of Nahshon's robe; also, surfaces are more embellished, including marbling on the front of the throne, and the use of red roundels in the ground. Because it has been noticed in the last section that the design for "Micheas" seems to have been created for "Ezekiel," in whom the turn of the head is better balanced, it follows that the design for Nahshon at Canterbury is derived from Reims, and not vice versa (Pl. 175).

Yet the Canterbury figures present a conundrum in relation to the developments in design noticed in the retrochoir of Saint-Remi; they appear later than Balaam in terms of a loss of anatomical structure, yet do not match the tendency to simplify details, reverting instead to extreme elaboration.[88] Possibly this is accounted for by the smaller absolute size of the Canterbury figures, and by the fact that the Trinity Chapel clerestory windows are much closer to the viewer even than those to the west because of the raised floor; there would have been no need for the drastic adjustments made at Saint-Remi.

There are also signs of the rémois team participating

[84] *Year 1200* I, no. 253, pp. 253–54; Lemps and Laslier, 1978, col. pl. VIII, no. 31. The use is that of Saint-Remi. H. Loriquet, *Catalogue Générale des manuscrits des bibliothèques publiques de France: Départements*, Paris, 1904, 38: 216, seems to be in error in suggesting that the gathering with this illumination (ff. 5–10v) is a later addition. In fact the Calendar (ff. 1–4v) is in a later script, and includes the Translation of the Relics of Thomas Becket (July 7, 1220) in the original hand (f. 3), whereas the next gathering is numbered at the end in a contemporary hand, .I. (f. 20v), and this sequence continues on ff. 34v (.III.) to 154v (.XVIII.), although it misses II on f. 26v. The penwork decoration of the initials changes on f. 52v in the middle of a gathering and continues in that vein to the end of the book; it is this hand that also appears in the

first gathering (ff. 5–10v).

[85] This name was suggested in Caviness, 1977a, pp. 77–82. Many of the ideas that I have attempted to refine here were presented at the Corpus Vitrearum Colloquium in Stuttgart (1977b), where however dating was still left open. A more cautious summary of my thinking at that time was also included in the *Corpus* volume for Canterbury: Caviness, 1981, pp. 16, 163–64, 181.

[86] Window N.X: Caviness, 1981, pp. 36–37, pls. 21–22.

[87] Caviness, 1987.

[88] This miniaturesque countercurrent was remarked on by Grodecki and Brisac, 1977, p. 210.

in others of a group of four clerestory windows at Canterbury, comprising N.VII through N.X: The painting style and durable glasses reappear in Obed, made for N.VIII (Pls. 73, 268). This smaller figure, in a restless pose more typical for the Canterbury series, offers cogent comparisons with glass from the nave of Saint-Remi, which will be reviewed later. The ornament from N.X, the window that contained Amminadab and Nahshon, cannot now be identified; yet the border in situ in its neighbor to the east (N.IX), with a meander stem and sideways-growing palmettes, is similar to one in Saint-Remi and even closer to a stray design documented there by Westlake (Catalogue D, R.b.24a, C.b.6),[89] and the wide decorative edging to the figure panels in N.IX has an affinity with the early lozenge patterns from the rémois abbey, even though a similar motif had already been used in the transept rose of Canterbury (Catalogue D, R.b.4 and 6; cf. C.b.6). It is interesting to note that Canterbury tradition is followed in giving these Trinity Chapel borders a pearled edging.

Another comparison provides a cautionary note: The border in N.VII at Canterbury uses almost the same cutline as one in Saint-Remi, although the fact that it is simpler in the latter example would normally be taken as a sign of later date (Catalogue D, R.b.20; cf. C.b.4). Furthermore, the Canterbury design seems to depend on an earlier, more energetic variant, with tightly curled leaves, which is in situ in an upper window of the north choir aisle and therefore probably dates before 1180.[90] From this it would appear that the rémois glazier learned the design from his English associates and carried it back to Reims for later use, possibly in the transepts or nave. The source of two other aspects of his work cannot be resolved from internal evidence: The aedicula over Amminadab could have been inspired by the more developed canopies used in the transepts at Canterbury and the concept carried back to Reims for use in the hemicycle there, or the glazier could have based it on the rémois examples, if his work at Canterbury was later (Pls. 4, 5, 139, 141, 180). Similarly, the red roundels in the grounds of Amminadab and Nahshon are also used in the next bay (N.IX) and are replaced in N.VII by white stars;[91] as with the border designs in N.VII, the idea could have been carried back to Reims for use in the panels with the Virgin in the hemicycle (yellow stars), and in the nave (red roundels), or it could have been brought to Canterbury by the rémois glazier if he already knew the entire retrochoir glazing, and perhaps even that of the nave. In view of the dates of the buildings it is more likely the idea came from Reims; the retrochoir glazing could have been completed about 1180–1182 whereas

the Trinity Chapel was not ready for clerestory glass until 1184.

One more panel from a Trinity Chapel clerestory window is to be associated with the rémois shop, the Last Judgment medallion from the axial window of the hemicycle, now in Richmond (Col. Pl. 25; Pl. 205).[92] Despite a high proportion of restored heads and the replacement of all of Christ but his feet, it provides a very useful example of a composition that is intermediate between the clerestory figures and smaller narrative ones in the lower windows, both in scale and in mode; in that several figures are seated hieratically in judgment, the impression is not predominantly a narrative one. Once more the rémois shop is to be recognized by the versatile rendering of clinging folds and the delicate coloring, including a range of warm greens. These are juxtaposed with light blue in the draperies, as also in the lower window of the Trinity Chapel and, for instance, in the lower panel of the king from Braine now in the Pitcairn collection (Col. Pl. 12).

The "Petronella Master" was originally named for a subject in a Trinity Chapel ambulatory window with miracles of Becket that is situated somewhat to the east of the clerestory bays in which this glazier has been seen to have participated (Pl. 212).[93] A possible implication of these spatial relationships is that the openings were glazed as the building progressed, since the ambulatory must have been vaulted a bay or more ahead of the main vessel, but such an early date will have to be reviewed in conjunction with the work at other sites. As in the clerestory, the rémois glazier seems to have had a major role in designing and executing one window and to have participated in a minor way in one to the east. The armature is again somewhat conservative in relation to its neighbors, although this time it appears very unusual in the Canterbury context; it consists of paired circles (Pl. 206). The colors are delicate, with a good deal of green and pale yellow, and the details of ornament and figures are extremely fine. It has already been seen that the very rich border, with berried palmettes in hoops, once had a close counterpart at Saint-Remi (Catalogue D, C.b.1 and [R.b.16]).

It is more difficult to associate the narrative mode of this ambulatory window with the clerestory figure style; the calm ponderation of the clerestory figures contrasts with the agitation of these scenes (Pls. 180, 209). Yet the circular form of the panels, stabilized by classicizing exergues and aediculae, imposes a certain serenity (Pls. 206, 209, 212.)[94] Furthermore, the narrow-shouldered, gaunt figures with their clinging draperies, and the miniaturesque decorative effects in pattern and color are

[89] Rubbings indicated that the variant now in Amiens and Los Angeles may have been based on the same cutline as the one remaining in Saint-Remi, preserving the same outlines of the palmettes but smoothing out the curve of the meander and stretching the repeat; the distribution of colors is almost identical. The dryer design in Canterbury might be later.

[90] Caviness, 1981, pl. 121.

[91] Ibid., pls. 60, 61, 69.

[92] Ibid., pp. 311–12, pls. 586, 587, with prior bibliography, and Caviness in *Corpus Vitrearum USA Checklist* II, p. 192.

[93] Window N.IV, Caviness, 1977a, plan, and 1981, pl. 224.

[94] Eva Frodl-Kraft, "Rezensionen: M. H. Caviness, *The Windows of Christ Church Cathedral Canterbury*," KunstChronik 37 (1984): 239, pls. 6a and b, compared these aediculae with extant Roman facades, as at Ephesos.

alike in upper and lower windows (Pls. 198, 206). The figure style of the lower window, typified by active, wiry figures and clinging and swirling draperies, departs from the sober monumentality that characterizes the life of St. Thomas from the first bay in the chapel and the neighboring miracle window.[95] A marked contrast is also to be noted in the easternmost window of the Trinity Chapel ambulatory, where the impact of Sens is felt; the ornament is more meager but the figured panels are more brilliant, with hot hues of red and yellow, and the figures are bolder, with draperies reduced to easily repeated schemata.[96]

Like the Last Judgment from Canterbury, the medallions from Braine provide a useful bridge between the large clerestory figures at all three sites and the small narrative figures at Canterbury; though personifications, the figures in these medallions are shown in various activities, and the scale is intermediate (Catalogue A, nos. 17–30). The colors are strikingly similar, in the predominance of green, purple, and white with some pale yellow (Col. Pls. 23–25; cf. Col. Pls. 2–14, 21, 22). Although none of these follow precisely the same moduli as the yet more active figures in Canterbury, there are numerous passages of drapery that seem to have been developed from a shared repertory. Among examples that may be noted are the energetic stride and gesture of Winter, set off by his straight hemline with pleated folds, stiff cloak, and bloused tunic, compared with similar features in the onlooker on the right in the sequence illustrating the cure of a cripple at the tomb (Pls. 206, 226).[97] The parenthetical figure at the left of this sequence has a flared cloak of comparable stiffness to the trailing scarf of Grammar (Pl. 231). A panel with Henry of Fordwich at the tomb shows even greater virtuosity in the rendering of complex folds than an angel offering a crown (Pls. 209, 218); the shell-like motif of the mantle, caught up over the angel's shoulder, is echoed in the floating end on the left, and the facial types, cowl-like folds of the mantle around the neck, and general effect of heavy drapery in the front of these figures offer points of comparison. Yet differences in handling have to be acknowledged; the Braine medallions do not have the highly wrought, decorative, and miniaturesque qualities of the narrative panels, whether for reasons of scale, iconography, or date.

One distinctive feature of the Canterbury window in its context is the diapered blue ground, which may be seen as another aspect of the predilection of this artist for breaking up solid color, as in the clerestory. It has been pointed out before that this, as well as the abbreviated

canopies and arching inscriptions that equilibrate the compositions, link his work with some late twelfth-century panels now in the south transept rose of Notre-Dame in Paris is now known, however, that the connection may not be Parisian, since Catherine Brisac has found a document indicating their purchase for the cathedral in the nineteenth century.[98] An affinity with the figural style practiced by one of the ateliers that worked in Troyes about the turn of the thirteenth century, as well as the presence in Troyes of earlier panels with blue diapered grounds, may rather confirm a champenois tradition.[99] On the other hand, diapered blue grounds have now been observed in the St. John the Evangelist window of the south nave aisle of Chartres Cathedral, but this is probably later than the Canterbury example.[100] Previous rather wide-ranging comparisons with French manuscripts and sculpture can now be better focused, but these are more conveniently discussed in a later section.

The Windows of Saint-Yved

The building chronology of Saint-Yved is presumed to be from east to west. The only clear indications of an internal chronology for the Braine glass derive from comparisons between medallions known to have been made for the transept roses (notably the labors and signs of the months mentioned by the eighteenth-century writers, Catalogue A, nos. 17–25; Pls. 221, 223, 226, 228, 233, 237) and the single medallion with an elder of the Apocalypse preserved from the west rose, no. 30; the west work is presumed to have been glazed later than the transepts. Based on this one example, the later work appears thinner in color and in painterly execution, yet this view has to be modified if the angels were, as I believe, also placed in this Last Judgment rose, since some are most robust (nos. 26–29; Pl. 218). The ancestors from the clerestory cannot be situated accurately in the building, but I have argued in Chapter 3 that Cainan must have been to the west of Amminadab, with Jechoniah and Abiud yet further to the east, if all four were on the north side (nos. 1–3, 5; Pls. 182, 192, 193).[101] I have preferred not to draw any chronological inferences from variations in style.

However, the chronology appears quite clear in relation to Reims and Canterbury. The use of an aedicula, as opposed to a more developed canopy as in Reims, over the lower figure occurred also at Canterbury, and I assume that was the model for the Saint-Yved series.

[95] For the sole surviving panel from the Life, now in Cambridge, Mass., at the Fogg Museum of Harvard University, but unfortunately not exhibited, see Caviness, 1981, pp. 313–14, fig. 589; for the heavily restored miracle window, apparently in the same style, see figs. 246–49.

[96] Window n.II: Caviness, 1981, pl. XIV, figs. 131–44.

[97] A similar figure, somewhat restored, also shows an analogous emphasis on the hip and thighs with the body thrust forward as seen in Spring (Pl. 221) or an Angel offering a Crown (Pl. 218a). See Caviness, 1981, fig. 266.

[98] Personal communication, 1986.

[99] Pastan, 1986, pp. 94–95, 103–13, pls. 70–85, 114–25. For the earlier panels, see Hayward and Cahn, 1982, pp. 105–7, no. 36, with bibliography.

[100] These were first commented upon during cleaning in 1988; I am grateful to Claudine Lautier for pointing them out to me.

[101] See the section in Chapter 3, "The Program of the Glass—the Clerestory Lancets."

Furthermore, Amminadab from Braine varies the design of "Micheas"-Nahshon, but the drapery system is bolder, the folds simpler, and the general effect flatter (Pls. 179–81); despite a stockier proportion than the Canterbury figure, and a less delicate and decorative handling of detail, there is less concern with three-dimensional rendering and physical weight than in the Saint-Remi version. The devolution from classicizing concepts follows that observed in the retrochoir clerestory of Saint-Remi. At the same time, very conservative features can be noted in the Braine figures, especially in the large heads of Abiud and Salathiel, with circinate delineation of the chin and the hair parted into very regular locks (Pls. 190, 192).[102] Yet although the prevalent treatment in the choir of Saint-Remi is freer, "Isaiah" (originally the Apostle James) reverts to a facial type and hair closely analogous to those of Salathiel, and the comparison extends to the drapery system, with the tunic bloused over a cummerbund that is very broadly delineated (Pl. 186). As in the case of the Canterbury figures vis-à-vis their rémois counterparts, it may also be noted that there is a loss of ease and logic in the overall drapery system of the Braine figures. One other derivative feature gives credence to the famous drawing by Viollet-le-Duc of the colossal king's head from Saint-Remi; although the size and colors scarcely demand it, the "Thadeus" in Baltimore has a mouth that is separately leaded from the white beard, and although the eyes are not also so leaded, the facial expression much resembles that recorded in the lost head (Pls. 201, 202).

The general modulus for the Amminadab at Canterbury seems to have been repeated on a larger scale at Braine, in the figure now in St. Louis (Col. Pl. 22; Pls. 198, 199); the drapery follows an almost identical arrangement, including a vertical colored band like a placket over the stomach, but the folds in the Braine figure are clarified and simplified.[103] The St. Louis figure is unique in the entire group attributed to the rémois shop in a curious torsion of the face; whereas the predominant angle of view, based on a reading of the neck and ear, the chin, and the direction of the eyes, accords with a three-quarter turn to the right, the nose is strongly outlined to the left, with a nostril to the right (Pl. 74). This feature is to be seen both in the figure of Luke in the sixth-century Gospels of St. Augustine, now in Cambridge, and in the figure of Methuselah from the Canterbury choir clerestory (Fig. 3).[104] The Canterbury glass painter may have known the manuscript, and it is tempting to imagine that the rémois painter in turn recorded the trait from the earlier glass, which he must have studied in situ. One of the few borders that can be attributed to Braine with some degree of confidence, with palmettes and "jack in the pulpit" berries close to the ornament from the transept roses, had an analogue at Saint-Remi (Catalogue D, B.o.1; cf. [R.b.14]); in fact, they are so nearly identical in motif and colors that I questioned whether the Buckler sketch of the rémois panel had simply omitted a trefoil leaf that breaks through the kidney-shaped band, but the surviving pieces have long been associated with the fragments of King David from Braine, (Catalogue A, no. 15). In this case it is the Saint-Remi version that has been simplified, by eliminating an overlapping element with a difficult contour to cut, and supplying a uniformly red ground. Wheres the retrochoir figures of Saint-Remi clearly appear earlier than the ancestors from Braine, the borders suggest that there was both earlier and later glass in the rémois abbey. In fact we shall see that the figures made for the nave clerestory derived in multiple ways from designs used at Braine or at Canterbury.

Details in the medallions from the Braine roses have already been compared with the Becket miracles window in Canterbury, indicating a shared repertory of moduli for draped figures, but a difference of scale and mode prevented a closer relationship between the two series. A complementary role was filled by the sculpture from the west portals of Braine, in the sense that it seems to have provided standards for a certain elegance and an impression of natural movement and poise, without giving rise to a borrowing of specific motifs; the affinity is demonstrated by comparison of Music with a prophet from the voussoirs of the central portal, and of Geometry with a sibyl or Old Testament queen, or with the enthroned Virgin and Child from the gable (Pls. 233, 234, 237, 241).

Yet given the chronology of the building it is unlikely that the painters were dependent on the sculptors without some reciprocal impact; even though the sculpture being prepared for the west portals may have become part of the visual background absorbed by the glass painters as they worked on the site, there are signs that the sculptors were equally aware of the designs for the glass.[105] Comparison between the Christ from the portal's Coronation and Salathiel from a clerestory window reveals similarities in the disposition of the bloused tunic and cummerbund, and even the gesture, that might be dismissed as inconsequential if it were not for the fact that the sculptural interpretation so strongly evokes the earlier figure of "Isaias" from Reims (Pls. 186, 189, 190); it differs in the broader proportion, especially in the shoulders and in the platform provided by the knee, but shares most other aspects of the design. This reciprocal

[102] Both loose, flowing hair and regularly stranded locks are juxtaposed in the Ingeborg Psalter, indicating that they had no chronological significance by about 1200 (e.g., the Crucifixion page, Deuchler, 1973, fig. 31).

[103] The harsh domical form over the knee has the appearance of being drastically repainted, and of course the entire lower third is modern.

[104] Corpus Christi, MS 286, f. 129v; Francis Wormald, *Collected*

Writings I: Studies in Medieval Art from the Sixth to the Twelfth Centuries, London and Oxford, 1984, pl. 2.

[105] Grodecki, in discussing the evident similarity between the clerestory window of the south transept with St. Denis and a donor (Baie CII), and two column statues of the same transept portal (notably St. Theodore and St. George) at Chartres, questions whether the same artist, be it sculptor or glass painter, designed both: Grodecki, 1978, pp. 57–58, figs. 24, 25, 27.

relationship at Braine, in style as in iconography, implies contemporaneity of design and production for the glass and sculpture.

We are now in a better position to review the question of the date of the Braine glass, and, more cautiously, the possibility of a connection with Canterbury through the intermediary of the queen of England. The homogeneous quality of all the surviving Braine glass and its close derivation from the retrochoir of Saint-Remi suggest a single rapid glazing campaign; thus, although lost glass from the lower windows of the choir and chapels could perhaps have been in place by 1179 when an altar seems to have put into use, the surviving glass must date not too long after about 1182 or so, when the atelier had finished the retrochoir glazing in Reims. Completion well before Agnes's death in 1204 would accord with dates argued for the sculpture, in the 1190s rather than ca. 1205.[106]

The other indication is very tenuous, though enticing. In addition to the statement by Hugo that Agnes had the stained glass brought from England, there is a reference from a lost document quoted by Miraeus in the seventeenth century and by Carlier in the eighteenth, to the effect that Agnes received the magnificent glass of Braine from her relative the queen of England.[107] The credibility of this statement might be questioned, in that sixteenth- and eighteenth-century authors claimed an English origin for some of the glass in the Cathedral of Soissons; glass was certainly given early in the thirteenth century by Eleanor, countess of Saint-Quentin, and by Philip Augustus, but the English tag seems to have been acquired later.[108] The duplication could have arisen from

a confusion between the two traditions, or such a claim might be a topos.[109]

Some plausibility is added to Braine's case by Peter of Celle's letter in which he warned Thomas Becket that Agnes and her husband had sided with the English king, and that cordial relations with the royal couple included the exchange of gifts.[110] The date, before Becket's martyrdom in 1170, is too early for the glass, but such a relationship with Agnes's former sister-in-law, Eleanor of Aquitaine, could have continued beyond the turn of the century.[111] Eleanor was not a blood relative, yet she provides a link with Canterbury, since she gave thanks there for the safe return of Richard I in 1194; I have suggested she was involved in the glazing of the Jesse Window, modeled on the one she knew in Saint-Denis.[112] She could have become acquainted with members of the rémois atelier then, and commissioned them to work in Braine.[113]

Agnes also had other, closer, relatives who were queens of England.[114] Another serious candidate as donor is Agnes's grandniece, Isabella of Angoulême, who was married to King John in 1200; the following year they were crowned together in Canterbury.[115] They are not particularly known for their largesse to churches, yet the political motivation to foster an ally in the strategic site of Braine would have been as valid in the early years of the thirteenth century as it was earlier. Agnes's sons, Robert II and Philip, bishop of Beauvais, were fierce adversaries of the English, campaigning with Philip Augustus in Normandy, but from 1198 to 1202 Philip of Braine was held prisoner.[116] There may have been attempts to shake the loyalty of the house of Dreux to the Capetian cause.

[106] McClain, 1974, pp. 142–50.

[107] Hugo is quoted at the opening to Chapter 3. Aub. Miraeus, *Ordinis Praemonstratensis Chronicon*, Cologne, 1613, p. 85: "Circa haec tempora [1131] excitatum est coenobium D. Evodio sacrum à Domina *Agnete*: Comitissa Branensi, in dioecesi Suessionensi, multis Principum sepulchris, ac vitreis fenestris à Regina quadam Anglie eò missis, insigne" ("About this time [1131] the abbey of St. Yved was built in the diocese of Soissons by Lady Agnes, countess of Braine; it is noted for its many royal tombs, and for the stained glass windows sent to her by a certain queen of England"). He goes on to describe the miracle of the Eucharist, concluding "Sic Servatius Larveltz in *Catalogo Coenobioru[m] Ord. Praemonstrat.*," which seems to be the *Index Coenobiorum ord. praem.* quoted by Carlier, Appendix 6, a. I have not been able to find this source. Le Vieil, 1774, p. 24, seems to repeat Carlier.

[108] Louis Grodecki, "Un Vitrail démembré de la cathédrale de Soissons," *Gazette des Beaux-arts* 43 (1953): 175, nn. 10, 11, quotes excerpts from the lost martyrology, dating Eleanor's gift before 1215 and the king's between 1212 and 1223. These excerpts and other existing documentation are given in Appendix 5, by Carl F. Barnes, Jr. He has noted that the king was in Soissons in 1213 for the Great Council and could have made the gift then. John Baldwin, who is preparing an edition of the registers of Phillip Augustus, informs me that the king was unusually restrained in his donations, which seems to emphasize the special nature of this gift.

[109] Le Vieil, 1774, p. 24, expands at length on the hypothesis that the Germans perfected glassmaking and the English were the best glass painters of the period; he is clearly arguing from eighteenth-century analogy when he speaks of their national talents. The opposite is claimed according to another tradition, by which a condition of one of

the treaties between Louis VII and Henry II was that the French king would allow one of his best artists in glass to go to England; Westlake, 1881, 1: 39, is among several authors of the nineteenth century who refer to this tradition, without citing primary sources. John A. Knowles, *Essays in the History of the York School of Glass-Painting*, London, 1936, p. 9, citing Drake, remarks on the lack of documentary evidence.

[110] See Introduction at n. 34 and following.

[111] Both died in 1204; for Eleanor, see *Dictionary of National Biography*, reprint, London, 1921–1922, 6: 593–95.

[112] Caviness, 1986, p. 267.

[113] The "Jesse Tree Master" worked in the adjacent clerestory window to Amminadab and Nahshon (N.IX) in which "rémois" ornament has been noted, so their activities on the site evidently overlapped; Madeline H. Caviness, "The Canterbury Jesse Window," in *Year 1200* I, pp. 379–80; idem, 1977a, pp. 71–75.

[114] A second possibility is her niece, Louis VII's daughter, Marguerite, who married Henry the young king in 1158; in 1185, after his death, she was still referred to as *regina anglorum*, but it is doubtful she had the means or incentive to make such a prestigious gift to Agnes's church. See Caviness, 1985, p. 47, n. 51.

[115] This hypothesis was given more weight in Caviness, 1985, pp. 44 and 47, n. 51. For her dates, see *Dictionary of National Biography*, 10: 500.

[116] Robert II was rewarded with the keep of Aumale in 1196, and in 1204 was at the seige of Rouen; he also fought at the Battle of Bouvines in 1214, according to the *Art de Verifier les dates*, 3, pt. 2, Paris, 1818 p. 161. And see Du Chesne, 1631, pp. 34–35.

Thus a donation of glass to Saint-Yved by a queen of England who was a relative of Agnes of Braine could have occurred within the limits set by the period of construction (1176–1204), and it does seem plausible. The events that were most likely to have initiated it—visits by the possible donors to Canterbury—took place in 1194 and 1200, and this would fit my view that the rémois glass in Canterbury was completed before the exile of 1207. Yet it is the compatibility of the style of the glass from Braine and Canterbury with these dates that lends credibility to a shaky document, and not the reverse.

Synagogue from a Symbolic Crucifixion Window in the South Transept of Saint-Remi

The figures of Synagogue and the donor "Petrus" that may come from the transept of Saint-Remi offer comparisons with the Canterbury work (Catalogue C); the drapery approaches but does not quite match the virtuosity of the Trinity Chapel window, if the mantle of the donor is compared with that of the attendant who takes the cripple's crutches, or the cloth draped on the lectern (Pls. 206, 211). The eponymous figure of Petronella fainting is like Synagogue in proportion and in the general disposition of her kerchief and skirt, but the treatment is broader in Synagogue despite the comparable size (Pls. 212, 215). The slightly dry treatment is in fact more closely akin to the west window medallions of Braine, such as the Elder, whose mantle may be compared with Synagogue's skirt, or one of the suppliant angels whose mantle end describes almost the same cascade of pleats as that of Petrus (Catalogue A, nos. 26–30).

The famous typological Crucifixion window of the Benedictine Abbey Church of Orbais, not far from Reims, also offers stylistic analogies (Pl. 213); it has most recently been dated about 1200.[117] The small-scale figures there seem more full-bodied, but the fold systems and crisp painting of the drapery are sufficiently alike to assume influence from the rémois atelier. It is also noted that the rather sparse border design has a counterpart in the clerestory of Orbais, which is unlikely to have been glazed until after 1200, (Catalogue D, R?b.42).[118] These observations would allow a date for the window in Reims after the Braine campaign, although dating on the basis of such isolated fragments must be tentative.

The Genealogical Figures in the Retrochoir Tribune of Saint-Remi

Only five and a half authentic figures survive from this series of standing ancestors of Christ. It has been seen that their present arrangement is not an original one, and I have speculated that they were made for the small eleventh-century windows of the nave aisles; the date was left open in Chapter 2, whether they were created under Abbot Odo about mid-twelfth century or whether they were part of the last refurbishing of the nave around 1200. Grodecki had suggested the earlier date.

The condition of these figures is extremely poor, making stylistic judgments seem uncertain; it is not so much a question of replacements, however, as crusting and paint loss in the original glasses. Yet certain traits emerge clearly. One is that two pairs of figures are cut from the same cartoon, but with the colors of the robes changed as if to disguise this fact (Pls. 248a, 248b).[119] This is not the kind of empirical change noted in the clerestory of the retrochoir but appears to be part of a more mechanical repetition.

The narrow-shouldered silhouettes, the use of colored bands in the robes, and the pronounced blousing of the tunic and sleeve notable in Abiud and Methuselah, serve to associate these figures with the latest ones in the east end of the choir—that is, the apostles such as James or Bartholomew and the Crucifixion—yet they seem flatter (Col. Pls. 8, 17; Pls. 110, 186, 248). The mannered pointing gesture, and the straight hem interrupted by a cascade of folds from the trailing mantle, recall the torso from Braine now attached to Abiud (Col. Pl. 11; Pl. 185). Eliakim and ?Jacob appear stiffer, but the way their bent arms are cocooned in their mantles recalls the Braine figure in St. Louis (Pls. 199, 247). Confirmation of a late date may be found in a splendid figure of St. James in a New Testament manuscript that is generally ascribed to the early thirteenth century (Pl. 249).[120]

If these figures were indeed made for the nave aisles, they could have been produced rather rapidly under Abbot Simon, that is before 1198, when he was directing the work on the nave; the aisles did not have to await the vaulting of the central vessel to receive new glass. Continuity with earlier workshop traditions, yet a decline in quality, might be expected a decade after the completion of the choir windows. If the shop was also supplying glass in Canterbury and Braine, its members may have been dispersed and its resources reduced.

[117] Kline, 1983, pp. 140–50; on pp. 102–39 she discusses the iconographic sources and related works.

[118] Kline, 1983, pp. 95–99, tentatively dates the apse clerestory windows ca. 1210–1215.

[119] Abiud, in St.II a, has a green mantle over a purple robe with pale blue bands, whereas Methuselah in Nt.II c has a purple mantle with blue bands over a green robe with yellow bands (both have white underskirts); the two figures in I a, Eliakim and Jacob?, have white mantles over purple or green robes, with bands counterchanged.

[120] Baltimore, Walters Art Gallery, MS W. 67; see *Year 1200* I, col. pl., no. 249, pp. 250–51. I am grateful to Lillian Randall for a copy of her catalogue entry for this manuscript, since published in Lillian M. C. Randall et al., *Medieval and Renaissance Manuscripts in the Walters Art Gallery* I: *France 875-1420*, Baltimore, 1989. I had previously relied on the line ending in this group of inscriptions in the glass, a circle with a halo of dots like a daisy, to argue a late date, on the basis of a late twelfth-century addition to a Saint-Remi lectionary (B.M., MS 300, f. 136), but the same scribal habit appears from midcentury on, for instance in the early Reims Bible, MS 18, f. 100 (Lemps and Laslier, 1978, no. 22, illus.). It is even used within decorative capitals in the late ninth-century Gospels from the Cathedral, Reims MS 11 (Lemps and Laslier, 1978, no. 8, illus.).

The Clerestory of the Nave of Saint-Remi

Eleven single round-arched lights in each wall of the nave belong to the eleventh century; they are now surmounted by oculi, added in the late twelfth century (Pls. 23, 35, 36). The program of glazing was reconstructed in Chapter 2 and may be summarized here: Twenty-one of the surviving figures are entirely or in part ancient; they comprise one bishop or archbishop (another of the same size is now in the tribune of the choir) (Pls. 253, 254); ten patriarchs or prophets, all with shoes and nimbed, some with scrolls or caps (Col. Pl. 13; Pls. 255–61); and ten kings of which one is inscribed *Chilperic* (Col. Pl. 14; Pls. 263, 265, 267, 270, 271). Allowing for the calculated height of the original openings, it was possible to reconstruct a compositional scheme with two superimposed figures within wide borders, as in the choir (Pl. 79). The Frankish kings apparently occupied the lower panels, and the patriarchs were placed above. Perhaps in the monks' choir, which extended four bays into the nave, patriarchs were placed over archbishops instead of kings.

The date of the nave glazing, whether before or after the choir, was left open in Chapter 2, since the creation of a series of Frankish kings could be justified in either period. The series appears fairly uniform in design, though less so in execution; the figures are minature versions of those in the choir, with rather elegant, mincing gestures and drapery falling in loops that tend to flatten their forms (cf. Col. Pls. 2, 14; 10, 13; Pls. 164, 255; 165, 175, 256; 169, 260); the perspective of footstools and thrones is also sometimes oddly flattened when compared with the spatial coherence of the choir compositions (Pls. 163, 164, 257, 259). Indeed, apart from rather mechanical details such as the treatment of jeweled bands, it is hard to imagine that the nave figures depended directly on those of the choir, or even on the graceful standing ancestors; proportions and postures are more awkward, and gestures more mannered. Indications of a later date include the large heads (perhaps a carryover from the modification observed in the choir) and the use of red roundels in the grounds, probably following their use in Canterbury (Col. Pls. 9, 13 14; Pl. 198; cf. Pl. 256, etc.). Some of the figures repeat the same design, with or without variations, although overall the variety of poses is larger than we have seen so far in the clerestory series.

Most persuasive of a late date, however, is the repetition of the same cartoon, as many as seven times among the surviving kings, with varied colors (Pls. 270, 271). As with the genealogical figures, it seems a response to the urgency of the work, and an economy of the kind

Prache has observed in the vault construction of the late period, rather than a sophisticated reworking of a design. In cases where a design is modified for reuse, there is no coherent sequence but rather a variation of the kind seen in the Braine series (Pls. 265, 267). Furthermore, specific traits in the rendering of drapery, such as the cowl-like folds that hug narrow shoulders and the bloused upper sleeves, are widespread in the early thirteenth century, as even in a panel with St. Jude, drawn by O. Hudson in Lincoln Cathedral (Pls. 255, 263, 264, 267).[121]

A series of comparisons with the figures from Braine reveals a somewhat similar repertory of compositions and iconography. For example, resemblances may be noted in the broad, flat frontal faces of Jechoniah and the king in S.XXII, and in the articulation of their throne backs (Pls. 193, 263). The patriarch in S.XVI and the ancestor in St. Louis share several motifs in the drapery folds, and the general contours of hair, facial features, and stomach (Col. Pls. 13, 22; Pls. 199, 255); the patriarch in S.XIX shares a similar neckline and pouched fold on the shoulder with the Amminadab in Soissons (Pls. 182, 256); and the bloused tunic and sweeping folds of Chilperic repeat those of Salathiel (Pls. 190, 265). The hands, with well-marked sinews, frequently hold the bunched end of a mantle (Pls. 257, 258, 270). Later traits in the Saint-Remi glass appear to be the greater use of large hooked folds, with broader pleating of the hems, together with the lesser occurrence of tightly organized locks in the hair and a greater loss of easy articulation than was noted in the Braine figures.[122]

Even closer correspondences were documented by comparisons of rubbings, between the "rémois" figures in Canterbury and these nave clerestory figures; since the dimensions are very nearly the same, it is possible that the same cartoons were adapted.[123] The feet, necks, and faces of Nahshon and the king in N.XXIV are of the same size, and the distances from the knee to the heel the same length; arms and hands are similarly proportioned (Pls. 180, 267). Comparing rubbings of the same king and Amminadab, the contour of their right arms and mantle are almost identical (Pls. 198, 267); and the latter share the same cutline for the left calf and drapery, although the feet are set at different angles and the knee of Amminadab extends higher. The patriarch in N.XVI shares the contour of head, shoulders, and arch with Nahshon. These examples could be multiplied, and they seem to indicate the same kind of designing in series that occurred within Braine.

More significant, because it helps to document the chronology of the work, are correspondences between two smaller figures in Canterbury, Obed and Jesse from Trinity Chapel clerestory N.VIII; Obed has many of the

[121] Morgan, 1983, illustrated others of this group (pl. 9), and dated them ca. 1250 (p. 45); in my view this is too late: Madeline H. Caviness, review of *The Medieval Painted Glass of Lincoln Cathedral* by Nigel Morgan, *Burlington Magazine* 127 (1985), p. 96; the author has generously accepted my suggestion.

[122] The figures in N.XXI, N.XVIII and S.XIX have tight "Mosan" locks such as those of Abiud.

[123] E.g., the two panels with a king in N.XXIV have a total height of 125 centimeters (cf. 150 for Nahshon at Canterbury); the figures themselves measure 111 vs. 125 centimeters.

hallmarks of the rémois atelier, both in the durable glasses and in the painting, but Jesse appears to be of different facture (Pls. 266, 268).[124] Once more, rubbings revealed that the cutline of the left legs of Obed and the king in N.XXIV coincide, except in the extension of the heel of the larger figure (Pls. 266, 267). Jesse departs from the rémois closed contour to use an old Canterbury formula, one arm placed akimbo; yet Chilperic also adopts this posture, and even follows the same contour, including that of the long loop of the mantle, and his original head would probably have matched that of Jesse (Pls. 265).[125] In other words, it seems that in designing the nave figures the glass painters profited from having worked on a similar scale in Canterbury; and that they burrowed from the repertory of their neighbors there in order to break away from the calm and stasis that had been appropriate to the spiritual leaders in the choir, to give the secular rulers bolder and more rentless poses.

At the same time, they were not reluctant to repeat designs that are identical, except in color, over and over again. It might be feared that the effect would have been relatively monotonous, the more so since the nave clerestory windows are more readily visible as a series than are the retrochoir windows, being less hidden by the webs of the vaults (Pls. 24, 26). In this way these images draw closer to icons, or even signs, than the procession of virgins that was overtly modeled on such a prototype (Pl. 98). Modern art has revitalized the concept of mechanical reproduction, in the ash can school, demonstrating that such relentless repetition dulls the viewer to the specific object and gives it new meaning, as when a word is repeated until it becomes pure sound.[126] Yet there are other parameters operating here. One, referred to already, is the similarity to decoration in the use of a repeat pattern, so that imagery is subsumed into ornament. Another is the sense of animation that might have been achieved kinetically if the repeated poses were alternated with others, as if the window surfaces were a film strip; this type of animation can be seen to operate in the use of horses as type figures in the Bayeux tapestry, and less dramatically in the processional figures of Sant'Appolinare Nuovo. Above all, this mode seems fitting for a processional space, and contrasts appropriately with the internalized affect of the *personae* in the contemplative space of the choir. Whatever the assessment of "quality" in the design and execution, the series can hardly be regarded as less successful in its context than the earlier productions of the shop.

Antecedents and Affiliates

Thus far, most comparisons evoked for the products of the rémois atelier have been from the immediate milieu in which it was working at a given time; the broader stylistic context, of which the conventional view was outlined in the Introduction, has been avoided. Indeed, the complexities of the interactions between the "formal" and "iconographic" aspects of the images studied here, and between expressions in different media, have scarcely been comprehended in the extensive literature on the "style 1200," in part because media tend to have been falsely isolated from one another, and in part because the multivalent relationships that can occur through the borrowing of motifs have not been recognized.[127] Far from trying to redress this balance, I prefer to overlook earlier concepts of style phases and development, and instead to trace part of the many stranded web that connects a number of works made in the northeastern quadrant of modern France in this period.[128]

Some rémois works have been cited that indicate a satisfactory climate for the intensely productive period of the choir glazing, such as the sculpture later installed on the north transept of the cathedral, and the Peter Lombard manuscript from St.-Denis (Catalogue D, R.b.34; Pl. 156). The glass paintings from Braine were also put in the immediate context of the sculpture from that site. Yet the "formative" years of the glass painting atelier are more difficult to place in an artistic context. Illuminations in rémois books of about midcentury do not have the vigor of the "petit St. Remi," which I dated by comparisons with works from elsewhere; the Bible from St.-Thierry, for instance, perpetuates a stiffer drapery style and more awkward contour (Pls. 81, 250). A drastic change can also be noted in sculptural styles, between the static Romanesque forms of the candlestick, and the figures of St. Remigius and St. Peter or the capital frieze of the west facade a decade later (Pls. 42–44, 90, 91); the figure of a man tempted by demons flanking the portal has a dramatic presence and convincing sweep of drapery that prepare one for the monumental figure of Henri de France a few years later (Pls. 90b, 145).

Despite the abundance of Roman antiquities in the region, there is little sign that this advance toward naturalism was achieved by copying ancient models, as was the case for the later sculpture of the cathedral (Pls. 13, 14, 19). Nor do Carolingian models seem to have played a major role, as except perhaps in iconography (Pls. 121,

[124] Caviness, 1981, pp. 39–40.

[125] The present head, already in place in the engraving reproduced by Ottin, 1896, frontispiece, is a stopgap, probably from the choir, but it seems to have been cut to fit the original halo and crown.

[126] I am indebted to Kenworth Moffett for a discussion of this phenomenon.

[127] This is especially true of painting and sculpture. Even Deuchler, in treating the Ingeborg Psalter and the Laon east windows together, overlooked the extent of interaction between these media throughout

the region. For instance, the Sens Good Samaritan window shares iconographic models, but not style, with the Ingeborg Psalter. See also my critique of the handling of "sources" in relation to the glass of Saint-Denis: Caviness, 1986, pp. 262–66.

[128] To be more precise, if Paris were taken as the center of a clock face, the area would be covered by the sweep of the hands from twelve to four, through the Ile-de-France, Picardie, and the Aisne to Champagne.

252, 273). The movement may have been more driven by Aristotelianism than by visual stimuli; this would explain the parallel directions taken in works created in Canterbury in John of Salisbury's time, and those created at the same time in Reims under Peter of Celle (Pls. 3, 145). Despite the friendship between the two patrons, there is no sign in this period of direct influences exchanged by the glass painters.[129] It is likely also that it was the passing of this generation, and the reaction against Aristotle, that fostered indifference to naturalism and gave rise to increasingly flat and decorative forms, as in the Canterbury clerestory figures and the nave glass of Saint-Remi about 1200 (Pls. 6, 256).[130]

At the same time, a new class of patrons had come into being. Agnes of Braine is one of the several wealthy aristocratic women who patronized the arts and the new orders. It should not be surprising that the glass painted for her has a certain affinity with the Psalter of Queen Ingeborg, the ill-fated wife of her nephew Philip Augustus, and ultimately with sculpture in the capital. Iconographic relationships have been noted in Chapter 3 between the figures from the Braine roses and their counterparts in the Ingeborg Psalter or in the west rose of Notre-Dame in Paris (Pls. 223–25; 226, 227; 228, 229). In the case of the Psalter group of manuscripts there are also coincidences in drapery moduli, although these do not go so far as to indicate a close stylistic affinity (Pls. 209, 210; 218, 219; 233, 236). In the case of Notre-Dame, the medallions inserted in the south rose are closer in style to the rémois atelier than are the panels in situ in the west rose, but some of the west portal sculpture deserves attention in the context of Braine; and here, as in the Ingeborg Psalter, an insistent *muldenfaltenstil* appears alongside the softer mode, with catenary folds, that relates to the rémois group (Pls. 233, 235). The sources for this sculptural style appear to lie to the east of Paris, in Sens.[131] Closer to Braine, the glass and sculpture of the Cathedral of Laon evidently exercised an influence on its decoration, especially in the programs of the roses and the portal sculpture (Pls. 232, 238, 243). And there too iconographic models were available that had been used for the Ingeborg Psalter.[132] The sculptures of the Saint-Remi choir consoles also seem to bear some relation to the developing style of the glass painters as seen at Braine (Pls. 33, 237).

A better sense of these relationships is obtained from contrasts. The twelfth-century Premonstratensian Missal referred to in Chapter 3, Bibliothèque Nationale MS lat. 833, exhibits a variant of the wet-fold byzantinizing style that had permeated Burgundian painting, even though the modeling is so painterly that a date toward the last quarter of the century must be postulated (Pl. 220). The angel illustrated here offers a cogent and instructive contrast to the Virgin of the Flight into Egypt in the Ingeborg Psalter, in that the Psalter shows an adaptation of similar postures and basic drapery configurations to the new soft contour-hugging style (Pl. 219). It is the latter that is quite closely mirrored in, for instance, the similarly draped angel from the Braine rose, and the boy leading the donkey offers a model for the figure of March (Pls. 218, 223). Yet a certain conservatism in the ornament of the rémois atelier is indicated by a repetition of palmettes and leaf types that are already current in this manuscript (Catalogue D, R.b.22; cf. C.b.1).

As indicated in Chapter 3, if any manuscripts were to be associated with Braine on stylistic grounds, it would be the glossed Epistles in the British Library (Royal 4 E IX), the Virgil manuscript in the Bibliothèque Nationale, and the Bible in Berlin that was published by Ayres.[133] The similarities may be reviewed in Pls. 190, 191; 221, 222; 229, 230; 237, 240; 182, 183; 199, 200. Author portraits in the glossed Epistles recall, on one hand, the Canterbury figure of Nahshon, in the taller proportion and more elegant gesture, and on the other hand the stockier, less coherent figures of the Reims nave clerestory (Pls. 180, 181, 257).[134] The manuscripts clearly depend on the Canterbury-Braine phase of the rémois shop, rather than on the more classicizing forms of the Saint-Remi clerestory figures, such as Balaam (Pl. 163).

An intriguing series of parallels to the glass of the rémois shop is offered by the great two-volume Bible once in Sainte-Geneviève in Paris and now Bibliothèque Nationale, MS lat. 11534–35; as discussed in Chapter 3, it is more likely to stem from the collegiate foundation at Troyes than from Braine, yet the drawings that lie behind it seem to relate in many cases to the work of the rémois glass painters. Even the composition and decoration are closer to stained glass than most books of the time. Especially notable is the great Genesis initial, filling an entire column in the double-column layout, that contains six medallions with the Creation in the central axis, and four pairs of demi-medallions forming a counterpoint to the sides, which take up the story of the Fall, from the creation of Eve to the death of Abel (Pl. 274);[135] the composition is close to one of the typological windows of Canterbury, including even a linking of the edges of the demi-medallions to the central roundels.[136] A series of rich designs, resembling the borders of a window, fills the sides between the demi-roundels, and together with a passage of interlace above and below and a narrow edging to the entire page, these fairly well cover

[129] For the shared intellectual interests of the two men, especially their knowledge of the ancients, see Janet Martin, "Uses of Tradition: Gellius, Petronius, and John of Salisbury," *Viator* 10 (1979): 57ff., esp. 74–76.

[130] Caviness, "The Simple Perception of Matter," unpublished manuscript.

[131] Willibald Sauerländer, "Zu den neugefunden Fragmente von No-tre-Dame in Paris," *Kunstchronik* 30 (1977): 300–301.

[132] Deuchler, 1967, pp. 149–62.

[133] See above, Chapter 3 at nn. 81 and 83–85.

[134] For an additional illustration of the Epistles, see n. 45 above.

[135] MS lat. 11535, f. 6v (photo D54/411).

[136] North Choir Aisle, n.XIV (third typological window); Caviness, 1981, p. 99, figs. 172, 175–76.

the repertory of border designs by the rémois atelier.[137] Also prevalent in the design are serrated quatrefoils like those in, for instance, the Synagogue panel, and many of the initials are formed by curling stems with single leaves at intervals such as frame Synagogue (Pls. 173, 207, 215, 274). Delicate rinceaux edging the ground of some of the scenes resemble the diapered grounds of the Trinity Chapel ambulatory window (Pls. 206, 208).[138] Elsewhere punched circles enliven the gold grounds like the roundels used in the glass (Pls. 173, 198, 207, 256). Other shared motifs include draped crossbars like the one over the king from Braine in Glencairn (Pls. 194, 195).[139]

Many hands were involved in the execution of the "Sainte-Geneviève" Bible, but at least one applied delicate colors, including soft pinks, greens, and yellows that resemble those in the glass, and more than one rendered drapery folds with a minuteness and a sensitivity to rapidly changing contour that rival the glass painters who worked in Reims and Canterbury, resulting at times in a similar attenuation of the forms (Pls. 171, 173; 206, 207; 212, 217), or a similar elegance of posture (Pls. 180, 190, 195); a good many of the seated figures in the manuscript clasp a loop of their mantle. The slender standing figure of St. James from his Epistle, head on hand in a pensive gesture and with insistent ropelike folds accentuating the contour of his leg contrasting with the vertical sweep and pleated folds of the mantle, has a counterpart in the Saint-Remi Crucifixion figures (Pls. 110, 112). The grouping of figures and expressive body language occasionally reach the level of dramatic intensity of the Petronella scene, notably in the Entombment of the Virgin placed in a tympanum of the canon tables (Pls. 208, 212), and the use of gesture to link groups, for instance in Job confronted by the kings, is similar though more stereotyped (Pl. 207). In fact the

repetitious movement of both arms in tandem in this scene is also found in the angels from the Braine rose (Pl. 218a).[140] Furthermore, a favorite drapery configuration is the triangular pouch over the upper arm that is so common in the clerestory figures by the rémois atelier (Pls. 182, 207).

Most of the execution, however, is rather coarse, and some mannerisms, such as a tendency to emphasize the breadth of the knees in frontal seated figures, and to create angular meander configurations in the hems of mantles and robes, depart radically from the rémois tenets. On the whole, the treatment is looser than the Petronella Master's; the veiled woman holding the earth approximates the handling of Synagogue (Pls. 215, 217), although the stiff folds of her mantle may be contrasted with the similarly draped Braine angel (Pl. 218a). The Prophet Amos, with kerchief and trailing hem like Petronella and Synagogue, demonstrates a coarser mode (Pl. 216). There is generally a lack of the classicizing traits that characterized the Ingeborg Psalter group. It is tempting to conclude that the manuscript borrowed eclectically from the rémois glass along with other sources; such a situation would not be surprising with William of Champagne as archbishop of Reims (1176–1202). In turn, the manuscript may have influenced later glass painting in Troyes.[141]

It is of course difficult to isolate "sources" from "derivative works" if the chronologies are not certain. At this point it seems we are dealing with the impact of the rémois glass shop on works produced elsewhere and in other media. The following chapter will deal more broadly with the impact of the group of windows that seem to have been produced in Reims, Canterbury, Braine, and again in Reims during the half century between 1160 and 1210.

[137] Compare these various elements with Catalogue D, R.b. 22, 28, 30, 32, 33, and the border in Canterbury, Trinity Chapel ambulatory n.IV, C.b.1.

[138] MS lat. 11535, f. 74 (photo D54/412).

[139] The frontal images of justice enthroned at the opening of the Book of Wisdom MS lat. 11534, f. 105 (photo A59/198) and of wisdom at the opening of Ecclesiastes MS lat. 11534, f. 114v (photo B 59/

230) offer other general resemblances and provide an example within the illuminators' shop of the readaptation of a modulus.

[140] A youthful angel with double wings at the opening to the Book of Tobit (MS lat. 11534, f. 165, photo B57/64) much resembles those from Braine.

[141] Similar ideas were proposed by Pastan, 1986, p. 111, figs. 138, 139.

CHAPTER V

Afterimages

The Crucifixion Window in the apse remains clearly in my memory as a
powerful and serene masterpiece. . . . That St.-Remi window seemed to
encourage contemplation while the cathedral window devoted to the same
subject, like most of the great areas there, was more clearly related to the
active life. I owe to the lost Church of St. Remi one of my first real lessons
in spiritual values as they are expressed in stained glass windows.

Charles Connick, 1937[1]

THE ACTIVITY of the rémois stained glass atelier has
been traced in three different locations. It began to
make windows for the old building at Saint-Remi per-
haps as early as the 1160s and continued to supply glass
for the new choir there through the early 1180s. The
program it executed for the choir seems as much a visual
expression of Peter of Celle's spiritual values as his writ-
ings are a verbal expression. Its campaigns in Canter-
bury and Braine may have been sequential or simulta-
neous and have been tentatively situated between about
1185 and 1200 or so. The patronage may have been sec-
ular and "royal" in these cases, but the Benedictines and,
to a lesser extent, the Premonstratensians seem to have
resisted emphases that might have exclusively served the
interests of the donors; the program in Braine might be
likened to a sermon addressed to lay patrons. The latest
productions of the atelier appear to have been made for
the nave windows of Saint-Remi, perhaps about 1195 to
1205, that is in the reign of Philip Augustus and possibly
in response to the Hohenstaufen program in Strasbourg
Cathedral; the subjects of these windows connected the
abbey once more to the coronation rite and to the world
of secular authority. Thus the same atelier had been

meeting the needs of diversified groups: the twelfth-cen-
tury Benedictines with their quest for individual spiri-
tuality; the canons who held *docere verbum et exemplum*
("to teach by word and example") as an ideal of com-
munal life; and the next generation of politically astute
monks, who used resplendent monumental images to
confirm the position of princes of the royal blood along-
side the princes of the Church.[2] This much might be
stated by way of summary.

Rather than closing off discussion with such a tidy
conclusion, the purpose of this brief chapter is to bring
together some of the multivalent legacies of this atelier
and of the programs of windows it created; many such
instances have been referred to in the course of previous
discussion. In some cases it may be appropriate to claim
direct influence, yet this is usually an oversimplification.
Partial imitations, it is supposed, may be understood as
critiques of the original rather than unskilled or imper-
fect copies; in the same way, the fact that some works
seem to owe no debt to the glazing of one or other of
these monuments even though their creators must have
known them may be due to "resistance" or "negative in-
fluence."[3] A few works will be dealt with that document

[1] Connick, 1937, p. 300. He first visited Saint-Remi before World
War I (p. 299), and used a photograph dating from 1920 in illustration,
Collotype XXXIII.

[2] Caroline Walker Bynum, *Docere Verbo et Exemplo: An Aspect of
Twelfth-Century Spirituality*, Harvard Theological Studies 31, Cam-

bridge, Mass., 1979, has presented a brilliant analysis of the differences
between Benedictines, such as Peter of Celle, and canons, such as
Hugh of Saint-Victor (pp. 41–48, 157–61, 181–97, esp. 188–91.)

[3] Bony, 1957–1958, p. 39, suggested that the architectural solutions
at Chartres met with resistance in a great many sites, and that "it is in

the reception of the great ensembles of glass in Saint-Remi and in Saint-Yved; most belong to the thirteenth century, but one is modern. They continue the debate about the nature and function of religious art that had been joined by Peter of Celle and his followers, and by Agnes of Braine and her spiritual advisors. Another phase of that debate unfortunately robbed us of many of the original works; from the sixteenth through the nineteenth centuries various rationalizations occasioned the most extreme negative responses, the destruction or transformation of these fragile images; that phase was dealt with in earlier chapters, leaving the more positive critiques for consideration here.

Conventional stylistic influences have been touched upon in Chapter 4, where it was argued that the great Bible from Troyes (B.N., MS lat. 11534–35) owes much to the figural and decorative conventions of the rémois glass. Among other works that have previously been discussed in relation to the "Petronella Master" of Canterbury is the St. Peter Window in Troyes Cathedral, which makes similar reference to the glass of Saint-Remi, without deriving solely from it, and which Pastan has compared with the Troyes Bible.[4] Another is the Psalter of Blanche of Castille (Paris, Bibliothèque de l'Arsenal, MS 1186).[5] This book has since been recognized by Branner as one of a significant group of early thirteenth-century manuscripts from the northeast of Paris by a "Blanche Atelier," which immigrated to Paris about 1220; others of the group include two Bibles once in the Abbey of Corbie, near Amiens, and one made for Lille, as well as a three-volume Bible in Reims and the Psalter with English connections that has been evoked in relation to the sculptures at Braine, Saint-Geneviève MS 1273 (Pl. 52).[6] Such peripatetic illuminators help to explain the diffusion of styles, and establish a direct link to Paris, much as the earlier sculptors who worked in Sens, Laon, and Braine can be traced to Paris and Chartres. The provincial origins of the Blanche Atelier call into question the Parisian derivation of another stylistic relative of the Reims-Braine glass, the Passion window of the Church of Saint Vincent in Saint-Germain-lès-Corbeil, which is situated on the Seine to the southeast of Paris (Fig. 1; Pl. 276).[7] The window is generally dated

about 1225, although the architecture is closer to the turn of the century, but the predominantly purple, white, and green palette, with some yellow and touches of red, and the elegant catenary folds are not far removed from Braine; yet signs of a later date are the mannered gestures and enlarged heads of the more active or expressive figures. Reminiscent of the two Crucifixion windows of Saint-Remi are the trees, now combined with Ecclesia and Synagoga, that flank the Christ crucified with the Virgin and St. John, but in scale and setting the image lacks the liturgical mystery of the great tribune window in Saint-Remi, being part of a narrative cycle. Similar configurations are in the castle chapel at Baye, not far from Reims, and in Beauvais Cathedral.[8]

The soft catenary-fold style coexisted with the better-known *muldenfaltenstil*, both of them originating outside Paris and both being practiced in the capital after about 1220; both seem initially to have been patronized by churchmen and secular aristocracy, but the hypothesis is worth risking that a royal connotation was increasingly adumbrated by the trough-fold style, as in the clerestory hemicycle windows of Soissons Cathedral (Pl. 278); yet if so, it had also been used in earlier "episcopal" windows there and was thus appropriated by the royal patrons.[9] A variant of the same style seems to have been introduced in Rouen, in a window with English royal connections, before Philip Augustus took the town in 1204.[10] The associations of the catenary-fold style are more diffuse, as in the case already of the rémois atelier. Therefore, it is not surprising to find it widely disseminated in the thirteenth century; we have seen relatives of the rémois figures in Lincoln Cathedral (Pl. 264). More subtle in color and form, this general style group was extremely versatile in adapting to different modes and scales, although it lacked the bold, declarative quality of the *muldenfaltenstil*.

The general success of the catenary-fold style indicates that there must have been a receptive climate for the productions of the rémois atelier well into the thirteenth century. Yet the atelier itself seems to have no immediate successor; the inference is that either its members disbanded and were absorbed elsewhere, or that in the next generation changes were effected that prevent recogni-

their conflict with the Chartres movement that these other forces can be reconstructed." Göran Hermerén, *Influence in Art and Literature*, Princeton, [ca. 1975], pp. 42–49, has usefully introduced the concept of "negative influence" when the reaction to the seminal work is one that repels, and produces a work that deliberately bears little resemblance to it.

[4] Caviness, 1977a, fig. 155; most recently Pastan, 1986, pp. 110–13, figs. 112–25.

[5] Caviness, 1977a, fig. 158.

[6] Amiens, B. M., MSs 23, 21, Douai, B. M., MS 173, and Reims, B. M., MSs 34–36; Robert Branner, *Manuscript Painting in Paris during the Reign of Saint Louis: A Study of Styles*, Berkeley, 1977, pp. 30–31. For the rémois Bible, which has marginal notations for the use of the cathedral and a pre-Vulgate text that Branner places before 1220, see also Lemps and Laslier, 1978, no. 33 (illus.).

[7] Grodecki et al., 1978, pp. 69, 83–84, pls. 6 (col.); cf. pl. XIV and fig. 35. Raguin has associated this style with another of the Troyes

windows, the Life of St. Andrew, and with one of the ateliers that worked at Auxerre and Semur-en-Auxois; see Virginia C. Raguin, "Windows of Saint-Germain-lès-Corbeil: A Traveling Glazing Atelier," *Gesta* 16 (1976): 265–72.

[8] Kline, 1983, pl. 189; Cothren, 1980, pl. 25.

[9] The permutations of this style are discussed by Caviness, Pastan, and Beaven, 1984, pp. 15–18. Beaven, MS, 1989, has investigated the iconography, patronage, and style of the chapel windows of Soissons; the dominant theme is canonized churchmen, suggesting episcopal control (Chapter 3, pp. 99–125).

[10] Michael W. Cothren, "The Seven Sleepers and the Seven Kneelers: Prolegomena to a Study of the 'Belles Verrières' of the Cathedral of Rouen," *Gesta* 25 (1986): 208–12; the case is closely argued from historical circumstances and iconography. He has also demonstrated the partisan connotations of the later style associated with Louis IX, which was adopted in the Theophilus window of Beauvais Cathedral about 1245; Cothren, 1980, pp. 145–46.

tion of a continuity. Where quirks of design or execution recall the earlier productions, it is hard to say whether they result from the dispersal of the craftsmen or from mere imitation. For instance in the nave clerestory of Chartres Cathedral, on the south side, an extraordinarily elegant Virgin and Child stands under a low canopy against a ground decorated with red roundels; her cowl turns round narrow shoulders with a familiar concave triangular fold that is repeated in the mantle over the upper arm, a name band passes behind her neck, and her robe is decorated with colored bands (Pl. 227).[11] Despite the sheer size of the figure, it is miniaturesque in the same terms as Nahshon in Canterbury (Pl. 180); furthermore, the hand exhibits the sinews that were a hallmark of the rémois painters, and the bridge of the nose is defined by a series of short perpendicular strokes that I have not seen in any faces of the period except Nahshon and Amminadab in Canterbury.[12] It is hard to imagine that this mannerism was learned anywhere but in the shop. Yet it was noted in the Introduction that the clerestory compositions and iconographies of Chartres might generally be placed in a category of "resistance" to Saint-Remi and Saint-Yved.

The closely contemporary windows in Bourges on the other hand seem to betray direct influence from the rémois shop. In formal terms, much of the glass in Bourges complies with the a-b-a rhythm of the triplets by placing a frontal figure between two that are based on the same cutline, and as in the retrochoir of Saint-Remi the turn of the head is adjusted; it would appear from this that there had been no technical revolution, such as a change to linen for the cartoons (Pls. 129, 280). The border designs are also often matched in the lateral lights. However, rather than maximizing this symmetry by the same distribution of colors in the figures, the later glaziers have masked the repetition by varying them; this has the effect of throwing off the balance that seems to have been sought in Saint-Remi.[13] Other differences are apparent; the figures belong to the new colossal order of Gothic, rejecting the humanistic aspect of the rémois figures that derives from their respecting a life-size canon. Yet they may owe much to unbroken workshop tradition.

The general design and iconography of the program in Bourges also appear to be free adaptations of the rémois prototype. As part of the response to scale, name bands are made legible by placing them under the figures and leading the letters in colored glass, and the individual figures stand to fill an entire light each. The images of bishops are thus updated to conform with their appearance on seals (Pls. 118, 279). As noted in the Intro-

duction, the bishops of Bourges are separated from the apostles and patriarchs, in the story below them, and actually in a different spatial plane; at their head is St. William, who may have presided over the program in its formative stage (Pl. 279). The kneeling figure of Countess Matilda at his feet may have been reminiscent of Agnes of Braine as she appeared at the feet of the Virgin in the Premonstratensian abbey; Matilda of Courtenai was in fact a great grandniece of William of Champagne.[14] The apostles and patriarchs, instead of being grouped in relation to the axial image of the Virgin and Child as in Saint-Remi, are among rare examples that follow Mâle's rule that places the New Testament figures on the side of light.

The Reims mosaic and the Braine rose windows cannot be claimed as unique sources for all subsequent rose window programs, although the impact of the Braine stonework is clear. There is a specific iconographic relationship to the very dense encyclopedic program of Lausanne Cathedral, which is not surprising in light of the northern origin of Peter of Arras who is documented painting glass in Lausanne between 1217 and 1234–1235.[15] The style is not recognizably dependent on the rémois atelier, but the use of an unusual violet-purple, like that noted in "Thadeus" in Baltimore, may be indicative of a common tradition of glassmaking (Col. Pl. 21).[16]

A formula that was easily lifted for use elsewhere was the arrangement in clerestory windows of two superimposed seated figures, yet this was not the most popular composition in the thirteenth century; it was noted in the Introduction that it is used in only one lancet in Chartres (Pl. 12). When it does appear, as in one light of the axial doublet in the Abbey Church of Orbais, after about 1210, it may be seen as a conscious response to the rémois program (Pl. 143). The presence of Christ in Majesty in Orbais as well as the Virgin, however, points up his absence in Saint-Remi, where Mary presided as Ecclesia over the apostles and archbishops (Pls. 141a, 141b). Other less well preserved figures in Orbais seem to indicate that the program comprised standing figures of apostles and episcopal saints flanking these Majesty images, again consistent with the shift from enthroned to standing image on episcopal seals.[17] In the rosettes above the doublets are male personifications, or practitioners, of the Liberal Arts, taken out of the encyclopedic context of the earlier rose windows and placed in the service of the church; they would serve to remind the Benedictines of their tradition of learning at a time when it was being challenged by the cathedral schools and the newer orders.

[11] For the whole figure, see Delaporte and Houvet, 1926, Baie 71, pl. CLXXXVI.

[12] Caviness, 1981, fig. 56.

[13] In the triplet illustrated here, Sophonias wears a yellow mantle over a pale blue robe, on a brilliant blue ground, whereas Naum is in a blue mantle and purple robe on a red ground. Other examples are illustrated in color in Cahier and Martin, 1841–1844, pls. XVIII, XXII,

XXV, XXVI; cartoons are not repeated in all cases.

[14] Cahier and Martin, 1841–1844, pp. 281–92, pls. XVII–XIX.

[15] Beer, 1956, pp. 69–70; cf. Beer 1975, p. 248, n. 166.

[16] Lafond, 1953, p. 48, comments on this color in Lausanne.

[17] Kline, 1983, pp. 91–92, pls, 22, 23, 58–64, has discussed the original disposition of these figures, relying in part on the partial analogue at Saint-Remi for her reconstruction.

In the single lancets of the hemicycle of Soissons Cathedral, on the other hand, the axial light with multiple enthroned images in the Jesse Tree seems to have been framed by smaller-scale scenes (Pl. 184). These flanking windows show the punishments of Adam and Eve and of the wicked in hell, perhaps in allusion to the expiatory nature of Philip Augustus's gift, following his reconciliation with Ingeborg and with the Church; but these in turn were probably flanked by a double range of immense seated apostles and patriarchs of which remnants survive in collections elsewhere (Pl. 278).[18] In other words, read in the context of the program of Saint-Remi it appears that a standard expression of ecclesiastical hierarchy at Soissons was interrupted at the king's pleasure by subjects that had greater personal relevance. Even in the Jesse Tree, the Virgin takes her place as a royal ancestor, enthroned among kings, whereas in Saint-Remi she is seated among churchmen.

Two other apse clerestory programs seem to be more direct adaptations from Saint-Remi. One is in the Gothic Cathedral of Châlons-sur-Marne, the other is in the Cathedral of Reims itself; both were discussed by Kline in relations to Orbais.[19] In each case, the adaptation seems at first sight to have been occasioned less by the wish to create a different emphasis than by extreme differences in the architectural design, but this in itself must be read as a commentary on the spatial disposition of the early abbey, with its inaccessible tribunes and mysteriously veiled triplets of lights. Three-story elevations with blind triforia, and with clerestory fenestration that follows the Chartrain formula of doublet and rose even in the hemicycle, demanded a rearrangement of the axial subjects of Saint-Remi. In both Châlons and Reims, the Crucifixion is moved up into the clerestory, where it is visible from almost every vantage point in the main vessel of the church, but not from the more private chapels beyond the choir (Pl. 283); this is directly inverse to the situation in the rémois abbey, and at Orbais where an early Redemption window is in the east window of the axial chapel (Pl. 213). No doubt this radical change after about 1200 was related to increasing lay concern to witness the elevation of the host, and to the "popularity" of eucharistic miracles, as noted in the context of Braine. Without an axial light in these clerestories, the Crucifixion is displaced to the viewer's right, so that adjacent

images in the twin light have the place of honor on the dexter of Christ. In Châlons there are three tiers of subjects, the Crucifixion being placed between a Christ in Majesty and an enthroned Virgin and Child, each paired with a standing bishop. The ranks of bishops extend into the adjacent bays.[20] In the Cathedral of Reims, the Virgin and Child are paired with the Crucifixion in the top of the lights, and the incumbent archbishop, Henry of Braine, is enthroned below, with his cathedral church on his right (Pl. 283); the chalice appears at the foot of the cross, as in the tribune of Saint-Remi, but the theme of resurrection is transposed to the rosette above the lancets, where Christ rises from the dead. In each case, priests hem in the image of the passion, as if to remind the viewer that they control access to the sacrament; this message was more subtly stated in Saint-Remi by shielding the corpus from lay view (Pl. 26). As choir screens became the norm in the thirteenth century, once more hiding the elevation of the host, the sight of these distant images of Christ's passion and of priests, brilliant yet inaccessible, must have substituted for direct visual experience of the Eucharist.

An extremely powerful response to the Crucifixion in the tribune of Saint-Remi in modern times deserves attention; it is the aniconic cross in the east window of the parish church of Saint-Jacques in Reims, glazed by Sima in the 1950s (Pl. 282).[21] The sixteenth-century design of the chancel provides a glazed triforium, and this opening is divided in the center by a mullion that serves as the fixed upright of the cross.[22] The crossbar in the glass gives the illusion of a hidden corpus, but of course diagonal views do not reveal it, and the sense of mystery is thus strenuously maintained. The predominantly grisaille tones of the composition recall the ornamental windows that accompanied the Crucifixion of Saint-Remi at the time Sima knew it.

The theme of *rex et sacerdotum* that was so clearly stated in the successive glazing of the clerestory windows of the liturgical choir and nave of Saint-Remi had reverberations in Reims itself in the Middle Ages. The special relationship of the abbey to the kings of France, through its possession of the Holy Chrism, was recalled on the seal of the *Archimonasterium* in use in 1241 and 1265 (Pl. 286).[23] St. Remigius is enthroned on a beast-headed foldstool on the obverse, with Clovis in the bap-

[18] For the Last Judgment and Genesis windows and also a narrative Death of the Virgin window next to the south, see Ancien, 1980a, pp. 100–25.

[19] Kline, 1983, pp. 90, 92, pls. 168–70. It has also been observed that the choir plan of Reims Cathedral and some details of the elevation were based on Saint-Remi: Hans-Joachim Kunst, "Freiheit und Zitat in der Architektur des 13. Jahrhunderts—Die Kathedrale von Reims," in *Bauwerk und Bildwerk in Hochmittelaiter*, ed. Karl Clausberg, Giessen, 1981, p. 93, figs. 4–7.

[20] An excellent color reproduction demonstrates how clearly the Majesty and Crucifixion light stands out among these iconic images; see Jean Rollet, *Les Maîtres de la lumière*, Paris, 1980, p. 38.

[21] I am grateful to M. Hubert Fandre of Reims for an introduction to this window in the winter of 1983; the church was generally locked,

so access was difficult, but it is now open to the public.

[22] For the building, see L. Demaison, "Eglise Saint-Jacques," *Congrès Archéologique de France*, Reims, 1911, (1912), 1: 106–17, and P. Kurmann, "L'Elise Saint-Jacques de Reims: L'Histoire de sa construction aux XIIᵉ et XIIIᵉ siècles et sa place dans l'architecture gothique," *Congrès Archéologique de France* (Champagne, 1977) (1980), 135: 134–61.

[23] An impression from 1241 is described in Paris, A. N., "Liste générale dressée par numéros courants des sceaux formant la collection d'empreintes des Archives Nationales," no. 2153. The same matrix seems to have been in use in 1265 (Reims, Archives de la Marne, dépôt annexe de Reims, H 484), but that impression has a reverse, with the baptism of Clovis. A more perfect impression was engraved for Isidor Taylor, *Voyages Pittoresques et romantiques dans l'ancienne France: Cham-*

tismal font to his right. The ground semée-de-lis alludes to contemporary Capetian arms. Yet the image of the saint seems to be consciously archaic, referring back to the episcopal seals and the choir windows of a hundred years earlier (Pls. 114–17); evidently this image had become authoritative, being the official sign by which the chapter was to be recognized.

Enthroned archbishops and bishops, however, were also crowded into the thirteenth-century clerestory windows of the Cathedral, as if in competition with the abbey (Pls. 283, 284).[24] Below the seated apostles that occupy all but the axial doublet of the choir are the suffragen bishops of the archbishopric of Reims, thus ranged on either side of Henry of Braine and the metropolitan church. Hagiography and historical reference, which were emphasized in Saint-Remi, are abandoned in favor of actual ecclesiastical hierarchies. This arrangement, probably chosen during Henry's lifetime, contrasts in its ostentation with the humble position in the wings that is given to Henri de France in the abbey church. The archbishop of Reims indeed held a special position among prelates because he ruled as a prince in his own right, subject only to the king; his temporal power was equivalent to that of a duke. He crowned the king of France in his cathedral, at which time the future monarch penetrated as far as an altar set up in front of the choir. Appropriately, therefore, images of "French" kings were placed in the nave clerestory, as in Saint-Remi, but they are now given the place of honor above former archbishops of Reims; the only recorded inscription among the kings is that of Charles or Charlemagne (Karolus) (Pl. 285). Tourneur has noted that in the pontifical for the use of the cathedral the prayers for the king come before those for the bishops, contrary to custom elsewhere.[25] They are also seated as frontally and symmetrically as the archbishops, in contrast to the unstable postures of the figures in the nave of Saint-Remi (Pls. 263, 265, 267, 270, 271). Thus during the reign of St. Louis, Reims Cathedral far outshone the older abbey church not only in sheer size but as a "royal" monument. There is evidence that Henri de Braine was favored by Louis IX, at least in a different context, and if he initiated the nave program it may seem to declare his loyalty to the king.[26] Yet, unlike several of his predecessors, he was not always able to rely on royal support against his burghers; in 1235 he was isolated from his king, his chapter, and his townsmen, with the support only of the pope.[27] In view of this, it is more likely that the nave glass marked a reconciliation between the institutions after 1236, or even after Henri's death in 1240. The "coronation program" extended to the inner west wall, where sculptural groups provided kingly exampla to be contemplated by the newly crowned monarchs as they went out into the world with their newly bestowed powers.[28]

Thus the glass of Saint-Remi and Braine was selectively imitated and competed with in a variety of ways, whether in style, composition, or iconography. The examples of strong positive influence seem to be largely local. It may be surmised that the programs of the ancient abbey were quoted in Orbais or in Reims Cathedral to lend weight to pictorial dialectic, but that the intention was also to outdo and update the spectacular early works. Another aspect of the legacy of the rémois atelier is the continuing tradition of artistic patronage by the house of Dreux, specifically the role of Agnes's descendants in creating programs in stained glass.[29] Because there was no room for further work in Saint-Yved, these are to be found elsewhere, in Dreux, in Chartres, and in the Cathedral of Reims.[30] It is as if the donors had been spurred to follow the example set by the founder of the line whose image appeared in the axial window at Braine, and especially his widow whose piety had been so highly praised. No other house, including the ruling one before the middle of Louis IX's reign, can be credited with so many sumptuous glazing programs.

A number of parallels were noted in Chapter 3 between Braine and Dreux: Both had collegiate churches in the castle precinct when they came under the control of Robert I, and both churches were laid out anew in his lifetime, although it is questionable whether he was directly involved in the mid-twelfth-century building and decoration of Saint-Etienne of Dreux. The nature of the work done at that time is humble and even old-fashioned in comparison with contemporary programs of reconstruction and decoration at the royal Abbey of Saint-Denis.[31] The twelfth-century church, it seems, was intended for the private use of its canons and their lay

pagne, 1857, Atlas, vol. 2 (no. 344 in the B. N. copy). The Seal of 1363–1394 shows little change: G. Demay, *Inventaire des Sceaux de la Flandre recueillis dans les dépôts d'Archives*, Paris, 1873, 2: 226, no. 6783 (Archives du Nord).

[24] Frodl-Kraft, 1972, p. 55. This article offers a detailed analysis of the program, including a plan of the windows.

[25] Victor Tourneur, "Mémoire sur l'Iconographie intérieure de la cathédrale de Reims (1)," *Travaux de l'Académie nationale de Reims* 24 (1855–1856): 149–54, also describes the glass, now heavily restored following damage in World War I.

[26] Chanoine Rome, "Henri de Braine, archevêque de Reims (1227–1240), Blanche de Castille et Saint Louis," *Travaux de l'Académie nationale de Reims* 54 (1941–1946): 71–92.

[27] Sadler-Davis, 1984, pp. 74–80, gives a useful outline of the conflicts.

[28] Sadler-Davis, 1984, chap. 4. In chap. 1, she has astutely traced the legacies of Clovis and Hincmar in the aggrandizement of the cathedral as the site of coronation.

[29] The material that follows is taken in part from a paper entitled "The House of Dreux as Patron of the Arts ca. 1140–1240," in Session 64, *Politics and Nobility in Twelfth- and Early Thirteenth-Century France*, chaired by Peggy Brown at the 100th Annual Meeting of the American Historical Association in New York City, December 29, 1985. I am extremely grateful to John F. Benton and Andrew W. Lewis for discussion of several points.

[30] In addition to the examples discussed here, the Château of Suscinio (Morbihan) has been found to have tiles of ca. 1200 and glass of ca. 1300 with the arms of Dreux/Brittany: "Chronique," *Bulletin Monumental* 142 (1984): 189–90.

[31] The sculptural fragments that survive locally, chiefly in the town

patrons, for whom the sculpted capitals provided some rudimentary instruction about the Holy Land.

In the first quarter of the thirteenth century, under Robert's successors, the interior decoration may have been enhanced by stained glass windows. Fragmentary cycles of St. Eustace, St. Nicholas, the Infancy, and the Theophilus legend, as well as a Tree of Jesse, were found in the nearby parish church of Saint-Pierre in 1938 and have now been installed in the Musée Municipal d'Art et d'Histoire in the town. The style is closer to that of Saint-Germain-lès-Corbeil than Braine (Pls. 275, 276). According to Moréchand-Chaussé these panels most probably came from Saint-Etienne when it was demolished in the Revolution; the scale would be consonant with the small openings of a Romanesque church.[32] The inclusion of a Jesse Tree might support an origin in a church with royal connections, following the examples at Saint-Denis, Canterbury, York, and Soissons; Moréchand-Chaussé in fact hesitates between Robert III and Blanche of Castille as possible donors.[33] As with the sculpture, however, there is no sign that the glass program addressed a populace from beyond the castle and college.

Robert's brothers were responsible for more flamboyant programs. Probably before his death in 1250 Peter "Mauclerc," count of Dreux/Brittany, and his wife Alix de Thouars, their daughter Yolanda, and their surviving son John were represented in the foot of the great lancets below the rose in the south transept of Chartres Cathedral (Pl. 281).[34] The kneeling figures of Peter and Alix must have recalled to those familiar with them the windows of Braine, with Agnes and Robert I at the feet of the Virgin. In this more public monument the Dreux arms—checky or and azure within a bordure gules, adopted by Robert I from Agnes of Braine, with a canton ermine for difference—are prominently displayed on a shield in the center light, and also figure on the surcoats and in the tracery of the rose. The program, for which the couple may be presumed to be the donors, is one of the most regal and solemn of the cathedral—Christ in Majesty holding a chalice, surrounded by the twenty-four crowned elders of the Apocalypse. A crowned Virgin and Child are placed above the arms of Dreux, prophets with the four evangelists on their shoulders above the donor portraits.

Delaporte has suggested a date for this glass after

Alix's death in 1221, since the children born shortly before are not represented as infants.[35] On the other hand, a date as late as 1230–1234 is unlikely since Peter was campaigning as a vassal of the king of England, and had made a truce with the French king to keep out of France.[36] His relations with the crown are significant in that the opposite windows in the end of the north transept exhibit the shield of arms of France and the blazon of Castille and of France in the tracery. Theologically the program is a complement to that in the south; it sets St. Anne and the infant Virgin across from the Virgin and Christ Child, Old Testament kings and high priests face the prophets, and the Virgin with the kings of Judea anticipate the Apocalyptic rose. The regency of Blanche of Castille (1223–1226) seems indicated by the arms, although a later date cannot be ruled out. If the two ensembles are contemporary, and if one assumes they were given in a spirit of mutual respect rather than of rivalry, 1227–1228 is the most likely period, when Peter had arranged a marriage for Yolanda with Blanche's third son, John.[37] Yet there is an important distinction between the two programs. No donors of the royal line are represented in the glass of the north transept, and the heraldic emblems might as well honor Blanche as be due to her munificence. Yet whatever the sequence of circumstances of the two donations, they create a parity between the house of France and the house of Dreux/Blois Champagne that might have made the former uneasy.

In the context of the Chartres Cathedral glazing, however, these two great window compositions help to redress a balance that might have been perturbing to the princes of the realm and of the church; the areas of the great church that were first to be completed—the nave aisles, the chevet with its chapels, the nave clerestory and that of the hemicycle of the apse—had been taken over by the patronage of lay corporations, chiefly artisanal.[38] There was no iconographic "program," only the inclusion, and repetition, of popular saints and Biblical figures (Lubin, Nicholas, Joseph, Noah) and a sanctification of menial work through association with sacred history. The transept programs reintroduced—for the first time since the triple openings of the west facade were glazed about 1145–1155—a coherent theological statement, one in which the choices made by Peter Mauclerc and by the royal house were guided by their spiritual confessors or by the cathedral canons. Yet images of

museum (and one recognized by Cahn, 1974, in the Yale University Art Gallery) attest to an Infancy and Passion cycle, apparently on capitals in the nave arcade, whereas historiated capitals are confined to the crypt at Saint-Denis. Another distinction between the sculpture of the two monuments is that the decoration of Saint-Etienne seems to have been applied exclusively to the interior; the portals, both on the west facade and to the south, appear to have had only dog-tooth moldings.

[32] Véronique Moréchand-Chaussé, "Les Vitraux du 13ème siècle de l'église Saint-Pierre de Dreux," Mémoire de maîtrise, Université de Paris IV, 1972–1973, pp. 23–25. I am grateful to Catherine Brisac for obtaining a copy of this thesis for me. See also Grodecki and Brisac, 1984, p. 247, illus. in col.

[33] Moréchand-Chaussé, "Les Vitraux," p. 27.

[34] Nineteenth-century tracings preserved in the Centre International du Vitrail in Chartres confirm the authenticity of this ensemble. A color reproduction is in *Corpus Vitrearum France Recensement* II, pl. II.

[35] Delaporte and Houvet, 1926, 1: 433.

[36] Maurice Powicke, *The Thirteenth Century*, Oxford, 1962, p. 96; by 1243, however, he was fighting on Louis IX's side in the south (p. 103).

[37] Ibid., p. 93.

[38] The distribution of donations by different classes was presented in a paper "Biblical Stories in Windows: Were they Bibles for the Poor?" at the Nineteenth Annual Medieval Conference, Binghamton, 1985, to be published in *The Bible in the Middle Ages*, Medieval and Renaissance Texts and Studies, ed. Bernard Levy, Binghamton, N.Y.

majesty, and emphasis on corporeal lineage, such as Anne bearing the Virgin, served secular ends as well.

In the choir of the Cathedral of Reims, Henry of Braine, brother of Robert III and of Peter Mauclerc, and archbishop of Reims from 1227 to 1240, supplied glass that is roughly contemporary with Peter's gift at Chartres.[39] It seems that an already completed axial window in the hemicycle clerestory, with images of St. John the Baptist, the Cathedral of Reims, the Virgin and Child and an archbishop, was supplanted by the images of Henry of Braine (inscribed ANRICUS ARCH . EP . . . O REMENSIS), his cathedral, the Virgin and Child, and the Crucifixion that were referred to already (Pl. 283).[40] The border is composed of fleurs-de-lis in honor of the royal house, and a reminder of the royal descent of the incumbent. The tomb of his uncle, Philip of Dreux, in Beauvais Cathedral had outshone those of his ancestors in Braine; and he was vested in a chasuble se-mée-de-lis, but Henry found a more splendid way to create an effigy for himself (Pl. 63a). The changed imagery answered more than a personal whim or secular ambition; it has been noted that the new program refers back to the retrochoir glazing of Saint-Remi, thus linking the cathedral once more to the pantheon of its archbishops and the protector of the Sainte-Ampoule that was used in the coronation rites of the cathedral. With reference to the abbey windows, the living archbishop has usurped the place given to St. Remigius, but after Henry of Braine's death his image might have received the prayers of the faithful below; he even presides over the Seven Churches of the Apocalypse.[41] His position is more commanding and more public than that of his grandparents in the "family church" of Braine.

Indeed, the works of art commissioned by members of the house of Dreux between about 1140 and 1240 were increasingly public; there is a great difference between the modest sculptures through which the canons of Saint-Etienne may have hoped to educate the family in their private church within the castle of Dreux, and the pilgrim-church setting created by Agnes of Braine for the family tombs; Agnes had been spurred to compete with royal works elsewhere, notably Saint-Denis, Mantes, and Senlis. The later windows at Chartres and Reims not only surpassed those of Braine in scale, but they outdid any known royal donations of the period; competing for visibility in these great cathedrals, the third generation laid claim to ensembles that could dominate the interiors. As demonstrations of munificence, these public displays must have been calculated to ensure the reputations—and even the salvation—of the secular and sacred seigneurs whose offerings they were. They are also memorials. And after their deaths these past founders and patrons, virtuous in their gifts, could be viewed as intercessors in the presence of the Virgin and the saints at the court of heaven—the guise in which they had already been represented in their lifetime. The quest for spirituality that informed the programs of the abbey in the late twelfth century has given way to a search for personal salvation in the thirteenth.

[39] For Henry's career, much helped by his uncle in Beauvais whom he served as treasurer, see William Mendell Newman, *Les Seigneurs de Nesle en Picardie*, Paris, 1971, 1: 227.

[40] Reinhardt, 1963, pp. 183–84; pl. 42 (left) illustrates the original glass that is surmised to have come from the axial window, now in the south transept.

[41] Yves Christe, "Cuncto Tempore saeculi: Théophanies présentes et futures dans l'iconographie monumentale du haut moyen âge," in *Atti del xxiv Congresso Internazionale di Storia dell'Arte 1: La Réforme religieuse et les arts a l'époque carolingienne*, ed. Alfred A. Schmid, Bologna, [1983], pp. 139–40. I am grateful to Peter Klein for this reference, and for discussion following a paper I gave at the Medieval Congress in Kalamazoo in 1988.

APPENDIX 1

Eighteenth-Century Restoration Documents concerning the Glass in Saint-Remi[1]

a) "Convention faite avec le Sr Payen notre vitrier pour les vitres de notre Eglise" [1738–1753]. Archives de la Marne, Dépot annexe de Reims, MS H.413.

On est convenu de lui donner dix sols du pied des vitres à la mosaïque tout posé et cimenté y comprise la taille des petits veres de couleur pour faire ladit mosaïque, on ne lui a point abandonné autrement les anciens verres peints, que pour s'en servir à faire la mosaïque, et doit garder le peu qu'il en reste pour remplacer ceux qui pourroient manquer dans la suite; on lui a abandonné les vieux plombs pour la position et scellage des grosses ferrures et pour faire les échafaux, qu'il a paier à nôtre couvreur qui les lui a faits.

b) Excerpts from "Procès avec l'abbé pour les réparations de l'église abbatiale" [1720–1759]. Archives de la Marne, Dépot annexe de Reims, MS H.409.

(f. 63) . . . Nous avons continué la visite de la ditte église [de l'abbaye de Saint Remy] et avons reconnu que la grande rose au milieu du portail de forme circulaire avec un cadre composé de ronds terminés par les treffles de pierre le surplus en fer / (f. 63v) dont plusieurs traverses et montans sont courbés et garnis de vitres à panneaux de verre en plomb, qu'elle a fait quelques effets tres anciens et quelques claveaux dérangés et disjonctions a quoy il a eté remedié par deux fortes pièces de bois po-

sées interieurement et horisontalement auxquelles sont retenues nombres de barreaux de fer ainsi que dans les murs en sorte que / (f. 64) la ditte rose au moyen des dittes deux barres de bois et nombres de barres et arpons de fer posés interieurement et exterieurement est en état de subsister et quil n'y a presentement a y faire que le replacement de deux claveaux et les rejointoiements ce qui est une reparation de vetusté que nous estimons la somme de trente livres, cy ————————— 30L-0-0 vetusté / (f. 64v)

Nef

Nous avons aussi remarqué que les trois harpons de fer qui retiennent la ditte rose à la première des dittes deux pièces de bois sont trop courts et insolides, qu'il est nécessaire d'en fournir trois autres qui embrassent la ditte pièce de bois et les dits vitreaux ce qui / (f. 65) est une reparation de deffaut de solidité dans son origine et que nous estimons sept livres, dix sols, cy ————— 7L-10-0 deffaut de construction . . .

(f. 86v) Aux galleries sur le bas coté à gauche qui s'étendent depuis l'intérieur du portail jusqu'à la croisée, les ayant visitées nous les avons reconnues en bon état et que la clef du centre du vitreau dans le portail est baissée / (f. 87) Croisée et cassée qu'il

[1] I am grateful to Madame Catherine Grodecki for checking and correcting my transcription of these excerpts. Punctuation, capitalization, and accents have been modernized, but the spelling is unchanged.

est nécessaire de revêtir par sous-oeuvre une autre clef de pierre dure d'épaisseur et de hauteur de coupe suffisantes . . .

(f. 105v) [the roof over the galleries] . . . de ce que dans son origine il n'a pas été bien construit et qu'on ne luy a pas donné assés de pente eu égard a toutes les eaux qu'il reçoit, la réparation qu'il y convient faire est de le démolir dans toute son étendue et hauteur et de le reconstruire à neuf en rem-ployant tous les bois de bonne qualité qui pourront l'être ainsi que la thuile et fournir les bois neuf au / (f. 106) deffaut des vieux et la thuile neuve au deffaut de la vieille posée sur un lattis neuf en observant plus de hauteur au dit comble pour qu'il ait plus de pente et pour ne point diminuer le jour des douze vitreaux qui éclairent la nef de ce coté, il soit fait au droit de chacun une petite terrasse couverte en plomb pour le rejet des eaux.

APPENDIX 2

Early Nineteenth-Century
Description of the Glass
in Saint-Remi

[Etienne-François-Xavier] Povillon-Piérard,[1] "Description historique de l'église Saint-Remi" [1824–1828]. Reims, Bibliothèque Municipale, MS 1837.

(f. 51v, p. 92) *Ses vitraux et son architecture*[2]

J'ai bien indiqué dans l'article précédent, le nombre des verrières et leur distribution; mais il me reste encore à faire la description des / (f. 52, p. 93) peintures qui en sont l'ornement, surtout au rond point dont toutes les verrières hautes et basses sont remplies. Je commence par le portail.

La grande rose dont l'architecture tout simple représente partout des fleurs de lis est en verres blancs qui répandent une très-belle clarté dans la nef, et se prolonge dans presque tout le principal corps de l'édifice. Ajoutez à ce jour admirable celui des cinq verrières qui sont au dessous de cette rose et sur la même ligne, également de verres blancs; mais celle du milieu et par conséquent la plus haute des cinq, a une image de médiocre proportion représentant SAINT CLEMENT, 1e du nom, quatrième successeur de Jésus-Christ sur la chaise pontificale de son église, en 91. L'histoire descriptive de la consécration de l'église actuelle nous apprend que ce Saint Pape est un des cinq principaux saints, en l'honneur des quels le grand autel fut consacré en 1049, par le pape Léon 9. de pieuse mémoire; et ça été sans doute pour en conserver le souvenir, que les abbés qui ont dirigé les travaux des vitraux de leur église, ont placé ici la figure de ce saint Pape,

comme l'abbé Pierres de Celles avait fait mettre au grand portail en dehors et de côté et / (f. 52v, p. 94) d'autre de cette verrière, les statues en pierre de S. Pierre et de Saint Remi, en l'honeur desquels aussi ce grand autel fut dédié. Les verrières qui accompagnent celle-ci, un peu moins hautes, représentent chacune en une image, LA-SAINTE VIERGE portant une légende déroulée sur laquelle se lisent ces paroles de la salutation angélique: *Ave, Marie, gratia plena, Dominus tecum.* Plus bas et de coté et d'autre des deux tours, sont deux verrières accompagnant la porte de la principale entrée au portail; elles ont chacune une image, celle à droite représente CLOVIS, 1er du nom, roi de France, dans la personne du quel S. Remi consacra à la religion de J.C. la nation française, à gauche est CLOTILDE épouse de ce prince: leurs noms écrits à leurs pieds.

Les Verrières des Collatérales de la Nef, et celles des Chapelles du rond point, tout en verre blanc; on en compte dix-huit pour les collatérales, et vingt-huit pour les sept chapelles du pourtour de l'église, et d'une croisée à l'autre. Toutes sont en verre blanc, mais quelques-unes ont seulement ont [sic] tout UNE BORDURE EN VITRAUX DE COULEURS, sans figures. Parmi toutes ces verrières, il faut en remarquer deux à droite dans les collatérales; l'une offre au centre du panneau de vître les armoiries de l'abbé de St. Remi, et / (f. 53, p. 95) l'autre le millésime de 1740, qui est l'époque où les religieux de l'abbaye de St. Remi, poussés par un zèle ardent pour la

[1] The full name is given in MS 1939, f. 19.

[2] Spelling and accents have been normalized. There are no capitals or italics in the original except for the inscriptions, but capitals are used for all the subjects to aid in their recognition.

139

décoration du temple du Seigneur, firent rétablir toutes les vitres de leur église en verre blanc, et en refaire à neuf la plus grande partie, notamment la grande rose du portail de la Nef et les verrières au-dessous. . . . [3]

Les verrières qui règnent tout autour de l'église dans la grande nef, dans le choeur, dans le sanctuaire et dans l'arrière-choeur, sont au nombre de 84; elles sont les unes en verre blanc, et les autres en verre de couleur avec des peintures représentant des ROIS, des ARCHE-VEQUES, des SAINTS DE L'ANCIEN ET DU NOUVEAU TESTAMENT, et / (f. 53v, p. 96) des PAPES, avec un sujet de la PASSION DE JESUS-CHRIST, au centre du rond point.

Parmi toutes les verrières tant ovales que demi ceintrées qui éclairent la Nef et le choeur, au nombre de 36, on en remarque huit qui ont des IMAGES DE ROIS ET DE SAINTS, dont quatre à droite et sur la première desquelles est écrite à la tête du personnage, le mot *CHILD-ERIC*; et quatre à gauche, dont les autres personnages ne sont pas nommés, comme ce roi. Ces huit verrières avec les ovales qui sont au-dessus, éclairent le choeur, en même temps qu'ils en marquent la longuer. La nef n'a aucunes verrières de verre de couleur.

Les verrières qui éclairent l'arrière-choeur de l'église, au nombre de 48, dont 24 triples et les plus proches des voûtes, et 24 ordinaires pour les doubles collatérales ou chapelles supérieures, sont toutes de verre de couleur, et représentent diverses figures de SAINTS, de ROIS, de PAPES, et d'EVEQUES.

Si, en me transposant sur les voûtes qui couvrent le passage du tour du rond point aux chapelles d'en bas, et où il y avait jadis des autels au dessous de chaque verrière, comme je le ferai voir dans le cours de cet ouvrage, j'examine de près les figures qui sont au mi / lieu (f. 54, p. 97) de chaque verrière de verre blanc, je vois de droite gauche 1° la figure d'une femme avec ce nom *SANCTA MARTHA*; 2° celle d'un ROI SANS NOM; 3° d'un SAINT TENANT UN LIVRE SOUS LE BRAS; il n'a point de nom; 4° d'un roi avec ce nom: *JORAM*; 5° d'un autre roi nommé ici *SALATHIEL* [the Table des Errata, f. 215, p. 103, supplies 6°] sur la verrière du milieu est la figure de JESUS-CHRIST ATTACHE SUR LA CROIX; sur sa tête et par conséquent au haut de cette croix est figurée une MAIN, sans doute celle DU TRES-HAUT, montrant de l'index aux pécheurs, qu'il a livré lui-même cette victime adorable, son propre fils, pour leur salut. Aux pieds du Christ mourant, sont peints sur la Croix le CALICE qu'un ange lui présenta aux Jardin des Oliviers, et le disque du SOLEIL. On sait que le Calice mystérieux est un signe par lequel Jesus-Christ a voulu, en le recevant de Dieu son père nous apprendre à recevoir à Dieu dans nos afflictions, demander et attendre le secours du Ciel, puisque les consolations solides ne vous doivent venir que d'enfant. Quant au dis-

que du soleil, on sait [encore, supplied in the Table des Errata, 35, f. 215, p. 103] que cet astre, le plus beau, le plus lumineux de tous les astres s'éclipse à l'aspect du Soleil de justice convert des ombres de la mort. 7° la figure d'un ROI SANS NOM; 8° de *MANASSER* dont on lit le nom; 9° d'une SAINTE TENANT UN LIVRE; son nom n'est point écrit; / (f. 54v, p. 98) 10° d'*ELI-ACHIM*, reconnaisable par son nom; 11° d'*ABIULD*, aussi nommé. 12° Une sainte, au-dessus le nom d'*AGNES* est écrit; elle tient une légende déroulée sur laquelle on lit: *Ave, Maria, gratiâ plena, Dominus tecum*.

On voit par cette description, qu'on n'a pas suivi l'ordre historique de l'ancien et du nouveau Testament. Aussi n'est-on pas plus heureux en examinant de la même manière les peintures des verrières triples qui sont au-dessus de celles-ci. Même défaut, même inexactitude dans l'ordre de toutes les figures. Je ne les ferai point connaître séparément, afin de ne point fatiguer le lecteur d'une description sans intérêt et sans prix. Dire que la chronologie historique des EVEQUES DE RHEIMS, qui y sont représentés depuis MANASSER jusqu'à ST. REMI, c'est à dire, en prenant de gauche à droite, est interrompue, et se trouve remplie d'anachronismes; Dire que les figures de ROIS, d'APOTRES, d'AUTRES SAINTS, de PAPES, même de quelques EVEQUES, sont toutes pêle-mêle et placées au hasard et sans ordre; c'est me justifier et demander grace de mon silence. Il suffit de voir le nom de *GERVASIUS* à côté et en suite de celui de *SONNATIUS*, pour convaincre d'erreur et d'ignorance tout-à la fois / (f. 55, p. 99) ceux qui, dirigeant l'exécution de ces peintures, auraient dû mieux apprendre l'histoire chronologique de nos evêques, où ils auraient lu que Gervais évêque de Rheims en 1055, ne pouvait être placé dans cet ordre, avant Sonnace qui occupait ce siège dès l'an 600; ou même, en supposant qu'il eut fallu lire au rebours, c'est à dire de droite à gauche, alors on se serait apperçu entre ces deux figures, d'un vide de 450 à 455 ans, pendant lesquels depuis Sonnace jusqu'à Gervais, vingt pontifes ont successivement gouverné l'église de Rheims. Comme toutes les autres figures d'apôtres, de rois, de Papes, et d'évêques, parmi lesquelles on voit plusieurs fois répété et sans ordre chronologiques, celle de BA-LAHAM, á côté tantôt d'un évêque de Rheims, et tantôt placé auprès de celle de S. PIERRE, ofrant par leur distribution les mêmes anachronismes, je passerai également sous silence leur description. Quoi qu'il en soit, les couleurs de ces images ne sont pas à dédaigner, et les dessins sont passablement bien faits. Le jour et surtout les rayons du soleil pénètrent aisément les couleurs et tout la vivacité autant que l'épaisseur du verre ne donnent point une teinte sombre semblable à l'obscurité qui / (f. 55v, p. 100) pénètre les forêts, mais laissent dessiner agréablement aux yeux du spectateur toutes les formes

[3] The gist is that the manuscripts indicate that this was before 1736 and that the cost was twelve thousand pounds. He takes issue with Chastelain's insistence that none of the glass was colored, while admitting that no document proves otherwise.

de la belle architecture du rond point, et le magnifique mausolée de Saint Remi élevé dans l'arrière-choeur.

Dans les deux croisées de l'église, les verrières sont toutes de verre blanc; on remarque seulement dans la croisée au midi, deux écussons aux armes du Cardinal de Lénoncourt, portés par des anges; ils sont peints sur la première verrière à droite en entrant dans l'église par cette croisée. On sait que ce prélat, digne sucesseur de S. Remi, a fait reconstruire à neuf le portail de cette croisée qu'il rallonga d'une toise . . .

APPENDIX 3

The Retrochoir Clerestory Program of Saint-Remi as Recorded in the Nineteenth Century

THE FOLLOWING TABLE enables rapid comparison of the lists of figures recorded ca. 1850 by Guilhermy,[1] in 1857 by Reimbeau,[2] about 1857 to 1868 by Poussin and Lacatte-Joltrois,[3] and in the Rothier photographs before 1896.[4] Information given by Tourneur in his less systematic description based on notes made about 1845 is supplied in the notes.[5] The right column gives the names currently to be seen in the windows; many of the nineteenth-century inscriptions were renewed in the restoration of the 1950s, but original medieval fragments are in italics.

		Figures Recorded by			
Window	Guilhermy	Reimbeau	Poussin and Lacatte-Joltrois	Rothier	Since 1958
STRAIGHT BAYS ON NORTH					
N.VI a	Balaam	Balaan	Balaam	Balaan	*Balaan*
	S.Remi[a]	Henreus	Henricus	Henricus	*Henricus*
b	Osée	Osee	Osée	Nathan	Nathan
	Manasses	Manasses	Manasses	Rainaldus	Rainaldus

[1] Guilhermy, MS 6106, f. 420.

[2] Reimbeau, MS 2100, III, i, no. 6 "Vitraux de l'abside en haut de la grand nef. St. Remi de Reims 1857," f. 2. A note at the front of the manuscript says it belonged to Victor Tourneur in 1865—that is, on the death of Reimbeau and after Tourneur's publications. Pencil corrections, transcribed in brackets here, might be Tourneur's.

[3] Poussin, 1857, p. 178. Lacatte-Joltrois, 1868, p. 65; he leaves out one of the upper figures and five of the lower on the south side, and I have adjusted his list to coincide with Poussin.

[4] Rothier photographs in the Simon atelier, taken between 1867 and 1896. A list in the Société des Amis de Vieux Reims, Boîte 7, corresponds to the order in N.V. It may have been made for Simon's restoration.

[5] Tourneur, 1856, pp. 90–95.

Window		Guilhermy	Reimbeau	Poussin and Lacatte-Joltrois	Rothier	Since 1958
	c	Elié	illisible	—	Elias	*Elie*
		S. Martin[b]	Mappinus	Mappinus	Gervasius	Gervasius
N.V	a	Isaïe	Ysaac	Isaïe[c]	No photo of N.V.	*Ysaie*[c]
		Egidius	Leudegisl	Leudgisèle		Fulco
	b	Abraham	Abraam	Abraham		Osee
		Gervais	Gervasius	Gervasius		Severus
	c	Daniel	Daniel	Daniel		Zacharias
		Sonnatius	Sonnatius	Sonnatius[d]		Rigobertus
N.IV	a	Nathan	Nathan	Nathan	Micheas	Micheas
		Vulfaire	Vulfarius	Vulfarius	Sonnatius	Sonnatius
	b	David	David Rex	David Rex	David Rex	*David* Rex
		Romule	Romulfus	Romulphus	Mappinius	Mappinius
	c	Jérémie	(G)érémias	Jeremias	Ezechiel	Ezechiel
		Engelbert	Engelbertus	Engelbertus	Bennadius	Bennadius
TURNING BAYS OF HEMICYCLE						
N.III	a		S.Iaco(b)	S.Jacob	Isaias	Isaias
			Reolus	Reolus[d]	Becasius	Becausius
	b		S.Simon	S.Simeon	St.Simon	St.Simon
			S.Rigobertus	Rigobertus	R?igobertus	S.Rigobertus
	c		S.Iudas?	S.Judas	St.Bartholomeus	St.Bartholomeus
			S.Nivonis?	Nivonis	St.Nivard	St.Nivard
N.II	a		S.Matheus	S.Mathaeus	S.Jacobus M	S.Jacobus
			S.Nicaisius	S.Nicasius[d]	S.Nicasius	S.Nicasius
	b		S.Petrus	S.Petrus[e]	S.Petrus	S.Petrus
			S.Nivard(us)	S.Nivardus[d]	S.Donatianus	S.Donatianus
	c		S.Iacob (bis)	S.Jacob	S.Johannes	S.Iohannes
			—	—	S.Amandus	S.Amandus
I	a		—	—	S.Andreas	S.Andreas
			—	—[f]	S.Sixtus y . .	S.Sixtus
	b		Vierge et enfant	Vierge et enfant	Virgin and Child	Virgin and Child
			2 evèques[g]	Remi et Nicholas[h]	S.Remigius	S.Remigius
	c		S.Ioannes	S.Joannes[e]	S.Jacobus	S.Jacobus
			S.Sinitus	S.Sinitius[i]	S.Sinitius	Sinicius
SII	a		S.Paulus	S.Paulus[j]	S.Thomas	S.Thomas
			S.(A)rnas	S.Sama	S.Maternianus	S.Maternianus
	b		—[j]	—	S.Paulus	S.Paulus
			—	—	S.Viventius	S.Viventius
	c		—	—	S.Philippus	S.Philippus
			—	—	S.Romanus	S.Romanus
S.III	a		—	—	S.Matheus	S.Matheus
			—	—	S.Reolus	S.Reolus

			Figures Recorded by		
Window	Guilhermy	Reimbeau	Poussin and Lacatte-Joltrois	Rothier	Since 1958
b		—	—	S. Thadeus	S. Thadeus
		—	—	S. Abel	S. Abel
c		S. Andreas	S. Andreas[k]	Jeremias	Jeremias
		—	—	Seulphus	Seu..hus

STRAIGHT BAYS ON SOUTH

S. IV a		—	—	Daniel	Daniel
		—	—	Flavius	Flavius
b		—	Ionas	Ionas	Ionas
		illisible	—	No inscription	No inscription
c		—	—	Abacuc	Abacuc
		—	—	Leudegasius	Leugegasius
S. V a		Ionas	Jonas	S. Malachias	S. Malachias
		brisé	—	S. Vulfurius	S. Vulfurius
b		Malachias	Malachias	Abraham	Abraham
		brisé	—	S. Hincmarus	S. Hincmarus
c		Abacuc	Abacuc	Moises	Moises
		. . . ius	I.H.S.	S. Lando[l]	S. Lando
S. VI a		Micheas	Micheas	Jacob	Iacob
		Rodolfus	Rodulphus	Manasses	Manasses
b		Samuel	Samuel	Samuel	*Samuel*
		Raimaldus	Rainaldus	Radulphus	Radulphus
c		Zacharias	Zacharias	Noe	Noe
		Sansun	Samson	Sansom	Sansom

[a] Guilhermy seems confused between north and south here; Tourneur had noted Henri de France in N. VI a.

[b] Again, Guilhermy who admits the haste with which he took notes probably misread the inscription here. Tourneur confirmed a Mappinius on the north side.

[c] Lacatte-Joltrois's reading. *Ys* survives in original glass, and *aie* appears old in the prerestoration photograph (MH 75 237). Poussin gives Isaac.

[d] Tourneur mentions Sonnace, Vulfarius, Reolus, Nicasius, and Nivardus in that order but without specific locations.

[e] Tourneur claimed S. Petrus, with keys, to the left of the Virgin, in I c, where Poussin and Reimbeau record John; he implied that John and Barnabas were to the north. Barnabas he said was drawn from the same cartoon as John, reversed, and placed in an adjacent light, which would be plausible in Lights c and a of different bays. The Rothier photographs, however, do not show such a repetition of cartoons among the apostles in the hemicycle (Fig 5; Pls. 139–41).

[f] Tourneur gave saint Sixte here.

[g] Tourneur mentioned two small figures here, inscribed *S. Remigius* and *S. Nicholaus*, no doubt the two since moved to the tribune. Reimbeau noted two figures one above the other: "un évêque; un autre évêque dont le nom est illisible."

[h] Poussin noted "deux evêques . . . noms illisibles." Lacatte-Joltrois commented that they were "fenêtres rapportées."

[i] Tourneur also placed saint Sinice next to the Virgin, below Peter.

[j] Tourneur noted in the next three windows to the south (S. II, III, and IV) only three instead of nine apostles (Paul, Andrew who is shod, and one without a name), the rest replaced by kings, and three archbishops also filled out with kings. He indicates that the panels are disordered, the kings too small for the openings, and that border panels had been used horizontally as filler (p. 94).

[k] This is no doubt the figure mentioned by Tourneur. From his description it is now in the tribune; the head and inscription do not belong with it. This is understandable if the inscription, and perhaps the face, had remained in place in the clerestory, and the smaller figure, which matches the series of kings from the nave clerestory, was moved there as filler.

[l] Landon is the last of the archbishops listed by Tourneur, without indicating his position.

APPENDIX 4

The Ancestors of Christ in
Canterbury, Braine, and Reims[a]

Luke 3:23–38	Matthew 1:2–16	Canterbury[b]	Braine[c]	Reims[d]
1 Adam		Adam		
2 Seth		[Seth]		
3 Henos		[Henos]		
4 Cainan		[Cainan]	Cainan (or Luke 13)	
5 Malaleel		[Malaleel]		
6 Iared		Iared		
7 Henoch		Henoch		
8 Mathusale		Mathusale		Matusale
9 Lamech		Lamech		
10 Noe		Noe		
11 Sem		Sem		
12 Arphaxad		[Arphaxad]		
13 Cainan		[Cainan]		
14 Sale		[Sale]		
15 Heber		Heber		
16 Phaleg		Phaleg	Phaleg? (or Luke 25)	
17 Ragau		Ragau		
18 Sarug		[Sarug]		
19 Nachor		[Nachor]		
20 Thare		Thare		
21 Abrahae	1 Abraham	Abrahae		
22 Isaac	2 Isaac	Isaac		Isaac
23 Iacob	3 Iacob	[Iacob]	Iacob (or Matthew 39)	Iacob
24 Iudae	4 Iudas	Iudae		
25 Phares	5 Phares	Phares	Phares? (or Luke 16)	
26 Esron	6 Esron	Esron		
27 Aram	7 Aram	Aram		

Luke 3:23–38	Matthew 1:2–16	Canterbury[b]	Braine[c]	Reims[d]
28 Aminadab	8 Aminadab	Aminadab	Aminadab	
29 Naasson	9 Naasson	Naasson		
30 Salmon	10 Salmon	Salmon		
31 Booz	11 Booz	Booz		
32 Obed	12 Obed	Obed		
33 Jesse	13 Iesse	Iesse		
34 David	14 David	David		
35 Nathan	15 Salomon	Nathan		
	16 Roboam	Roboam		Roboam?
	17 Abias	Abias		
	18 Asa			
	19 Iosaphat			
	20 Ioram			[Ioram?] (or Luke 46)
	21 Ozias			
	22 Ioatham			
	23 Achaz			
	24 Ezechias	Ezechias		
	25 Manasses			[Manasses]
	26 Amon			
	27 Iosias	Iosias		
	28 Iechonias	Iechonias	Ieconias	
		Salathiel (Matthew 29)		
		Achim? (Matthew 35)		
		Ioseph (Matthew 40)		
36 Mathatha		[Mathatha]		
37 Menna		[Menna]		
38 Melea		[Melea]	Melea?	
39 Eliakim		[Eliakim]		
40 Iona		[Iona]		
41 Ioseph		[Ioseph]		
42 Iuda		[Iuda]		
43 Simeon		[Simeon]		
44 Levi		[Levi]		
45 Mathat		[Mathat]		
46 Iorim		[Iorim]		
47 Eleizer		[Eliezer]		
48 Iesu		Iesu		
49 Her		Her		
50 Elmadan		[Elmadan]		
51 Cosan		Cosan		
52 Addi		[Addi]·		
53 Melchi		[Melchi]		
54 Neri		Neri		
55 Salathiel	29 Salathiel	[Salathiel]	Salathiel	[Salathiel]
56 Zorobabel	30 Zorobabel	Zorobabel		
57 Resa		Resa		
58 Ioanna		Ioanna		

Luke 3:23–38	Matthew 1:2–16	Canterbury[b]	Braine[c]	Reims[d]
59 Iuda		Iuda		
60 Ioseph		Ioseph		
61 Semei		Semei		
62 Mathathiae		[Mathathiae]		
63 Mahath		[Mahath]		
64 Nagge		[Nagge]		
65 Hesli		[Hesli]		
66 Nahum	31 Abuid	[Nahum]	Abuid	Abuid
67 Amos	32 Eliacim	[Amos]		Eliacim
68 Mathathiae	33 Azor	[Mathathiae]		
69 Ioseph	34 Sadoc	[Ioseph]		
70 Ianne	35 Achim	[Ianne]		
71 Melchi	36 Eluid	[Melchi]		
72 Levi	37 Eleazar	[Levi]		
73 Mathat	38 Mathan	[Mathat]		
74 Heli	39 Iacob	[Heli]		
75 Ioseph	40 Ioseph	[Ioseph]		
		[Virgin]		
76 Iesus	41 Iesus	[Iesus]		

[a] The orthography is that of the Vulgate

[b] Names in brackets for lost figures are supplied from the genealogies.

[c] Names that occur twice in the genealogies are listed only once, with the alternative position in Luke's or Matthew's text in parentheses.

[d] Names in brackets were recorded in the nineteenth century but the figures are now missing.

APPENDIX 5

Recorded Gifts of Stained Glass in Soissons Cathedral

EDITED AND TRANSLATED BY

CARL F. BARNES, JR.

"Ex Martyrologio Ecclesiae S Gervasii Suessionensis," Paris, B.N., MS Coll. Baluze, vol. 46, f. 463r. Excerpt made in the 1660s(?) by Etienne Baluze from the now-lost obituary of the cathedral chapter.

Item [xi kal. iulii anno Domini M.CC.XV] obiit Ainors comitessa sancti Quintini qui dedit nobis totiam merrinum quod superposit est super caput ecclesiae nostrae et totiam merrinum stallarum nostrarum et peroptimam vitream . . .

Item [July 22, 1215] died Eleanor, countess of Saint-Quentin, who gave us all the oak which is located above the head of our church and all the oak of our [choir] stalls and a wished-for window . . .

v idus iulii [anno Domini M.CC.XX.III] obiit Illustrissimum regum Francorum Phillipus . . . Dedit etiam nobis haec pallia et xxx libras Parisiensis ad faciendum maiorem vitream in capite ecclesiae nostrae . . .

[On July 11, 1223] died the most illustrious of the kings of the French, Philip. The same gave to us his pallium and thirty pounds of Paris for the making of the major window in the head of our church . . .

N. Berlette, *Recueil des antiquités et choses memorables ad venir en la ville de Soissons* and *Les antiquitez de Soissons recueillies de divers autheurs et chroniques,* in *Bulletin de la Société Archéologique de Soissons* ser. 2, 19 (1888): 83–154, esp. 102.[1]

. . . les Anglois y aiant faict faire les vitres [de la cathédrale], commes l'on dit . . .

. . . the English there having caused the windows [of the cathedral] to be made, as it is said . . .

A. Cabaret, "Mémoires pour servir à l'histoire de Soissons et du Soissonnais," [1767–1772] Soissons, B.M., MS 237, ff. 275–276.[2]

La princess Elenors fit . . . part de ses largesses et temoigna beaucoup de zêle pour la perfection de l'enterprise [de la construction de la cathédrale]. Cette comtesse de Valois, fameuse par son testament eleemosinaire, non seulement fournait de sa forest de Retz tous les bois necessaires pour les chapentes mais même se joignit [avec le roi Philippe Auguste] au décorer les croisées du rond point du choeur des beaux vitrages en peinture qu'il fit venir express d'Angleterre.

[1] The reference is incomplete; Nicolas Berlette, a monk of Saint-Jean des Vignes at Soissons who died in 1584, had been discussing the Huguenot destruction of the furnishings of the cathedral in 1568, and adds this to the end of a sentence. Although Berlette claims to have consulted older authors and works, his own is the first history of Soissons written in the city, and most uncritical indeed.

[2] Pierre-Antoine Cabaret (1712–1785) was a canon of the cathedral chapter and secretary of the chapter commission charged with the 1767–1772 renovation of the cathedral choir. He had access to the capitular archives and used these, for the most part accurately or at least sensibly, in his history.

Princess Eleanor gave . . . part of her wealth and proved much zeal for the perfection of the undertaking of the construction of the cathedral. This countess of Valois, famous for her charitable will not only furnished from her forest at Retz all the timber necessary for the roof but also collaborated with king Philip Augustus in decorating the windows of the hemicycle of the choir with beautiful painted windows, which he had sent expressly from England.

APPENDIX 6

Eighteenth- and Nineteenth-Century Descriptions of the Glass in Saint-Yved

a) Martène and Durand, 1724, 1: 32[1]

L'église qui renferme tous ces tombeaux est belle & ancienne. On y voit dans les vitres peintes la vie de notre Seigneur representée avec toutes les figures du Sauveur, tirées de l'ancien Testament. Elle est consacrée à S. Yvè, en latin *Evodius*, archevêque de Rouen, dont les reliques sont conservées sur le grand autel dans une fort belle chasse d'argent. . . .

b) Carlier, 1764, 2: 65[2]

L'Eglise est éclairée par des vitraux, ornés de sujets pris de l'Ancien & du Nouveau Testament. Le vitrail du fond du Sanctuaire représente le Comte Robert I & la Comtesse son épouse, qui offrent la nouvelle Eglise à la Sainte Vierge. On lit dans le Cartulaire de l'Abbaye de S. Ived & dans l'*Index Coenobiorum ord. praem.* que les vitraux de cette Eglise ont été envoyés à la Comtesse de Braine, par la Reine d'Angleterre sa parente. On remarque dans l'Eglise trois roses, qui sont pareillement ornées de verres peints. Le vitrail des orgues représente le Jugement dernier. Les douze Apôtres & les quatorze vieillards de l'Apocalypse sont figurés sur la rose du bascoté gauche. On voit sur la troisième rose, qui est parallele à la seconde, un calendrier ou sont figurés les signes célestes, & les constellations; le triomphe des vertus sur les vices, & celui de la religion sur l'hérésie. Un double rang de belles fenêtres regne autour de la nef & du choeur.

c) Le Vieil, 1774, p. 24[3]

On doit encore mettre au rang des plus anciennes vitres peintes du 12e. siècle, une partie de celles de l'Eglise de l'Abbaye de l'Ordre de Prémontré à Braine-le-Comte, diocèse de Soissons, sous l'invocation de S. Yved Archevêque de Rouen.

Entre le nombre considérable de vitreaux remplis de vitres peintes des 12 & 13e siècles, dont les fenêtres de cette Eglise sont fermées, il en est un au fond du sanctuaire derrière le grand autel, dans lequel au-dessous de deux Figures qui paroissent présenter de concert à la Ste. Vierge, l'élévation de l'Eglise de ce Monastère, on lit d'un côté *Robertus Comes*, & de l'autre *Agnes Comitissa*. Ce Robert étoit fils de Louis VI dit le gros, Comte de Dreux, & avoit épousé en troisièmes noces en 1153, Agnès de Baudemont, héritière de Braine & fondatrice de ce Monastère. Le Cartulaire de l'Abbaye & l'*Index Coenobiorum Ordinis Praemonstratensis* font mention que

[1] The Maurist fathers seem to have visited the sites they describe in person, and their notes on Braine are thus the earliest eyewitness account of the glass; they were more interested, however, in the library and the relics.

[2] Carlier himself seems not to have seen the glass, but relies on a communication from Claude-Robert Jardel, a well-known local antiquarian who had a thorough knowledge of the manuscripts of the abbey (see Chapter 3, n. 60).

[3] The erroneous designation le-Comte caused a confusion with the place of that name in Normandy: Mrs. Merrifield, *Original Treatises dating from the XIIth to the XVIIIth Centuries on the art of painting . . .*, London, 1849, 1: lxxvii.

cette vitre avoit été envoyée à la Comtesse de Braine par la Reine d'Angleterre sa parente.

Cette notice qui m'a été adressée par un Amateur de ce canton (M. Jardel). . . .

d) Duflot, MS [1786], p. 7[4]

L'église est éclairée par les vitraux munis de sujets de l'ancien et du nouveau testament, qui ont été donnés par la reine d'Angleterre à la fondatrice, sa parente; on a remarqué surtout trois roses très belles; la première, au-dessus de l'orgue, représente le jugement dernier; celle dans la croisée du nord représente les apôtres et les vingt-quatre vieillards de l'Apocalypse, et celle du côté du midi les constellations, les douze signes du zodiaque, le triomphe des vertus sur les vices et de la religion sur l'hérésie.

e) Guilhermy, MS n. acq. fr. 6097 [ca. 1840?][5]

(f. 136) *Etat ancien de l'eglise* . . . Un double rang de belles fenêtres éclairaient la nef et le choeur. Elles étaient garnies de vitraux représentants des sujets de l'ancien / (f. 136v) et du nouveau testament. Carlier assure qu'ils furent envoyés à la reine d'Angleterre sa parente. Les trois roses de la nef et des croissillons possèdaient aussi de riches verrières. A la rose occidentale, c'était le juge-ment universel; à celle du Nord, on voyait deux cercles formés des figures des douze apôtres et les vingt-quatre

vieillards de l'Apocalypse; à celle du midi, il y avait un calendrier, les constellations, les signes célestes, le triumphe des vertus sur les vices et de la religion sur l'hérésie.

Il existait, dit-on, sur une des verrières un portrait de S. Bernard, qui passait pour authentique et presque con-temporain.

Pierre Levieil, dans son traité de la peinture sur verre, cite parmi les vitraux les plus remarquables du XIIe siè-cle, les nombreuse verrières de Braine. Elles dataient sans doute de la fin de ce siècle, et peuvent bien se rap-porter au règne de Philippe Auguste, à en juger par leurs débris qui one été transportés à la cathédrale de Soissons. A la fenêtre du fond du sanctuaire de l'église abbatiale, derrière la grand autel, il y avait, suivant Levieil, un vi-trail représentant deux personages, qui offrirent à la Vierge le modèle d'une église. On lisait au dessous de ces figures Robertus comes. Agnes comitessa. C'étaient les fondateurs de l'abbaye, Robert fils de Louis VI, et Agnès de Baudemont sa femme. Levieil ajoute que, d'après le cartulaire des moines, ce vitrail aurait été en-voyé à la / (f. 137) comtesse par la reine d'angleterre. . . .

(f. 142v) *Vitraux enlevés*. Les roses, ainsi que toutes les autres fenêtres, ont perdu leurs vitraux, dont il ne reste plus le moindre vestige; la cathédrale de Soissons en a receuilli une portion assez considérable.

[4] Nicholas François Duflot was a canon of Braine, and must have known the glass well.

[5] Guilhermy probably did not see the glass in place in Braine; his notes on Soissons, edited in Appendix 7, began in the 1840s. Whereas he relies closely on Carlier and Le Vieil in the following, there are ad-ditions that may have been based on another eyewitness account.

APPENDIX 7

Nineteenth-Century Documents concerning the Glass in Soissons Cathedral

a) Guilhermy's description: Excerpts from MS n. acq. fr. 6109

According to notes on f.248, the Baron François de Guilhermy visited Soissons in 1828, 1839, 1842, 1858, and 1862. The bulk of the observations in the main text appear to date from 1842, with corrections made in black ink in 1858 and further additions in 1862 and 1864; additions are italicized in the transcription that follows, and parts of the previous text that are scored through are in parentheses. Lengthy additions in the margins of his main text are reordered here so as to appear adjacent to the original notes. Since Didron's extensive restorations were underway by the late 1850s, Guilhermy's detailed marginal notes, and his corrections, may have been made from closer proximity to the glass, either from scaffolding or in the atelier; indeed he mentions seeing some of the glass in the shop. Guilhermy's observations are supplemented in the notes by the rather poetic account of the Abbés Poquet and Daras, published in 1848, in which a good many inscribed names are recorded without their exact position. Window numbers supplied in brackets correlate with the Recensement.[1]

Excerpts from Guilhermy's text are presented to give a general sense of the distribution of the old glass in the cathedral, and specifically to identify panels from Braine that were still integrated with the glazing, many of which were subsequently scattered in collections.[2] These subjects are capitalized, and where possible identified by a number that refers to the checklist of surviving glass that follows in Catalogue A. A query indicates that the provenance is uncertain, since the subjects could have originated in the cathedral. If their whereabouts is unknown, they are noted as lost.

(f. 254) Intérieur—Nef

La rose occidentale est presque complètement masquée par le buffet d'orgue. On voit, cependant, qu'il y reste encore quelques vitraux du XIII^e siècle, ou du XIV^e. [A description of the architecture of the nave follows.]

Les fenêtres hautes sont en nombre de sept sur chaque flanc de la nef; ogivales, géminées, sans meneaux, elles présentent, à leur tympan, une petite rose. Presque toute ces roses conservent des vitraux du XIII^e siècle. Les baies des fenêtres, au nord, / (f. 254v) possèdent, de la même époque, de très beaux motifs de grisailles.

Le Croisillon—nord [A description of the architecture of the transept follows.] . . . les fenêtres, au nombre de six, ont également de vitraux colorés aux roses, et des grisailles dans les baies (XIII^e s.).

La décoration du mur de fond de ce croisillon n'est guère antérieur au XIV^e siècle. Grande rose [Window 121] à douze compartiments, vitrée à fonds de mosaïque et médaillons à sujects. Au-dessous du cercle, quatre ogives, qui . . . [no more on glass].

[1] *Corpus Vitrearum France Recensement* I, fig. 93. 0 and 100 are axially positioned in the east, and sequences alternate north and south, such that even numbers are always on the south side. No numbers are supplied beyond the choir, except for the north transept rose.

[2] Ancien, 1980b, pp. 20–34, has also presented excerpts, but I am not always in agreement with his reading of the manuscript.

(f.255) **Croisillon sud** [Description includes the sculpted keystones of the chapel and tribune.]

(f. 255v) [Long note appears in left margin, apparently made in 1862 or later.]

Vitraux [West Rose] A la pointe de la grande baie ogivale de l'Oeust, quelques panneaux du XVIe siècle, notamment une sainte debout, accompagnée de moutons; est-ce Ste. Geneviève? Dans la rose, quelques médaillons cerculaires, XIIIe, au XIVe siècle; ils sont petits; le buffet d'orgues les cache.

Fenêtres hautes de la nef

Au Nord. Ire grisaille . . . *restaurée*; à la rose, sur un fond de mosaïque, une tête de roi, nimbée, réparée; nimbe rouge. Dans cette fenêtre il y a une baie ouverte.

2e Comme la première, grisaille restaurée, en deux baies; tête de roi nimbée de bleu.

3e Le tout enlevé, pour une restauration, était remis en place en 1862; grisaille: tête de roi, imberbe, nimbée de rouge.

4e Grisaille ancienne, dont il manque un peu; à la rose, un homme d'église, près d'un autel, sur lequel il ne semble voir une croix d'or [lost?].[3] Restaurée depuis; à la rose une tête de roi nimbée de rouge.

5e Grisaille comme à la 4e; à la rose, tête de roi nimbée de rouge; restauré.

6e id id id id non restauré.

7e id id id la tête est mutilée; non restauré.

Au Sud. Il ne reste de grisaille à aucune fenêtre; pas de restauration.

1e et 2e Les roses sont confuses.

3e A la rose, un petit personnage, XIIIe siècle? tenant une fleur; il provient peut-être d'ailleurs, à côté, le mot VIRGO [lost].[4]

4e Rose confuse.

5e A la rose, un petit personnage, debout, avec son nom au-dessous VICTOR OU VINCEN? [Perhaps this window is from Braine, though the identification does not fit the roses; lost.]

6e Rose; petit personnage assis, couronné, tenant un vase à long cou à la main droite, un plectrum à la gauche. [an ELDER OF THE APOCALYPSE, presumably a lost companion to no. 30.][5]

7e Rose confuse.

(f. 256, left margin) **Fenêtres hautes du Croisillon Nord**

A l'Est. Trois grisailles, XIIIe siècle, endommagées.

Une des roses confuse. Dans une autre, une tête d'évêque nimbée. A la 3e, buste d'évêque tenant une croix et bénissant.

Dans le tympan de **la galerie, sous la grande rose**, les quatres emblêmes des Evangelistes, avec banderoles, XVe ou XVIe siècle.

Aux pointes de **deux ogives, sous la rose**, des lambeaux de vitraux.

A **la rose [Window 121]** elle même, vitrage, XIVe siècle; au centre, la Vierge assise, couronnée, avec l'enfant; dans les médaillons, sur fonds de mosaïque, l'Annonciation; La Visitation; La naissance; les bergers avertis; la Présentation; la Fuite; les Mages dans un vaisseau; les mêmes devant Hérode; ils adorent le groupe placé au centre; ils se montrent l'étoile; deux anges tenant une nappe; le Christ recevant dans son sein l'âme toute blanche de sa mère; le couronnement de Marie par Jésus. En dehors du cercle, dans les intersterces, deux anges avec des encensoirs.

Aux **fenêtres de l'Ouest**, quelques panneaux seulement de grisailles. Dans leurs roses, débris confus.

Choeur

Ire fenêtre haute, au Nord [Window 113] rien (baie unique).

2e Rose [Window 111]; tête de roi nimbée.

3e [Window 109] id id

4e [Window 107] id. Tête de femme dans un cercle, couronnée d'or, voilée de bleue. Dans les deux baies, bordures fleuronnées, XIIIe siècle; dans le bas, HUIT PETITS PANNEAUX, DU MEME TEMPS, RAPPORTÉS D'AILLEURS, qu'on voit mal [?lost, perhaps from Braine]; on y distingue des martyrs qui sont emmenés.

5e Rose [Window 105] tête de femme, couronnée, voilée de brun, MISERICORDIA [lost; perhaps from Braine]. L'inscription est bien du XIIIe siècle.

6–10 Fenêtres absidales [Windows 100–104. A fuller description of these windows is given further on.]

6e [Window 103] Les sujets primitifs sont disposés de manière que Dieu, qui crée Adam, au sommet de l'ogive, se trouve ensuite placé plusiers fois au milieu de la verrière, tandis qu'Adam et Eve nus occupent les parties latérales, Adam à la droite, Eve à la gauche.

7e [Window 101] Les QUATRES PERSONNAGES en robes et manteaux riches [nos. 1–4]. Leur noms auprès de leur têtes; je ne puis les lire.[6] Sur les côtés, morceaux du XIIIe siècle; on reconnait DES ANGES et

[3] From what follows, it seems a king's head replaced this panel. This may well be the core of the early thirteenth-century panel in the Cathedral style now in the Detroit Institute of Arts, 59.34; see M. H. Caviness in *Corpus Vitrearum USA Checklist* III, p. 156.

[4] Poquet and Daras, 1848, p. 67 mention "à gauche [i.e., south] dans les médaillons de la nef, reparaissent les emblêmes du temps," presumably referring to this and perhaps other signs of the zodiac. They also describe a figure of Religion that may have come from Braine, and, on the north side, "les grandeurs de la terre," perhaps the elements.

[5] The west rose of the cathedral also had figures described as "les vieillards de l'Apocalypse, portant dans leurs mains les palmes de la

victoire," according to Poquet and Daras, 1848, p. 68, but three preserved in storage at the Dépôt of Champs-sur-Marne have stiff scrolls with mock inscriptions. The attributes mentioned by Guilhermy accord with the Braine figure.

[6] Poquet and Darass, 1848, p. 66, however, list "Aminadab, Salathiel, Cainan, Jéchonias, Joram and Osias"; The last certainly belongs to the Jesse Tree, now in the axial window: *Corpus Vitrearum France Recensement* I, fig. 94. The early authors also confirm the presence nearby of "la sphère zodiacale . . . des SCIENCES ET DES ARTS, comme LE SAGITTAIRE [no. 24], LA MUSIQUE [no. 17], LES MATHEMATIQUES [no. 18]."

d'autres personnages qui encensent [nos. 26–29]; UN VIEILLARD TENANT UNE FIOLE ET UNE VIOLE [no. 30]; UN MORT QUI RESSUCITE [?];[7] LE SAGITTAIRE, homme nud, qui tire de l'arc [no. 24]; LES DEUX JUMEAUX [no. 23]; UN HOMME QUI TAILLE LA VIGNE [no. 22]; un autre qui porte du bois HYEMS [no. 20]; fleurs de lis.

(f. 256v, left margin, continued)

8ᵉ [The Axial Window, 100] Christ en croix moderne. Le bas confus. Personnages assis, avec un nom. De chaque côté, un personnage entier, un en buste, un autre entier, un ange, tous nimbés. A l'exception des anges, ces personnages tiennent les banderoles portant des noms. Il y a en a un couronné. Au centre, un roi assis; le Christ assis, nimbe croisée, peut-être les colombes autour de sa tête; plus haut, encore un personnage assis. Le déplacement des figures est ici évident.

9ᵉ–10ᵉ [Windows 102 and 104] Voir à une page précédente [i.e., f. 255v; the transcription follows later].

11ᵉ Rose [Window 106] PERSONNAGE ASSIS, NIMBE, COURONNE, TENANT UN VASE [lost, probably a companion to no. 30].

12ᵉ Rose [Window 108] buste mutilé.

13ᵉ [Window 110] LES DEUX POISSONS AVEC LE NOM [no. 25]; rose.

14ᵉ Rose [Window 112] XIIIᵉ siècle; buste de femme, couronnée, viol brun, IUSTICIA [lost; perhaps from Braine].

15ᵉ [Window 114] Une seule baie. Rien.

(f. 255v, main text continued) **Choeur et abside** [A description of the architecture follows.]

Vitraux XIIIᵉ s. Les Cinq fenêtres absidiales [Windows 100–104] ont conservé, (presque en totalité) *en partie* leurs vitraux du XIIIᵉ siècle. Voici l'indication (d'une partie) des sujets. Très belles fenêtres, XIIIᵉ siècle, *à peu près* complète.

1ᵉ [Window 103] (Iacob) IACOB, assis, imberbe sous un arc cintré [no. 8].[8]

Adam & Eve *à mi-corps, le bas avant été détruit; au milieu Dieu émergeant d'un nuage.*

Adam, tenant une pomme; *l'arbre et* le serpent; Eve, *recevant une pomme; Dieu probablement, dont il reste seulement la partie inférieure avec les pieds nus; réparé avec une tête de roi nimbée, près de laquelle j'ai lu DAVID* [no. 15].

Adam. (David) Eve

Adam emdormi Dieu à nimbe croissé *(tenant) le tient par (la) une* main, *(Adam et Eve) et de la main gauche lève[?] Eve du côté. A la pointe de l'ogive, Adam . . . ; Dieu le bénit et l'anime. (Un dernier sujet, ou je distingue à peine un personnage nimbé . . . figures).*[9]

Fond bleu très vif: de chaque côté quatre rangs de personnages nus d'un effect singulier. Le Iacob, placé en bas de la fenêtre, vient sans doubte d'ailleurs.[10] *Il est accompagné de six panneaux étrangers; une femme étendue, probablement la Vierge mourante, et près d'elle, deux apôtres; un ange et la Vierge; une scène de . . . naire; trois autres petits panneaux que je ne distingue pas.*[11]

2ᵉ fenêtre [Window 101] Quatre personnages assis, dont les noms se voyent, sans qu'on puisse les lire. *On a rempli la baie de pièces et de morceaux confus. La partie centrale présente QUATRE PERSONNAGES assis, les uns au dessus des autres; le premier couronné et nimbé* [no. 3] *le second tête nue* [no. 1] *le troisième avec une calotte à point* [no. 4]; *le quatrième, tête nue et nimbé* [no. 2].[12]

3ᵉ fenêtre. Celle du fond [Window 100] Il y a rapporté un crucifix moderne, qui a . . . *interrompu* la chaine des sujets anciens, et qui gâte toute la fenêtre.

4ᵉ fenêtre [Window 102] (Jugement dernier. Le) Christ (des anges lui présentant des âmes, d'autres sonnent de la trompette. Des démons attirent; un foyer, sur lequel est placé une chaudière.) *Vitrail très confus. Deux anges portant une espèce de tabernacle; deux autres qui sonnent de la trompette. Une cuve contenant les damnés, et posée sur la flamme; elle est employée à raccommoder la partie inférieure d'un roi assis dans les branches et nimbé. /* (f. 256) *La Vierge assise entre les branches et accostée de deux anges. Le Christ assis; nimbe croisé. Des anges; quelques démons. Le haut très confus. Il n'y avait-it pas là primitivement un arbre de Jessé?*[13]

(Vie de J.C.) *Mort et Assomption de Marie*

5ᵉ [Window 104] (sujets de la vie du Christ) *Ce vitrail se trouvant à Paris, pour cause de restauration, au mois d'août 1864, dans les ateliers de mon ami, M. Edouard Didron où je l'ai vu. Mort de la Vierge: le Christ et l'âme de sa mère; anges; la Vierge en gloire; XIIIᵉ siècle.*[14] *Verrière très confuse, mais très endommagée, raccommodée avec des médaillons à petits sujects, du même temps. Histoire des MARTYRS CONDAMNES PAR AURELIUS* [?no. 32]. *Un médaillon représentant APRILES une clef en la main droite, une fleur en la gauche. C'est le mois d'avril qui ouvre, en quelque sorte, le printemps* [lost].[15] *Autres débris remarquables en la même fe-*

[7] The dead rising from the tomb was either from the west rose of Braine, or from the Last Judgment window in the apse clerestory of the cathedral, now Window 101.

[8] This hardly seems to be the "vieux Jacob, prophétisant sur son lit de mort la stabilité du sceptre de Juda," seen by Poquet and Daras, 1848, p. 66, in one of the windows of the hemicycle.

[9] The Genesis cycle is now in Window 102. Poquet and Daras, 1848, p. 65, refer to these subjects "à la naissance de l'abside" and "au fond de l'abside," implying the axial window.

[10] *Doubte*, which was not transcribed by Ancien, is hidden under the flap where the page is tipped in, and was read by holding the page to the light.

[11] These panels, with scenes from the life of the Virgin, are now in Window 104.

[12] These figures were in the same order as they are now, if Guilhermy read from the bottom up, but they have been placed in Window 103.

[13] Poquet and Daras, 1848, p. 66, added Joram and Osias, and also David, Jeremiah, Daniel, Zachariah, and Micheas. The Virgin and the upper part of a king from this Jesse Tree were apparently not replaced after the restoration; one was acquired by the Berlin Museums and destroyed in World War II, the other is probably the one in the Glencairn Museum; see Hayward and Cahn, 1982, no. 52, pp. 140–42. A heavily restored Jesse Tree is now in the axial window, 100, whereas the Last Judgment is in Window 101.

[14] These subjects complete the Life of the Virgin in this same window now.

[15] Poquet and Daras, 1848, p. 66, recorded this inscription.

nêtre. Voici la note que j'avais prise sur la 5ᵉ fenêtre, avant qu'elle fut déposée: Verrière très raccommodée et confuse. Beaucoup de petits médaillons, provennant d'ailleurs. Un garde qui décapite un personnage [?no. 32 again]. Plusieurs sujets de la vie d'un saint évêque, entre autres une sépulture. Deux saintes femmes, sans nimbes. La Vierge assise sur un siège à dossier. Des anges. Le Christ debout, tenant une petite âme nue. Un petit personnage tenant un bouquet [the lost APRIL again]; il provient peut-être d'une scène des mois; le nom y est. On ne pourra bien juger de cette verrière que quand elle aura été descendue.

(f. 257, main text) **Chapelles de Choeur**. Autels et statues modernes [A description follows.]

Vitraux XIIIᵉ siècle, provenant de Braine. Les trois fenêtres [de la 2ᵉ chapelle, celle de Saint-Pierre; Windows 3, 5, 7] sont garnies de vitraux, dont une partie et dans un tel état de mal propreté qu'on n'y distingue rien. Il y a plusiers figures de prophètes, dans lesquelles on a maladroitement intercalé des morceaux rapportées d'ailleurs. PROPHETES; LA PASSION [?]. (Une légende à petits sujets remplit toute une fenêtre. On y reconnait plusiers sujets de la Passion et la scène des disciples d'Emmaus). Ces vitraux, commes tous ceux des fenêtres basses de l'abside, ont été extraits de l'église abbatiale de Braine, et replacée ici avec une extrême confusion.[16] Ils datent du XIIIᵉ siècle.

La Troisième chapelle est celle de la Vierge. Les Vitraux de ses trois fenêtres méritent d'être étudiés.

Iᵉʳᵉ fenêtre [Window 1] Histoire de Moïse. Moïse (passe la mer rouge) *sans cornes, touche la mer avec une baguette; Pharaon et les Egyptiens sont engloutis. . . .* [The glass described is in a style associated with the Sainte-Chapelle, of mid-thirteenth century, and was probably moved here from the west end of the nave.][17]

(f. 257v) **2ᵉ fenêtre [Window 0]** Sujets divers. Figures héraldiques. *Vitraux remaniés et rapiciés. Bordure à châteaux de Castille et fleurs de lis. Une femme sans nimbe, à table, Une femme plusiers fois en scène avec des querriers; c'est probablement Judith.* [A full description continues; again this is glass in the Sainte-Chapelle style. There are a good many later corrections, and even some pencil notes that have been crossed out.][18]

3ᵉ fenêtre [Window 2] *Dieu assis; Moïse cornu, assis; les deux personnages se tournent le dos; ils faisaient sans doute partie de deux sujets différents. Histoire de Moïse.* (Moïse reçoit la Loi. Aron au veau d'or . . . [other Moses scenes] Martyre de S. Jean baptiste? Baptême du Christ?) Aaron, avec l'ephod, devant un groupe. Un baptême dans l'eau d'un fleuve. Décollation d'un personnage; un assistant; deux gardes . . .[19]

Chapelle Saint-Paul [An eighteenth-century statue is described.] Personnages Divers. Des vitraux garnissent les fenêtres. Les personnages en sont, par leur grande taille, hors de proportion avec le place qu'il occupent maintenant.[20]

Iᵉʳᵉ fenêtre [Window 6] Habacuc. *La moitié supériuere de personnage; il tient un rouleau.* Le Prophète Habucuc, vu à mi-corps, nimbé de rouge (. . . cuc *p*pa) *habacuc ;ppha* autre prophètes *Figure entière* Autre prophète assis, pieds nuds, nimbé de rouge, tenant une (légende sur laquelle . . . aspē) *banderole avec un texte du XIIIᵉ siècle. (N'est-ce pas un Apôtre? . . . c'est un . . . le lire).* Entre ces deux personnages (une ville enceint de tours et murailles) *la partie haute d'un dais on bastille.*

(f. 258) **2ᵉ fenêtre [Window 6]** Prophêtes. Prophête, nimbé de rouge, vu à mi-corps (. . . ob pfeta) *(La moitié supérieure du personnage) probablement: iohel ppha. Personnage entier* (Autre prophète) assis, nimbé de rouge, pieds nuds, tenant une (banderole . . . lie . . . peut-être Elie) *longue epée, S. Paul*ᵘ.[21]

3ᵉ fenêtre [Window 8] Fragments. Divers personnages. UN ROI, tenant un septre fleurdelysé, assis, mutilé [?no. 9]. UN BUSTE, à nimbe rouge; *c'est une tête d'apôtre ou de prophète* [it could be nos. 5, 11, or 12, but it might equally be one of the large figures in Baltimore or Glencairn mentioned in n. 21]. Un PERSONNAGE ASSIS nimbé de rouge, fleur de lys d'or.

La cinquième chapelle [Windows 10, 12, 14] n'a pas de vitraux . . .

(f. 257, left column) [This is clearly a later addition.] *Il n'v a de vitraux que dans* **les trois chapelles du fond de l'abside.**

Iᵉʳᵉ de ces trois chapelles [i.e., the Chapel of St. Peter] **Iᵉʳᵉ fenêtre [Window 3][22]** *Un groupe envahi par la pous-*

[16] This is evidently an exaggeration; most of the glass that can be identified in Guilhermy's description, including all that now remains in the chapels, belongs to the cathedral, even though some had been interpolated from other windows.

[17] For this glass, see most recently Madeline H. Caviness and Virginia Chieffo Raguin, "Another Dispersed Window from Soissons: A Tree of Jesse in the Sainte-Chapelle Style," *Gesta* 20 (1981): 191–98.

[18] Mlle. Vinsot has examined Guilhermy's text carefully, and finds it corresponds with existing scenes in the axial chapel.

[19] These subjects correspond to photographs in the possession of M. Jean Ancien; the glass disappeared in the restorations of the 1920s and has not yet been traced.

[20] Fragmentary clerestory figures seem to have been used to fill these openings, probably after the explosion of 1815. Some can tentatively be identified in collections, and their style and very large size indicate an origin in the choir clerestory of the cathedral; there are two such figures, with banderoles, in the Glencairn Museum (see Pl. 278), and

two in the Walters Art Gallery, including one inscribed ABACUC PROPHETA (Michael Cothren and Madeline H. Caviness in *Corpus Vitrearum USA Checklist* II, pp. 57, 111).

[21] The upper parts of a Prophet Ezekiel with an inscribed scroll, and a St. Paul with a sword as described here are now in the Kiev Museum; see Xenia Muratova, "Deux panneaux inconnus de vitraux français du XIIIᵉ siècle au Musée de Kiev," *Revue de l'Art* 10 (1970): 63–65. They were acquired by Bogdan Khanenko between 1885 and 1915. The prophet has a name band EZEC[H]IEL, noted later by Guilhermy (f. 257), and the quotation SPECIES EL[E]CTR[I]; other figures of this series are in Baltimore and Glencairn; see Madeline H. Caviness, "Ein Spiel des Zusammensetzene: Rekonstruktion der Hochchorglasfenster in der Kathedrale von Soissons," in *Festschrift für Edgar Lehmann*, ed. Erhard Drachenberg, Berlin, 1989.

[22] The glass described here corresponds to the Life of St. Gilles, now in Window 12.

sière. Un saint et un personnage en simple braies devant un roi. Un saint personnage élevant un objet d'or; plusieurs personnages derrière lui. Quatre personnages agenouillés devant un autel sur lequel est posé un chalice. Inscriptions en caractères trop menus pour qu'on puisse le lire. Un roi fléchit le genou devant un saint assis. Un roi; un saint devant l'autel; un ange lui apporte une banderole. Le même saint à genoux devant un autel sur lequel est posé un calice; un personnage en arrière. Deux chasseurs; chien, cheval. Le saint, déjà vu, chasse un démon d'un possédé. Le même dans la campagne. Le même près d'un évêque couché, mort? Le haut confus.

2ᵉ fenêtre [**Window 5**] *Morceaux d'un grand personnage ezec . . . avec banderole écrite, mutilé.*[23] *Tout le reste confus. Fleurs de lis.*

3ᵉ fenêtre [**Window 7**] *Sur un nimbe, en caractères du XIIIᵉ siècle. Iohannes evangelista*[24] *Un saint personnage qui*

paraît mené en prison. Un saint évêque et une sainte femme; trois guerriers furieux, tirent l'épée. Une femme, un homme, un saint qu'on frappe la glaive, guerriers. Inscriptions. Une sainte qu'on décapite, s evaronea ou evfroma; guerriers armés de hâches et de lances. Trois scènes qui paraisent se rapporter à un même sujet de sépulture par un évêque, etc. Deux fois, deux anges tenant des âmes sur les nappes. Deux anges apportant des couronnes. Il s'agit d'un double martyre.

b) Letter from the Cathedral architect à propos the 1884 exhibition: Paris, A.N., F¹⁹ 7889

This contains the only mention preserved in the archives that a decision had been made to take down some of the glass in the cathedral and assemble it in one of the buildings of the diocese; it was supposed to be in Didron's atelier in Paris.

Ministère de la Justice
et des Cultes

———

Direction générale des Cultes

———

Diocèse de Soissons.

———

Cathédrale.
Vitraux du XIIIᵉ Siècle.

———

Exposition
de l'Union centrale
des Arts décoratifs
en 1884

———

69.

966

Paris, le 7 Juin 1884.

à Monsieur le Ministre de la Justice et des Cultes.

Monsieur le Ministre,

En réponse à la lettre que vous avez bien voulu m'adresser le 6 Juin, j'ai l'honneur de vous faire connaître que les vitraux légendaires de la nef, actuellement en réparation, ne me semblent pas assez intéressants pour figurer à l'exposition rétrospective de 1884, organisée par les soins de l'Union centrale des Arts décoratifs.

Mais on pourrait trouver facilement, parmi les vitraux dont votre administration a autorisé le dépose et le rangement dans une des dépendances de la cathédrale, un ou plusieurs panneaux qu'il suffirait de consolider pour pouvoir les transporter et les exposer sans danger pour leur conservation.

Si vous voulez bien l'ordonner, Monsieur le Ministre, il sera possible, avec le concours de Mʳ. Didron, Peintre-verrier le la Cathédrale de Soissons, de choisir 2 ou 3 de ces panneaux qui figureront avec honneur parmi le plus beaux specimens des vitraux français du XIIᵉ et du XIIIᵉ siècles.

En ma qualité de membre du Conseil d'administration de l'Union centrale des Arts décoratifs et de président d'une des sections de l'Exposition de 1884, il me sera possible de veiller au placement et à la conservation de ces précieux documents de notre art national; je serai très-heureux de pouvoir me mettre tout à la disposition de votre administration.

Je suis avec un profond respect,
Monsieur le Ministre,
Votre très-humble et très-dévoué serviteur

Ed. Corroyer,
architecte Diocesain
à Soissons.

[23] Presumably Ezekiel, now companion to St. Paul in the Kiev Museum; see n. 21 above.

[24] This first was probably the bust of a figure from the clerestory. The rest of the window contained the lives of St. Nicasius and St. Eu-tropia, now divided between the Louvre and the Gardner Museum; the text has been translated in Caviness, Pastan, and Beaven, 1984, pp. 11-12.

BIBLIOGRAPHY

ABBREVIATIONS USED IN CITATIONS: Listed here are the sources that are cited by author or title more than once in the text and notes, list of illustrations, or catalogues. A list of nonbibliographic abbreviations is included in the front matter.

UNPUBLISHED SOURCES
(CITED IN THE NOTES BY AUTHOR
OR TITLE, MS AND NUMBER)

Beaven, Marilyn. "The Legendary Stained Glass from the Thirteenth-Century Choir of Soissons Cathedral." M.A. thesis, Tufts University, 1989.

Bettembourg et al.: MCC. Laboratoire de Recherches des Monuments Historiques, "Reims 51—Marne. Basilique Saint Remi. Conservation des vitraux du 12ᵉ siècle," by Jean-Marie Bettembourg, Jean-Jacques Burck, Geneviève Orial, December 18, 1981, Rapport Nᵒ 445B.

Buckler Bequest: C. A. Buckler, "Vitraux"—small drawings, England and France. B.L., Buckler Bequest XVI: Add. MS 37, 138.

Cartulary [of saint-Yved of Braine]: A.N., LL 1583.

Chastelain, Pierre: "Histoire abrégée de l'église Saint-Remi de Reims," Reims, B.M., MS 1828.

Château: "Histoire de Braine, depuis son origine jusqu'à présent, de la fondation de l'abbaye de St.-Yved, des religieux prémontrés, celle de l'abbaye de Chartreuse . . . ," 1829, Soissons, B. M., Collection Périn no. 1019.

Dessins, Vitraux: Paris, Musée des Arts Decoratifs, Dessins originaux [XIXᵉ s.] 123: Vases-Vitraux, "9 feuilles originaux . . . du R. P. Martin."

Deuchler, Florens. "Die Chorfenster der Kathedrale in Laon: Ein ikonographischer und stilgeschichtlicher Beitrag zur Kenntnis nordfranzösischer Glasmalerei des 13. Jahrhunderts." 2 vols. Ph.D. dissertation, Bonn University, 1956.

Duflot, Nicolas-François: "Description topographique de Braine," Soissons, Société archéologique. Copy in Soissons, B.M., Collection Périn no. 1014.

Farquhar, M. M. "A Catalogue of the Illuminated Manuscripts of the Romanesque Period from Rheims, 1050–1130." Ph.D. dissertation, London University, 1968.

Guilhermy, François de: "Notes sur diverses localités de la France," B.N., Collection Guilhermy, 18 vols., MSs nouv. acq. fr. 6094–6111.

Heaton Collection: Princeton University, Marquand Library, Noel Heaton Albums of Stained Glass.

Herbelin, Mathieu: "Les Anciennes et modernes Genealogies, Epitaphes et armoires de tous les sieurs Contes et Contesses de Dreux et de Braine . . . ," Paris, Bibliothèque Sainte-Geneviève, MS 855.

Povillon-Piérard: "Description historique de l'église Saint-Remi de Rheims [*sic*]," 1824–1828, Reims, B.M., MS 1837.

Reimbeau, Auguste: "Etudes sur l'église Saint-Remi de Reims, texte et desseins par Auguste Reimbeau, architecte à Reims, décédé en 1865," Reims, B.M., MS 2100. Notes on the choir glass are dated 1870. Another section has the date 1860.

Rothier photographs: complete set of black and white prints of Saint-Remi glass (lacks only choir clerestory N. II) taken between 1867 and 1896, Reims, atelier of Brigitte Simon and Charles Marq. Some copy negatives were made by Bulloz of Reims in 1983. A second original set, less complete, is in the Société des Amis de Vieux Reims.

PRINTED SOURCES:
ABBREVIATED TITLES USED
IN REFERENCES

L'Art Sacré [before June 1902]. Two pages from this issue, with a commemorative article on Edouard Didron, jeune, are in Reims, B.M., Estampes XVIII, I fb7; no other copy has been found.

Corpus Vitrearum France Recensement I: Louis Grodecki, Françoise Perrot, Jean Taralon. *Les vitraux de Paris, de la région parisienne, de la Picardie, et du Nord-Pas-de-Calais*, Corpus Vitrearum Medii Aevi: France, série complémentaire: Recensement des vitraux anciens de la France. Paris, 1978.

Corpus Vitrearum France Recensement II: Louis Grodecki, Françoise Perrot, et al. *Les Vitraux du Centre et des pays de la Loire*, Corpus Vitrearum Medii Aevi: France, série complémentaire: Recensement des vitraux anciens de la France. Paris, 1981.

Corpus Vitrearum USA Checklist I: "Stained Glass before 1700 in American Collections, New England and New York." *Studies in the History of Art* 15 (1985).

Corpus Vitrearum USA Checklist II: "Stained Glass before 1700 in American Collections, Mid-Atlantic and Southeastern Seaboard States." *Studies in the History of Art* 23 (1987).

Corpus Vitrearum USA Checklist III: "Stained Glass before 1700 in American Collections, Midwest and West." *Studies in the History of Art* 28 (1989).

Corpus Vitrearum USA Occasional Papers: I. *Selected Papers from the XIIth International Colloquium of the Corpus Vitrearum*, New York, June 1–6, 1982, edited by

Madeline H. Caviness and Timothy Husband. New York, 1985.

Courtauld Archives: Peter Lasko, ed. *Medieval Architecture and Sculpture in Europe* Courtauld Institute Archive 3, London: *France—Laon Cathedral*, part 6, 1978; *France—Soissons and Braine*, part 12, 1985. Citations follow the format of the captions, viz. 3/6/- and 3/12/-.

Gallia Christiana, in provincias ecclesiasticas distributa, vol. 9. 1751. References are to the reprint, Paris, [1870?].

Hortus Deliciarum, 1977: A. Straub and G. Keller, ed. and tr. *Herrad of Landsberg, Hortus Deliciarum (Garden of Delights)*. New Rochelle, N.Y.

————, 1979: Rosalie Green, Michael Evans, Christine Bischoff, and Michael Curschmann. *Herrad of Hohensburg: Hortus Deliciarum*, 2 vols. London.

Liber Floridus: Albert Deroulez. *Lamberti S. Audomari canonici Liber Floridus codex autographus Bibliothecae Universitas Gandavensis*. Ghent, 1968.

Medieval Art: The Metropolitan Museum of Art. *Medieval Art from Private Collections—A Special Exhibition at the Cloisters, October 30, 1968 through March 5, 1969*, introduction and catalogue by Carmen Gomez-Moreno. New York, 1968.

The Metrical Life of St. Hugh, edited by J. F. Dimock. Lincoln, 1860.

P.L.: J. P. Migne, ed. *Patrologia [Latina] cursus completus*. Paris, 1844–1864.

Rhin-Meuse: Art et Civilisation 800–1400, Une Exposition des Ministères belges de la Culture française et et la Culture néerlandaise du Schnütgen-Museum de la Ville de Cologne [catalogue]. Cologne and Brussels, 1972.

Vitrail: Paris, Musée des Arts Décoratifs. *Le Vitrail Français*. Paris, 1958. Text by Marcel Aubert, André Chastel, Louis Grodecki, Jean-Jacques Gruber, Jean Lafond, François Mathey, Jean Taralon, and Jean Verrier.

Year 1200 I: The Metropolitan Museum of Art. *The Year 1200: A Centennial Exhibition at the Metropolitan Museum of Art, I: Catalogue*, edited by Konrad Hoffmann, The Cloisters, *Studies in Medieval Art* I. New York, 1970.

Year 1200 III: The Metropolitan Museum of Art. *The Year 1200: A Symposium*, edited by Jeffrey Hoffeld. New York, 1975.

Zeit der Staufer: Württembergisches Landesmuseum, Stuttgart. *Die Zeit der Staufer: Geschichte-Kunst-Kultur, Katalog der Ausstellung*, edited by Reiner Haussherr, 5 vols. Stuttgart, 1977.

PRINTED WORKS
CITED BY AUTHOR AND DATE

Adhémar, J. 1939. *Influences antiques dans l'art du moyen-âge: français*, Studies of the Warburg Institute 8. London.

Ancien, Jean. 1980a. *Vitraux de la cathédrale de Soissons*. Soissons. Privately printed.

————. 1980b. *Vitraux de la cathédrale de Soissons comme on les voyait entre 1817 et 1882*. Soissons. Privately printed.

————. 1987. *Les Mysterieux vitraux de Braine*. Soissons. Privately printed.

Aubert, Marcel. 1946. *Le Vitrail en France: Arts, styles et techniques*. Paris.

Aubert, Marcel, and Paul Claudel. 1937. *Vitraux des cathédrales de France aux XIIᵉ et XIIIᵉ siècles*. Paris.

Aubert, Marcel, with Louis Grodecki, Jean Lafond, and Jean Verrier. 1959. *Les Vitraux de Notre-Dame et de la Sante-Chapelle de Paris*, Corpus Vitrearum Medii Aevi: France, I, Département de la Seine, pt. 1. Paris.

Backmund, Norbert. 1952. *Monasticon Praemonstratense*, vol. 2. Straubing.

Barral I Altet, Xavier. 1980. "Les mosaïques de pavement médiévales de la ville de Reims." *Congrés archéologique de France*, Champagne, 1977, 135: 79–108.

Beer, Ellen J. 1952. *Die Rose der Kathdrale von Lausanne und der kosmologische Bilderkreis des Mittelalters*, Berner Schriften zur Kunst 6, edited by Hans Hahnloser. Berne.

————. 1956. *Die Glasmalereien der Schweiz vom 12. bis zum Beginn des 14. Jahrhunderts*, Corpus Vitrearum Medii Aevi: Schweiz, I. Basel.

————. 1975. "Les Vitraux du Moyen Age de la cathédrale." In société de l'Histoire de l'Art en Suisse, *La Cathédrale de Lausanne*, pp. 221–56. Berne.

Bettembourg, J.-M., with J.-J Burck, G. Orial, M. Perez y Jorba. June 1983. "La dégradation des vitraux de St. Rémi de Reims (Marne)." *Corpus Vitrearum Newsletter* 35/36: 10–17.

Beyer, Victor, with Christianne Wild-Block, Fridtjof Zschokke. 1986. *Les Vitraux de la cathédrale Notre-Dame de Strasbourg*. Corpus Vitrearum, France 9, pt. I. Paris.

Bloch, Peter. 1961. "Siebenarmige Leuchter in Christlichen Kirchen." *Wallraf-Richartz Jahrbuch* 23: 55–190.

Bony, Jean. 1957–1958. "The Resistance to Chartres in Early Thirteenth Century Architecture." *Journal of the British Archaeological Association* 3d ser. 20–21: 35–52.

————. 1983. *French Gothic Architecture of the 12th and 13th Centuries*. Berkeley.

Bornstein, Christine Verzar. 1982. "Matilda of Canossa, Papal Rome and the Earliest Italian Porch Portals." In *Romanico padano, Romanico europeo*, Convengo internationale di Studi, Modena-Parma, 1977, pp. 144–58. Parma.

Brouette, E. 1958. "Obituaire de l'abbaye de Saint-Yved de Braine." *Analecta Praemonstratensia* 34: 274–337.

Bur, Michel. 1977. *La Formation du comté de Champagne v. 950–1150*, Mémoires des Annales de l'Est 54. Nancy.

Cahier, Charles, and Arthur Martin. 1841–1844. *Monographie de la cathédrale de Bourges*. Paris.

Cahn, Walter. Winter 1974. "A King from Dreux." *Yale University Art Gallery Bulletin* 34, no. 3: 14–29.

————. 1982. *Romanesque Bible Illumination*. Ithaca, N.Y.

Carlier, Claude. 1764. *Histoire du duché de Valois, ornée de cartes et de gravures*, 3 vols. Paris.

Caviness, Madeline H., 1977a. *The Early Stained Glass of Canterbury Cathedral, circa 1175–1220*, Princeton.

———. 1977b. "New Observations on the Channel School: A French Glass-Painter in Canterbury" (abstract). In *Akten des 10. Internationalen Colloquiums des Corpus Vitrearum Medii Aevi*, Stuttgart/Freiburg-i-B. May 22–28, 1977, edited by Rüdiger Becksmann, pp. 30–31. Stuttgart.

———. 1979. "Conflicts between *Regnum* and *Sacerdotium* as Reflected in a Canterbury Psalter of ca. 1215." *Art Bulletin* 61: 38–58.

———. 1981. *The Windows of Christ Church Cathedral, Canterbury*, Corpus Vitrearum Medii Aevi: Great Britain, 2. London.

———. 1982. "Canterbury Cathedral Clerestory: The Glazing Programme in Relation to the Campaigns of Construction." In *Medieval Art and Architecture at Canterbury before 1220*, The British Archaeological Association Conference Transactions for the Year 1979, 5, pp. 46–55. London.

———. 1983. "Images of Divine Order and the Third Mode of Seeing." *Gesta* 22: 99–120.

———. 1984. "Saint-Yved of Braine: The Primary Sources for Dating the Gothic Church." *Speculum* 59: 524-58.

———. 1985. "Rediscovered Glass of about 1200 from the Abbey of St.-Yved at Braine." *Corpus Vitrearum: USA Occasional Papers*: 34–47.

———. 1986. "Suger's Stained Glass at St.-Denis: The State of Research." In Metropolitan Museum of Art, *Abbot Suger and Saint-Denis: A Symposium*, edited by Paula Gerson, pp. 257–72. New York.

———. 1987. "Romanesque belles-verrières in Canterbury?" In *Romanesque and Gothic: Essays for George Zarnecki*, edited by Neil Stratford, pp. 35–38. Woodbridge.

———. 1990. "The Twelfth-Century Ornamental Windows of Saint-Remi in Reims," in *On Romanesque and Gothic Art: A Symposium to Celebrate the Fiftieth Anniversary of The Cloisters*, edited by Elizabeth C. Parker. New York.

Caviness, Madeline H., et al. 1978. *Medieval and Renaissance Stained Glass from New England Collections*, exhibition catalogue, Cambridge, Mass., Busch-Reisinger Museum, April 25–June 10. Medford.

Caviness, Madeline H., Elizabeth Pastan, and Marilyn Beaven. 1984. "The Gothic Window from Soissons: A Reconsideration." In Isabella Stewart Gardner Museum, *Fenway Court 1983*, pp. 6–25. Boston.

Collery. 1857–1858. "Note sur les statuettes qui décorent les piliers: Choeur de Saint-Remi, de Reims." *Travaux de l'Académie impériale de Reims* 27: 265–73.

[Collon–]Gevaert, Suzanne. 1942. "Le Chandelier de Reims." *Revue belge d'archéologie et d'histoire de l'art* 12: 21–30.

Connick, Charles J. 1937. *Adventures in Light and Color: An Introduction to the Stained Glass Craft*. New York.

Cothren, Michael W. 1980. "The Thirteenth and Fourteenth-Century Glazing of the Choir of the Cathedral of Beauvais." Ph.D. dissertation, Columbia University.

Coutansais, F. Poirier. 1961. "Un projet de 'Gallia Monastica' I: Abbayes du diocèse de Reims, quelques résultats obtenus." *Revue d'histoire ecclésiastique* 56, no. 3–4: 793–812.

Cowen, Painton. 1979. *Rose Windows*. London.

Day, Lewis F. 1909. *Windows: A Book about Stained and Painted Glass*, 3d ed. London.

Delaporte, Yves, and Houvet, Emile. 1926. *Les Vitraux de la cathédrale de Chartres*, 4 vols. Chartres.

Demotte, L.-J. 1929. *Catalogue of an Exhibition of Stained Glass from the XIth to the XVIIIth Cent*. New York.

Demus, Otto. 1970. *Romanesque Mural Painting*. New York.

Deuchler, Florens. 1967. *Der Ingeborgpsalter*. Berlin.

———. 1973. *Gothic Art*. New York.

Didron, Adolphe Napoléon. 1844. "Symbolique chrétienne: La Gloire." *Annales archéologiques*, Paris, 1: 1–13.

Dodwell, Christopher R. 1954. *The Canterbury School of Illumination*. Cambridge.

———. 1971. *Painting in Europe 800 to 1200*. Harmondsworth.

Douët d'Arcq, Louis. 1863–1868. *Collection de Sceaux*, Archives de l'Empire, Inventaires et Documents, 3 vols. Paris.

Dow, Helen J. 1957. "The Rose Window." *Journal of the Warburg and Courtauld Institutes* 20: 248–97.

Du Chesne. 1631. *Histoire Généalogique de la maison royale de Dreux*. Paris.

Eames, Elizabeth. 1982. "Notes on the Decorated Stone Roundels in the Corona and Trinity Chapel in Canterbury Cathedral." *Medieval Art and Architecture at Canterbury before 1220*, The British Archaeological Association Conference Transactions for the Year 1979, 5, pp. 66–70. London.

Erlande-Brandenburg, Alain. 1975. *Le Roi est mort: Etude sur les funérailles, les sépultures et les tombeaux des rois de France jusqu'à la fin du XIIIe siècle*, Bibliothèque de la Société française d'Archéologie, 7. Geneva.

Florival, Adrien de, and Midoux, Etienne. 1882–1891. *Les Vitraux de la cathédrale de Laon*, 4 vols. Paris.

Frankl, Paul. 1960. *The Gothic: Literary Sources and Interpretations through Eight Centuries*. Princeton.

———. 1963. "The Chronology of the Stained Glass in Chartres Cathedral." *Art Bulletin* 45: 301–22.

Frodl-Kraft, Eva. 1970. *Die Glasmalerei: Entwicklung, Technik, Eigenart*. Vienna and Munich.

———. 1972. "Zu den Kirchenschaubildern in den Hochchorfenstern von Reims—Abbildung und Abstraktion." *Wiener Jahrbuch für Kunstgeschichte* 25: 28–52.

———. 1985. "Problems of Gothic Workshop Practices in Light of a Group of Mid-Fourteenth-Century Austrian Stained Glass Panels." In *Corpus Vitrearum, USA: Occasional Papers*: 107–23.

Gervase (Gervasius). 1879. *Gervasii Canturiensis Opera Historica*, vol. 2, Rolls Series 73, edited by W. Stubbs. London.

———. 1930. *Of the Burning and Repair of the Church of Canterbury in the Year 1174*, translated by Charles Cotton, pp. 6–24. Canterbury.

Greenhill, Eleanor S. 1976. "Eleanor, Abbot Suger, and Saint Denis." In *Eleanor of Aquitaine: Patron and Politician*, edited by William W. Kibler, pp. 81–113. Austin and London.

Gregory of Tours. 1974. *Gregory of Tours: The History of the Franks*, edited by Lewis H. Thorpe. Harmondsworth.

Grodecki, Louis. 1953. *Vitraux de France du XIᵉ au XVIᵉ siècle*, exhibition catalogue, Musée des Arts décoratifs, May–October. Paris.

———. 1960. "Les vitraux soissonnais du Musée Marmottan et des Collections américaines." *Revue des Arts* 10: 163–78.

———. 1963. "Problèmes de la peinture en Champagne pendant la second moitié du douzième siècle." In *Romanesque and Gothic Art: Studies in Western Art*, Acts of the Twentieth International Congress of the History of Art, 1, pp. 129–41. Princeton.

———. 1964. "Chronologie des vitraux de Chartres." *Bulletin Monumental* 122: 99–103.

———. 1965. "Le Maître de Saint Eustache de la cathédrale de Chartres." In *Gedenkschrift Ernst Gall*, edited by Margarete Kühn and Louis Grodecki, pp. 171–94. Berlin.

———. 1969. "Le Psautier de la reine Ingebourge et ses problèmes." *Revue de l'Art* 5: 73–78.

———. 1975. "Les Plus anciens vitraux de Saint-Remi de Reims." In *Beiträge zur Kunst des Mittelalters: Festschrift für Hans Wentzel zum 60. Geburtstag*, edited by Rüdiger Becksmann, Ulf-Dietrich Korn, and Johannes Zahlten, pp. 65–77. Berlin.

———. 1976. *Les Vitraux de Saint-Denis: Etude sur le vitrail au XIIᵉ siècle*, Corpus Vitrearum Medii Aevi, France Etudes 1. Paris.

———. 1978. "Les Problèmes de l'origine de la peinture gothique et le 'Maître de Saint Chéron' de la cathédrale de Chartres." *La Revue de l'Art* 40–41: 43–64.

Grodecki, Louis, and Catherine Brisac, with Claudine Lautier. 1977. *Le Vitrail roman*. Fribourg.

———. 1984. *Le Vitrail gothique 1200–1300*. Fribourg. [See also *Gothic Stained Glass*, Ithaca, N.Y., 1984.]

Hamann-Mac Lean, Richard. 1949–1950. "Antikenstudium in der Kunst des Mittelalters." *Marburger Jahrbuch für Kunstwissenschaft* 15: 157–250.

———. 1983. "Die reimser Denkmale des französischen Königtums im 12. Jahrhundert: Saint-Remi als Grabkirche im frühen und hohen Mittelalter." In *Beiträge zur Bildung der französischen Nation im Früh- und Hochmittelalter*, Nationes 4, edited by Helmut Beumann, pp. 93–259. Sigmaringen.

Hayward, Jane, and Walter Cahn. 1982. *Radiance and Reflection: Medieval Art from the Raymond Pitcairn Collection*, exhibition catalogue, The Cloisters, The Metropolitan Museum of Art. New York.

Heaton, Clement. 1908. "Early Stained Glass and Romanesque Architecture in Reims." *Burlington Magazine* 12: 366–68.

Hinkle, William M. 1965. *The Portal of the Saints of Reims Cathedral: A Study in Mediaeval Iconography*, College Art Association Monographs on Archaeology and Fine Arts, 13. New York.

Hugo, Charles-Louis. 1734. *Sacri et canonici ordinis Praemonstratensis Annales*, vol. 1. Nancy.

Katzenellenbogen, Adolf. 1964. *The Sculptural Programs of Chartres Cathedral: Christ–Mary–Ecclesia*. New York. First ed., Baltimore, 1959.

Kauffmann, C. M. 1975. *Romanesque Manuscripts 1066–1190*, A Survey of Manuscripts Illuminated in the British Isles, 3. London and Boston.

Kimpel, Dieter, and Robert Suckale. 1985. *Die gotische Architektur in Frankreich 1130–1270*. Munich.

King, Thomas H., and George T. Hill. 1857. *Etudes pratiques tirées de l'architecture du moyen âge en Europe*, vol. 1. Bruges. Translation: *The Study-Book of Medieval Architecture and Art*, vol. 1. London, 1868.

———. 1859. *Monographie de l'Abbaye royale de St. Yved de Braine en Soissonais*, Paris. [Reissue of part of 1857 title.]

Kitzinger, Ernst. 1977. *Byzantine Art in the Making: Main Lines of Stylistic Development in Mediterranean Art, 3rd–7th Century*. Cambridge, Mass.

Klein, Bruno. 1984. *Saint-Yved in Braine und die Anfänge der hochgotischen Architektur in Frankreich*, Veröffentlichung der Abteilung Architektur des Kunsthistorischen Instituts der Universität zu Köln 28. Cologne.

Kline, Naomi. 1983. *The Stained Glass of the Abbey Church at Orbais*. Ph.D. dissertation, Boston University. Ann Arbor, Mich.

Lacatte-Joltrois, Auguste. 1843. *Essais historiques sur l'église de Saint-Remi de Reims, ce qu'elle a été et ce qu'elle est actuellement*. Reims.

———. 1868. *Histoire et description de l'église de Saint-Remi de Reims*, augmenté par M. l'abbé Cerf. Reims.

Lafond, Jean. 1953. "Les Vitraux anciens de la cathédrale de Lausanne." *Congrès archéologique de France (Suisse romande)* 110: 116–32.

———. 1955. "Les Vitraux de la cathédrale Saint-Pierre de Troyes." *Congrès archéologique de France* 113: 29–48.

Leclercq, Jean. 1946. *La Spiritualité de Pierre de Celle (1115–1183)*. Paris.

Lemps, Michel de, and Roger Laslier. 1978. *Trésors de la Bibliothèque Municipale de Reims*. Reims.

Lepaige, Jean. 1633. *Bibliotheca Praemonstratensis Ordinis*. Paris.

Leroquais, Victor. 1940–1941. *Les Psautiers manuscrits latins des bibliothèques publiques de France*, 2 vols. Macon.

Le Vieil, Pierre. 1774. *L'Art de la peinture sur verre et de la vitrerie*. Paris. Reprint, Geneva, 1973.

Lewis, Andrew W. 1985. "Fourteen Charters of Robert I of Dreux (1152–1188)." *Traditio* 41: 145–79.

Lillich, Meredith Parsons. 1970. "The Band Window: A

Theory of Origin and Development." *Gesta* 9 (1970): 26–33.

Magne, Lucien. 1884. *Vitraux anciens . . . catalogue*, Union Centrale des Arts Décoratifs, Section des monuments historiques. Paris.

———. 1885. "Le Vitrail," *Gazette des Beaux-arts* 2d ser. 31: 138–63, 417–24.

Mâle, Emile. 1953. *L'Art religieux du XIIe siècle en France*, 6th ed. Paris.

———. 1958. *L'Art religieux du XIIIe siècle en France*, 9th ed. Paris.

Marlot, G. 1843–1845. *Histoire de la ville, cité et université de Reims, métropole de la Gaule belgique*, 4 vols. Reims.

Martène, Edmond M., and Ursin Durand. 1724. *Voyage littéraire de deux religieux bénédictins de la Congrégation de Saint-Maur*, 2 vols. Paris.

McClain, Jearaldean. 1974. *A Reconstruction of the Sculpted Portals of the West Facade of Saint-Yved de Braine*. Ph.D. dissertation, Ohio State University. Ann Arbor, Mich., 1981.

———. 1985. "A Modern Reconstruction of the West Portals of Saint-Yved at Braine." *Gesta* 24: 105–19.

———. 1986. "Observations on the Geometric Design of Saint-Yved at Braine." *Zeitschrift für Kunstgeschichte* 49: 92–95.

Merson, Olivier. 1895. *Les Vitraux*, Bibliothèque de l'enseignement des beaux-arts. Paris.

Morgan, Nigel J. 1983. *The Medieval Painted Glass of Lincoln Cathedral*, Corpus Vitrearum Medii Aevi, Great Britain, Occasional Papers 3. London.

Morizot, P. 1939–1942. "John of Salisbury et la Champagne." In *Mémoires de la société académique d'agriculture, sciences, arts et belles-lettres du département de l'Aube* 99: 257–85.

Nilgen, Ursula. 1985. "Amtsgenealogie und Amtsheiligkeit: Königs- und Bishofsreihen in der Kunstpropaganda des Hochmittelalters." *Studien zur mittelalterlichen Kunst 800–1250: Festschrift für Florentine Mütherich zum 70. Geburtstag*, edited by K. Bierrauer et al., pp. 217–34. Munich.

Oppenheimer, Francis. 1953. *The Legend of the Ste. Ampoule*. London.

Ottin, L. 1896. *Le Vitrail: Son histoire, ses manifestations à travers les âges et les peuples*. Paris.

Panadero, Marjorie Jean H. 1984. *The Labors of the Months and the Signs of the Zodiac in Twelfth-Century French Facades*. Ph.D. dissertation, University of Michigan. Ann Arbor, Mich.

Parker, Elizabeth C. 1978. *The Descent from the Cross: Its Relation to the Extra-Liturgical Deposition Drama*. Ph.D. dissertation, NYU, 1975. Ann Arbor, Mich.

Pastan, Elizabeth. 1986. *The Early Stained Glass of Troyes Cathedral: The Ambulatory Chapel Glazing c. 1200–1240*. Ph.D. dissertation, Brown University, Ann Arbor, Mich.

Péré, Georges, 1921. *Le Sacre et le couronnement des rois de France dans leurs rapports avec les lois fondamentales*. Thèse: Sciences politiques. Toulouse.

Pestell, Richard. 1981. "The Design Sources for the Cathedrals of Chartres and Soissons." *Art History* 4: 1–13.

Peter of Celle. 1977. *Pierre de Celle. L'Ecole du Cloître: Introduction, texte critique, traduction et notes*, edited by Gérard de Martel. Paris.

Petit, François. 1947. *La Spiritualité des Prémontrés*. Paris.

Poquet, A.-E. and L. N. Daras. 1848. *Notice historique et archéologique de la cathédrale de Soissons*. Soissons.

Poussin, Clovis. 1857. *Monographie de l'Abbaye et de l'Eglise de St.-Remi de Reims*. Reims.

Prache, Anne. 1969. "Les Monuments funéraires des Carolingiens élevés à Saint-Remis de Reims au XIIe siècle." *Revue de l'Art* 6: 68–76.

———. 1978. *Saint-Remi de Reims: L'oeuvre de Pierre de Celle et sa place dans l'architecture gothique*, Bibliothèque de la Société française d'Archéologie, 8. Geneva.

———. 1981. "Le Vitrail de la Crucifixion de Saint-Remi de Reims." In *Etudes d'art offertes à Louis Grodecki*, by the International Center of Medieval Art and Association des publications près les universités de Strasbourg. Paris.

Prioux, Stanislas R. 1846. *Histoire de Braine et de ses environs*. Paris.

———. 1859. *Monographie de l'ancienne abbaye royale Saint-Yved de Braine*. Paris.

Raguin, Virginia Chieffo. 1982. *Stained Glass in Thirteenth-Century Burgundy*. Princeton.

Ravaux, J. P. 1972. "L'Eglise Saint-Remi de Reims au XIe siècle." *Bulletin archéologique du comité des travaux historiques et scientifiques* n.s. 8: 51–98.

Reinhardt, Hans. 1963. *La Cathédrale de Reims: Son histoire, son architecture, sa sculpture*. Paris.

Rothier, F. 1896. *Souvenir de l'Eglise St.-Remi de Reims*. Reims.

Sadler-Davis, Donna, 1984. *The Sculptural Program of the Verso of the West Facade of Reims Cathedral*. Ph.D. dissertation, Indiana University. Ann Arbor, Mich.

Sars, Maxime de, and Lucien Broche. 1933. *Histoire de Braine*. La Charité-Sur-Loire.

Sauerländer, Willibald. 1972. *Gothic Sculpture in France, 1140–1270*. New York.

———. 1982. "Radiance and Reflection: Medieval Art from the Raymond Pitcairn Collection. Ausstellung im Metropolitan Museum of Art, New York, 25.Februar bis 25.September 1982." *Kunstchronik* 35: 383–91.

Schiller, Gertrud. 1972. *Iconography of Christian Art, vol. 2: The Passion of Christ*, translated by Janet Seligman. Greenwich, Conn.

Schramm, Percy Ernst, and Florentine Mütherich. 1981. *Denkmale der deutschen Könige und Kaiser I: Ein Beitrag zur Herrschergeschichte von Karl dem Grossen bis Friedrich II. 768–1250*, Veröffentlichungen des Zentralinstituts für Kunstgeschichte in München 2. Munich.

Schreiner, Ludwig. 1963. *Die frühgotische Plastik Südwestfrankreichs: Studien zum Style Plantagenet zwischen 1170 und 1240 mit besonderer Berücksichtigung der Schlusssteinzyklen*. Cologne.

Simon, Jacques. 1959. "Restauration des vitraux de

Saint-Remi de Reims." *Les Monuments Historiques de la France* n.s. 5: 14–25.

Steger, Hugo. 1961. *David Rex et Propheta: König David als vorbildliche Verkoeperung des Herrschers und Dichters im Mittelalter, nach Bilddarstellungen des achten bis zwoelften Jahrhunderts,* Erlanger Beitraege 6. Nuremberg.

Stern, Henri. 1957. "Recueil Général des mosaïques de la Gaule." *Gallia Supplément* 10. Paris.

Stirnemann, Patricia. 1984. "Quelques Bibliothèques princières et la production hors scriptorium au XII^e siècle." *Bulletin archèologique du C.T.H.S.* n.s. 17–18: 7–38.

Suckale, Robert. 1981. "Thesen zum Bedeutungswandel der gotischen Fensterrose." In *Bauwerk und Bildwerk im Hochmittelalter,* edited by Karl Clausberg et al., pp. 259–94. Giessen.

Suger. 1979. *Abbot Suger on the Abbey Church of St.-Denis and Its Art Treasures,* edited, translated, and annotated by Erwin Panofsky, 2d. ed. Princeton, 1979.

Swarzenski, Hanns. 1967. *Monuments of Romanesque Art: The Art of Church Treasures in North-Western Europe,* 2d ed., London.

Tarbé, Prosper. 1844. *Reims: Essais historiques sur ses rues et ses monuments.* Reims.

Temple, E. 1976. *Anglo-Saxon Manuscripts 900–1066.* London.

Theophilus. 1961. *Theophilus, De diversis artibus: Theophilus, The Various Arts,* edited and translated by C. R. Dodwell. London.

Theophilus. 1963. *On Divers Arts: The Treatise of Theophilus,* edited and translated by John G. Hawthorne and Cyril Stanley Smith. Chicago. (Page references are to the reprint, New York, 1979.)

Tourneur, Victor. 1846. *Mémoire sur les vitraux de Notre Dame de Reims.* Reims.

———. 1856. "Quelles sont les verrières les plus remarquables du département?" *Congrès archéologique de France,* Châlons-sur-Marne, 1855, 22: 88–90.

———. 1862. "Mémoire." *Congrès archéologique de France,* Reims, 1861, 28: 87–102.

Viollet-le-Duc, Eugène E. 1868. "Vitrail." In *Dictionnaire raisonné de l'architecture française du XI^e au XVI^e siècle,* vol. 9. Paris. Reprint, 1870.

Wander, Steven. 1978. "Westminster Abbey and the Apostolic Churches of Northern France: A Contribution towards an Iconography of Medieval Architecture." *Studies in Iconography* 4: 2–22.

Westlake, N.H.J. 1881–1894. *A History of Design in Painted Glass,* 4 vols. London.

Wirth, Karl-August. 1970. "Notes on some Didactic Illustrations in the Margins of a Twelfth-Century Psalter." *Journal of the Warburg and Courtauld Institutes* 33: 20–40.

Woodman, Francis. 1981. *The Architectural History of Canterbury Cathedral.* London.

Zarnecki, George et al. 1984. *English Romanesque Art, 1066–1200,* exhibition catalogue, Hayward Gallery, April 5–July 8. London.

Zschokke, Fridtjof. 1942. *Die romanischen Glasgemälde des Strassburger Münsters.* Basel.

Illustrations

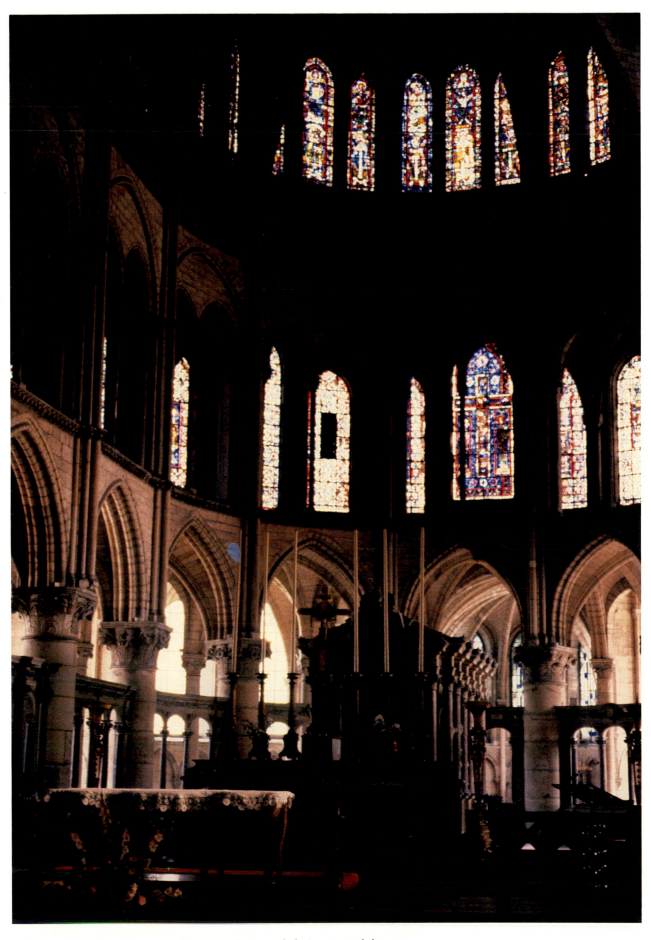

1. Reims, Saint-Remi, interior of the retrochoir, angled view toward the east

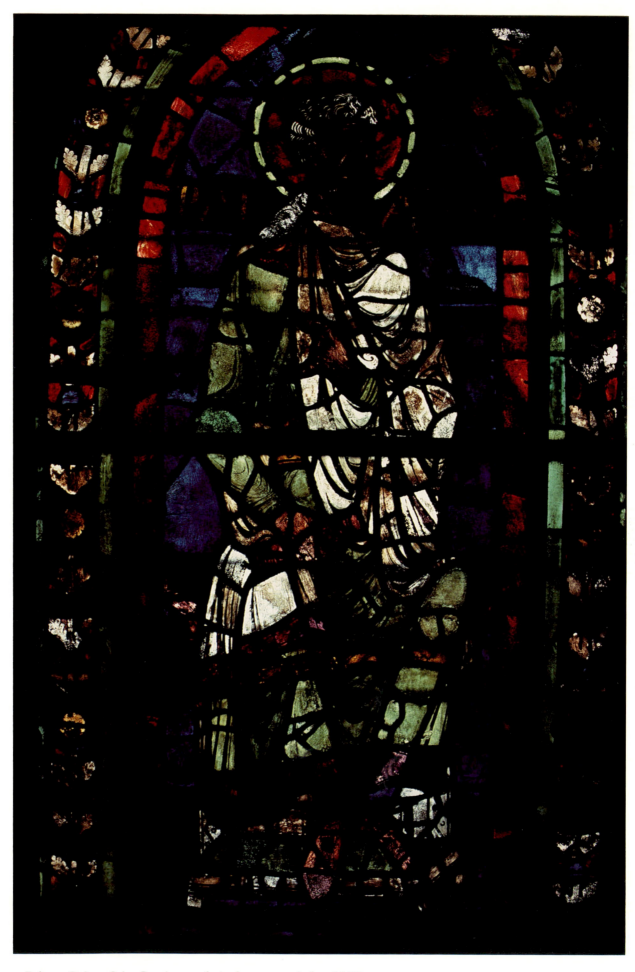

2. Balaam, Reims, Saint-Remi, retrochoir clerestory, window N.VI a

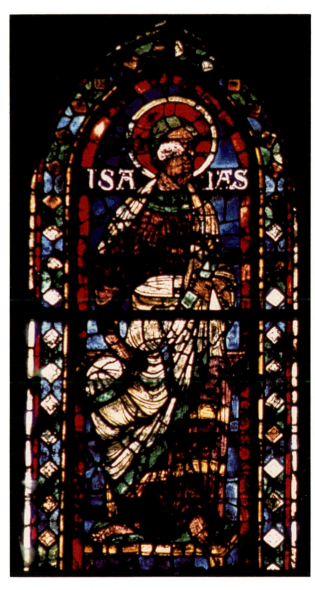

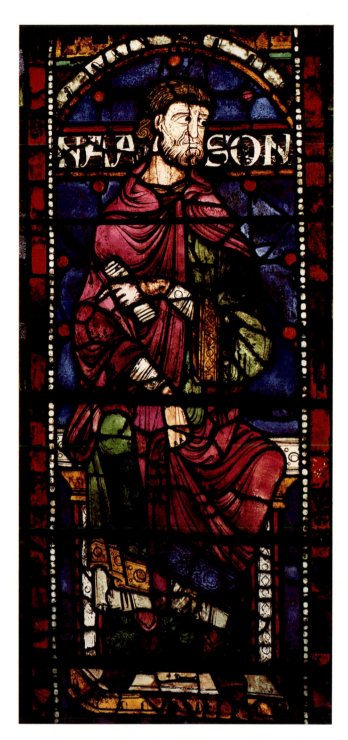

8. "Isaias," Saint-Remi, retrochoir clerestory, window N.III c

9. Nahshon, from Canterbury, Christ Church Cathedral, Trinity Chapel clerestory, window N.X

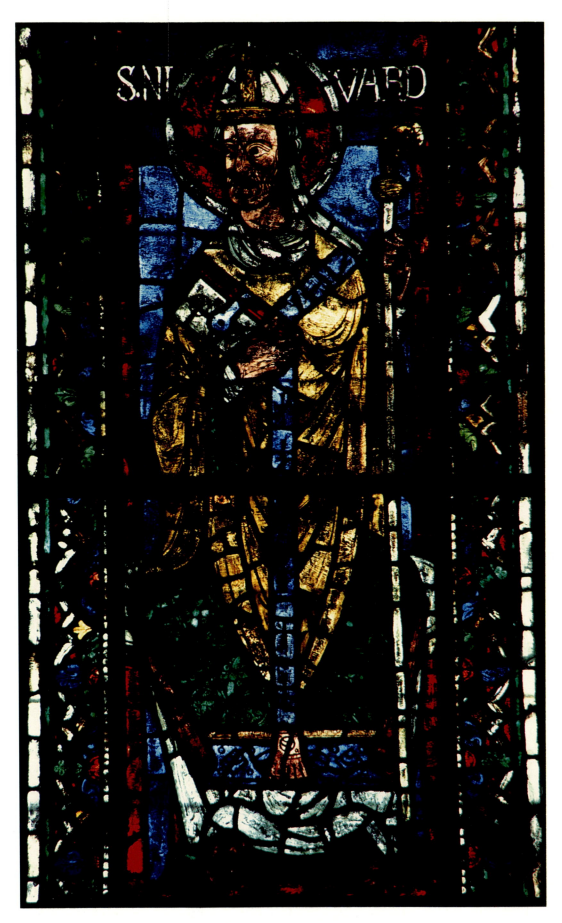

7. Archbishop "Nivard," Reims, Saint-Remi, retrochoir clerestory, window N.III c

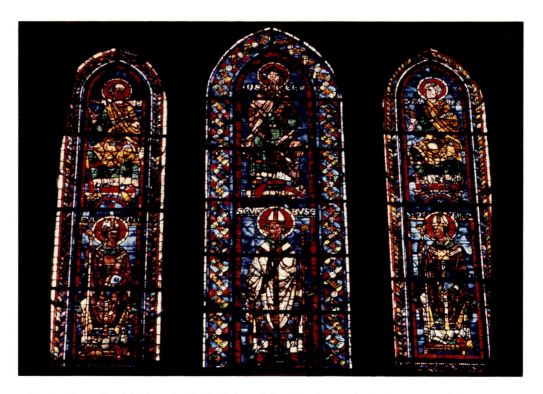

4. Patriarchs and archbishops in situ in Reims, Saint-Remi, retrochoir clerestory, windows N.V a–c

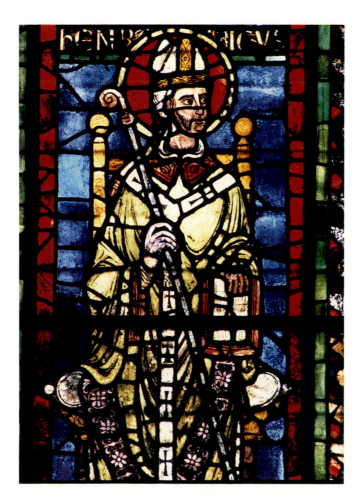

5. Archbishop Henri de France, Reims, Saint-Remi, retrochoir clerestory, window N.VI a

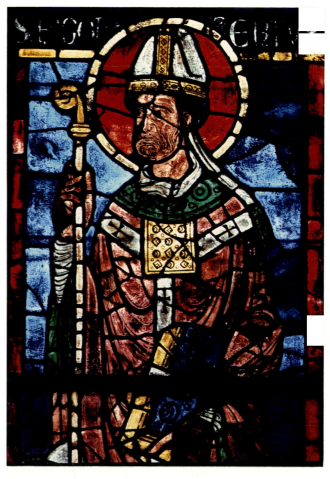

6. Archbishop Rigobertus, Reims, Saint-Remi, retrochoir clerestory, window N.III b

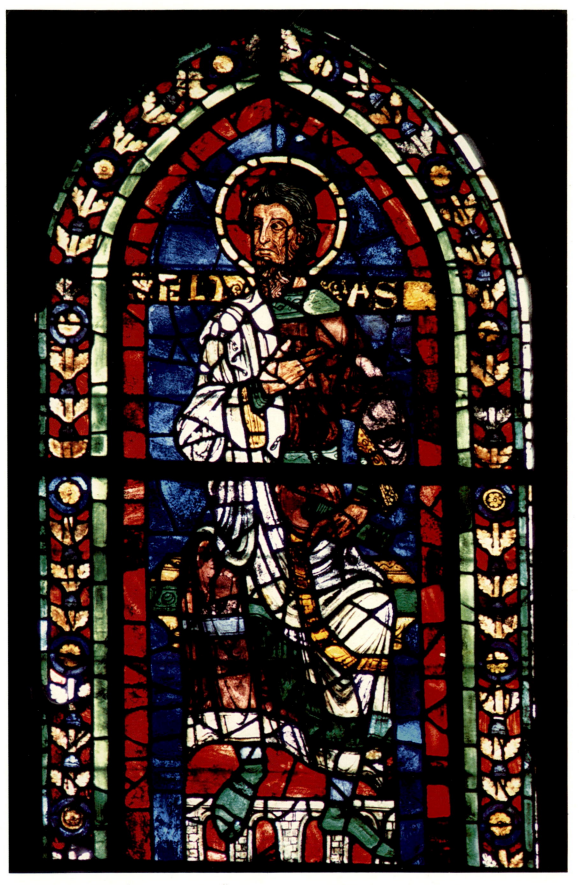

3. Elias, Reims, Saint-Remi, retrochoir clerestory, window N. VI c

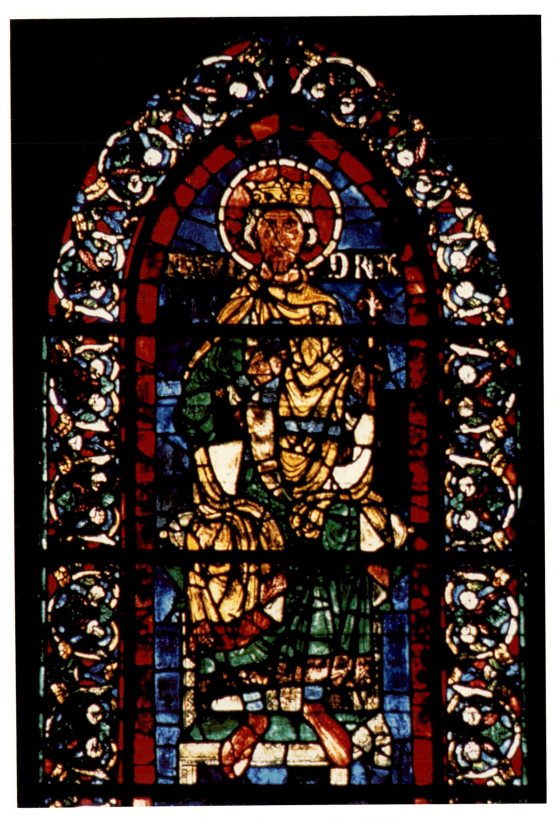

10. King David, Reims, Saint-Remi, retrochoir clerestory, window N.IV b

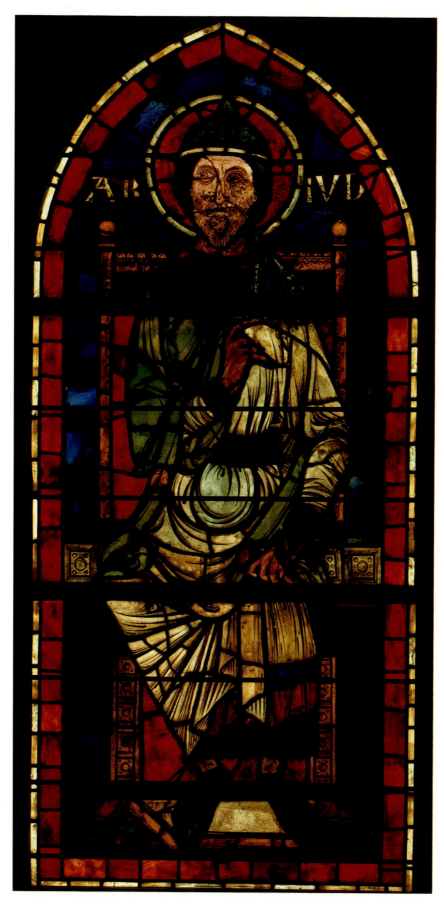

11. Bust of Abiud and part of another ancestor of Christ, from Braine, Saint-Yved, clerestory (Catalogue A, nos. 5, 6); now in New York, Metropolitan Museum of Art, accession no. 14.47 a–c

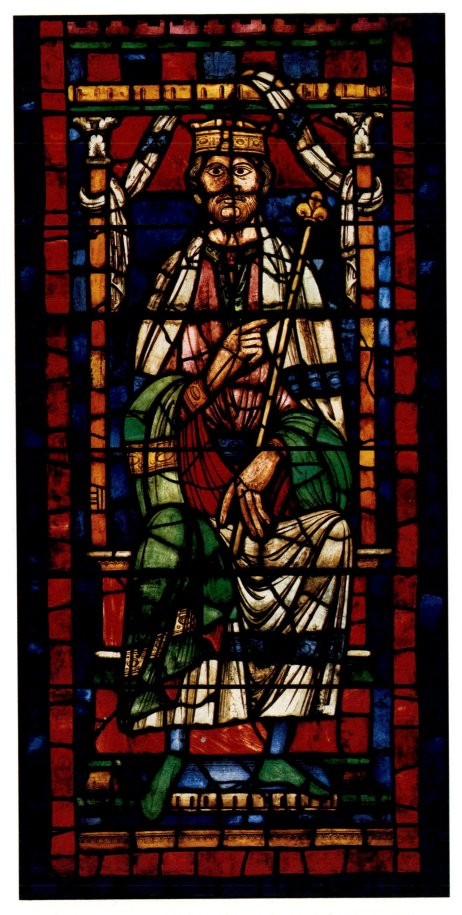

12. Parts of two ancestors of Christ (middle panel restored) from Braine, Saint-Yved, clerestory (Catalogue A, nos. 9, 10); now in Bryn Athyn, Glencairn Museum, accession no. 03.SG.234

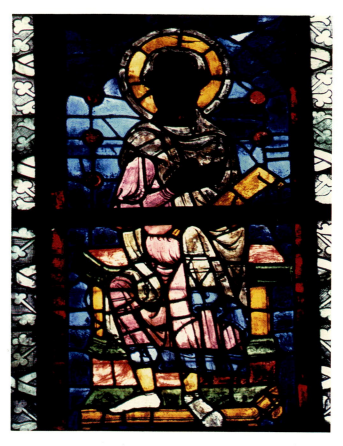

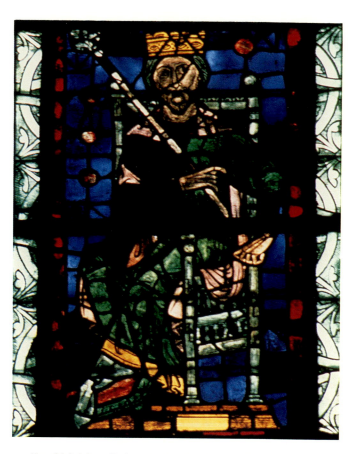

13. Patriarch or prophet, Reims, Saint-Remi, nave clerestory, window S.XVI

14. Frankish king, Reims, Saint-Remi, nave clerestory, window S.XXII

15. Border (Catalogue D, R.b.5), Reims, Saint-Remi, retrochoir tribune, window Nt.I a

16. Border (Catalogue D, R.b.11), Reims, Saint-Remi, retrochoir clerestory

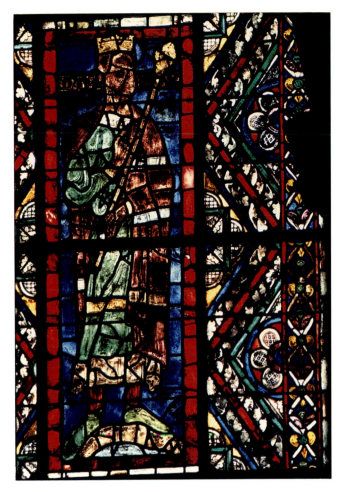

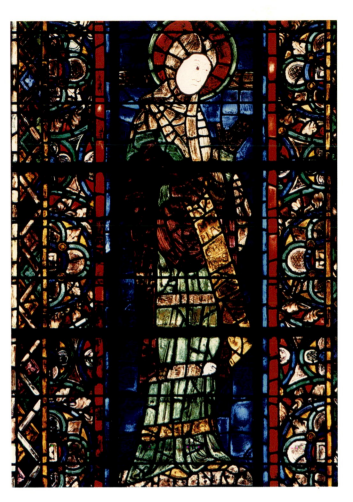

17. Methuselah, and ornament (Catalogue D, R.o.1, R.b.35), Reims, Saint-Remi, retrochoir tribune, window Nt.II c

18. St. Agnes, and ornament (Catalogue D, R.o.2), Reims, Saint-Remi, retrochoir tribune, window Nt.II a

19. Ornamental glass (Catalogue D, R.o.4, R.b.26), Reims, Saint-Remi, retrochoir tribune, window St.II c

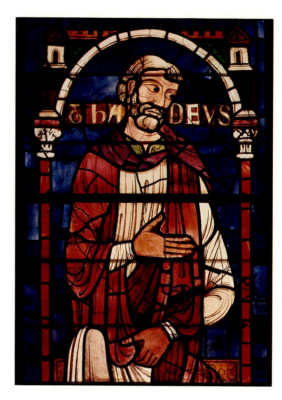

21. Parts of two ancestors of Christ, from Braine, Saint-Yved, clerestory (Catalogue A, nos. 12, 13); now in Baltimore, Walters Art Gallery, accession no. 46-38 (detail)

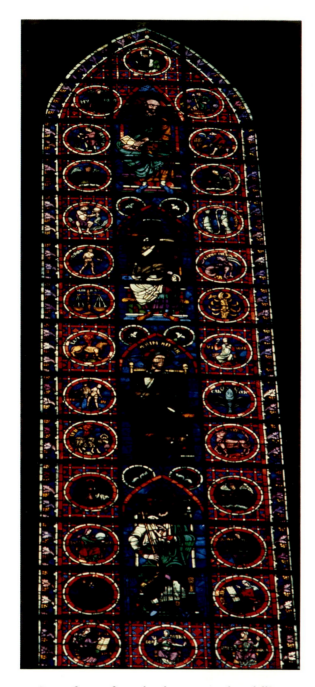

20. Large figures from the clerestory and medallions from the rose windows of Saint-Yved of Braine, now in Soissons, Cathedral of Saint-Gervais et Saint-Protais, choir clerestory

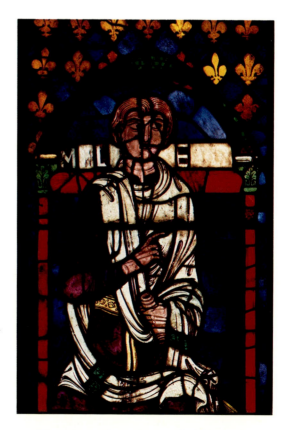

22. Upper part of an ancestor of Christ from Braine, Saint-Yved (Catalogue A, no. 11); now in St. Louis, City Art Museum, accession no. 137.20

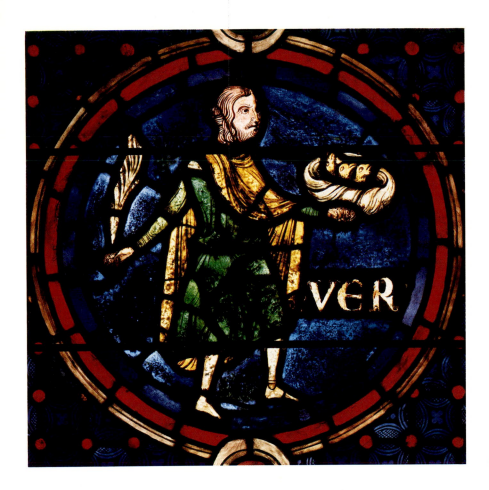

23. Spring, from Braine, Saint-Yved, transept rose (Catalogue A, no. 21); now in Bryn Athyn, Glencairn Museum, accession no. 03.SG.178

24. Grammar, from Braine, Saint-Yved, transept rose (Catalogue A, no. 19); now in Bryn Athyn, Glencairn Museum, accession no. 03.SG.179

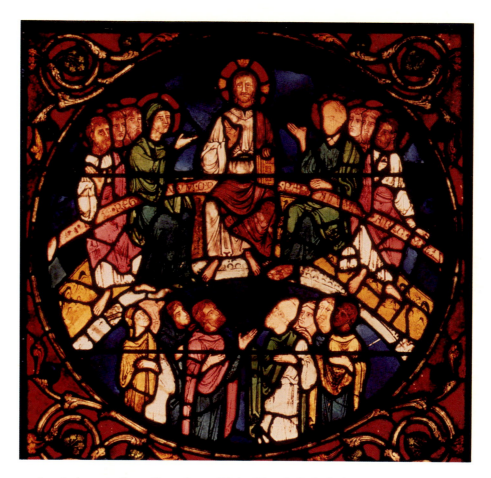

25. Last Judgment, from Canterbury, Christ Church Cathedral, Trinity Chapel clerestory, window I; now in Richmond, Virginia Museum of Fine Arts, The Adolph D. and Wilkins C. Williams Fund, accession no. 69-10

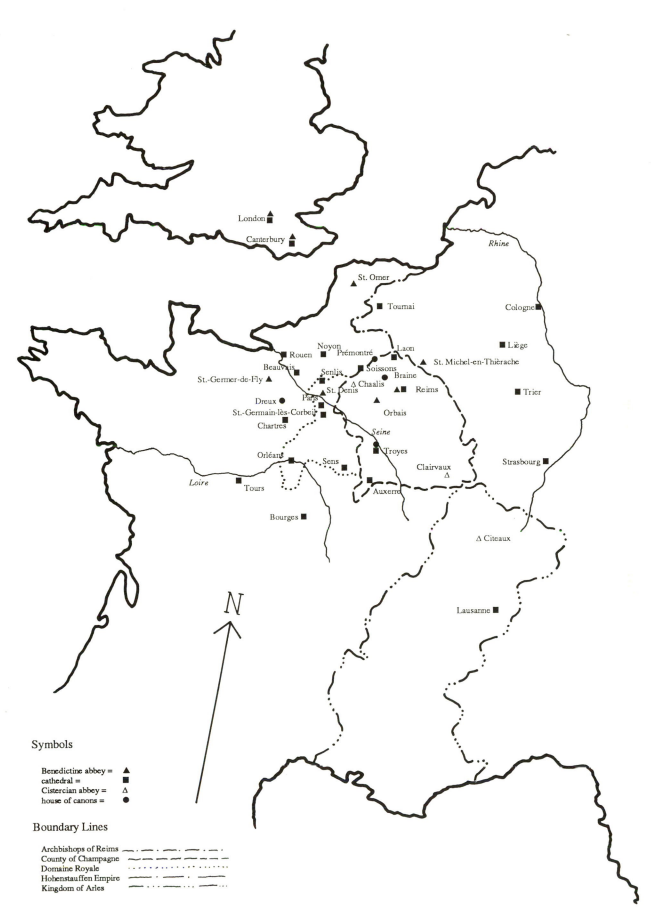

London ■
Canterbury ▲

St. Omer ▲
Tournai ■
Cologne ■
Noyon ■ Prémontré ● Laon ■ Liège ■
Rouen ■ St. Michel-en-Thièrache ▲
Beauvais ■ Senlis ■ Soissons ■ Braine ●
St.-Germer-de-Fly ▲ △ Chaalis Reims ▲■ Trier ■
Dreux ● Paris ▲ St. Denis ▲
St.-Germain-lès-Corbeil ■ Orbais
Chartres ■
Orléans ■ Seine
Sens ■ Troyes ■■
Loire Clairvaux Strasbourg ■
Tours ■ △
 Auxerre ■
Bourges ■
 △ Citeaux
 Lausanne ■
Rhine

N

Symbols

Benedictine abbey = ▲
cathedral = ■
Cistercian abbey = △
house of canons = ●

Boundary Lines

Archbishops of Reims
County of Champagne
Domaine Royale
Hohenstauffen Empire
Kingdom of Arles

1. Map of northern and central France and adjacent areas

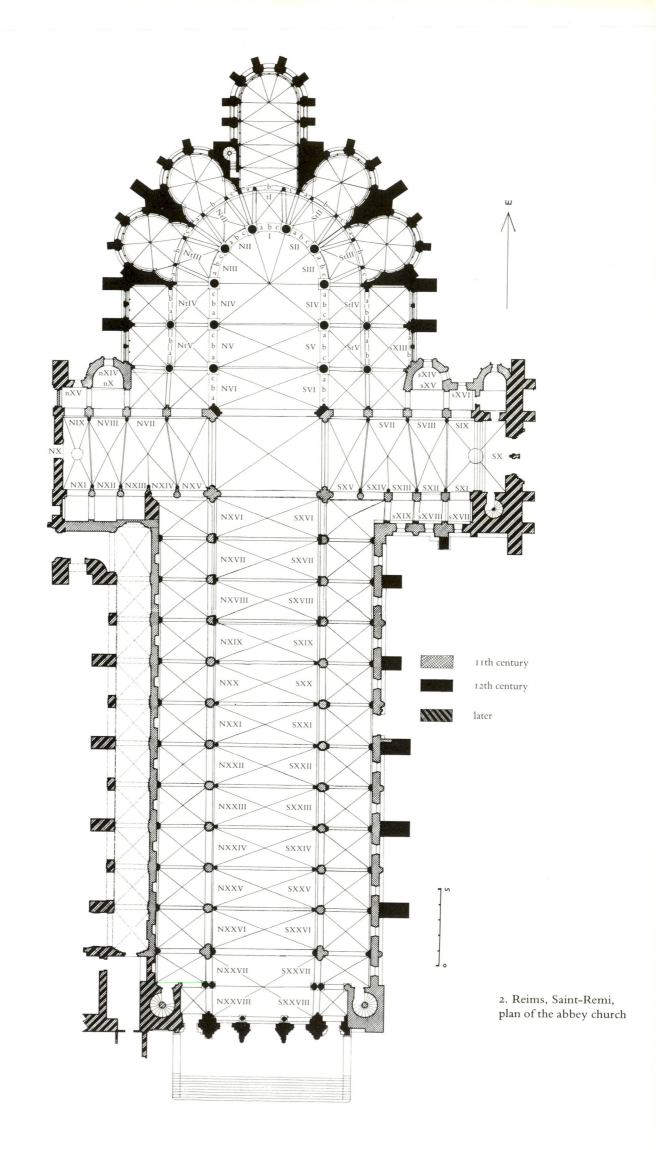

E

NtII
NII
SII
StII
NtIII
NIII
I
SIII
StIII
NtIV
NIV
SIV
StIV
NtV
NV
SV
StV
SXIII
NVI
SVI
nXIV
nX
sXIV
sXV
nXV
sXVI
NIX
NVIII
NVII
SVII
SVIII
SIX
NX
SX
NXI
NXII
NXIII
NXIV
NXV
SXV
SXIV
SXIII
SXII
SXI
sXIX
sXVIII
sXVII
NXVI
SXVI
NXVII
SXVII
NXVIII
SXVIII
NXIX
SXIX
NXX
SXX
NXXI
SXXI
NXXII
SXXII
NXXIII
SXXIII
NXXIV
SXXIV
NXXV
SXXV
NXXVI
SXXVI
NXXVII
SXXVII
NXXVIII
SXXVIII

11th century

12th century

later

5

0

2. Reims, Saint-Remi,
plan of the abbey church

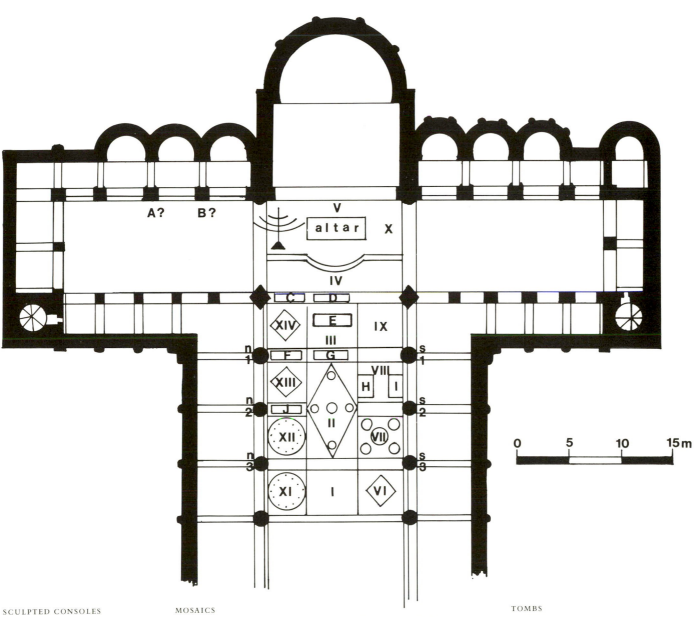

SCULPTED CONSOLES

n.1 Jeremiah, Ezekiel, and Aaron's rod

n.2 Daniel [?], Habbakuk, and instruments of the Passion

n.3 Enoch, Elijah

s.1 Moses, Aaron, and brazen serpent

s.2 David, Solomon [?], and pelican

s.3 John the Baptist [?], and the lamb [?]

MOSAICS

I figure of David

II busts of Jerome and the Biblical authors (Old and New Testament)

III "marquetry" and cantors either side of tomb E (Expilly)

IV Jacob's ladder

V Sacrifice of Isaac

VI four rivers; four elements

VII Orbis terrae and four seasons

VIII Tree of Life [?]

IX seven liberal arts

X Wisdom with Sloth and Ignorance

XI Moses and twelve months

XII constellations of the Great Bear and Little Bear, and zodiac

XIII four corners of the world

XIV four cardinal virtues

TOMBS

A&B enthroned effigies of Louis IV d'Outremer and Lothair

C Count Burchard

D Queen Gerburge

E Abbot Airard (d. 1005)

F Archbishop Arthaud

G Abbot Thierry (d. 1035)

H Archbishop Guy de Chatillon

I Arnoul, Count of Roucy

J Albrade, daughter of Louis IV d'Outremer

3. Reims, Saint-Remi, plan of the east end as in the early twelfth century, with the placement of the mosaic and later sculpted capitals

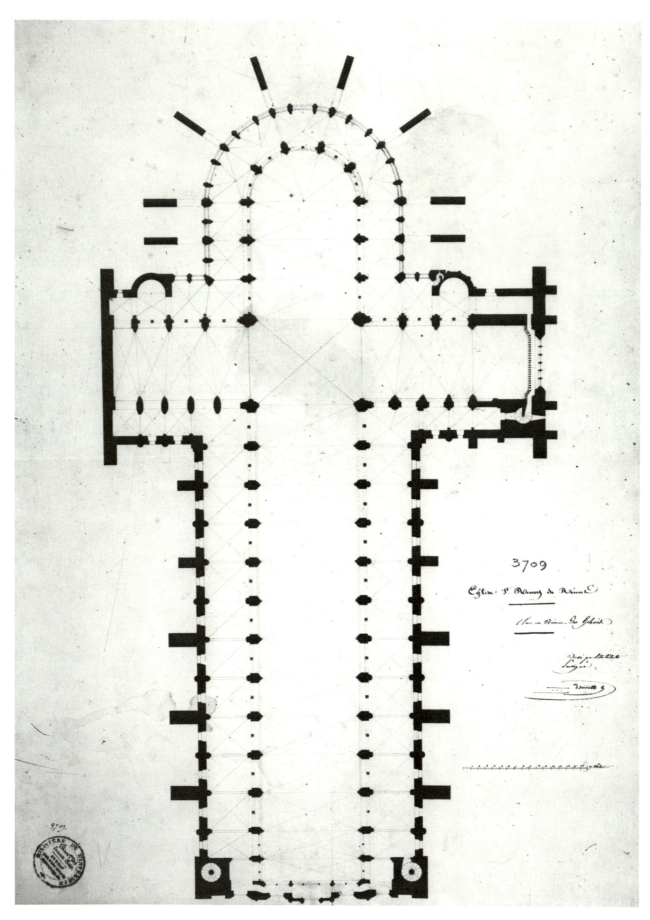

4. Reims, Saint-Remi, plan of the vaulting of the tribunes and central vessel

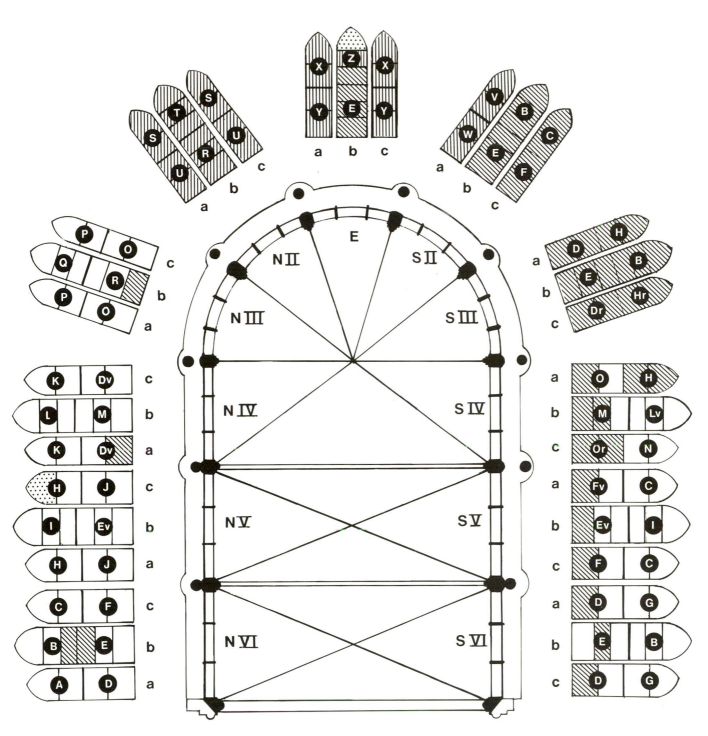

▨▨▨ lost since Rothier (ca. 1895)

▥▥▥ already replaced before Rothier

⠿⠿⠿ preserved elsewhere

5. Reims, Saint-Remi, plan of the clerestory windows of the retrochoir showing the use of cartoons

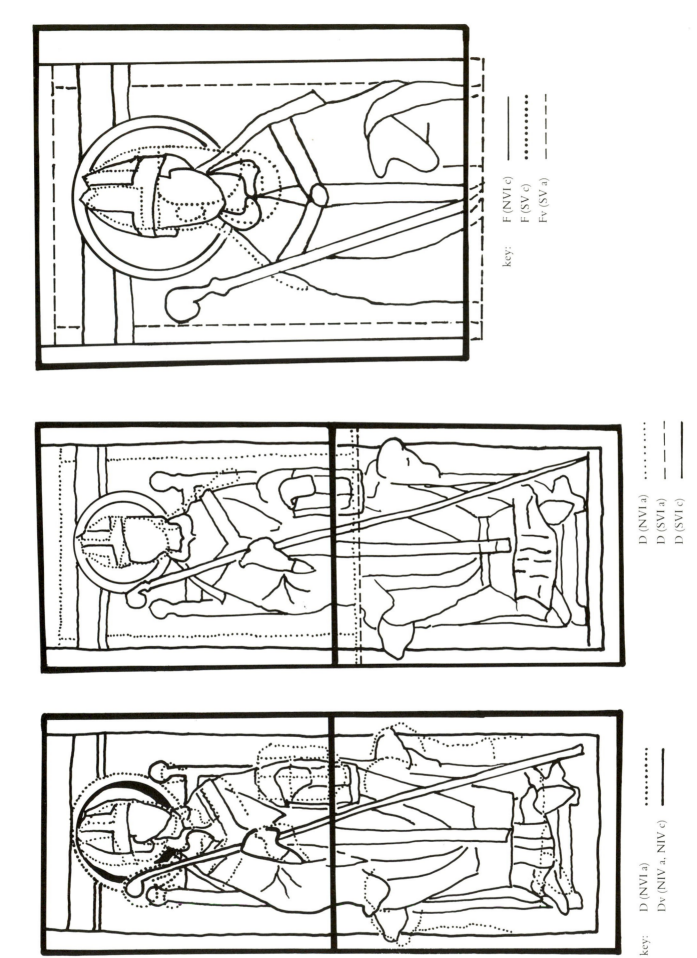

key: F (NVI c) ————
 F (SV c) ··········
 Fv (SV a) – – – –

D (NVI a) ··········
D (SVI a) – – – –
D (SVI c) ————

key: D (NVI a) ··········
 Dv (NIV a, NIV c) ————

6 and 7. Reims, Saint-Remi, adjustments to cartoons D and F as used in the retrochoir clerestory windows

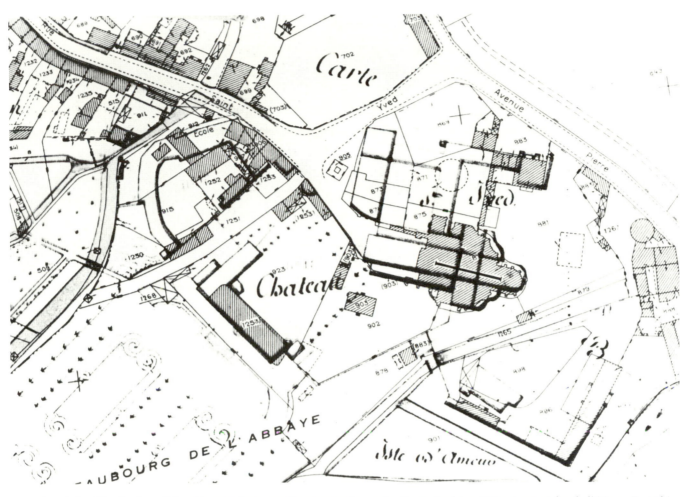

8. Braine, Saint-Yved, plan of the abbey and surrounding properties, 1782, Laon, Archives Départementales de l'Aisne, E 130bis

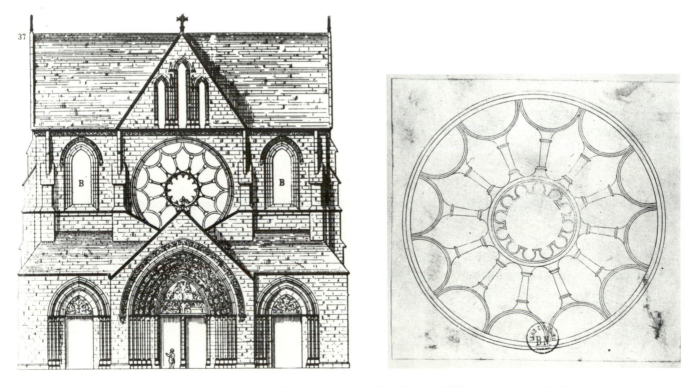

10. Braine, Saint-Yved: a. reconstructed elevation of the west facade (after King and Hill, 1857); b. detail of west rose, anonymous nineteenth-century drawing: B.N., Estampes V^c 140a vol. 29 (Collection Fleury: Braine), f.33

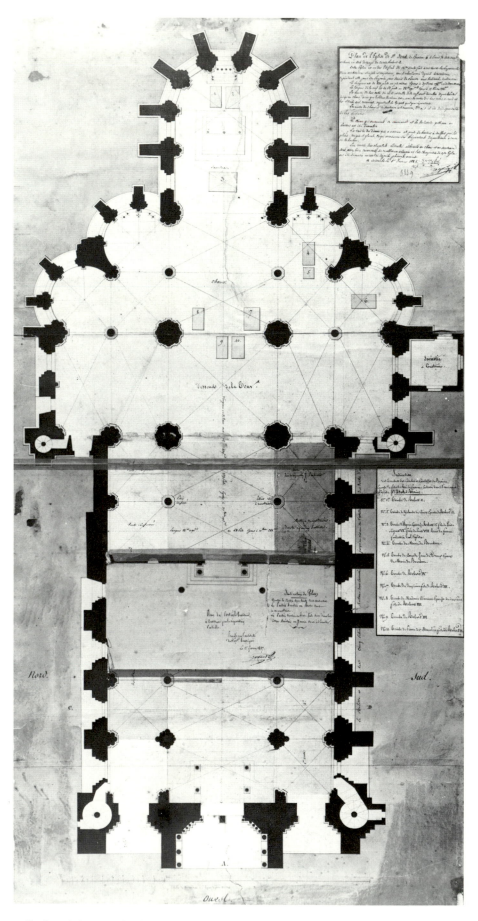

9. Braine, Saint-Yved, plan of the abbey church drawn by Paul Duroche, 1825

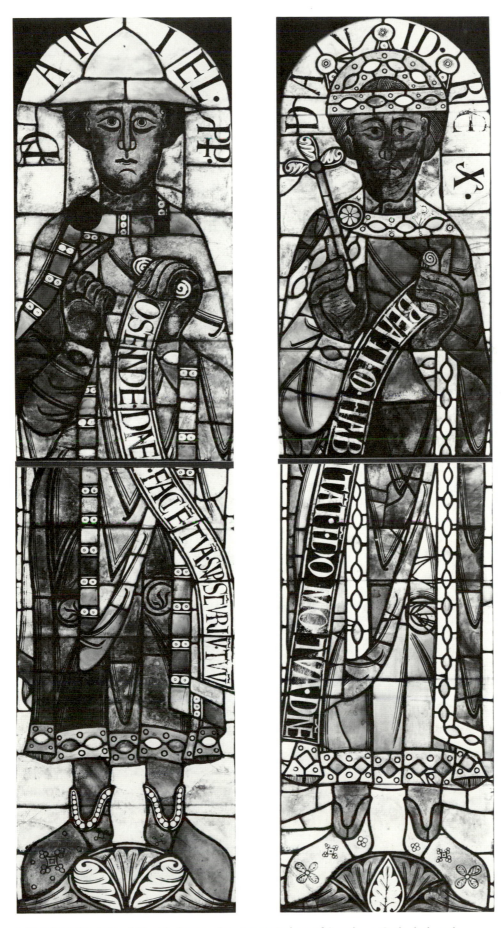

1. Prophets Daniel and David, from a clerestory window of Augsburg Cathedral, early twelfth century

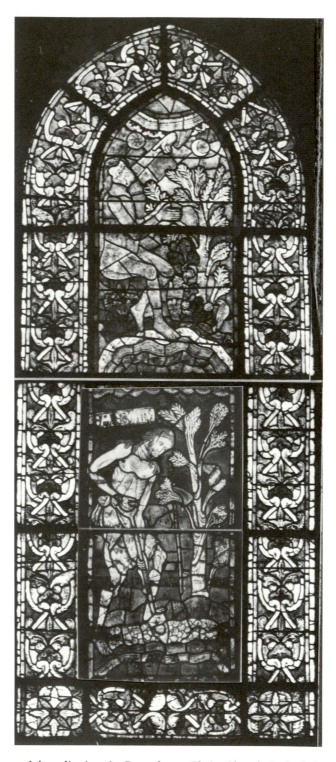

2. Adam digging, in Canterbury, Christ Church Cathedral,
choir clerestory window N.XXV, ca. 1178–1180

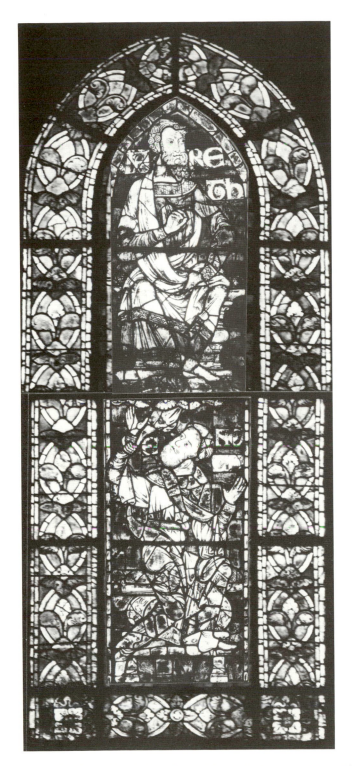
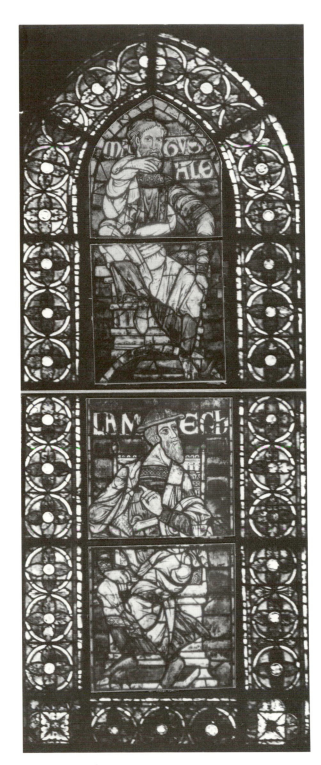

3. Jared and Enoch, Methuselah and Lamech, in Canterbury, Christ Church Cathedral, choir clerestory windows N.XXII and XXI, ca. 1178–1180

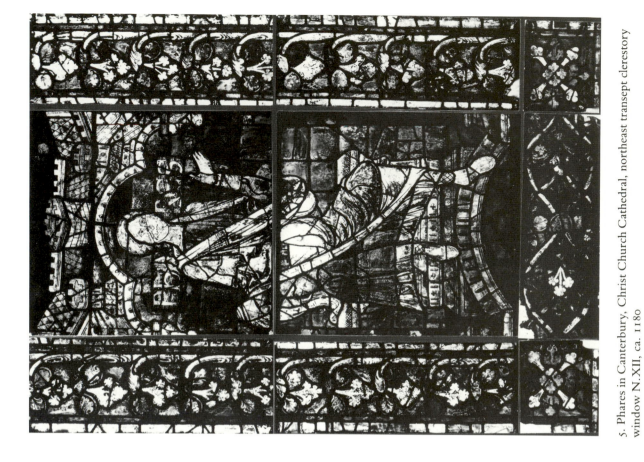

5. Phares in Canterbury, Christ Church Cathedral, northeast transept clerestory window N.XII, ca. 1180

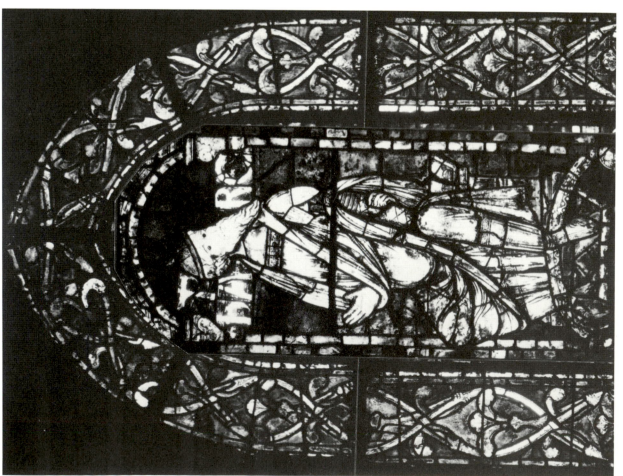

4. Thara in Canterbury, Christ Church Cathedral, northeast transept clerestory window N.XIV, ca. 1180

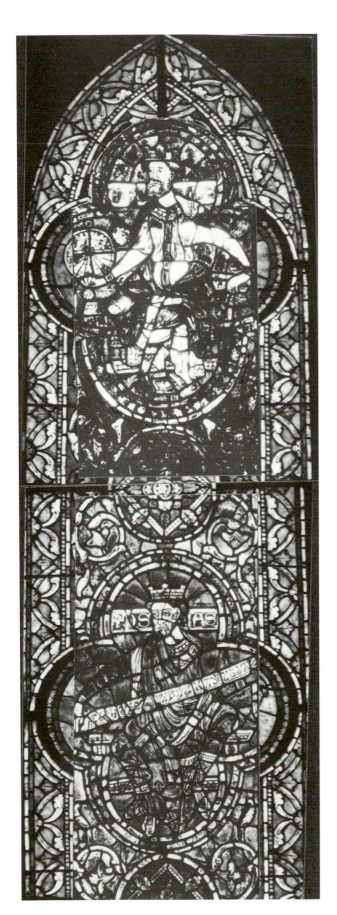

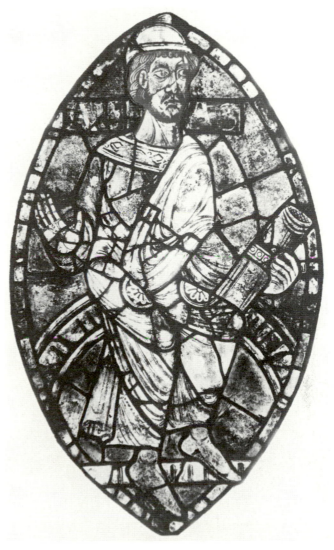

7. Abijah, Canterbury, Christ Church Cathedral, from Trinity Chapel clerestory window N.VI, ca. 1155–65; original head montaged

6. Hezekiah and Josiah in Canterbury, Christ Church Cathedral, Trinity Chapel clerestory window N.V., ca. 1210–1220

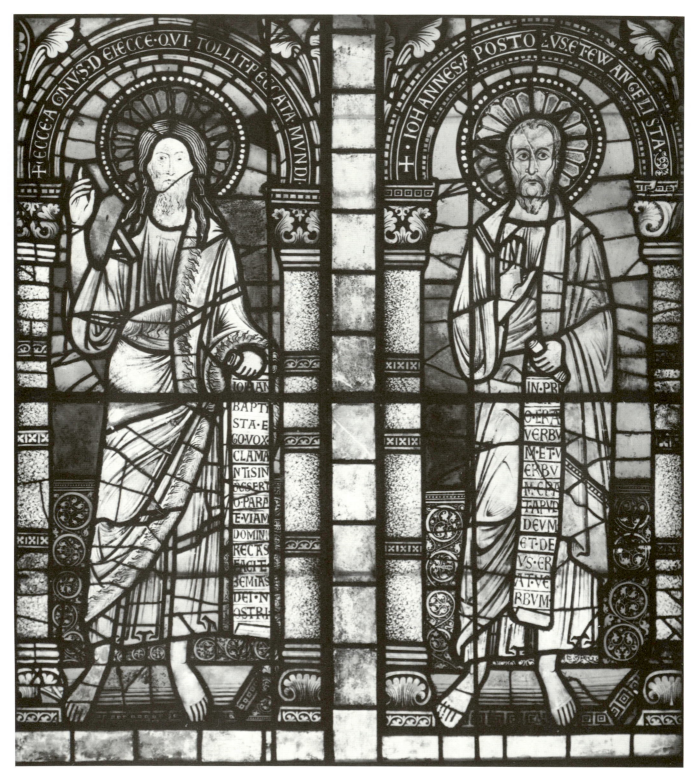

8. St. John the Baptist and St. John the Evangelist, Strasbourg Cathedral, north transept window n.IV, late twelfth century

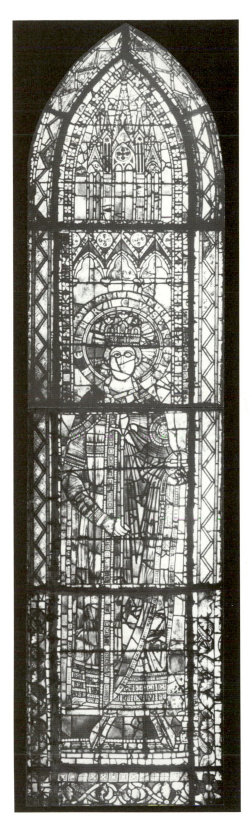

9. a. Reconstruction of the nave aisle and clerestory program of Strasbourg Cathedral in the twelfth century

9. b. King Henry, Strasbourg Cathedral, north nave aisle window n. VII, late twelfth century with late thirteenth-century canopy

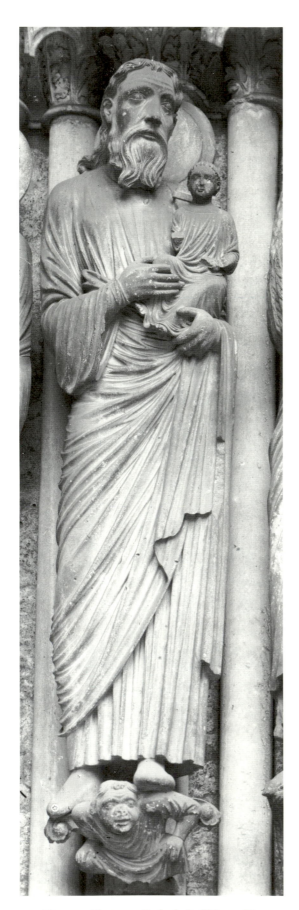

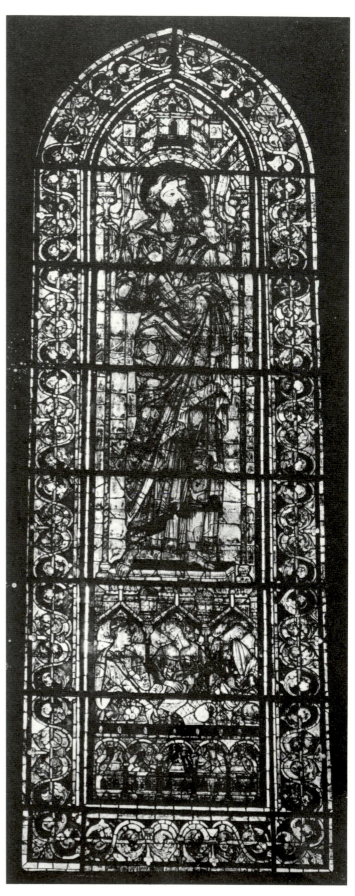

10. Simeon, Chartres, Cathedral of Notre-Dame, north transept, center doorway, right jamb, ca. 1205–1210

11. An apostle and moneychangers, Chartres, Cathedral of Notre-Dame, nave clerestory window CLXIV, ca. 1205–1210

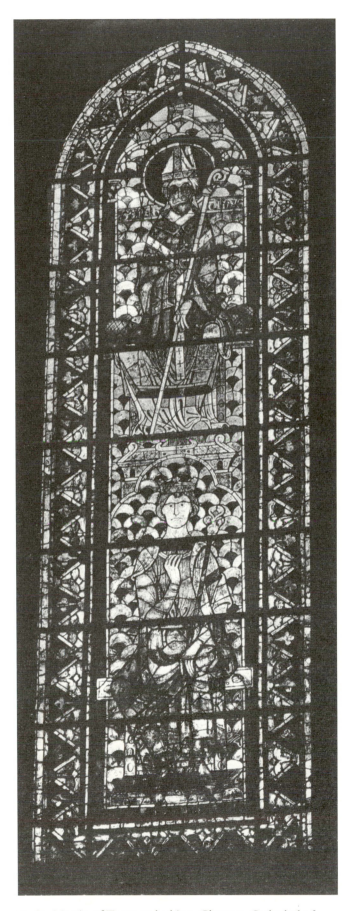

12. St. Martin of Tours and a king, Chartres, Cathedral of
Notre-Dame, nave clerestory window CLVI, ca. 1205–1210

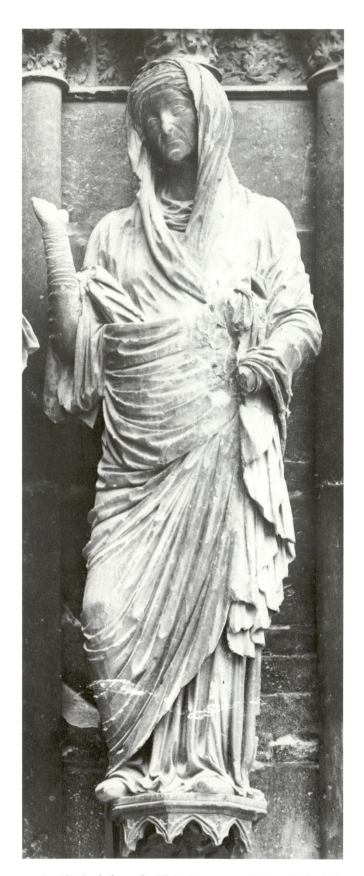

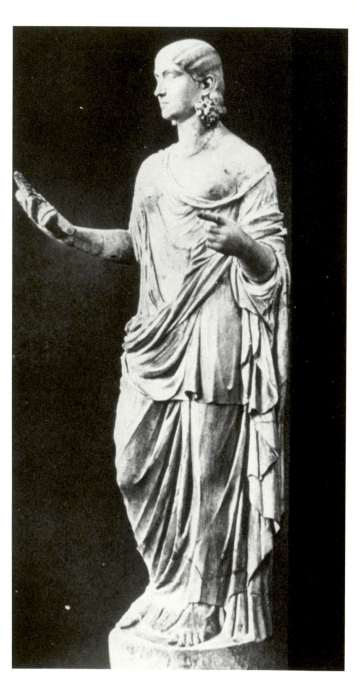

13. St. Elizabeth from the Visitation group, Reims, Cathedral of Notre Dame, west portal, center doorway, right jamb, ca. 1230–1233

14. Draped female, restored as Ceres, Roman statue, first century A.D. (head early third century), Paris, Musée du Louvre, Collection Borghese, no. 1075

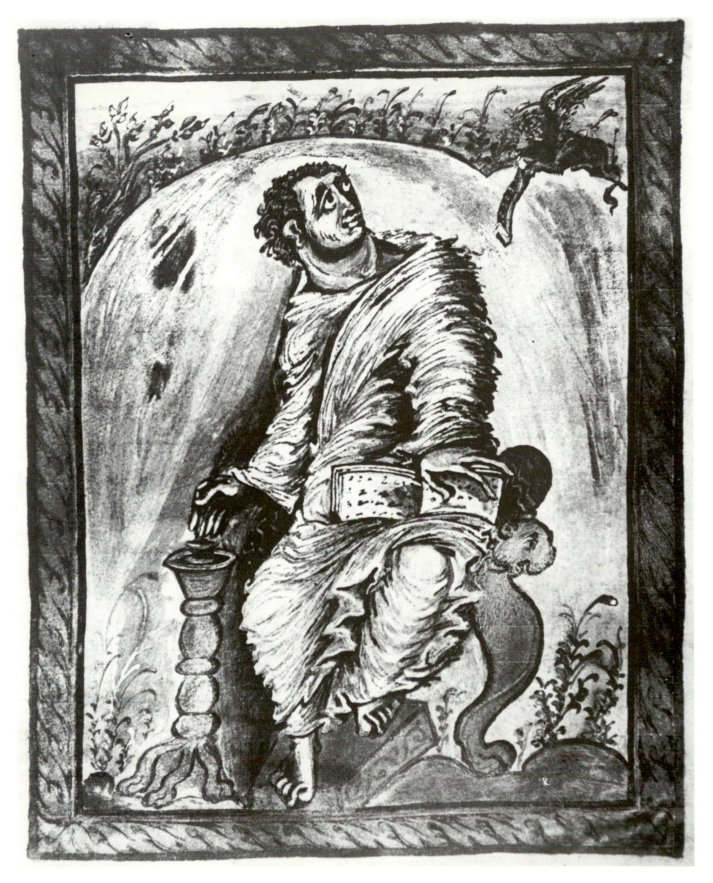

15. Evangelist Mark from the Ebo Gospels, Reims school, 816–835, Epernay, B.M., MS 1, f. 60v

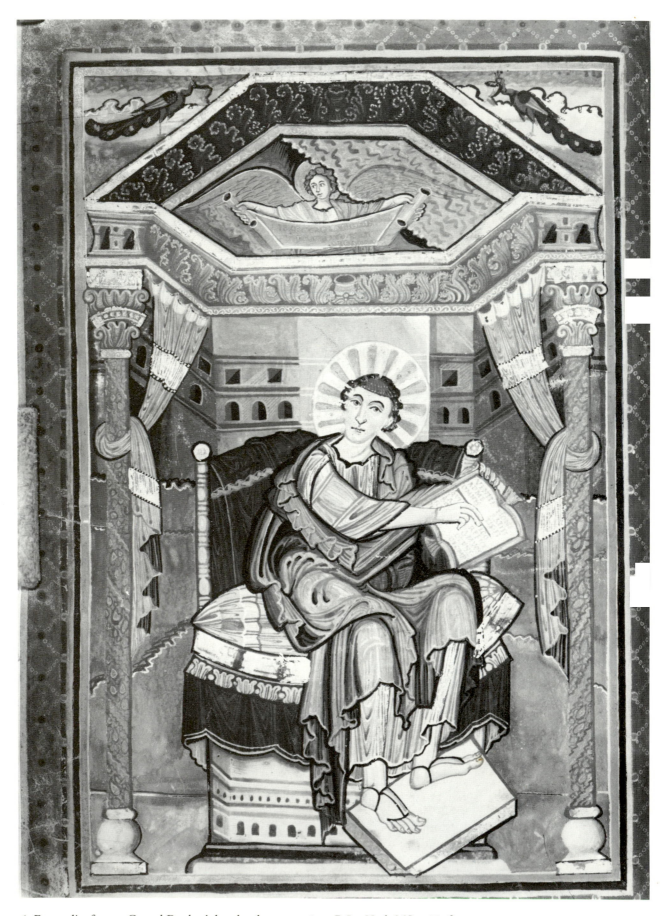

16. Evangelist from a Gospel Book, Ada school, ca. 790–800, B.L., Harl. MS 2788, f. 13v

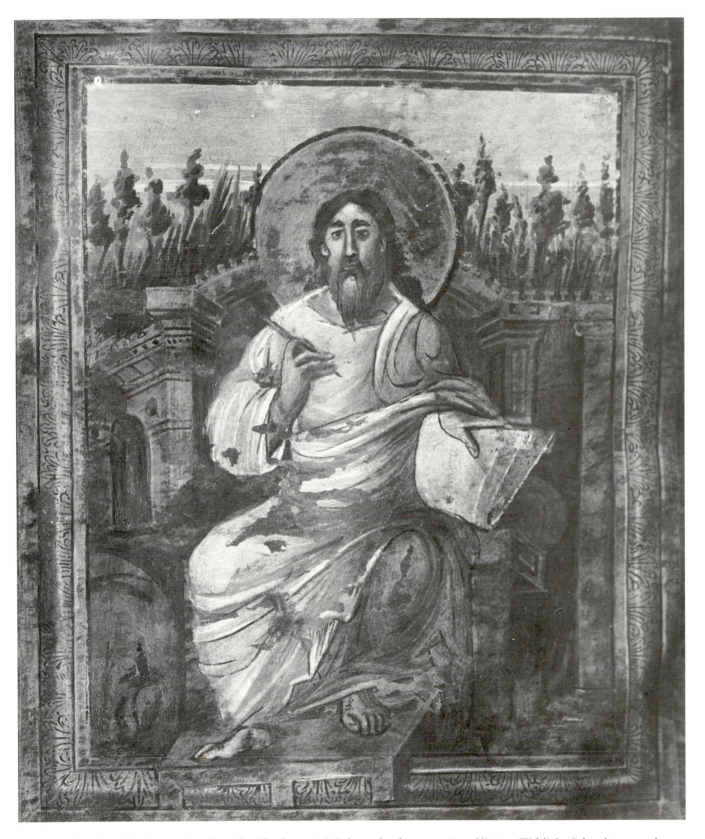

17. Evangelist from the Coronation Gospels, Charlemagne's Palace school, ca. 795–810, Vienna, Weltliche Schatzkammer der Hofburg, f. 15

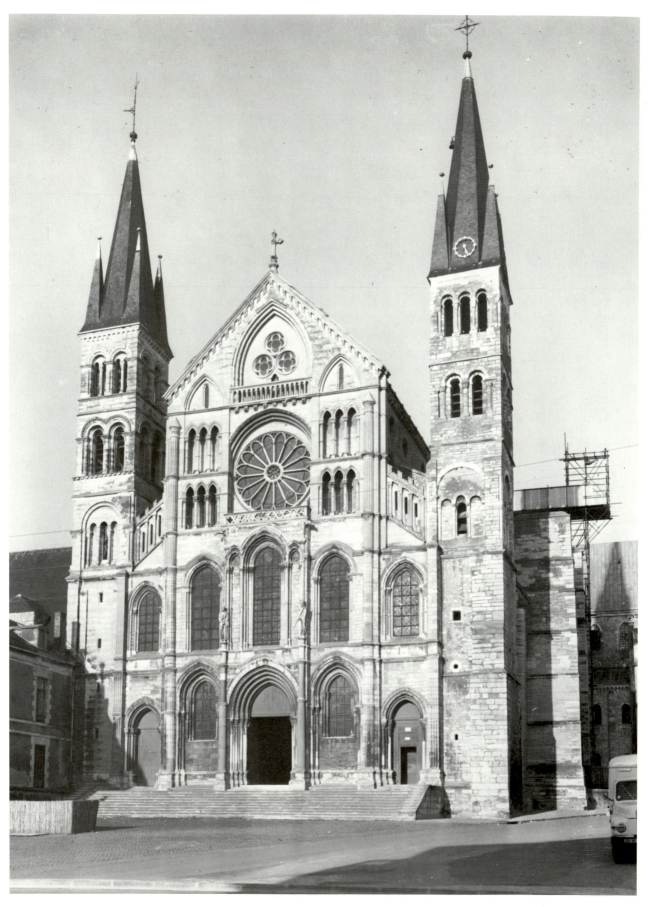

18. Reims, Saint-Remi, the abbey church from the west

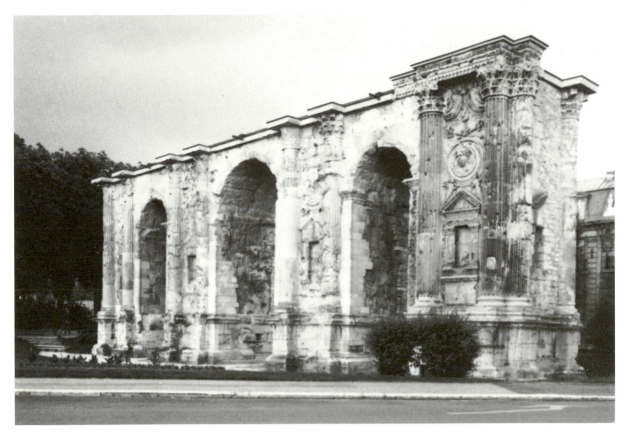

19. Reims, Porte de Mars (Roman arch), third century

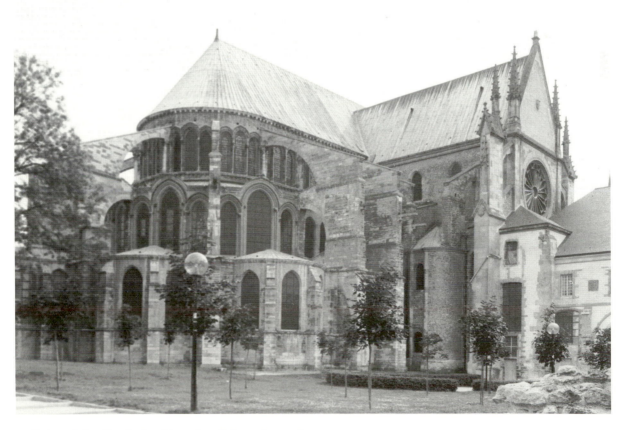

20. Reims, Saint-Remi, the abbey church from the northeast

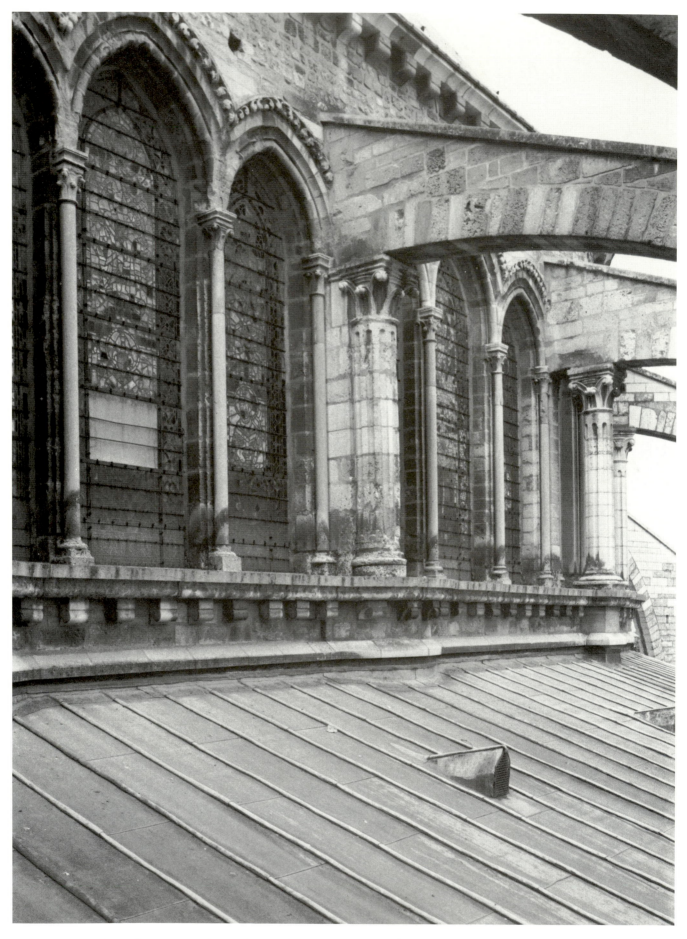

21. Reims, Saint-Remi, buttresses on the south side of the retrochoir clerestory

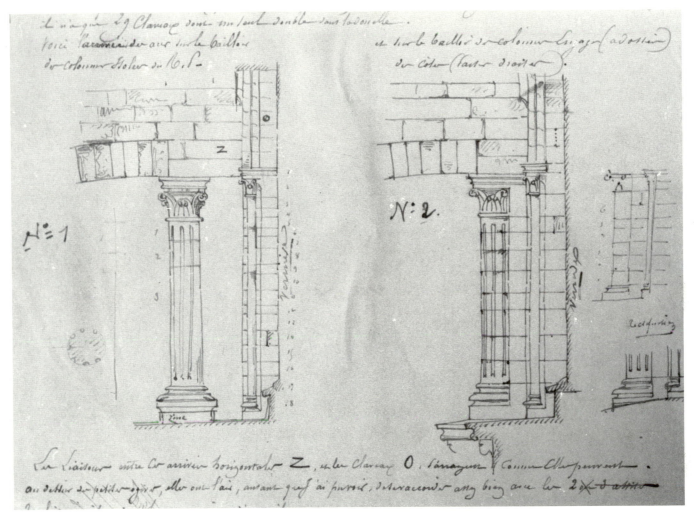

22. Reims, Saint-Remi, drawing by Auguste Reimbeau, before 1865, of the columns under the buttresses on the retrochoir clerestory, Reims, B.M., MS 2100, dossier III, i, no. 4, f. 1

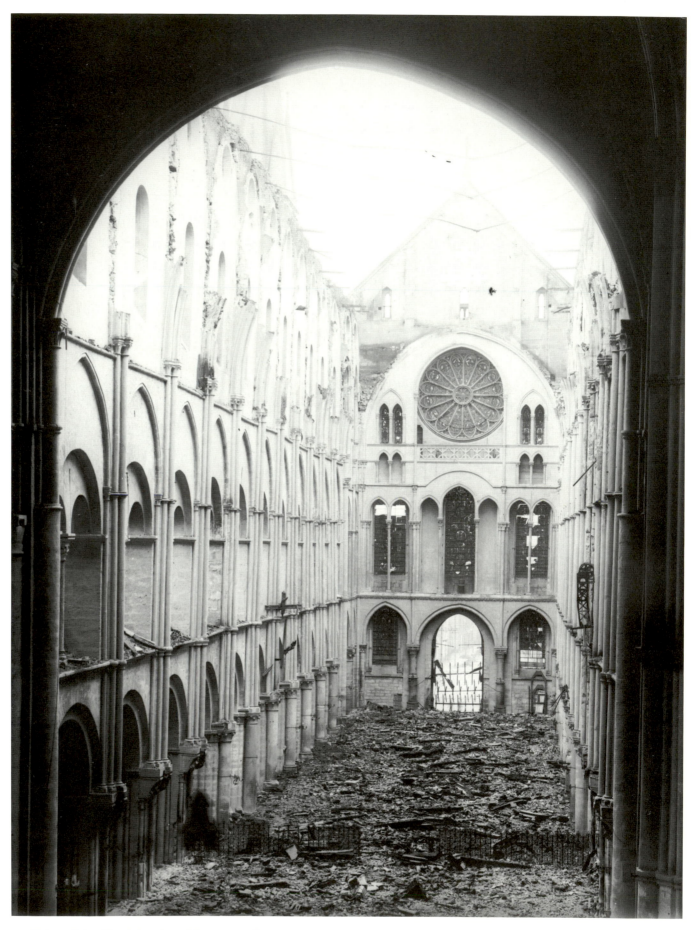

23. Reims, Saint–Remi, interior of the nave to the west, ca. 1917

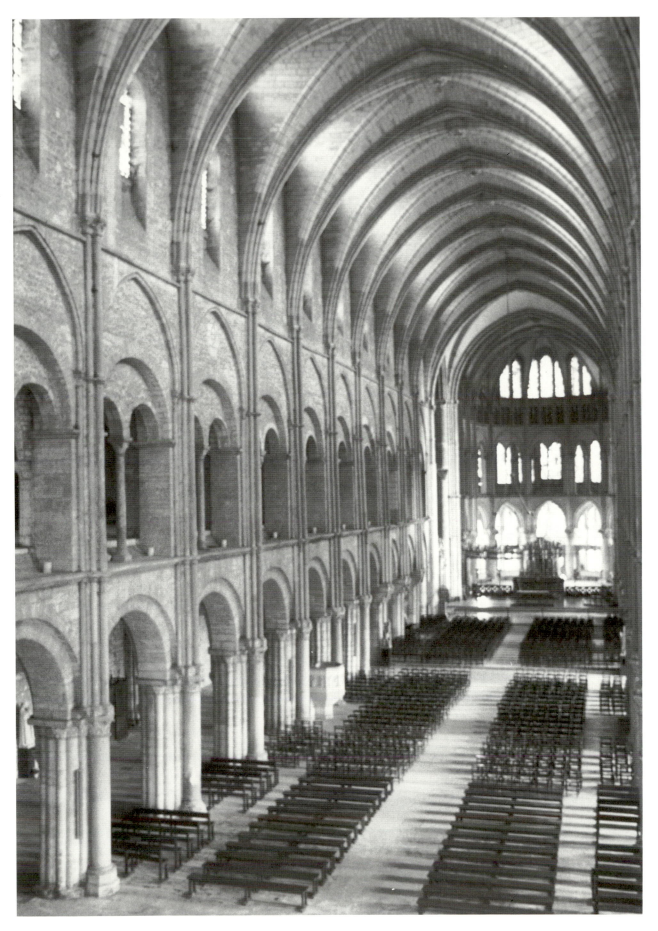

24. Reims, Saint-Remi, interior to the east, angled view

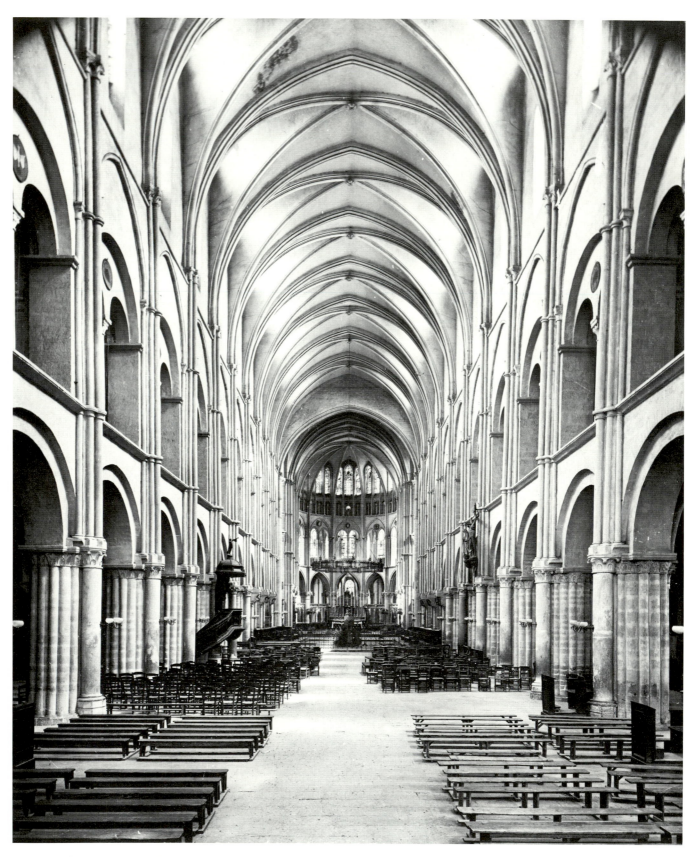

25. Reims, Saint-Remi, interior to the east, axial view

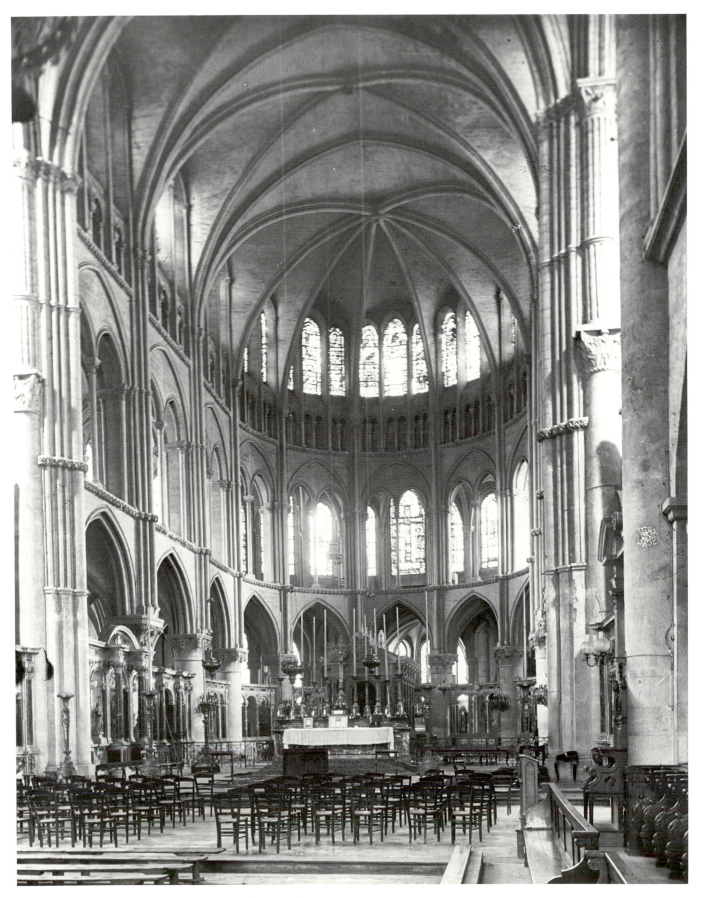

26. Reims, Saint-Remi, interior of the retrochoir, angled view

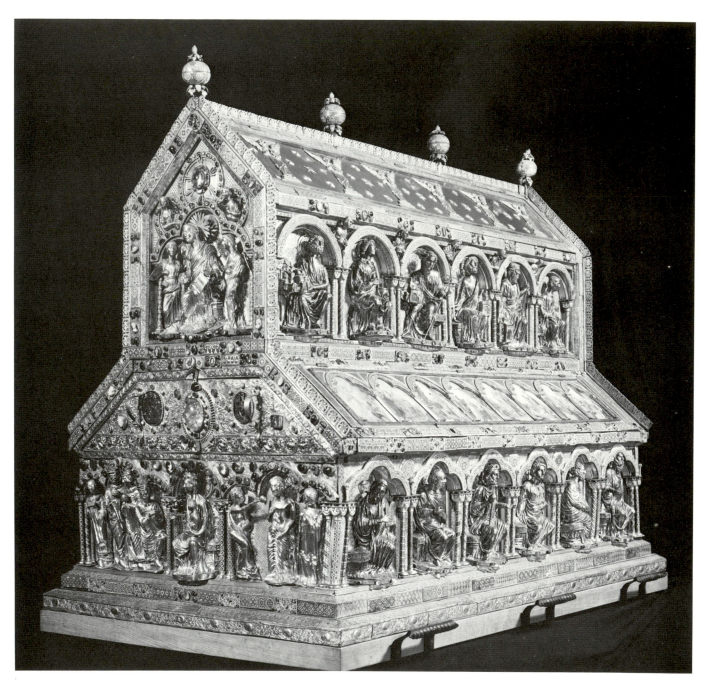

27. Workshop of Nicholas of Verdun, Shrine of the Three Kings, ca. 1190–1200, Cologne Cathedral choir

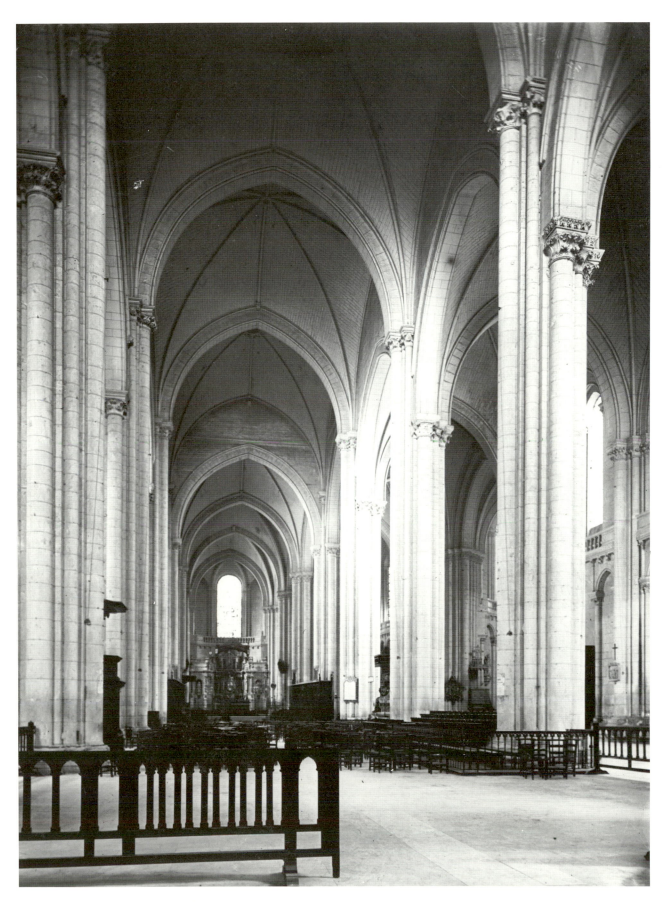

28. Poitiers, cathedral, interior to the east

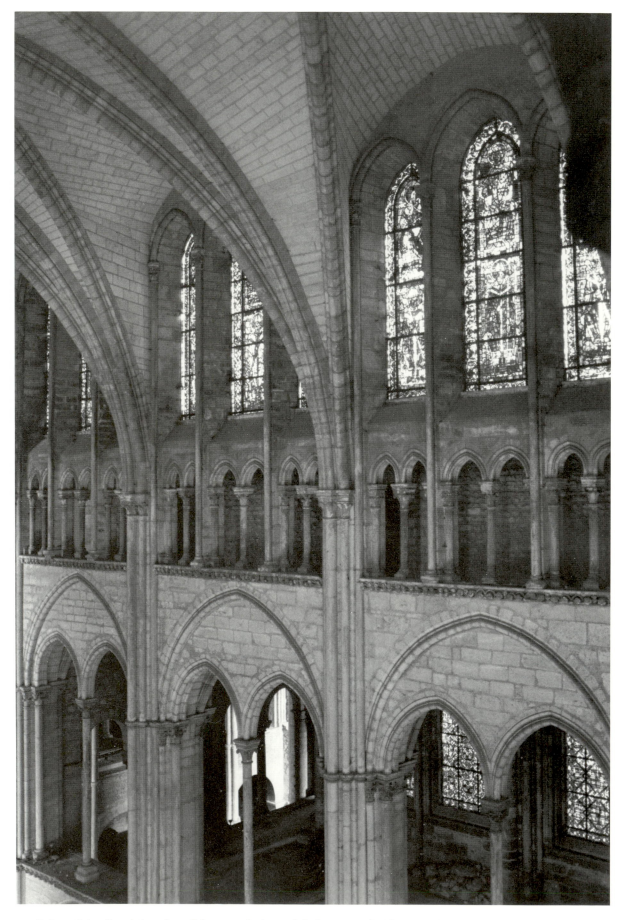

29. Reims, Saint-Remi, interior of the retrochoir, straight bays, north side, upper levels

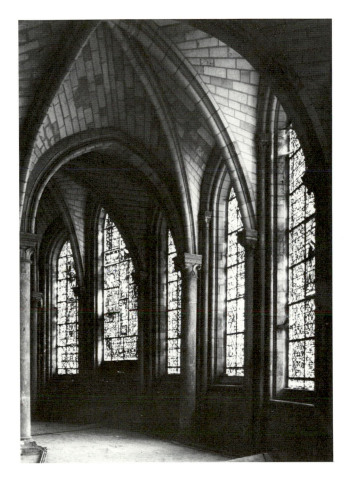

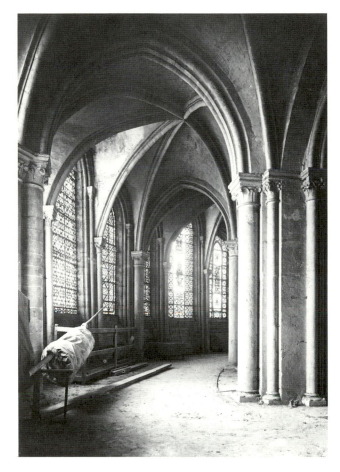

30. Reims, Saint-Remi, interior of the tribune of the retrochoir, toward the northeast

31. Reims, Saint-Remi, interior of the tribune of the retrochoir, north side, before 1916

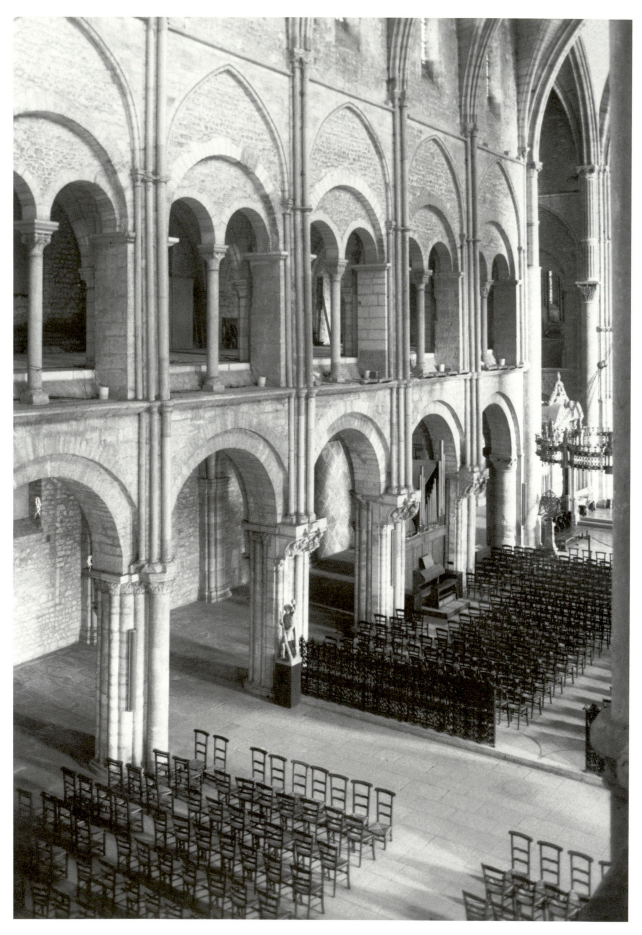

32. Reims, Saint-Remi, north arcade and tribune of the nave with the monks' choir

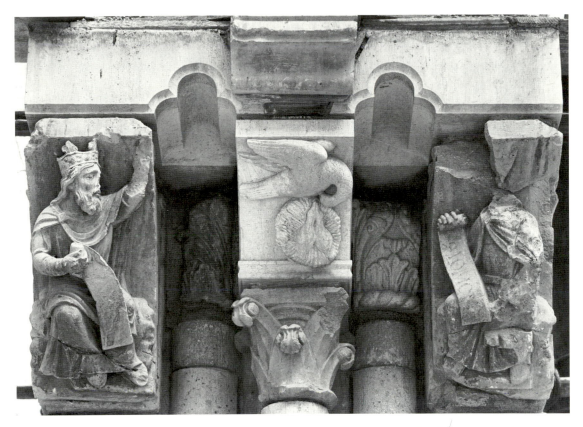

33. King David, the pelican in its piety, and Solomon, Reims, Saint-Remi, sculpted console on the south side of the monks' choir, second pier from the crossing, ca. 1190

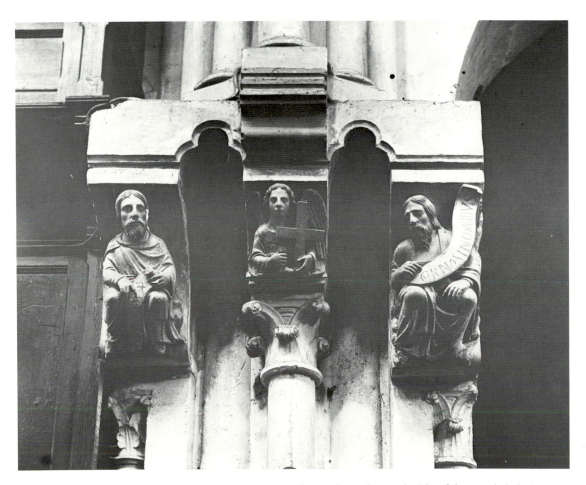

34. Prophets and an angel, Reims, Saint-Remi, sculpted console on the north side of the monks' choir, second pier from the crossing, ca. 1190 (heads nineteenth century)

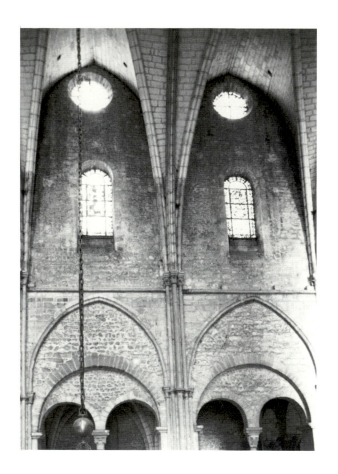

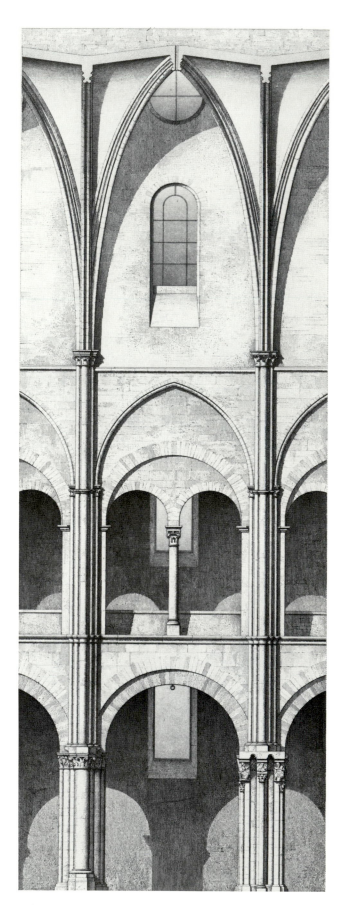

35. Reims, Saint–Remi, a. interior elevation of the nave tribune and clerestory, north side; b. exterior of nave clerestory and aisle roof, south side, after Rothier ca. 1896

36. Reims, Saint–Remi, interior elevation of the nave, drawing by Auguste Reimbeau

37. a. Fragment of inscription from the floor mosaic of the monks' choir, early twelfth century, Reims, Musée Saint-Remi; b. fragment with faces, probably from the floor mosaic of the monks' choir, early twelfth century, Reims, Musée Saint-Remi

38. Display capitals, Homilies, Reims Cathedral, late eleventh century; Reims, B.M., MS 294, f. 14

39. Tomb slab of Gerberge, Reims, Saint-Remi, first half of the twelfth century

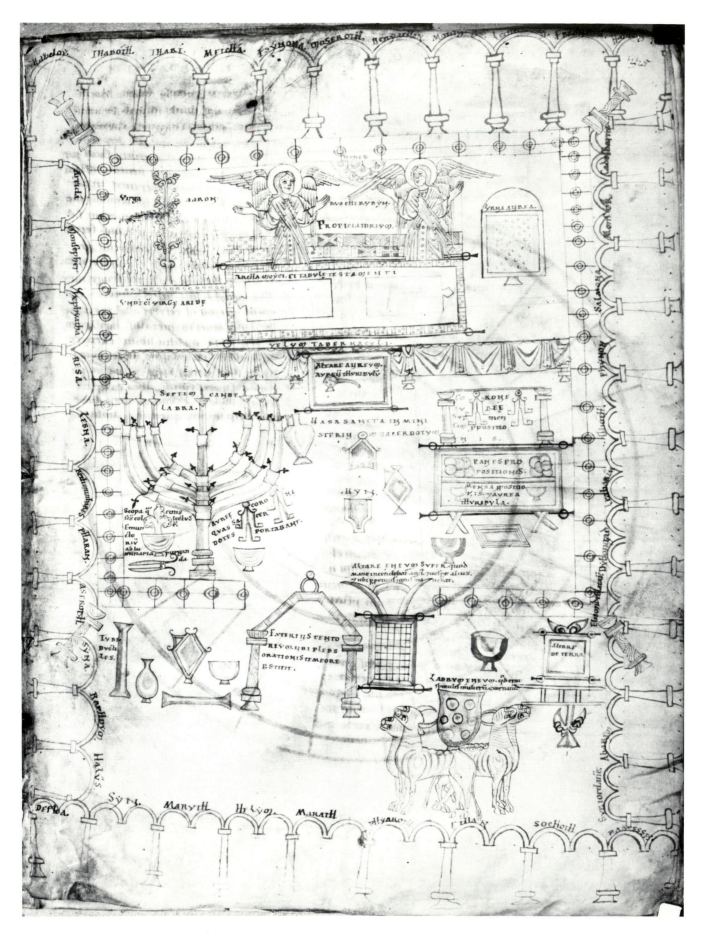

40. The Hebraic Temple according to Exodus, twelfth-century drawing; Vienna, Nationalbibliothek Cod. 10, f. 325r

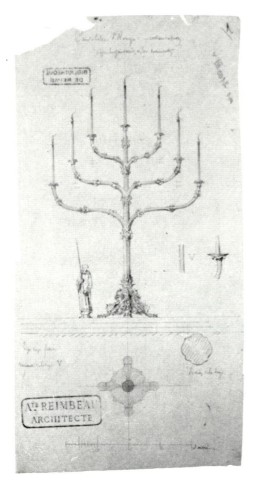

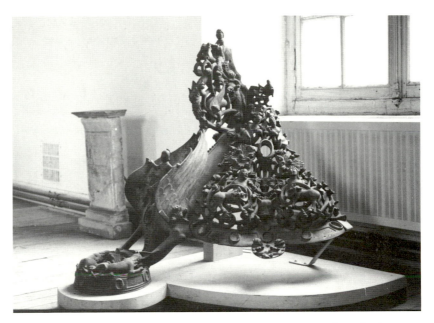

41. Scale reconstruction of the seven-branched candlestick in Saint-Remi, Reimbeau, MS 2100, Dossier III, v, no. 1, based on Lenoir ?

42. Fragment of the gilded bronze base of the Saint-Remi candlestick, first half of the twelfth century, Reims, Musée Saint-Remi

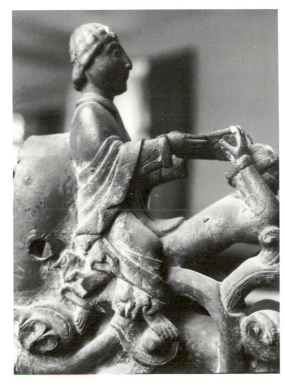

43. A priest with an acrobatic lectern, detail of the Saint-Remi candlestick, Reims, Musée Saint-Remi

44. Nude riding a Siren, detail of the Saint-Remi candlestick, Reims, Musée Saint-Remi

46. Lower part of funerary statue of King Louis IV d'Outremer from the choir of Saint-Remi, early twelfth century, Reims, Musée Saint-Remi

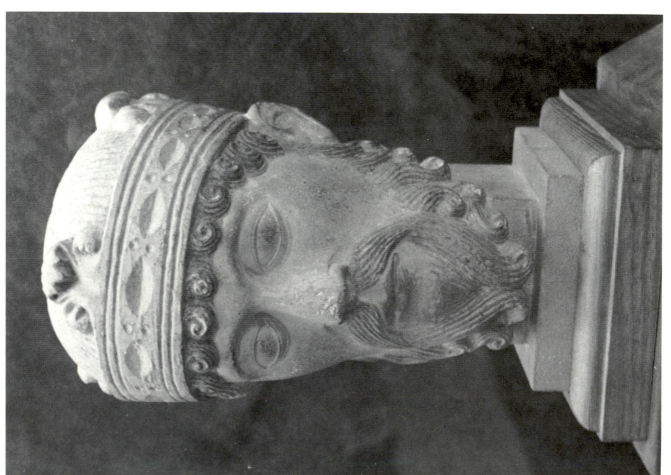

45. Head of funerary statue of King Lothaire from the choir of Saint-Remi, early twelfth century, Reims, Musée Saint-Remi

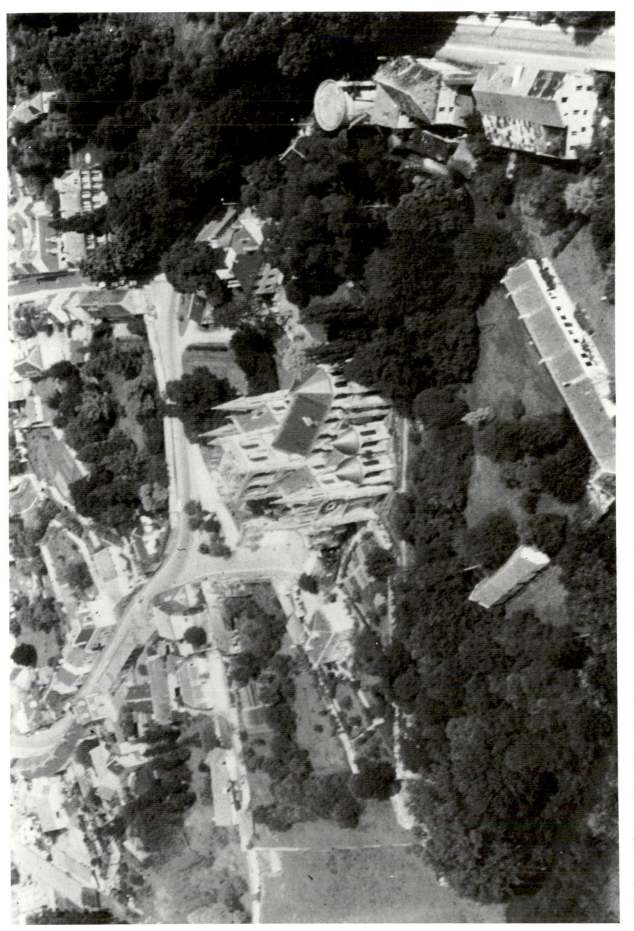

47. Braine, aerial view of the Abbey Church of Saint-Yved from the southeast

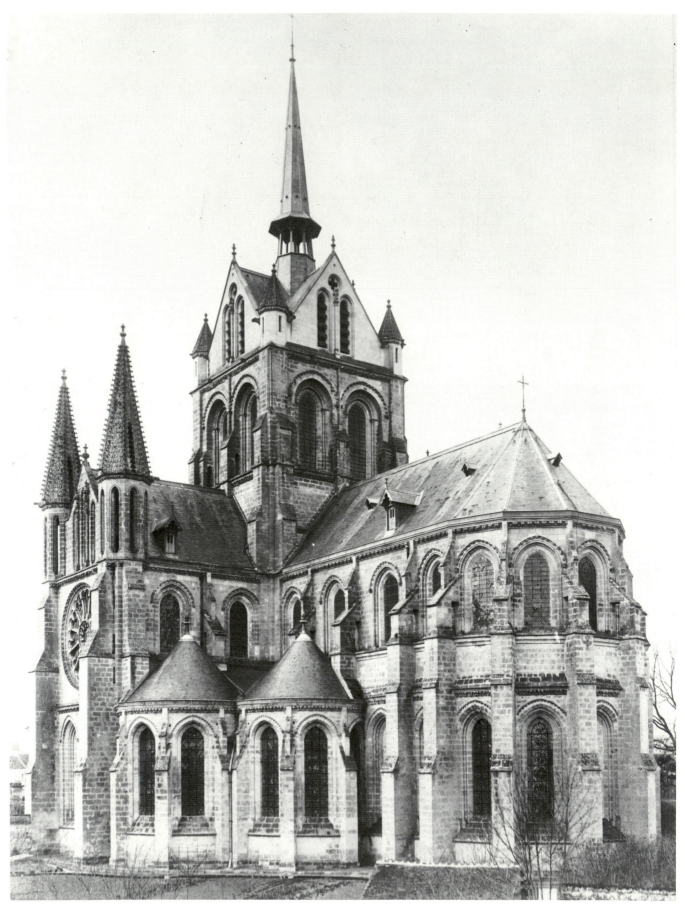

48. Braine, the Abbey Church of Saint-Yved from the southeast in the nineteenth century

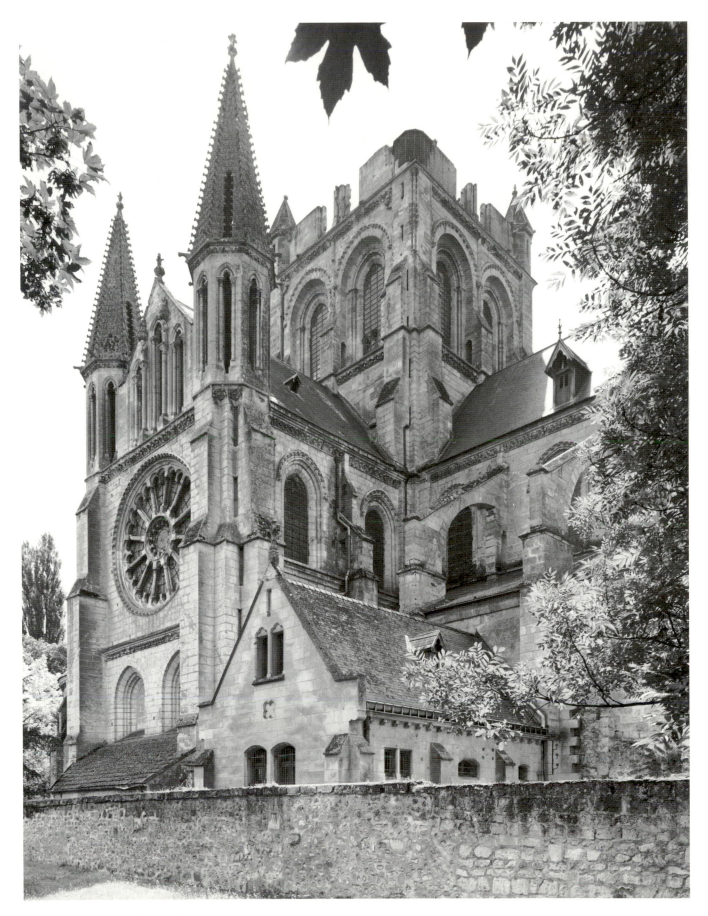

49. Braine, Saint-Yved from the northwest

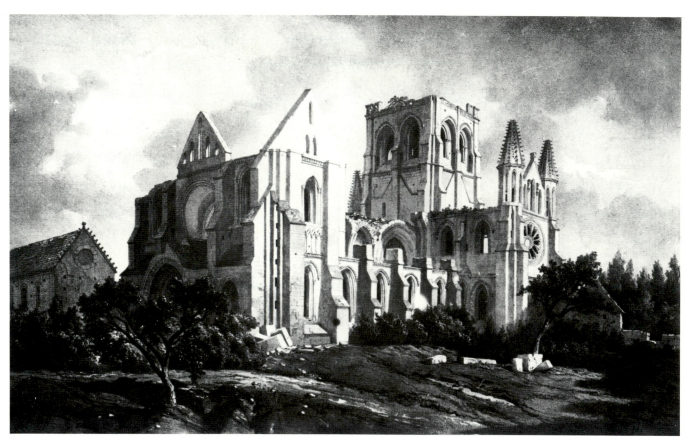

50. Braine, Saint-Yved from the southwest, lithograph by Dauzats, ca. 1820

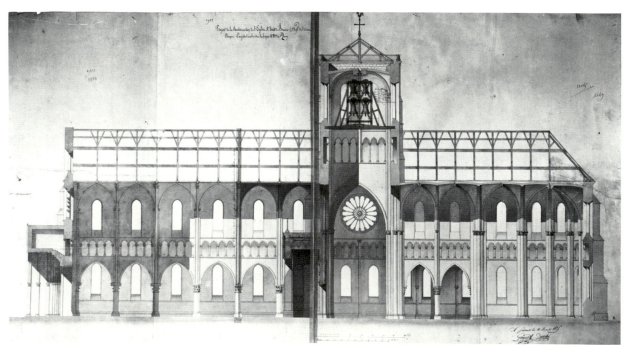

51. Braine, Saint-Yved, longitudinal section, including the west end, since demolished, by Paul Duroche?, ca. 1840

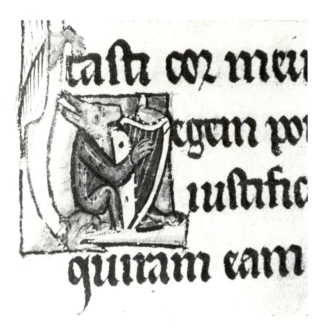

52. Ass with a lyre, initial in a Psalter made for a woman,
English or northern French, ca. 1225, Paris, Bibliothèque
Sainte-Geneviève, MS 1273, f. 135r

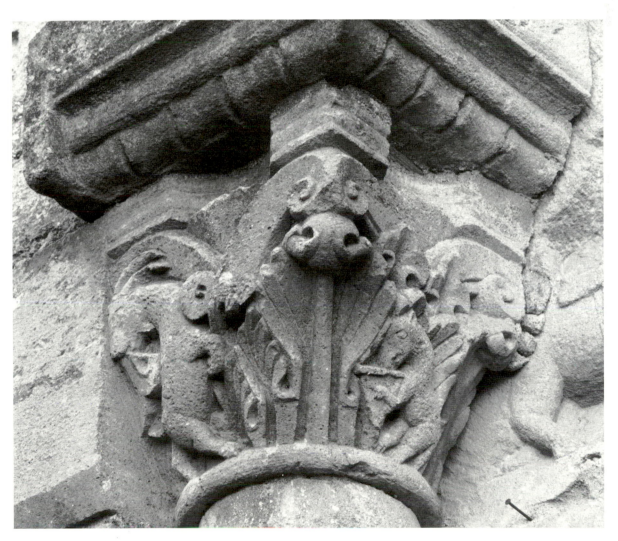

53. Goat with a rebec and ass with a lyre, sculpted capital, early twelfth century, Fleury-la-Montagne (Sâone-et-
Loire)

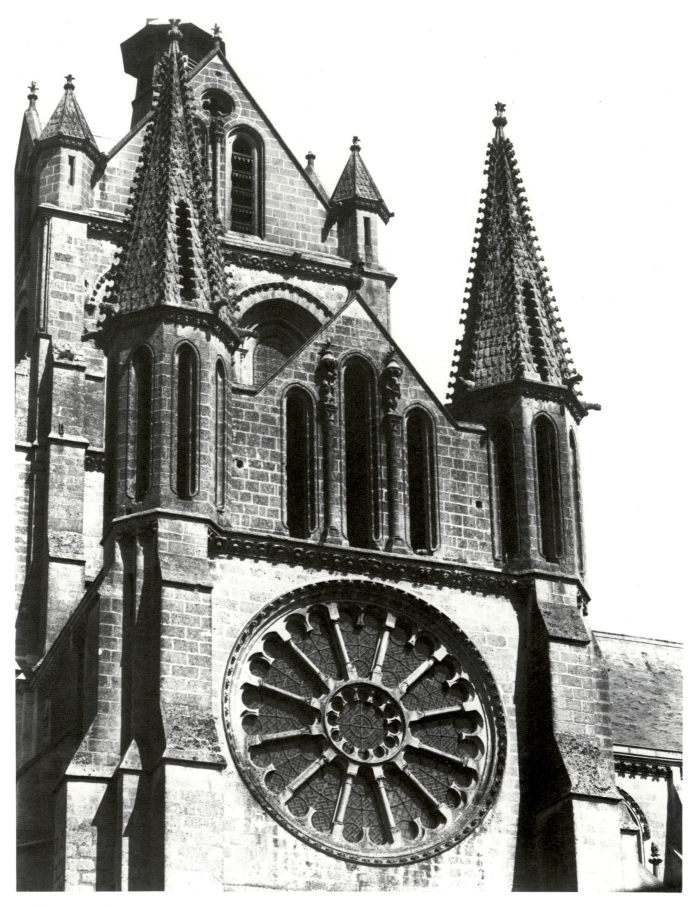

54. Braine, Saint-Yved: a. gable and rose of the south transept

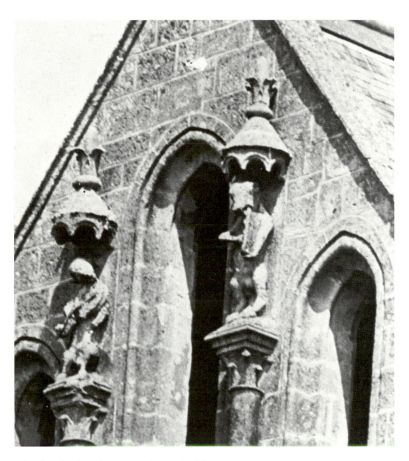

54b. detail of sculpture with musical beasts

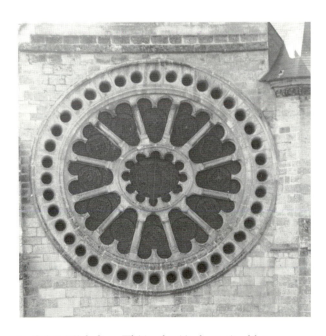

55. Saint-Michel-en-Thiérache (Ardennes), abbey church, north transept rose

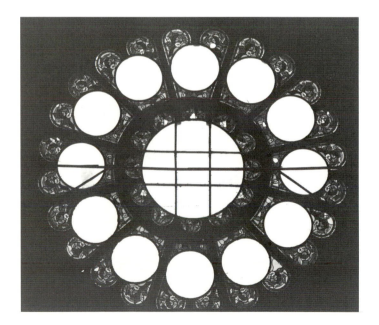

56. Vaux-sous-Laon (Aisne), Parish Church of St.-Jean Baptiste, rose in the east wall of the choir

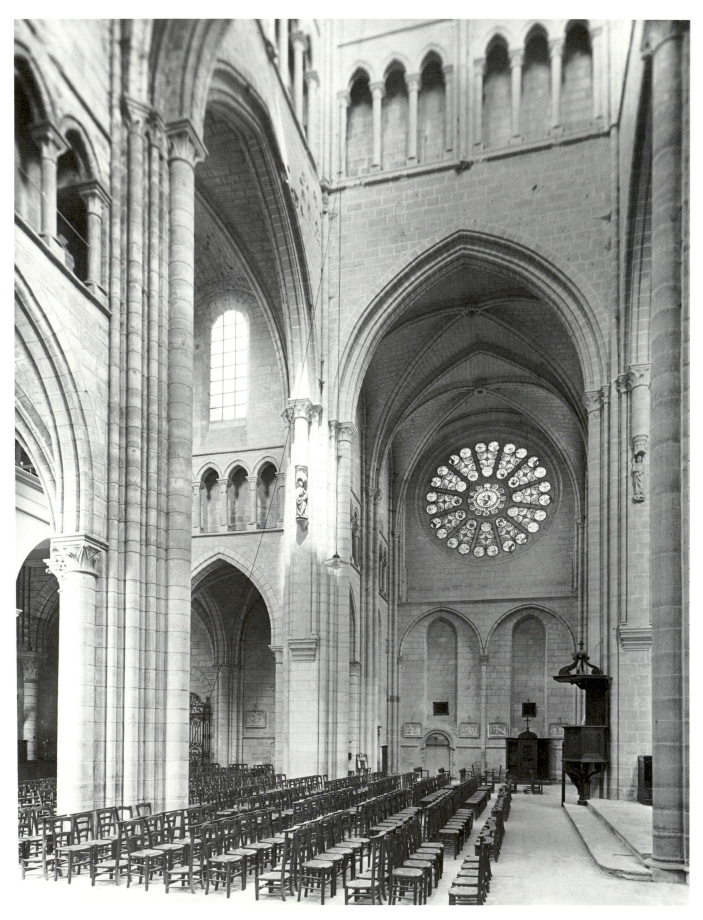

58. Braine, Saint–Yved, interior of crossing to the northwest

57. Braine, Saint-Yved, choir, detail of clerestory sill, showing fill above the splay

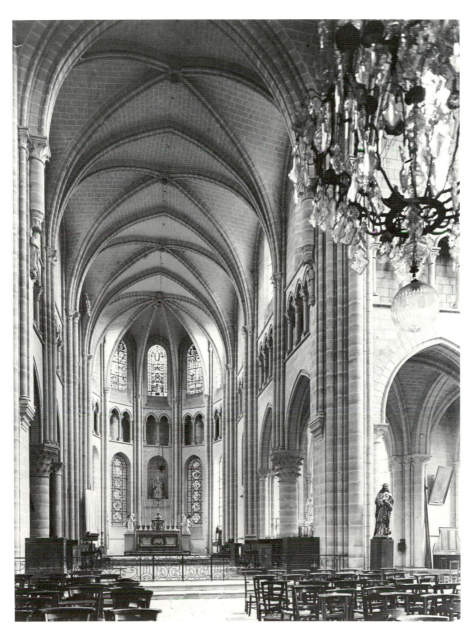

59. Braine, Saint-Yved, interior of choir to the southeast

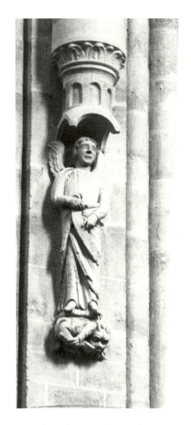

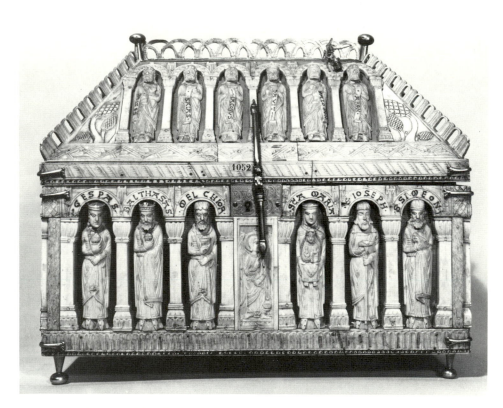

60. Angel trampling a demon, sculpted corbel at the entrance to the choir, Braine, Saint-Yved

61. Ivory reliquary, said to be the shrine of Sts. Barnabas, Luke, and Nicasius from Braine, late twelfth century; Paris, Musée de Cluny, acession no. 1564

62. Lost tomb effigies drawn in Saint-Yved of Braine by Gaignières: a. Agnes of Braine, d. 1204; b. Robert II of Dreux, d. 1218

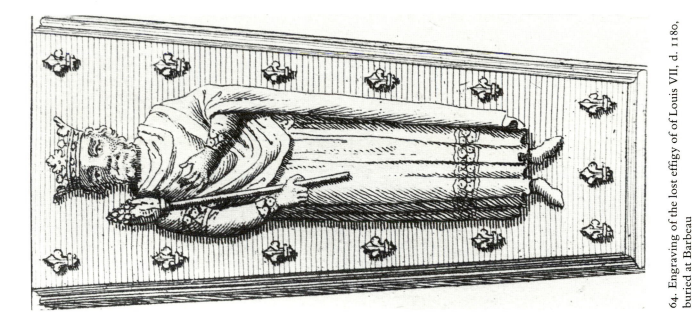

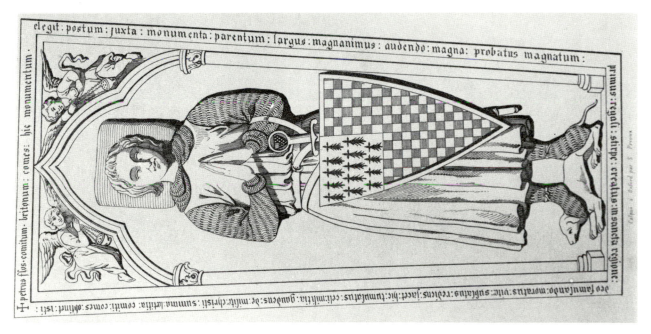

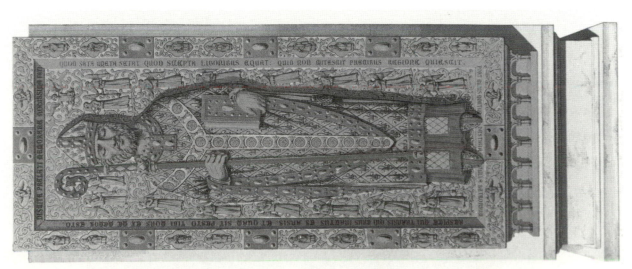

64. Engraving of the lost effigy of Louis VII, d. 1180, buried at Barbeau

63. Lost tombs drawn by Gaignières: a. Philip, bishop of Beauvais, d. 1217, buried in his cathedral; b. Peter of Dreux, called "Mauclerc," Duke of Brittany, d. 1250, buried in Saint-Yved

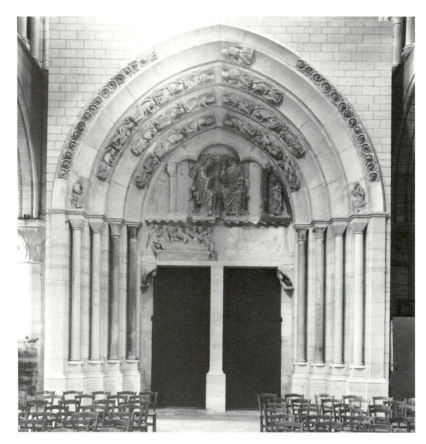

65. Braine, Saint-Yved, reconstructed central west portal, ca. 1195–1205, interior of the west facade

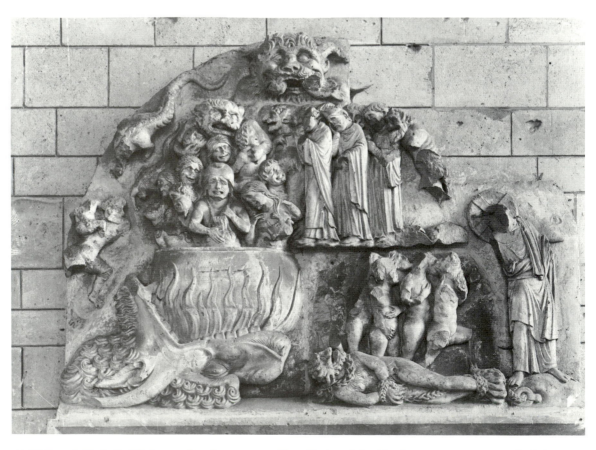

66. Hell, and Christ in Limbo, sculpted tympanum from Braine, Saint-Yved, ca. 1195–1205, now in Soissons, Musée Municipale

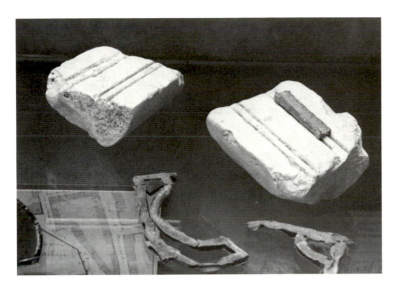

67. Chalk came mold, found in a well under Saint-Remi, twelfth century; now in Reims, Musée Saint-Remi

68. Exterior detail of border in original lead cames, Reims, Saint-Remi, retrochoir clerestory, window S.IV b

69. Exterior detail of head and shoulders of Archbishop "Severus," showing back painting of the eyes, Reims, Saint-Remi, retrochoir clerestory, window N.V b

70. Interior detail in reflected light of left shoulder and ground of Archbishop "Hincmarus," showing chips at the edge of the glass, Reims, Saint-Remi, retrochoir clerestory, window S.V. b

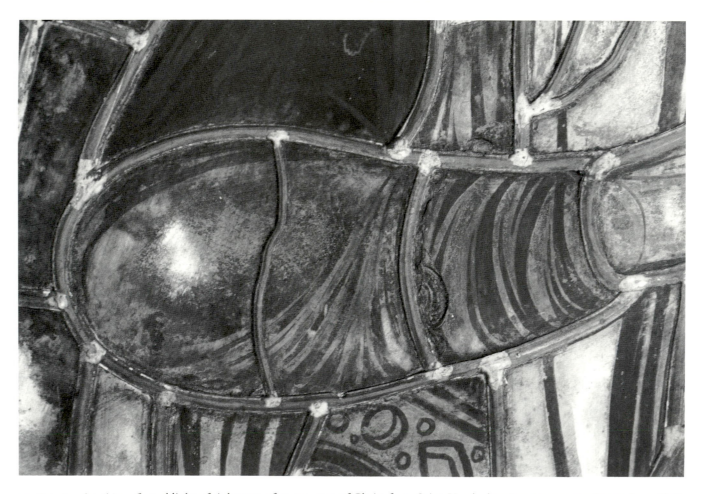

71. Interior detail in reflected light of right arm of an ancestor of Christ from Saint-Yved, showing uneven grozing at the cuff; St. Louis, City Art Museum, accession no. 137.20 (Braine, Catalogue A, no. 11)

73. Detail of the hands of Obed from Canterbury, Christ Church Cathedral, Trinity Chapel clerestory, window N.VIII

72. The right hand of the same ancestor of Christ from Saint-Yved; St. Louis, City Art Museum, accession no. 137.20 (Braine, Catalogue A, no. 11); a. interior detail in reflected light; b. exterior detail

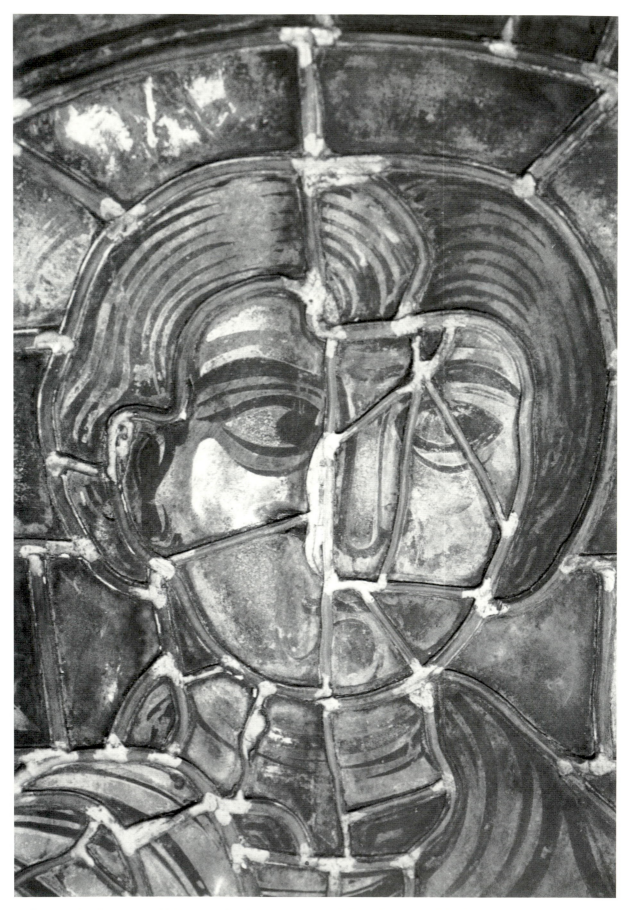

74. Interior detail in reflected light of the head of the ancestor of Christ from Saint-Yved; St. Louis, City Art Museum, accession no. 137.20 (Braine, Catalogue A, no. 11)

76. Interior detail of the same as in Pl. 75 seen by translucent light

75. Interior detail of the stopgap head of Chilperic, Reims, Saint-Remi, nave clerestory, window S.XXIV seen by reflected light

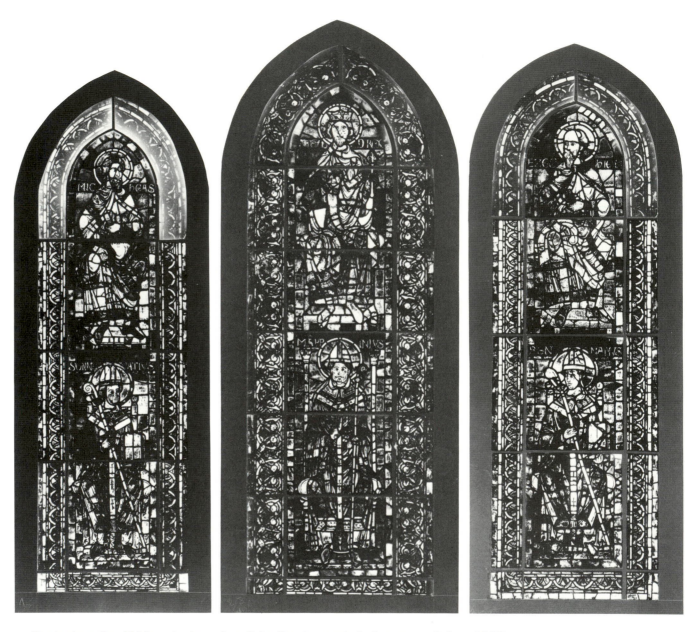

77. Patriarchs and archbishops in situ, reims, Saint-Remi, retrochoir clerestory, windows N.IV a–c

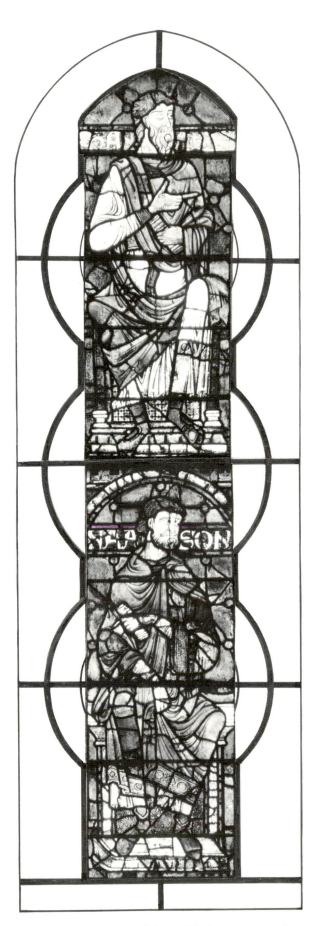

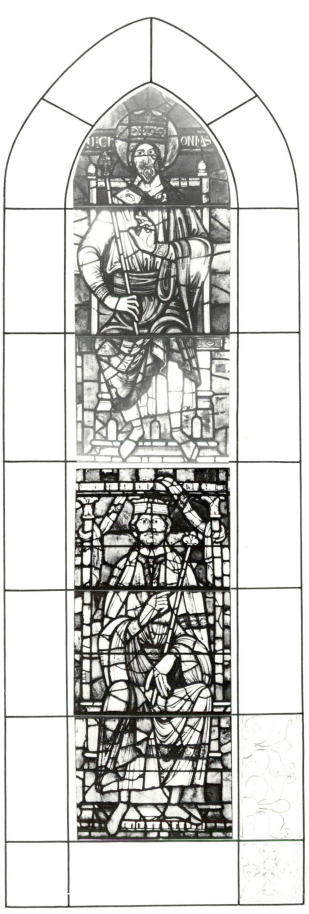

78. Amminadab and Nahshon with the armature of Canterbury, Christ Church Cathedral, Trinity Chapel clerestory, window N.X

79. Jechoniah and a king of Judaea, with an armature to fit the original clerestory openings of Saint-Yved of Braine

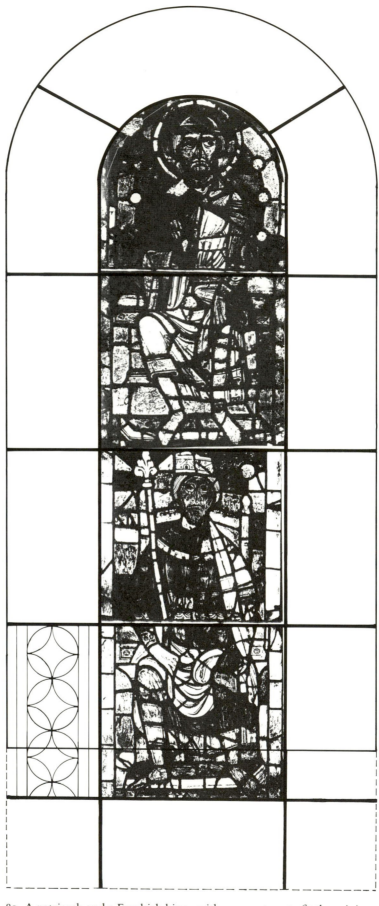

80. A patriarch and a Frankish king, with an armature to fit the original clerestory openings of the nave of Saint-Remi, Reims

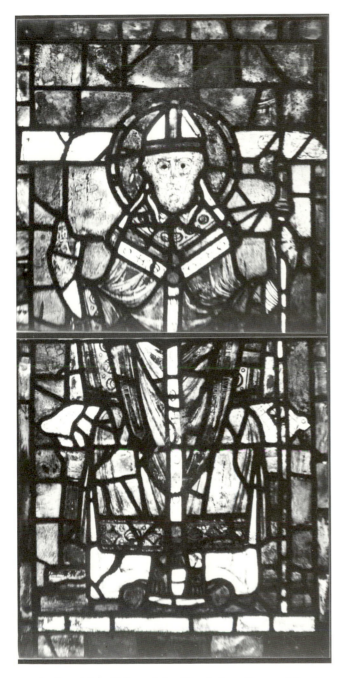

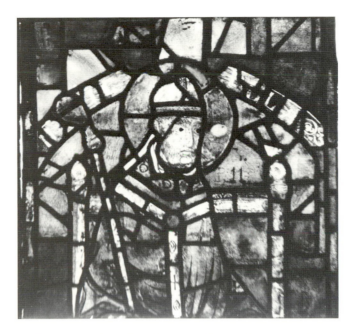

82. Fragment of St. Nicholas, Saint-Remi, the tribune of the retrochoir, window Nt. II b

81. St. Remigius, Reims, Saint-Remi, the tribune of the retrochoir, window Nt.II b

83. Interior detail of Pl. 81: the decorative line ending to the name band of St. Remigius, seen by reflected light

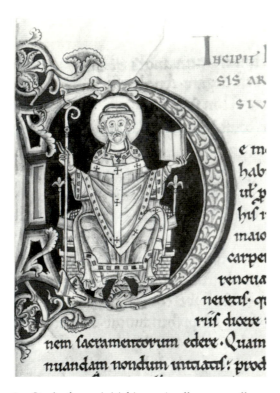

84. St. Ambrose initial in a miscellaneous collection from Rochester, first half of the twelfth century; B.L., Royal MS 6 B.vi, f. 2

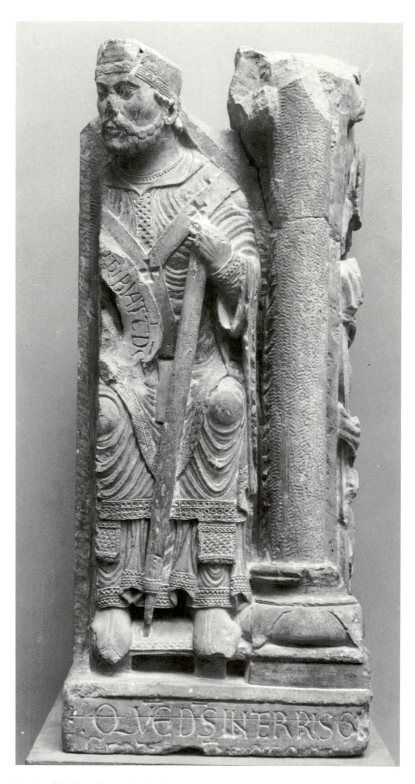

85. Archbishop from the "Odo tomb" excavated in Reims, ca. 1160; Reims, Musée Saint-Remi

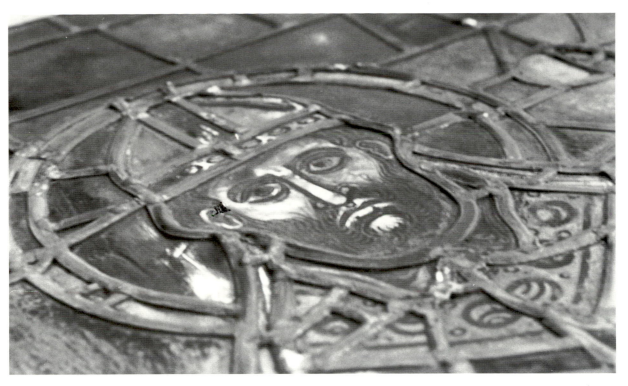

86. Interior detail of the head of St. Remigius seen by reflected light, Reims, Saint-Remi, retrochoir tribune Nt.11b

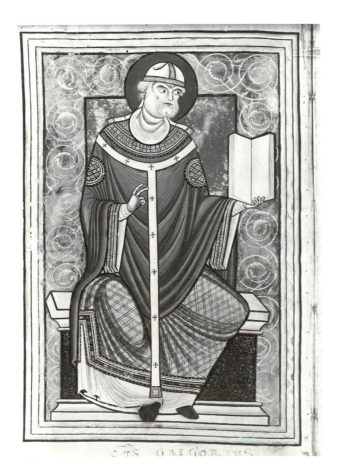

87. St. Gregory, in a *Registrum Gregorii* from Saint-Amand, second half of the twelfth century; B.N., MS lat. 2287, f. 1ᵛ

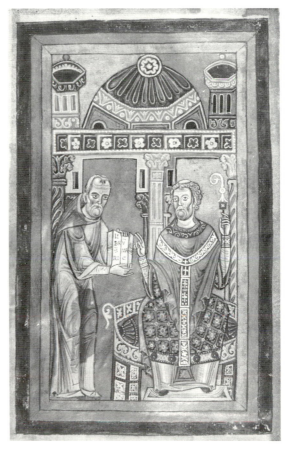

88. Gómez presenting his book to Gotiscalc, Ildefonsus, *De Virginitate*, from Cluny?, early twelfth century; Parma, Biblioteca Palatina, MS 1650, f. 102ᵛ

89. Secular figures, sculpted tympanum excavated in Reims, ca. 1160–70; Reims, Musée Saint-Remi

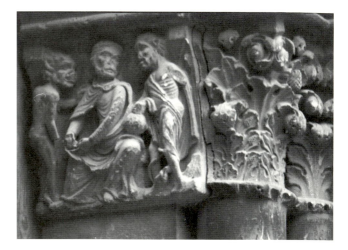

90. Capital friezes, Reims, Saint-Remi, central west portal, ca. 1160–70: a. two men with shields, perhaps a judicial combat, left jamb; b. rich man giving alms, tempted by a demon, right jamb

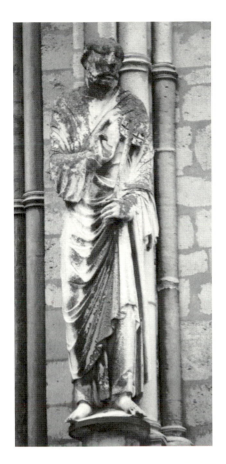

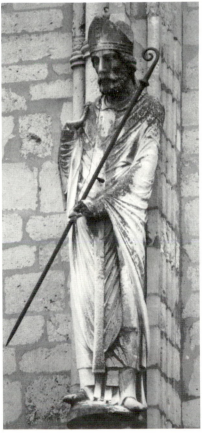

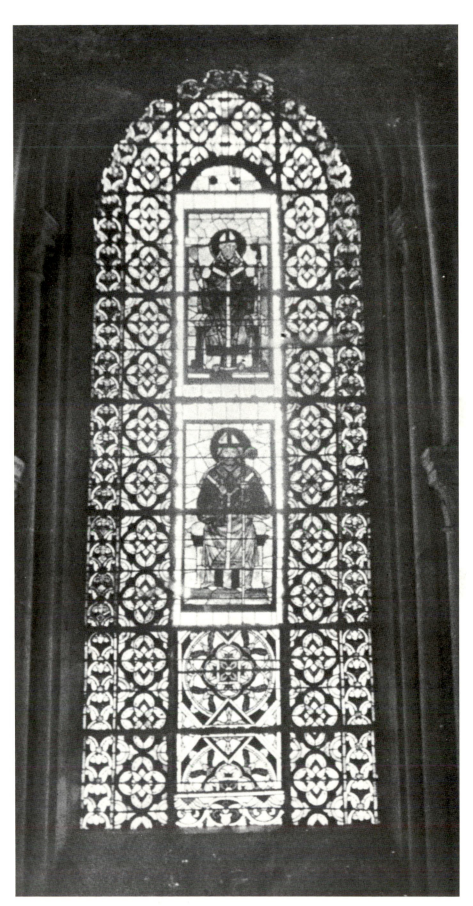

91. Statues above the portals on the west facade, Reims, Saint-Remi, ca. 1160–1170: a. St. Peter, left; b. St. Remigius, right

92. St. Remigius and another archbishop, Reims, Saint-Remi, in a window of the retrochoir tribune, Rothier photo taken before 1896

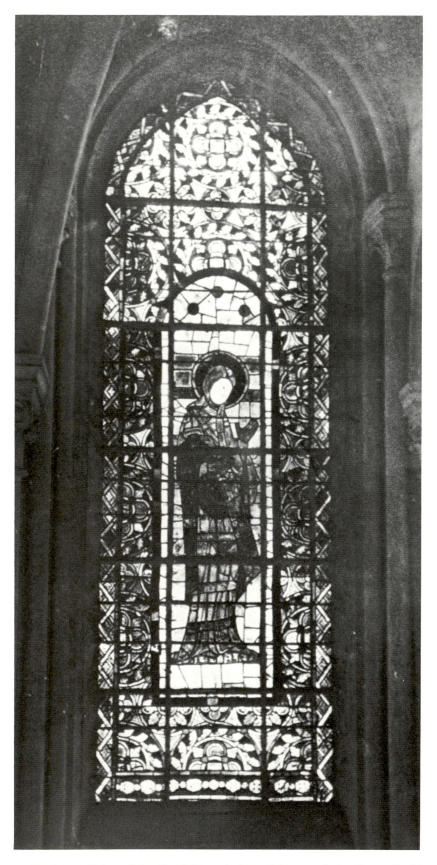

93. St. Agnes, Reims, Saint-Remi, in a window of the retrochoir tribune; Rothier photo taken before 1896

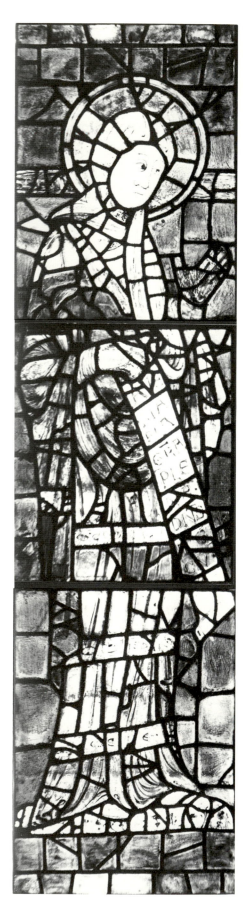

94. St. Agnes, Reims, Saint-Remi, retrochoir tribune, window Nt. II a

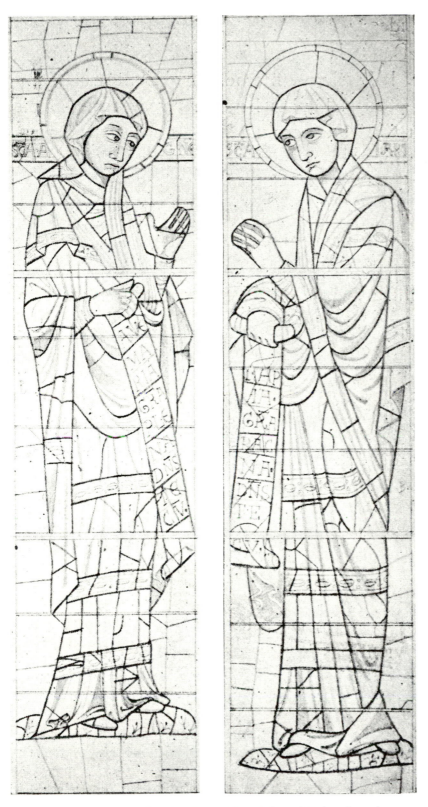

95. St. Agnes and St. Martha, sketches made by Edouard Didron jeune before 1902; a page from *L'Art Sacré*, Reims, B.M., Estampes XVIII. I fb 7

96. Figure of Religion?, from the Abbey of Saint-Bertin; Saint-Omer, B.M., MS 12 II, f. 84v

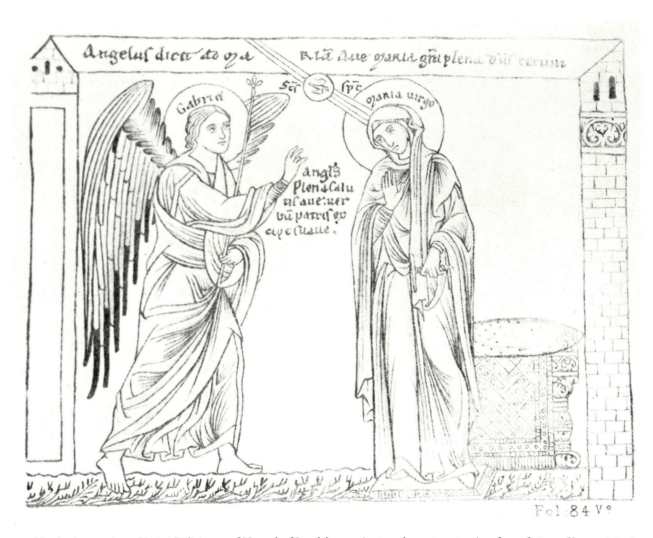

97. Virgin Annunciate, *Hortus Deliciarum* of Herrad of Landsberg, nineteenth-century tracing from f. 84v of lost original of ca. 1180; Berlin, Royal Cabinet

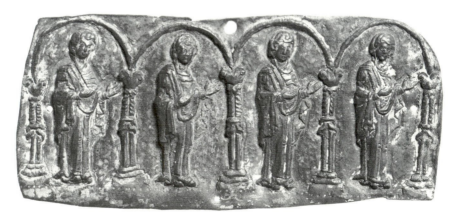

98. Four female figures, Byzantine copper plaque, tenth or eleventh century; Washington, D.C., Dumbarton Oaks, accession no. 63.25

99. St. Martha, Reims, Saint–Remi,
retrochoir tribune, window St. II c

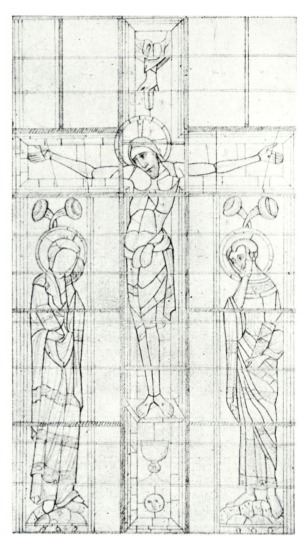

100. Crucifixion with Mary and John, Reims, Saint-Remi, axial window of the retrochoir tribune, t.I b

101. Crucifixion with Mary and John, sketch made by Edouard Didron jeune before 1902; a page from *L'Art Sacré*, Reims, B.M., Estampes XVIII. I fb 7

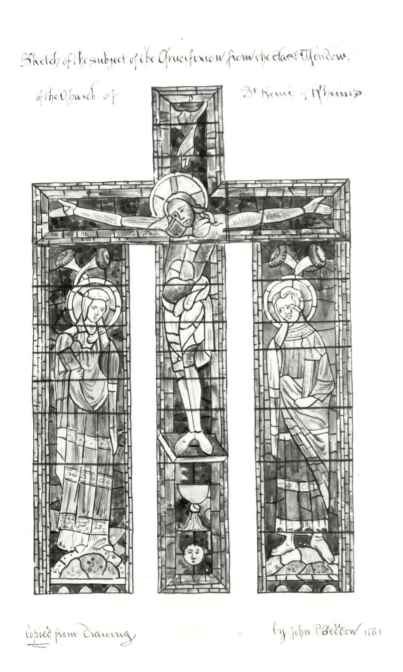

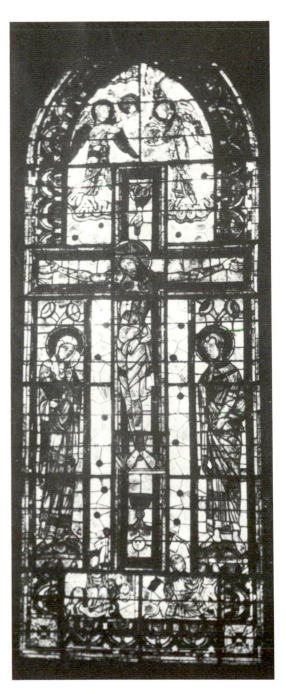

102. "Sketch of the subject of the Crucifixion from the East Window of the Church of St. Remi of Rheims. Copied from a drawing by John P. Seddon 1861"; London, Victoria and Albert Museum, Department of Prints, 8825 78 (Album 93 E-6)

103. The Crucifixion window with additions of about 1870, photo by Rothier, before 1896

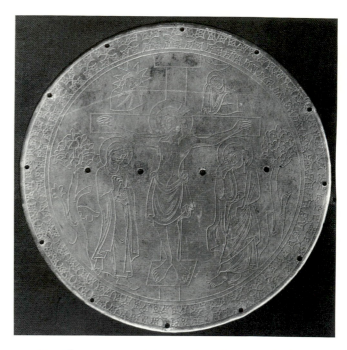

105. Crucifixion, engraved bronze plate from the Aachen candlewheel, ca. 1165–1170; Aachen, cathedral

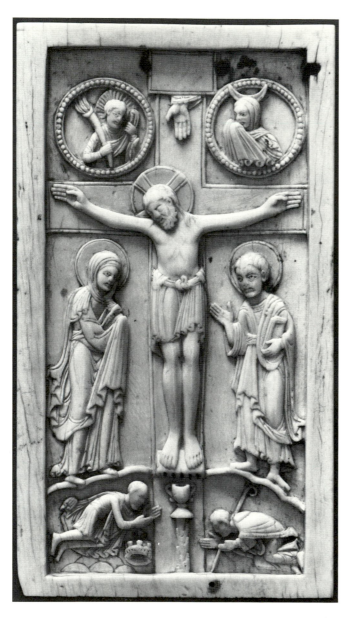

104. Crucifixion, Mosan ivory plaque, mid-twelfth century; Frankfurt-am-Main, Liebieghaus, accession no. 913

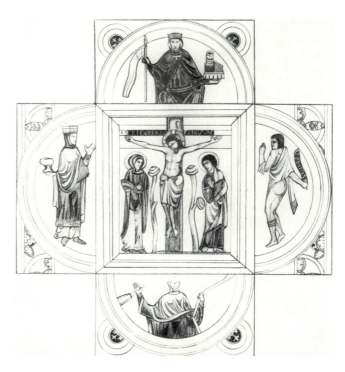

106. Crucifixion, with Faith and Paganism, Ecclesia and Synagoga, in the Lady Chapel of the Abbey Church of Saint-Germer-de-Fly (Oise), second half of the twelfth century

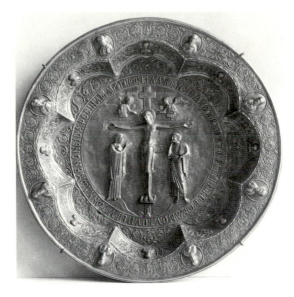

108. Crucifixion, gilded silver repoussé paten, Byzantine, eleventh century; Halberstadt, Domschatz, accession no. 36

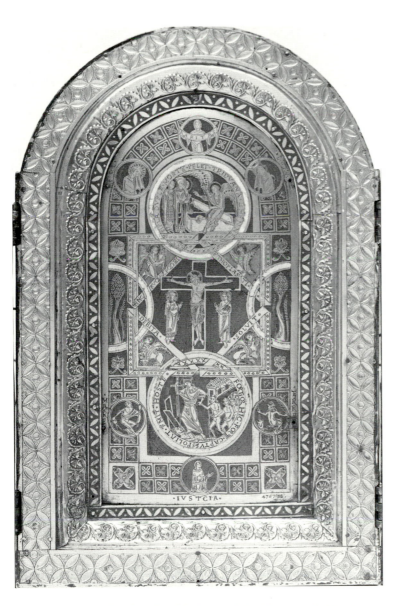

107. Descent into Limbo, Crucifixion, and the Marys at the Tomb, with symbolic subjects, Alton Towers Triptych, central valve, second half of the twelfth century; London, Victoria and Albert Museum, Department of Metalwork, accession no. 4757.1858

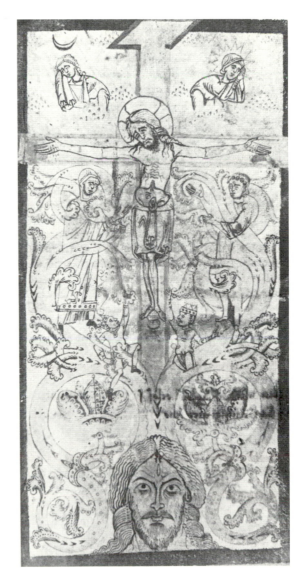

109. Crucifixion with tree of life and symbolic figures, Gladbach Missal, ca. 1140; Mönchengladbach, Minster Archives, Cod. 1, f. 2r

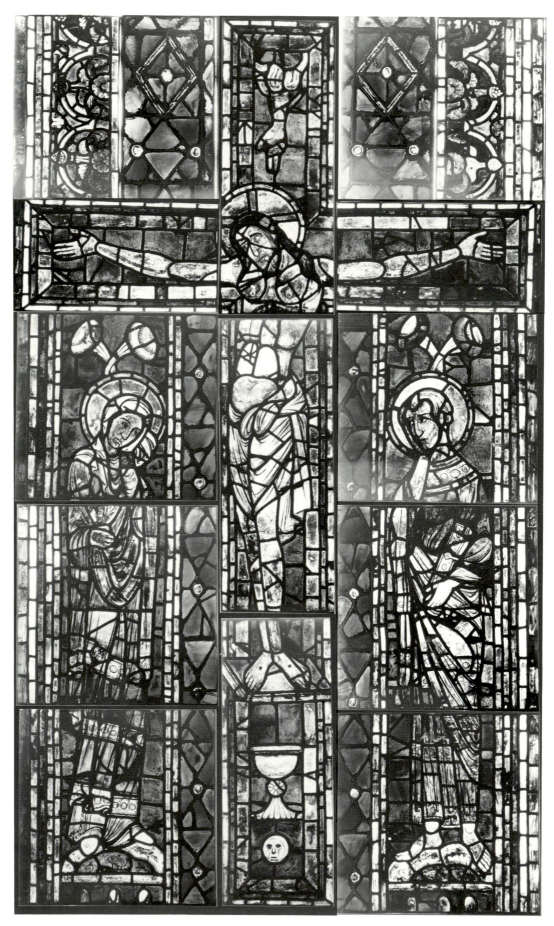

110. Crucifixion in the tribune of Saint–Remi, detail of Pl. 100

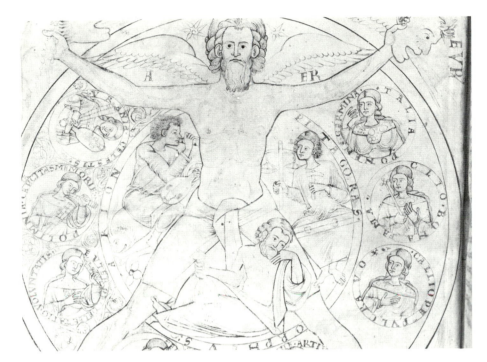

111. Harmony of the Spheres (detail), late twelfth-century drawing, probably from Reims; Reims, B.M., MS 672, frontispiece

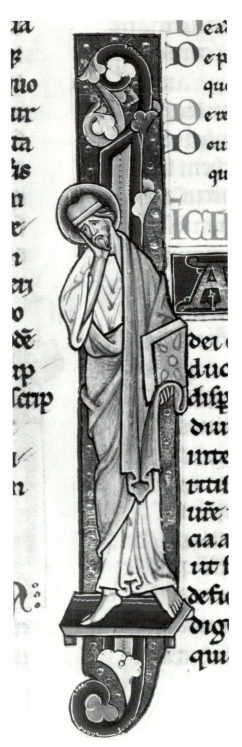

112. St. James, "Sainte-Geneviève Bible," late twelfth century; B.N., MS lat. 11534, f. 285v

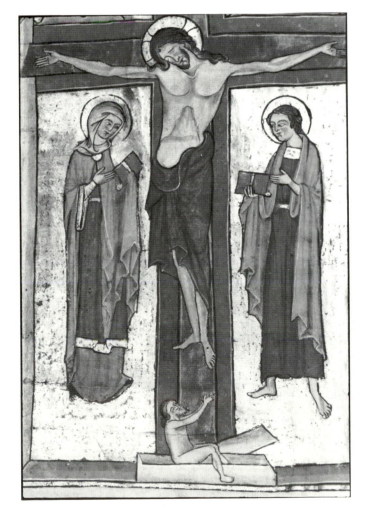

113. Crucifixion (detail), Missal from Saint-Remi, ca. 1200; Reims, B.M., MS 229, f. 10v

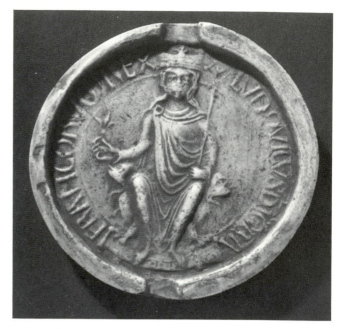

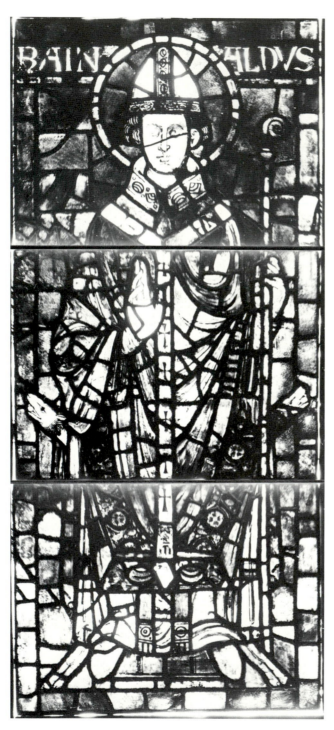

115. Seal of Louis le Jeune, 1175; A.N.

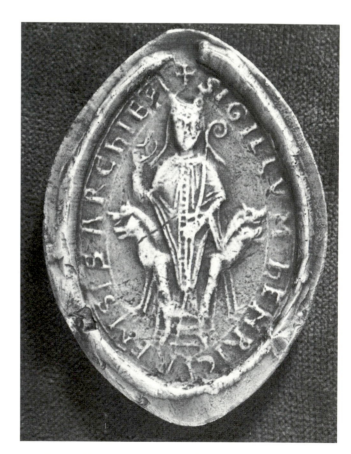

114. "Rainaldus," Reims, Saint-Remi, retrochoir clerestory, window N.VI b, (cartoon E)

116. Seal of Henri de France as archbishop of Reims, 1173; A.N.

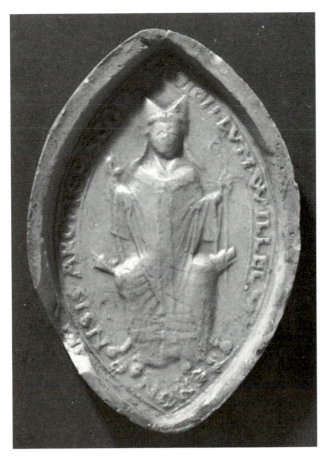

117. Seal of William of Champagne as archbishop of Sens, 1172; A.N.

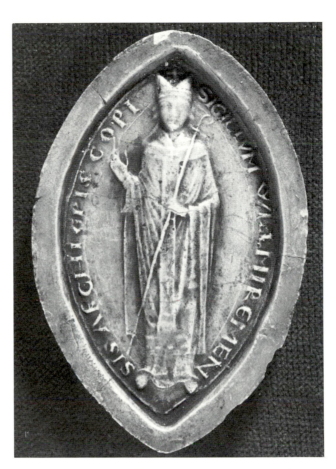

118. Seal of William of Champagne as archbishop of Reims, 1183; A.N.

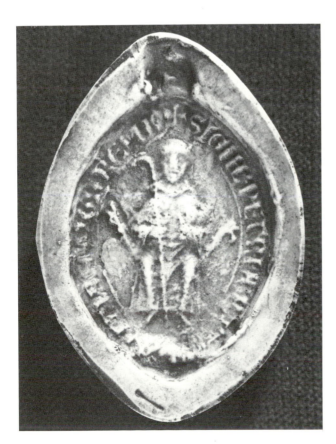

119. Seal of Peter of Celle as abbot of Saint-Remi, 1170; A.N.

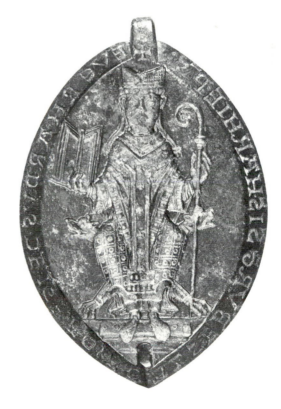

120. Seal of Eberhard I, archbishop of Salzburg, 1164; Salzburg, Museum Carolino Augusteum, accession no. 213/58

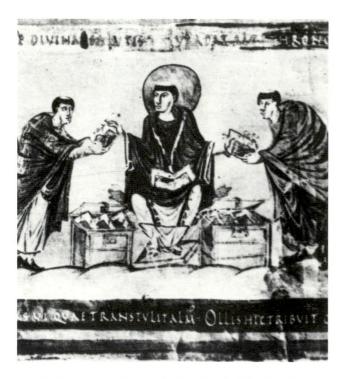

121. St. Jerome distributing Bibles, detail of the frontispiece to the Prefaces of St. Jerome, Vivian Bible, Tours, 845–846; B.N., MS lat. 1, f. 3v

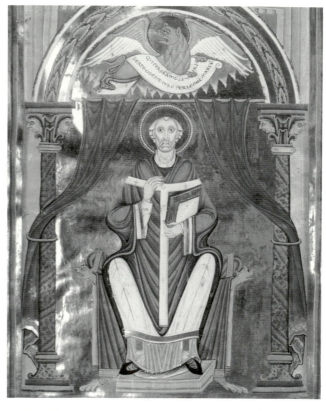

123. St. Mark, Speier Golden Gospels, Echternach school, 1045–1046; Madrid, Escorial, f. 61v

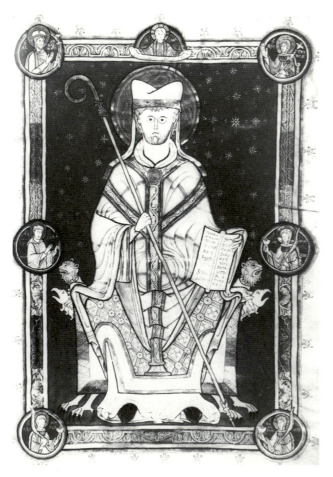

124. St. Augustine, Commentary of St. Augustine, from Marchiennes, ca. 1130–1160; Douai, B.M., MS 250, f. 2

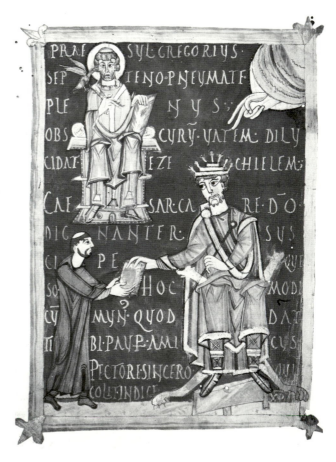

122. St. Gregory with King Henry II receiving a book, Gregory's Commentary on Ezekiel, south German, 1014–1024; Bamberg, Staatliche Bibliothek, Bibl. 84, f. 1r

125. St. John vested as a bishop, with a scribe, Bede's *Commentary on the Apocalypse*, from Ramsey, ca. 1150–1170; Cambridge, St. John's College, MS H.6, f. ii^v

126. Hugo de Folieto, *De Rota Verae et Falsae Religionis*, Heiligenkreuz, late twelfth century; Heiligenkreuz, Stiftsbibliothek, MS Cod. 226: a. False Religion (f. 149v); b. True Religion (f. 146r)

127. Patriarchs and archbishops, Reims, Saint-Remi, retrochoir clerestory, window N.VI (cartoons A, B, C; D, E, F; Rothier photo before 1896)

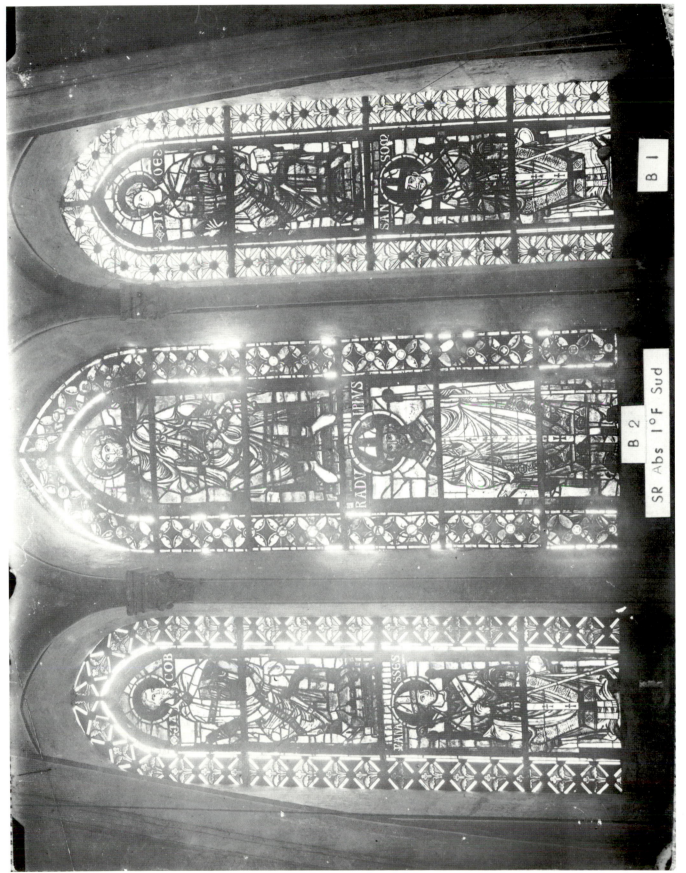

128. Patriarchs and archbishops, Reims, Saint-Remi, retrochoir clerestory, window S.VI (cartoons G, B, G; D, E, D; Rothier photo before 1896)

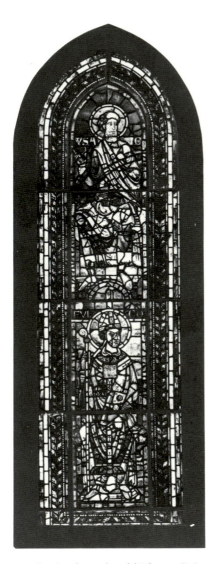
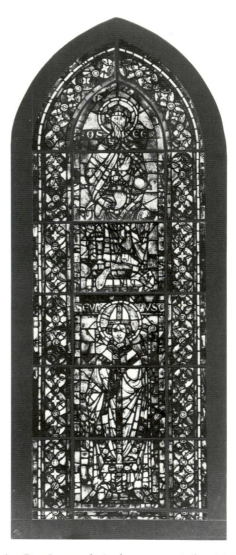
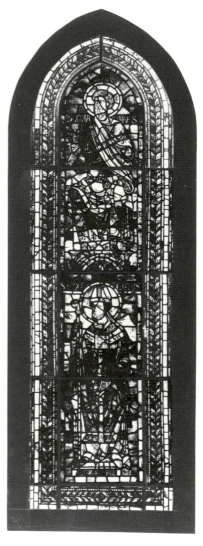

129. Patriarchs and archbishops, Reims, Saint-Remi, retrochoir clerestory, window N.V (cartoons, H, I, H; J, Ev, J)

131. Original lead cames from the up-per part of Isaiah from the retrochoir clerestory, window N.V a (cartoon H); Reims, Atelier Charles Marq

130. Upper part of a patriarch, Reims, Saint-Remi, south transept, from the retrochoir clere-story, window N.V c (cartoon H)

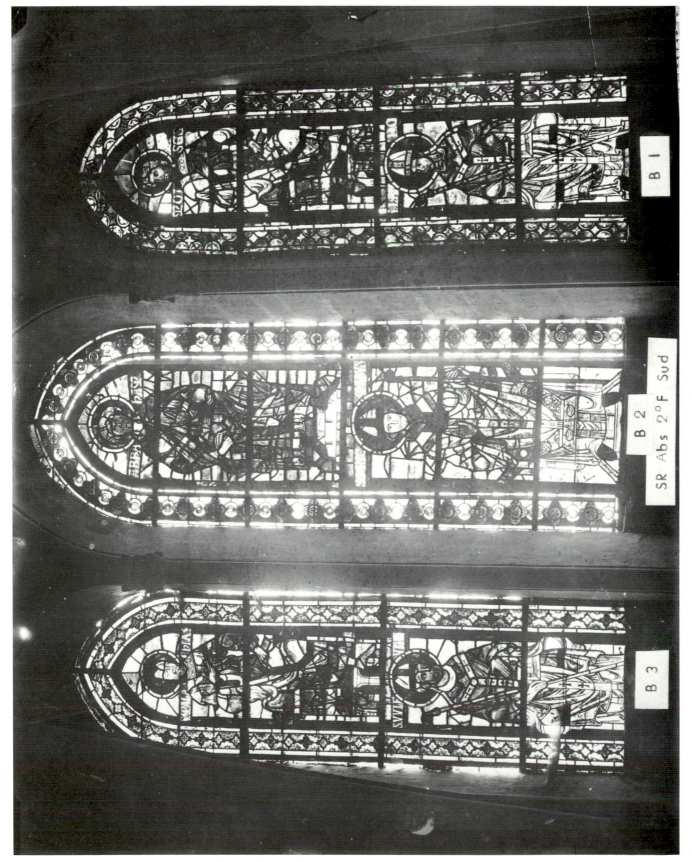

132. Patriarchs and archbishops, Reims, Saint-Remi, retrochoir clerestory, window S.V (cartoons C, I, C; Fv, Ev, F; Rothier photo before 1896)

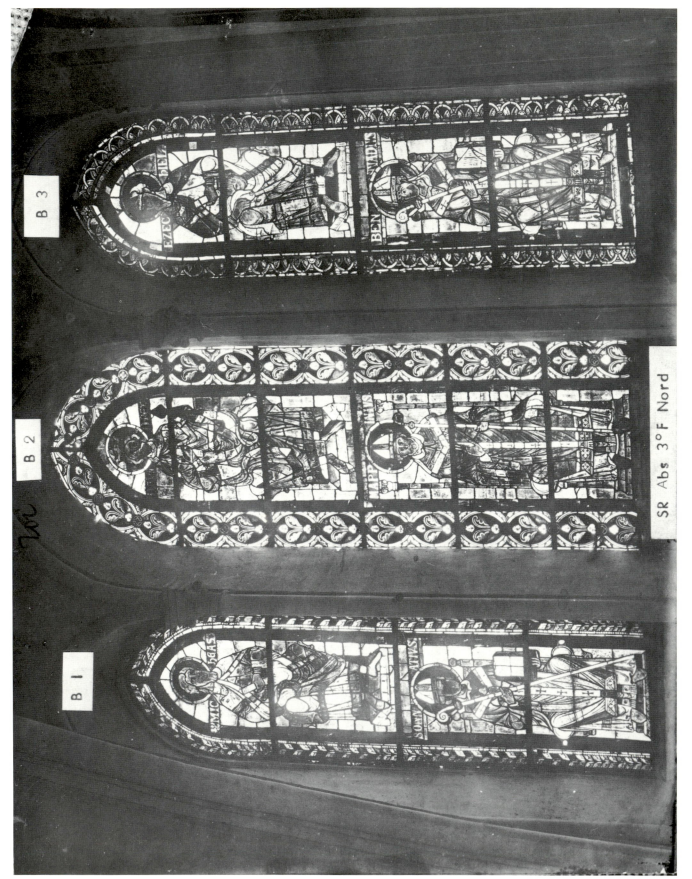

133. Patriarchs and archbishops, Reims, Saint-Remi, retrochoir clerestory, window N.IV (cartoons K, L, K; Dv, M, Dv; Rothier photo before 1896)

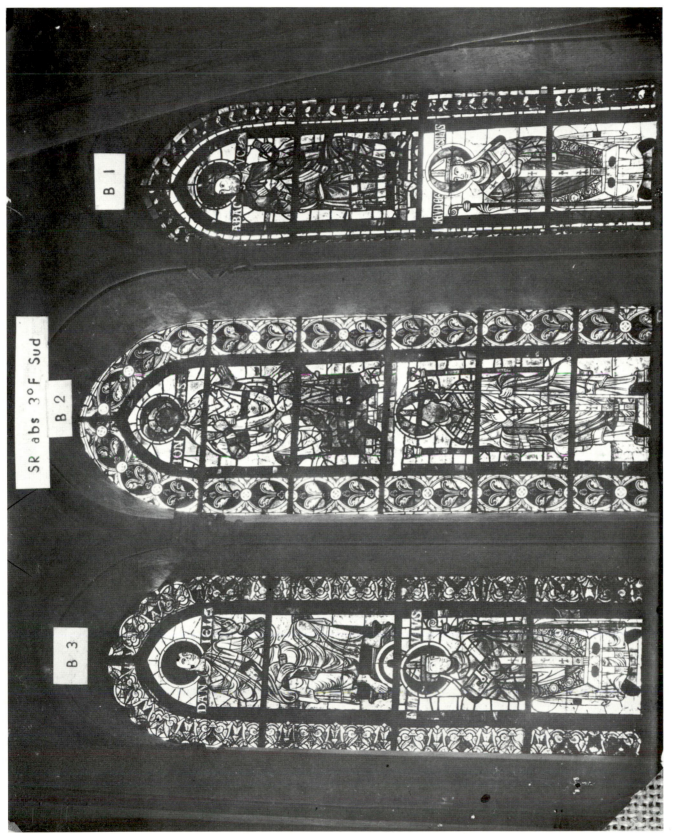

134. Patriarchs and archbishops, Reims, Saint-Remi, retrochoir clerestory, window S.IV (cartoons H[new], Lv, N; O, M, Or [new]; Rothier photo before 1896)

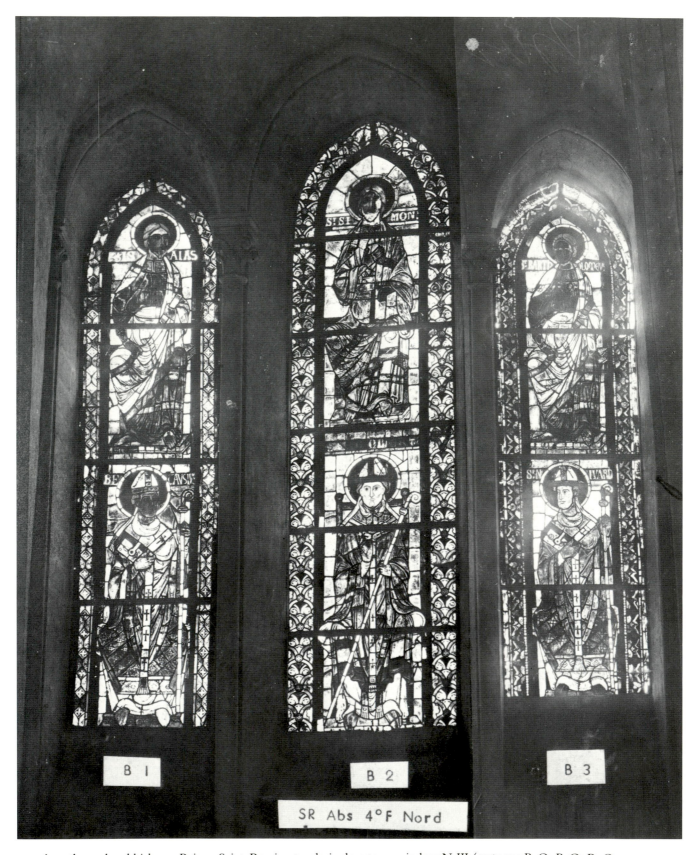

135. Apostles and archbishops, Reims, Saint–Remi, retrochoir clerestory, window N.III (cartoons P, Q, P; O, R, O;
Rothier photo before 1896)

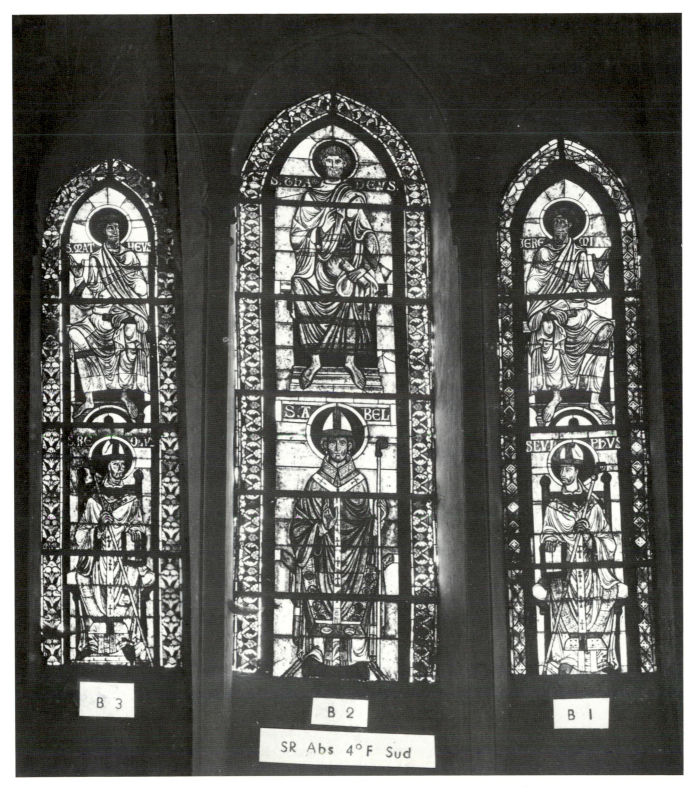

136. Apostles and archbishops, Reims, Saint-Remi, retrochoir clerestory, window S.III (cartoons H, B, Hr; D, E, Dr [all new]; Rothier photo before 1896)

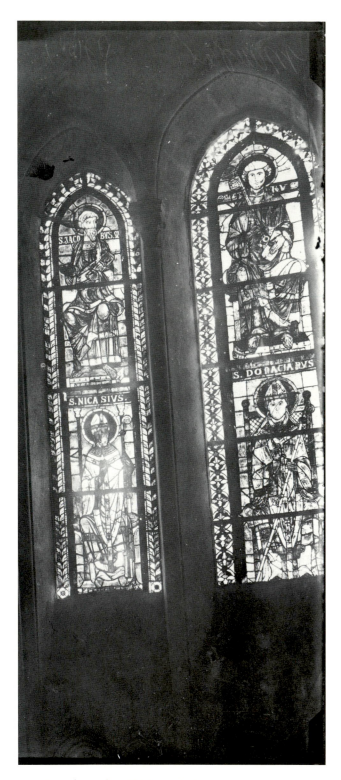

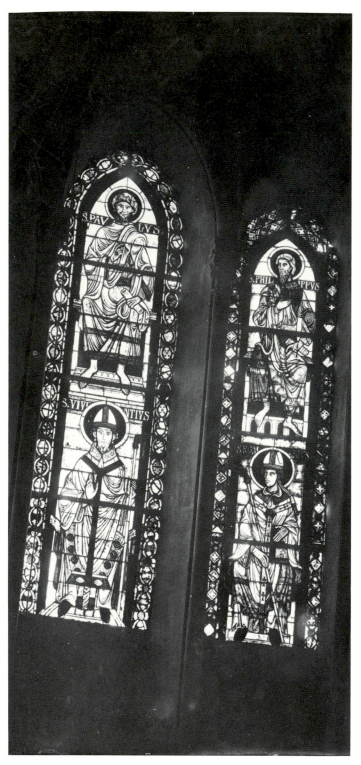

137. Apostles and archbishops, Reims, Saint–Remi, retro-
choir clerestory, window N.II a and b (cartoons S, T; U, R;
Rothier photo before 1896)

138. Apostles and archbishops, Reims, Saint–Remi, retrochoir
clerestory, window S.II b and c (cartoons B, C; E, F [all new];
Rothier photo before 1896)

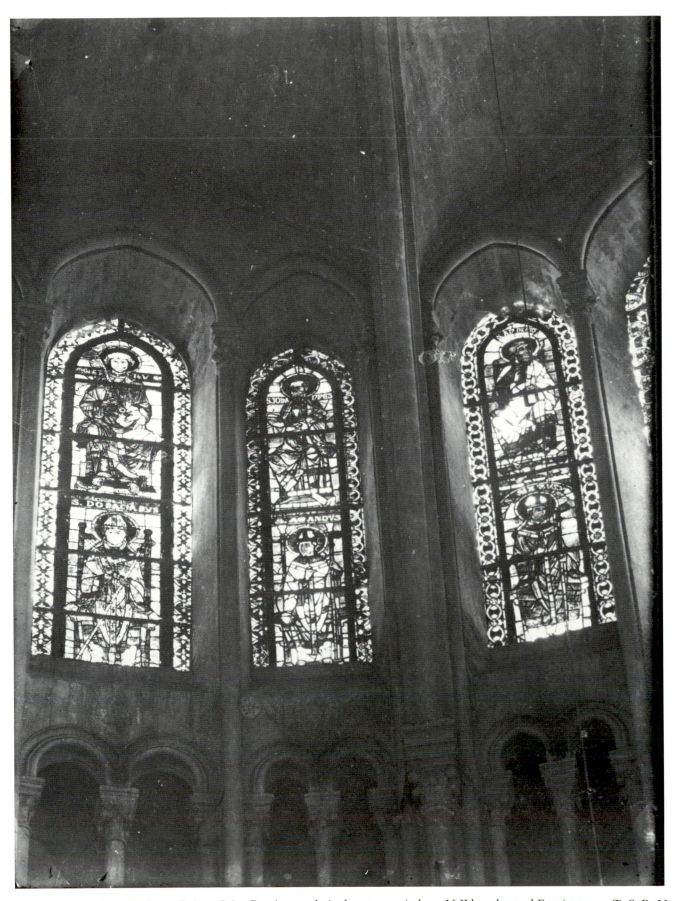

139. Apostles and archbishops, Reims, Saint-Remi, retrochoir clerestory, windows N.II b and c, and E, I (cartoons T, S; R, U and X; Y; Rothier photo before 1896)

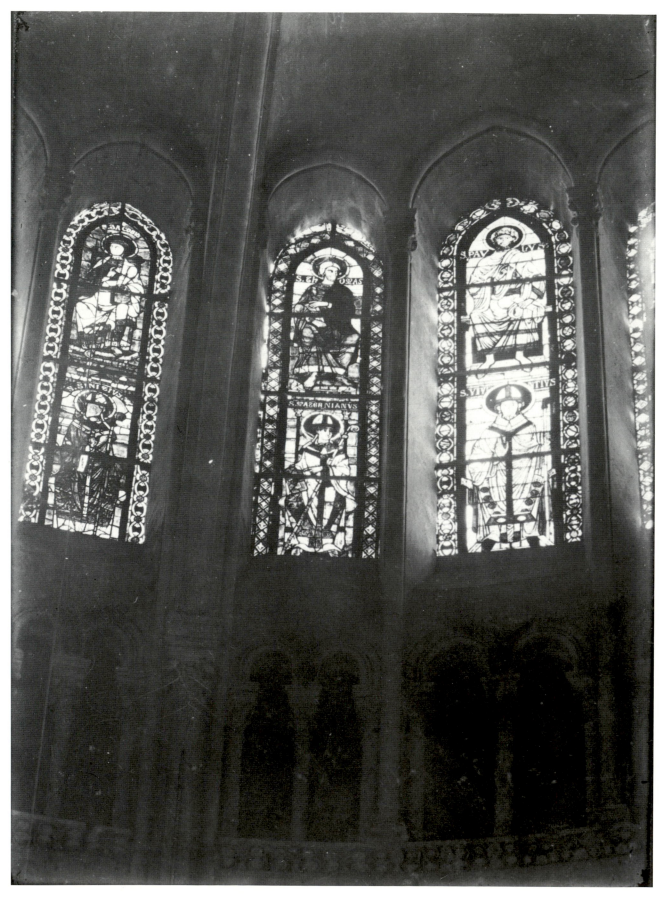

140. Apostles and archbishops, Reims, Saint-Remi, retrochoir clerestory, windows I c and S.II a and b (cartoons X, V, B [new]; and Y, W, E [new]; Rothier photo before 1896)

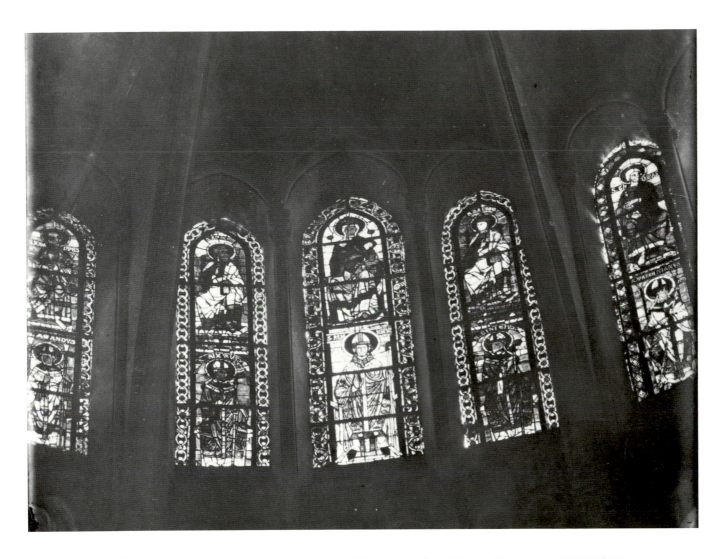

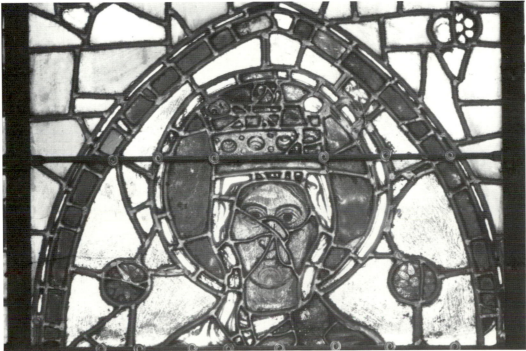

141. a. The Virgin, apostles, and archbishops, Reims, Saint-Remi, retrochoir clerestory, window I (cartoons X, Z, X; Y, E [new], Y; Rothier photo before 1896); b. upper part of the Virgin from the retrochoir clerestory, window I b (cartoon Z), now in the south transept

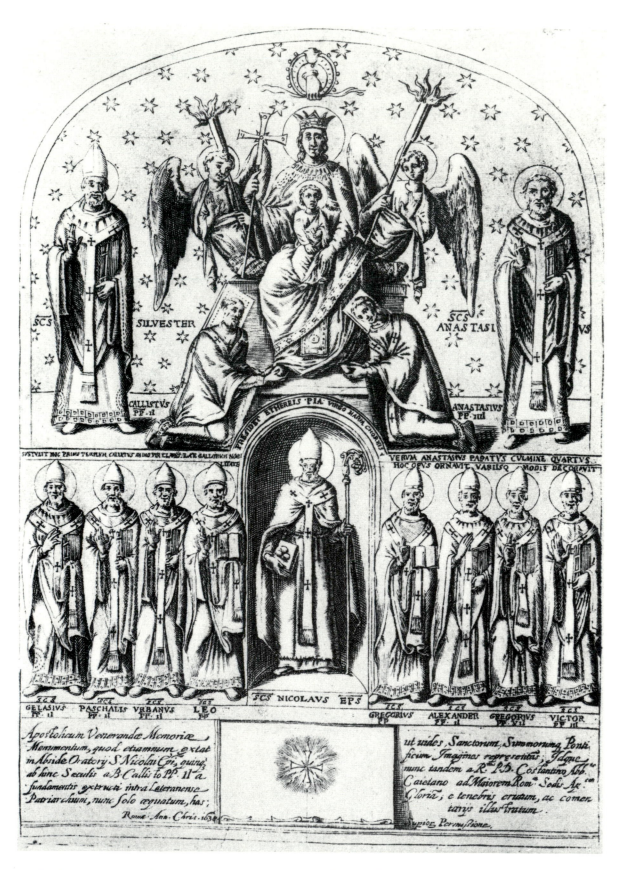

142. The Virgin with papal saints, fresco formerly in the St. Nicholas Chapel, Lateran Palace, Rome, from a print of 1638

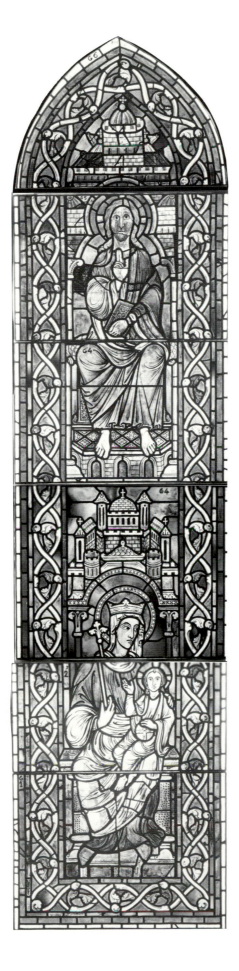

143. Christ and the Virgin and Child, Orbais Abbey Church, Choir clerestory, east window

144. Setting table with cartoon for stained glass, fourteenth century; Gerona, Diocesan Museum: a. photograph of the original; b. detail under ultraviolet light to show more clearly the changes made for repeated use

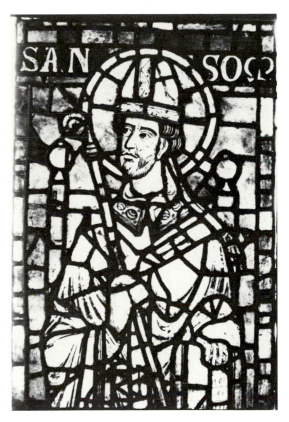

146. Archbishop "Sansom," Reims, Saint-Remi, retrochoir clerestory, window S.VI c (cartoon D)

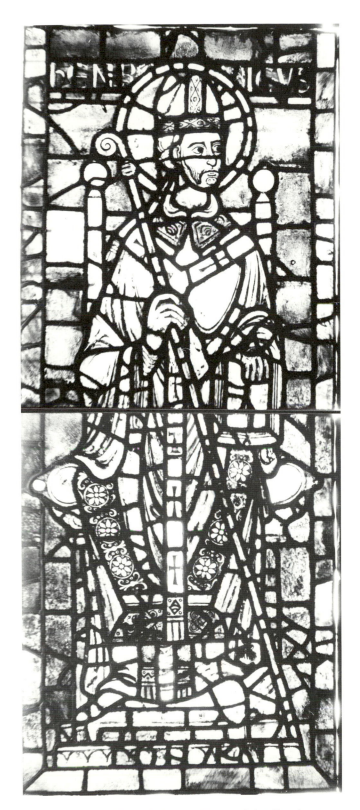

145. Archbishop Henri de France, Reims, Saint-Remi, retrochoir clerestory, window N.VI a (cartoon D)

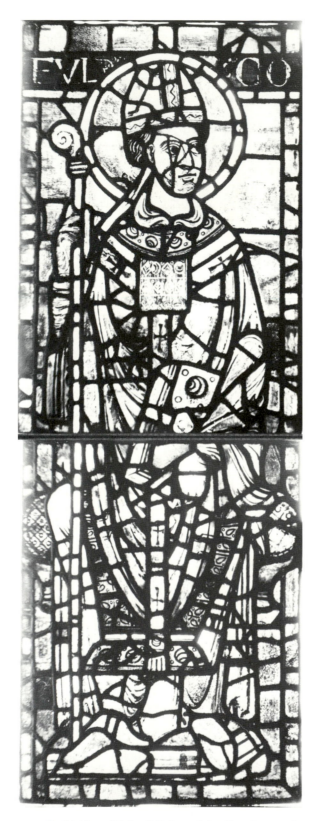

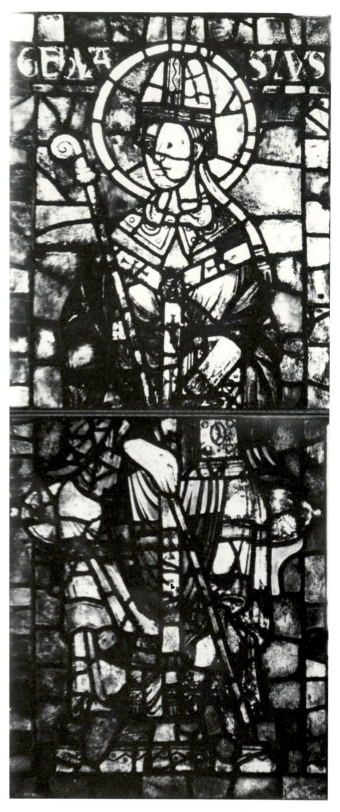

147. Archbishop "Fulco," Reims, Saint-Remi, retrochoir clerestory, window N. V a (cartoon J)

148. Archbishop "Gervasius," Reims, Saint-Remi, retrochoir clerestory, window N. VI c (cartoon F)

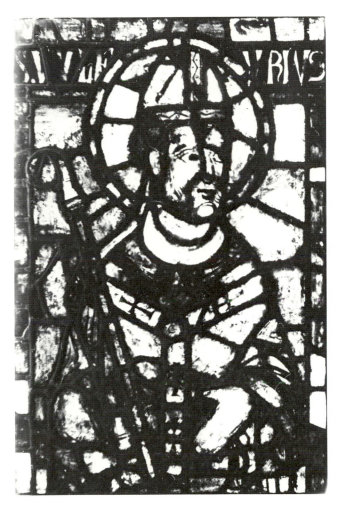

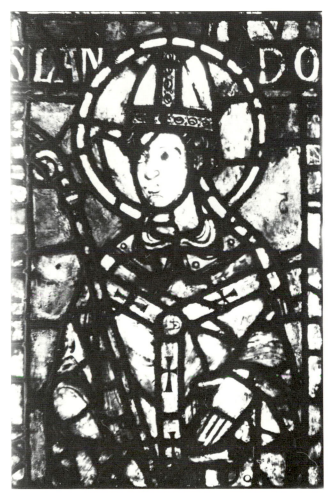

149. Archbishop "Vulfurius," Reims, Saint-Remi, retrochoir clerestory, window S. V a (cartoon Fv)

150. Archbishop "Lando," Reims, Saint-Remi, retrochoir clerestory, window S. VI c (cartoon F)

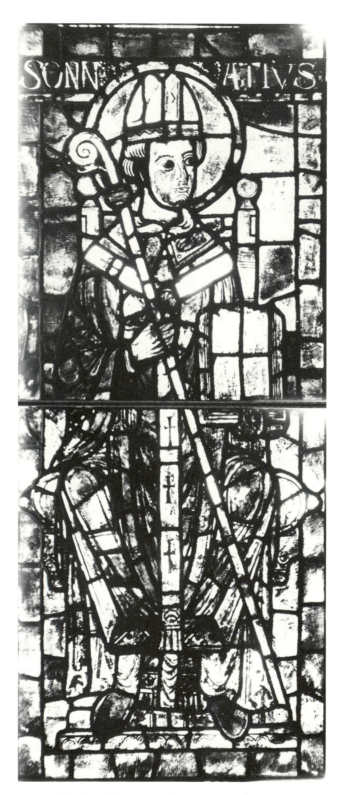

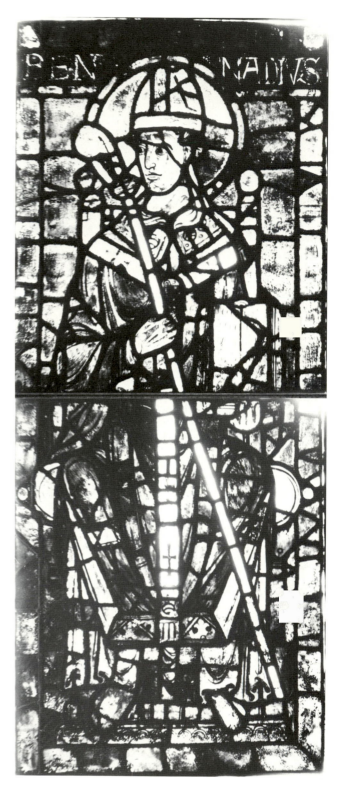

151. Archbishop "Sonnatius," Reims, Saint-Remi, retrochoir clerestory, window N.IV a (cartoon Dv)

152. Archbishop "Bennadius," Reims, Saint-Remi, retrochoir clerestory, window N.IV c (cartoon Dv)

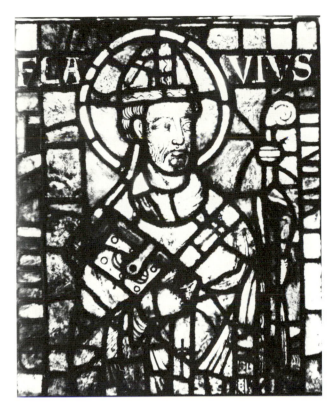

153. Archbishop "Flavius," Reims, Saint-Remi, retrochoir clerestory, window S.IV a (cartoon O)

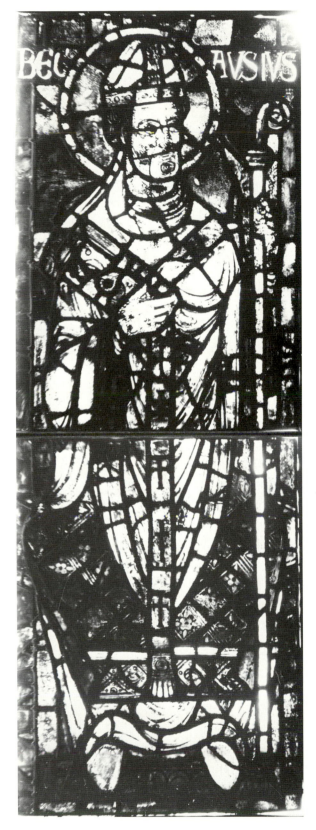

154. Archbishop "Becasius," Reims, Saint-Remi, retrochoir clerestory, window N.III a (cartoon O)

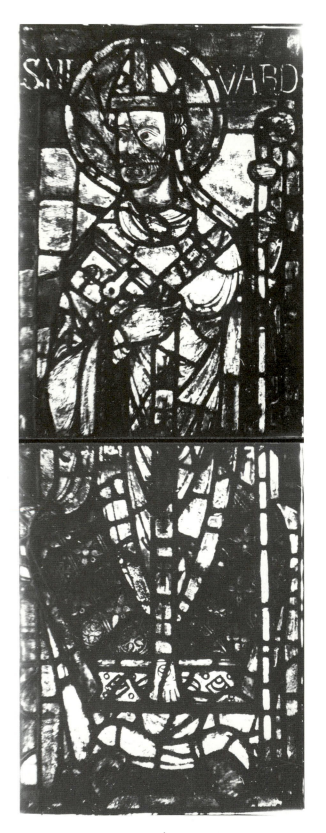

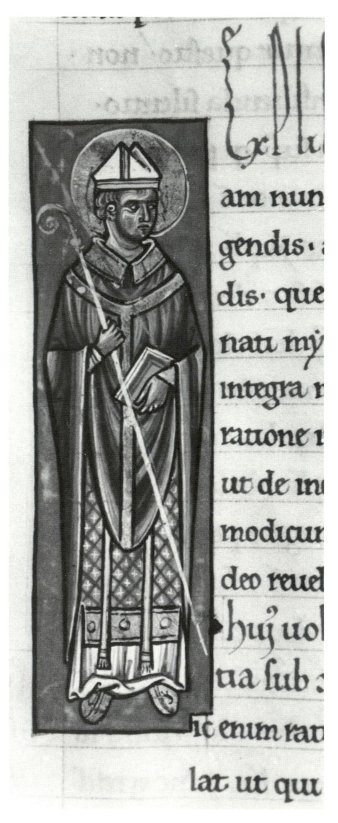

155. Archbishop "Nivard," Reims, Saint-Remi, retrochoir clerestory, window N.III c (cartoon O)

156. Archbishop, Peter Lombard, *Liber Sententiae*, from Saint-Denis of Reims, late twelfth century; Reims, B.M., MS 460, f. 157v

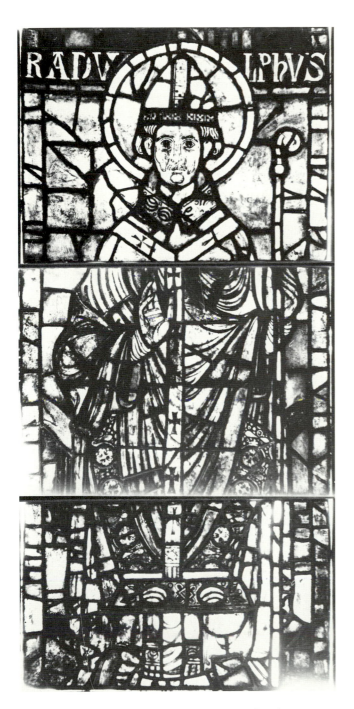

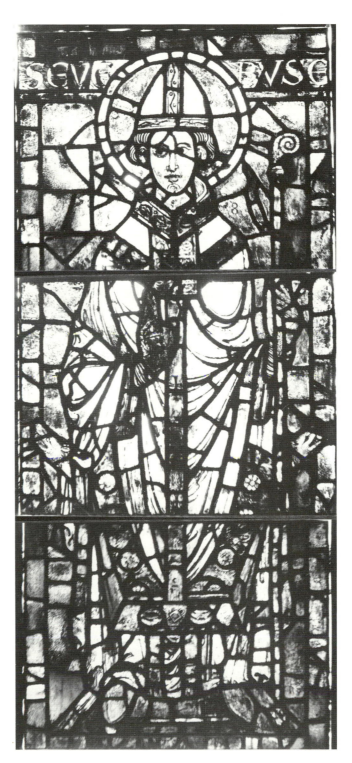

157. Archbishop "Radulphus," Reims, Saint-Remi, retrochoir clerestory, window S. VI b (cartoon E [top new])

158. Archbishop "Severus," Reims, Saint-Remi, retrochoir clerestory, window N. V b (cartoon Ev)

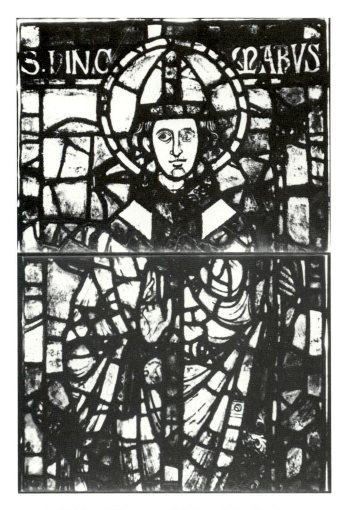

159. Archbishop "Hincmarus," Reims, Saint-Remi, retro-choir clerestory, window S.V b (cartoon Ev)

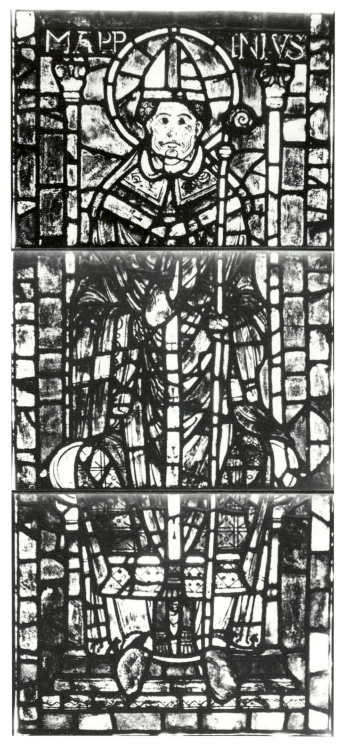

160. Archbishop "Mappinius," Reims, Saint-Remi, retrochoir clerestory, window N.IV b (cartoon M)

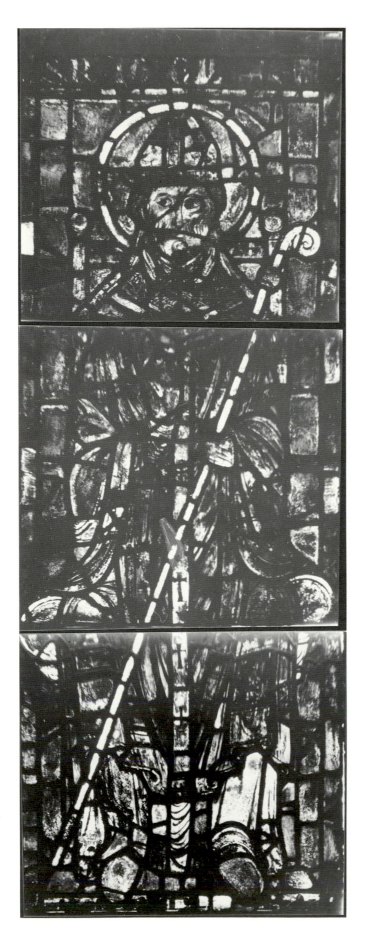

161. Archbishop Rigobertus, Reims, Saint-Remi, retrochoir clerestory, window N.III b (cartoon R)

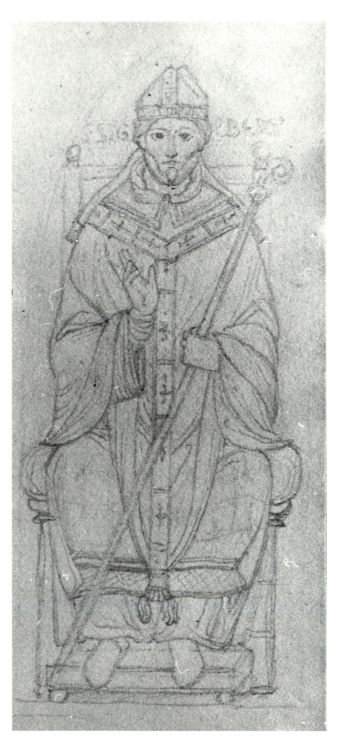

162. Archbishop "Sigobert," anonymous nineteenth-century drawing before 1870 restoration; Paris, Musée des Arts Décoratifs, Desseins, Vitraus, no. 2509

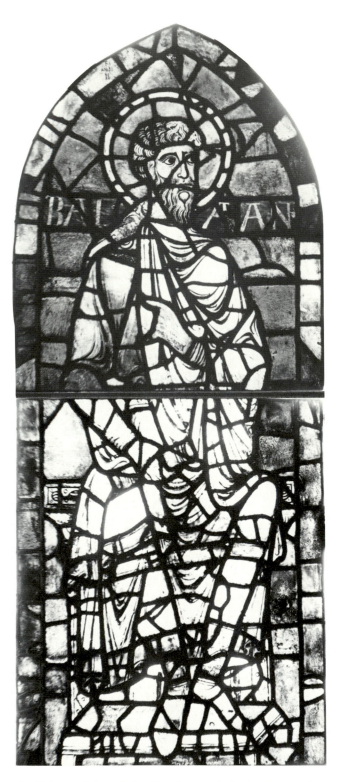

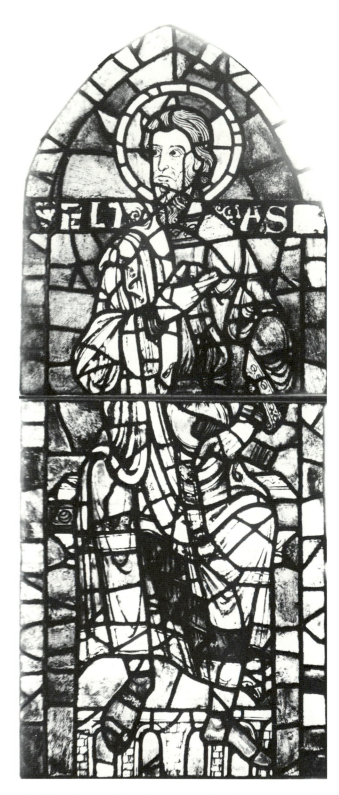

163. Balaam, Reims, Saint-Remi, retrochoir clerestory, window N.VI a (cartoon A)

164. Elias, Reims, Saint-Remi, retrochoir clerestory, window N.VI c (cartoon C)

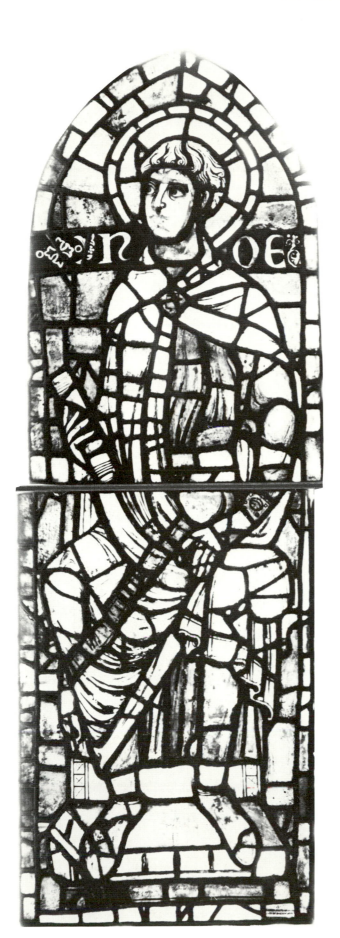

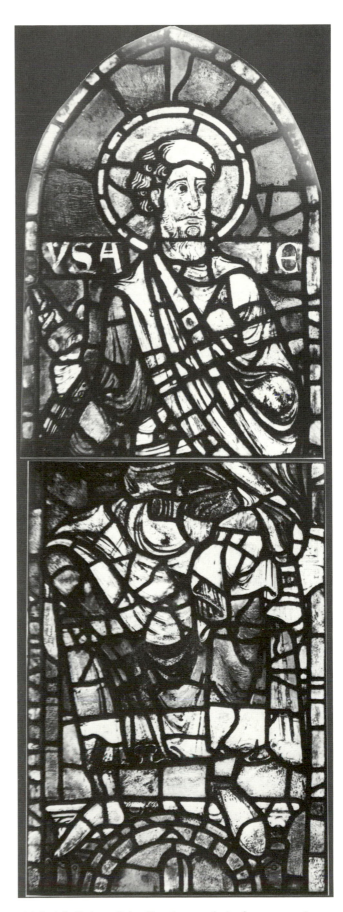

165. "Noe," Reims, Saint-Remi, retrochoir clerestory, window S. VI c (cartoon G)

166. Isaiah, Reims, Saint-Remi, retrochoir clerestory, window N. V a (cartoon H)

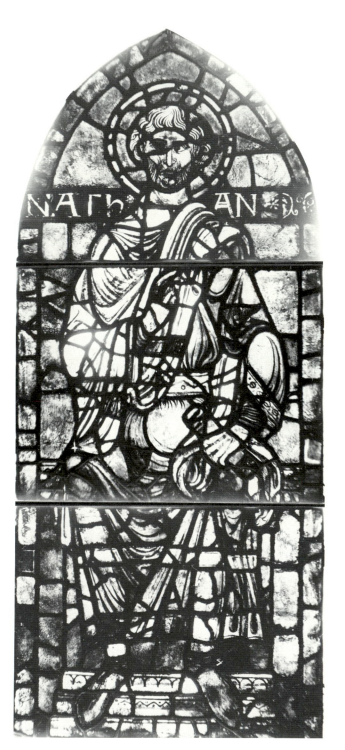

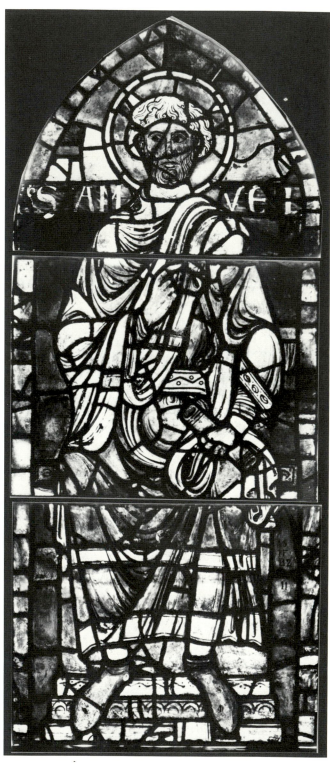

167. "Nathan," Reims, Saint-Remi, retrochoir clerestory, window N. VI b (cartoon B)

168. "Samuel," Reims, Saint-Remi, retrochoir clerestory, window S. VI b (cartoon B)

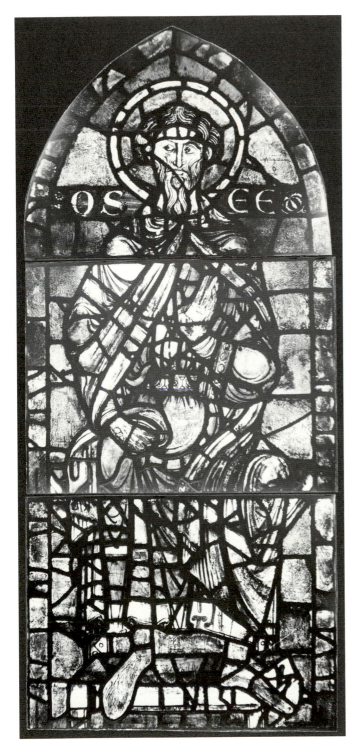

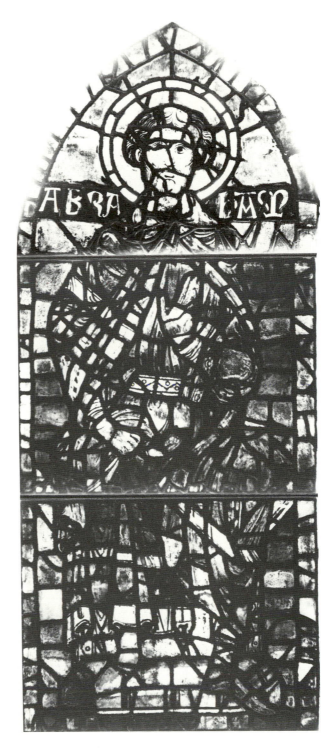

169. "Osee," Reims, Saint-Remi, retrochoir clerestory, window N.V b (cartoon I)

170. "Abraham," Reims, Saint-Remi, retrochoir clerestory, window S.V b (cartoon I)

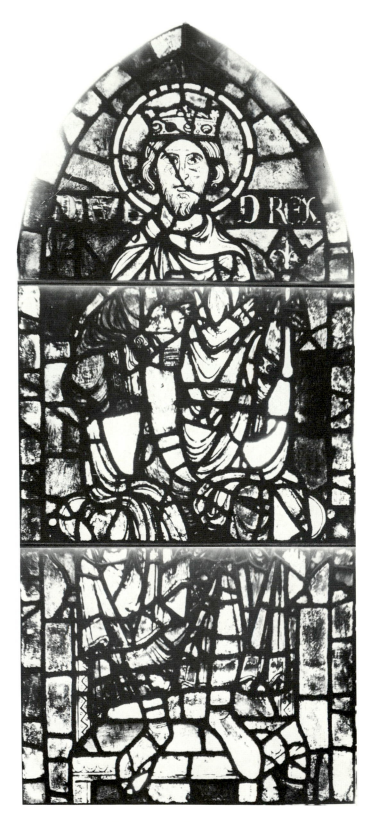

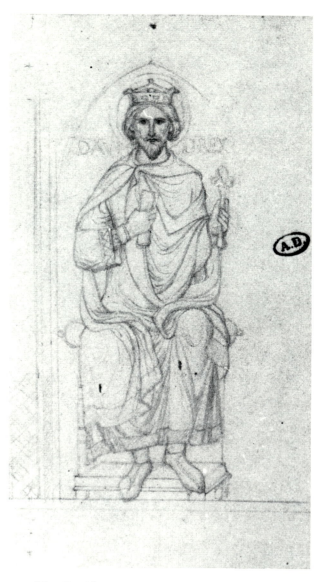

172. King David, anonymous nineteenth-century drawing, before restoration; Paris, Musée des Arts Décoratifs, Desseins, Vitraux, no. 2509

171. King David, Reims, Saint-Remi, retrochoir clerestory, window N.IV b (cartoon L)

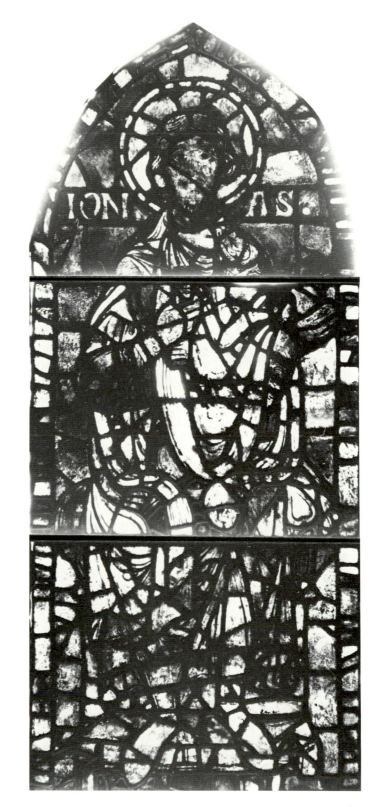

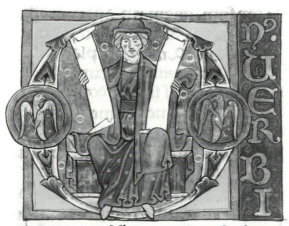

173. Prophet Malachi, "Sainte-Geneviève Bible;" B.N., MS lat. 11535, f. 345v

174. "Ionas," Reims, Saint-Remi, retrochoir clerestory, window S.IV b (cartoon Lv)

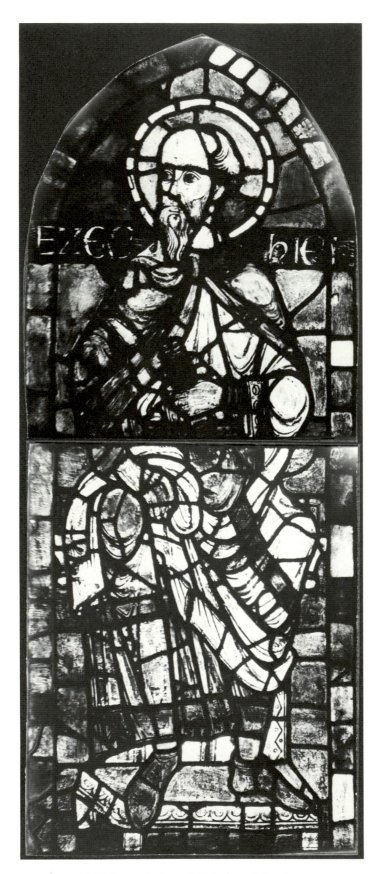

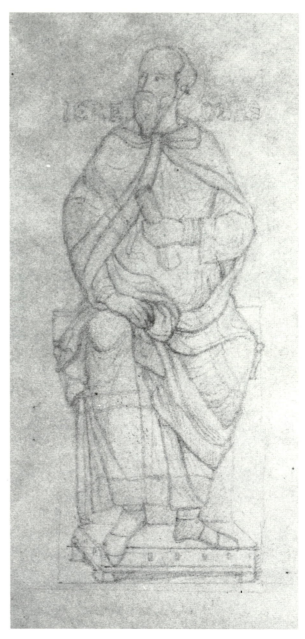

175. "Ezechiel" (formerly Jeremiah) Reims, Saint-Remi, retro-choir clerestory, window N.IV c (cartoon K)

176. Jeremiah, anonymous nineteenth-century drawing, before restoration; Paris, Musée des Arts Décoratifs, Desseins, Vitraux, no. 2508

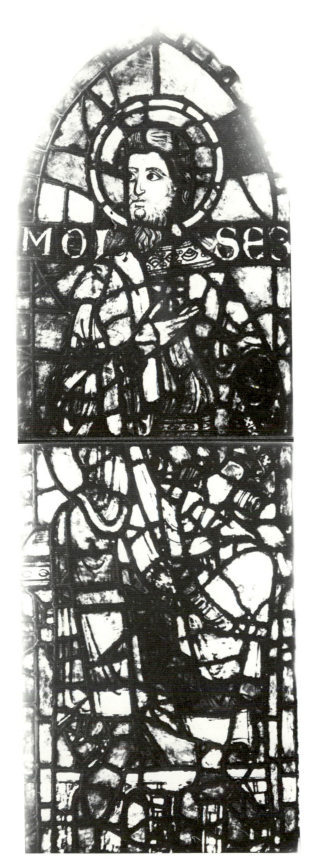

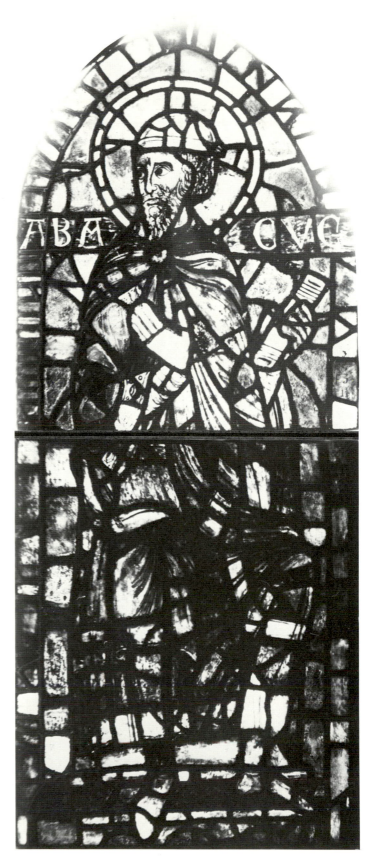

177. "Moises," Reims, Saint-Remi, retrochoir clerestory, window S.V c (cartoon C)

178. "Abacuc," Reims, Saint-Remi, retrochoir clerestory, window S.IV c (cartoon N)

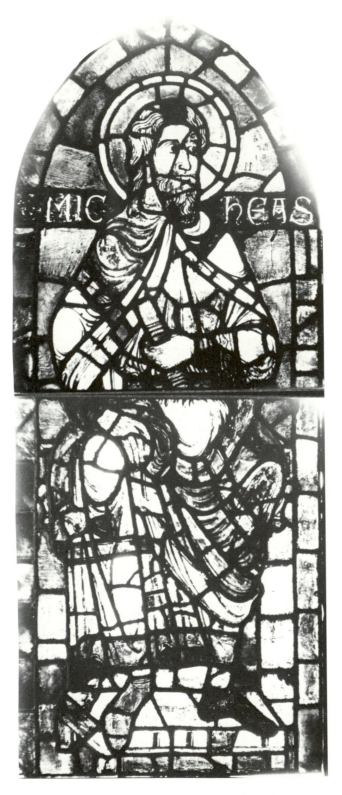

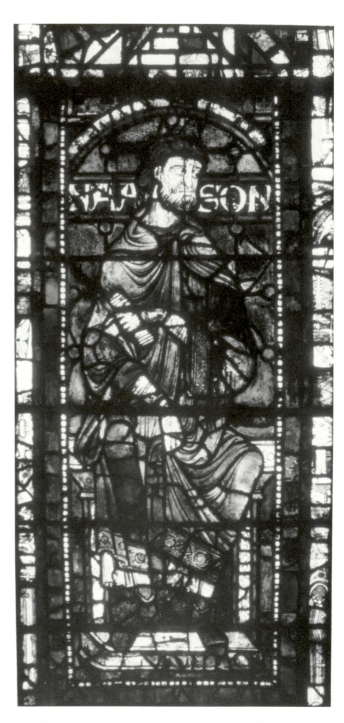

179. "Micheas," Reims, Saint-Remi, retrochoir clerestory, window N.IV a (cartoon K)

180. Nahshon, Canterbury, Christ Church Cathedral, from Trinity Chapel clerestory, window N.X

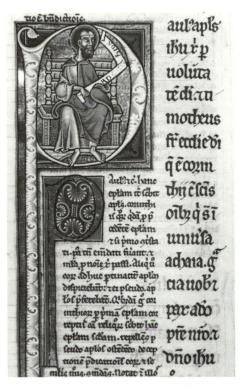

181. St. Paul, Pauline Epistles, northern France, ca. 1200; B.L., Royal MS 4.E.ix, f. 84v

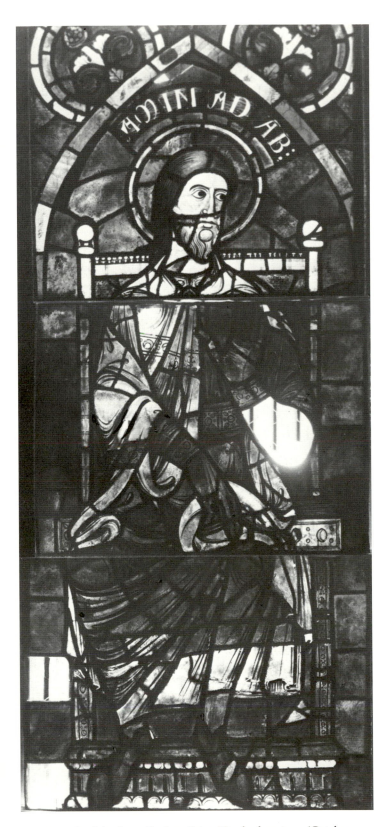

182. Amminadab, from Braine, Saint-Yved, clerestory (Catalogue A, no. 1); now in Soissons, Cathedral of Saint-Gervais et Saint-Portais, apse clerestory, Window 103

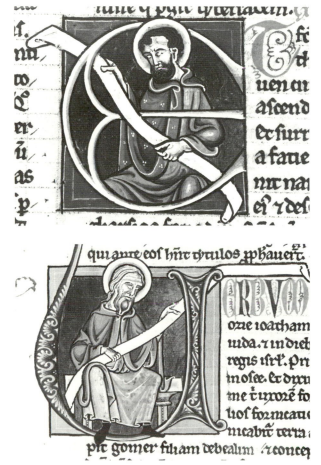

183. a. Jonah, f. 147; b. Hosea, f. 144, Bible from northern France, ca. 1200; Berlin, Staatsbibliothek Preussischer Kulturbesitz, MS theol. lat. fol. 9

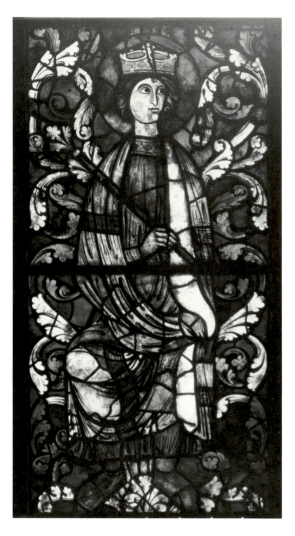

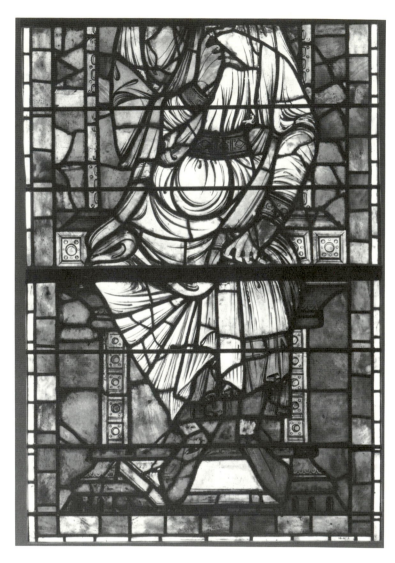

184. King in the Jesse Window, Soissons, Cathedral of Saint-Gervais et Saint-Protais, apse clerestory, Window 100

185. Lower part of an ancestor of Christ from Braine, Saint-Yved, clerestory (Catalogue A, no. 6); now in New York, Metropolitan Museum of Art, accession no. 14.47 b and c

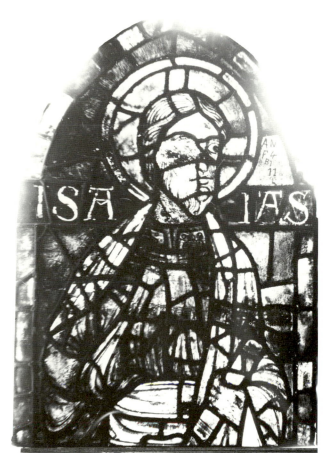

187. St. James, anonymous nineteenth-century drawing, before restoration; Paris, Musée des Arts Décoratifs, Desseins, Vitraux, no. 2508

186. "Isaias" (formerly St. James), Reims, Saint-Remi, retrochoir clerestory, window N.III a (cartoon P)

188. "Isaias" (formerly St. James), before restoration, ca. 1950, from Reims, Saint-Remi, retrochoir clerestory, window N.III a

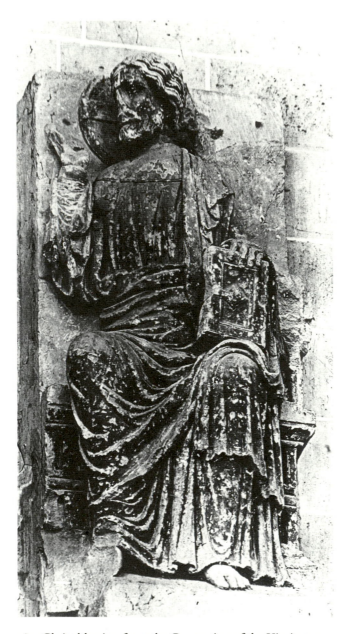

189. Christ blessing from the Coronation of the Virgin tympanum of the central west portal, Braine, Saint-Yved, ca. 1195–1205

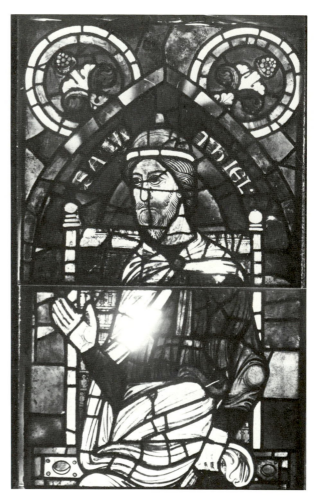

190. Salathiel, from Braine, Saint-Yved, clerestory (Catalogue A, no. 4); now in Soissons, Cathedral of Saint-Gervais et Saint-Protais, apse clerestory, Window 103

191. An Alexandrian presenting the head of Pompey to Caesar, *Pharsale*, Virgil collection, northern France, ca. 1200; B.N., MS lat. 7936, f. 181

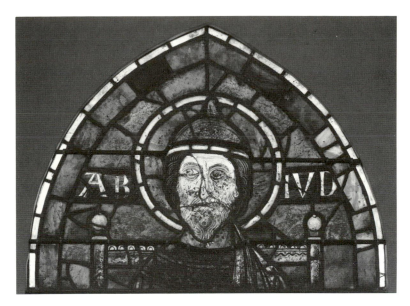

192. Bust of Abiud, from Braine, Saint-Yved, clerestory (Catalogue A, no. 5); now in New York, Metropolitan Museum of Art, accession no. 14.47 a

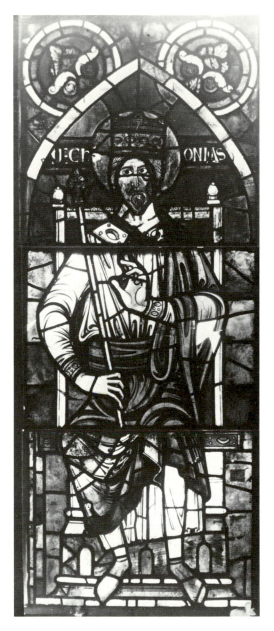

193. Jechoniah, from Braine, Saint-Yved, clerestory (Catalogue A, no. 3 [center panel new]); now in Soissons, Cathedral of Saint-Gervais et Saint-Protais, apse clerestory, Window 103

194 a. Bust of a royal ancestor of Christ; and b. the lower part of another figure, Braine, Saint-Yved, clerestory (Catalogue A, nos. 9 and 10); now in Bryn Athyn, Glencairn Museum, accession no. 03.SG.234

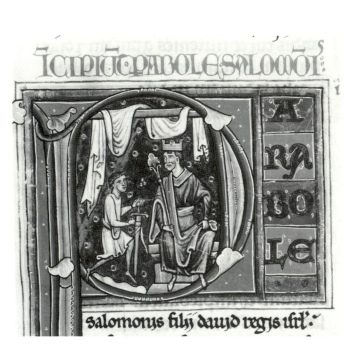

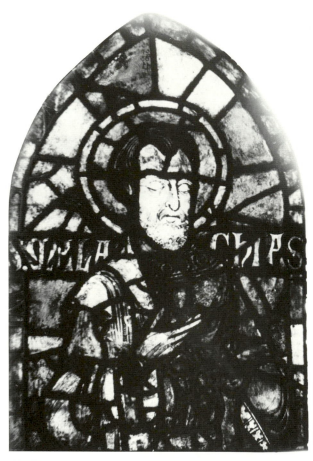

195. King Solomon with sword-bearer, "Sainte-Geneviève Bible"; B.N., MS lat. 11534, f. 54r

196. Lower part of an ancestor of Christ, from Braine, Saint-Yved, clerestory (Catalogue A, no.16); now in Glendale, Forest Lawn Memorial Park, lot 11/12/60/85

197. "Malachias," Reims, Saint-Remi, retrochoir clerestory, window S.V a (cartoon C)

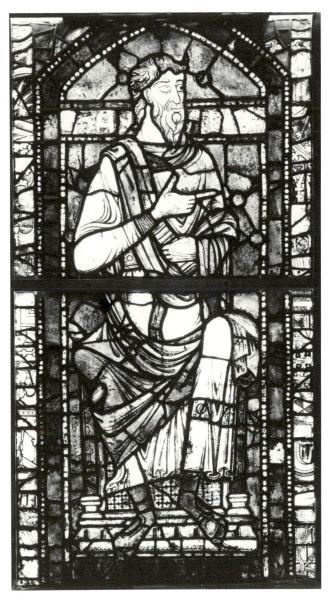

198. Amminadab, Canterbury, Christ Church Cathedral, from Trinity Chapel clerestory, window N.X

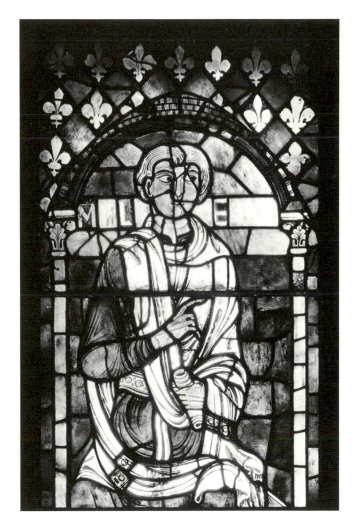

199. Upper part of an ancestor of Christ, from Braine, Saint-Yved, clerestory (Catalogue A, no. 11); now in St. Louis, City Art Museum, accession no. 137:20 (detail)

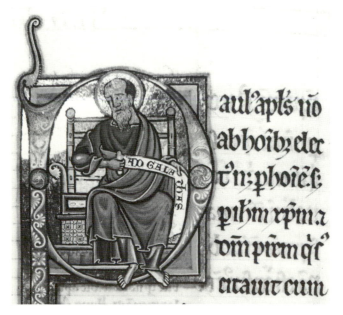

200. St. Paul, Pauline Epistles, northern France, ca. 1200; B.L., Royal MS 4.E.ix, f. 102v

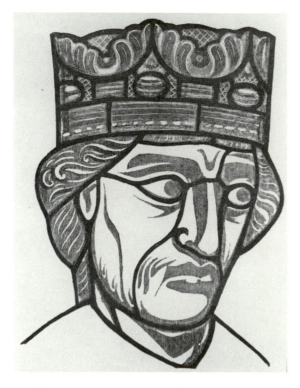

201. Head of a king from Reims, Saint-Remi, drawing b E. E. Viollet-Le-Duc, made before 1868

204. Torso of a royal ancestor of Christ, from Braine, Saint-Yved, clerestory (Catalogue A, no. 7); now in Philadelphia, Philadelphia Museum of Art, accession no. 1928–40–1 (detail)

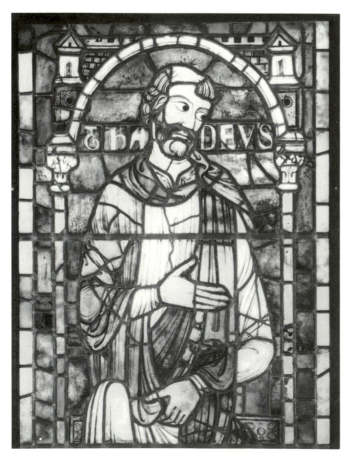

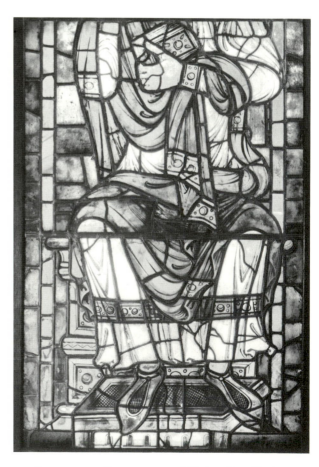

202. Parts of two ancestors of Christ, from Braine, Saint-Yved, clerestory (Catalogue A, nos. 12 and 13); now in Baltimore, Walters Art Gallery, accession no. 46–38 (detail)

203. Lower part of an ancestor of Christ, from Braine, Saint-Yved, clerestory (Catalogue A, no. 14); now in Baltimore, Walters Art Gallery, accession no. 46–39 (detail)

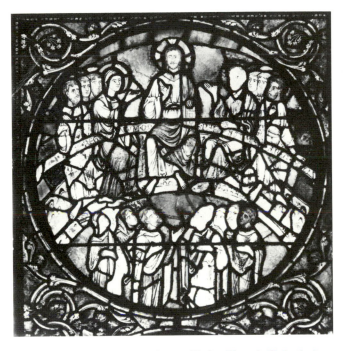

205. Last Judgment, Canterbury, Christ Church Cathedral, from Trinity Chapel clerestory, window I; now in Richmond, Virginia Museum of Fine Arts, 69–10

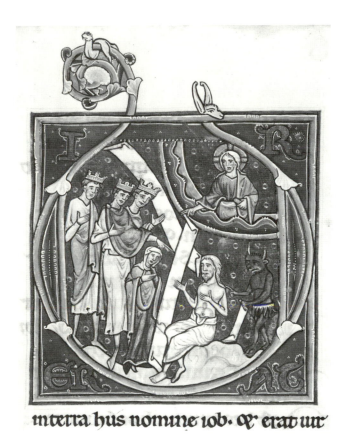

207. The sufferings of Job, "Sainte-Geneviève Bible"; B.N., MS lat. 11534, f. 3

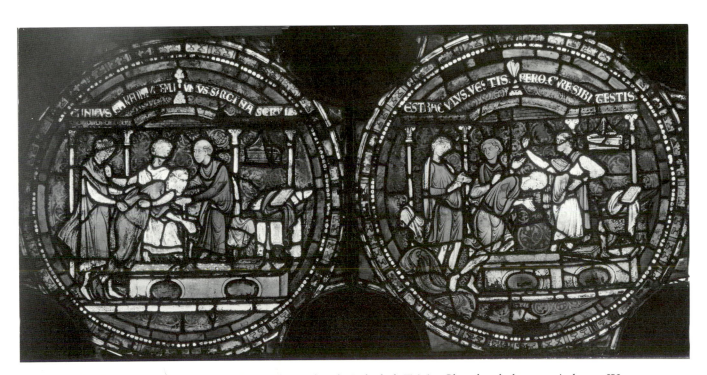

206. Cure of Robert of Cricklade?, Canterbury, Christ Church Cathedral, Trinity Chapel ambulatory, window n.IV

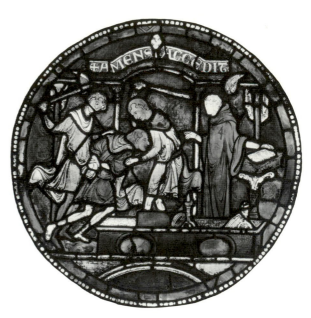

209. Cure of Henry of Forwich[?], Canterbury, Christ Church Cathedral, Trinity Chapel ambulatory, window n.IV

208. The Entombment of the Virgin, detail from canon tables, "Sainte-Geneviève Bible"; B.N., MS lat. 11534, f.205.

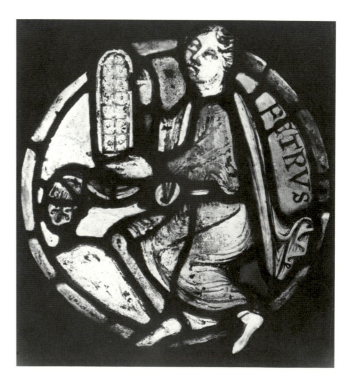

210. Noah building the Ark, initial to Psalm 27, Morgan Psalter, northern France, ca. 1200; New York, Pierpont Morgan Library, MS 338, f. 105r

211. Donor ("Petrus"), from Reims, Saint-Remi, symbolic Crucifixion window in the south transept; now in Bryn Athyn, Glencairn Museum, accession no. 03.SG.11

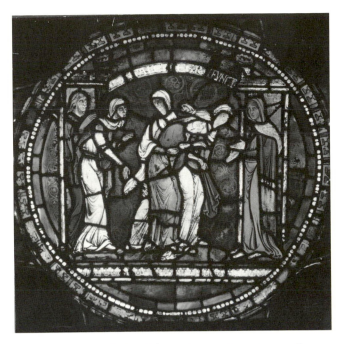

212. Petronella suffering from epilepsy, Canterbury, Christ Church Cathedral, Trinity Chapel ambulatory, window n.IV

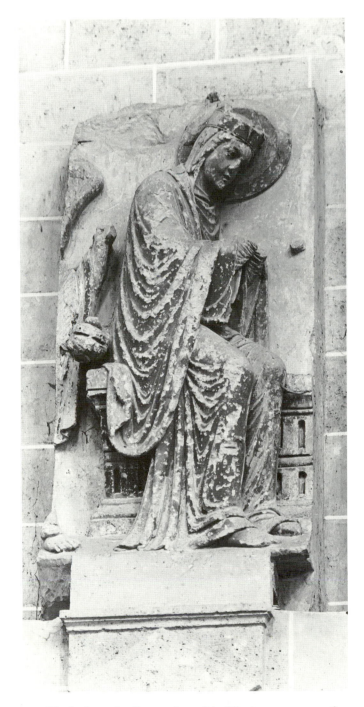

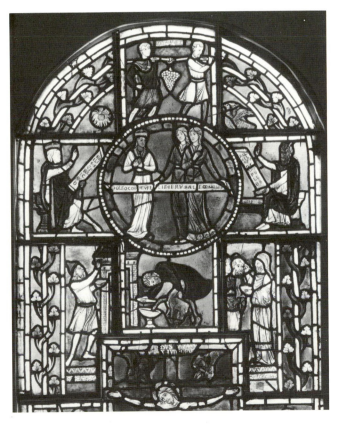

213. Symbolic Crucifixion window, detail of upper part, Orbais Abbey Church, east window of axial chapel

214. Virgin from the Coronation of the Virgin tympanum of the central west portal, Braine, Saint-Yved, ca. 1195–1205

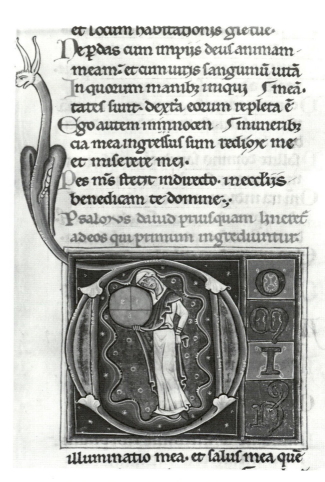

215. Synagogue from Reims, Saint-Remi, symbolic Crucifixion window in the south transept; now in Bryn Athyn, Glencairn Museum, accession no. 03.SG.25

217. The World, "Sainte-Geneviève Bible"; B.N., MS lat. 11534, f. 23r

216. Amos, "Sainte-Geneviève Bible"; B.N., MS lat. 11535, f. 329v

218a. Angel offering a crown, from Braine, Saint-Yved, west rose? (Catalogue A, no. 28); now in Soissons, Cathedral of Saint-Gervais et Saint-Protais, apse clerestory, Window 103. b. Angel, Chartres Cathedral, west rose, ca. 1215–1225

219. Flight into Egypt, the Ingeborg Psalter, northern France, ca. 1190–1210; Chantilly, Musée Condé, MS 1695, f. 18v

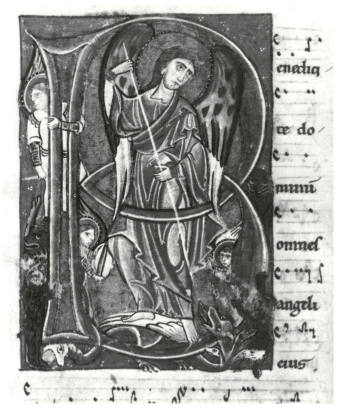

220. Archangel Michael, Premonstratensian Missal, northern France, second half of the twelfth century; B.N., MS lat. 833, f. 227v

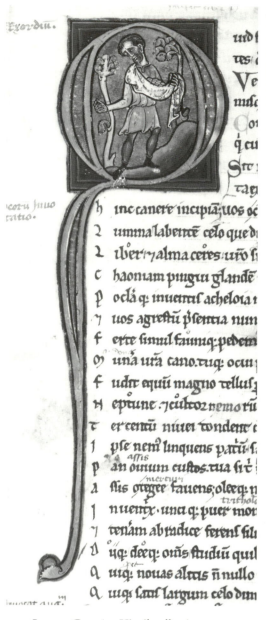

222. Sower, *Georgics,* Virgil collection, northern France, ca. 1200; Paris, B.N., MS lat. 7936, f. 6r

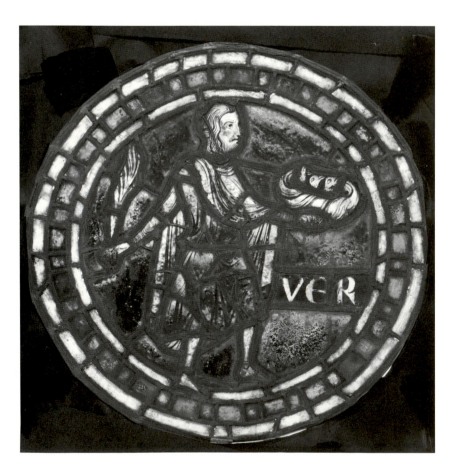

221. Spring, from Braine, Saint-Yved, transept rose (Catalogue A, no. 21); now in Bryn Athyn, Glencairn Museum, accession no. 03.SG.178

224. March, calendar illustration, Ingeborg Psalter, northern France, ca. 1190–1210; Chantilly, Musée Condé, MS 1695, f. 4v

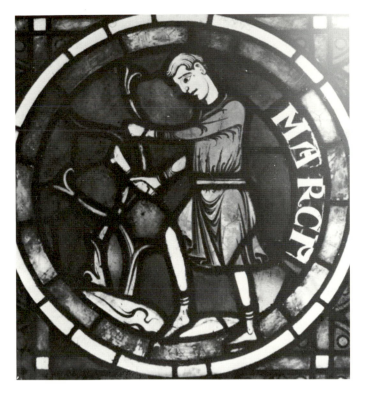

223. March, from Braine, Saint-Yved, transept rose (Catalogue A, no. 22); now in Soissons, Cathedral of Saint-Gervais et Saint-Protais, apse clerestory, Window 103

227. November, calendar illustration, Ingeborg Psalter, northern France, ca. 1190–1210; Chantilly, Musée Condé, MS 1695, f. 8v

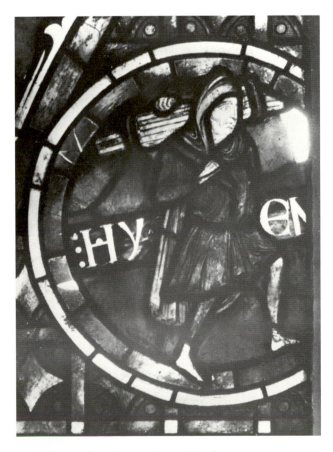

226. Winter, from Braine, Saint-Yved, transept rose (Catalogue A, no. 20); now in Soissons, Cathedral of Saint-Gervais et Saint-Protais, apse clerestory, Window 103

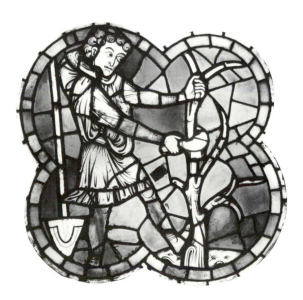

225. March, Paris, Cathedral of Notre-Dame, west rose, ca. 1225

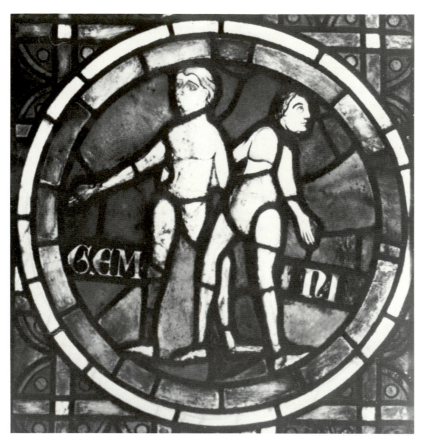

228. Gemini, from Braine, Saint-Yved, transept rose (Catalogue A, no. 23); now in France, Aisne, Soissons, Cathedral of Saint-Gervais et Saint-Protais, apse clerestory, Window 103

230. Ancient idol, Virgil collection, northern France, ca. 1200; B.N., MS lat. 7936, f. 174v

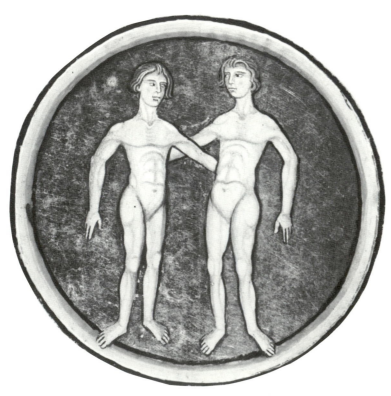

229. Gemini, calendar illustration for May, Ingeborg Psalter, northern France, ca. 1190–1210; Chantilly, Musée Condé, MS 1695, f. 5v

231. Grammar, from Braine, Saint-Yved, transept rose (Catalogue A, no. 19); now in Bryn Athyn, Glencairn Museum, accession no. 03.SG.179

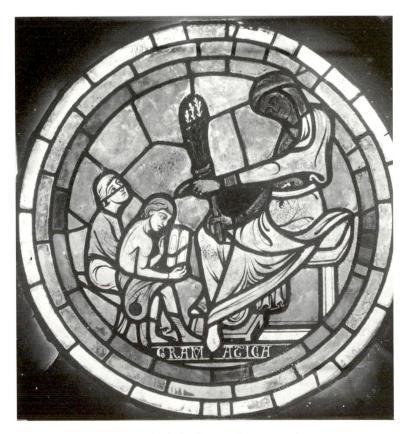

232. Grammar, Laon, Cathedral of Notre-Dame, north transept rose (heavily restored)

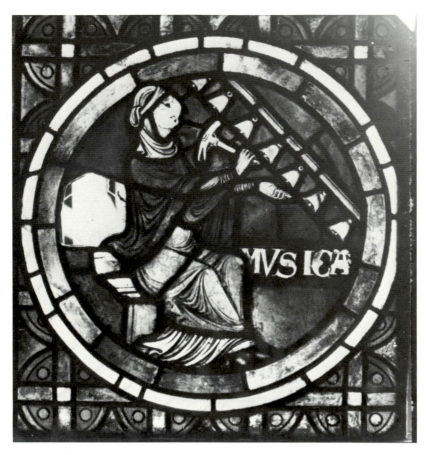

233. Music, from Braine, Saint-Yved, transept rose (Catalogue A, no. 17); now in Soissons, Cathedral of Saint-Gervais et Saint-Protais, apse clerestory, Window 103

234. Prophet, Braine, Saint-Yved, archivolt of central west portal

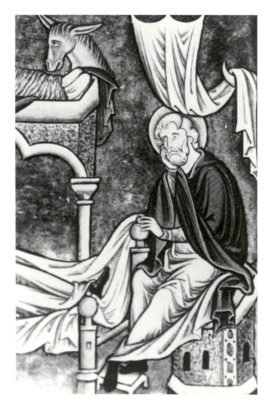

236. Joseph, detail from the Nativity, Ingeborg Psalter, northern France, ca. 1190–1210; Chantilly, Musée Condé, MS 1695, f. 15r

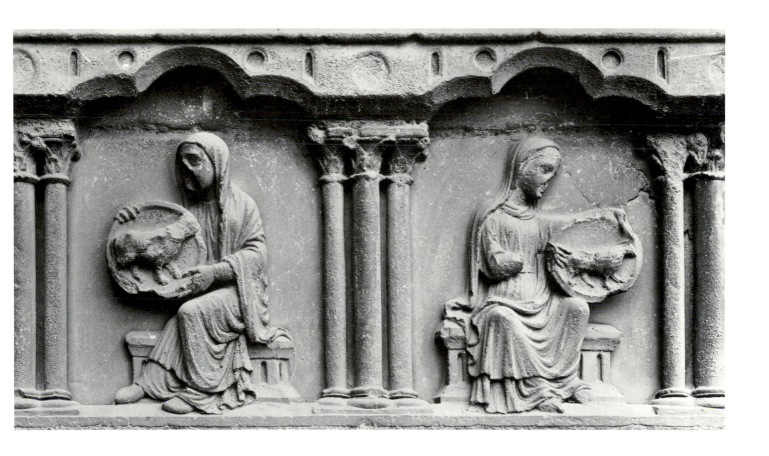

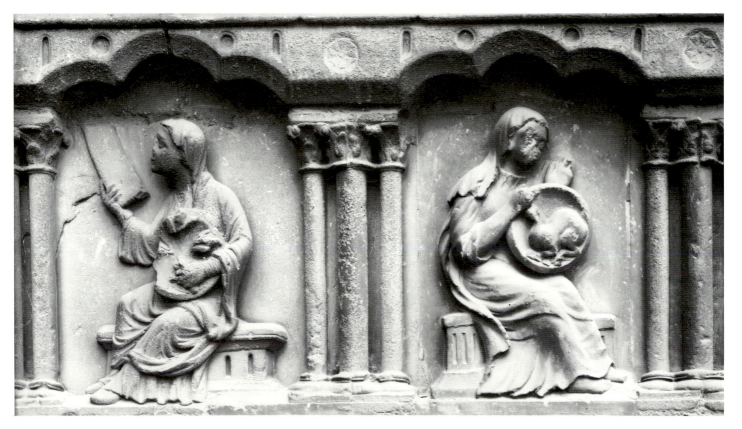

235. Virtues, Paris, Cathedral of Notre–Dame, central west portal, right socle

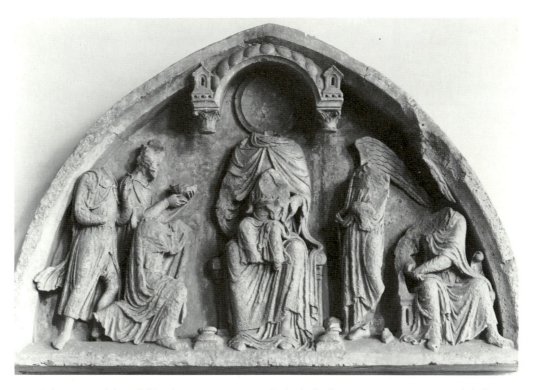

238. Adoration of the Child (plaster cast), Laon, Cathedral of Notre-Dame, west portal (left); Paris, Musée des Monuments français

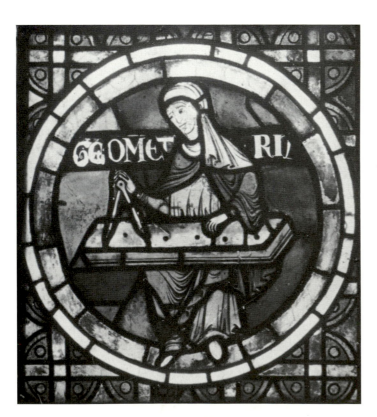

237. Geometry, from Braine, Saint-Yved, transept rose (Catalogue A, no. 18); now in Soissons, Cathedral of Saint-Gervais et Saint-Protais, apse clerestory, Window 103

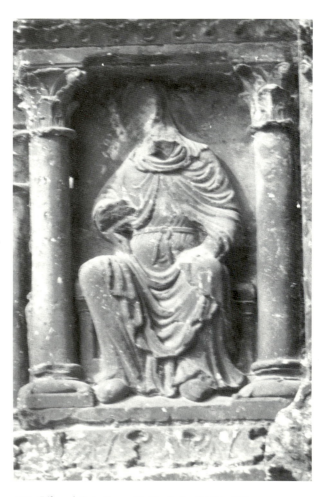

239. Liberal Art, Sens, Cathedral of Saint-Etienne, central west portal, left socle

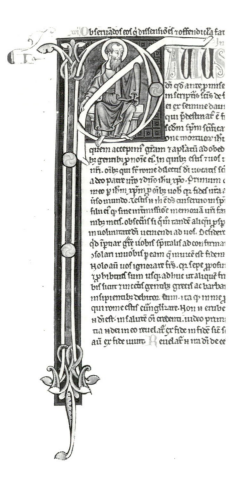

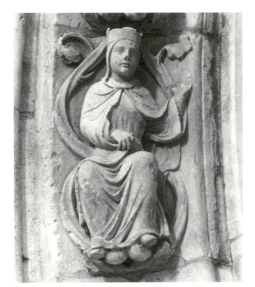

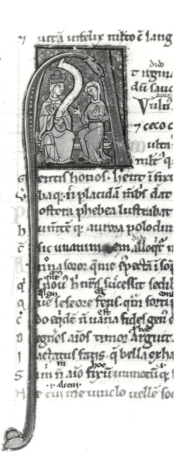

240. St. Paul, Bible from northern France, ca. 1200; Berlin, Staatsbibliothek Preussischer Kulturbesitz, MS theol. lat. fol. 9, f. 190

241. Sibyl or Old Testament Queen, Braine, Saint-Yved, archivolt of central west portal

242. Dido and her sister, *Aneid*, Virgil collection, northern France, ca. 1200; B.N., MS lat. 7936, f. 33

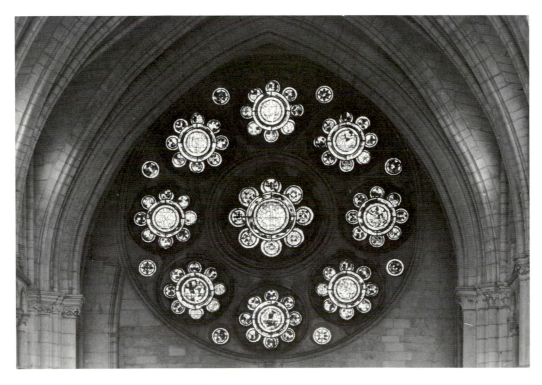

243. North rose, Laon, Cathedral of Notre-Dame

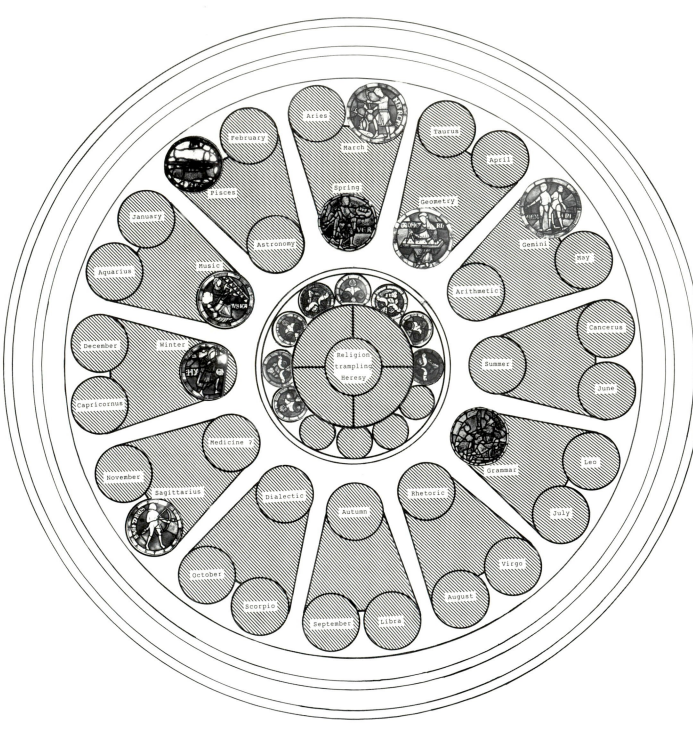

244. South rose, Braine, Saint-Yved, reconstruction

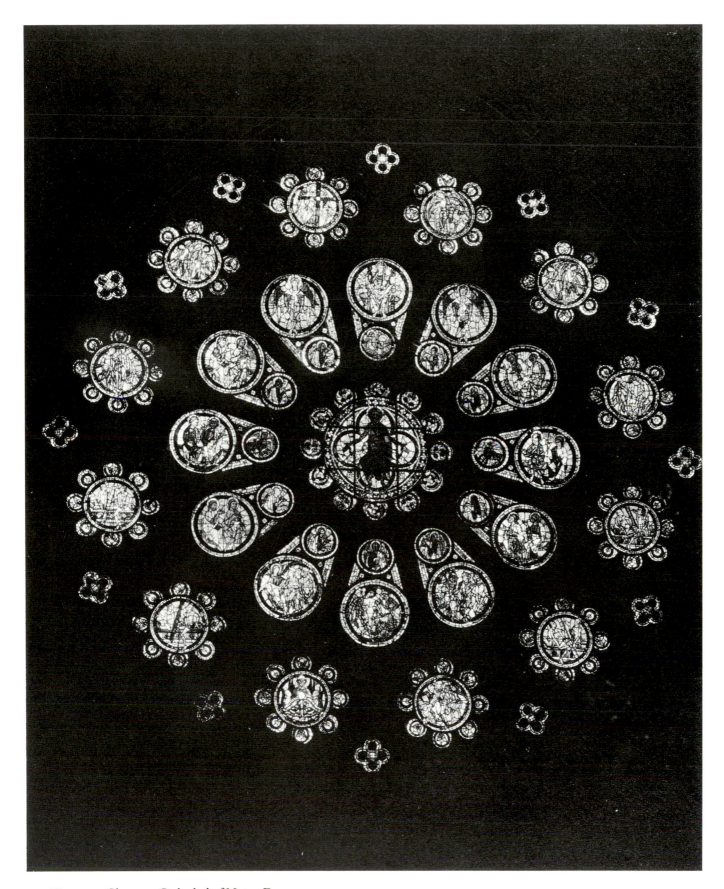

245. West rose, Chartres, Cathedral of Notre-Dame

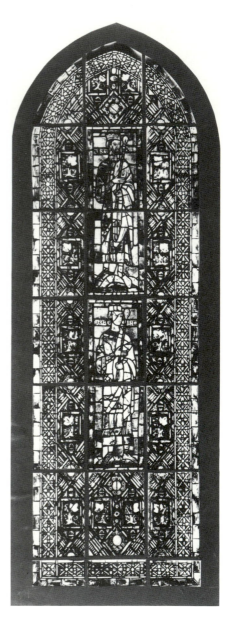

246. Methuselah in nineteenth-century setting, Reims, Saint-Remi, retrochoir tribune

247. Eliakim (below) and another ancestor of Christ, Reims, Saint-Remi, retrochoir tribune t.I a

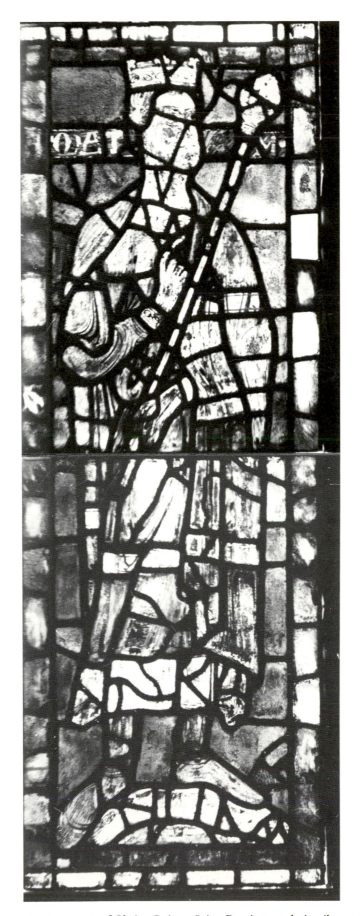

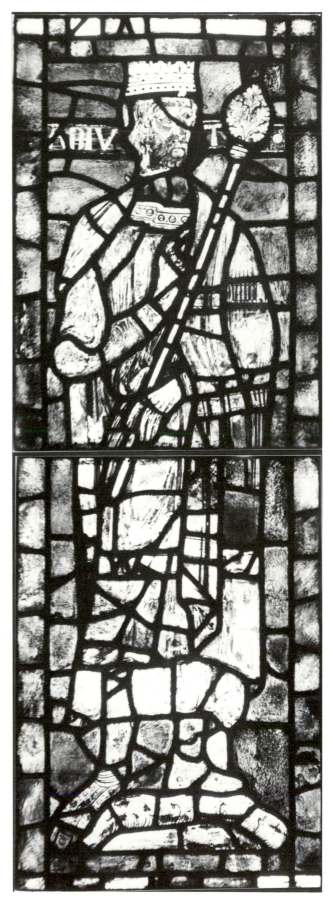

248. Ancestors of Christ, Reims, Saint–Remi, retrochoir tribune: a. Methuselah, Nt.II c; b. Abiud, St.II a

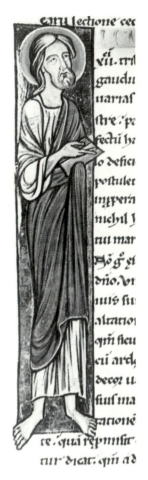

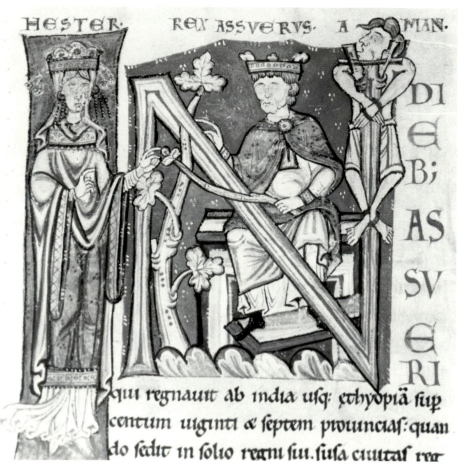

249. St. James, New Testament, northern France, ca. 1205–1210; Baltimore, The Walters Art Gallery, MS W.67, f. 48v

250. Esther with King Xerxes, Bible from Reims, Saint-Thierry, second half of the twelfth century; Reims, B.M., MS 23, f. 69v

252. Opening of the Gospel of St. Matthew, Gospels from Lorsch, ca. 800, Christ and his ancestors; Alba Julia, Batthyáneum, p.27

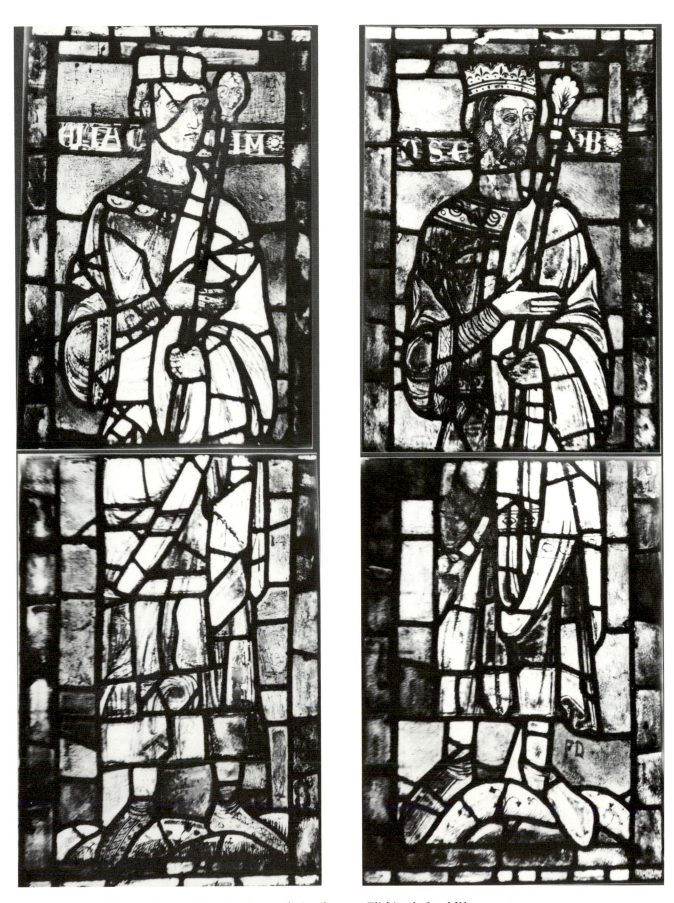

251. Ancestors of Christ, Reims, Saint-Remi, retrochoir tribune: a. Eliakim; b. Jacob[?]

253. Upper half of an archbishop, Reims, Saint-Remi, retro-choir tribune, St. II b, from the nave clerestory

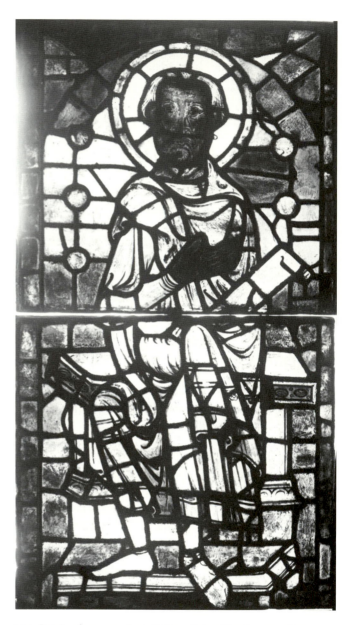

254. Lower half of an archbishop, Reims, Saint-Remi, nave clerestory, window N.XX

255. Patriarch or prophet, Reims, Saint-Remi, nave clerestory, window S.XVI

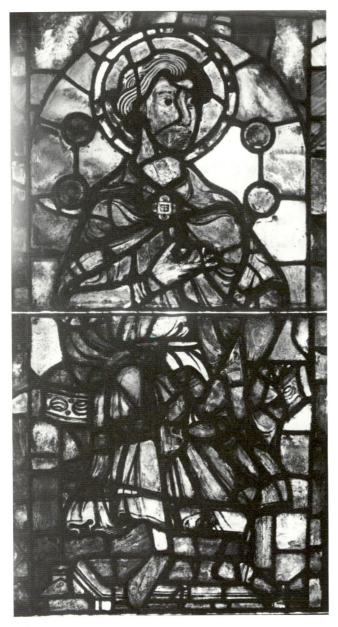

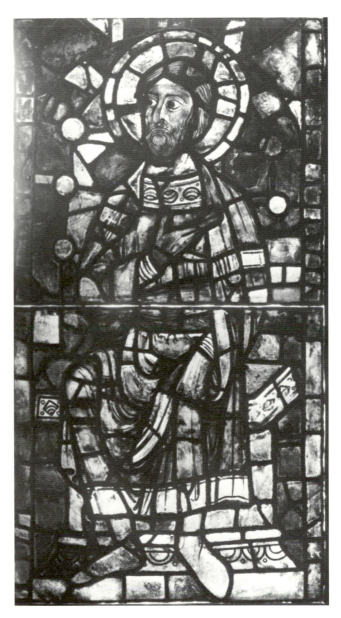

256. Patriarch or prophet, Reims, Saint-Remi, nave clerestory, window S.XIX

257. Patriarch or prophet, Reims, Saint-Remi, nave clerestory, window S.XX

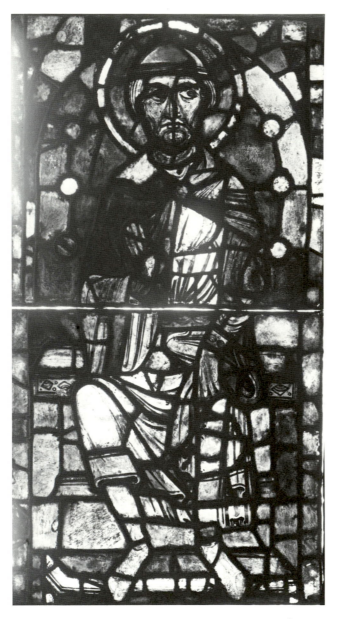

258. Patriarch or prophet, Reims, Saint-Remi, nave clerestory, window S.XVIII

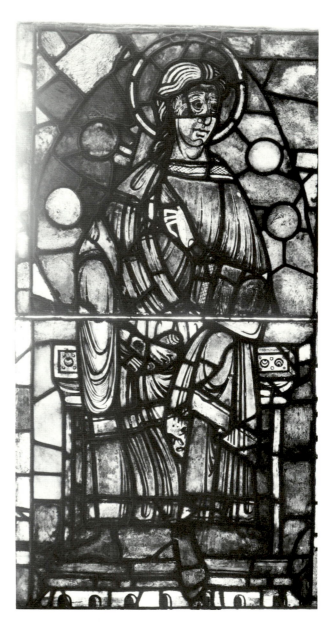

260. Patriarch or prophet, Reims, Saint-Remi, nave clerestory, window N.XVIII

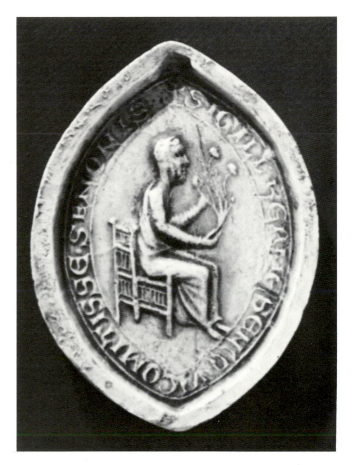

262. Seal of Ermensende, Countess of Sens, 1190; A.N.

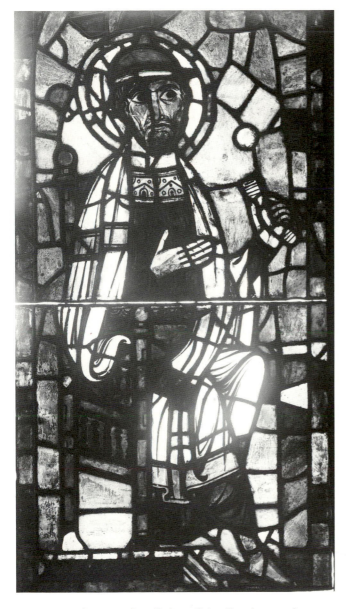

261. Patriarch or prophet, Reims, Saint-Remi, nave clerestory, window N.XVII

259. Lower half of a patriarch or prophet, Reims, Saint-Remi, nave clerestory, window N.XIX

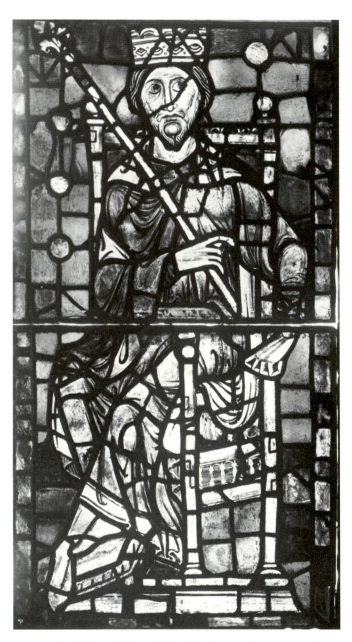

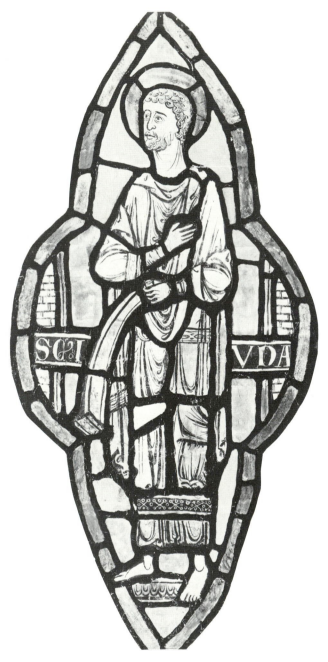

263. Frankish king, Reims, Saint-Remi, nave clerestory, window S.XXII

264. St. Jude, Lincoln Cathedral, north choir aisle, window n.II; drawing by O. Hudson: Victoria and Albert Museum, Department of Prints and Drawings, 4152.1

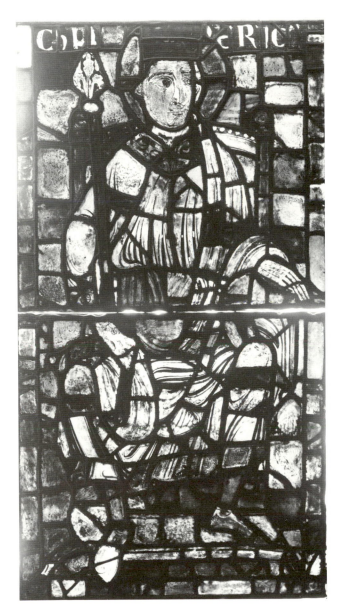

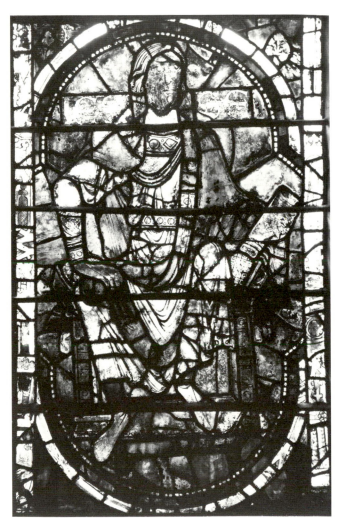

265. King Chilperic, Reims, Saint-Remi, nave clerestory, window S.XXIV (before restoration)

266. Jesse, Canterbury, Christ Church Cathedral, from Trinity Chapel clerestory, window N.VIII

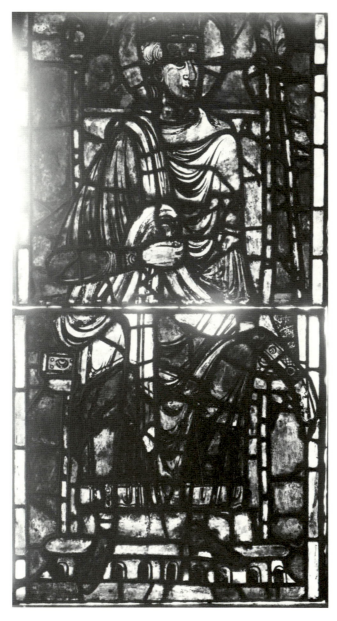

267. Frankish king, Reims, Saint-Remi, nave clerestory, window N. XXIV

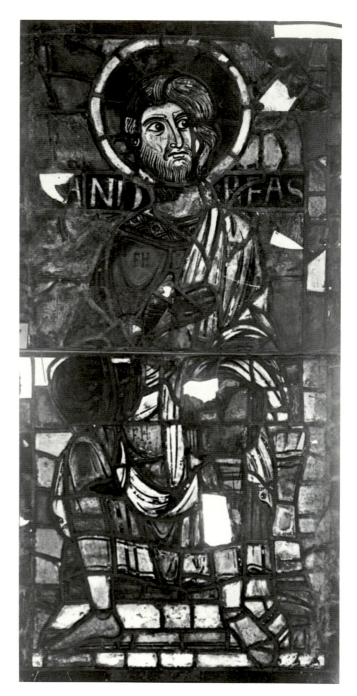

269. Patriarch or prophet?, Reims, Saint-Remi, tribune St.II b, from the nave clerestory (before restoration, ca. 1950, with the face and inscription of St. Andrew from the retrochoir clerestory)

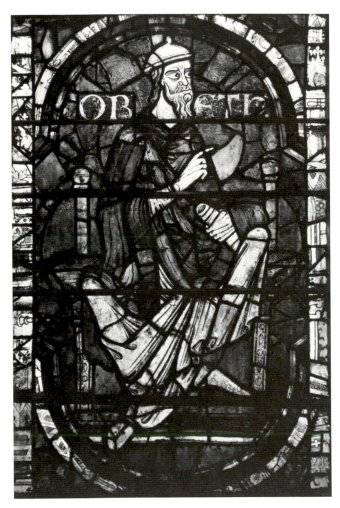

268. Obed, Canterbury, Christ Church Cathedral, from Trinity Chapel clerestory, window N.VIII

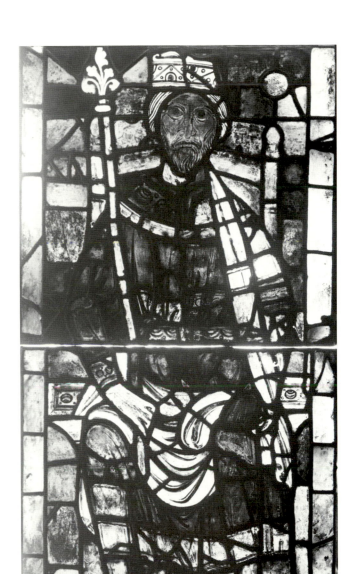

270. Frankish king, Reims, Saint-Remi, nave clerestory, window S.XXIII

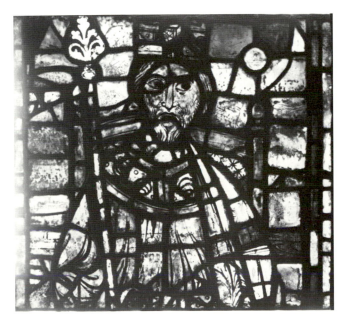

271. Upper half of a Frankish king, Reims, Saint-Remi, nave clerestory, window N.XXII

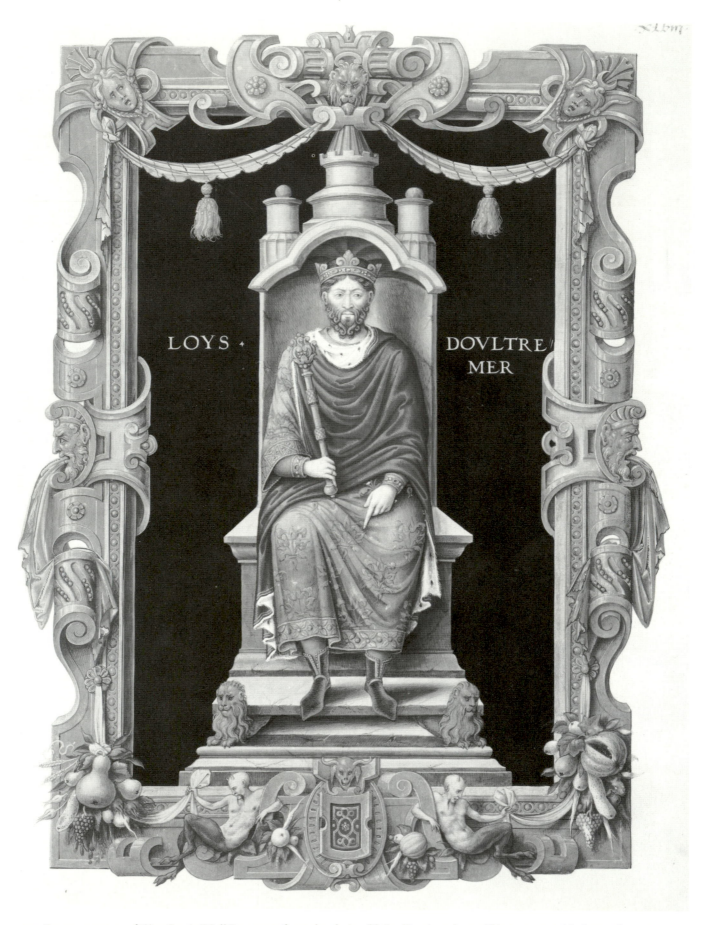

LOYS · DOVLTRE
 MER

272. Funerary statue of King Louis IV d'Outremer from the choir of Saint-Remi, early twelfth century; mid-sixteenth-century painting in Du Tillet, B.N., MS fr. 2848, f. 48

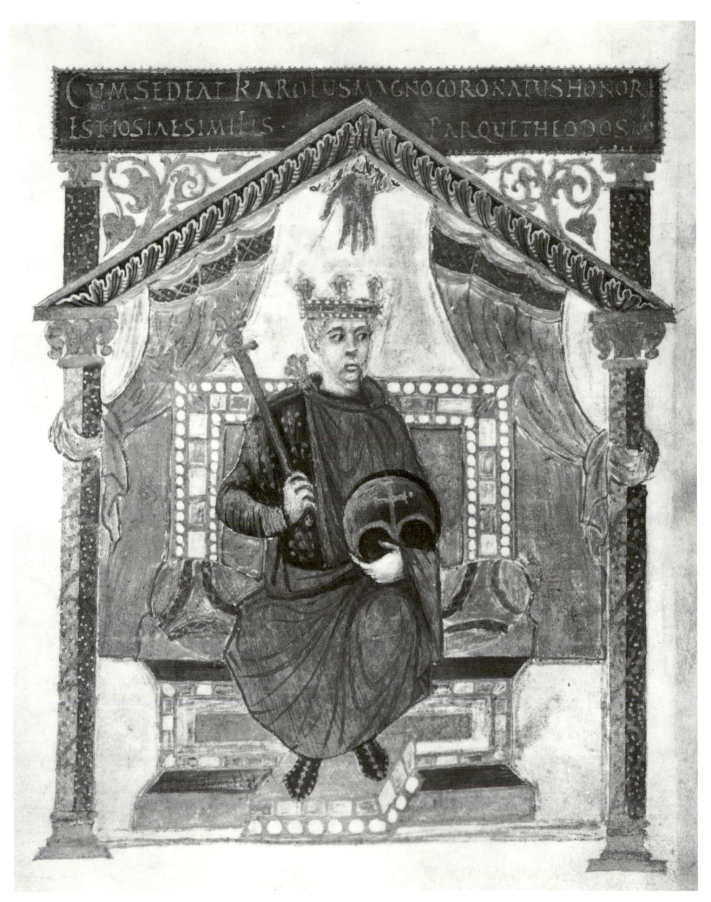

273. Charles the Bald, frontispiece to his Psalter, Saint–Denis?, late ninth century; B.N., MS lat. 1152, f. 3v

274. Genesis initial, "Sainte-Geneviève Bible," Troyes?, ca. 1200; B.N., MS lat. 11535, f. 6v

275. The Devil giving up the contract to the Virgin (Theophilus legend), from Saint-Etienne of Dreux?; now in Dreux, Musée municipale d'Art et d'Histoire

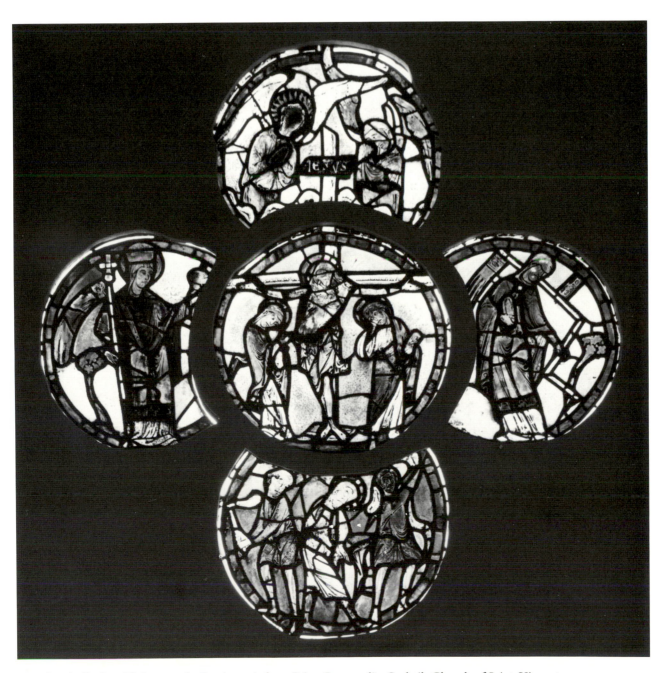

276. Symbolic Crucifixion panels, Passion window, Saint-German-lès-Corbeil, Church of Saint-Vincent, ca. 1215–1225

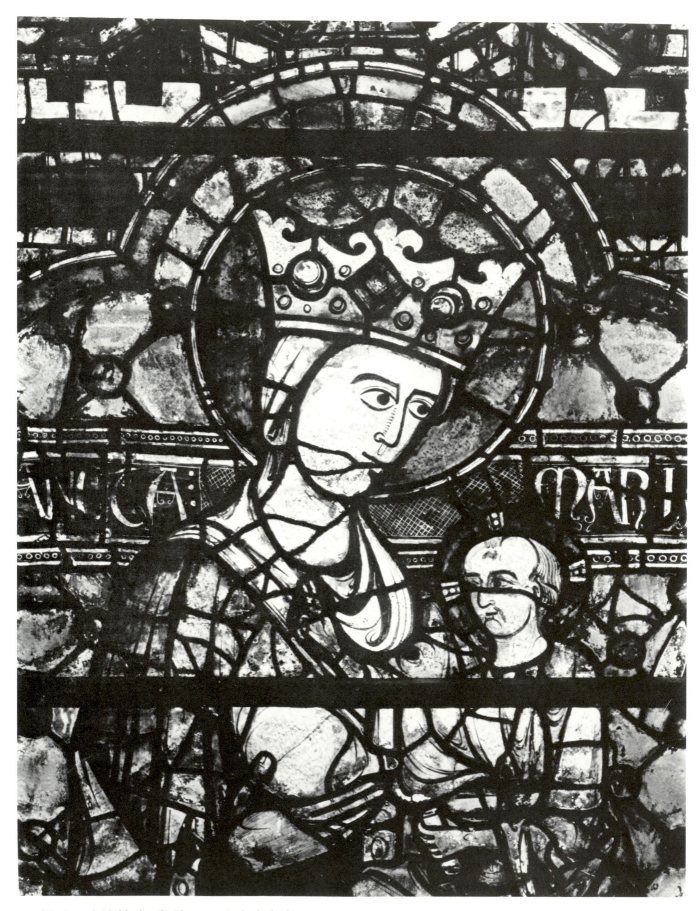

277. Virgin and Child, detail, Chartres, Cathedral of Notre-Dame, nave clerestory Baie LXXVII

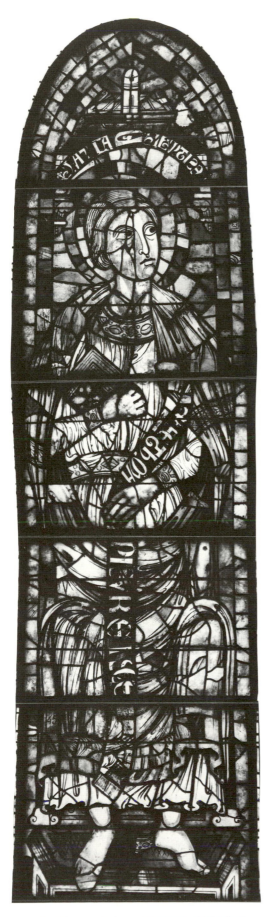

278. St. Thomas?, from Soissons, Cathedral of Saint-Gervais et Saint-Protais, apse clerestory?; now in Bryn Athyn, Glencairn Museum, accession no. 03.SG.235

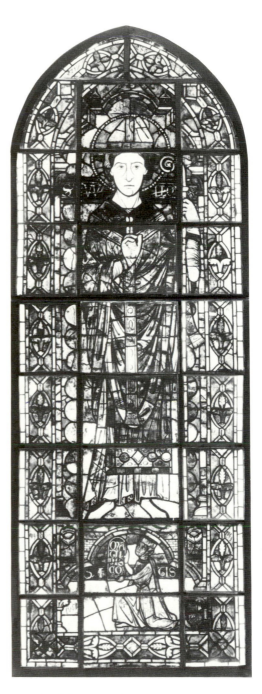

279. St. William and kneeling donor, Bourges, Cathedral of Saint-Etienne, upper window of inner aisle

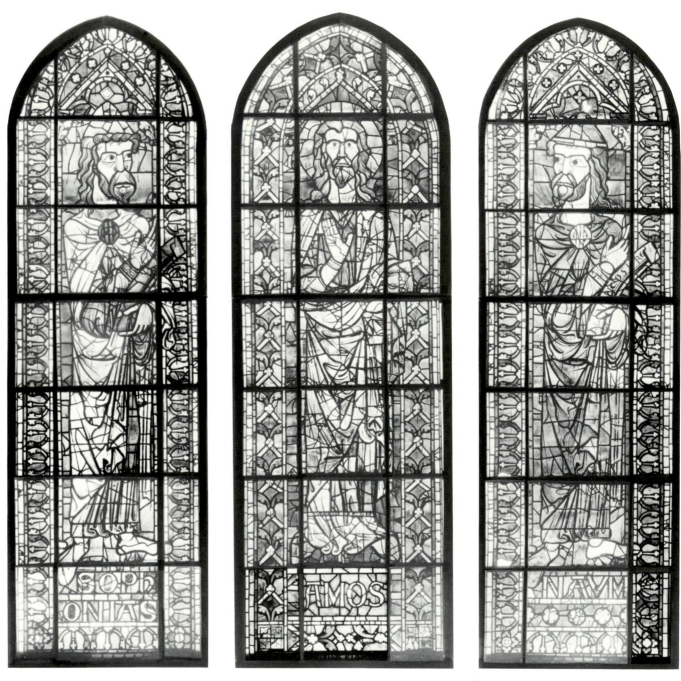

280. Prophets Zephaniah, Amos, and Nahum, Bourges, Cathedral of Saint-Etienne clerestory window, north side of the choir

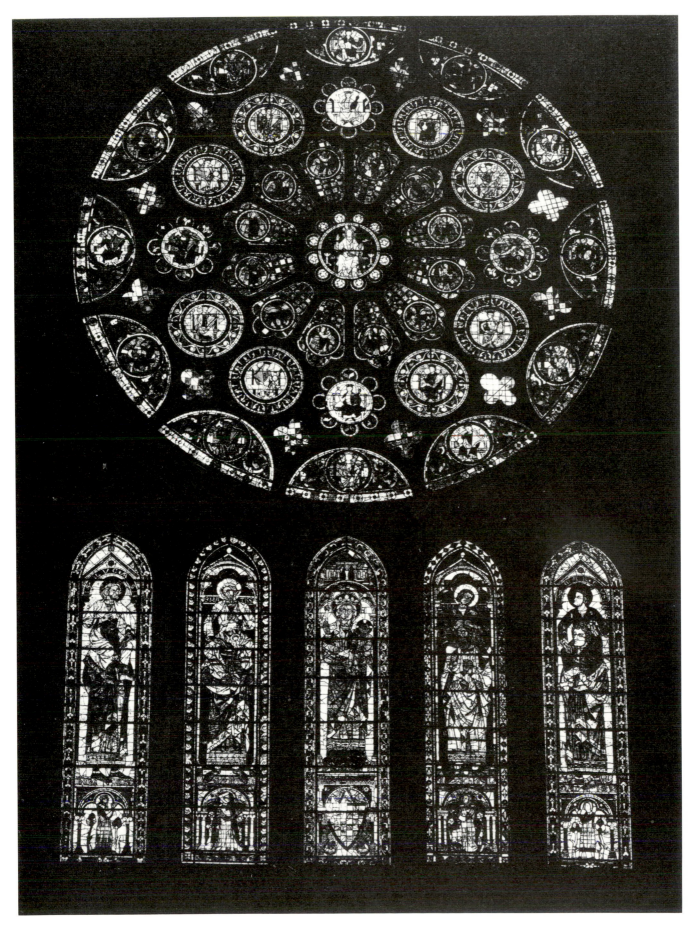

281. South rose and lancets, with Peter of Dreux and his family as donors, Chartres, Cathedral of Notre-Dame

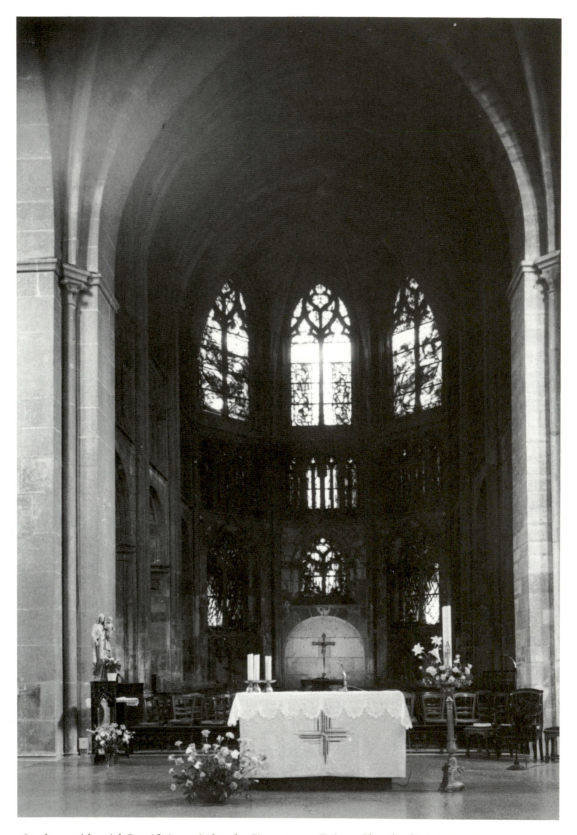

282. Apse with axial Crucifixion window by Sima, 1950s, Reims, Church of Saint-Jacques

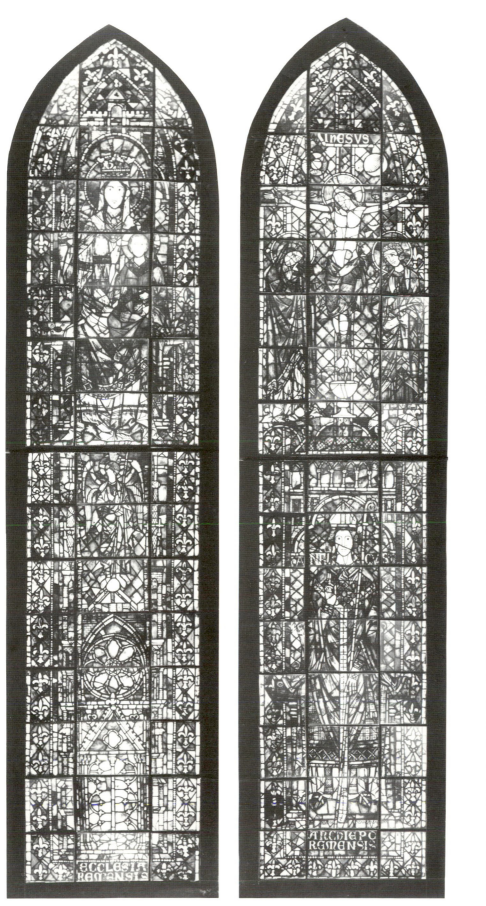

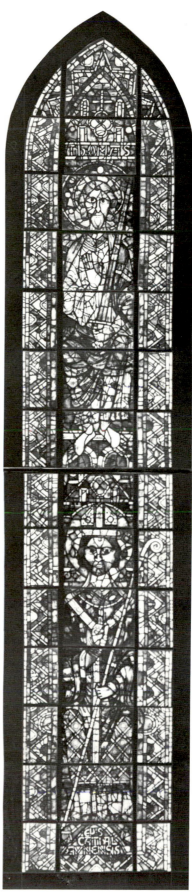

283. Crucifixion and Virgin and Child, with Archbishop Henry of Braine (1227–1240) and the Cathedral of Reims, Reims, Cathedral of Notre-Dame, axial doublet of the apse clerestory

284. St. Thomas and the bishop of Châlons-sur-Marne, Reims, Cathedral of Notre-Dame, choir clerestory

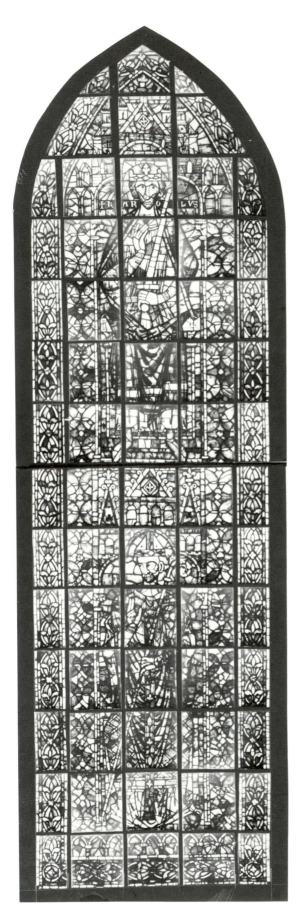

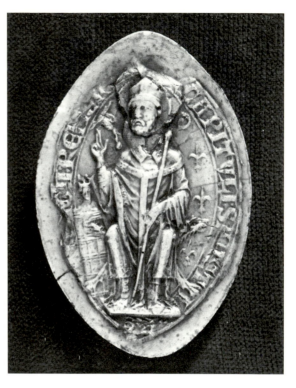

286. Seal of the Abbey of Saint-Remi, in use in 1241; Paris, Archives Nationales

285. Charlemagne? above an archbishop of Reims, Reims, Cathedral of Notre-Dame, nave clerestory

Catalogues

CATALOGUE A

Checklist of Surviving Figural Glass from Saint-Yved

THE FOLLOWING brief catalogue entries enable rapid comparison of measurements and of the recent history of the glass, as well as its appearance; major replacements are noted. The form of presentation is based on the *Corpus Vitrearum Checklist of Stained Glass before 1700 in American Collections*, but renewed letters in the inscriptions are placed in brackets, and the dimensions do not include modern edging fillets. Measurements are given first in centimeters, height before width where appropriate; their equivalent in inches is provided in parentheses. Panels are numbered according to the Corpus Vitrearum system, from the bottom left in rows. For Window 103 in the clerestory of Soissons Cathedral, measurements could not be verified above panels 13 to 15; those given derive from the Archives Photographiques photographs. Examination was made from the outer sill and from a hydraulic ladder.

Although all the surviving panels may have been in Soissons Cathedral in the nineteenth century, that provenance is given only to those that are identifiable in Guilhermy's account (see Appendix 7). Following the rationale stated in Chapter 3, detailed observations, especially of color, that help to associate all the panels with Braine are included here since in some cases documentary evidence for the provenance is ambiguous; the figures in

Soissons set the parameters of the style. A few additional panels are attributed to Braine on the basis of style and interim ownership; these are listed at the end (nos. 31–33).

Some previous attributions or suggestions by others have been rejected. Four medallions with Dead Rising from their Tombs in the Glencairn Museum (03.SG.204–207), acquired from Bacri Frères, Paris, and attributed to Braine by Hayward, have been discussed in Chapter 3. A lost kneeling female donor, from a severely damaged panel with St. Martin now in Forest Lawn Memorial Park, California, does not appear to have been of the right period for Braine, and the inscription did not conform to that given for Agnes by Le Vieil (Appendix 6 c); see Jane Hayward and Madeline H. Caviness in *Corpus Vitrearum USA Checklist* III, p. 50. Medallions installed in 1942 in a Memorial Window to Carolyn H. Lyon in Brighton Presbyterian Church, Rochester, N.Y., include a king with a viol resembling no. 30, but it is doubtful whether any of the glass is medieval; I am extremely grateful to Helen Zakin and Meredith Lillich for their opinions, and for the loan of slides relating to this window.

Ornamental glass from Saint-Yved is dealt with in Catalogue D.

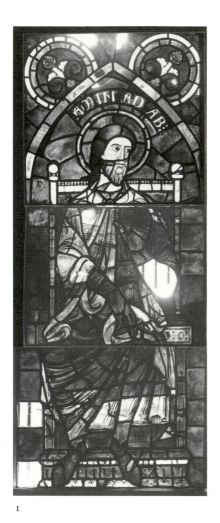

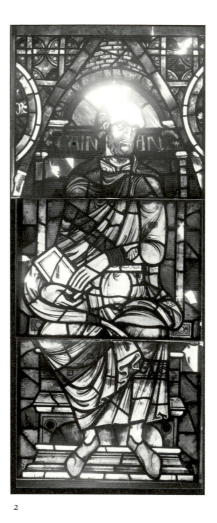

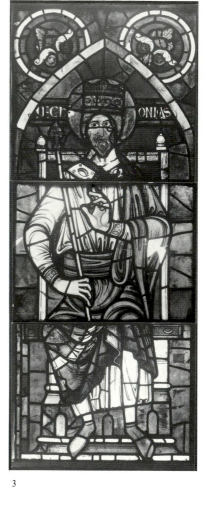

1

2

3

1. *Amminadab*

(Col. Pl. 20; Pl. 182)

From the clerestory

France, Aisne, Soissons, Cathedral of Saint-Gervais et Saint-Protais, apse clerestory, Window 103, Panels 17 (lower), 20 (middle), 23 (upper)

Inscription: AMINADAB:

Panels 17 and 20: ca. 60 × 80 (23½ × 31½) each; Panel 23: ca. 50 × 80 (19¾ × 31½)

The arched fillet is modern; above it is stopgap of ornament and modern fill.

The robe is soft warm green, with rose purple belt and cuffs and a yellow band and white hem in the skirt; the mantle is white, the shoes blue.

Bibliography: Guilhermy, MS 6109, f. 256; Poquet and Daras, 1848, p. 66; Grodecki, 1960, p. 171, n. 24; *Corpus Vitrearum France Recensement* I, p. 171; Ancien, 1980a, pp. 15, 37, 80, 86, 93–99, col. pl. 3; II, pp. 14, 18, 23–24; Caviness, 1985, pp. 43–44, fig. 14; Ancien, 1987, pp. 8–9, 18, fig. 1.

2. *Cainan* (Col. Pl. 20)

From the clerestory

France, Aisne, Soissons, Cathedral of Saint-Gervais et Saint-Protais, apse clerestory, Window 103, Panels 35 (lower), 38 (middle), 41 (upper)

Inscription: CAIN [A]N

Panels 38 and 41: ca. 60 × 78 (23½ × 30¾) each

The lower panel (35) is modern and the middle one (38) restored in the lower left and upper right segments; the head appears partly replaced, partly repainted. The canopy has evidently been cut down by the restorer who provided the sharply angled pointed arch in red glass.

Brilliant hues of yellow and cold green are used in the robe and mantle. Red columns frame the figure, with white capitals. The ground under the canopy is red, but the only piece of old glass in the ground below the inscription is blue. This change of ground color is unusual but it will be noted in other panels of the series. The partial

red ground is another departure from the standard cool palette of green, white, and purple on a blue ground.

Bibliography: As no. 1, except for the illustrations.

3. *Jechoniah* (Ca. Pl. 20; Pl. 193)

From the clerestory

France, Aisne, Soissons, Cathedral of Saint-Gervais et Saint-Protais, apse clerestory, Window 103, Panels 8 (lower), 11 (middle), 14 (upper)

Inscription: IECH ONIAS

Panel 8: 60.5 × 71.5 (23¾ × 28⅛); Panel 14: 59 × 70 (23¼ × 27½)

The middle panel (11) is modern, as is the arched fillet in the top (14); above it is stopgap of ornament and modern fill.

A white robe sets off the brilliant warm green mantle with its yellow band and purple hem, the shoes and neckband are blue, and blue hair is placed against a red nimbus and banded

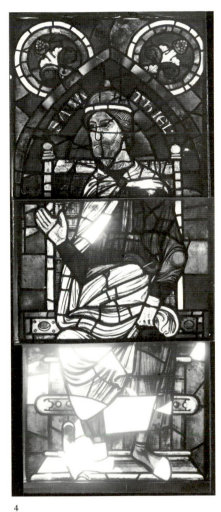

4

green and yellow crown; the inscription is yellow, framed by green bands. Only the color distribution in the throne is different from that of Amminadab, in that the back is pierced to the blue ground; the seat and base read as a series of horizontal bands: purple, yellow, white, green, red, white, green. These bands are not decorated as they were in the first figure; the red forms an arcade with green openings, and the white bands have the profiles of moldings, so that here spatial design dominates over surface pattern.

Bibliography: As no. 1, except for the illustrations.

4. *Salathiel* (Col. Pl. 20; Pl. 190)

From the clerestory

France, Aisne, Soissons, Cathedral of Saint-Gerais et Saint-Protais, apse clerestory, Window 103, Panels 26 (lower), 29 (middle), 32 (upper)

Inscription: SALA THIEL

Panels 29 and 32: ca. 60 × 78 (23½ × 30¾) each

The lower panel (26) is modern, the middle one (29) restored in its bottom and upper right segments. The arched fillet in the top is modern, and above it is stopgap of ornament and modern fill.

The white mantle, looped into a rather clawlike left hand, behaves differently from that of Amminadab; sweeping tracelines describe swaths that encircle Salathiel's stomach, but there is little sign of hooked folds or troughs. The purple tunic, instead of being flattened under a high belt, blouses over the mantle. The throne back, however, is of the familiar type, with decorated yellow frame and green inset panel; the latter in fact has a minutely executed pattern consisting of rows of knopped rungs. The beard, though fuller than that of Jechoniah or Amminadab, has the same tight, parallel strands and protruding chin; the green hair falls into neatly overlapped locks, as does that of Jechoniah. The inscription, in reserve on yellow glass, forms the sides of a pointed arch above the finials of the throne back; the concept is similar to that used in Amminadab, but allows for the greater height taken up by the head.

Bibliography: As no. 1, except for the illustrations.

5. *Bust of Abiud*

(Col. Pl. 11; Pl. 192)

6. *Part of an Ancestor of Christ?*: Torso and lower part

(Col. Pl. 11; Pl. 185)

From the clerestory

United States, New York Metropolitan Museum of Art, Medieval Department, accession no. 14.47, Panels a (top), b and c (lower two panels)

Inscription: AB IVD

Panel a: 56.5 × 72 (22½ × 28¾); Panel b: 61.5 × 72 (24½ × 28¾); Panel c: 58 × 72 (22⅞ × 28¾)

The right half of the lowest panel (c) is heavily restored.

The circinate line describing the chin of Abiud and the white edging to the nimbus are found in Amminadab (no. 1). The pointed green cap is like that of Salathiel (no. 4), and the execution is close; the heads are equally large, set on

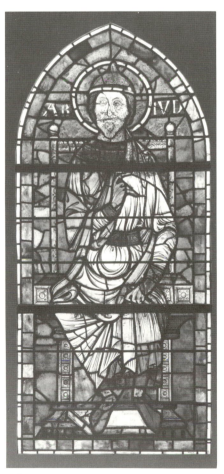

5 / 6

narrow shoulders, and the eyes equally wide open; the hair is rather mechanically rendered in the same plaitlike curls, and the top rung of the throne back is decorated with identical motifs.

The lower part is based on a cartoon that resembles that of Amminadab (no. 1), but the different positions of the arms have involved an adjustment of the cutline. The sweeping tracelines that delineate the stomach and the wide flat belt, however, are more clearly revealed here than in Amminadab; they resemble those of the St. Louis figure (no. 11), whereas the bloused tunic is more like that of Salathiel (no. 4). The rather stabbing tracelines in some of the drapery also find counterparts in Salathiel rather than Amminadab; the contrast with the softer, more painterly manner of that figure is clearly seen in the passage of the mantle that follows the same *modulus*.

Provenance: Bacri Frères, Paris

Bibliography: Guilhermy, MS 6109 f. 257? W. F. Stohlman, "French Stained Glass," *Metropolitan Museum of Art Bulletin* 12, no. 8 (August 1917): 174; A. K. Porter, "A Stained Glass Panel at the Metropolitan Museum," *Art in America* 7 (1818): 39–43, pl. 1; Joseph Breck and Meyric Rogers, *The Pierpont Morgan Wing: A Handbook*, 2d ed., New York, 1929, p. 116; Louis Grodecki, "Quelques Observations sur le vitrail au XIIe siècle en Rhénanie et en France," *Mémorial de la Société Nationale des Antiquaires de France*, Paris (1953): 46–47; *Year 1200* I, no. 202; *Metropolitan Museum of Art Bulletin* 30 (1971–1972): 112–13; Grodecki, 1975, pp. 70–73, fig. 3; Grodecki and Brisac, 1977, pp. 134, 288, fig. 115; Ancien, 1980a, pp. 94–95, pl. following p. 99, no. 4; Caviness, 1984, p. 546; Caviness, 1985, p. 46, n. 40; Jane Hayward in *Corpus Vitrearum USA Checklist* I, p. 95; Ancien, 1987, pp. 9–11, fig. 4.

7. Ancestor of Christ?:

Torso and face (Pl. 204)

From the clerestory

United States, Philadelphia, Philadelphia Museum of Art, accession no. 1928-40-1 (Given by Mrs. John A. Brown, Jr. in memory of John A. Brown, Jr.)

179.0 × 69.0; (70 × 27¼); original panel (center): h. 58.5 (23)

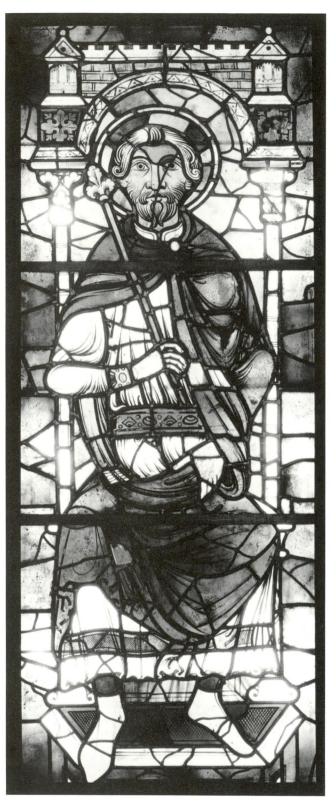

7

The upper panel is new except the face, which is retouched; the lower panel is new but for a few fragments of drapery and ground.

Provenance: Seligman Rey Co., Paris

Bibliography: Francis Henry Taylor, "A Memorial Stained Glass Window of the Middle Ages," *The Pennsylvania Museum Bulletin* 23 (1927–1928): 13–15; Nicolo D'Ascenzo, "Stained Glass in the Pennsylvania Museum," *Stained Glass* 27 (1932): 85, 87, fig. 1; Grodecki, 1975, p. 67 n. 9; Caviness, 1985, p. 46, n. 40; Madeline H. Caviness in *Corpus Vitrearum USA Checklist* II, p. 148.

8. *Bust of Jacob* (and foliate lobes)

From the clerestory (and a transept rose)

United states, Pennsylvania Bryn Athyn, Glencairn Museum, accession no. 03.SG.230

Inscription: IA COB

86 × 76 (33⅞ × 30); h. 67 (26⅜) to the top of the arch

Many restorations and stopgaps are above arch, in some cases using palimpsest glass; central "finial" is a prophet's cap from another figure in the series; face is retouched; ornament is stopgap from a rose window.

The connection with the other figures is confirmed by the ornamental lobes above the arch, identical to those above Jechoniah (no. 3). Two richly painted pale yellow capitals under a decorated white arch would have been supported on columns.

Provenance: Cathedral of Soissons; Henry C. Lawrence, New York; Raymond Pitcairn, Bryn Athyn

Bibliography: Guilhermy, f. 255v; Poquet and Daras, 1848, p. 66?; *Collection of a Well-Known Connoisseur, A Noteworthy Gathering of Gothic and Other Ancient Art Collected by the Late Mr. Henry C. Lawrence of New York* [sale cat.] New York, January 28, 1921, no. 373, illus.; Ancien, 1980a, pl. facing p. 93; 1980b, p. 40; Jane Hayward in Hayward and Cahn, 1982, pp. 145–47; Caviness, 1985, pp. 40–44, fig. 12; Michael Cothren in *Corpus Vitrearum USA Checklist* II, p. 109; Ancien, 1987, pp. 10–11, illus. p. 20.

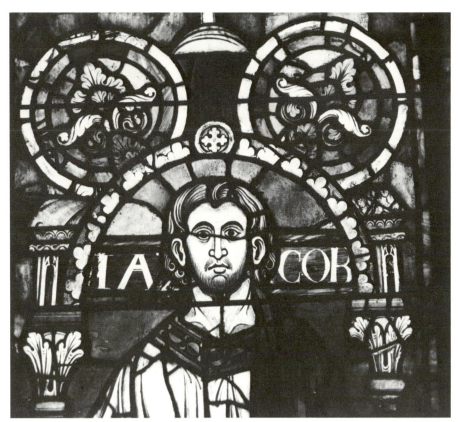

8

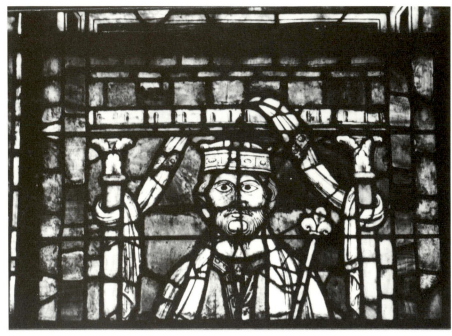

9

10

9. *King*:

Bust, C (Col. Pl. 12; Pl. 194a)

10. *Ancestor of Christ?*:

Lower panel, A (Col. Pl. 12, Pl. 194b)

From the clerestory

United States, Pennsylvania, Bryn Athyn, Glencairn Museum, accession no. 03.SG.234 A&C

Panels A, B, C: 192 × 94 (75½ × 37); without modern surrounding: 170.6 × 69.5 (67⅜ × 27⅜); h. of old panels: 56 (22) for Panel C, 55.5 (21⅞) for Panel A

In this composite figure, the middle section (B) and two bands surrounding the entire composition are modern; there are some replacements in medieval sections.

A bearded king, with yellow crown and pale green hair, is represented frontally, a pale yellow scepter extending over his left shoulder. He is framed by hot yellow columns with white capitals and a green and yellow architrave with a white cloth draped over it. As with Cainan in Soissons, the ground behind the figure's head is streaky red, whereas it is blue behind his shoulders, but there is no room for an inscription here; in all probability this was placed on the second level of the architrave, now incongruously red and blue.

In the lower panel, the robe is white with a bright blue decorated band, and the mantle warm green with a pale yellow band and with a pale streaky red lining that shows where the zigzag folds turn back.

Provenance: Cathedral of Soissons; Bacri Frères, Paris; Raymond Pitcairn, Bryn Athyn.

Bibliography: Guilhermy, MS 6109 fol. 258?; Jane Hayward in Hayward and Cahn, 1982, pp. 124–25, colorplate v; Sauerländer, 1982, p. 387; Caviness, 1985, pp. 40–44, fig. 9; Michael Cothren in *Corpus Vitrearum USA Checklist* II, p. 108.

11. *Ancestor of Christ (Melea or Melchi)?*

(Col. Pl. 22; Pls. 71–74, 199)

From the clerestory

United States, Missouri, St. Louis, City Art Museum of St. Louis, accession no. 137:20

Inscription: M . . . L . . . E . . .

167.5 × 62 (66 × 24⅜); h. top panel, including old canopy: 57 (22½); center panel: 60.5 (23⅞)

The bottom panel is modern, except for three fragments; left halves of the two upper panels are heavily restored, with fill of later quarries with fleurs-de-lis found above the canopy. The pointed arch formed by the vault of the baldachin describes the same form as those over the other three figures in Soissons (nos. 1, 3, 4).

The canopy, almost identical in form to the one over Cainan (no. 2), has red columns (restored), white capitals, a purple arch, and green masonry. The robe is deep rose purple, of an extremely durable, streaky variety, with a pale yellow band like a placket on the center front; the mantle is cool white with green decorated bands, the hair rose purple. The fragmentary inscription, in reserve on white glass, has a wide red band below it, reminiscent of the change of ground color above Cainan.

Provenance: French & Co., New York, 1920.

Bibliography: Guilhermy, MS 6109 f. 257?; *Bulletin of the City Art Museum of St. Louis* 6 (1921): 1–6; Orin Skinner, "Stained Glass in the City Museum of St. Louis," *Stained Glass* 29, nos. 1–2 (Spring–Summer 1934): 7–10, illus.; *The St. Louis Art Museum Handbook of the Collection*, 1975, illus. p. 53; Caviness, 1985, pp. 43–44, 46 n. 40, fig. 13; Caviness in *Corpus Vitrearum USA Checklist* III, p. 201.

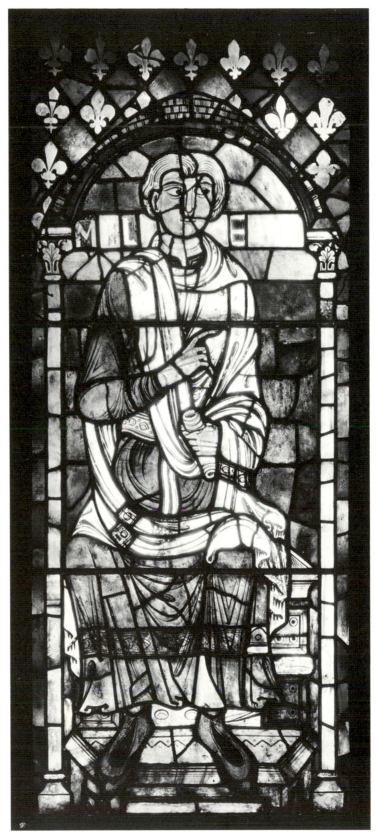

11

12. *Bust of an Ancestor of Christ?* (Col. Pl. 21; Pl. 202)

13. *Torso of an Ancestor of Christ?* (Col. Pl. 21; Pl. 202)

From the clerestory

United States, Baltimore, Walters Art Gallery, accession no. 46-38

Inscription: [T]HA[D]E[VS]

Top and middle panels: 58–59 × 78 (22⅞–23¼ × 30¾)

The bottom panel is modern. The two old panels do not match; both are moderately restored, and the face has been retouched.

The face and neck are a light streaky purple, a type of glass already seen in the St. Louis figure (no. 11), the hair and beard are cold white. The large eyes and loosely structured tracelines in the upper face are even more exaggerated than those of Salathiel, and some re-touching may have taken place.

Provenance: Raoul Heilbronner, Paris, 1910.

Bibliography: Guilhermy, MS 6109 f. 257?; José Pijoán, *Art of the Middle Ages* (The University of Knowledge Wonder Books), Chicago, 1940, p. 241, illus.; Caviness, 1985, p. 46, n. 40; Caviness in *Corpus Vitrearum USA Checklist* II, p. 56.

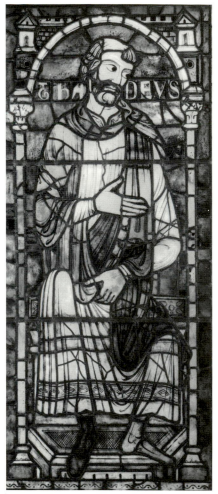

12 / 13

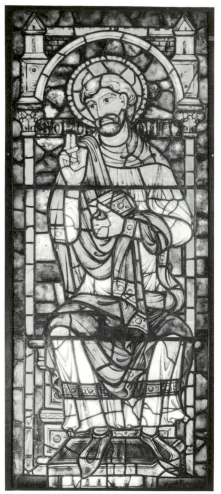

14

14. *Lower Part of an Ancestor of Christ?* (Pl. 203)

From the clerestory

United States, Baltimore, Walters Art Gallery, accession no. 46.39

Inscription: SOPHONIAS

Middle and bottom panels: 61–62 × 78 (24–24⅜ × 30¾)

Top panel is almost entirely modern. Lower panels are moderately restored, with some repainted glass.

The throne base has yellow molding and green decorated panels; it belongs to the same general type as that of Je-choniah (no. 3), except for the flared molding under the seat and the addition of a purple and blue footrest. The white robe, and the purple mantle with green decorative bands and yellow hem fit the usual chromatic range of the Braine glass.

Provenance and *Bibliography*: As nos. 12 and 13.

15. *King David*: Fragment of nimbus, ground and inscription (photo: del Alamo; illus. before damage, after Demotte, 1929)

From the clerestory

United States, California, Glendale, Forest Lawn Memorial Park, Lot 11/12/60/85

Inscription: DA[VID]

Old fragments: 40 × 43 (15¾ × 17)

The glass was severely damaged in the Forest Lawn fire. The inscription is partly overpainted on old glass.

Provenance: Demotte, New York; William Randolph Hearst

Bibliography: Guilhermy, MS 6109 f. 255v; Poquet and Daras, 1848, p. 66?; Demotte, 1929, no. 14; Gimbel's & Sons, *Art Objects and Furniture from the William Randolph Hearst Collection, Catalogue Raisonné*, sale catalogue, Hammer Galleries, New York, 1941, p. 131, no. 459-16; Ancien, 1980b, p. 40; Jane Hayward and Madeline H. Caviness in *Corpus Vitrearum USA Checklist* III, p. 48.

16. *Ancestor of Christ?*: Lower panel (Pl. 196; illus. before damage, after Demotte, 1929)

From the clerestory

United States, California, Glendale, Forest Lawn Memorial Park, Lot 11/12/60/85

51.7 × 66 (20⅜ × 26)

Provenance and *Bibliography*: As no. 15.

15

16

15 and 16 before damage

17. Music

(Col. Pl. 20; Pls. 233, 244)

From the south transept rose?

France, Aisne, Soissons, Cathedral of Saint-Gervais et Saint-Protais, apse clerestory, Window 103, Panel 7

Inscription: MVSICA

Diameter: 48 (18⅞)

The head and parts of the ground are new.

Bibliography: Poquet and Daras, 1848, p. 66; Beer, 1952, p. 69; *Corpus Vitrearum France Recensement* I, p. 171, fig. 95; Ancien, 1980a, pp. 87–93; Caviness, 1985, p. 38, fig. 2.

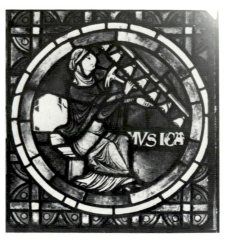

17

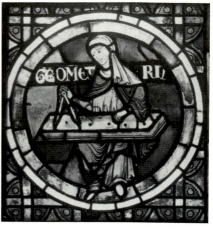

18

18. Geometry

(Col. Pl. 20; Pls. 237, 244)

From the south transept rose?

France, Aisne, Soissons, Cathedral of Saint-Gervais et Saint-Protais, apse clerestory, Window 103, Panel 12

Inscription: GE[OME]TRIA

Diameter: 45.5 (17⅞)

The face and ground lower left are restored.

Bibliography: Poquet and Daras, 1848, p. 66?; Beer, 1952, p. 69, pl. 64; *Corpus Vitrearum France Recensement* I, p. 171, fig. 95; Ancien, 1980a, pp. 87–93; Caviness, 1985, p. 38.

19

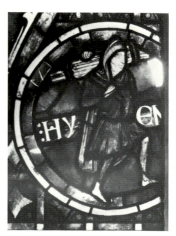

20

19. Grammar

(Col. Pl. 24; Pls. 231, 244)

From the south transept rose?

United States, Pennsylvania, Bryn Athyn, Glencairn Museum, accession no.03.SG.179

Diameter: 46.5 (18½)

There are some stopgaps, including the band that would have been inscribed.

Provenance: Cathedral of Soissons (?); Julien Chappé, Le Mans (?); Raoul Heilbronner, Paris; Arnold Seligmann, Paris; Raymond Pitcairn, Bryn Athyn

Bibliography: *Catalogue des sculpture . . . et . . . vitraux . . . Collections de M. Raoul Heilbronner* [sale cat.], Paris, May 17, 1924, no. 96; Beer, 1952, p. 69; Jane Hayward in *Medieval Art*, nos. 186–87;

Raguin, 1982, p. 129; Jane Hayward in Hayward and Cahn, 1982, pp. 125–29; Sauerländer, 1982, p. 387; Caviness, 1985, p. 34; Michael Cothren in *Corpus Vitrearum USA Checklist* II, p. 109; Ancien, 1987, pp. 10–11.

20. Winter

(Col. Pl. 20; Pls. 226, 244)

From the south transept rose?

France, Aisne, Soissons, Cathedral of Saints-Gervais et Saint-Protais, apse clerestory, Window 103, Panels 40, 41

Inscription: HYEM[MS]

Panel 40: ca. 48 × 38 (19 × 15)

The cowl and ground above the inscription are restored; the right section (41, not ills.) is stopgap.

Bibliography: Guilhermy, MS 6109 f. 256; Carlier, 1764, p. 65?; Beer, 1952, p. 58; Beer, 1956, p. 31, n. 52, comparative illus. 13; *Corpus Vitrearum France Recensement* I, p. 171; Ancien, 1980a, pp. 87–93; Caviness, 1985, p. 38.

21. *Spring*

(Col. Pl. 23; Pls. 221, 244)

From the south transept rose

United States, Pennsylvania, Bryn Athyn, Glencairn Museum, accession no. 03.SG.178

Inscription: VER

Diameter: 46 (18)

Fillets are restored with some stopgaps. The original glass is heavily corroded.

Provenance: As no. 19

Bibliography: As no 19; Renate Kroos, "Zur Ikonographie des Jahrzeiten- sockels in Schnutgen-Museum," *Walraf-Richartz Jahrbuch* 32 (1970): 55 and 63, n. 57.

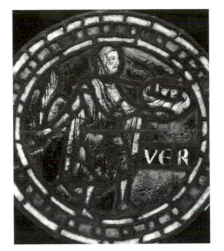

21

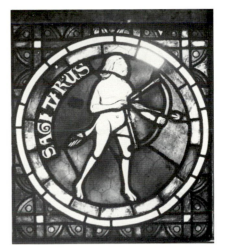

24

22. *March*

(Col. Pl. 20; Pls. 223, 244)

From the south transept rose

France, Aisne, Soissons, Cathedral of Saint-Gervais et Saint-Protais, apse clerestory, Window 103, Panel 37

Inscription: MARCI'

Diameter: ca. 48 (19)

The ground in the upper right is restored; the head and end of inscription might be replacements.

Bibliography: Guilhermy, MS 6109, f. 256; Carlier, 1764, p. 65?; Beer, 1952, p. 58, pl. 64; Beer, 1956, p. 31, n. 52; *Corpus Vitrearum France Recensement* I, p. 171; Ancien, 1980a, pp. 87–93; Caviness, 1985, p. 38.

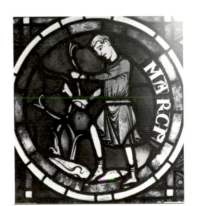

22

24. *Sagittarius*

(Col. Pl. 20; Pl. 244)

From the south transept rose

France, Aisne, Soissons, Cathedral of Saint-Gervais et Saint-Protais, apse clerestory, Window 103, Panel 28

Inscription: SAGITAR[VS]

Diameter: ca. 49 (19¼)

The lower part of the left leg is restored; the torso may also be modern.

Bibliography: As no. 20, except for the illustration.

23. *Gemini* (Pls. 228, 244)

From the south transept rose

France, Aisne, Soissons, Cathedral of Saint-Gervais et Saint-Protais, apse clerestory, Window 103, Panel 19

Inscription: GEMI[NI]

Diameter: ca. 48 (19)

There are replacements in the lower ground; beginning of the inscription and right hand might be replacements.

Bibliography: As no. 20, except for the illustrations.

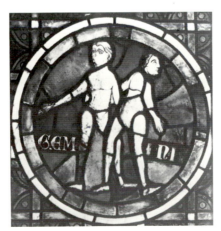

23

25

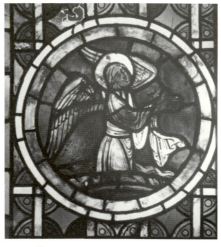

26

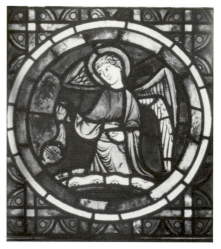

27

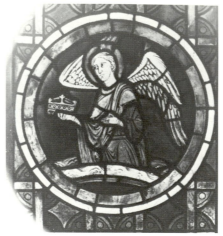

28

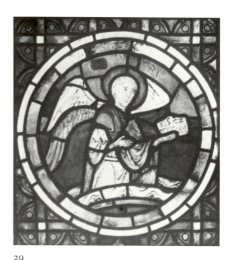

29

25. *Pisces* (Pl. 244)

From the south transept rose?

Germany, private collection

Inscription: PISCES

Diameter: 57 (22½), including edges?

The glass was not examined; it could be a replica.

Bibliography: Guilhermy, MS 6109, f. 256v?; Carlier, 1964, p. 65?; *Catalogue des sculpture . . . et . . . vitraux . . . Collections de M. Raoul Heilbronner* [sale cat. May 17], Paris, 1924, p. 16, no. 96; *Art of Four Centuries: Italian Renaissance Furniture, Bronzes and Sculptures, Gothic Stained Glass . . . Property of Arnold Seligmann, Rey & Co Inc* [sale cat., Parke-Bernet], New York, 1947, p. 120, lot 393: "Romanesque Stained and Painted Glass Medallion French, XIII Century. Circular medallion depicting the Zodiacal sign of Pisces, with two gold and silver fish. Framed. Diameter 22½ inches [57 cm.];" Sauerländer, 1982, fig. 2, p. 387; Caviness, 1985, pp. 38, 45–46, n. 36.

26, 27. *A Praying and a Censing Angel* (Col. Pl. 20)

From the west rose?

France, Aisne, Soissons, Cathedral of Saint-Gervais et Saint-Protais, apse clerestory, Window 103, Panels 13, 36

Diameter: ca. 46 (18)

The skirt and nimbus in no. 26 (Panel 13) appear restored. The left ground and right wings in no. 27 (Panel 36) are restored; the head might be new.

Bibliography: Guilhermy, MS 6109, f. 256; *Corpus Vitrearum France Recensement* I, p. 171; Ancien, 1980a, pp. 87–93; Caviness, 1985, p. 38.

28, 29. *Angels Offering Crowns* (Col. Pl. 20; Pl. 218a)

From the west rose?

France, Aisne, Soissons, Cathedral of Saint-Gervais et Saint-Protais, apse clerestory, Window 103, Panels 15, 34

Diameter: ca. 46 (18)

No. 29 (Panel 34) is inside out, and the paint is damaged.

Bibliography: Guilhermy, MS 6109, f. 256?; *Corpus Vitrearum France Recensement* I, p. 171; Ancien, 1980a, pp. 87–93; Caviness, 1985, p. 38.

30. *Elder of the Apocalypse*
(Col. Pl. 20)

From the north transept rose

France, Aisne, Soissons, Cathedral of Saint-Gervais et Saint-Protais, apse clerestory, Window 103, Panel 44

Diameter: ca. 45.5 (18)

The sleeve to the right and ground to the left are restored.

Bibliography: Guilhermy, MS 6109, f. 256; Carlier, 1964, p. 65?; Beer, 1952, p. 58, pl. 64; *Corpus Vitrearum France Recensement* I, p. 171; Ancien, 1980a, pp. 87–93; Caviness, 1985, p. 38.

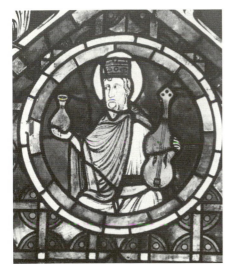

30

31. *Christ Blessing, from a Coronation of the Virgin?*

Tentatively attributed to a lower window

United states, Pennsylvania, Bryn Athyn, Glencairn Museum, accession no. 03.SG.22

47.5 × 33.2 (18⁹⁄₁₆ × 13¹⁄₁₆)

The head appears to be a stopgap of thirteenth-century Soissons glass.

Provenance: Soissons Cathedral?; Octave Homburg, Paris; Lucien Demotte, Paris; Raymond Pitcairn, Bryn Athyn

Bibliography: Galerie Georges Petit, *Catalogue des objets d'art et de haute curiosité . . . composant la collection de feu M. O. Homberg* [sale cat. May 11–16], Paris, 1908, p. 59, no. 440 (illus.); Hayward and Cahn, 1982, pp. 162–63; Michael Cothren in *Corpus Vitrearum USA Checklist* II, p. 118.

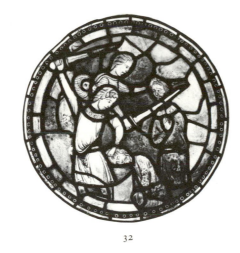

32

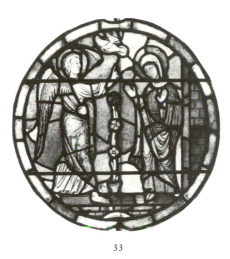

33

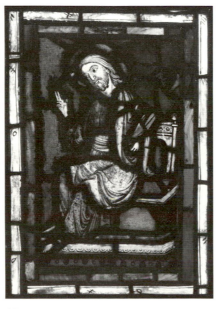

31

32. *Scene of Martyrdom?*

Tentatively attributed to a lower window

United States, Pennsylvania, Bryn Athyn, Glencairn Museum, accession no. 03.SG.112

Diameter, including the inner edge: 48.2–48.5 (19–19¹⁄₈)

Outside fillet is modern; there is extensive use of stopgaps.

Provenance: Soissons Cathedral?; Raoul Heilbronner, Paris; Michel Acézat, Paris; Raymond Pitcairn, Bryn Athyn

Bibliography: Guilhermy, MS 6109, f. 256?; *Catalogue des sculptures . . . et . . . vitraux . . . Collections de M. Raoul Heilbronner* [sale cat.], Paris, May 17, 1924, no. 98; Jane Hayward in *Medieval Art*, no. 188; Jane Hayward in Hayward and Cahn, 1982, pp. 168–70, no. 63; Michael Cothren in *Corpus Vitrearum USA Checklist* II, p. 118.

33. *The Annunciation*

Tentatively attributed to a lower window

United States, Pennsylvania, Bryn Athyn, Glencairn Museum, accession no. 03.SG.236

Diameter without fillets: 50.8 (20)

Fillets and ornamental surround are modern; within the medallion, there are many restorations, concentrated to the right.

Provenance: Raoul Heilbronner, Paris: Michel Acézat, Paris; Raymond Pitcairn, Bryn Athyn

Bibliography: Catalogue des sculptures . . . et . . . vitraux . . . Collections de M. Raoul Heilbronner [sale cat.], Paris, May 1924, no. 92; Jane Hayward in Hayward and Cahn, 1982, pp. 129–32; Sauerländer, 1982, p. 387; Michael Cothren in *Corpus Vitrearum USA Checklist* II, p. 117; Ancien, 1987, p. 10.

CATALOGUE B

Dimensions of Rose Windows (Metric)

Braine North Transept Type

	Braine	Saint–Michel	Vaux-sous-Laon
Diameter of whole[a] (1)	7.5	7.59	—
Diameter of "Braine unit" (2)	6.5	5.21	6.00 ± ★
Diameter of outer lobes (3)	55.0	37.2	53.0
Diameter of inner circles (4)	55.	45.0	70.0
Diameter of inner lobes (5)	30.	22.3	42.0
Radius of (5)	25.	20.0 ±	31.0

★to outer molding.

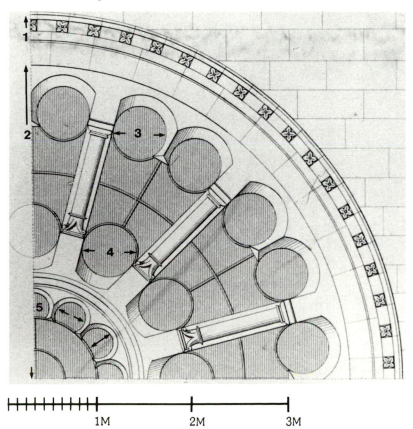

CATALOGUE C

Reconstruction of the Symbolic Crucifixion Window in Saint-Remi

THE ACCOMPANYING diagram is based on the present dimensions, 2.16 meters high and 1.10 meters wide, of Window s.XIX in the west wall of the south transept of Saint-Remi. It belongs to the eleventh-century structure, but all the stonework has been renewed, and it is possible that the opening was enlarged at some time. A drawing in the municipal library, Reims, B.M., Estampes XVIII Ifa dating from 1841–1851, shows a project by Charles Givelet for new glazing, at which time the opening was its present size. If one assumes the scale of the drawing is 1:10, the window dimensions are 2.20 meters high and 99 centimeters wide. The armature gives the configuration I suggest here, except that the circles are only 34 centimeters in diameter, instead of the 43 required by the curvature of the Synagogue panel. The Givelet project, however, was not executed (see Chapter 1, n. 76), and by 1857 Didron is recorded to have supplied new glass in the baptistry that was situated here. A photograph by Rothier entitled "Les Trois Baptêmes," included in his "Souvenir" album (Reims, B.M., Estampes, Ve 156a 8°), shows figural glass of a different composition to the Givelet project.

Scale photographs of the panels with Synagogue and "Petrus," now in the Glencairn Museum, are montaged with a probable reconstruction of the armature. No openings of the right size are likely to have existed in Braine. One alternative composition that was considered consists of two circles placed tangentially side-by-side, to give a window 1.22 meters wide. The Gothic openings in Braine, however, are larger (1.44).

Since the reconstruction is not entirely satisfactory,

additional evidence may be cited for the provenance. Some weight can be given to the note in the Demotte catalogue that the glass was acquired from a Monsieur Marchand who had "withdrawn" it from Saint-Remy during restorations after the war of 1870. At least one glass painter of that name is known to have been active somewhat earlier: J. Marchand, co-author of *Les Verrières du choeur de l'église métropolitaine de Tours*, published in Paris in 1849, is described on the title page as "ancien directeur de la manufacture de vitraux peints, à Tours." And an L. A. Marchand had published a book in Gien in 1844 entitled *Notices sur Saint Brisson et les vitraux de l'église de Sully*. On the other hand, "Mr. Dealer" might be a euphemism for Edouard Didron jeune who I have suggested carried out an extensive restoration soon after 1868.

Furthermore, the style of the figures is entirely in keeping with the work of the Reims atelier, as discussed in Chapter 4; the rather dry style appears later than the window at Canterbury, and might therefore belong to the campaigns of decoration associated with completion of the nave vaults in Saint-Remi, around 1200. The ornament too is rather dessicated, the border sparser than most, with a single trefoil leaf filling the elliptical interstices of a crisscrossing vine, comparable with a type used in the clerestory of Orbais (Catalogue D, R? b.42; cf. Pl. 143). Yet some of the foliage in the ground is very crisply painted, with a series of strokes placed close together that resemble those applied to the rich palmettes in one extant border in Saint-Remi, which also has a stem with leaf scars (Catalogue D, R.b.15). The closest

comparison, however, is provided by two border panels now in the Cloisters, which are of uncertain provenance (Catalogue D, B/R? b.1). It may be significant that prior to accession in 1979, these had been leaded together into a squarish panel, as had pairs of border lengths in the Amiens Museum that seem to have come from Saint-Remi (R.b.12, 13, 30, 31, 34).

Particulars of the surviving panels are now provided; measurements are again given in centimeters, then inches, height before width.

Synagogue

United States, Pennsylvania, Bryn Athyn, Glencairn Museum, accession no. 03.SG.25

57.5 × 40 (22⅝ × 15¾)

There are minor replacements, but the leading is probably medieval.

Provenance: Monsieur Marchand, Reims?; Lucien Demotte, Paris; Raymond Pitcairn, Bryn Athyn

Bibliography: Demotte, 1929, no. 6; Jane Hayward in *Medieval Art*, no. 190; Caviness, 1977, p. 80, fig. 157; Jane Hayward in Hayward and Cahn, 1982, pp. 117–19, col. pl. IV; Ragiun, 1982, p. 93, n. 171; Kline, 1983, pp. 147–48, pl. 149; Michael W. Cothren in *Corpus Vitrearum USA Checklist* II, p. 106.

Donor Portrait

United States, Pennsylvania, Bryn Athyn, Glencairn Museum, accession no. 03.SG.11

Inscription: PETRVS (repainted)

24 × 23 (9⁷⁄₁₆ × 9¹⁄₁₆)

The glass is heavily corroded, resulting in loss of paint; some leads are medieval.

Provenance: M. Marchand, Reims?; Lucien Demotte, Paris; Raymond Pitcairn, Bryn Athyn

Bibliography: Demotte, 1929, no. 4; Louis Grodecki, "Nouvelles découvertes sur les vitraux de la cathédrale de Troyes," in *Intuition und Kunstwissenschaft: Festschrift für Hanns Swarzenski*, ed. Peter Bloch et al., Berlin, 1975, p. 203, n. 17; Jane Hayward in Hayward and Cahn, 1982, pp. 119–21; Michael W. Cothren in *Corpus Vitrearum USA Checklist* II, p. 106.

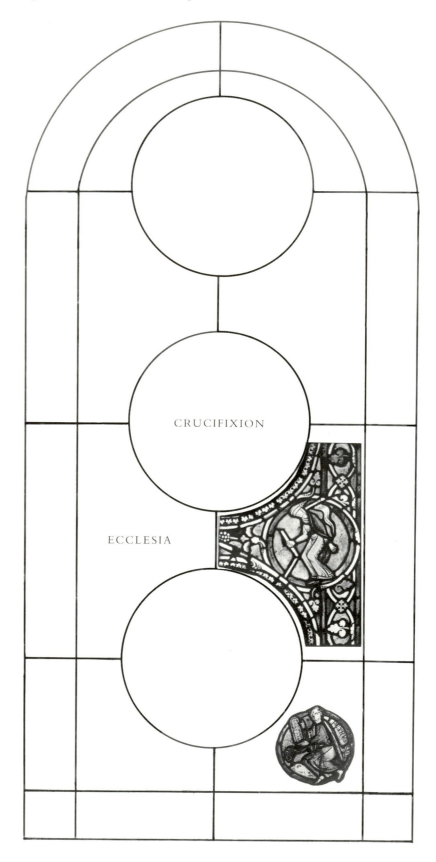

CATALOGUE D

Ornament from the Rémois Shop

A CATALOGUE of the ornamental panels and borders surviving in Saint-Remi or recorded there at some time is appended for reference and as a tool for further research. The discovery of original watercolors in Paris (Dessins, Vitraux) that appear to be more accurate than the reproductions in Cahier and Martin, and presumably predate that publication of the 1840s, has added to the repertory, as have watercolors in the Buckler album in London. In both cases a Saint-Remi label served to attribute several stray panels. For those watercolors that do not agree in all details with an existing design I have often labeled the variant *a*; more significant deviations are recognized by a separate designation. Unfortunately, neither artist recorded the positions of the panels at the time of study.

Listed here in addition are panels, whether extant or not, that I attribute on less certain grounds to Saint-Remi or Braine. Ornamental designs in Canterbury that are associated with figural subjects by the rémois shop are catalogued after the Saint-Remi entries, with others there that are attributed to it.

Ornamental lobes that plausibly come from the roses of Braine and borders that I speculate originated in the lancets are listed last and compared with analogous designs in Reims and Canterbury. A fairly large group of borders was recorded in Soissons Cathedral in the nineteenth century, but in the present state of our knowledge any of these that were not clearly shown to be integral with the cathedral glazing could, in fact, have come from Braine, so they are included tentatively here.

Among those that appear integral, and are therefore not included, are the borders with geometric ornament in the Gardner Museum, Boston, framing panels from the Sts. Nicasius and Eutropia window (*Corpus Vitrearum USA Checklist* I, pp. 15, 40; also ills. Cahier and Martin, 1841–1844, Mosaiques K, 11); the border and geometric ornament of the St. Gilles window in the cathedral, (R.b. 39a, B), and fragments of four borders in the apse clerestory where they are associated with glass

that originated in the cathedral (Cahier and Martin, 1841–1844, Mosaiques K, 8, and *Corpus Vitrearum France Recensement* I, pp. 170–71, pl. 13, Baies 10, 12, 14, 100–102, 104. The former has been closely studied by Marilyn M. Beaven, who concluded that the surviving border panels, though separately leaded from the figure panels, belong with them (MS, 1989, p. 66). The unresolved problem of attribution for those in the Pitcairn Collection is taken into account by M. Cothren in *Corpus Vitrearum USA Checklist* II, pp. 111–14.

An issue that I will not attempt to resolve, following the few comments in Chapter 4, concerns the lost ornamental colored glass recorded by Cahier and Martin in Soissons (1841–1844, Mosaïques F, 1, 2, 4, 8). As Kline has pointed out in a pioneering study of this type of ornament (1983, pp. 51–52), the only part of the cathedral of suitable date to have contained these designs is the south transept. This glass could, however, equally have come from Braine; the close relationship between the sculpted capitals of the south transept of the cathedral and the chapels at Braine would allow an analogous relationship in glass prior to 1200 (Caviness, 1984, p. 544, figs. 9, 10, and n. 78; I do not agree with Kimpel and Suckale [1985, p. 268] that the capitals are an isolated case). On the other hand, it is hard to imagine nonfigural glass in the choir or chapels of Braine, and the nave aisles are probably later than the Soissons transept construction, since they have a different repertory of capitals.

Saint-Remi: Ornamental Colored Glazing

Examination of the Rothier photographs indicates few losses of this type of ornamental glass from the tribune since the late nineteenth century; for instance, the corroded panels in Nt.II a, surrounding St. Agnes, have the same distribution as they do now, the old ornament having already been reduced to four half-panels and a few

fragments at the core of two others (Pl. 93; R.o.2 below). Quite possibly the drawings reproduced by Day in 1899, showing whole elements of each design, were based on the restored panels, but they are nonetheless valuable records. One impressive rosette design recorded both by Day and in the Buckler drawings is represented by a whole window now, incorporating four half-panels and some other fragments (R.o.3).

An authentic panel that entered the Metropolitan Museum in 1926 as part of the Pratt bequest is closely related to a design recorded by Merson prior to 1895. Two lancets seem to have been filled with one or both of the rosette designs preserved in this panel, at different times; one was photographed by Rothier in an interior view of the south tribune, evidently in the first window on the north (Pl. 31); the other, photographed from outside ca. 1942–1944 (M.C.C. 823, 7ᵉ dossier), appears to have been on the north side of the Lady Chapel. On the other hand, it became abundantly clear in Chapter 1 that the likelihood of any of this ornament being in situ by the late nineteenth century is remote indeed and prior losses must have been great. The panels referred to by Viollet-le-Duc in storage were probably dispersed (see Chapter 4, n. 54).

The conclusion I reached in Chapter 4, and in a forthcoming study in *Essays in Honor of the Cloisters Fiftieth Anniversary*, ed. E. C. Parker, New York, 1990, is that the ornamental colored glass of Saint-Remi was created to fill whole windows, either in the tribune itself where the figures now framed by it were clearly inserted from elsewhere, or in the lower level. The density of the designs, with tight leaves and abundant cross-hatching, shows an affinity with the earliest group of borders, and some of the early records show such panels leaded together; they may date in the 1170s to 1180s.

Saint-Remi Borders

It is just as unlikely that any of the Saint-Remi borders have been returned to their place of origin; their history is traced in Chapter 1 and may be summarized here. Elimination of the original borders from the clerestory, most probably by the Maurists, eventually resulted in the provision of replacements by Ladan in the nineteenth century. These can be seen in the Rothier photographs, from which it is clear that some old pieces were incorporated in the retrochoir, alongside strident new designs (Pls. 92, 93, 132–41a). There are also Rothier photographs for the nave clerestory windows, in the Simon-Marq atelier, and here all the borders are clearly nineteenth century.

Since old borders had been observed in the lower windows of the chevet earlier in the century, it is probable that these were the ones available to Ladan; no doubt others had already left the site—hence, the number preserved in collections, principally in the Musée de Picardie in Amiens and the Glencairn Museum near Philadelphia. The borders in Amiens were a bequest of Maig-

nan-Larivière in 1947. R.b.30, R.b.31, R.b.34 and R?b.39a were leaded to a medallion with St. Remigius at one time, as recorded in a black-and-white photograph of the panel when it was in the collection of Albert Maignon: Paris, Union Centrale des Arts Decoratifs, Collection Maciet, Album 482/5, Vitraux—France, Moyen Age, Villes S-Z; others were leaded in pairs and thus once shared an accession number. (I am grateful to the former conservateur, Mme Véronique Alemany, for information and to Benoit Marq for permission to examine them in his atelier.) Provenance for the pieces in the Glencairn Museum is given in the *Corpus Vitrearum USA Checklist* cited in the bibliography for each item; for the most part, they were purchased by Raymond Pitcairn from dealers in France in the 1920s.

After World War II Simon was careful to supply designs based on, and frequently incorporating, old fragments; in making new borders he respected the a-b-a rhythm of the triplets. He provided a careful record, now in the Ministry archives, of the postrestoration placement of old borders in the hemicycle of the choir clerestory: Bibliothèque de la Direction de l'Architecture, M.C.C., Dossier 8ᵉ 823, devis 1080/53 (June 1952); on p. 11 (April 1954), conservation of forty-four border panels for the hemicycle bays is mentioned. (In this plan, of course, the individual designs are not recorded, nor were they photographed because they were associated, before and after, with modern figures.) As far as possible the medieval pieces were left in their original leads, which often reveal an original panel length (Pl. 68), but without any armatures in situ it does not serve to position them in the medieval glazing scheme.

The primary classification I applied to the Saint-Remi borders recognized three basic types, comprising side-by-side or additive motifs that are often predominately geometric (R.b.1–11), sideways-growing palmettes or other vegetal forms (R.b.12–15), and upward-growing elements that sometimes have a trellis (R.b.27–33) and sometimes not (R.b. 34–40). These divisions, however, do not coincide the chronological distinctions argued in Chapter 4. It was suggested there that types 1–4 (perhaps also 5) and 27 belong to a period before 1175, possibly as early as 1150–1165; types 6, 12, 16, 28, and 31–34 might belong to the 1170s or at least to the last quarter of the century and to lower windows, by analogy with Canterbury; types 8–11, 20, 24, 26, 36, and 38–41 show the kind of bold simplification that at Canterbury is associated with developments in clerestory glazing about 1180–1205. Some of these designs (e.g., R.b.11) might be from the nave clerestory, hence perhaps later than those attributed to Braine.

Borders in Canterbury, Attributed to the Rémois Shop

Most of the borders at Canterbury associated with figures that I attribute to the rémois shop stand out as belonging to the first or second type, that is additive or

sideways-growing, whereas the third, upward-growing, type is the norm there (C.b.1, 4, 6); two of the "rémois" borders, however, are of the third type (C.b.2, 3) (see Caviness, 1977a, pp. 44–45). Comparison of rubbings of closely similar designs (R.b.24a and C.b.5) revealed that the meander stem is almost identical in width (14; cf. 14.7 cm) and the cutline of the outer curve of the meander, with the "nested" calyx, coincides, but the repeat is stretched at Canterbury and the palmettes differ.

Saint-Yved Ornament

The foliate lobes from one or both of the transept roses, used as fill in the spandrels over four of the figures, are the only elements of ornament that can be ascribed to Braine with certainty; they fit the stonework exactly (Pl. 244; Catalogue A, nos. 1, 3, 4, 8). Next to these, the border in Forest Lawn is a very strong candidate, both because it was with the fragmentary remains of the David from Braine as early as 1929, and because the foliate clusters are so like those of the lobes. Of the panels known to have been in Soissons, I have included here several that fit into the repertory of the rémois shop; they are in fact quite distinct from the types that are known to belong to the cathedral glazing.

Catalogue

The following catalogue is arranged in order to present a visual survey of types within each monument. One early lost border said to come from Reims Cathedral is included at the outset of the sequence. *R* refers to Saint-Remi of Reims, *C* to Christ Church Cathedral, Canterbury, *B* to Saint-Yved of Braine, *B/R* to designs attributed to Braine or Saint-Remi, and *B/S* to panels recorded in Soissons Cathedral but perhaps from Braine; in each case a question mark indicates an attribution; if panels are in situ, this is noted. The letter *b* indicates a border design; *o* denotes ornament other than borders. Designs now lost are in brackets. Comparative illustrations (labeled A, B, C, D, as appropriate) are captioned in the text. Measurements are given in centimeters, with their equivalent in inches provided in parentheses. Unless noted otherwise, measurements for ornament list height before width; the single value for borders represents width. Widths for both do not include edging lines, since these have often been replaced, unless they are invaded by the decorative motif.

For the positions of windows in Saint-Remi, see Fig. 2. Following the window number are the panels with authentic borders, which are numbered throughout the window from the bottom left; these numbers differ from the designations in the Archives Photographique in that three panels of border were added across the bottom of the windows in the restoration of the 1950s (hence, subtract these from my designations to match the archival record).

R.o.1. *Tribune, St.II a,* 4 and 6 containing some old fragments, leaded to R.b.20 (Nt.II c has a modern replica, with R.b.35) (Col. Pl. 17)

The rectilinear armature forms the design unit, centering on a six-lobed rosette, cross-hatched in reserve, with blue middle and red ground. A lattice of red fillets with inscribed green-edged or blue-edged lozenges edged with dense wreaths of curled acanthus fronds forms a counterpoint, with secondary yellow and green quatrefoil centers quartered by the irons.

Full unit: 77 × 55 (30¼ × 21⅝)

Photographs: S.P.A.D.E.M (montage)

Bibliography: Cahier and Martin, 1841–1844, Mosaïques F, 5 (with border 11a); Day, 1909, fig. 25 (illus. 1a); Kline, 1983, pl. 122.

Comparison: R.b.27; Saint-Denis, griffin window (Grodecki, 1976, pp. 122–25, pl. xv, figs. 183–92; [B/S, Cahier and Martin, 1841–1844, Mosaïques F, 4; Kline, 1983, pl. 156]; Orbais, N.XI a (Kline, 1983, painted grisaille 2, pp. 226–27, pl. 44).

R.o.1

R.o.2. *Tribune, Nt.II a,* 7, 9, 10, 12, 13, 15, leaded to R.b.4 (Col. Pl. 18)

A foliate wreath with red ground, and green and blue fillets is centered on a composite quatrefoil, with lobes cross-hatched in reserve; a counterpoint is provided by smaller quatrefoils, halved by the armature.

Full unit: 76 × 56 (29⅞ × 22)

Photographs: S.P.A.D.E.M. (montage)

Bibliography: Westlake, 1881, 1: pl. XXXIII; Kline, 1983, pl. 124.

Comparison: A: Later (thirteenth-century) reliquary of St. Sixtus, Reims Cathedral Treasury, Palais du Tau (Musée des Arts Decoratifs, *les Trésors des églises de France* [exhibition cat.], Paris, 1965, p. 66, no. 133, pl. 96; photo: Caviness)

R.o.2

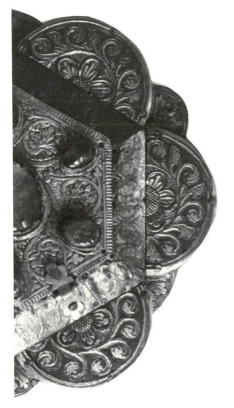

R.o.2A

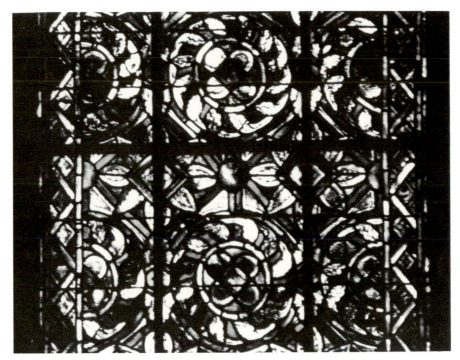

R.o.3

R.o.3. *Tribune, St.III a*, 13, 15, 16, 18, and some fragments in 10, leaded to R.b.4

A foliate wreath, this time with the fronds curled inward on a red ground, is centered on a composite quatrefoil with lobes cross-hatched in reserve and a green middle; green fillets describe lozenges forming a counterpoint, with eight leaves in a rosette around a purple center, quartered by the irons.

Full unit: 77 × 55 (30¼ × 21⅝)

Photographs: Caviness

Bibliography: Buckler Bequest, no. 38 (photo: B. L.); Cahier and Martin, 1841–1844, Mosaïques F, 7 (leaded to R.b.31); Day, 1909, fig. 249; Kline, 1983, pl. 123.

Comparisons: A: Orbais, N.III b (Kline, 1983, ornamental colored glass 3, pp. 223–24, pl. 40; photo: S.P.A.D.E.M.); [Soissons Cathedral: Cahier and Martin, 1841–1844, Mosaïques F, 2; Kline, 1983, p. 224, pl. 157].

R.o.3A

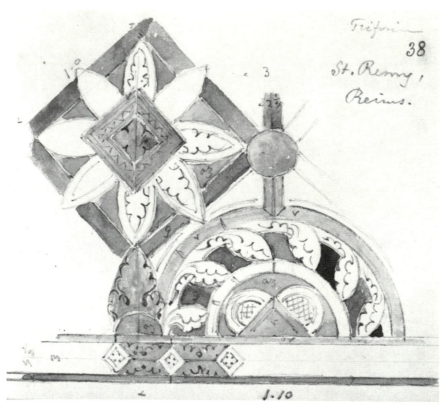

R.o.3

R.o.3

R.o.4

R.o.4. *Tribune, St.II c, 7, 9, 10, 12, 13, 15, with fragments in 16 and 18, leaded to border 26*

Large and small lozenges outlined by green or red interwoven fillets occupy the vertical center of the unit, the large ones containing composite quatrefoils outlined in purple and blue; small wreaths edged in yellow form a counterpoint and are halved by the armature. The ground is cross-hatched, and the foliage predominantly small palmettes.

Full unit: 78 × 52 (30¾ × 20½)

Photographs: S.P.A.D.E.M. (montage)

Bibliography: Day, 1909, fig. 76.

Comparisons: Orbais, S.III a and N.III b; N.X b (Kline, 1983, ornamental colored glass 1 and 2, pp. 221–25, pls. 38, 39; painted grisaille 1, pl. 43); [B/S: Cahier and Martin, 1841–1844, Mosaïques F, 8; Kline, 1983, pl. 159].

R.o.5. United States, New York, Metropolitan Museum of Art, 26.218.1

Three composite quatrefoils in the central field and demi-rosettes to the sides are on a yellow ground. Fillets and centers are predominantly green and red. The lobes of the quatrefoils alternate acanthus fronds with cross-hatching in reserve.

94 × 31.7 (37 × 12½)

Photographs: Metropolitan Museum of Art

Bibliography: Rothier photograph of the tribune, before 1896; photograph, 1940, Paris, Bibliothèque de la Direction de l'Architecture, M.C.C., Restoration Accounts 823, dossier 7, exterior view of Lady Chapel [copy by Ladan]; Cahier and Martin, 1841–1844, Mosaïques F, 6; Merson, 1895, fig. 46 (or a variant); Kline, 1983, pl. 128; *Corpus Vitrearum USA Checklist* I, p. 94.

Comparisons: [B/S: Cahier and Martin, 1841–1844, Mosaïques F, 1; Kline, 1983, pl. 158].

[R.o.6]. Formerly Saint-Remi, leaded to R.b.35

Large rosettes are outlined in blue against a yellow ground, their fillets linked by small quatrefoil leaves. A decorative white edging within frames, four white leaves in saltire, on alternating green and blue lozenges. Small rosettes with red centers form a counterpoint.

Photographs: Musée des Arts Decoratifs

Bibliography: Watercolor in Dessins, Vitraux, no. 2500.6; reproduced in Cahier and Martin, 1841–1844, Grisailles E, 6; Kline, 1983, pl. 125.

Comparisons: R.b.11; A: Orbais, S.III b, (Kline, 1983, ornamental colored glass I, pp. 220–22, pl. 38; photo: S.P.A.D.E.M).

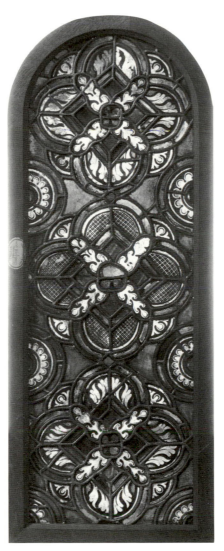

R.o.5

R.o.6

R.o.6A

[R.C.b.1]. Formerly Reims Cathedral

Of an early type, this border has beading and decorative masks. The Heaton watercolor gives red and blue grounds and an alternation of colors in the palmettes, pairing purple and green leaves in one unit and green and yellow in the next. He may, however, have worked up a full-size colored design from Merson's plate.

Ca. 20 (7⅞)

Photographs: Corpus Vitrearum (United States)

Bibliography: Heaton Collection II, pp. 24–25; Paris, Collection of François Perrot, Jean Lafond papers, Reims dossier, notes dated 1935 (with incorrect photo no.); Merson, 1895, fig. 51.

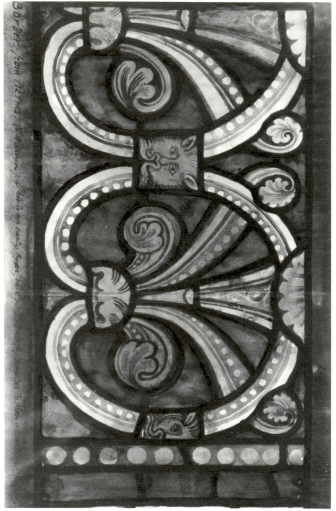

R.C.b.1

R.b.1. N.III a, 1–3?, 7, 9, 10, 12, 13, 15; N.III b, four panels; S.III c, 6, 7, 9, 12, 15, fragments in 10 and 13; S.III b, 6; S.III, a, top two panels

White lozenges appear between pairs of alternating green and blue palmettes.

8.3 (3⅛)

Photographs: S.P.A.D.E.M.

Bibliography: Buckler Bequest, no. 38 (leaded to R.o.3).

Comparisons: A: Gospel concordance, Saint-Remi, late twelfth century, Reims, B.M. MS 47, f. 7 (Lemps and Laslier, 1978, no. 30); B: Temptation of Christ from Troyes, ca. 1170–1180, London, Victoria and Albert Museum, no. C. 108–1919 (Grodecki and Brisac, 1977, pp. 141, 294, fig. 118; photo: Victoria and Albert Museum); C: Strasbourg Cathedral, late twelfth century (Zschokke, 1942, no. 27).

R.b.1A R.b.1B R.b.1C

R.b.1

R.b.2. S.II c, 4 and 6, fragments in 12 and 15; S.II b, 4, 6, 7, 9, 10, and 12

White lozenges appear between alternating red quatrefoils with pairs of blue leaves, and yellow with green.

10–10.5 (4–4⅛)

Photographs: Caviness

Comparisons: R.b.2a; A: Saint-Remi candlestick base, mid-twelfth century, Musée Saint-Remi (photo: Caviness).

R.b.2A

R.b.2

[R.b.2a]

Thus variant has a red ground to the paired leaves, and more elaborately painted yellow or white lozenges.

Photographs: Musée des Arts Decoratifs

Bibliography: Dessins, Vitraux, no. 7, reproduced in Cahier and Martin, 1841–1844, Mosaïques M, 7.

R.b.2a

R.b.3. S.IV c, all but 1–3

Blue and green are counterchanged in the demi-rosettes; the central quatrefoils alternate yellow and white.

10–10.5 (4–4⅛)

Photographs: Caviness

Comparisons: A: Strasbourg, twelfth-century fragment (Zschokke, 1942, no. 37); B: inner borders on St. Nicholas scenes from Troyes Cathedral, ca. 1170–1180, London, Victoria and Albert Museum, no. C.106-1919, and Paris, Musée de Cluny, no. Cl. 22.849 (Grodecki and Brisac, 1977, p. 295, pls. 123, 124 [col.]; photo: Victoria and Albert Museum).

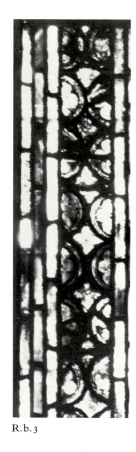

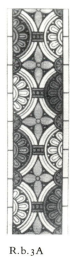

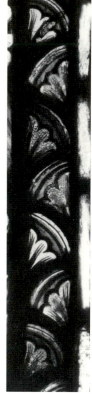

R.b.3A

R.b.3

R.b.3B

R.b.4. Nt.II a, with R.o.2; St.II a, 1–3

Demi-lozenges of purple, blue, yellow, and green, each with three quatrefoils, are subdivided by a zigzag white fillet.

9.5 (3¾)

Photographs: S.P.A.D.E.M

Comparisons: A: Strasbourg, twelfth-century fragment (Zschokke, 1942, no. 29); B: Gospel concordance, Saint-Remi, late twelfth century, Reims, B.M. MS 47, f. 8 (Lemps and Laslier, 1978, no. 30; photo: Caviness); Sens Cathedral, axial chapel n.II a and b (M.C.C. G), probably a nineteenth-century copy.

R.b.4

R.b.4A

R.b.4B

R.b.5. Nt.I a, all but 4 and 6
(Col. Pl. 15)

Curled-over acanthus of yellow and an unusual reddish purple form quatrefoils in a white lattice with green flowers at the intersections, on a ground of light streaky red, and blue.

12.5–12.75 (4⅞–5)

Photographs: S.P.A.D.E.M.

Bibliography: Watercolor, "S. Remy, Reims," Buckler Bequest, no. 30[a]

Comparisons: R.b.11; B/S ? b.7; borders from Saint-Denis, 1141–1144, in storage at the Château de Champs-sur-Marne, A: type H, B: type J (Grodecki, 1976, pp. 129–31, figs. 205–7); C: Bible from the cathedral, ca. 1150–1160, Reims, B.M. MS 19, f. 35v (photo: Caviness); D: "Coronation chalice," late twelfth century, Cathedral Treasury (photo: Caviness); Altar-cross, enamel, Mosan ca. 1160, London, British Museum, Department of Medieval and later Antiquities 1856, 7–18, 1

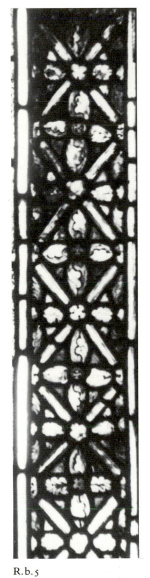

R.b.5

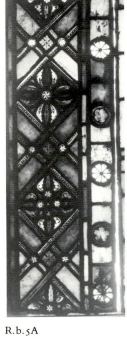

R.b.5A

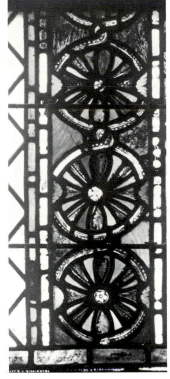

R.b.5B

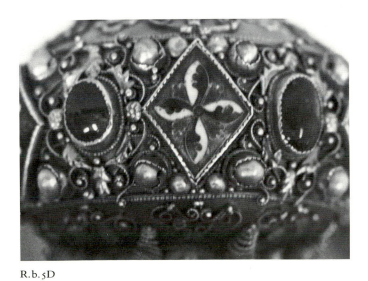

R.b.5D

R.b.5C

[R.b.6]

Blue quatrefoils and pairs of yellow and green fronds appear on a red ground.

Bibliography: "Saint-Remi de Reims," Dessins, Vitraux, no. 16, reproduced Cahier and Martin, 1841–1844, Mosaïques et Bordures M, no. 16.

Comparisons: A: Twelfth-century fragment from Strasbourg (Zschokke, 1942, no. 24).

R.b.7. Nt.II b, 4, 6, 7, 9, 10, 12, 13 15, 22, 24

White and brilliant yellow flowers with green centers alternate on a blue ground.

11.5 (4½)

Photographs: S.P.A.D.E.M.

Bibliography: "Cath. de Sens," Dessins, Vitraux, no. 3, reproduced Cahier and Martin, 1841–1844, Mosaïques et Bordures M, no. 2 (corrected to Saint-Remi).

R.b.8. s.XVII, 4 and 6 (before 1916 in Nt.II a, with R.o.2)

Bright blue quatrefoils are framed by brilliant yellow shoots, with white flowers between them.

12 (4¾)

Photographs: Caviness (S.P.A.D.E.M. prerestoration)

Comparison: C.b.6.

R.b.6

R.b.6A

R.b.9. Retrochoir clerestory I c, 4, 6, 7, 9

Blue flowers are drawn on a red ground, with yellow quatrefoil centers joined by elliptical white stems.

12–12.5 (4¾–4⅞)

Photographs: Caviness

Comparisons: Canterbury Cathedral, clerestory: A: north rose (N. XVII), outer border (photo: Caviness/Conway); N. XXI (Caviness, 1981, fig. 8).

R.b.7

R.b.8

R.b.9

R.b.9A

R.b.10. S.II b, 4, 6, 7, 9, 10, 12; United States, Pennsylvania, Bryn Athyn, Glencairn Museum, 03.SG.173

Yellow quatrefoils with elliptical white stems are on a red ground, as in no. 9, but with alternating green and blue quatrefoils filling the ellipses.

12.5 (4⅞)

Photographs: Caviness (and Pitcairn)

Bibliography: Michael Cothren in *Corpus Vitrearum USA Checklist* II, p. 107.

R.b.11. S.V a, 7; b, all but 1–3 (Col. Pl. 16)

Four leaves that curl over on themselves are arranged in saltire around a white quatrefoil flower on a red ground; they are paired diagonally, green and blue, and their contours form interlocking circles; the concave intervals in the center are filled by yellow quatrefoils.

18 (7⅛)

Photographs: S.P.A.D.E.M.

Bibliography: Buckler Bequest, no. 25.

Comparisons: R.b.5; B/S ? b.7; opus sectile design and Orvieto window border (Day, 1909, figs. 21, 22).

R.b.12. Clerestory I a; N.III b, 14, 18, 19, 21; France, Amiens, Musée de Picardie, Inv 87.4.41(H)

On a blue ground leafy shoots spring in one direction from a white fillet, alternating purple, green, and yellow with white and green.

13 (5⅛)

Photographs: (Saint-Remi, Caviness) Musée de Picardie

Comparisons: A: Canterbury Cathedral, type H (Caviness, 1981, p. 218, fig. 374; photo: Caviness/Conway).

R.b.13. N.III c (Col. Pls. 7, 8); France, Amiens, Musée de Picardie, Inv 87.4.40 (E)

On a red ground dense palmettes of red with green and blue counterchanged, interspersed with yellow leaves, spring in one direction and are contained under a white meander.

9.5 (3¾); with one old fillet, 11.8 (4⅝)

Photographs: (S.P.A.D.E.M./Caviness, Saint-Remi); B. Marq, Reims

R.b.10 R b.11 R.b.13

R.b.12 R.b.12A

[R.b.14]

On a red ground, white stems form kidney-shaped frames joined by quatrefoil flowers with a green leaf; within them pairs of yellow fronds spring from a green calyx.

Photographs: British Library

Bibliography: "S. Remy, Reims," Buckler Bequest, no. 30.

Comparisons: B.b?1; A: Canterbury Cathedral, type I (Caviness, 1981, p. 218, fig. 375, and Loyola, Martin D'Arcy Gallery of Art, *Corpus Vitrearum USA Checklist* III, p. 128; photo; Caviness/Conway); and B: type J (Caviness, 1981, p. 218, fig. 376; photo: Caviness/Conway); Bryn Athyn, Glencairn Museum, 03.SG.144 (Michael Cothren in *Corpus Vitrearum USA Checklist* II, p. 105).

R.b.14

R.b.14A

R.b.14B

R.b.15. S.IV b, 4, 7, 9, 10, 13, 15, (Col. Pl. 10, modern copy); France, Amiens, Musée de Picardie, Inv 87.4.44 (G); United States, Massachusetts, private collection

Panel 4, and the fragments in America, are in original leads.

On a red and blue ground white stems form kidney-shaped frames around and between rich palmettes of green, red, white, blue, and yellow foliage.

20 (7⅞)

Photographs: S.P.A.D.E.M. (and Corpus Vitrearum USA)

Bibliography: "Reims, Saint-Remi," full-size watercolor, Heaton Colleciton II, p. 27 (colors reversed); Caviness, 1977a, p. 51, fig. 5; Caviness in *Corpus Vitrearum USA Checklist* I, p. 67.

Comparisons: A: Canterbury Cathedral, type A (Caviness, 1981, p. 216, fig. 369; photo: Caviness/Conway); B: St. Augustine, Expositio in Psalmos, from Saint-Remi, late twelfth century (scribe Robertus Anglicus), Reims, B.M. MS 90, f. 3v (photo: Caviness); C: Peter Lombard, Sententiae, from Saint-Denis in Reims, late twelfth century, Reims, B.M. MS 460, f. 1 (Lemps and Laslier, 1978, no. 28; photo: Caviness).

R.b.15A

R.b.15B

R.b.15

R.b.15C

[R.b.16]

A white stem forms a series of hoops between red and blue grounds on which multicolored palmettes grow in the same direction.

Photographs: British Library

Bibliography: "St. Remy, Reims," Buckler Bequest, no. 28.

Comparison: C.b.1.

[R.b.17]

White hoops divide red and blue grounds filled with palmettes formed by leaves springing in opposite directions and counterchanged green and white with a yellow tip; between the hoops are three tiers of leaves, white, yellow, and green.

Ca. 26 (10¼), including fillets

Photographs: Musée des Arts Decoratifs

Bibliography: Watercolor in Dessins, Vitraux, no. 2.

Comparisons: Canterbury Cathedral type G (Caviness, 1981, pp. 217–18, fig. 373); United States, Pennsylvania, Bryn Athyn, Glencairn Museum, 03.SG.121 (Michael Cothren in *Corpus Vitrearum USA Checklist* II, p. 120).

[R?b.17a]

White hoops divide red and blue grounds filled with red[?] and yellow palmettes growing in the same direction.

Ca. 26 (10¼) including fillets

Photographs: Musée des Arts Decoratifs

Bibliography: Water-color in Dessins, Vitraux, no. 11 (listed as Laon, as is no. 3 which is a known Saint-Remi border, R.b.7).

R.b.18. S.III b, 6; s.XVII

(fragment)

White hoops on a red ground are almost entirely covered by blue, white, yellow, and green curled fronds.

13.5 (5¼)

Photographs: S.P.A.D.E.M. (and Caviness)

Comparisons: A and B: capitals, wall arcade, eastern chapels of Saint-Remi (photos: Caviness); C: penwork capitals, Saint-Remi Bible ca. 1080, Reims, B.M. MS 16, f. 121 (photo: Caviness); and MS 460 f. 8 ("D") and passim.

R.b.18 A

R.b.18 B

R.b.16

R?b.17a

R.b.18

R.b.18 C

R.b.19. s.XVII, 2 (fragments); United States, Pennsylvania, Bryn Athyn, Glencairn Museum, 03.SG.34 and 216, and Connecticut, Greenwich, Douglass Collection, no. 36

White hoops divide red and blue grounds, with purple, green, and yellow palmettes.

12.2 (4¾)

Photographs: Caviness (and Glencairn Museum; Corpus Vitrearum USA)

Bibliography: Michael Cothren in *Corpus Vitrearum USA Checklist* II, p. 107; Jane Hayward in *Corpus Vitrearum USA Checklist* I, p. 23.

Comparisons: R?b.45; A: capital in wall arcade, Lady Chapel of Saint-Remi (photo: Caviness); Gargilesse (Indre), apse window, late twelfth century (Grodecki and Brisac, 1977, pl. 60).

R.b.20. St.II a, 4, 6, 7, 9, 10, 12, 13, 15

White hoops on a red ground frame palmettes with paired blue and green leaves and a yellow central shoot springing from yellow and purple demi-quatrefoils; between them, single green and blue leaves grow in the other direction, from red demi-quatrefoils.

11 (4⅜)

Photographs: S.P.A.D.E.M.

Bibliography: Buckler Bequest, no. 28.

Comparisons: R?b.43; C.b.4.

R.b.21. N.V c, 4, 6, 9, 10, 12, 13, 15

White hoops on a red ground spring from purple demi-flowers on which are centered semicircles of green foliage, providing a counterpoint.

10 (4)

Photographs: S.P.A.D.E.M.

Comparisons: R?b.43.

R.b.19

R.b.19A

R.b.20

R.b.21

R.b.22. Tribune I b, 4-7, 18, 22, 23, 26, 27, 28

White hoops divide red and blue grounds, the arches filled by palmettes of green, purple, and white with yellow berry clusters.

22.5 (8⅞)

Photographs: S.P.A.D.E.M.

Bibliography: Westlake, 1881, 1: pl. XXXIV, D.

Comparisons: A: Candlestick base, Musée Saint-Remi (photo: Caviness); B: capital, Lady Chapel, Saint-Remi (photo: Caviness); C: sculpted molding, Saint-Remi choir (engraving after Auguste Reimbeau, Reims, B.M. Estampes Saint-Remi collection eb3; photo: Caviness); Psalter, northern France or Flanders, late twelfth century, B.N. MS lat. 833 f. 184 (see C.b.1, C).

R.b.22

R.b.22A

R.b.22C

R.b.22B

R.b.23. S.VI c, 4

White hoops divide red and blue grounds, the arch filled by white, purple, and green palmettes, and between them a single green leaf grows in the same direction from a yellow calyx.

15 (5⅞)

Photographs: S.P.A.D.E.M.

Bibliography: Kline, 1983, p. 269.

Comparisons: Orbais, "Border I" (Kline, 1983, p. 268).

R.b.23

R.b.24. Tribune I c, all but 1–3 and 7

A white meander stem divides red and blue grounds; from it palmettes of green, purple, and yellow or white, blue, and green grow in opposite directions.

13.5 (5¼), including two fillets that are overlapped

Photographs: S.P.A.D.E.M.

Bibliography: "St. Remy, Reims," Buckler Bequest, no. 30 (with minor differences; the green tip that overlaps the fillet is not included).

Comparisons: C.b.5.

R.b.24a. S. transept, S.XVI, fragment. France, Amiens, Musée de Picardie, Inv 87.4.32, 43, 48 (J, 1–5); United States, California, Glendale, Forest Lawn Memorial Park

12 (4¾)

Photographs: Caviness (and Corpus Vitrearum USA for Saint-Remi)

Bibliography: Cahier and Martin, 1841–1844, Mosaïques 8aN; Westlake, 1881, I: pl. XXXIV, F; Kline, 1983, pl. 172. Caviness and Hayward in *Corpus Vitrearum USA Checklist III*, pp. 46, 49.

Comparisons: The cutline and color distribution vary only slightly from R.b.24; A: Orbais (Kline, 1983, "Border III," p. 271; photo: S.P.A.D.E.M.); B: Premonstratensian Missal, Champagne or Soissonais, ca. 1200, B.N. MS lat. 238 f. 187v (photo: B.N.).

R.b.25. Clerestory I b, straight panels in sides

A white meander divides red and blue grounds and a second stem forms a counterpoint; palmettes of alternating green, blue, and white or yellow, purple, and green foliage grow in the same direction.

16.5 (6½) (including a fillet that is overlapped)

Photographs: Caviness (and S.P.A.D.E.M. before restoration)

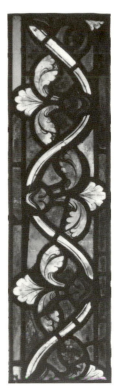

R.b.24 R.b.24a R.b.24aA

R.b.24aB R.b.25

R.b.26. St.II c, all but 1–3 and 20 (with R.o.4)

A white meander divides red and blue grounds; from each loop, in opposite directions, grow simplified green and yellow shoots.

11 (4⅜)

Photographs: S.P.A.D.E.M.

R.b.27. N.V c, all but 1 and 3 (2 heavily restored; Col. Pl. 4, modern copy)

Pairs of fronds on cross-hatched grounds alternate green and red, yellow and blue.

8. 5 (3⅜)

Photographs: S.P.A.D.E.M.

Bibliography: Grodecki and Brisac, 1977, col. pl. 116.

Comparisons: A: capital of the wall arcade, Lady Chapel, Saint-Remi (photo: Caviness); B: panel from the Life of St. Nicholas, from Troyes, ca. 1170–1180, now in Paris, Musée de Cluny, inv. Cl. 22.849 (Grodecki and Brisac, 1977, p. 295, col. pl. 124).

R.b.28. S.IV c, all but 1–3

On a red ground, single fronds alternating blue and white spring from green calyxes.

9 (3½)

Photographs: S.P.A.D.E.M.

Comparisons: Canterbury Cathedral triforium (Caviness, 1981, fig. 135); Bryn Athyn, Glencairn Museum, 03.SG.175 (Michael Cothren in *Corpus Vitrearum USA Checklist* II, p. 114).

R.b.27

R.b.27B

R.b.26

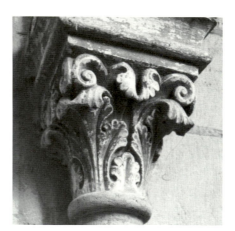

R.b.27A

R.b.28

R.b.29. N.II a, 4 and 6

On a yellow ground, green fronds springing from white calyxes curl symmetrically to form ellipses.

10.5 (4¼)

Photographs: Caviness; Musée des Arts Decoratifs

Comparisons: A: Strasbourg Cathedral, late twelfth century (Zschokke, 1942, no. 19); B: Canterbury Cathedral, "triforium" level of choir, Nt. XI (Caviness, 1981, p. 67, fig. 114).

[R.b.29a]

A lozenge with a quatrefoil flower is inserted between the fronds in this version.

Bibliography: Watercolor in Dessins, Vitraux, no. 14.

R.b.30. S.III a, upper curve only; France, Amiens, Musée de Picardie, Inv 87.4.38, 46 (B, 1–2)

On a red ground, blue and green shoots are framed by pairs of alternating white and yellow fronds.

12.5 (4⅞)

Photographs: S.P.A.D.E.M.; B. Marq, Reims

Bibliography: Watercolor in Dessins, Vitraux, no. 15; photograph, Musée des Arts Decoratifs, Pair, Album 482/5.

Comparisons: A: Canterbury Cathedral, "triforium" of choir aise, Nt.IX (Caviness, 1981, p. 71, fig. 133; photo: R.C.H.M.E.); Cologne, St. Cunibert (Day, 1909, fig. 260).

R.b.29

R.b.29a

R.b.29A

R.b.29B

R.b.30

R.b.30A

R.b.31. France, Amiens, Musée de Picardie, Inv 87.4.43, 47 (C, I–2)

Pairs of white fronds form heart-shaped frames, dividing red grounds outside from blue inside; they contain palmettes of counterchanged purple and yellow leaves, with green shoots between them.

Photographs: B. Marq. Reims

Bibliography: Watercolor "St. Remy Reims," Buckler Bequest, no. 25A; photograph, Musée des Arts Decoratifs, Paris, Album 482/5; Cahier and Martin, 1841–1844, Mosaïques F, 7.

Comparisons: C.b.2.

[R.b.32]

Two white stems divide red and blue grounds and form paired ellipses filled by a palmette of blue, yellow, and green is alternated sequences; the stems interlace at intervals.

Ca. 13 (5⅛)

Photographs: Musée des Arts Decoratifs

Bibliography: Watercolor in Dessins, Vitraux, no. 9.

Comparisons: Reims, B.M. MS 90 (see R.b.15, B); Rémois Bible, ca. 1150–1160, Reims, B.M. MS 19 (esp. for interlace).

[R.b.33a]

On a red ground, a white stem forms a meander with leafy shoots of green and blue that curl up and back.

Ca. 13 (5⅛)

Photographs: Musée des Arts Decoratifs

Bibliography: Watercolor in Dessins, Vitraux, no. 6 (upside down).

[R.b.33b]

This differs only in the addition of a central yellow trellis.

8.5 (3¾) measured on the Heaton watercolor

Photographs: Corpus Vitrearum USA

Bibliography: "Border from Reims (O. Merson)," full-size watercolor, Heaton Collection II, p. 26; Merson, 1895, fig. 54 (not colored).

[R.b.33c]

Another version, with the palmettes growing from a vertical stem at one side, may not be an accurate rendering.

Bibliography: Merson, fig. 46 (with R.o.5 or a variant).

R.b.31

R.b.33b

R.b.32

R.b.33a

R.b.33C

R.b.34. France, Amiens, Musée de
Picardie, Inv 87.4, 34, 35, 37, 39, 45 (D,
1-5)

A substantial white stem forms a me-
ander dividing red from blue grounds;
it has interlaced spiral offshoots bearing
blue, green, and yellow palmettes or
grape leaves and clusters of green ber-
ries or grapes.

14.3 (5⅝)

Photographs: Musée de Picardie

Bibliography: Photograph in Musée des
Arts Decoratifs, Paris, Album 482/5.

*Comparisons: A: capital in wall arcade of
Lady Chapel, Saint-Remi (photo: Cavi-
ness); B: reused sculpture of ca. 1170–
1180, north transept of Reims Cathedral
(photo: S.P.A.D.E.M.); C: Reims,
B.M. MS 460, F. 218 (photo: Caviness);
Canterbury Cathedral, north choir aisle
n.XV (Caviness, 1981, fig. 172a); Lost
border from Reims Cathedral (Ottin,
1896, fig. 148; Kline, 1983, p. 275: after
Ottin, but as a Saint-Remi border).*

[R.b.34a]

No grape leaves, or bunches of grapes
on the red ground, are shown.

Ca. 22.5 (8⅞)

Photographs: Musée des Arts Decoratifs

Bibliography: Watercolor in Dessins, Vi-
traux, no. 13; Cahier and Martin, 1841–
1844, Mosaïques, Bordures etc. M, 13.

R.b.34

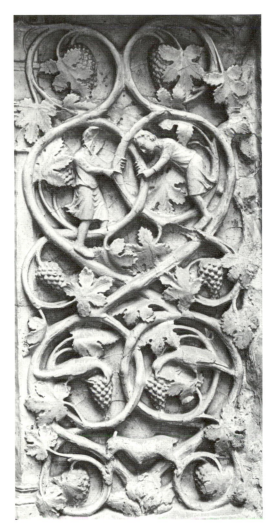
R.b.34B

R.b.34a

R.b.34A

R.b.34C

R.b.35. Nt. 11 c, 4, 6, 7, 9, 10, 12, 19–21, fragments in 16, 18 (Col. Pl. 17); United States, Pennsylvania, Bryn Athyn, Glencairn Museum, 03.SG.145

On a blue ground two white stems form ellipses joined by green quatrefoil flowers; purple and green palmettes fill the lower part of each ellipse, and from them spring a pair of yellow fronds that pass behind the stems to fill the lateral spaces.

10 (4)

Photographs: S.P.A.D.E.M. (and Glencairn Museum)

Bibliography: Cahier and Martin, 1841–1844, Grisailles E, 6 (with R.o.6); Kline, 1983, p. 274, pl. 125 (after Cahier and Martin); Michael Cothren in *Corpus Vitrearum USA Checklist* II, p. 107.

Comparisons: A: Sculptured fragment of "tomb of Hincmar," ca. 1130–1150, Musée Saint-Remi (photo: Caviness); B. Canterbury Cathedral type K (Caviness, 1981, p. 218, fig. 377; photo: NMR); C: Strasbourg Cathedral, late twelfth century (Zschokke, 1942, no. 18); Cologne, St. Cunibert (Day, 1909, fig. 259); see also Kline, 1983, p. 274.

[R.b.36]

Two white stems form ellipses separating red and blue grounds, and are joined by trefoil shoots; green, white and blue palmettes fill the lower part of each ellipse, and from them springs a pair of green vine leaves that pass in front of the main stems and fill the lateral spaces.

Ca. 14.5 (5¾)

Photographs: Musée des Arts Decoratifs

Bibliography: Watercolor in Dressins, Vitraux, no. 8.

Comparisons: R.b.35 appears similar, but not the same unless the drawing is inaccurate.

 R.b.35
 R.b.35A
 R.b.35B
 R.b.36
 R.b.35C

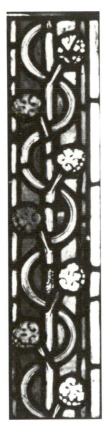

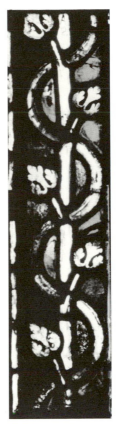

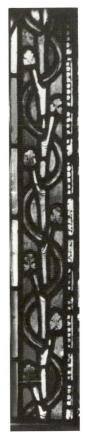

R.b.37 R.b.38 R.b.39 R.b.39a R.b.39aB

R.b.37. N.II a, 6; N.II b, 4, 6, 9 (in old leads); N.II c, 6, 10, 13, 15 and fragments in 4, 7, 9 (all cut in half lengthwise)

White circles with yellow quatrefoil flowers at their intersections separate blue and red grounds; they are filled by blue and green palmettes and stems counterchanged.

16 (6¼)

Photographs: Caviness

Comparisons: C.b.3; B/R ? b.2.

R.b.38. N.VI a, 5 panels in sides; N.VI c, the same and 10, 12, 13, 15 (Col. Pls. 2, 3)

On the red ground, blue circles filled by yellow flowers are separated by three pairs of white leaves interspersed with blue calyxes.

9.50–10 (3¾–4)

Photographs: S.P.A.D.E.M.

Comparisons: Canterbury Cathedral, Trinity Chapel s.VI (Caviness, 1981, fig. 335).

R.b.39. St. II b, 10, 12 and all panels above

A central white stem divides red and blue grounds and sprouts yellow and purple cinquefoil "grape" leaves with fruit; a white meander passes through the fork of each leaf stem.

13.5 (5¼), includes two fillets that are overlapped

Photographs: S.P.A.D.E.M.

Bibliography: Cahier and Martin, 1841–1844, no. 8 (though the leaves do not have berries).

R.b.39a. France, Amiens, Musée de Picardie, Inv. 87.4.33, 36 (A, 1-2)

Differs from R.b.39 in the trefoil form of the leaves, which alternate blue and purple, and the green color of the meander

12.5 (5)

Photographs: B. Marq, Reims

Bibliography: Photograph, Musée des Arts Decoratifs, Paris, Album 482/5

Comparisons: A: Orbais, Abbey Church, east crucifixion window (see Pl. 213); B: Soissons Cathedral, St. Giles window (photo: S.P.A.D.E.M.); Chartres Cathedral, Joseph window LXI (all are noted in Kline, 1983, pp. 104, 246–47, 275; the leaves are closer to R.b.39a).

R.b.40. s. vi a, 7

On a red ground white arches in scale formation with a red quatrefoil flower at the intersections are in front of yellow and blue palmettes.

18 (7⅛)

Photographs: S.P.A.D.E.M.

Bibliography: Watercolor in Dessins, Vitraux, no. 4.

Comparisons: R.b.35; A: Troyes Cathedral, n.XIX, ca. 1200 (Merson, 1895, fig. 53; Pastan, 1986, pp. 104–5, pls. 16, 17; photo: Pastan).

R.b.41. N.vi b, all but 1–3

(fragments only in 4 and 6)

On a white cross-hatched ground, blue and green arches in scale formation with yellow quatrefoil flowers at the intersections are in front of purple, red, and white palmettes.

17 (6¾)

Photographs: S.P.A.D.E.M. (illus. pre-restoration)

Comparisons: A: Canterbury Cathedral, St.XI, 14–17 (Caviness, 1981, p. 74, fig. 145; photo: Caviness/Conway); B: Strasbourg Cathedral, late twelfth century (Zschokke, 1942, no. 17).

R?b.42. United States, Pennsylvania, Bryn Athyn, Glencairn Museum, 03.SG.25

White stems from elipses with green quatrefoils at the intersections and divide red from blue grounds; in each elipse, yellow and purple trefoil leaves alternate in color and direction of growth.

11 (4¼)

Photographs: Glencairn Museum

Bibliography: Michael Cothren in *Corpus Vitrearum USA Checklist* II, p. 106; see also Catalogue C.

Comparisons: R.b.8–10 and 12; Orbais, clerestory I (see Pl. 143).

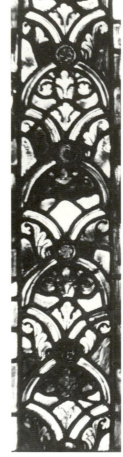

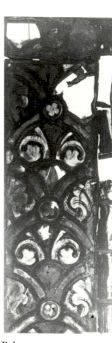

R.b.40 R.b.40A R.b.41

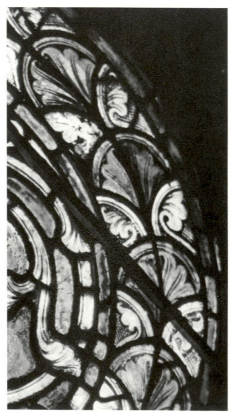

R.b.41A

R.b.41B

R?b.43. France, Amiens, Musée de Picardie, Inv 87.4.42 (F)

Interlocking white hoops with alternating red and blue grounds are partially filled by green, yellow and purple palmettes.

12 (4¾)

Photographs: Musée de Picardie

Comparisons: R.b.21.

R?b.44. United States, Pennsylvania, Bryn Athyn, Glencairn Museum, 03.SG.128

Blue and white palmettes on a red ground spring from yellow calyxes.

Ca. 15 (5⅞)

Photographs: Glencairn Museum

Bibliography: Michael Cothren in *Corpus Vitrearum USA Checklist* II, p. 112.

Comparisons: R.b.12 (palmettes without trellis); R.b.40 (foliage); the stopgap in the center is of the same design as fill between the borders leaded into double panels in Amiens, e.g., R.b.12 and R?b.43.

R?b.45. United States, Pennsylvania, Bryn Athyn, Glencairn Museum, 03.SG.129

White hoops divide red and blue grounds; palmettes spring from demi-rosettes to curl over the hoops, and the intervals are filled with leaves of the same three colors.

Ca. 19 (7½)

Photographs: Glencairn Museum

Bibliography: Michael Cothren in *Corpus Vitrearum USA Checklist* II, p. 108.

Comparisons: R.b.19–24; A: Strasbourg Cathedral, late twelfth century (Zschokke, 1942, no. 11).

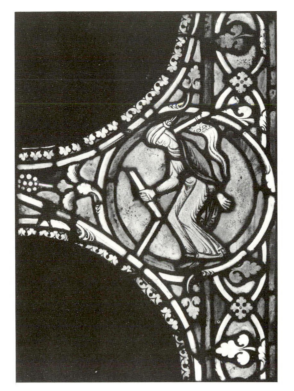

R?b.42

R?b.43

R?b.44

R?b.45

R?b.45A

C.0.1. rosettes; **C.0.2.** bottom corners: Trinity Chapel n.IV, in situ

On a blue ground, white stems with green and purple foliage radiate from a yellow wreath filled by a green quatrefoil leaf.

Diameter 30 (11⅞) for rosettes; 25 square (9⅞) for corners

Photographs: R.C.H.M.E and Caviness/Conway

Bibliography: Caviness, 1981, pp. 180–81, pl. XIII.

Comparisons: R.b.18, R.b.34.

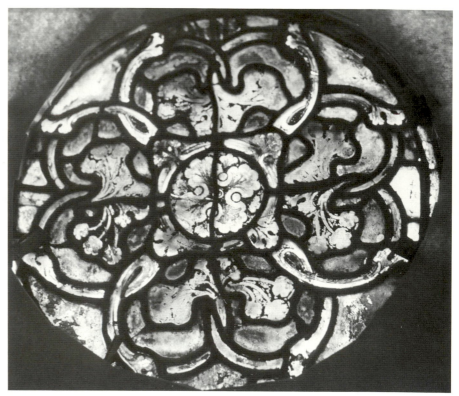

C.0.1

C.0.2

C.b.1. Trinity Chapel, n.IV, in situ

White hoops spaced at intervals divide red and blue grounds with blue, green, yellow, and purple palmettes and berry clusters.

17 (6¾)

Photographs: R.C.H.M.E.

Bibliography: Caviness, 1981, pp. 180–81, fig. 256, pl. XIII.

Comparisons: R.b.15–16, R.b.22–23; R.b.24a; A: Orbais Abbey Church, S.II b (Kline, 1983, pl. 41, pp. 244, 268–69; photo: S.P.A.D.E.M.; B: Reims Cathedral, north transept portal, reused late twelfth-century sculpture (photo: S.P.A.D.E.M.); C: Psalter, northern France or Flanders late twelfth century, B.N. MS lat. 833, f. 184 (photo: B.N.); Premonstratensian Missal, Champagne or Soissonais, ca. 1200, B.N. MS lat. 238, f. 187v (see R.b.24a, B).

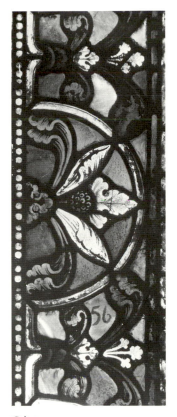

C.b.1 C.b.1A

C.b.1B

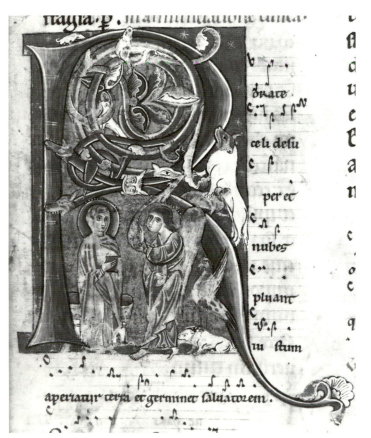

C.b.1C

C.b.2. Trinity Chapel s.IV (possibly not in situ), and private collection

Pairs of white fronds form heart-shaped frames, dividing red and blue grounds; they contain palmettes of green, yellow, purple, and white leaves, with green shoots between them.

17 (6⅝), without fillets

Photographs: Caviness/Conway (and R.C.H.M.E.)

Bibliography: Caviness, 1981, pp. 203–4, 315 no. 13; Grodecki and Brisac, 1977, pl. 185.

Comparisons: R.b.31; R.b.35; B/R?b.3; A: Canterbury Cathedral type L (and Sens Cathedral St. Eustace window; Caviness, 1977a, figs. 177–78; Caviness, 1981, p. 218, fig. 378; photo R.C.H.M.E.)

C.b.3. Trinity Chapel N.III in situ

White circles, spaced apart, divide red and blue grounds; a central green stem has alternating yellow and white calyxes with pairs of purple or blue leaves.

23 (9)

Photographs: Caviness/Conway (and R.C.H.M.E.)

Bibliography: Caviness, 1981, p. 185.

Comparisons: R.b.37; B/R?b.2; Canterbury, Trinity Chapel N.II, and Sens Cathedral, Becket window (Caviness, 1977a, figs. 175 [inverted] and 176).

C.b.4. Trinity Chapel N.VI in situ

Yellow hoops springing from blue demi-quatrefoil flowers divide red and blue grounds; between them are single green leaves, and within, pairs of white leaves grow in reverse direction, from the apex.

18 (7⅛), with fillets

Photographs: Caviness/Conway

Bibliography: Caviness, 1981, p. 43, fig. 71.

Comparisons: R.b.17; R.b.20.

C.b.2

C.b.2A

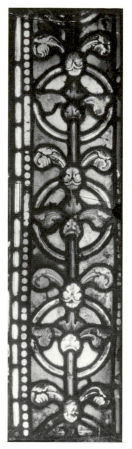

C.b.3

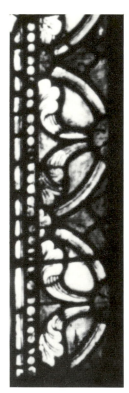

C.b.4

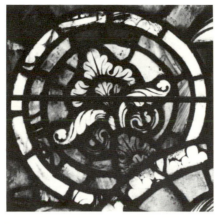

B.o.1

B.o.1A

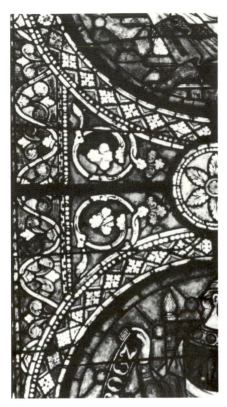

C.b.5/6

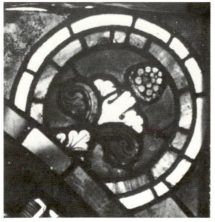

B.o.2

B.o.2A

C.b.5. Trinity Chapel N.IX, outer border

A white meander stem divides red and blue grounds; from it, palmettes of green or purple and white grow in opposite directions.

14.7 (5¾)

Photographs: Caviness/Conway

Bibliography: Caviness, 1981, p. 37, fig. 59.

Comparisons: R.b.24 and 24a; R.b.25.

C.b.6. Trinity Chapel N.IX, border to medallions

On a blue checkered ground, alternating purple and white lozenges are painted with quatrefoil leaves.

7 (2¾), without fillets

Photographs: Caviness/Conway

Bibliography: Caviness, 1981, p. 37, fig. 59.

Comparisons: R.b.1; R.b.2a; R.b.4.

B.o.1. Four foliate lobes from the transept roses (Pl. 244): France, Aisne Soissons, Cathedral of Saint-Gervais et Saint-Protais, baie 103 (above Jechonias, Col. Pl. 20); and United States, Pennsylvania, Bryn Athyn, Glencairn Museum, 03.SG.230 (above Jacob)

On a blue ground, a dense palmette has green, purple, white and yellow leaves.

26 × 28.4 (10¼ × 11¼), including red fillet

Photographs: Caviness (Glencairn Museum; and S.P.A.D.E.M.)

Bibliography: See Catalogue A, nos. 3 and 8.

Comparisons: R.b.40; C.b.2; A: Laon Cathedral, north rose, ca. 1180 (photo: S.P.A.D.E.M.).

B.o.2. Four foliate lobes from the transept roses (Pl. 244): France, Aisne, Soissons, Cathedral of Saint-Gervais et Saint-Protais, baie 103 (above Amminadab and Salathiel, Col. Pl. 20)

On a blue ground, a palmette of green, purple (?), and white terminates in a yellow berry cluster (the colored glass is very corroded).

26 × 28.4 (10¼ × 11¼)

Photographs: S.P.A.D.E.M.

Bibliography: See Catalogue A, nos. 1 and 4.

Comparisons: R.b.22–24a; A: Laon Cathedral, north rose, ca. 1180 (photo: S.P.A.D.E.M.)

B?b/1. United States, California, Glendale, Forest Lawn Memorial Park

White kidney-shaped stems, with green quatrefoils at their intersections and blue berry clusters between, separate red and blue grounds; they are filled with palmettes of alternating color combinations of white, yellow, and purple springing from green trefoils.

16 (6¼)

Photographs: C. del Alamo

Bibliography: Demotte, 1929, no. 14 (with King David from the Braine clerestory: Catalogue A, nos. 15, 16); *Corpus Vitrearum USA Checklist* III, p. 47–48.

Comparisons: B.o.1 and 2; R.b.14; Canterbury type I (see R.b.14: A); Premonstratensian Missal, Champagne or Soissonais, ca. 1200, B.N. MS lat. 238 f. 187v (see R.b.14: B); A: Missal from Saint-Remi, Reims, ca. 1200 (with later calendar), Reims B.M. MS 229 f. 11 (photo: Caviness).

B/R?b.1. United States, New York, Metropolitan Museum of Art, Cloisters Collection, 1978.408.1 and 2

A white stem forms alternating circles and double arches, dividing red from blue grounds; the circles are filled with yellow, green, and blue foliate bosses, the arches with elaborate palmettes of green, yellow, white, and purple leaves and green berry clusters.

18 (7⅞)

Photographs: Metropolitan Mueseum of Art

Bibliography: Jane Hayward in *Corpus Vitrearum USA Checklist* I, p. 96.

Comparisons: B.o.1 and 2; R.b.15; R.b.24; R.b.34; Canterbury type A (see R.b.15: A).

B?b/1

B/R?b.1

B?b.1A

B/R?b.2. United States, Pennsylvania, Bryn Athyn, Glencairn Museum, 03.SG.135; New Jersey, Princeton, The Art Museum, 46–103

Tangential white circles separate red and blue grounds; a central yellow stem has green, blue, yellow, and white palmettes that fill the circles.

Ca. 21.3 (8⅜)

Photographs: Glencairn Museum (and Princeton)

Bibliography: *Corpus Vitrearum USA Checklist* II, pp. 75, 114.

Comparisons: R.b.37; C.b.3.

B/R?b.3. United States, Pennsylvania, Bryn Athyn, Glencairn Museum, 03.SG.147

White stems form teardrop-shaped compartments dividing red and blue grounds; they are filled by yellow, blue, white and green palmettes with leaves extending to curl around the stems (the light blue bird probably is not part of the original design).

15.5 (6¼)

Photographs: Glencairn Museum

Bibliography: *Corpus Vitrearum USA Checklist* II, p. 110.

Comparisons: R.b.31; R.b.35 and 36; C.b.3; Canterbury type K (see R.b.35: B).

B/R?b.4. United States, Pennsylvania, Bryn Athyn, Glencairn Museum, 03.SG.144

White stems form kidney-shaped compartments joined by green rosettes and dividing red and blue grounds; they are filled by green, yellow, and purple palmettes.

Ca. 13 (5⅛)

Photographs: Glencairn Museum

Bibliography: Michael Cothren in *Corpus Vitrearum USA Checklist* II, p. 105.

Comparisons: [R.b.14]; R?b.43; B?b.1; Canterbury types I and J (see R.b.14)

 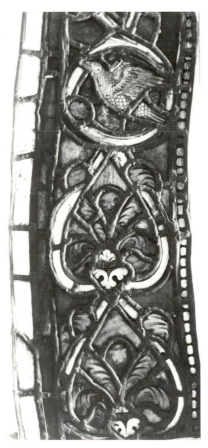

B/R?b.2 B/R?b.3

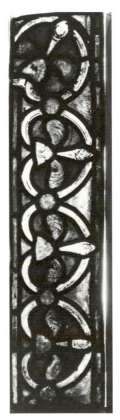

B/R?b.4

B/S.b.1. United States, Pennsylvania, Bryn Athyn, Glencairn Museum, 03.SG.134

White hoops divide red and blue grounds; they are filled by palmettes of yellow, green, and purple that spring from a white demi-flower and entwine with the hoop.

20.5 (8⅛)

Photographs: Glencairn Museum

Bibliography: Michael Cothren in *Corpus Vitrearum USA Checklist* II, p. 112.

Comparisons: C.b.1.

B/S.b.2. United States, Pennsylvania, Bryn Athyn, Glencairn Museum, 03.SG.154

A white band zigzags between demi-quatrefoil flowers dividing red from blue grounds; the angles are filled with palmettes alternating white, green, and light blue with white, yellow, and purple.

20.5 (8⅛)

Photographs: Glencairn Museum

Bibliography: Watercolor in Dessins, Vitraux, no. 12; Michael Cothren in *Corpus Vitrearum USA Checklist* II, p. 113.

Comparisons: Canterbury Trinity Chapel S.X (Caviness, 1981, p. 54. fig. 92).

B/S.b.3. United States, Pennsylvania, Bryn Athyn, Glencairn Museum, 03.SG.136

On a red ground, simple palmettes of white with alternating pairs of green and blue shoots form a chain.

18.25 (7⅜)

Photographs: Glencairn Museum

Bibliography: Watercolor in Dessins, Vitraux, no. 1; Michael Cothren in *Corpus Vitrearum USA Checklist* II, p. 113.

Comparisons: Canterbury N.XXII and type F (Caviness, 1981, pp. 19, 217, figs. 47, 372).

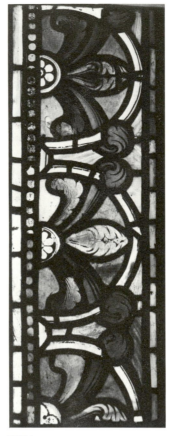

B/S.b.1

B/S.b.3

B/S.b.2

B/S. b.4. United States, Pennsylvania, Bryn Athyn, Glencairn Museum, 03.SG.233; 03.SG.130–133 and 174; Baltimore, Walters Art Gallery, 46.41

On a red ground, simple palmettes form a chain; pairs of blue shoots and white centers alternate in the Glencairn version with blue and green, in the Baltimore version, with white and yellow

17.5–22 (6⅞–8⅝)

Photographs: Glencairn Museum

Bibliography: Michael Cothren in *Corpus Vitrearum USA Checklist* II, pp. 57, 111–12.

B/S. b.5. United States, Washington, Corcoran Gallery of Art, 26.793; Baltimore, Walters Art Gallery, 46.40; Pennsylvania, Bryn Athyn, Glencairn Museum, 03.SG.235

On a red ground, leaves are arranged in saltire, paired diagonally white and blue around alternating yellow and green quatrefoil flowers.

16–18 (6¼–7⅛)

Photographs: Glencairn Museum (and Corcoran and Walters)

Bibliography: Michael Cothren in *Corpus Vitrearum USA Checklist* II, pp. 28–29, 57, 111.

Comparisons: R.b.11.

B/S. b.6. United States, Pennsylvania, Bryn Athyn, Glencairn Museum, 03.SG.244, 245

White stems divide red and blue grounds and form a figure of eight between flowers; from a yellow lozenge painted with a quatrefoil leaf at the center of the figure eight spring two palmettes of blue or green and white.

20.3 (8)

Photographs: Glencairn Museum

Bibliography: Michael Cothren in *Corpus Vitrearum USA Checklist* II, p. 113.

[B/S. b.6a]

Differs only in that single green leaves fill the lateral spaces between the figure eights.

Photographs: Musée des Arts Decoratifs

Bibliography: Watercolor in Dessins, Vitraux, no. 5.

B/S.b.4

B/S.b.5

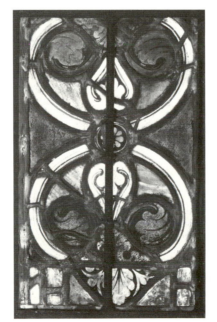

B/S.b.6

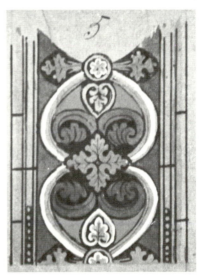

B/S.b.6a

B/S?b.7. United States, Pennsylvania, Bryn Athyn, Glencairn Museum, 03.SG.137

Tangential white circles on red and blue grounds have yellow quatrefoil leaves at the intersections from which spring pairs of leaves alternating purple and green. Yellow demi-flowers are placed to the sides between the circles.

27 (10⅝), including fillets

Photographs: Glencairn Museum

Bibliography: Michael Cothren in *Corpus Vitrearum USA Checklist* II, p. 114 (this is the only one of the group not documented in Soissons Cathedral by Cahier and Martin).

Comparisons: B/S?b.6a; B/R?b.2; C.b.3 and Trinity Chapel n.II/Sens.

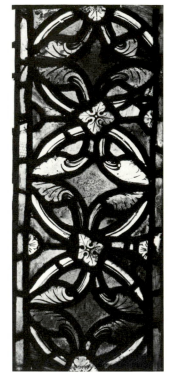

B/S?b.7

ICONOGRAPHIC INDEX

INDEX OF PROPER NAMES, PLACE DESIGNATIONS, THE DECORATIVE ARTS, THEIR DESIGN MOTIFS AND TECHNIQUES